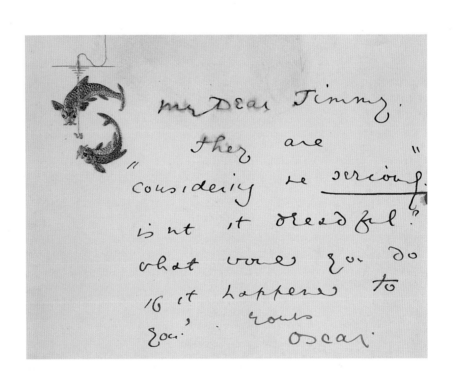

UNEASY PIECES

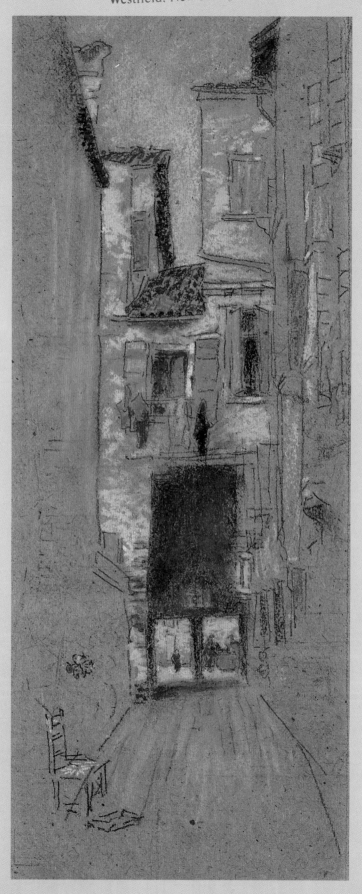

James McNeill Whistler
UNEASY PIECES

by David Park Curry

VMFA

Virginia Museum of Fine Arts, Richmond
in association with The Quantuck Lane Press, New York

Copublished by The Quantuck Lane Press; hardcover trade edition available at www.quantucklanepress.com

Layout and Composition by John Bernstein Design, Inc., New York

Printed in Verona, Italy

LIBRARY OF CONGRESS CATALOGING-IN-PUBLICATION DATA

Curry, David Park.

James McNeill Whistler: uneasy pieces / David Park Curry — 1st ed.

p. cm.

Includes bibliographic references.

Hardcover: ISBN 1-59372-001-7 | Softcover: ISBN 0-917046-67-6

1. Whistler, James McNeill, 1834–1903 — Criticism and interpretation.

2. Modernism (Art) I. Title.

N6537.W4C87 2004

760.092—dc22 2003019877

Jacket illustration: James McNeill Whistler (1834–1903), *Symphony in White, No. 2: Little White Girl* (see fig. 7.41)

Copyright © Tate Gallery, London / Art Resource, NY

Back jacket portrait by London Stereoscopic Company, 1878 (see fig. 8.14)

Courtesy Glasgow University Library, Department of Special Collections

FIG. F.1: *Notecard*, Oscar Wilde (1854–1900), Chicago, to James McNeill Whistler, London, February 1882.

"My Dear Jimmy. They are 'considering me *seriously*.' Isn't it dreadful? What would you do if it happened to you? Yours, Oscar."

Glasgow University Library, Special Collections, W 1042 [BPII 35.5]

FIG. F.2: (FRONTISPIECE) James McNeill Whistler, *Sotto Portico—San Giacomo*,

1879–80, pastel and charcoal on brown wove paper, 12 x 5½ inches.

VMFA, The J. Harwood and Louise B. Cochrane Fund for American Art, 2002.524

BUTTERFLIES

A number of Whistler's little butterfly drawings adorn the chapter titles in *Uneasy Pieces*. Designed by the artist to express his mood in connection with the texts they illustrated originally, each has been pulled from the 1892 edition of Whistler's book *The Gentle Art of Making Enemies*. Here, the butterflies adorning chapters one through eight come from pp. 183, 261, 39, 60, 172, 73, 120, and 335 respectively. Whistler's butterflies evolved out of his initials — "J. M.W." — gradually changing from a geometric cipher to animated anthropomorphic insects, some of them armed with barbed stings in their tails. Whistler's easily recognized butterflies are best understood today as his personal trademark or logo, used to sign individual works of art, pieces of private correspondence, pages of published commentary, and even entire gallery walls.

Contents

6

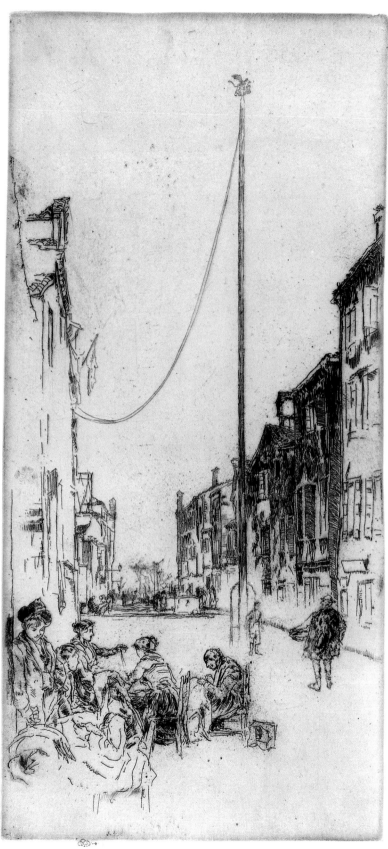

F.3

Foreword

A CENTURY AFTER WHISTLER'S BIRTH IN 1834, etchings by this American expatriate were among the first artworks to enter the permanent collection of the Virginia Museum of Fine Arts. Founded in 1934, VMFA opened its doors to the public two years later with the special exhibition *Main Currents in the Development of American Painting*. On view were twenty-three impressions by Whistler, ranging from his earliest French tenement subjects to images of the industrialized Thames River and poetic glimpses of old Venice, including *The Mast* [fig. F.3].

Since then, the Museum has continued to seek fine examples of Whistler's art. Most recently, we acquired *Sotto Portico—San Giacomo*, an elegant Venetian pastel featured as the frontispiece to this book. Like *The Mast*, *Sotto Portico* was one of many Italian works created at a significant turning point in Whistler's career. Facing financial ruin after his London bankruptcy in 1879, Whistler spent a brief but fruitful sojourn in Venice, producing new work in a determined campaign to recoup his fortunes. Armed with beautiful prints, pastels, and paintings deemed radical for their time, Whistler returned to London, and during the 1880s he mounted a series of carefully orchestrated exhibitions that revolutionized the public presentation of fine art.

The context in which that revolution took place was both complex and controversial. At present, as VMFA embarks on the biggest expansion in its 68-year history, a timely review of Whistler's career reminds us that theories concerning the display of art in public galleries have changed greatly with time; and that exhibition design is an elaborate decision-making process with an immediate impact upon the viewer's perception of the art on display.

Uneasy Pieces is an innovative monograph by our Curator of American Arts, Dr. David Park Curry, a noted Whistler specialist. Formerly Curator of American Art at the Freer, he wrote *Whistler at the Freer Gallery of Art* in 1984, celebrating the 150th anniversary of the artist's birth in 1834. This new book, which appears just after the centennial of the artist's death, typifies VMFA's commitment to original scholarship brought forth in well-designed publications. Dr. Curry's research and publication have been supported by the Luce Foundation for American Art, the J. Paul Getty Trust, and FLOWE, a private Denver foundation. In these pages, seven richly illustrated essays link Whistler and his oeuvre to issues of performance, fashion, and display. An eighth chapter revisits *Arrangement in White and Yellow*—Whistler's first one-man exhibition to tour the United States during his lifetime, giving Americans their first taste of the white gallery walls that would become commonplace in the twentieth century.

Whistler's paintings, drawings, and prints offer exquisite beauty. But his career also lets us reflect upon the ways we encounter art, and how—once perceived—the contextual circumstances of both creation and presentation enhance and enrich our experience.

—Michael Brand, *Director*

FIG. F.3 Whistler, *The Mast*, 1879–80, etching, 5th state, K195, 13¼ x 6⁵⁄₁₆ inches.
VMFA, Bequest of John Barton Payne, 35.1.44.

Acknowledgments

ONE DARKENING FEBRUARY AFTERNOON, as I was conducting research for this book in the archives at the Fine Art Society in New Bond Street, London, the guitarist Julian Bream came in to rehearse for a concert he would present in the gallery later that evening. Mr. Bream left the door that separated us slightly ajar. Disconnected snatches of his lyrical music floated out from time to time as I paged through old ledgers hoping to make sense of Whistler's tangled finances in the late 1870s and early '80s, the years bracketing his Venetian sojourn.

Before he went to Italy, Whistler was actively involved with the London theater, both as an observer and as an amateur actor. One of my favorite works from this period is a diminutive oil on panel, *Harmony in Blue: The Duet* [fig. F.4].[1] Several costumed performers occupy a stage. A pair of rather small figures seems to be holding forth. Perhaps they are young lovers. The other character might have wandered in from the commedia dell'arte. Wearing tights and a tricornered hat, he vaguely resembles Harlequin, an "infinitely repeated, theatrically persuasive" character whose lasting power is something of an enigma.[2] We might say the same of Whistler.

The presence of this third figure in Whistler's *Duet* is unexplained. He looks on, elbows aggressively akimbo. Harsh stage lighting casts somewhat sinister shadows. There is no scenery. Perfectly balanced, empty space and eloquent color synthesize into the disquieting beauty often found in Whistler's work. Interpretation falls to the viewer.

When I look at the painting, I am reminded—as I was when I overheard Julian Bream practicing pieces ranging over several hundred years—how layers of ideas underlie those currently being expressed; and how myriad components of *any* performance take place behind the scenes. So it is with the creation of a book. In finally completing *Uneasy Pieces*, I am indebted to so many organizations and individuals that it feels like a cast of thousands. Without innumerable contributions by many friends and colleagues in Britain and the United States, no curtain could now go up.

I am particularly indebted to Estelle Wolfe and the F.L.O.W.E. Foundation of Denver. Without her initial support, this project would never have developed beyond the conceptual stage. For both generous funding and fathomless patience, I gratefully acknowledge the Henry Luce Foundation for American Art, New York, with special thanks to Mary Jane Crook and Ellen Holtzman. The J. Paul Getty Trust injected new life into the project with the award of a Curatorial Fellowship that allowed, among other things, a very fruitful time in Venice, comparing Whistler's images to surviving sites, and an uninterrupted period of research in British archives and museums. The Virginia Museum of Fine Arts has supported the project not only with additional funding, through the Elisabeth Shelton Gottwald Fund, but also with the gift of time, the resource most precious to anyone attempting sustained thinking amidst the demands of the current museum environment. To our very special museum patrons, Harwood and Louise Cochrane, many thanks for the

beautiful Whistler pastel that serves not only as a frontispiece to this book but also as a sparkling new jewel in VMFA's permanent collection of American Art.

Colleagues at VMFA facilitated many aspects of my work, from the initial outline through the writing of grants to the final preparation and publication. Elizabeth O'Leary, Associate Curator of American Arts here at the Virginia Museum of Fine Arts, has aided the project unceasingly, helping to corral, control, and analyze the disparate materials on which these essays rest. At the same time, she has carried much of the burden of running a small but active curatorial department where the devil is in the details, freeing me to wrestle with the research. I offer her my deepest thanks. The unfailing skills and limitless good cheer of Head Fine Arts Librarian Suzanne Freeman, along with Doug Litts, Rebecca Dobyns, and Courtney Yevich, are reflected in this book. I fondly thank Chief Operating Officer Carol Amato for a decade of strategic support and personal friendship. In the museum administration, I am also grateful to Director Michael Brand, Curatorial Chair Joseph M. Dye III, and Kathy Morris, Associate Director, Exhibitions and Collections Management. I thank recently retired curator Malcolm Cormack, who shares my delight in arcane aspects of British history; Chief Graphic Designer Sarah Lavicka, who has enhanced my commitment to beautiful graphics; and Editor-in-Chief Rosalie West, who understands my love of the written word. Sharon Casale in the development office was instrumental in successful grantsmanship for this project. Curatorial executive secretary Connie Morris helped maintain order in the manuscript and its gradual transfer to New York. Photo researcher Stacy Moore performed the miracle of the transparencies. Without her, the images in this book would never have been assembled

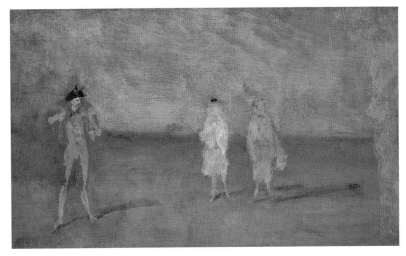

F.4

from an international array of public and private sources in time to be included here. Ably assisted by Susie Rock, the talented Katherine Wetzel and Denise Lewis ensured that in-house photography was of the finest quality. Howell Perkins assisted with permissions. Research interns and curatorial assistants who contributed substantially to the project include Caroline Smith Older, Mark Sprinkle, Jonathan Stuhlman, and Robin Hoffman. I am also grateful to a number of summer interns from Randolph Macon Woman's College, Lynchburg, Virginia.

For significant impact on my ideas as expressed in these essays I thank restoration architect Jared I. Edwards, with whom I studied the premises of the Fine Art Society and related architecture in London, as well as countless architectural drawings by E. W. Godwin at the Victoria and Albert Museum. Special thanks also to Nigel Thorpe, director of the Centre for Whistler Studies at Glasgow University, who granted me early access to the Whistler correspondence electronic archive. Martha Mayer Smith, paper conservator at the Freer Gallery of Art, who did so much to facilitate my 1984 Whistler catalogue, once again shared her insights and common sense as we pored over numerous exquisite Venetian proofs gathered

9

by Charles Lang Freer more than a century ago. Sinclair Hitchings and Karen Shafts facilitated a similar experience at the Boston Public Library Department of Prints and Drawings, as did Patrick McMahon and Alan Chong at Boston's Isabella Stewart Gardner Museum. Roberta Waddell and her staff at the New York Public Library graciously accommodated my numerous visits, as did Martha Tedeschi at the Art Institute of Chicago. I also thank the prints and drawings staff at both the British Museum and the Boston Museum of Fine Arts. I am grateful to Doreen Bolger and H. Barbara Weinberg for our work together on *American Impressionism and Realism: The Painting of Modern Life, 1885–1915*. Though it interrupted this project, it expanded the scope of inquiry immeasurably.

I have benefited greatly from perceptive insights shared by colleagues who read the text at various junctures as it evolved into its current form. Both during and after her long and fruitful tenure as Curator of American Art at the Freer Gallery, Linda Merrill has been unfailingly generous with her deep knowledge of Whistler, including his confusing foibles that can lure the less informed into dangerous waters. Erica Hirshler, Curator of American Art at the Boston Museum of Fine Arts, took time from her own busy research and writing schedule to read the manuscript at a crucial point, helping me to situate it against overarching issues in American art. And Eileen Mott, Exhibitions Coordinator at VMFA's Center for Education and Outreach— and constant reader—perused the manuscript to ensure that the text remained accessible to a general audience.

Since I began the project, I have had the opportunity to test out some of these ideas in lectures and symposia. I am grateful to responsive audiences at the Art Institute of Chicago, and, in Washington, D.C., the National Gallery of Art, the National Portrait Gallery, the Freer Gallery of Art, the Smithsonian Associates, and the Washington Design Center. I thank the universities of Georgia, Kansas, Michigan, Virginia, and Glasgow. I am especially grateful to Lisa Konigsberg and the department of continuing education at New York University. I also thank Augustana College, Rockville, Illinois; the Frick Collection, New York; the Virginia Museum of Fine Arts, Richmond; and the English Speaking Union in London.

I appreciate permission to revisit parts of the text that appeared earlier in the pages of *The Magazine Antiques* and in a catalogue essay for *Whistler and Godwin*, an exhibition at the Fine Art Society in 2001. I thank Allison Ledes, Eleanor Gustafson, Andrew Patrick Mackintosh, Peyton Skipwith, and Max Donneley. I am also grateful for the opportunity to use archival materials as cited in the endnotes.

Friends and colleagues in other institutions were generous with time and help. I thank Katharine Lochnan at the Art Gallery of Ontario; Judith Barter at the Art Institute of Chicago; George T. M. Shackelford at the Museum of Fine Arts, Boston; Giles Waterfield, formerly of the Dulwich Picture Gallery; and Rebecca Barker, Elizabeth Dooley, Colleen Hennessey, Linda Machado, Josephine Rodgers, and Kenneth John Myers at the Freer Gallery of Art, Smithsonian Institution. I also thank Julian Raby, Director of the Freer Gallery of Art and the Arthur M. Sackler Gallery, along with Karen Sasaki, Dennis Kois, and his team for the elegant exhibition *Mr. Whistler's Galleries*, which preceded this publication. Thanks to Susan Galassi at the Frick Art Gallery; Pamela Robertson and Peter Black at the Hunterian Art Gallery, University of Glasgow; Richard Campbell and Christopher Monkhouse at the Minneapolis Institute of Art; Kathy Adler at the National Gallery of Art, London; Ruth Fine and Charles Brock at the National Gallery of Art, Washington, D.C.; Moira

Thunder, Amin Jaffer, and Malcolm Baker at the Victoria and Albert Museum; Catherine Carter Gobel and Sherry C. Maurer at Augustana College; and independent scholars Susan Hobbs and Rosemary Smith. Finally, I thank Eli Wilner and Suzanne Smeaton at Eli Wilner and Company, as well as Jonathan Boos, Stacey Epstein, Richard L. Feigen, Debra Force, David Nissensen, and Bruce Weber. Teddy Craig was especially generous with material regarding his illustrious forebear E. W. Godwin.

The staffs of the following institutions were helpful in locating rare books, documents, and objects for this study: American Wing at the Metropolitan Museum of Art, New York; Archives of American Art, Washington, D.C.; Archives of Art and Design, Victoria and Albert Museum, London; Avery Architectural Library, Columbia University, New York; Boston Public Library; British Library, London; Centre for Whistler Studies, Glasgow University; Chelsea Public Library Special Collections; Cooper-Hewitt Museum, New York; Historical Buildings Library of the Greater London Council; Leighton House, London; Library of Congress, Washington, D.C., including the Pennell Collection and the Rare Maps Collection; Museum of London; National Monuments Record, London; National Museum of American Art Library, Washington, D.C.; Royal Institute of British Architects, London; University of the South, Sewannee; Sir John Soane House and Museum, London; Special Collections, Glasgow University Library; The Tate Archive and Westminster Archives, both in London; and Waddesdon Manor, Aylesbury, Buckingham.

In bringing forth his three exhibitions at the Fine Art Society (1880, 1881, 1883), Whistler benefited from the sympathetic pragmatism of gallery director and editor Marcus Huish. Similarly, I have the pleasure of bringing forth a third publication under the able editorship of Jim Mairs, publisher of The Quantuck Lane Press. Assistant publisher Brook Wilensky-Lanford coordinated the effort; John Bernstein transformed heaps of images—high tech and low—into a beautiful publication; the perspicacious copy editor, Donald Kennison, saved the author from many a gaffe; and Mary Gladue developed the index. I hope that unlike Whistler at the Fine Art Society, I will not have worn out my welcome.

Deepest personal thanks to John and Julia Curtis, whose unstinting sustenance over the years have kept me from losing sight of the joy of research and discovery; to my imperturbable brother Jamison, who not only reads Italian maps but also finds they lead to the best restaurants; and to Miss Becky, who has had about enough of "our Jimmie" in her dining room. In 1984 she was awarded a note in pink. This time, it's a symphony.

Reviewing Whistler's amateur performance in *Twenty Minutes Under an Umbrella*, a farce staged as a charity benefit, one journalist observed how Whistler "indulges somewhat too freely in subtleties and refinements, which would make his success in public and before a mixed audience doubtful." The journalist continued, "The same fault is found with his paintings and etchings which, nevertheless, are held in high esteem by the cognoscenti. In his acting, as in his painting, he aims at harmonizing the details of this work in such a way that the whole first strikes the spectator."[3] Having sheltered under various intellectual, archival, and personal umbrellas as noted above, I can only hope that I have given readers a whole that is worthy of the sum of its parts.

David Park Curry, Richmond, Virginia
15 April 2004

Introduction

Expatriate artist, writer, performer, self-publicist, sometime gunrunner, James McNeill Whistler (1834–1903) was one of the most easily misinterpreted creative talents to enliven the second half of the nineteenth century. Devoted to the expression of the beautiful, Whistler's art is characterized by delicacy of palette and line, evanescent brushwork, and somewhat dégagé subjects drawn from modern life but pushed toward abstraction. Yet he was also among the first of his generation to recognize that the popularization of the arts and the commercialization of leisure were complex, interrelated phenomena that made urban life "modern." Whistler's showmanship had far greater impact than countless imitations of his *White Girls* and *The Painter's Mother* might suggest. His purposeful use of past art; his awareness of the collapse of private and public spaces; his ability to tailor his work to the realities of the Victorian marketplace; his understanding and exploitation of changing economic, class, and gender roles; and his clever use of fashion and decoration all lead us to a richer understanding of "modernism" and a broader assessment of Whistler's contribution to it.

My general thesis is a simple one: although he was hailed as a precursor of modern abstraction for much of the twentieth century, Whistler's runic images can be visually grounded not only within his own milieu but also as part of a complex artistic past. This exercise illuminates Whistler's calculated use of tradition to negotiate aesthetic issues within the social and economic confines of his time. A leading advocate of the lessons of Japanese art, Whistler maintained an equally strong commitment to European tradition that is easy to overlook when casting him in the role of avant-garde iconoclast.

Seen as opposite sides of the same coin, Whistler's abrasive behavior and his esoteric art can be reconnected by focusing on shared issues of performance, fashion, and display. If we would genuinely understand the import of Whistler's career for his countrymen, we must look beyond the brief influence of his painting style to consider the significance of his subject matter—some of it preceding the gritty urbanism of the so-called Ashcan school by a quarter of a century. We must also consider his lasting impact on attitudes toward the framing and presentation of art, and the rights of the

artist as creative force, as well as his widely imitated manipulation of the popular press to advance a carefully constructed public persona.

Whistler's emphatically aesthetic paintings, drawings, and prints—made the more inscrutable by his purposefully confusing titles—remain uneasy pieces to the present day. To probe some of these tensions, I have explored the intersection of his determined aestheticism with the commercial art world. In these pages, I have gathered key examples from the artist's oeuvre and set them against related images from both fine art and popular culture drawn from the past two hundred years, using period literature to further amplify the wellsprings of Whistler's inspiration. I hope that a rich program of illustration will allow my arguments to advance through what is *seen* as well as what is read, for Whistler— the artist who claimed to make nonnarrative art—told many a story on canvas and paper.

In a period of unprecedented social and economic change, Whistler's refined artistry served to distance his subject matter from his audience. Similar desires for an aesthetic buffer are expressed in period novels. In *Daniel Deronda* (1876), George Eliot celebrated the beauty of atmospheric perspective. "What horrors of damp huts, where human beings languish, may not become picturesque through aerial distance! What hymning of cancerous vices may we not languish over as sublimest art in the safe remoteness of a strange language and artificial phrase!"[1] Whistler's own visual language, marked by unconventional facture and unpredictable topics, seemed strange indeed to Victorian viewers. They had become accustomed to artworks imbued with easily perceived, didactic narrative delivered in precisely limned, tightly finished compositions. Even portraiture— that long-established mainstay of many an artistic career, including Whistler's own— was not spared his rejection of conventionality. He remarked,

> As the light fades and the shadows deepen, all petty and exacting details vanish, everything trivial disappears, and I see things as they are in great strong masses: the buttons are lost, but the garment remains; the garment is lost, but the sitter remains; the sitter is lost, but the shadow remains; the shadow is lost, but the picture remains. And *that*, night cannot efface from the painter's imagination.[2]

Whistler's daunting ability to turn an artificial phrase was unprecedented among visual artists of his time. The nineteenth-century modernist best known for the self-serving publicity now called "buzz" invested his portraiture with a timelessness that has long outlived the elegant men and women who sat to him.

The years 1877–79 mark a watershed in Whistler's life as an artist. During that brief period, several of the most significant events of his long career transpired in rapid succession. These tumultuous events prove to be interrelated through the common denominators that govern my study—performance, fashion, and display.

In February 1877, *Harmony in Blue and Gold*, Whistler's redecoration of the dining room at a private London residence, was largely complete when he breached the manners of polite society by inviting newspaper critics to view what became known as the "Peacock Room." His patron Frederick Richards Leyland was not at home. Whistler created his decorative scheme to enhance the display of an extensive collection of blue-and-white pottery, not to mention a large canvas, *The Princess of the Porcelain Country*, a significant example of his cutting-edge *japonisme*. The Peacock Room project brought forth one of the great Aesthetic-movement domestic interiors of the late nineteenth century. It also hatched a distasteful, highly public quarrel between the artist and his first major patron.[3] Leyland was a self-made shipping baron whose thirst for refinement made him an avid and generous supporter of then-contemporary avant-garde British painting. Ostensibly about money (the price demanded and refused for unauthorized work), the quarrel actually underscores Whistler's unwavering conviction that an artist's right to self-determination exceeded that accorded ordinary mortals, be they patrons, members of the press, or public onlookers.

That sense of artistic entitlement escalated a few months later in May when Whistler exhibited *Nocturne in Black and Gold: The Falling Rocket* at the Grosvenor Gallery. London's new venue for the commercial display of art was decorated like a sumptuous town house, and its proprietor, Sir Coutts Lindsay, committed the gallery to showing the latest contemporary artistic developments.[4] But growing critical discontent over the expatriate Whistler's saucy public posturing, unfinished style, and inscrutable musical titles exploded into another controversy when John Ruskin, then the single most influential art critic in Europe, found Whistler's *Falling Rocket* unacceptably abstract. Ruskin dismissed both the artist and his work with a now-infamous commentary on the "eccentricities" found in "pictures of the modern schools." According to Ruskin, such works were

almost always in some degree forced; and their imperfections gratuitously, if not impertinently, indulged. For Mr. Whistler's own sake, no less than for the protection of the purchaser, Sir Coutts Lindsay ought not to have admitted works into the gallery in which

the ill-educated conceit of the artist so nearly approached the aspect of willful imposture. I have seen, and heard, much of cockney impudence before now; but never expected to hear a coxcomb ask two hundred guineas for flinging a pot of paint in the public's face.[5]

Whistler sued Ruskin for libel, asking a thousand pounds in damages plus court costs. By initiating *Whistler v. Ruskin* the artist clearly anticipated additional publicity and, at least in regard to quantity, he was not disappointed on that front. However, many of the published accounts read as frivolous entertainment news.

Unwisely, Whistler may have expected to generate additional income from the trial as well. Having lost Leyland's patronage in the springtime, Whistler put himself at further financial risk in the fall. He commissioned E. W. Godwin to build an elegant studio house in Tite Street, Chelsea. That project was well under way when the suit came to trial in November 1878. The verdict in Whistler's favor awarded him damages of only one farthing (a quarter of a penny) without costs. Conjoined with the withdrawal of Leyland's fiscal support and cost overruns on the new house, this legal contretemps soon precipitated the high-living artist into bankruptcy. In December, Whistler published his own account of the trial, *Whistler v. Ruskin: Art and Art Critics*. Over the years, a series of such pamphlets would ensue, becoming one of his chief avenues of expression. Each is distinguished by trademark brown-paper covers enclosing a slim but irreverent text.

In May 1879, Whistler had to endure the sale of his household goods and the occupation of his beloved "White House" by bailiffs.[6] By September, the bankruptcy had driven Whistler to Italy, sustained by the company of his mistress Maud Franklin and a modest commission from the Fine Art Society. Whistler was invited to create twelve etchings of Venice in time for the Christmas market. While in Italy, Whistler aimed to recoup his fortunes with new material freshly approached. Typically, he far exceeded the commission. Asked to return in three months, he remained for more than a year, creating a body of fifty etchings and a hundred pastels as well as a few oils. The beautiful but decaying Italian city had become almost a cliché in artistic circles. However, Whistler saw the Serenissima as no other artist had done before him. While the past exemplars he took for his work were Canaletto and Guardi, Whistler injected a modernist spirit into his art.

Returning to London in November 1880, he set about resurrecting his stalled career with all the energy of a Hollywood has-been mounting a comeback. By 1883

Whistler had staged a trio of controversial, specially decorated one-man exhibitions that set the Victorian art establishment atwitter. No wonder! These landmark exhibitions presage twentieth-century performance and installation art, not only through the packaging and presentation of the pictures but also in the ways their maker positioned himself as an entertaining performer and publicity magnet.

The first piece featured in Whistler's 1881 exhibition of Venetian pastels at the Fine Art Society was *Sotto Portico—San Giacomo* [fig. F.2, frontispiece]. Whistler used a compositional device he came to favor in Venice—a distant view focused through layers of intervening architecture. A *sotto portico* is a passageway that cuts under densely packed buildings to admit pedestrians to otherwise-hidden courtyards. The site has recently been identified as a still-extant narrow passageway in the district of Santa Croce near the beautiful Campo San Giacomo da l'Orio.[7] Whistler was looking west into the sunlit *campo*, or large city square. He has, of course, captured one of the chief charms of the tortuously laid-out city—that sense of potential discovery always waiting just ahead.

Layers of gray-blue and gray-white, punctuated by smaller passages of turquoise and acid green, float upon the brown paper, much of which is left bare. Whistler leads the eye into the composition by means of a stick chair colored in primary yellow and placed at the near end of the empty passageway. Lying before the chair is a large, bright-blue portfolio, such as an artist might have temporarily laid down. Whistler fixed his coral butterfly signature just above it. Rich color pulls the eye through the shadowy passage, under the darkened *sotto portico*, and into the almost blinding white light of the sunny *campo* beyond. There, with a few tiny, deft strokes, Whistler conveys Venetian women leaning on an old stone wellhead.

Always eager to stretch the artistic point, Whistler here practiced advanced aestheticism, creating formulaic, almost abstract relationships of color and line. Narrative elements are suppressed or hidden beneath shimmering surface layers in what became popularly known as "art for art's sake." But Whistler reassured viewers accustomed to storytelling pictures by choosing something familiar—in this case, old Venetian buildings—as a departure point.

Properly confounded, a humorist for the magazine *Punch* described *Sotto Portico* as "a sort'o portico. Pretty clear so far."[8] Innumerable late-nineteenth- and twentieth-century texts amply demonstrate that Whistler's work was nothing of the kind.

I began this project back in the mid-1980s with an initial study of Whistler as exhibition designer.[9] At that time, little attention had been paid to this aspect of Whistler's complex career. As I further pursued the topic, it proved far richer than I had imagined. Over time, I became interested in sifting Whistler's artistic choices and behavior on both sides of his late-1870s career crisis and in trying to reconnect them, as if Whistler were an aesthetic Humpty Dumpty. My approach to the material for these essays in visual synthesis has not been strictly chronological. Rather, I am interested in exploring the ways visual art enters cultural discourse. Visual images respond to, cut against, and help to shape that conversation. While I have been given full access to many archives, my primary evidence for the choices Whistler made are the works of art themselves.

Whistler's career as a nineteenth-century expatriate artist whose work might now be claimed by the Americans, and by the British, perhaps even by the French, reminds us that the generally accepted convention of writing art history from national perspectives while isolating tidy blocks of time as discrete entities can be well served by occasional wider forays across periods and cultures to look for shared styles, typologies, and iconographies.

The following essays invite readers to participate in the multivalent conversation between art and artist, artist and milieu, milieu and art. Examined from various viewpoints, themes appear and disappear, sparked by the artist's combative confrontations, bold monologues, and, on occasion, obvious enjoyment of visual obfuscation. If the conversation is sometimes confusing, it is never dull.

Since I started this project, the sheer depth of accomplished new scholarship by many other historians—not only monographic but also contextual—has opened new avenues of inquiry again and again. It always seems that just one more brightly lit courtyard invites further exploration. And it always lies just beyond the darkening passageway of my previously reached conclusions.

Whistler exploited musical titles to help evoke the abstract qualities of his work—from modest "notes" to richer "nocturnes" and "harmonies" to his most ambitious "symphonies" in color and form. If there were a musical equivalent to current studies in the history of art, it would perhaps be jazz. We revisit the same works but continue to find fresh aspects to engage us. I hope the reader will enjoy these essays as meditations on an artist whose work sustains—and rewards—repeated, ongoing investigation.

1. Prelude

Nature contains the elements of color and form of all pictures—as the keyboard contains the notes of all music—but the artist is born to pick, and choose, and group with science, these elements, that the result may be beautiful—as the musician gathers his notes, and forms his chords, until he brings forth from chaos, glorious harmony.—To say to the painter, that nature is to be taken, as she is, is to say to the player, that he may sit on the piano!—

—James McNeill Whistler, from the "Ten o'Clock" lecture (1885)

J AMES MCNEILL WHISTLER ended his student days in Paris by presenting a thoroughly modern picture of a private musical performance [fig. 1.1]. Whistler's haunting image, completed in 1859, captures his half sister, Deborah Delano Haden, bending gracefully over a rosewood grand. Her daughter, Annie Harriet Haden, nestles in the elegant curve of the piano case. Mrs. Haden does not look at Annie, whose gaze seems purposefully obscured. Clad in Victorian mourning dress, the two figures form a taut set of black-and-white parentheses bracketing the keyboard from which issues a melody we can but imagine. The atmosphere in the room strikes a chord of refined solemnity, amplified by the apparel of grief.[1] Even viewers unfamiliar with Whistler's private life can detect restrained tension in this uneasy piece, one that established Whistler's position on the cutting edge of modern portraiture.

In the hands of Whistler and the French avant-garde artists of his generation, portraiture was virtually absorbed into naturalist genre painting.[2] With its highly formalized structure, its nod to stereoscopic photography,[3] and a pronounced realism that evoked the admiration of Gustave Courbet, *At the Piano* falls neatly into the modernist canon, as dissected and debated by present-day scholars such as Thomas Crow. If we

OPPOSITE: Detail from fig. 1.1

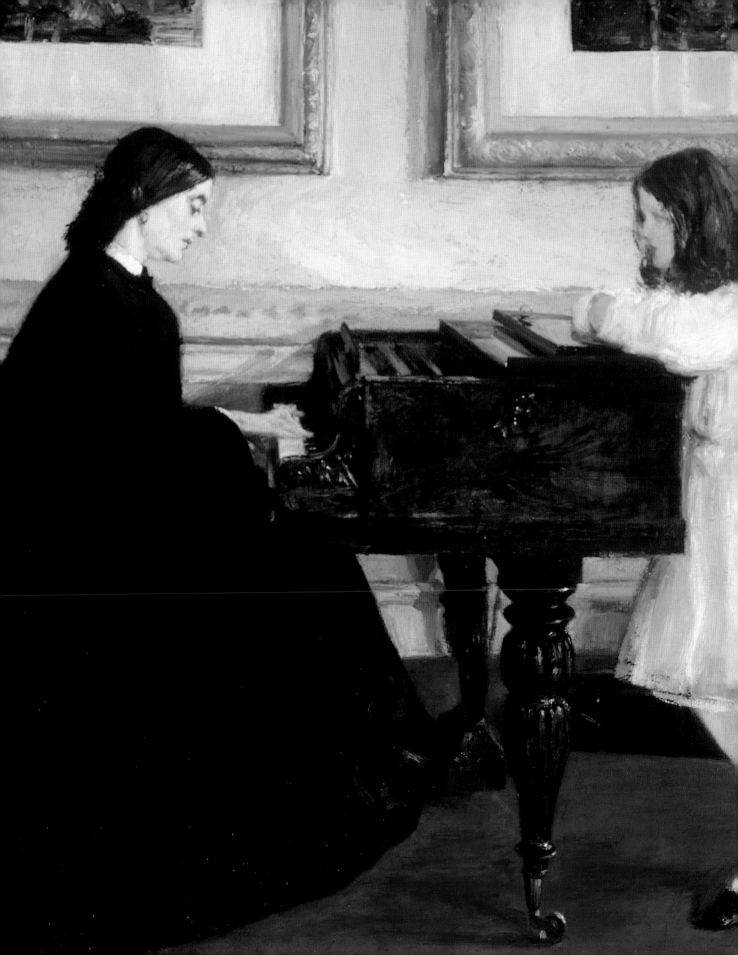

accept that discourses on mass culture and modernist art spring from a shared moment and are thus inseparable, the palpable dissonance in Whistler's image begins to resolve:

> Culture under conditions of developed capitalism displays both moments of negation and an ultimately overwhelming tendency toward accommodation. Modernism exists in the tension between these two opposed movements. And the avant-garde, the bearer of modernism, has been successful when it has found for itself a social location where this tension is visible and can be acted upon.[4]

Operating from such a location, Whistler found opportunity in the complex, interrelated phenomena that made urban life "modern." *At the Piano* presents us choices that will engage the artist for a lifetime: the use of subjects from contemporary life, a conscious linkage of art and music, a carefully restricted palette, arbitrary patterning, the flattening of form, and the continuing dialogue between his works in various mediums.

Bent over needlework rather than music, Deborah struck the same profile pose for *The Music Room* (1858) [fig. 1.2], an etching closely related to *At the Piano*. The print also captures Deborah's spouse, Dr. Francis Seymour Haden, as a dégagé Victorian husband perusing a newspaper. But the prominent London surgeon—an amateur print-maker and cellist as well—is conspicuously absent from *At the Piano*. Instead, Whistler suggests the presence of Dr. Haden with dark green cases for stringed instruments lying under the piano against the wall. Meanwhile, two gilt-framed images declare the presence of art, if not the artist himself. Inventorying the elements of the composition, a critic for *The Times* (London) pointed out that the wall behind the piano is "ornamented with two prints in plain frames."[5] This adds further tension to the scene. Given their large scale, the framed works could be hand-colored reproductive engravings, the type of expensive commercial print challenged in the marketplace by Whistler and other participants in the era's etching revival, including Haden.[6]

We know that jealousy ruined the relationship between Whistler and his brother-in-law. In 1867 it ended with a crash when the artist pitched the

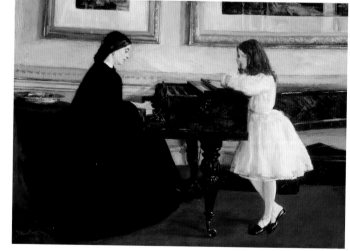

1.1

doctor through a plate-glass window.[7] As a har-
binger of things to come, Whistler, who had
initially given *At the Piano* to Haden, promptly
sold it for thirty pounds to John Phillip, a Royal
Academician, following the picture's successful
exhibition in London. Haden did not regain
possession until after Phillip's death.[8]

If Whistler and Haden—two incom-
patible personalities—can be represented by
inanimate objects, *At the Piano* nonetheless offers
an overture to the ever more operatic personal

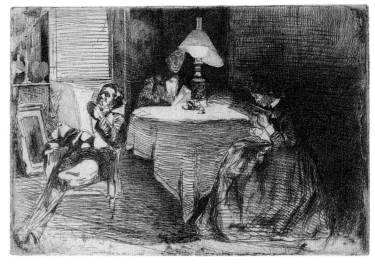

controversies that would surround the artist until the end of his life. Although he accepted
portrait commissions for more than four decades, portraiture—almost half of his
surviving work in oil—proved an especially dangerous ground for the volatile Whistler,
involving, as it must, some sort of personal relationship with each sitter.[9] Eventually,
his idiosyncratic intransigence spawned an anecdotal bibliography of staggering propor-
tions. For most of the twentieth century, these stories and recollections remained
strangely divorced from discussions of the art itself.[10]

Years after the piano picture was completed, Whistler codified his position on
pictorial content in a memorable, if somewhat misleading, pronouncement: "As music is
the poetry of sound, so is painting the poetry of sight, and the subject-matter has nothing
to do with harmony of sound or of colour."[11] Such dicta bewildered a public encouraged
by the popular press to cling to the notion of uplifting narration.

Privileged aesthetics, however, don't necessarily preclude content. Fifty years
after the advent of modernism, Meyer Schapiro observed, "Although painters will say again
and again that content doesn't matter, they are curiously selective in their subjects.
They paint only certain themes, and only in a certain aspect."[12] Among these modernist
themes Schapiro listed "symbols of the artist's activity; individuals practicing other
arts, rehearsing, or in their privacy; instruments of art, especially of music, which suggest
an abstract art and improvisation."[13]

Of course, aspiring avant-garde modernists never cornered images of entertain-
ment. In his densely detailed *Derby Day*, William Powell Frith carefully staged seemingly

FIG. 1.2 Whistler, *The Music Room*, 1858, etching, 2nd state, K33, 5⅝ x 8⅜ inches. VMFA, Gift of Dr. and Mrs. Helmut Wakeham.

impromptu elements of social performance [fig. 1.3]. Contemporary with *At the Piano,* Frith's seven-foot-wide canvas teems with distinctive types, both high and low, familiar to Victorian gallery goers through a welter of novels and popular imagery. A trio of carnivalesque incidents forms the backbone of the painting.[14] On the far left, a thimble-rigger practices his sleight of hand for a group of men in top hats, including a "city gent" who is about to lose at an ancient con game. At the far right, another sport, wearing a green scarf, lounges against the carriage that isolates his mistress from the rest of the crowd. As her lover buys a (soon-to-be-wilted) bouquet from a flower seller—among the most clichéd of all street types in the Victorian imaginary—a gypsy accosts the mistress, offering to tell a fortune that would have been crystal clear to Victorian observers. These and other mildly deadly sins surround the central group of well-dressed aristo-cratic racegoers who are observing a little acrobat. His performance has been interrupted by their footman, who sets out a sumptuous picnic and distracts the hungry child.[15]

Instead of a moralistic outdoor crowd scene set at Epsom Downs, Whistler offered a highly personal vision staged in a comfortable upper-middle-class English home. Creating art about art, Whistler spotlighted music—the prime metaphor for spontaneous visual improvisation. Concomitantly, *At the Piano* resonates with complex familial overtones that are not readily apparent at first glance. Visitors to the Royal Academy in 1860 could have known little if anything about these personal issues, offering a case in point for how "art for art's sake" can rest on inaccessible content.[16]

With its use of modern clothing and decoration, *At the Piano* reveals the general tendency of Whistler's generation to exploit not only self-referential snippets of personal

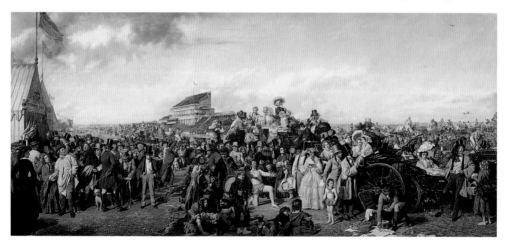

1.3

experience but also contemporary fashion to sidestep historical narrative. The French critic and writer Théophile Gautier averred that current fashion, not the imitation of antiquity, gave access to the eternal, universal beauty of the classical ideal.[17] In his second painting of the music room at 62 Sloane Street, Whistler would continue the approach advocated by Gautier. *Harmony in Green and Rose* (1860–61) [see fig. 3.30] includes not only Deborah and Annie, but also a woman impeccably dressed in black, carrying a riding whip.

In this self-styled *tableau avec l'amazon*,[18] Whistler relied on a strictly defined costume associated with dandyism to create a visual euphemism for glamorous courtesans, who were often accomplished horsewomen. The fearsome heroism of ancient female warriors—a tale from the labors of Hercules revolving around one woman's desire for an article of fashion belonging to another—elided into the bold behavior adopted by *les grandes horizontales* of politically repressive Second Empire Paris as well as the "pretty horse-breakers" who rode with conspicuous skill in Hyde Park.[19] Whistler refers to such demimondaines at the same time that his own dandified dress, first seen during his student days in Paris, was helping to establish him as a nonconforming modernist presence within the confining strictures of the Victorian art world. As we will see, such carefully chosen costumes carried eighteenth-century valences of both style and significance.

At the Piano's critical success at the Royal Academy in 1860 indicates that Whistler's contemporary domestic subject was acceptable, despite its closed narrative and its brooding undercurrent of familial disharmony. Both artist and audience lived, after all, in an era of unprecedented social, economic, and aesthetic disruption. Whistler and his contemporaries witnessed the celebration of the artist's studio and the artistic house as benchmarks of fashion, the rise of the art press as arbiter of taste, and the advent of the solo exhibition. Desire for possessions, unsatisfied personal and professional needs, and the wish to assert the artistic self surely were among the most salient characteristics of the milieu Whistler inhabited. A legitimate desire for new patronage— a market share—was fundamental to the formation of artists' groups later considered movements in Europe and America, such as the Impressionists, or The Ten or The Eight, to name just a few. Economics also motivated Whistler's Société des Trois, although the loose association of like-minded artists seeking sales never was perceived as a movement.[20]

During this self-conscious, anxiety-ridden era, an artist's success required a skilled performance. After his Royal Academy debut, Whistler spent a decade establishing himself as an artistic presence of note. By articulating French concepts of aestheticism— proclaiming that artistic merit lay in a work's formal organization, not in its subject matter—Whistler quickly became identified with a fresh aesthetic approach to the arts in Britain.[21]

At the Piano exposes a private moment to public view. The painting's early exhibition history encompasses the two most important types of venue available to would-be artists when Whistler began his professional career: the official salon and the individually controlled artist's studio, both already rivaled by the burgeoning of commercial galleries in Europe, Britain, and the United States. Whistler showed the picture in François Bonvin's Paris studio in 1859 after a French jury rejected its submission to the spring Salon.[22] The next year, he succeeded with more liberal-minded British judges when *At the Piano* became his first oil painting to be displayed by the Royal Academy in London.[23] The picture was again shown in London at the Morgan Gallery in Berners Street in 1862.[24] Then, following Henri Fantin-Latour's advice, Whistler directed the picture to the Paris Salon in 1867 while exhibiting other works in the American section at the Exposition Universelle.[25] He was practicing the same kind of strategic placement of his pictures that other artists engaged in, but this particular effort struck a sour note. Finally admitted to the Salon almost a decade after its initial rejection, *At the Piano* was not taken seriously by French critics.[26]

Just as Whistler was launching his professional career, Frith's *Derby Day* entered the National Gallery of Art. Later cited by *Punch* as "something everybody can understand, and somebody buy," the painting was the antithesis of Whistler's elite aestheticism, even though each picture was grounded in modern life.[27] Whistler might have taken heed of the rival painting's provenance as a warning against the difficult audience he planned to engage. Left as a bequest to the National Gallery, the first version of *Derby Day* belonged to Jacob Bell, a contemporary English art collector. Having been expelled from art school, Bell became wealthy as a dispensing chemist, eventually founding the Pharmaceutical Society. His taste ran to animal scenes and anecdotal subjects by Edwin Landseer, Frith, and others.[28]

Published auction records reveal that the secondary market for Whistler's paintings remained spotty until the end of his life. "Whistlers for a long time have been snapped up privately and have little chance of arriving at auction," lamented *The Year's Art for 1903*.[29] In 1886, when *Nocturne: Blue and Gold—Old Battersea Bridge* [see fig. 5.45] was auctioned in London at Christie's, the canvas was hissed at in the sales room as if it were a villain in a publicly performed melodrama. Shortly after Whistler's death in 1903, as memorial exhibitions in London and Boston celebrated the expatriate American's career while auction prices for his paintings boomed, this incident would be recalled with shame by the editor of London's leading art-market chronicle.[30] He drew readers' attention to the large retrospective organized by the International Society of Sculptors, Painters and Gravers in 1905, making "particular mention" of Whistler's *Portrait of the Painter's Mother* [see fig. 6.15], lent from the Musée de Luxembourg by special decree of President Loubet. "Everybody knows that this inspired work might have been, under different auspices, in an English national collection."[31] As something of a consolation prize, the once-derided *Nocturne: Blue and Gold* was presented to the National Gallery in London that year thanks to "the enterprise of the National Art Collections Fund."[32]

As for *At the Piano,* the canvas changed hands frequently after Haden sold it to a Glasgow art dealer in 1897. It was shown in the London memorial exhibition, but didn't enter a public collection until well into the twentieth century. At last it was donated to an American museum in 1962.[33] By then the international art world looked far different from the one Whistler had known at the time of his professional debut. How he accelerated some of the changes that took place in that world during his long career, and how he provides lasting continuities with still-current issues about content, meaning, audience, presentation, and the role of the artist, are themes that recur throughout my present study.

A resonant hum lingers after a pianist ceases playing. The next time the piece is performed, it may be subject to a different interpretation. Whistler, too, left a resonant hum as he exited the stage. However widely interpreted his performance is today, whether we see him as an immodest virtuoso, a gifted aesthetician, or an effective combination of both, Whistler's belief in the autonomy of art may be his most often-heard encore.

2. Fashion's Wheel

Who breaks a butterfly upon a wheel?

—James McNeill Whistler (1883)

Wer schön sein will muss leiden.

—old German proverb

P
lucked from Alexander Pope's "Epistle to Dr. Arbuthnot" (1735), Whistler's arch query "Who breaks a butterfly upon a wheel?" signals the artist's ability to utilize the past in order to manipulate the fashions of his own day. Whistler recycled this eighteenth-century one-liner as the opening salvo in his mischievous catalogue *Etchings & Drypoints. Venice. Second Series*, compiled to accompany his 1883 exhibition at the Fine Art Society, London. Along with fifty-one prints, the audience was treated to "Mr. Whistler and His Critics," a wickedly judicious selection of edited critical commentary that still stands as one of Whistler's most unforgettable tools for establishing a distinctive presence in an increasingly commodified art world.[1] Like many of his contemporaries, Whistler constantly negotiated the troubled borderland between artistic freedom and economic confines. Gradually he transformed himself from decried "artistic Barnum" to aesthetic senior statesman during the last two decades of the nineteenth century.[2] Although *Nocturne: Blue and Gold—Old Battersea Bridge*, an important picture in his oeuvre, was hissed at on Christie's auction block and sold for a mere sixty guineas in 1886, Whistler received almost immediate posthumous acknowledgment as an old master when two minor oil sketches and an etching together fetched nearly seven hundred guineas at public sales in 1904.[3]

From the outset, Whistler's fame rested as securely upon his eye-catching presence—punctuated by a plume of white hair in a mass of black curls, and emphasized by an exaggerated walking stick—as it did on the subtle works of art he produced with needle, pencil, crayon, and brush. These seemingly opposed parts of his persona merge in issues of fashion, performance, and display, connected with Whistler's art by

26

OPPOSITE: Detail from fig. 2.23

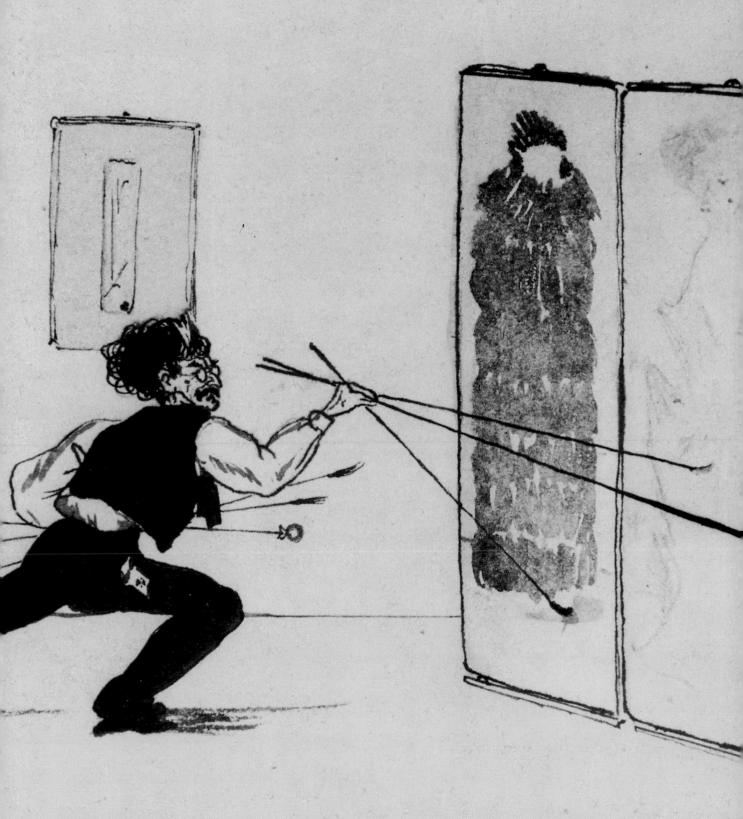

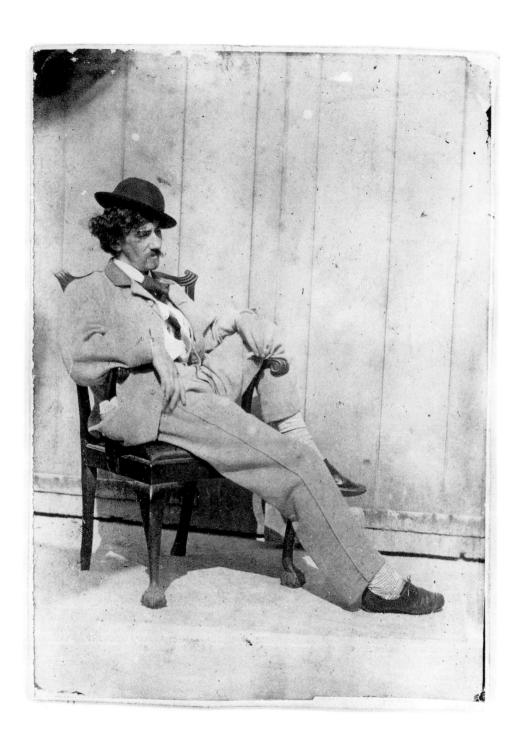

FIG. 2.1 *Whistler seated on Chippendale chair,* ca. 1860, gelatin silver print, 6⅜ x 4⁹⁄₁₆ inches. Charles Lang Freer Papers, Freer Gallery of Art and Arthur M. Sackler Archives, Smithsonian Institution, Washington, D.C., Gift of the Estate of Charles Lang Freer.

writers and illustrators of the period. Such interests make his personality easy to conflate with that of Oscar Wilde. But Whistler would be the first to remind us that he *made* art, whereas Wilde only talked about it, often appropriating Whistler's own words. It is now a matter of record that Whistler's uncompromising devotion to aesthetic issues coupled with his relentless self-promotion led to significant personal and professional difficulties. In retrospect, the American expatriate's long and controversial career bears out the old German proverb, "wer schön sein will muss leiden," meaning that those who would be beautiful must suffer.

During his lifetime, Whistler's patrons were almost without exception self-made, newly rich, or at the very least socially unconventional. Although he was by no means a gifted teacher, Whistler attracted a following of younger artists in the years leading up to and immediately after his death in 1903. What, then, was the essence of Whistler's simultaneous appeal to the recently arrived collector and the would-be modern artist, whether printmaker, painter, or photographer?

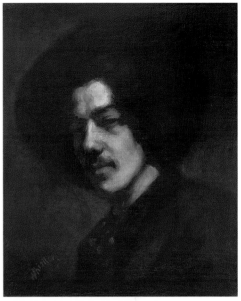

Throughout his career, Whistler engaged in self-portraiture; he also posed for others. Looking backward at images of Whistler, we find ample evidence of his evolving self-image. In a photograph made about 1860, the artist is awkwardly seated, wearing a pale "suit of dittos"—the matching jacket and trousers that predate the modern business suit. A newly fashionable cigarette dangles from his fingers [fig. 2.1].[4] A snappy derby sits at a rakish angle on his soon-to-be-famous curls. Photography, the latest medium, captured the very picture of unbuttoned bohemian nonchalance, but Whistler's sprawling figure is framed by the reassuring curves and angles of a Chippendale-style armchair with prominent projecting ears and vigorous claw-and-ball feet. Traditional seating supports his artistic slouch, just as Whistler's position as an iconoclastic modernist rested firmly on the foundation of past art.

Early on, Whistler identified himself with Rembrandt [fig. 2.2], not only a recognized old master painter but also a talented etcher whose prints Whistler would rival in his earliest bids for public acclaim. Whistler's white plume had not yet appeared, but the notion of casting himself in a telling role by projecting an assumed personality had. In the phrase "old master" we have the impetus for Whistler's role playing. Although he

FIG. 2.2 Whistler, *Self-Portrait with a Hat*, 1857–58, oil on canvas, 18¼ x 15 inches, inscribed l.l.: "Whistler". Freer Gallery of Art, Smithsonian Institution, Washington, D.C., Gift of Charles Lang Freer, F1906.57.

carefully maintained his romantic public posture as a creative genius, his work was closely related to the rich heritage of western Europe as well as to the artistic events of his own generation. Whistler himself is reported to have said, "It is the business of the artist to carry on tradition." The quote is secondhand, from the Pennells, Whistler's biographers.[5] The hard evidence is in his pictures. It is in his frames. It is also in his behavior.

In histories organized along nationalistic lines, it is difficult to place the peripatetic American-born painter, but most of Whistler's formal training was French and his professional concerns were to a large extent those of the French modernists of the 1860s. It can be argued that his American expatriate status made him one of the more acceptable channels through which "foreign" ideas could be funneled to American painters coming of age at a time when the United States had only just emerged on the stage of international politics. As early as 1879, while Whistler was working in Venice and befriending numerous young expatriate American artists,[6] a journalist reviewing the annual spring exhibition at the National Academy of Design in New York asserted, "We cannot expect from our painters that kind of Americanism in art which consists in finding subjects at home."[7] Two decades later, Whistler was swept into the vanguard of American imperialism when he showed three portraits at the 1900 Exposition Universelle in Paris at the invitation of the American arts commissioner.

During opening ceremonies, America's commissioner general announced, "A gold medal at Paris in 1900 will be a trophy [signaling] supremacy over the best mankind can accomplish."[8] Whistler garnered one Grand Prize for the three oils, including *The Little White Girl* [see fig. 7.41], painted thirty-six years earlier. He was awarded another for his etchings as well. His utterly European pictures were co-opted on the basis of their creator's birthplace as the United States Department of Fine Arts set out to promote a distinctly "American" school of art under the aegis of President William McKinley's frankly imperialistic administration.[9]

Stylistically, Whistler's work helped to feed successive generations of his compatriots still hungry for French modernist ideas after such men as William Morris Hunt, John La Farge, and George Inness had encountered the brushy freedoms of the Barbizon school. Ranging from brooding portraits to sprightly landscapes, Whistler's paintings and prints bridged the two-step transfer of French modernism to American soil. First affected by Whistler were American Impressionists, drawn to the light palette

and sun-filled landscapes of Claude Monet and Camille Pissarro. Dark urban scenes by Édouard Manet and Edgar Degas later appealed to the American Realists. Although the younger group vociferously challenged the supremacy of the older one, members of each admired Whistler [see figs. 5.5, 5.6].

As artists became involved in framing, exhibiting, or publicizing their own work, or in loudly seceding from various art establishments amidst extensive press coverage, lines between life and theater blurred for them. Modern life, it seemed, was a continuous performance. Many came to understand that just as an actor is crucially dependent upon making a connection with the audience, so by implication is the draughtsman or painter, who chooses to perform with pencil or brush.[10] Whistler was early in the field. One critic often at cross purposes with Whistler rightly perceived that "a gallery does not suffice for Mr. Whistler. He needs a stage."[11]

Of course, Whistler was by no means alone in constructing a public persona, but recent scholarship spotlights him as a key role model for artistic self-promotion in the twentieth century.[12] A few years after Whistler's death, William Merritt Chase, a fellow American painter well acquainted with the parameters of expatriate status—and no stranger to self-invention himself—pinpointed the dual nature of Whistler's artistic being shortly after he had completed a compelling portrait of Whistler [fig. 2.3]:

> He succeeded as few ever have in creating two distinct and striking personalities, although as unlike as the storied Dr. Jekyll and Mr. Hyde. One was Whistler in public—the fop, the cynic, the brilliant, flippant, vain, and careless idler; the other was Whistler of the studio—the earnest, tireless, somber worker, a very slave to his art, a bitter foe to all pretense and sham, an embodiment of simplicity almost to the point of diffidence, an incarnation of earnestness and sincerity of purpose.[13]

Chase's further description of the public Whistler reads like copy for a fashion magazine:

> The Whistler of Cheyne Walk was a dainty, sprightly little man, immaculate in spotless linen and perfect-fitting broadcloth. He wore yellow gloves and carried his wand poised lightly in his hand. He seemed inordinately proud of his small feet and slender waist; his slight imperial and black mustache were carefully waxed; his monocle was indispensable.[14]

Whistler's Janus-faced persona emerged at a point when, as cultural historian Sarah Burns puts it, "the artistic performance of personality became an important

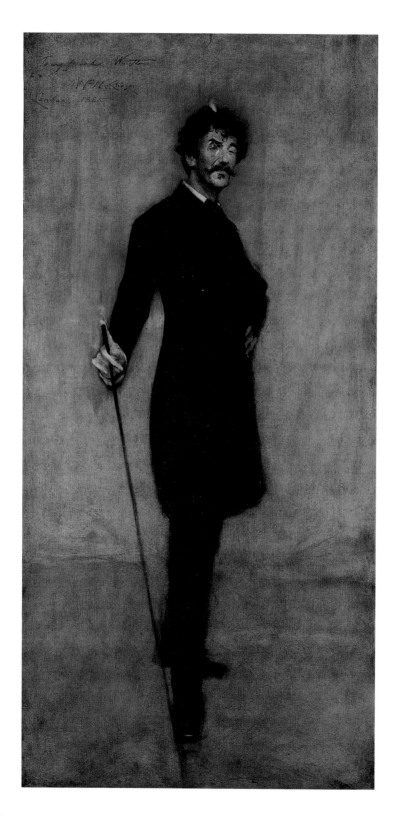

FIG. 2.3 William Merritt Chase (1849–1916), *James Abbott McNeill Whistler*, 1885, oil on canvas, 74⅛ x 36¼ inches, signed, dated, and inscribed u.r.: "To my friend Whistler/Wm. M. Chase/London 1885". The Metropolitan Museum of Art, Bequest of William H. Walker, 1918 (18.22.2).

substitute for the loss of readable narrative and conventionally symbolic meaning."[15]
Until recently, when scholarly inquiry into the workings of the Victorian art marketplace
became de rigueur, Whistler's carefully constructed "self" remained largely the province of anecdote. Meanwhile his art—runic narratives of contemporary life and social
change masked by aesthetic beauty—was only marginally accessible for the first three
quarters of the twentieth century.[16] Separated from the art, Whistler's showmanship
is easily trivialized. However, we can now better understand Whistler's public behavior
as a sales tool, intended to draw attention to the art as well as to its maker.

Commercialized leisure became a hallmark of changing social patterns in
the eighteenth century, long before artists operating in Second Empire Paris, late
Victorian England, and Gilded Age America chose theater subjects to spotlight social
performances—on the stage, in the audience, or behind the scenes.[17] The dichotomy
between the staged illusion and the performer's hardworking life was charged by the
plangent presence of the sad clown, a subject that resonates across the centuries.[18]
A character portraying an eighteenth-century actress in the 1856 production of *Masks
and Faces* turned to her New York audience with these lines:

> Nor ours the sole gay masks that hide a face
> Where cares and tears have left their withering trace,
> On the world's stage, as in our mimic art,
> We oft confound the actor with the part.[19]

Or, in Whistler's case, with the art.

In an era that expected painters to perform at a moment's notice, the
eminently quotable Whistler had a gift for learning his lines. However, his
facility with the well-turned phrase did not always work in his favor.
Purposeful yet flippant, his comments are recorded in countless letters,
essays, biographies, reminiscences, critical reviews, exhibition catalogues,
and art historical assessments. Like a deadly fog hovering over Victorian
London, what Whistler said still has the power to smudge our understanding
of what Whistler did as one of the foremost modern artists of his time.
As he became ever more adept at practicing the aesthetics of the beautiful,
his public relations campaign gained steam during the late 1860s and '70s,

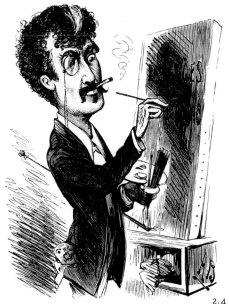

2.4

FIG. 2.4 Alfred Bryan (1852–1899), *Mr. J. Whistler: An Arrangement in Done-Brown*, woodcut engraving, from *The Entr'acte and Limelight Almanack*,
London, 1879. San Francisco Public Library, Special Collections.

albeit not without causing suffering to the artist himself. The controversies over the Peacock Room and the *Whistler* v. *Ruskin* libel suit—for press coverage alone, his two biggest public relations triumphs of the 1870s—were, after all, calamitous fiscal disasters.[20]

"An Arrangement in Done-Brown," a theater-journal cartoon published just after the libel suit of 1878, sends mixed signals, poking fun at the paltry farthing in damages awarded to Whistler while making a pun on *The Arrangement in Brown*, displayed at the Westminster Palace Hotel during the trial [fig. 2.4].[21] Whistler is shown painting the phrase "Done-Brown" onto a canvas. Dun is a drab brownish color; it is also a persistent demand for money. Was the cartoonist sympathetic to Whistler or was he implying that the public was being had by an artist whose objective was profit, not pulchritude?[22] A "brown study" indicated depression, certainly appropriate on Whistler's part in the face of this financial fiasco, while the general public was "browned off" (upset), to use another popular slang phrase. The cartoonist's ambivalent stance accords with the outcome of the trial, where Whistler won the suit but received minuscule—indeed ruinous—damages.[23] Whistler was said to have later worn a farthing on his watch chain, perhaps inspiring Aubrey Beardsley to acknowledge him in a group of tongue-in-cheek designs for "new coinage" [fig. 2.5].[24]

In November 1880, after his pivotal fourteen-month sojourn in Venice, Whistler returned to London with his artistic fire rekindled. He began reconstructing his fortunes with a series of controversial single-artist exhibitions that presage performance and installation art of the twentieth century.[25] Following his 1885 delivery of the "Ten o'Clock" lecture, an elaborate monologue on "art for art's sake" presented with the help of Mrs. D'Oyly Carte, wife of a leading Victorian theater entrepreneur, the constant attention of the international art press ensured that Whistler's name remained current at home and abroad. Although he was by no means paid handsomely, Whistler's strategic sale of the well-traveled *Arrangement in Grey and Black: Portrait of the Painter's Mother* to the French government in November 1891 did much to legitimize his art in the eyes of contemporary art circles.[26] It was this picture he sketched on his letter of thanks when made an Honorary Member of the American Art Association shortly thereafter [fig. 2.6].[27]

While no further disasters on the magnitude of the Peacock Room or the Ruskin lawsuit befell him, the artist remained

2.5

FIG. 2.5 Aubrey Beardsley (1872–1898), *Whistlerian coin* from "The New Coinage: Four designs which were not sent in for competition," *The Pall Mall Budget*, 9 February 1893. VMFA Library.

a performer throughout his mature career. Whistler was always primed to create controversy should none exist. "Games you know!... Really I do believe 'I am a devil' like Barnaby Rudge's raven!" Whistler told Waldo Story in 1885, alluding to Charles Dickens's novel of 1841. Caricatures of the artist as a racy, wicked creature are abundant. Clearly Beardsley's "Pan" distills the son from the *Mother*.[28] [fig. 2.7] But Whistler's white plume has metamorphosed into a pair of horns. Beardsley perceived mischief, but these are the horns of Whistler's own dilemma. Easily recognized idiosyncrasies such as the ready quip, the shocking plume of hair, the affected walking stick, the indispensable monocle, or the insouciant butterfly signature with a sting in its tail fostered brand-name recognition in an art market thronged with new customers. Yet Whistler's theatrical stance—that blurring of life and theater—made it difficult to trust his product, the art he made.

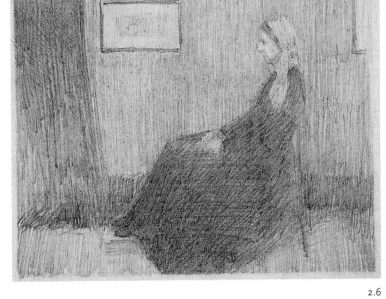

2.6

During his lifetime, Whistler's duality—dedicated artist / aesthetic flibbertigibbet—caused a great deal of confusion, clouding attempts to evaluate his artistic contribution. After his death, colorful stories maintained the memory of Whistler's independent bohemian spirit. The naughty artistic devil still serves a viable role in the contemporary art world, however tame the *Nocturnes* and *Symphonies* of the man who so inspired such behavior might now appear.[29] Whistler's exemplar tints the widespread romanticized concept of the isolated twentieth-century modernist, equally adept at self-criticism and self-promotion while thoroughly engaged by contemporary life and culture. Robert Mapplethorpe's 1985 *Self-Portrait with Horns* [fig. 2.8] illustrates *A Season in Hell*, a symbolist text written by Arthur Rimbaud in Whistler's own time. A recent analysis of Rimbaud's anguished poetry might apply as well to Whistler's pictures:

2.7

FIG. 2.6 Whistler, sketch of *Arrangement in Grey and Black: Portrait of the Painter's Mother*, 15 February 1894, pencil on paper, 2½ x 3¼ inches. VMFA, Bequest of Douglas H. Gordon.

FIG. 2.7 Aubrey Beardsley, *Whistler as Pan*, 1892–93, lithograph, 7 x 2⁄16 inches, published as "Whistler as a Faun on a Sheraton Settee," title page of *The Dancing Faun*, by Florence Farr, London, 1894. Victoria & Albert Museum, London.

some works…transcend artistic conventions, and here…the artist is momentarily possessed by a vision—he has a voice or an eye or an ear pitched toward the future. He breaks out of the role of "the artist" that society has assigned to him and becomes a prophet of sorts—he… creates something universal.[30]

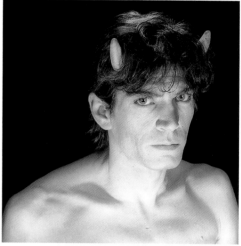

2.8

Reams of surviving criticism indicate that Whistler's pictures have always been uneasy pieces. Neither advocates nor detractors managed to synthesize the man and his work. At the turn of the twenty-first century, journalists and their readers are still fascinated and disturbed by Whistler's stage presence.[31] Enough doubt yet lingers for high-rolling contemporary collectors and critics to find the artist's oeuvre unstable ground. Although prices are on the rise, the monetary values placed on significant works by Whistler—by no means a fully vested member in the Impressionists' club—still fall considerably below those assigned to equivalent works by Monet or Degas.[32]

By the time Max Beerbohm published his tongue-in-cheek assessment *Rossetti and His Circle* (1922), writers on Whistler were already falling into separate camps. Whistler-as-Jekyll, credited with lasting art, vied with Whistler-as-Hyde, outrageous publicity seeker. Both roles inform Beerbohm's image *Blue China* [fig. 2.9]. If Beerbohm gave us a cartoonish Whistler, he also plucked his profile of Carlyle from an iconic work, Whistler's *Arrangement in Grey and Black, No. 2: Portrait of Thomas Carlyle* [fig. 2.10]. The setting for these two figures—a spare white and yellow interior embellished with a vast blue ginger jar, a few reticent prints in white frames, and a vaguely japanesque arrangement of branches placed on an attenuated stand—refer to Whistler's fashionable activities as a pioneering collector of blue-and-white china and to his advanced ideas on interior decoration as a foil for the effective display of art. Whistler's plume of white hair bristles as he lectures Carlyle, the influential Victorian social critic and historian, on the beauties of the ginger jar.[33] Squinting through his trademark monocle, Whistler reaches out to caress the jar in a gesture redolent with Victorian materialism and the rage for bric-a-brac that formed a safe haven for middle-class collectors who might aspire to collect fine art. Whistler's gesture indicates his full approval, but Carlyle doesn't look very convinced by this passionate exhortation. In Beerbohm's image, the lanky Scots philosopher looms

36

FIG. 2.8 Robert Mapplethorpe (1946–1989), *Self-Portrait with Horns*, 1985, photograph.

over the tiny expatriate artist, just as Whistler's artistic legacy towers above the fodder for frivolous anecdote he also left behind. Whistler proved right about ginger jars, as a laudatory rubric in *The Year's Art for 1905* indicates:

> Chinese porcelain, especially of the K'ang Hsi period, is rapidly ousting—or at least equaling—the position of old Sèvres in the eyes of enlightened collectors, and in his admiration for the wondrous craft of the Chinese ceramist the painter of "La Princesse du Pays de la Porcelaine" showed his prescience.[34]

Whistler packaged art and anecdote together in February 1883, when his specially decorated exhibition of etchings and drypoints, *Arrangement in White and Yellow*, was launched and received as a full-fledged performance at the Fine Art Society in New Bond Street. During the exhibition's subsequent American tour, the *New York Times* ran an article emphasizing Whistler's inclination for theatrics. Almost buried in the welter of riveting detail is some significant information. Flamboyance did not prevent Whistler from exercising sound aesthetic judgment:

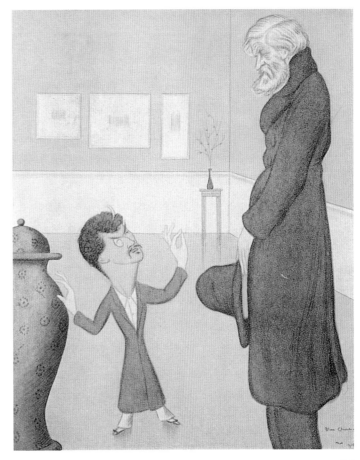

> Seen in Paris at the Salon [was] a remarkable-looking person [who] rushed forward with loud speech and louder laughter…holding court….I noticed that the blatant troupe picked out the very best pictures in the room and that their vociferous criticisms were professional and sound, not literary or amateurish. It was evident they were all artists—young artists— and that he whom they surrounded was a sort of artistic high priest among them….He was dressed, as he always is, in the very height of the mode, and with eccentricities that prophesied the coming rather than followed the present fashion.

Couching his comments in the language of both the theater and performance, the journalist dwelt on Whistler's longevity:

2.9

FIG. 2.9 Sir Henry Maximilian (Max) Beerbohm (1872–1956), *Blue China*, color lithograph, from *Rossetti and His Circle*, 1922. Private collection.

Whistler is a dandy and an old one in spite of the natty, slight figure, preternatural blackness, and juvenile manners. His face is covered with a network of wrinkles; his step becomes uncertain when off smooth gallery floors and carpets and along a country road.... He is 62 years of age and has been a fast liver, but to the cursory eye he has that same superficial air of youthfulness that well made up actresses have even late in life when they have the good fortune not to lose their slenderness of figure and erectness of carriage. Whistler has always been a thorough bohemian by nature although such a dandy. He is sensational and noisy in all things, and one of the figures in modern life that give most to talk and write about to the chronicler of vivid social incidents and character.[35]

In 1885, the same year the above commentary appeared in the *New York Times*, Chase presented a soigné Whistler on canvas as a confident performer [see fig. 2.3]. The portrait would be widely exhibited in the United States.[36] Like a director, Chase staged Whistler before a luxurious curtained backdrop, as if he had just stepped out from the wings to greet his audience. Whistler's graceful white plume stands out from his curly black mane, immediately drawing the viewer's eye to the cocked head with its slightly amused expression. The glittering monocle, the fastidiously tailored frock coat, the silk-ribboned opera shoes, the slender cane reminiscent of a painter's maulstick are the props—the signature elements of Whistler's public role. What, the viewer might wonder, is this well-preserved latter-day dandy going to say? "Art is upon the town!" Whistler declaimed in his "Ten o'Clock" lecture delivered at the Prince's Hall, Piccadilly, in the year Chase painted him. One reviewer called Chase's portrait of Whistler "a smoky vision which leaves a vivid impression of a long lank form, a Mephistophelean face surmounted by a white plume, and a long wand. As for the deep study of character, it is not asked for."[37] Chase masked Whistler's "earnestness" under his somewhat sulfurous theatrical presence.[38]

Both saucy pose and studied costume, carefully cultivated by Whistler over the previous decade, had been regularly recorded in caricatures as well as photographs by the time Chase undertook the portrait of Whistler, an artist he greatly admired.[39] Chase cannot be accused of exaggerating Whistler's posture. He witnessed it in the flesh [fig. 2.11].

Whistler's "Jekyll-and-Hyde" behavior—more accurately his intricately meshed duality—conflates thinking about fashion and modernity as advanced by poet and art critic Charles Baudelaire following the Salon of 1859, the year Whistler made his debut

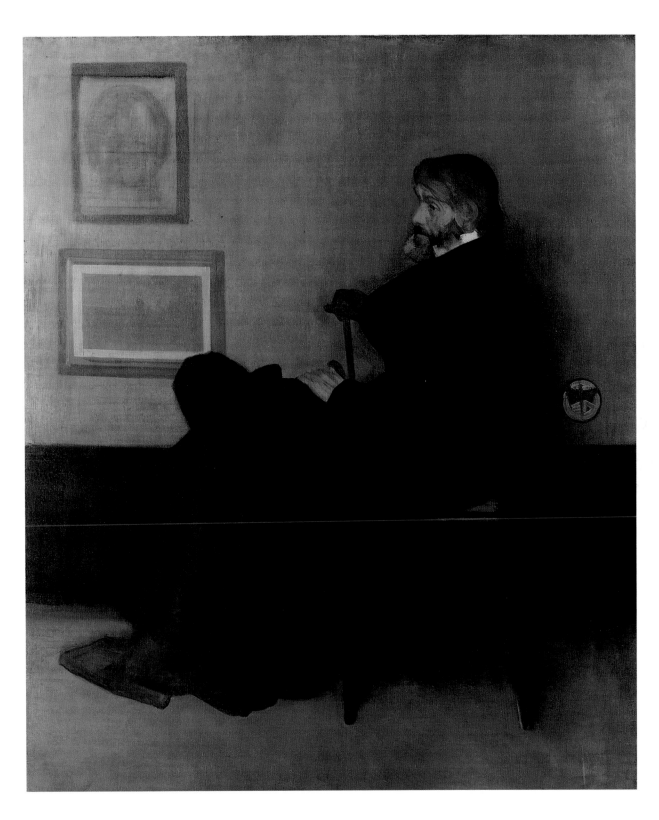

FIG. 2.10 Whistler, *Arrangement in Grey and Black, No. 2: Portrait of Thomas Carlyle*, 1872–73, oil on canvas, 67¼ x 56½ inches.

Glasgow Museums: Art Gallery and Museum, Kelvingrove.

as a professional artist with *At the Piano*. Analyzing Baudelaire's use of fashion as the basis for his "rational and historical theory of beauty"—the aesthetic of modernity—Marie Simon observes that Baudelaire juxtaposed "antithetical concepts—eternal and temporal, invariable and occasional—to express the duality of beauty, a fusion of the abstract and the contingent."[40] Explaining why Baudelaire might have chosen Constantin Guys to illustrate his definition of a modern painter, she writes:

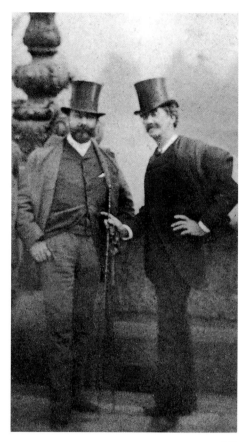

2.11

> From the tart to the society lady, Guys chose those whose aim was to project an appearance, and in them Baudelaire found his own cultural idols of fashion. But what attracted the poet most of all was that all the artist's different sketches of the crowd have a quality which transcends representation. Constantin Guys was able to give his silhouettes and their attitudes a look of eternity; he elevated them to the status of historic figures.[41]

This is also an important function of Chase's multivalent canvas.

Exploring portraits in fiction, A. S. Byatt recently observed that a painting both "exists outside time and records the time of its making."[42] In Whistler's case, the portrait *as* fiction merits close attention. How "modern" was his behavior? And how much was a clever fiction? What does Chase's portrait of Whistler, now extant outside time, tell us about the time of its making? The history of fashion helps us to position Whistler midway on a continuum that stretches from eighteenth-century constructs of self as seen in portraiture to performance art of the twentieth century. Whistler's intentionally projected appearance, "the very height of the mode," according to the *New York Times* in 1885, was in every sense the equivalent of costume and makeup.

Mortimer Menpes recounts a dramatic tale of Whistler's imperious behavior at a London hairdresser's establishment:

> Suddenly to the intense surprise of the bystanders, [Whistler] put his head into a basin of water.... With a comb he carefully picked out the white lock...wrapped it in a towel, and walked about the room for from five to ten minutes.... Still pinching the towel, Whistler would then beat the rest of his hair into ringlets (to comb them would not have

FIG. 2.11 *William Merritt Chase (left) and James McNeill Whistler,* London, 1885, gelatin silver print, 3¼ x 1⅞ inches. The William Merritt Chase Archives, The Parrish Art Museum, Southampton, N.Y., Gift of Jackson Chase Storm, 89.Stm.2.

given them the right quality) until they fell into decorative waves all over his head. A loud scream then rent the air! Whistler wanted a comb! This procured, he would comb the white lock into a feathery plume, and with a few broad movements of his hand form the whole into a picture. Then he would look beamingly at himself in the glass and say but two words,— "Menpes, amazing!"—and sail triumphantly out of the shop.[43]

Chase's painting shares its stylish nonchalance with Sir Leslie Ward's attenuated caricature for *Vanity Fair*, published during the controversial libel suit between Whistler and Ruskin [fig. 2.12]. By blending popular culture and high art, Chase indulged in a transaction common for artists of the late nineteenth century. In her present-day study of Whistler as a modern artist injected into the realm of spectacle, Burns takes the confluence of cartoon and canvas as evidence that "the border between the 'real' Whistler and his mediated image was almost undetectable."[44]

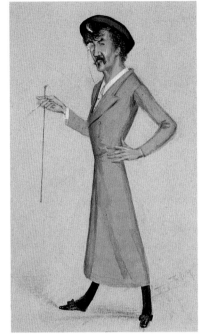

2.12

Although the *New York Times* opined that Whistler "prophesied the coming rather than followed the present fashion," his self-created theatricality had instructive antecedents. Men's clothing styles stabilized early in the nineteenth century, changing very little throughout Whistler's lifetime.[45] The frock coat, closely identified with Whistler, was once a workman's garment; it entered more fashionable circles by the 1740s. Rakish "Macaroni"—young, well-traveled aristocrats active at the court of St. James—wore short, close-fitting frock coats along with huge wigs and small round hats. They carried not only decorative swords but also effeminate floral bouquets.[46] Their arresting attire, exaggerated manners, and mincing gait predict Whistler's antics by more than a hundred years.[47] Whistler's beautifully tailored clothing also emulated the example set by Beau Brummell (1778–1840), the taste arbiter of Regency England.

41

The period around 1800 was a transitional phase for British men's clothing as court and country styles merged to spawn diverse long and short coats embellished with all kinds of collars, capes, turned-back lapels (revers), froggings, and trims. Fashion plates from 1859 and 1880 show the range of clothing we see in images of the artist [figs. 2.13, 2.14]. In *Whistler Times Seven* [fig. 2.15], an etching by Mortimer Menpes, Whistler models a greatcoat with shoulder capes, a garment first seen in the coaching

FIG. 2.12 Sir Leslie Ward (Spy) (1851–1922), *Whistler,* watercolor and graphite on blue paper, 12 x 7⅛ inches, published as a caricature in *Vanity Fair,* 12 January 1878. National Gallery of Art, Washington, Rosenwald Collection.

2.13 2.14

trade a hundred years earlier. As the etching makes clear, it was the artist's animated presence as much as the cut of his clothes that created so lasting an impression.

Dark or black garments dominated Whistler's wardrobe, if we can trust surviving images of him. Industrializing England, not politically volatile France, set the fashion first for plain, then dark, and finally black attire. Historian John Harvey unravels the tangle of possible meanings for black clothes:

> The plain style had its origins not so much in social leveling as in the practical requirements
> of the English gentry, travelling not in carriages but on horseback. And as to blackness,
> the first item of menswear to be black was not the daytime frock-coat of the democratic
> bourgeois, it was the evening dress, the "dinner-jacket" of high society.[48]

A perfectionist rather than an innovator, Beau Brummell "set the seal on this new fashion by removing the odour of the stables" from his perfectly tailored clothing.[49] Brummell's highly publicized career as a meteor of fashion during the Regency further illuminates Whistler's decision half a century later to use mode of dress as a magnet for publicity in Victorian England. The nation's skillful tailors had dominated the international men's clothing trade since the end of the eighteenth century when interest in male dress changed from cut to fit. As men of assorted backgrounds began to mingle, fine tailoring became evident only at close range.

FIG. 2.13 *British fashion plate* showing a morning coat, a chesterfield, and a Tweedside jacket with matching trousers, 1859, lithograph. VMFA Library.

FIG. 2.14 *British fashion plate* showing a lounge jacket, a morning coat, and a topcoat, 1880, lithograph. VMFA Library.

Dandyism remained a style of confrontation, as costume historian Norah Waugh notes:

> The dandy style declines the assertion of rank, but is still a style more of assertion than
> of conciliation, asserting a character equivalent to rank, the character of the "gentleman" —
> a term that had many inflections, but which steadily tended to emancipate itself from the
> ties of money and blood.[50]

Whistler would have understood that Beau Brummell's style was based on impeccable, unassailable self-respect, irrespective of his humble birth. Dangerously independent of rank, dandyism spread from England to France, embodied in portraits such as Eugène Delacroix's *Louis-Auguste Schwiter* [fig. 2.16], painted in the manner of Sir Thomas Lawrence. On the backs of French dandies, "English black" became fashionable in France during the early decades of the nineteenth century.[51]

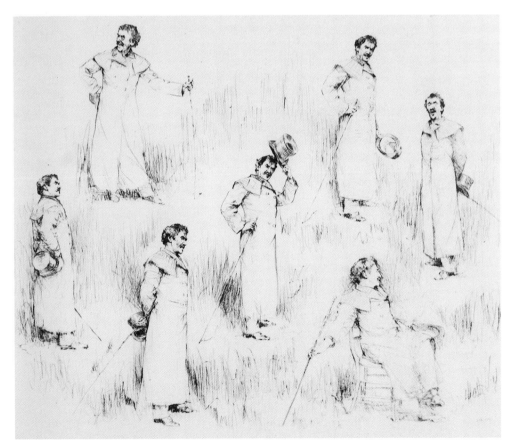

2.15

FIG. 2.15 Mortimer Menpes (1860–1938), *Whistler Times Seven*, ca. 1880–85, drypoint, 5½ x 7½ inches. Private collection.

One wonders whether Whistler had read the twenty-two "maxims of dress" in Edward Bulwer-Lytton's *Pelham, or the Adventures of a Gentleman* (1828). As Harvey points out, "There is scant sign of democracy about Pelham's black, it is much more distinguished, *distingué*, though associated also with the leisured melancholy of the romantic hero…with all the genteel Hamletizing that was in those years à-la-mode."[52] As we will see in later chapters, Shakespeare regularly hovers in the background of commercialized leisure, whether in novels of manners, amenities for pleasure gardens, or motifs for painters.

Carlyle satirized British dandies in *Sartor Resartus: The Life and Opinions of Herr Teufelsdrockh.* (*Teufel* means "devil" in German.) Harvey calls Carlyle's book "the great mock-metaphysic of Clothes" and observes that Carlyle chose Bulwer-Lytton's character Pelham as the "Mystagogue, and leading Teacher and Preacher" of "the Dandiacal Sect."[53] It is ironic that Carlyle chose to sit for Whistler, the latter-day dandy who would preach confrontational aesthetics codified in the "Ten o'Clock" lecture. After more sittings than he bargained for, Carlyle is reported to have said, "All Whistler's anxiety seemed to be to get the *coat* painted to ideal perfection; the face went for little."[54] Whistler entertained hopes of following up the portrait of Carlyle—a distinctive figure on the Victorian cultural landscape—with one of Queen Victoria's former prime minister Benjamin Disraeli.[55] While the portrait did not come to fruition, it is worth remarking here that Disraeli used dandyism to advance his political agenda, just as Whistler used it to advance an aesthetic one.[56] Oscar Wilde later proclaimed, "Dandyism is the assertion of the absolute modernity of Beauty."[57]

Black clothing could send a different message when adopted by a person other than a dandy. Whistler's first important patron, Frederick Richards Leyland [fig. 2.17] comes to mind. Dark

2.16

FIG. 2.16 Eugène Delacroix (1798–1863), *Louis-Auguste Schwiter*, 1826, oil on canvas, 85¾ x 56¼ inches. National Gallery, London.

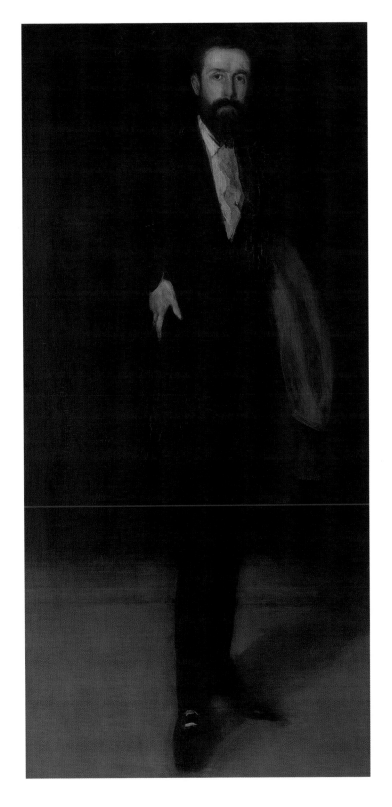

FIG. 2.17 Whistler, *Arrangement in Black: Portrait of F. R. Leyland*, 1870–73, oil on canvas, 80 x 36 inches. Freer Gallery of Art, Smithsonian Institution, Washington, D.C., Gift of Charles Lang Freer, F1905.100.

raiment had two centuries of association with English middle-class merchants, sober in their attire, acute in their transactions, austere in their political and religious leanings.[58] Before Whistler quarreled irreparably with Leyland, the artist's mother considered the self-made Liverpuddlian shipping magnate "a very cultivated gentleman of taste."[59] In Whistler's *Arrangement in Black*, Leyland wears a black dinner suit. Here, black signals economic if not social power—it is the color of mastery; new money as well as old embraced it.[60]

While the proportions of men's outerwear changed over the years, frock coats became a safe choice for conservative members of the middle classes by the 1840s. Such coats gradually achieved "the hallmark of Victorian respectability," albeit in a looser, less defined silhouette than the closely fitted garments worn by the perennially slender Whistler.[61] Eventually replaced by the morning coat, the frock coat did not long survive the Edwardian age, during which an ever fatter but always fashion-conscious prince of Wales modified it, leaving it to hang open or be held across his expanding girth by two linked buttons.[62] Oscar Wilde, himself liable to excess avoirdupois, was happy to see it go:

> At present we have lost all nobility of dress and, in doing so, have almost annihilated
> the modern sculptor. And, in looking around at the figures which adorn our parks, one
> could almost wish that we had completely killed the whole art. To see the frockcoat of
> the drawing-room done in bronze, or the double waistcoat perpetrated in marble, adds a
> new horror to death.[63]

Whistler chose his clothing at the time when the history of costume infatuated the growing fashion industry. Eighteenth-century and earlier modes were regularly reworked for a glittering international constellation of high-society fancy-dress parties and public entertainments. Henry Adams's novel *Democracy* (1880) evokes precious Whistlerian imagery translated into the glamorous world of history-based fashion associated particularly with the newly rich:

> Schneidekoupon, who was proud of his easy use of the latest artistic jargon, looked with
> respect at Mrs. Lee's silver-grey satin and its Venetian lace, the arrangement of which
> had been conscientiously stolen from a picture in the Louvre, and he murmured audibly,
> "Nocturne in silver-grey!"[64]

As Western culture became increasingly egalitarian, costume parties allowed everyone—society matron, shop girl, even the occasional tart—an opportunity to revisit the ancien régime in imagination. Public dance halls and rooftop theaters partook of the vogue. One might find "Marie Antoinette at Mabille," the Goncourt brothers joked, while a costumed milkmaid, complete with goat, conjured up *la Petite Ferme* at Versailles for visitors to Hammerstein's Rooftop Garden in New York.[65] Meanwhile, eighteenth-century French architecture provided lavish decorative programs for historically self-conscious urban theater interiors. Decorated in Louis XV and Louis XVI styles, the stalls and boxes of theaters such as New York's Olympia (1895) framed the modern audience, just as clever dealers packaged modern pictures in elaborate Louis-revival frames to make them more salable.[66]

2.18

The presence of the past can be detected in Whistler's behavior, just as it can in his clothing. However modern, Whistler's dandyism becomes more meaningful when we see how closely he allied his public stance to postures first affected by royalty, then advocated for several centuries by manuals on proper masculine deportment and furthered by dancing masters, among the chief purveyors of refinement [fig. 2.18]. Stock poses were intended "to assist the body and limbs with attitudes and motions easy, free, and graceful, and thereby distinguish the polite gentleman from the rude rustick."[67] The position most often incorporated into male portraiture was that used when bowing or presenting oneself to another for the first time. A typical manual postulated, "The whole body must rest on the right foot, and the right knee, and also the back be kept straight; the left leg must be foremost, and only bear its own weight, and both feet must be turn'd outwards" at a right angle to each other.[68] Correct physical bearing was intended to indicate social grace, a quality Whistler had difficulty maintaining in the competitive turmoil of the international art world.

In portraying Whistler, Chase could hardly stop his subject long enough to stand still for a portrait. Apparently Chase turned to earlier paintings for his compositional strategy, not only nodding to Whistler's recently completed portrait of the acclaimed violinist Pablo de Sarasate [1884, Carnegie Institute, Pittsburgh], but also perhaps updating Hyacinthe Rigaud's regal image of Louis XIV in his coronation robes [fig. 2.19].

2.19

FIG. 2.18 Louis Truchy (1731–1764), *Standing Male Figure*, ca. 1745, mezzotint after Hubert Gravelot (1699–1772), 9½ x 6¾ inches. The British Museum, London.

FIG. 2.19 Hyacinthe Rigaud (1659–1743), *Portrait of Louis XIV*, 1701, oil on canvas, 109 x 76½ inches. Louvre, Paris.

FIG. 2.20 William Downey (1829–1908), *William Bell Scott (left), John Ruskin (center) and Dante Gabriel Rossetti (right)*, ca. 1863, photograph.

Equating modernity with contemporary clothing in his polemic *L'art décoratif d'aujourd'hui* (1925), the architect Le Corbusier later illustrated the royal portrait by Rigaud as a counterfoil to the "bowler hat and a smooth white collar" of the twentieth-century managing class. "By G−...we're going to stun them!," murmurs the Sun King at the beginning of Le Corbusier's wry little drama on men's dress: "The King enters, with a coiffure of ostrich feathers, in red, canary, and pale blue; ermine, silk, brocade, and lace; a cane of gold, ebony, ivory, and diamonds."[69]

More than one nineteenth-century commentator lamented that the anonymous republican black wool suit had replaced the luxurious velvets, laces, and ermine of the ancien régime.[70] But black clothing did not necessarily signify democracy. Historically it is the color of power and had been used as such in many cultures centuries before European patricians began to wear it.[71]

More effective than any sumptuary laws of the past, the pared-down frock coat's ability to homogenize masculine appearance would call forth subtle emphasis on cut and quality of dark fabric to help maintain social distinctions.[72] Whistler, like Louis, intended to stun with his sartorial talents. To be sure, he had to depend on his own curly black hair and white forelock rather than a full-bottomed wig. And rainbow colors were to be found on some of his canvases, but not in his clothing.

Against his dark garments, Whistler's accessories gained visual power. It was not the fact but the style of Whistler's accoutrements that drew attention. He was by no means the only one to go about equipped with a walking stick, as witness a photograph of John Ruskin clutching one in a manner that seems as menacing as the influential Victorian critic's attitude toward Whistler's paintings [fig. 2.20]. This rather fierce image may remind us that the walking stick replaced the court sword as a fashion accessory during the eighteenth century. Moreover, the murder weapon in *Dr. Jekyll and Mr. Hyde* was a walking stick. But Whistler's version [fig. 2.21] was so attenuated that it caused a visiting American painter to sneer, "He carried a cane about the size of a darning needle."[73]

Like a Bourbon monarch, Whistler gestured with his stick to command attention. His accessory contrasts sharply with another performance-linked stick, seen in an early dance studio image by Edgar Degas [fig. 2.22]. Painted in 1872, it pictures Louis Merante, dressed in white and using a large wooden staff to tap out the time like a human

2.21

FIG. 2.21 *Whistler's walking stick*, bamboo and metal, length 45¼ inches. Isabella Stewart Gardner Museum, Boston.

metronome. The ballet master is giving direction to the dancer at the far left of the canvas.[74] Degas constructed the image so that the staff is an integral part of the controlled pictorial space, forming a straight vertical to the horizontal of the dancers' barre.[75] The dance master's stick implies aural rhythms while providing visual ones, helping to create the sense of a collaborative performance. But Whistler's stick *was* the performance, so much a solo that in one cartoon he is nothing but a head on the end of a long maulstick jammed into a bunch of paintbrushes.[76] The association of Whistler, his stick, and his art is even stronger in a cartoon fantasy where Whistler "performs" in the studio, painting three portraits of Lady Meux simultaneously with three brushes, each as impossibly long as his walking stick [fig. 2.23].[77] In a sense, the cane as maulstick cross-links the two parts of Whistler's persona. The cane was carried in public as a fashion accessory; the brush was used in the studio as a working tool.

Painted in 1881, the portrait of Lady Meux in black offers further evidence binding Whistler's works to fashion's wheel [fig. 2.24]. In 1878, having met Henry Bruce Meux at the bar of the Horseshoe Tavern, Valerie Langdon secretly led him to the altar, much to the dismay of his wealthy brewery family. Whistler's own notoriety was at its height when he undertook to paint this social interloper, known as "Val Reece"

2.22

FIG. 2.22 Edgar Degas (1834–1917), *The Opera Dance Studio on the Rue Le Peletier*, 1872, oil on canvas, 12½ x 18 inches. Musée d'Orsay, Paris.

among denizens of the Casino de Venise, a dance hall of ill repute in Holborn.
As Whistler worked on the canvas, an observer recalled, "his movements were those
of a duelist fencing actively and cautiously with the small sword."[78]

Like Leyland, clad in black, Lady Meux is presented in a portrait of power.
The seductive silk velvet surface of her voluptuously clinging gown is enlivened with
£10,000 worth of diamonds.[79] Just before Whistler painted *Arrangement in Black, No. 5*,
Mary Eliza Haweis, author of numerous middle-class tastemaking manuals, twice
illustrated a clumsy woodcut. In *The Art of Beauty* (1878) Haweis advised her readers
to "study the room that you are to appear in, if you ever mean to look right." She coun-
seled that "modern white and glaring drawing-rooms" called for plain black dresses
"but *never* with low neck and short sleeves." Warning of "the hard line round the bust
and arms" making "too great a contrast to the skin," she recommended, "if you must
wear a low black bodice, let it be cut square, giving the height of the shoulders (or better,
with the angles *rounded*, for corners are very trying) and have plenty of white or pale
gauze…to soften the harsh line between the skin and the dress" [fig. 2.25].[80] In the
portrait by Whistler, Mrs. Meux's full-length white sable stole softened the trying corners
admirably. The following year, in *The Art of Dress*, the woodcut appeared again, but
Mrs. Haweis had somewhat dramatized her advice:

FIG. 2.23 Attributed to Mortimer Menpes or Charles Brookfield (1857–1913), *Whistler's "Lady Meux,"* before 1911, pen, ink, watercolor, and pencil, 5 x 7½ inches.
Rosenbach Museum and Library, Philadelphia.

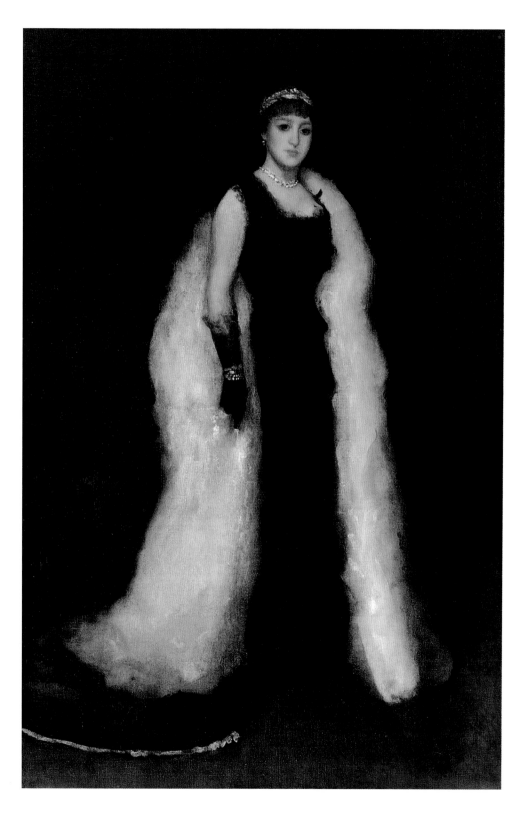

FIG. 2.24 Whistler, *Arrangement in Black, No. 5: Lady Meux*, 1881, oil on canvas, 76½ x 51¼ inches. Honolulu Academy of Arts, Purchase, Acquisition Funds, funds from public solicitation, Memorial Fund, and Robert Allerton Fund, 1967.

With the question of indelicacy I do not pretend to deal. That must be left to feminine good feeling; I am chiefly concerned with beauty. If a woman has very beautiful shoulders, it is of course a pity to hide them; but that objection would apply to any charms which are out of fashion. One cannot hope to display one's whole fortune at once, and, as something must be kept back, it is better to sacrifice breadth than height. A low bodice with short sleeves has many faults—its poverty of design, its uninteresting bareness, its incongruity with a large mass of material below, the difficulties of trimming it without spoiling the figure, should be sufficient to taboo it. When made in a dark material and seen against a dark background, the effect is as seen in [the woodcut]. Temple Bar stuck with ghastly limbs of malefactors was only a little worse.[81]

At this time, as London attempted to regularize and enlarge its medieval streets and to accommodate new systems of urban transport, Temple Bar—the old west entrance to the City of London and once a prized landmark—was under attack as a barrier to traffic flow, an outdated symbol of London's ancient history now blocking modern commerce [fig. 2.26]. Whistler etched it in 1877, including the scaffolding that shored it up.

Although her portrait was exhibited at the Salon in Paris, Lady Meux herself was barred from polite society. She was never received despite her beautiful clothes, her jewels, her collection of Egyptian antiquities, her well-appointed town house in Park Lane, and her eventual possession of the family seat, Theobalds Park, in Hertfordshire. After its demolition, Temple Bar also belonged to Lady Meux. The famed London landmark was literally rusticated—installed by her husband as a garden folly on the edge of Theobalds Park, a silent testament to the constant shifting of aesthetic as well as social and economic barriers.

At a time when fact and fiction often appeared to be entangled, women such as Lady Meux brought characters like Zola's *Nana* uncomfortably to life.[82] And, as we have seen, Chase chose a dramatic literary pair—Jekyll and Hyde— to characterize Whistler in print as a multifaceted personality. Likewise, when he painted Whistler, Chase emphasized the theatrical, but did more than feature a devilish fop. Drawn

2.25

FIG. 2.25 *Low Bodices*, woodcut from *The Art of Dress*, by Mrs. H. R. Haweis, London, 1879. VMFA Library.

from conventions of portraiture traceable to the work of Velázquez, the velvety background Chase selected focuses the eye upon the black-clad figure, an issue Oscar Wilde addressed in connection with the stage:

> In modern plays the black frock-coat of the hero becomes important in itself, and should be given a suitable background. But it rarely is.... As a rule, the hero is smothered in *bric-a-brac* and palm trees, lost in the gilded abyss of Louis Quatorze furniture, or reduced to a mere midge in the midst of marqueterie; whereas the background should always be kept as a background, and colour subordinated to effect. This, of course can only be done when there is one single mind directing the whole production. The facts of art are diverse, but the essence of artistic effect is unity.[83]

Whistler's performance included not only his constant presence in public, and his regular appearance as subject on canvas or paper, but also the considered ways in which he framed and exhibited his work. The background of Chase's portrait conjures up the rich yet neutral gold and brown color scheme that, after 1884, Whistler came to prefer whenever he could maintain control of the gallery interiors where his own artworks were shown.[84]

Having inferred a reference to Whistler's exhibitions in Chase's use of the luxurious velvety background, we might offer a comparison with David Teniers II's most famous subject, *Archduke Leopold Wilhelm in His Picture Gallery*, a type of composition used by numerous court painters to record royal painting collections during the seventeenth century [fig. 2.27].[85] Teniers focused on the archduke, surrounded by his enormous holding of canvases, which numbered 1,397 works by 1659. Leopold is posed at the forefront, flanked by the artist himself along with other supernumeraries, all respectfully placed in a more distant plane. Leopold's stance trenchantly mimics an armored St. George hanging above him.

Images of rulers and their collections invite us to speculate on Chase's implication of future "old masterhood" for his subject. By having Whistler take center stage

FIG. 2.26 "Forlorn Condition of Temple Bar," wood engraving, from the *Illustrated London News*, 14 March 1868. Library of Virginia, Richmond.

while striking that same regal pose as Leopold or Louis XIV, Chase privileged the nobility of the modern artist, not the patron-collector. Whistler ardently felt that distinction. As aesthetic knight Whistler did battle without St. George's shining armor, but he learned quickly enough that the pen was mightier than the sword, in Victorian Britain anyway. He scornfully denounced collectors who made profits by selling their Whistlers and treasured a typographical error that read, "pictures kindly lent their owners" in one of his exhibition catalogues. In establishing himself as a "new master," the need to honor influential forebears was not strong enough for him to resist the quip, "Why drag in Velázquez?" when the perfectly valid comparison between his work and the Spaniard's was made.[86]

While Louis XIV was delighted with Rigaud's effort, Whistler did not care for Chase's penetrating image, even though the portrait is quite close to the caricature from *Spy* that Whistler enjoyed enough to give autographed copies to friends.[87] Sounding a bit like the mother of Virginie Gottreau following the Parisian scandal over John Singer

2.27

FIG. 2.27 David Teniers (1610–1690), *Archduke Leopold Wilhelm in His Picture Gallery*, 1651–56, oil on canvas, 27½ x 33⅞ inches. Kunsthistorisches Museum, Vienna.

Sargent's revealing portrait of *Madame X* (1883), another shockingly modern black-clad portrait reliant on the clever use of old master painting,[88] Whistler dismissed Chase's work as a "monstrous lampoon." He snapped, "How dare he—Chase—to do this wicked thing? And I, who was charming and made him beautiful on canvas, the masher of the avenues."[89] Whistler's angry reaction to Chase's work requires some explanation.

Rigaud's portrait of Louis XIV depicts an aging majesty. Recalling that the *New York Times* waspishly associated Whistler with an aging actress as well as calling him an old dandy, we might note that by the 1870s the languid affectation of walking sticks, parasols, or umbrellas exuded a decided air of feminine fashion. We can see this in *Mary Cassatt at the Louvre* [fig. 2.28], etched by Degas a few years before Chase painted Whistler. Choosing a vertical format reminiscent of a Japanese pillar print, Degas applied pastels over the ink in colors not unlike Chase's scheme in the Whistler portrait. Wearing black, tightly corseted, Cassatt is on display herself. She stands out from the rich tonal background of subdued golds and browns, leaning on her furled umbrella to contemplate pictures in the Long Gallery.

In a work by Chase's friend Alfred Stevens, another woman strikes the noble pose so long ago derived from royal decorum. Lest viewers miss the doubtless correct position of her feet under her long gown, the image was frankly titled *Her Majesty, La Parisienne*. The work was reproduced in 1880 in *L'Art de la mode*, a progressive fashion journal. The idealized Parisienne was a mannered creature of fashion—"half-angel, half-demon, child and adult." Her ambiguity sends the same seductive message that, as we will see, emanates from Whistler's paintings of women in white.[90] This push-pull creature parallels the dual persona Whistler used to attract attention to his art. Many subsequent images attest that the way Whistler handled his cane and crooked his elbow to align himself within the ranks of the Victorian dandy took his posturing to the edge of gender limits. By echoing the eighteenth-century Macaroni's unconventional behavior, Whistler exposed himself to such remarks as Degas's cross riposte, "Whistler, you have forgotten your muff!"[91]

A bit of high-fashion theater occurred when, shortly after his return from Venice in November 1880, Whistler suddenly appeared at the Fine Art Society with a small, hapless dog in tow:

FIG. 2.28 Edgar Degas, *Mary Cassatt at the Louvre: The Paintings Gallery*, 1885, pastel over etching, aquatint, drypoint, and crayon électrique on tan wove paper, 12 x 5 inches. The Art Institute of Chicago, Bequest of Kate L. Brewster, 1949.515.

2.28

Well, you know, I was just home; nobody had seen me, and I drove up in a hansom. Nobody expected me. In one hand I held my long cane; with the other I led by a ribbon a beautiful little white Pomeranian dog; it too had turned up suddenly. As I walked in I spoke to no one, but putting up my glass I looked at the prints on the wall. "Dear me! Dear me!" I said, "still the same old sad work! Dear me!" And Haden [Whistler's hated brother-in-law] was there, talking hard to Brown [a staff member at the Fine Art Society], and laying down the law, and as he said "Rembrandt," I said "Ha ha!" and he vanished.[92]

2.29

Not long after, the dog vanished too. Whistler did not share the general Victorian fondness for pets. His little white dog was an accessory, one that reminds us how frequently fashion's wheel turns. Introduced to Britain by Queen Charlotte, the German wife of King George III, Pomeranian dogs, a subgroup within the spitz breeds in Germany, were featured in stylish portraits such as *Mrs. Mary Robinson* by Thomas Gainsborough [fig. 2.29]. Whistler would have seen this portrait when he visited the Manchester Art Treasures exhibition in 1857.[93] Given that the twin poles of high fashion have long been the aristocracy (whether of birth or of power) and the demimonde, it should surprise nobody that Mrs. Robinson was an actress, the former mistress of Queen Charlotte's son the prince of Wales (later George IV), whose miniature she holds in her hand. Beside her sits a white Pomeranian dog. If true to its breeding, the dog would have proved more loyal to Mrs. Robinson than did the prince.[94]

Dogs are sometimes featured as accessories in fashionable pictures contemporary with Whistler. At the Salon of 1874, Ernest-Ange Duez scored a success with an idealized contemporary woman titled *Splendeur* [fig. 2.30]. She clutches a miniature poodle rather than a miniature portrait in her hand. The white dog's golden chain forms a graceful arc that counters the voluptuous curves of the woman's heavily trimmed costume. Her be-furred bustle echoes the projecting posterior of the hapless little animal dangling from her grasp like a fuzzy handbag. As Duez also exhibited a counterpart, called *Misère*, a social comment on the excesses of fashion seems intended. Novelists, too, confirm Whistler's little dog as a fashion statement. In *Daniel Deronda*, George Eliot describes

FIG. 2.29 Thomas Gainsborough (1727–1788), *Mrs. Mary Robinson (Perdita)*, 1781, oil on canvas, 90 x 60¼ inches. Wallace Collection, London.

Lady Mallinger's "fair matronly roundness, and mildly prominent blue eyes," as she "moved about in her black velvet, carrying a tiny white dog on her arm as a sort of finish to her costume."[95]

One suspects that Whistler would have derived especial pleasure in taking up the elegant foxlike Pomeranian, "vivacious and dainty," according to the Breed Standard, a decade before Queen Victoria fostered a second vogue for them. The queen brought back several Pomeranians from her travels in Italy in 1888; perhaps Whistler, too, got his dog there during his Venetian sojourn.

On his return to London, Whistler held three exhibitions at the Fine Art Society centered on his Venetian work. The third and most elaborate of these, the *Arrangement in White and Yellow*, then traveled to the United States, although Whistler himself had considered and then declined to undertake such a tour. Meanwhile, and against Whistler's wishes, Chase exhibited his portrait of Whistler in Boston, New York, and Chicago shortly after *Arrangement in White and Yellow* had made stops in each of these cities.[96] Whistler had asked Chase not to show the portrait until his own image of Chase (now lost) could be shown with it. His diatribe against Chase's portrait may have gained steam from territorial jealousy.

2.30

The circulation of *Arrangement in White and Yellow* to six American cities after its London run follows the example of Oscar Wilde's speaking tour of the United States in 1881–82. It also overlapped with grand American tours taken by famous European actors and actresses, such as Henry Irving and Ellen Terry. The Irving-Terry theatrical company played New York, Boston, Philadelphia, Chicago, Baltimore, and Washington from October 1883 to April 1884.[97] All but those in Washington also witnessed Whistler's *White and Yellow* exhibition, and Washingtonians could have traveled up to Baltimore to see it. Whistler's art reached American soil but the artist did not. During the exhibition's run in the United States, Whistler himself was represented by a photograph [see fig. 8.14]. Picturing Whistler as a dandy, the photograph attracted "as much attention as the prints," according to newspaper accounts.[98] Inclusion of the now-notorious *Falling Rocket* added further éclat to the American tour [see fig. 5.16].

FIG. 2.30 Ernest-Ange Duez (1843–1896), *Splendeur*, 1874, oil on canvas, 32¼ x 37½ inches. Musée des Arts décoratifs, Paris.

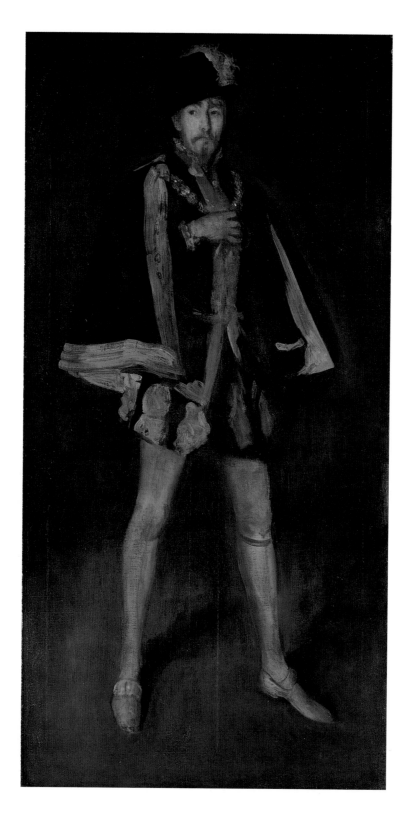

FIG. 2.31 Whistler, *Arrangement in Black, No. 3: Sir Henry Irving as Philip II of Spain*, 1876–85, oil on canvas, 84¾ x 42¾ inches.
The Metropolitan Museum of Art, Rogers Fund, 1910 (10.86).

Although it is now in the Metropolitan Museum of Art, and has been since 1910, Irving's portrait by Whistler [fig. 2.31] remained in England at the time the actor was touring across the Atlantic.[99] Whistler's vigorous likeness of the self-made, world-famous actor is instructive for understanding changing tastes and widening acceptance of Whistler's work in the context of performance and display. Like the artist's own white plume in an otherwise black head of hair, an extravagant feather in a high-crowned hat draws the eye to the actor's face. The picture quotes *Pablo de Valladolid* (ca. 1635) by Velázquez. Whistler kept a photograph of the oft-cited Spanish painting in his studio [fig. 2.32]. Viewing the *Irving* back in 1877 at the Grosvenor Gallery, Henry James dismissed Whistler's effort as "ghosts of Velasquezes." He went on: "To be interesting it seems to me that a picture should have some relation to life as well as to painting. Mr. Whistler's experiments have no relation whatever to life."[100] Twenty years later at an exhibition of paintings and prints related to the theater, James encountered the *Irving* again. By then, the writer had reconsidered his opinion of both painting and artist:

> To pause before such a work is in fact to be held to the spot by... the charm of a certain degree of melancholy meditation...the effect of Whistler at his best is exactly to give the place he hangs in—or perhaps I should say to the person he hangs for—something of the sense, of the illusion, of a great museum. Whistler isolates himself in a manner all his own; his presence is in itself a sort of implication of a choice corner. Have we, in this, a faint foresight of the eventual turn of the wheel—of one of the nooks of honour, those innermost rooms of great collections, in which our posterity shall find him?[101]

Shortly after the deaths of both artist and sitter, the Irving portrait was validated in more prosaic terms when it "received at auction the hall-mark of an accepted master" at the actor's estate sale in 1905. Bringing 4,800 guineas at public auction, it was the sixth most expensive picture of the year.[102]

2.32

FIG. 2.32 Diego Velázquez (1599–1660), *Pablo de Valladolid*, photograph from Whistler's studio. Glasgow University Library, Department of Special Collections.

Only a decade before these "old master" accolades, a dapper drypoint portrait of Whistler, etched in the early 1880s by Mortimer Menpes, introduced the 1895 issue of *The Year's Art*, an important art-market annual inaugurated by Whistler's old associate from the Fine Art Society, Marcus Huish. Like a wrinkled movie star glimpsed through a soft-focus lens, or the judiciously airbrushed cover image of a jowly politician, the use of an early drypoint conveys a flattering, upbeat message of eternal youth hardly commensurate with Whistler's sixty-one years. In contrast, Seymour Haden, also included in this issue, was represented by a recent photograph recording tired eyes, sagging flesh, and fusty white muttonchop whiskers.[103]

Brown and Gold (1895–1900), a late self-portrait, seems far more revealing than either the flattering image of Whistler selected for publication in *The Year's Art* or the mythic anecdotes and perky caricatures that have outlived the artist himself. In *Brown and Gold* we see the artist presented once again as if on stage, standing before the footlights [fig. 2.33]. For his own self-portrait, Whistler again quotes the *Pablo de Valladolid*. Whistler's overt reference to an image that both he and his contemporaries believed to be the portrait of an actor confirms his own sense of continuous performance, as does the color scheme associated with his exhibitions. Although only a decade had elapsed between the completion of Chase's vigorous image and Whistler's commencement of this canvas, the artist had grown patently tired of keeping up his role.

Here, at the end of his career, Whistler's stance is a little precarious, his posture a bit slumped, his gesture tenuous. Painted during some of the most harrowing years of his life, the period when Whistler's beloved wife, Trixie, sickened and died, the self-revealing portrait poignantly records the effects of anxiety and care. Years earlier, when a young American in Venice entered a studio to encounter the hardworking Whistler-as-Jekyll without benefit of his customary theatrical grooming, Whistler told him, "I leave all gimcracks outside the door."[104] Now the indispensable monocle is not in evidence. The white plume pales against Whistler's graying curls. Gone is the walking stick. Whistler's hands are empty. Haunted by his bereavement, Whistler wrote from Honfleur, "I still put out my hand to take the [hand] that I may never again hold and again I know that I journey by myself."[105] When it was exhibited at the Paris Exposition Universelle in 1900, the critic Gustave Geffroy found the portrait ghostly—"vague tout d'abord comme une apparition."[106]

FIG. 2.33 Whistler, *Brown and Gold: Self Portrait*, ca. 1895–1900, oil on canvas, 37¾ x 20¼ inches. Hunterian Art Gallery, Glasgow University, Bernie Philip Bequest.

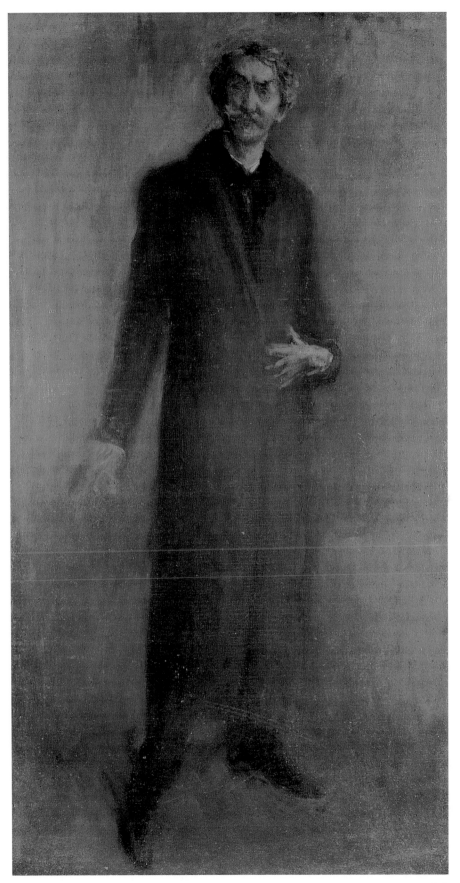

2.33

FIG. 2.34 Whistler, *Harmony in Grey and Green: Miss Cicely Alexander*, 1872–73, oil on canvas, 74¾ x 38½ inches. Tate Gallery, London.

Familiar as he was with the significance of costume, Oscar Wilde made a comment about men's clothing that offers an appropriate door through which to pass, leaving this shadowy, scraped-down image of the once vital Whistler in his long, somber overcoat:

> Perhaps one of the most difficult things for us to do is to choose a notable and joyous dress for men. There would be more joy in life, if we were to accustom ourselves to use all the beautiful colours we can in fashioning our own clothes.[107]

Mark Twain expressed similar wishes three years after Whistler's death:

> I can't bear to put on black clothes again....I should prefer, of course, to wear colors, beautiful rainbow hues, such as the women have monopolized. Their clothing makes a great opera audience an enchanting spectacle, a delight to the eye and to the spirit—a garden of Eden for charm and color. The men, clothed in odious black, are scattered here and there over the garden like so many charred stumps....I should like to dress in a loose and flowing costume made all of silks and velvets resplendent with stunning dyes, and so would every man I have ever known; but none of us dares to venture it....When I put on black it reminds me of my funerals.[108]

Not only Wilde but also Baudelaire, Gautier, Musset, Maupassant, Dickens, and Ruskin had commented on the funereal aspect of men's clothing during the nineteenth century. Perhaps this is not surprising as the most enduring association of black is with night and death.[109]

Twain finally decided, "I have made up my mind not to wear black any more, but white and let the critics say what they will."[110] Rainbow colors were out of the question, but Twain wore white suits almost exclusively for the rest of his life. William Dean Howells still sensed something disturbing in Twain's new wardrobe when he praised it as "an inspiration which few men would have had the courage to act upon."[111]

Although best known for his black frock coats, Whistler occasionally sported crisp white ducks, primarily in his youth. As we will discover in the following chapter, white clothing has a long, sometimes unsettling social history. Twain himself explored the issue in "Wapping Alice," a tale centering on a male transvestite wearing a "white summer gown, with a pink ribbon at the throat and another one around her waist." Written in 1897,

the farce remained unpublished until well after the author's death.[112] Decades earlier, Whistler had painted a woman engaged in what is probably a sexual transaction, and titled the painting *Wapping* [see fig. 5.14].[113]

Like Whistler, Twain was comfortably at ease with the significance of the past. On his way to Washington to lobby Congress for extended copyrights, Twain mused:

> There is no such thing as a new idea…we simply take a lot of old ideas and put them into a sort of mental kaleidoscope. We give them a turn and they make new and curious combinations. We keep on turning and making new combinations indefinitely; but they are the same old pieces of colored glass that have been in use through all the ages.[114]

Fully informed by past fashion, Whistler's sartorial aplomb lived on, not only in the legends surrounding his own riveting appearance but also in the clothing he recorded on canvas. In some cases he himself first designed costumes for sitters, including Frances Leyland, gowned in her Watteau-pleated dress [see fig. 5.1], and Cicely Alexander, holding a feathered, broad-brimmed hat like a cavalier from the days of King Charles I [fig. 2.34].

As fashion's wheel turned and turned again, collectors bid up Whistler's prices while the artists he inspired paid him homage in beautiful echoes of his work. Lit by the magical glow of paper lanterns, young girls in white dresses haunt a luxuriant garden in Sargent's *Carnation, Lily, Lily, Rose* [fig. 2.35], and Dewing's *DeLancey Iselin Kane*, clad in a white sailor suit, stands in a haze of nuanced lavenders and pinks, forever captured in the promise of youth [fig. 2.36]. However, white clothing is not always as innocent as it seems.

66

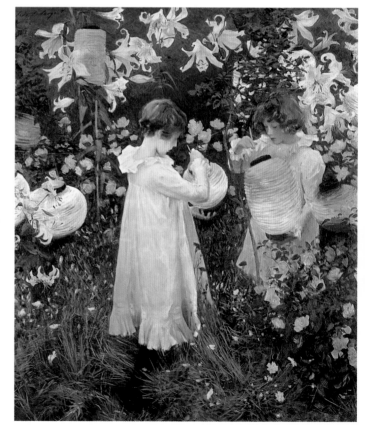

2.35

FIG. 2.36 Thomas Wilmer Dewing (1851–1938), *Portrait of DeLancey Iselin Kane*, 1887, oil on canvas, 72 x 48½ inches. Museum of the City of New York,

Gift of Miss Georgine Iselin, 40.417.

3. Women in White

Miss Fairlie was unpretendingly and almost poorly dressed in plain white muslin. It was spotlessly pure; it was beautifully put on; but still it was the sort of dress which the wife or daughter of a poor man might have worn; and it made her, so far as externals went, look less affluent in circumstances than her own governess.

—Wilkie Collins, *The Woman in White* (1860)

The fact was, you could hardly tell a lady now from an actress.

—Edith Wharton, *The Buccaneers* (1938)

The white dress first worn by Jo Hiffernan in Whistler's retroactively titled *Symphony in White, No. 1: The White Girl* (1862) [see opposite and fig. 3.11] conjures up Oscar Wilde's comment "One should either be a work of art or wear a work of art."[1] Fashion feeds art as much as intellectual curiosity does, a harsh fact of life that successive generations of hungry painters face as they reconcile the ethereal realm of "art for art's sake" with the less exalted world of social performance, characterized by shopping, collecting, and commercialized entertainment. In contrast to his flamboyant public behavior, Whistler tailored his art to these issues with the subtlety of a gifted dressmaker.

Sprawled on a banquette in a most unladylike pose, Jo wore the white dress again for *Symphony in White, No. 3*, shown at the Royal Academy in 1867 [fig. 3.1]. The third of Whistler's "White Girls" was the first to be exhibited with a musical title, inscribed boldly on the canvas at the lower left.[2] Jo is joined by another model also wearing white. This languid image of two young women and the faint suggestion of home proved acceptable to the Hanging Committee—the first "White Girl" had not. But *Symphony in White, No. 3* then provoked one of the most excoriating of all Whistler's bromides later preserved in *The Gentle Art of Making Enemies*. A critic for the *Saturday Review* complained that the picture was:

68

OPPOSITE: Detail from fig. 3.11

3.1

> Not precisely a symphony in white. One lady has a yellowish dress and brown hair and a
> bit of blue ribbon, the other has a red fan.…There is a girl in white on a white sofa, but
> even this girl has reddish hair, and of course there is the flesh colour of the complexions.

Whistler chastised the literal-minded journalist for expecting a one-note symphony, crying
"F, F, F?…Fool!"[3]

When painter James Tissot saw Whistler's picture, he warned his colleague to
expect imitations, and works by Degas and Manet followed [fig. 3.2].[4] However flattering
such compositional borrowing by influential French colleagues might be for a rising
American talent, Whistler might later have wished to add "F-F-F—flood!" as a host of
women in white dresses floated onto canvas, playing countless variations on this theme
during the following six decades. There are so many women in white that we can't blame
Whistler for all of them. Yet Whistler's "White Girls" inspired costume-driven works
as dissimilar as George Clairin's sensuous *Sarah Bernhardt* of 1876 [fig. 3.3] and Thomas
Wilmer Dewing's stately *Old Fashioned Gown*, painted in 1921 [fig. 3.4].

During an era that wholeheartedly embraced the use of vivid chemical dyes
following Sir William Perkin's accidental discovery of the color mauve, a coal-tar product,[5]
Jo's plain white dress was an unusual choice for an ambitious full-length figure painting

FIG. 3.1 Whistler, *Symphony in White, No. 3*, 1865–67, oil on canvas, 20¼ x 30⅛ inches, inscribed, signed, and dated l.l.: "Symphony in White. No. III.—
Whistler, 1867—". The Barber Institute of Fine Arts, University of Birmingham/Bridgeman Art Library.

intended for public display. Whistler was well ahead of the Aesthetic movement cartoonist George du Maurier, who lampooned aniline dyes in 1877 with "True Artistic Refinement." The affected Mr. Mirabel refuses an introduction to Miss Chalmers, because "she affects aniline dyes, don't you know? I weally couldn't go down to suppah with a young lady who wears mauve twimmings in her skirt, and magenta wibbons in her hair!"[6]

However, in the early 1860s, as we see in *Symphony in White, No. 1*, Jo's attire was as simple in relation to fashionable dress as Whistler's virtually detail-free canvas was in relation to fashionable exhibition pictures. The "aesthetic" gowns of the mid-1870s— "lank garments of white muslin, crumpled in a million creases," embellished with shoulder puffs that "gave the impression of being dilated by an immense sigh"[7]—were yet to become common. When they did, some journalists continued to speak against them:

> On white paper the whitest hand looks brown, a reddish hand quite beefy. Does not this warn us not to envelope ourselves in snow-white garments, and explain why a bride usually looks her worst on her wedding-day?[8]

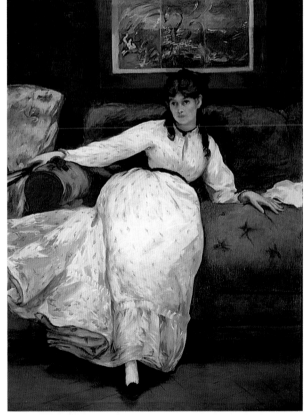

3.2

Frothy, lace-trimmed white "lingerie dresses" could impersonate feminine undergarments in public without a blush by the late nineteenth century, but such attire was hardly à la mode in the early 1860s.[9] Having been stylish for decades, white dresses for public wear in Britain went out of fashion in the 1820s and remained so for forty years, appearing outside the home only occasionally in evening gowns "cut down to the due pitch of indecency" to be worn by those wealthy enough to keep them clean in soot-ridden Victorian cities and towns.[10]

Wearing white in public extends back to the sixteenth century. Previously donned next to the skin, white linens began to appear in outer layers of clothing as a signal of bodily cleanliness. But if whiteness implies cleanliness, even perfection, it is no guarantee. By dressing his model in white, Whistler set up a calculated implication of innocence countered by the ambiguity necessary for open-ended

FIG. 3.2 Édouard Manet (1832–1883), *Le Repos*, 1870, oil on canvas, 59 ⅛ x 47 ⅞ inches, signed: "Manet". Museum of Art, Rhode Island School of Design, Providence, Bequest of the Estate of Edith Stuyvesant Vanderbilt Gerry.

3.3

3.4

interpretation. As Oscar Wilde later observed, "Costume is a means of displaying character without description."[11]

No restrictive whalebone shapes Jo's pleated bodice; her otherwise ungoverned waist is marked at its natural point by a discreet ribbon belt. The long sleeves, puffed at the shoulder and tight at the wrist, recall Renaissance attire.[12] The skirt does not depend upon voluminous starched crinolines or flexible steel hoops for its shape. Rather, its softly draped skirt flows into a train, recalling medievalizing gowns like the one worn by Jane Morris in a portrait painted by her husband in 1858 [fig. 3.5].[13] But the rich patterning typical of the Pre-Raphaelites is absent in Whistler's luscious mass of white, set off only by the model's red hair and her modest, already wilting little bouquet, most of it dropped just behind the grimacing head of a bearskin rug.

Not only the rough painterly surface of *The White Girl*, but also its early exhibition history recall Whistler's debt to the ideas and practices of Gustave Courbet. Having been rejected by the Royal Academy in 1862, Whistler's realist vision was installed that year along with *At the Piano* in a commercial London gallery.[14] The following year, again rejected—this time by the French Salon—*The White Girl* gained notoriety at the Salon des Refusés, joining Édouard Manet's *Le Déjeuner sur l'Herbe* (1863) in a succès de scandale. The picture has maintained its high profile in Whistler's oeuvre ever since.

3.5

73

With this canvas Whistler initiated his career as a self-publicist corresponding with the press—a "game" he regularly described in bellicose terms. By 1865 he would be a regular customer of a press clipping agency, and he also relied upon family, friends, and colleagues to supply him with snippets from the ever burgeoning art press.[15] While *The White Girl* was on view in Berner's Street, Whistler privately crowed:

> She shows herself proudly to all London…[she] creates an excitement in the Artistic World here which the Academy did not prevent, or, foresee after turning it out I mean—In the

FIG. 3.3 Georges Clairin (1843–1919), *Sarah Bernhardt*, 1876, oil on canvas, 98⅛ x 78¾ inches. Musée de Petit Palais, Paris.

FIG. 3.4 Thomas Wilmer Dewing (1851–1938), *The Old Fashioned Gown*, 1921, oil on canvas, 14½ x 13 inches. Private collection.

FIG. 3.5 William Morris (1834–1896), *La Belle Iseult (Queen Guinevere)*, portrait of Jane Morris, 1858, oil on canvas, 28 x 19⅝ inches. Tate Gallery, London.

catalogue of this exhibition it is marked "Rejected at the Academy." What do you say to that! isn't that the way to fight 'em! Besides which it is affiched All over the Town as Whisller's [*sic*] Extraordinary picture the WOMAN IN WHITE [this appearing on a sketch of a man with a billboard]…That is done of course by the Directors but certainly it is waging an open war with the Academy, eh?[16]

3.6

Whistler made an amusing private drawing of the man with the sandwich board [fig. 3.6], but he also issued a public denial of any connection between his painting and the novel *The Woman in White*. This melodramatic serial adventure mesmerized readers of *All the Year Round* in 1859, just as Whistler was setting up shop in London. Responding to *The Athenaeum*, whose critic had asserted, "The face is well done, but it is not that of Mr. Wilkie Collins's *Woman in White*," Whistler wrote:

> The Proprietors of the Berner's Street Gallery have, without my sanction, called my picture "The Woman in White." I had no intention whatsoever of illustrating Mr. Wilkie Collins's novel; it so happens, indeed, that I have never read it. My painting simply represents a girl dressed in white standing in front of a white curtain.[17]

As Whistler was working on the painting, Collins's page-turner was consolidated in novel form, quickly eclipsing the previous record-holding best-seller, *Uncle Tom's Cabin* (1852).[18] The publication of the book in 1860 also set off a merchandising boom:

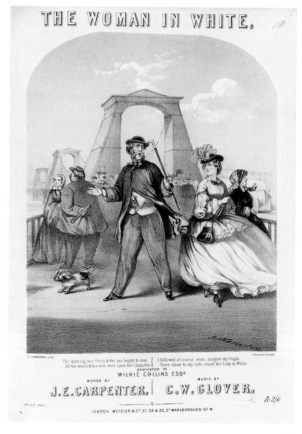

3.7

> While the novel was still selling in its thousands, manufacturers were producing *Woman in White* perfume, *Woman in White* cloaks and bonnets, and the music-shops displayed *Woman in White* waltzes and quadrilles…[19] [fig. 3.7]

Clearly, Whistler's letter was disingenuous.[20] Dressing Jo in white—"the sort of dress which the wife or daughter

FIG. 3.6 Whistler, *sketch* included in his letter to George Lucas, in Paris, sent from London, 26 June 1862, pen and brown ink on off-white laid paper, 9 x 8⅞ inches. Wadsworth Athenaeum, Hartford, Gift of John F. Kraushaar.

FIG. 3.7 Robert Johnson Hamerton (fl. 1831–1860), *The Woman in White*, lithograph for sheet music by Joseph Edward Carpenter and Charles William Glover, dedicated to Wilkie Collins, London, 1860. British Library, London.

of a poor man might have worn"—and presenting her in the full-length format more appropriate to a society portrait in the grand manner rode a popular marketing trend while tweaking the Victorian art establishment's sense of propriety.[21]

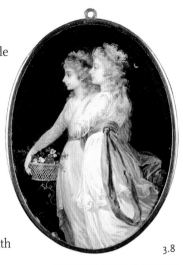

It cannot have helped that historical precedent for a soft, fluid "boudoir" look could be traced to Marie Antoinette, whose all-white informal *robes à la creole* spread across the Channel. They were first worn in public by such Regency fashion plates as the French queen's friend Georgiana, the controversial duchess of Devonshire, and her equally racy companion Lady Elizabeth Foster [fig. 3.8].[22] After the French revolution, unstructured, high-waisted Empire dresses were popular in England, as they were in France. They are as closely associated with the genteel world of Jane Austen [fig. 3.9] as with the excesses of Napoleonic France, where the Empress Eugénie, Madame Recamier, and Pauline Borghese sometimes dampened their flimsy white dresses to reveal feminine curves [fig. 3.10]. Whistler's women in white are thus charged with a mixed message. John Harvey observes, "As art, dress is also performance art, for playing both safe and dangerous games. The clothed person is a persona we perform." He adds that the woman in white, like the man in black, is multivalent—"a whole family."[23]

3.8

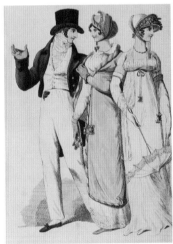

Feeling the need to read meaning into Whistler's picture [fig. 3.11], Jules-Antoine Castagnary interpreted *Symphony in White, No. 1* as a song of lost innocence, albeit within the bounds of nineteenth-century propriety and having eighteenth-century precedents. The critic challenged the artist:

3.9

> Does a tour-de-force in painting consist of putting white on white?! I think not. Permit me to see something higher in your work: *the bride's morning after,* that troubling moment when a young woman reflects on the absence of yesterday's virginity.... There are white curtains at a closed alcove. Behind them the *other one* is doubtless still sleeping. You recall *La Cruche cassée* or *la Jeune fille pleurant son oiseau mort,* the playful subjects beloved by Greuze. Whistler's interpretation is graver, more severe, more English. His *White Girl* is evidently married; the night she has just passed was legitimate, approved by the Church and the world…but ask the wilting flower she holds in her hand. This is the continuation of the allegory begun with the broken pitcher and the little dead bird.[24]

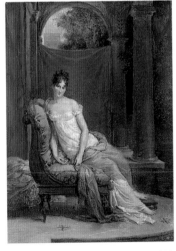

FIG. 3.8 Jean-Urbain Guerin (1761–1836), *Georgiana, duchess of Devonshire and Lady Elizabeth Foster,* 1791, gouache on ivory, 3¾ x 2¾ inches. Wallace Collection, London.

FIG. 3.9 *Kensington Garden Dresses for June,* engraving, in *Le Beau Monde,* London, 1808. University of Virginia Libraries.

FIG. 3.10 François-Pascal-Simon Gérard (1770–1837), *Madame Recamier,* 1802, oil on canvas, 12½ x 8½ inches.
Chateaux de Versailles et de Trianon, Versailles.

3.10

Whistler copied Jean-Baptiste Greuze's allegory of lost innocence, *La Cruche Cassée* [fig. 3.12], at the Louvre in 1857, only a few years before he painted *The White Girl*.[25] But he gave no evidence of *The White Girl*'s marital status. Unlike his *Symphony in White, No. 2*, where Jo wears a gold wedding band [see fig. 7.41], she is without jewelry in this picture. Whistler's personal life at this point was conducted completely outside the bounds of the picture as interpreted by male journalists, and Castagnary's commentary was as much about the critic as about the work of art, as Whistler would later explain in the "Ten o'Clock" lecture. Whistler sought to neutralize Jo's countenance. Yet, given the ringless woman's forthright stance atop a decidedly flattened bearskin with its mouth agape and teeth bared, while her *other* (Whistler himself) slumbered only when he wasn't furiously engaged in painting his mistress, we might wonder who has ravished whom?

Jo is staged abruptly in front of a closed curtain, recalling the traditional "Parade" or sideshow held out on the curb to entice customers into French theaters, a topic explored in other modernist works, from Manet's *The Old Musician* (1862) to Georges Seurat's *La Parade* (1889). Jo is exposed to the eyes of the crowd; she "shows herself proudly to all London," having graced "a sketch of a man with a billboard," as Whistler first told us. All these paintings reprise a chain of imagery stretching from the street theater of the nineteenth century back to the old commedia dell'arte. Watteau's *Le Grand Gilles* [fig. 3.13], the image of a stock character from the Italian comedy, was shown in Paris at the 1860 exhibition of French masters and engraved that year for the *Gazette des Beaux-Arts*. In 1863 one journalist constructed a melodramatic scenario for Gilles that remarked specifically upon the tragic yet sublime aspect of the painting: "For a moment the clown has forgotten the stage. In the middle of the crowds he dreams (so many things!—he sees life in a flash)—he dreams, he is overwhelmed."[26]

Although critics made no specific connection with the Watteau painting, some immediately perceived the poetic melancholy of Whistler's

3.11

3.12

76

FIG. 3.11 Whistler, *Symphony in White, No. 1: The White Girl*, 1862, oil on canvas, 83⅞ x 42½ inches. National Gallery of Art, Washington, D.C., Harris Whittemore Collection.

FIG. 3.12 Jean-Baptiste Greuze (1725–1805), *La Cruche Cassée*, 1771, oil on canvas, 43 x 34¼ inches. Louvre, Paris.

FIG. 3.13 Jean-Antoine Watteau (1684–1721), *Le Grand Gilles*, 1717–19, oil on canvas, 73 x 59 inches. Louvre, Paris.

enigmatic figure in white. *The White Girl* addressed the sensitivities of French critics at about the same time that Jules and Edmond de Goncourt, avid students of eighteenth-century French art, were praising Watteau's painting as the creation of poetry and dreams. Ernest Chesneau used language suspiciously close to the Goncourts', praising *The White Girl* for its revelation of "a romantic imagination of dreams and poetry." Fernand Desnoyers also was touched by the painting's haunting presence. He wrote that it was the portrait of a spiritualist or a medium.[27] In Watteau's evocative canvases, the Goncourts saw "poetic love that dreams and thinks, modern love with its hopes, crowned with melancholy."[28] Their perception could be appropriately extended to Whistler's *Symphony in White, No. 1*. Whistler may well have intended to recast an old theme, creating an allegory of modern love clad in contemporary dress, visually reinforced by the popularity of the white clown on the nineteenth-century stage, as well as in popular illustrations by Paul Gavarni and others.[29]

Sinister implications of inevitable sorrow in theater life are to be found in Victorian paintings that initially appear straightforward. *Her First Bouquet* by Charles Green depicts known performers at the Britannia Theatre in Hoxton, an old London suburb by then equally renowned for its music halls and its overcrowded squalor [fig. 3.14].[30] The young ballerina holding her nosegay of flowers is bracketed not only by her mother and a clown in white makeup, but also—at the far edges of the canvas—by a virile, predatory-looking young Harlequin on the left and an old, top-hatted roué chatting up a teenaged ballerina on the right. The little performer's success may invite similar

FIG. 3.14 Charles Green (1840–1898), *Her First Bouquet: the Lane Family with the Clown George Lupino at the Britannia Theatre, Hoxton* (DETAIL), 1868, oil on canvas, 22½ x 32 inches. Location unknown.

transactions of a nature much more harshly depicted in the ballet scenes of Edgar Degas.

If white ballet costumes were confined to the stage, the vogue for diaphanous white Grecian dresses recalling Aphrodite and Diana, successful in the theater, were also popular at home, coinciding with the white hangings for bedrooms that came into fashion in the late eighteenth century.[31] Easily washed, they helped maintain the appearance of household cleanliness; the herbal aroma of snow-white linens scented with camphor, lemon verbena, or rose geranium is fondly remembered in many period documents.

During the Colonial revival, as certain segments of American society began to redefine New England in terms of its past, seeking a more "innocent" time, the burgeoning of white dresses and white interiors suggests that white maintained its ancient connotation of purity, one it shares with interpretations of Whistler's work. Cecilia Beaux's 1895 portrait of Julia Leavitt Richards [fig. 3.15] indicates that the fashion lingered in rural New England, where Whistler is certain to have encountered it during his childhood. Beaux's color scheme may evoke Whistler's "White Girls," but the pose clearly quotes Whistler's *Mother*; Anna McNeill Whistler was noted for her insistence upon

3.15

hygiene, a concern shared by many home-makers in the nineteenth century.

Enigmatic love veiled all in white was still an effective formula a century later, when Louise Nevelson surprised visitors to New York's Museum of Modern Art with a white-on-white installation, titled *Dawn's Wedding Feast* [fig. 3.16]. Dore Ashton commented on this "extraordinary white room," saying that it was "bizarre, humorous, and at the same time, resplendent as all Nevelson's dream places are." Ashton admired

79

3.16

FIG. 3.15 Cecilia Beaux (1855–1942), *New England Woman (Mrs. Jedediah H. Richards, née Julia Leavitt)*, 1895, oil on canvas, 43 x 24¼ inches. Pennsylvania Academy of the Fine Arts, Philadelphia, Joseph E. Temple Fund Purchase.

FIG. 3.16 Louise Nevelson (1899–1988), *Dawn's Wedding Feast*, 1959, installation of white-painted wood sculptures at the Museum of Modern Art, New York, 16 December 1959–14 February 1960. Estate of Louise Nevelson.

The baroque finery—lacy and latticed like a small Victorian town with its wooden houses and daintily fenced garden—seemed peculiarly American. In fact, New England. And the first thought I had when I saw it was that Emily Dickinson might have described such a place as she peered down from her wooden tower in Massachusetts.[32]

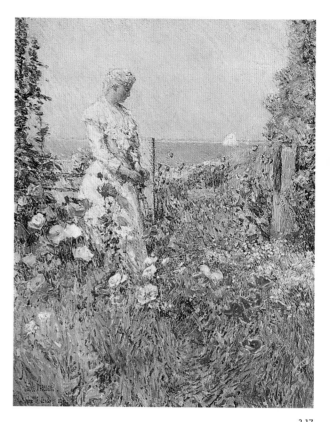

Shields and moons adorned the bases of two large freestanding totems from Nevelson's installation. Tall, white, monumental, they let us move backward in time to another statuesque woman in white, the poet Celia Laighton Thaxter, painted by Childe Hassam on Appledore Island, off the New England coast [fig. 3.17]. Her snowy hair crowned with an ornament in the shape of a crescent moon, Thaxter stands in her Victorian wild garden, reminding us that a profuse flowering of women in white followed Whistler's "White Girls."

Celia Thaxter considered her dress suitably old-fashioned.[33] Stark and unadorned as Jo appears in *Symphony in White, No. 1* thirty years before, she too wears a dress that nods to the past—evoking both medieval and Renaissance times. Indeed, the gown's similarity to Pre-Raphaelite costumes helped push critics toward the conventional mid-Victorian interpretation of the red-haired Jo as a fallen woman.

Added later, Whistler's musical title does not reveal his historicism; Dewing's title, *The Old Fashioned Gown*, does [see fig. 3.4]. Dewing's prop, a secondhand satin wedding dress, became the central feature of his white-on-white composition. It proves, on closer examination, another sensuous orchestration of opalescent tints.[34] Tradition lies under the seductive surfaces of these pictures. White-on-white paintings offered their creators—artists determined to wrest authority from the mainstream artistic establishment—an opportunity to address a technical challenge long recognized by the most powerful circles of academic painting. At the same time, Dewing's use of an old wedding gown would resonate with a sense of recognized convention. Although the tradition of a white wedding dress worn by wealthy brides stretches back to the sixteenth century,

3.17

80

FIG. 3.17 Childe Hassam (1859–1943), *In the Garden (Celia Thaxter in Her Garden)*, 1892, oil on canvas, 22 x 14⅛ inches. Smithsonian American Art Museum, Gift of John Gellatly.

Queen Victoria stimulated a general vogue for white wedding dresses in the 1840s, once she had married Prince Albert in white rather than in the customary royal silver.

Paul Mantz, writing in 1863 for the *Gazette des Beaux-Arts*, linked *Symphony in White, No. 1* to the work of eighteenth-century still-life painter Jean-Baptiste Oudry:

> We would indeed reveal our ignorance of the history of painting if we dared to pretend
> that Mr. Whistler is an eccentric when, on the contrary, he has precedents and a tradition
> that one should not ignore, especially in France....Whistler could have learned that [Oudry]
> sought on many occasions to group...objects of different whites....These associations
> of analogous nuances were understood a hundred years ago by everyone, and the difficulty
> which would baffle more than one master today passed then for child's play. In searching
> for a similar effect Mr. Whistler continues therefore in the French tradition.[35]

Mantz was talking about *The White Duck* [fig. 3.18], an academic exercise on canvas, shown at the 1753 Salon and based upon a paper the artist had delivered to his colleagues. Criticism at that time made much of the painting as a splendid performance, concluding with the comment that such pictures "always reveal the great talents of the artist."[36] Here, Whistler's academic ambitions, as well as his eighteenth-century orientation, are illuminated. Whistler could have seen *The White Duck* in the large exhibition of eighteenth-century French paintings held in Paris in 1860.[37]

He cannot have been disappointed by the reaction to *The White Girl* on the part of his peers. Henri Fantin-Latour assured Whistler:

> We find the whites excellent; they are superb, and at a distance (that's the real test)
> they look first class. Courbet calls your picture an apparition....Baudelaire finds
> it charming, exquisite, absolutely delicate. Legros, Manet, Bracquemond, De Balleroy,
> and myself, we all think it admirable.[38]

Only snow scenes offered Whistler's Impressionist contemporaries so wide a field for bravura displays of talent in painting white on white.

When Sargent exhibited *Fumée d'Ambergris* [fig. 3.19] at the Paris Salon of 1880, seventeen years after Whistler scandalized Parisians with his *White Girl* at the Salon des Refusés, critical reactions were positive yet remain predictably close to commentary on the earlier picture. Like *The White Girl*, Sargent's

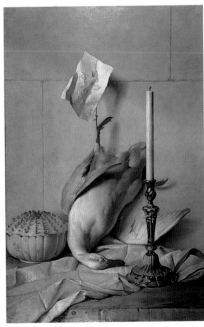

3.18

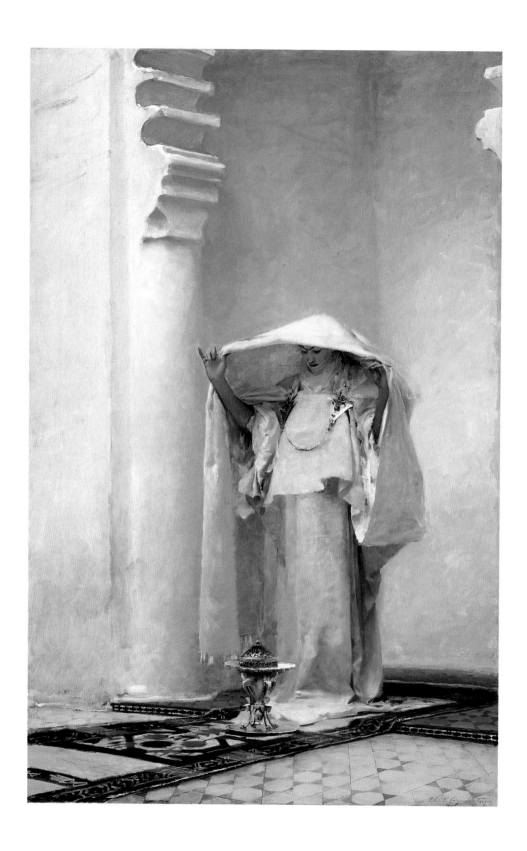

FIG. 3.19 John Singer Sargent, *Fumée d'Ambergris*, 1880, oil on canvas, 54¾ x 35 inches. Sterling and Francine Clark Art Institute, Williamstown, Massachusetts.

tour de force stimulated associations with the boudoir.[39] Again we have a white-on-white canvas at once virginal and seductive, although Sargent chose the exoticized and distanced trappings of *orientalisme* to suggest what Whistler managed with a contemporary white muslin housedress and an old fur rug.

Paul Mantz was especially moved by Sargent's admixture of dexterity and decadence, finding the work a "melodic fantasy" that only Théophile Gautier, whose novel *Mademoiselle de Maupin* (1835) had done so much to advance the cause of "art for art's sake," could have adequately described in words. Mantz had a good try, however, acutely assessing the subtlety of the color scheme while reading the figure as both votary and priestess, a woman sacrificing to herself.[40] Another critic connected the arresting subject—sniffing ambergris to revive sexual ardor—with Casanova's habit of mixing powdered ambergris into his pre-amatory cup of chocolate.[41] Perhaps Henry James's reaction was the most evocatively poetic:

3.20

> I know not who this stately Mohammedan may be, nor in what mysterious domestic or religious rite she may be engaged; but in her muffled contemplation and her pearl colored robes, under her plastered arcade, which shines in the Eastern light, she is beautiful and memorable. The picture is exquisite, a radiant effect of white upon white, of similar but discriminated tones.[42]

By the time Charles Sheeler painted *Upper Deck* in 1929, the exotically dressed woman as subject had given way to a love affair with machinery [fig. 3.20]. Sheeler based his composition on one of his own photographs,[43] but the painted ship, her surfaces gleaming white in the bright sunlight, must relate also to Le Corbusier's use of a similar image to introduce "A Coat of Whitewash: The Law of Ripolin" in *L'art décoratif d'aujour-d'hui* [fig. 3.21]. Recently, Mark Wigley has investigated why the very identity of modern architecture is bound up in the whiteness of its surfaces, even as whiteness itself is considered "neutral," "pure," "silent," "plain," or "blank."[44] He explores early-twentieth-century architectural theory, which he finds riddled with the language and logic of clothing drawn from earlier writers such as Whistler's contemporaries Gottfried Semper and Hermann Muthesius. The theoretical discourse sidestepped the fact that white is

3.21

FIG. 3.20 Charles Sheeler (1883–1965), *Upper Deck*, 1929, oil on canvas, 29 ⅛ x 22 ⅛ inches. Fogg Art Museum, Harvard University, Louise E. Bettens Fund.

FIG. 3.21 *Canadian Pacific*, from "A Coat of Whitewash: The Law of Ripolin," in Le Corbusier, *L'art décoratif d'aujourd'hui*, Paris, 1925. VMFA Library.

just a layer. Wigley explains, "By sustaining a logic of clothing, modern architecture participates in many of the economies from which it so loudly announces its detachment."[45] He further observes that "a crucial part of fashion is the turning of anti-fashion statements into fashion. Fashions are, as it were, propelled forward by their criticism."[46]

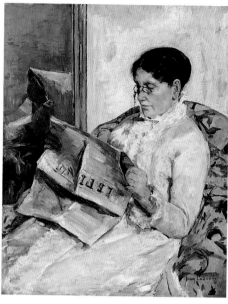

Time and time again, paintings of women in white signal fundamental social change. Of course, even when white-on-white showmanship is not an artist's central goal, a crisp white passage of pigment helps to focus a composition, whether the white-clad figure herself is playing a leisurely game of croquet, as in Winslow Homer's *Croquet Players* (1865), or trotting down to the corner for a bucket of beer as in John Sloan's *Sixth Avenue and Thirtieth Street* (1907). Not long after Homer completed his croquet series, a conservative and alarmed element in American culture reinterpreted the first sport allowing women to compete in public with men and win as the thin edge of the wedge. Passionate debates over advanced education for women, women in the workplace, birth control, suffrage, the broken family, and a host of other thorny issues were not far behind.[47] Transporting herself far beyond the confines of her plush Parisian apartment via the latest news, Mary Cassatt's mother indulges in a once almost exclusively masculine pursuit by *Reading Le Figaro*, 1878 [fig. 3.22]. Thirty years later, Sloan depicts independent young working girls sharing coffee and cigarettes in a Manhattan cold-water flat at *Three A.M.* [fig. 3.23].

In 1860, the dress Jo wore for *Symphony in White, No. 1* was not suitable for the streets, but in 1907 a group of women in white "lingerie dresses" step from the sidewalk into a nightclub in Sloan's *Haymarket* [fig. 3.24].[48] Near the brightly lit doorway, several men cluster around an obvious prostitute. Far from the coolly ambiguous Whistler, the American Realist Sloan can't resist a visual homily on good and evil. To the left, an honest woman, the hooker's counterpart, trudges away from the sordid negotiations, carrying a heavy basket of laundry and trailing a little daughter, also clad in white. The child looks back with undisguised curiosity—the analogue to the curiosity of a middle-class audience willing to go slumming, so long as it is safe. This sensibility repeats the spirit in which Whistler's etchings of the Thames near Wapping were received in London half a century earlier.

84

FIG. 3.22 Mary Cassatt (1845–1926), *Reading Le Figaro*, 1878, oil on canvas, 39½ x 32 inches. Private collection, Washington, D.C.

In American Realist painting, the laundry is always clean, carrying forward the traditional meaning of white clothing as signaling cleanliness. Already some hundreds of years old, this convention was reinforced by scientific advances leading to the identification of the microbe causing tuberculosis in 1882. A rising standard of cleanliness ensued as these discoveries reshaped prescriptive literature and recast housecleaning as an ongoing campaign against disease.[49]

Sloan airs the topic of laundry again in *A Woman's Work* (1912) [fig. 3.25]. Such toil would seem to have little in common with high-style portraits and figure pieces like Frank W. Benson's Impressionist canvas *Lady Trying on a Hat* (1904), although only a decade separates the two paintings typical of movements once considered distinct [fig. 3.26].[50] Titles, as well as appearances, suggest class divisions. The "lady" is set against delicate flowers, precious objects, and luxuriant materials, her slim form encased in a becoming lingerie dress. The "woman" wears a dumpy smock while she cranks out a line of wet washing.

However, each painting addresses received notions of beauty. Benson's refined white and rose color scheme forwards his conventional interpretation of a feminine ideal: the household goddess whose "woman's work" is that of a beautifully costumed performer on the social scene.[51] Contemporary novelists reveal that the job was not as enjoyable as it might appear:

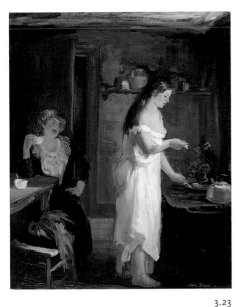

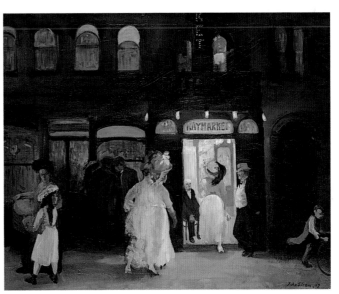

3.23 3.24

FIG. 3.23 John Sloan (1871–1951), *Three A.M.*, 1909, oil on canvas, 32 x 26¼ inches. Philadelphia Museum of Art, Gift of Mrs. Cyrus McCormick.

FIG. 3.24 John Sloan, *Haymarket*, 1907, oil on canvas, 26¼ x 32⅛₆ inches. Brooklyn Museum of Art, Gift of Mrs. Harry Payne Whitney, 23.60.

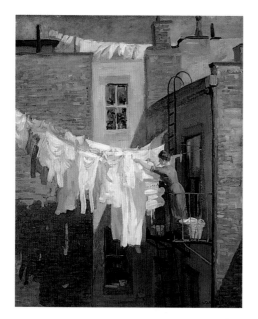
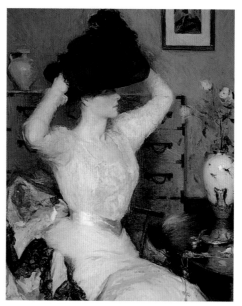

3.25 3.26

I feel in my heart of hearts that I at present am a very pretty Dresden shepherdess. It cost a
mint of money to make me what I am, yet all I am good for is ornament. A genuine Dresden
shepherdess could end her sufferings by smashing herself; but if I should commit suicide
it would be ascribed to blighted affections.[52]

Meanwhile, lower down on the scale, Sloan's ostensibly realistic painting also
addresses ideal beauty. The undergarment nearest his sturdy domestic laborer is a corset.
We don't know whose it is. Either the woman in the painting or another, whose clothes
she washes, might strive for the fashionable if unhealthy hourglass figure showcased
in Benson's work.[53] In any case, the luxuriant ease of one class of women rested firmly
on the hard labors of another. "You start with three tubs" typifies recollections of late-
nineteenth-century laundry processes.[54]

In truth, laundry has always been a burden, but especially before the invention
of the washing machine. Mrs. Beeton's daunting paragraphs on the "Duties of the
Laundry-Maid" make this amply clear. Her prescriptive *Book of Household Management*
was published in 1860, the year before Whistler began painting *The White Girl*. Just to iron
a dress like the one Jo wears required a special "skirt-board covered with flannel" while
numerous heavy "sad irons" had to be passed carefully over yards of delicate fabric without
leaving unsightly scorch marks.[55] Had she been less beautiful, the Irish-born Jo might well

FIG. 3.25 John Sloan, *A Woman's Work*, 1912, oil on canvas, 31⅝ x 25¾ inches. The Cleveland Museum of Art, Gift of Miss Amelia Elizabeth White, 1964.160.

FIG. 3.26 Frank W. Benson (1864–1951), *Lady Trying on a Hat (The Black Hat)*, 1904, oil on canvas, 40 x 32 inches. Museum of Art, Rhode Island School of Design,
Providence, Gift of Walter Callender, Henry D. Sharpe, Howard L. Clark, William Gammell, and Isaac C. Bates.

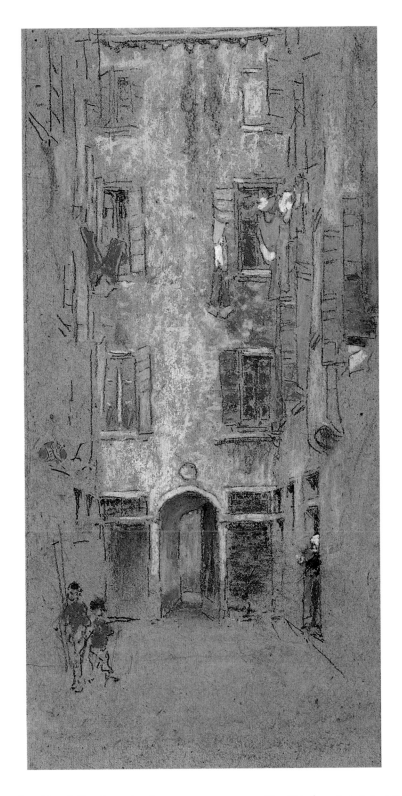

CHAPTER 3 | WOMEN IN WHITE

87

FIG. 3.27 Whistler, *Corte del Paradiso*, 1880, chalk and pastel on brown-gray wove paper, 11½ x 5½ inches. Art Institute of Chicago, Gift of Walter Aitken, Margaret Day Blake, Harold Joachim Memorial, Julius Lewis and Sara R. Shorey endowments; Sandra L. Grung, Mr. and Mrs. David C. Hilliard, and Julius Lewis funds; restricted gifts of William Vance and Pamela Kelley Armour; through prior acquisitions of Katherine Kuh.

have found herself saddled with the duties of a full-time washerwoman[56] rather than living as an artist's model.

One would hardly suspect how onerous caring for the family linens could be from Whistler's beautiful images of Venetian back alleys where freshly washed clothes flutter like gaily colored pennants high above the streets [fig. 3.27]. In Alfred Stieglitz's unpeopled Venetian photograph of 1894, white sheets and towels are co-opted as crisp geometries, doing little to convey clean laundry's lasting ability to confer the mark of upward mobility [fig. 3.28].[57] Yet clean white fabric still has the power to move us artistically. When Christo's twenty-four-mile running fence was unfurled, white fabric snapping in a fresh breeze triumphed over property lines and state bureaucracy, bringing people together in a celebration of beauty [fig. 3.29].

The duties are social for three women in an early canvas, *Harmony in Green and Rose: The Music Room* (1860–61) [fig. 3.30]. Whistler completed it just before he undertook the series of "White Girls." Here, a child's white dress implies innocence as Whistler staged an ambiguous allegory of choice, couched in what Baudelaire called "the beauty of circumstance and the sketch of manners." Whistler's sister Deborah Haden is a ghostly reflection in the mirror; she evokes a conventional Victorian marriage. As previously noted, the robust Isabella Boott sports the iconic black riding costume of the horsewoman, or Amazon, often linked to French courtesans. Deborah's daughter Annie, clad in white, is poised between convention and freedom. Just as Annie averts her gaze from both adults, Whistler avoids clear narrative, giving us scant information about Annie's thoughts or prospects. Awkward aspects of Whistler's composition remind us that, for many, it was an awkward age: the artist's niece would grow up in a world of shifting values characterized by unprecedented social and economic change.

3.28

3.29

FIG. 3.28 Alfred Stieglitz (1864–1946), *Venice, 1894*, ca. 1924–34, gelatin silver print, 4 x 5 inches. George Eastman House, Rochester, NY.

FIG. 3.29 Christo (b. 1935) and Jeanne-Claude (b. 1935), *Running Fence, Sonoma and Marin Counties*, 1972–76, woven nylon fabric, steel cables, and steel poles, 18½ feet x 24½ miles.

FIG. 3.30 Whistler, *Harmony in Green and Rose: The Music Room*, ca. 1860–61, oil on canvas, 37⅝ x 27⅞ inches. Freer Gallery of Art, Smithsonian Institution,
Washington, D.C., Gift of Charles Lang Freer, F1917.234.

Painting would provide an important visual stage for presenting some of these changes.[58] An earlier portrait of Queen Victoria, painted by her first teacher, forewarns us of what lay on the horizon [fig. 3.31]. Like Annie Haden, the young queen wears white. She holds out a watercolor sketchbook and calculates her perspective with a professional air that belies her eleven years of age. Over the queen's long reign, the international popularization of fine art, fanned by the Great Exhibition (1851) and subsequent world's fairs, would reach heights unimagined in previous centuries, engaging ever broader audiences.

During the 1860s, as Whistler sought his fortune abroad, competitive new fortunes were on the rise in America. Winslow Homer's *Long Branch, New Jersey* (1869) [fig. 3.32] suggests that—following the Civil War—seaside vacation spots were not much more idyllic than battlefields. Homer evokes a scene described by a contemporary journalist:

> It was easy to detect [any class of people] by the quality of their cigars, the outline of their features, the comparative obtrusiveness of their attire, the freedom of their tongues, the latitude of their grammatical idioms, and the eccentricity of their positions. The air was full of loud laughter, and there was a flaming newness to all the hats and gowns that dazzled the eyes, and made one think of a modiste's pattern-plate come to life.[59]

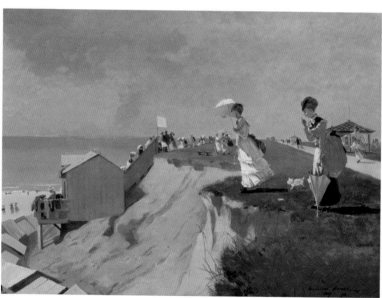

3.31

3.32

"The fact was, you could hardly tell a lady now from an actress," grumped Edith Wharton as America's wrenching transformation from an agrarian economy to an industrialized urban society engaged succeeding generations of American artists.[60] In 1883 Sargent portrayed Mrs. Henry White, an ambassador's wife [fig. 3.33]. She is uncomfortably swathed in white satin with an overskirt draped *à la polonaise*—alluding to the glories of the ancien régime as the United States assumed a powerful new role on

FIG. 3.31 Richard Westall (1765–1836), *Portrait of Queen Victoria as a Girl*, 1830, watercolor, 57 x 47½ inches. The Royal Collection, Her Majesty Queen Elizabeth II.

FIG. 3.32 Winslow Homer (1836–1910), *Long Branch, New Jersey*, 1869, oil on canvas, 16 x 21¾ inches. Museum of Fine Arts, Boston, The Hayden Collection, Charles Henry Hayden Fund, 41.631.

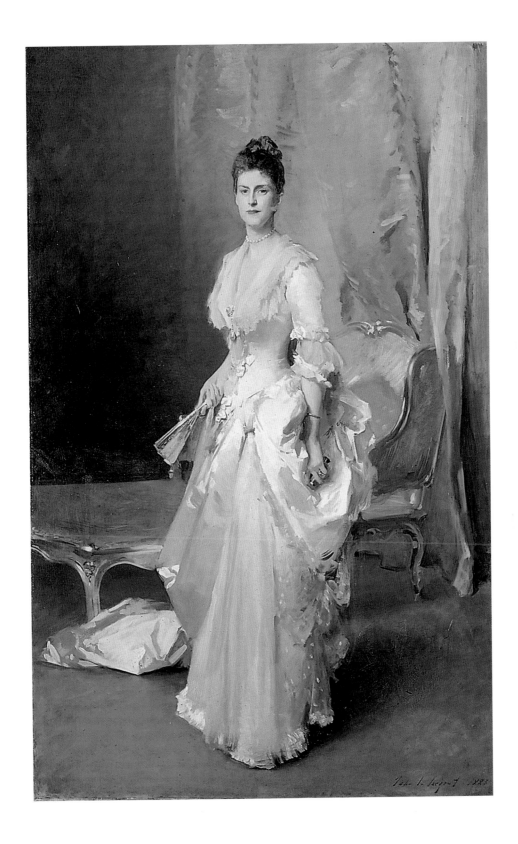

FIG. 3.33 John Singer Sargent, *Mrs. Henry White*, 1883, oil on canvas, 87 x 55 inches. Corcoran Gallery of Art, Gift of John Campbell White.

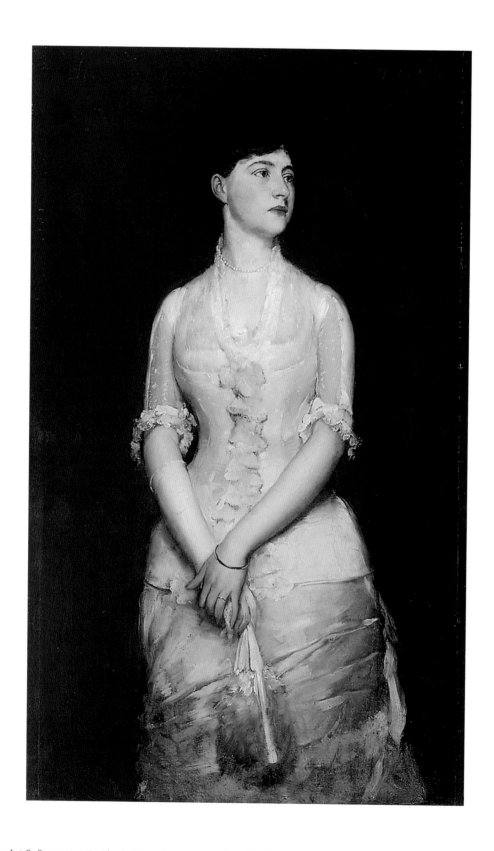

FIG. 3.34 Frank Duveneck (1848–1919), *Miss Blood*, 1880, oil on canvas, 48 x 28 inches. Warner Collection of Gulf States Paper Corporation.

the international stage.[61] Like Jo in *Symphony in White, No. 1*, Mrs. White stands before a white curtain, but the Louis revival chaise longue behind her reinforces Sargent's overt nod to eighteenth-century France.

A portrait can convey far more than the likeness of a sitter, as Frank Duveneck's portrait of Gertrude Blood in 1880 attests [fig. 3.34]. The sitter's aloof countenance masks layers of social precedent and change, although we are spared the sordid details. Miss Blood, a London socialite, pursued the American Duveneck through their mutual association in a Venetian sketching club. Though she tried to advance Duveneck's career, she didn't quite capture the artist.[62] By the time he painted her, she was already engaged to marry Lord Colin Campbell, an alliance that eventually ended in a particularly scandalous divorce. Divorced women were as controversial as stylistically advanced painters who hoped to break the bonds of traditional painting by exchanging broadly brushed subjects from modern life for the tightly finished, trite themes of academic art. With its elegant tonal harmony and tactile surface, the portrait of Miss Blood would have appeared stark to contemporary viewers. But artists regularly seek reassurance for their own choices by looking at earlier art. Clearly Duveneck admired the seventeenth-century Spanish painter Velázquez, as well as the much-discussed series of women in white by Whistler, who was working in Venice when Duveneck was there.

Duveneck's picture also addresses fashion and decorum. Miss Blood's regal posture is noticeably shaped by tight corseting that played "a major supporting role in the life of Victorian women."[63] The conventionally demure sitter has her hands crossed, and the artist's reduced color scheme lends special prominence to a gold bracelet she wears on her left wrist. Her pose recalls that of Hiram Powers's *Greek Slave* [fig. 3.35], a shackled figure that achieved unprecedented fame in American art after the white marble sculpture was exhibited at the Crystal Palace in London in 1851. "So un-dressed yet so refined," purred Henry James.[64] *The Greek Slave* was celebrated in amateur and professional poems, not to mention endless replications. While not exactly up for auction, Miss Blood is imprisoned in a stylish dress that expresses established conceptions of women's limited roles, just as painters were hemmed in by traditional ideas of how a picture should be painted or what it might legitimately represent. "It is…undeniably the truth that from the age of eighteen until she is either married or shelved a girl is on exhibition," complained one writer in the year Duveneck painted the portrait.[65]

3.35

FIG. 3.35 Hiram Powers (1805–1873), *The Greek Slave*, 1873–77, marble, height 46 inches. Warner Collection of Gulf States Paper Collection.

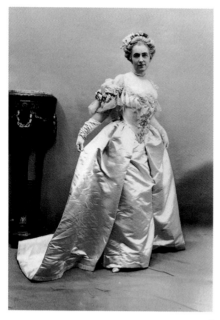

Elsie de Wolfe, an actress who *did* become a lady by marrying minor nobility, based her costume for a lavish banquet given by New Yorker Hazen Hyde on portraits of the famous dancer Mlle. Camargo, a stage favorite in the days of Lancret and Watteau [fig. 3.36].[66] De Wolfe proved as clever a publicity hound as Whistler himself, although her overt use of the past was more pronounced and obvious than was Whistler's. As she went on, she tended more and more to identify with late-eighteenth-century France. Throughout her life, a profusion of ostensibly candid photographs pictured

3.36 de Wolfe holding beribboned lapdogs, sitting on Watteauesque swings, or conducting elaborate *fêtes champêtres*.

America's international innocence was already eroding in the years before Hyde's 1905 costume party—the apogee of Gilded Age excess—shocked an increasingly jaded public. Alfred Maurer parodied the grand manner portrait in 1904 with a louche, cigarette-smoking model, *Jeanne* [fig. 3.37]. She was an actress whose hat in the portrait recalls a snatch of a then-popular song — "you don't know Nellie like I do, said the saucy little bird on Nellie's hat." Motivated by materialism, the song's Nellie kept her eye out for the main chance while retaining various presents her series of suitors bestowed in their attempts to win her love.

Dudie Baird, the woman who posed for Dewing's *Carnation* (1893) [fig. 3.38], was also an actress. Despite Dewing's advanced aestheticism, inspired largely by Whistler's example, his work reflects general patterns seen at the time when commercialized leisure became dominant in public life. *The Carnation* can be interpreted as a multilevel metaphoric "performance" of a type that was common in American art by the turn of the century as artist and audience acknowledged—even as they questioned—certain moral values. Dewing's model, an independent working girl, sat—with and without white dresses—for many of New York's major artists, just as Jo Hiffernan had done for French modernists decades earlier.

FIG. 3.36 *Elsie de Wolfe* dressed for the James Hazen Hyde Ball at Sherry's restaurant, New York City, 31 January 1905, photograph. Museum of the City of New York, Byron Collection, 93.1.1.9426.

FIG. 3.37 Alfred Maurer (1868–1932), *Jeanne*, 1904, oil on canvas, 74¾ x 39⅜ inches. Collection Wendell Cherry.

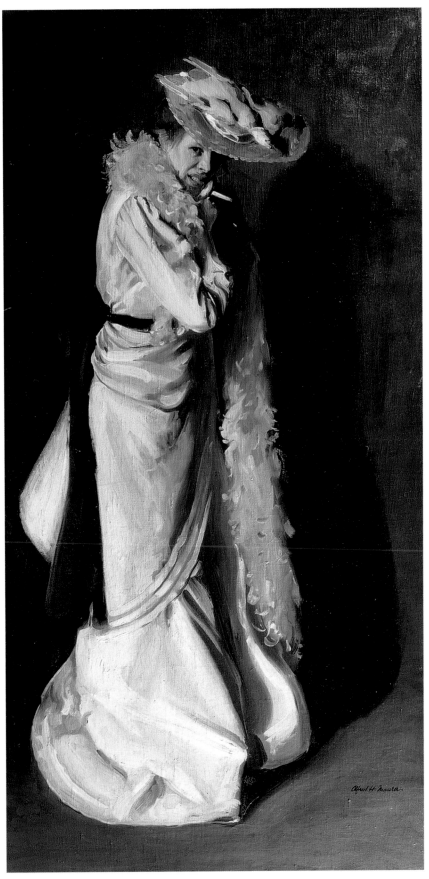

3.37

The theater has long provided a platform for women to advance themselves, sometimes to the dismay of social commentators.[67] As one critic observed sardonically in the year Dewing painted *The Carnation*, "That cunning prestidigitator, miscalled Progress, laughs in its sleeve as it leads the girl bachelor to the footlights and introduces her as the woman of the future."[68] Dudie Baird also trod the boards as one in an endless series of "Flora Dora Girls" who twirled their enticing pink parasols on the Broadway stage. Although Dudie found herself living "without benefit of economic protection" from father or husband, many of her fellow actresses managed to engineer advantageous marriages.[69]

Whistler relays the situation from the perspective of the stage door "Johnnie" in a lithograph. One swain slumps, dejected, on the curb to the left of the *Gaiety Stage Door* (1879 and 1887) [fig. 3.39]. Presumably he has failed to gain access. The door

stands open, but it is blocked by a rotund figure before whom a top-hatted "sport" seeks entrance. The supplicant curve of the young man's back and the four-square blockage by the stage manager shows that Whistler was well aware of this social dynamic, one that later became a cliché in American movies.

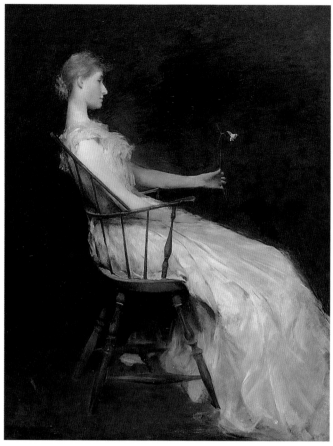

3.38

Dudie's white carnation, an emblem of pure love, is noticeably wilting, as is Jo's lily, symbolic of purity and sweetness, in *Symphony in White, No. 1*.[70] The very real message of the performer's hard life—be it in the legitimate theater or on some less exalted stage—charges many images. As was the case earlier in France, American pictures gain an added resonance from the sad clown, a figure that echoes across the centuries in guises ranging from Watteau's martyrlike Gilles to this introspective young woman upon whom we intrude unexpectedly, as if we had slipped in through the stage door.

By the late nineteenth century theatergoing was the most popular of all urban entertainments. In 1885, suggesting that London society was "in a sense, stage-struck,"

FIG. 3.38 Thomas Wilmer Dewing, *The Carnation*, 1893, oil on wood panel, 20 x 15⅝ inches. Freer Gallery of Art, Smithsonian Institution, Washington, D.C., Gift of Charles Lang Freer, F1896.33.

a social commentator noted, "There is a certain prurient prudishness, a salacious inquisitiveness about London society. It loves to hover over, or alight on, the borderland which separates conventional respectability from downright dissoluteness. There is nothing which it so dearly loves as a soupçon of naughtiness."[71] By 1913 an Englishman could opine, "You Americans who believe it to be the 'smart' thing to go to Paris for a 'fast' time, do not have to go out of Times Square." But later historians detect the vicarious nature of fast times in urban America, labeled by one perceptive critic as "devilish as deviled

3.39

ham."[72] How could it be otherwise when middle-class cabaret goers sought just a touch of wickedness in their lives but had no desire to renounce convention completely? Whistler's friend and chief patron, the ever reticent Charles Lang Freer, seems to have savored Dewing's *The Carnation* in this manner.[73] A textbook exemplar of new money conjoined with exquisite taste, Freer knew the model's history, probably derived a frisson of excitement in looking at the picture, and enjoyed a reputation as an unabashed consumer of female beauty while masking his more esoteric interests during a period when the rhetoric of art changed from effete aestheticism to manly vigor.[74]

97

During the mid-1880s, entire audiences had the opportunity to fantasize over statuesque, gracefully draped actresses in neoclassical plays such as *Helena in Troas*, a production designed by E. W. Godwin and presented in 1886.[75] When Oscar Wilde commissioned Lady Archibald Campbell to write an article on the play for his short-lived magazine *Woman's World*, she reported:

> Like figures on a marble frieze, the band of white robed maidens wound through the
> twilight past the altar of Dionysus, and one by one in slow procession climbed the steps,
> and passed away [as] the audience were absolutely stilled in their excitement.[76]

FIG. 3.39 Whistler, *Gaiety Stage Door*, 1879 and 1887, transfer lithograph, c14, only state, 5 x 7¾ inches, inscribed with butterfly in pencil. Freer Gallery of Art, Smithsonian Institution, Washington, D.C., Gift of Charles Lang Freer, F1888.24.

The male reaction to such entertainments was often more cynical. William Butler Yeats noted that Godwin's carefully staged production [fig. 3.40] made many people "feel religious," adding, "Once get your audience in that mood, and you can do anything with it."[77] Assessing the "Pygmalion-like activities of audience and critics," Gail Marshall recently explored the role of American-born actress Mary Anderson as a statue come to life in *Pygmalion and Galatea* [fig. 3.41].[78] Advised on costuming by painters Lawrence Alma-Tadema and Frank D. Millet, Anderson achieved a blend of classical art, the legitimate theater, and the burlesque stage or music hall. Alma-Tadema later recalled, "She moved like a very lovely Greek statue, taking successive and evidently studied attitudes that reminded the eye of the Venus of Milo, the daughters of Niobe, and other standard works of antiquity."[79] But Anderson's popularity rested upon her beauty, not her acting ability. In a lengthy review *Punch* could discern little difference between Anderson's "classic studies of the female form divine" and "the Lotties and Totties of our extravaganzas and pantos":

3.40

> Let it once be known far and wide that a lively woman, exhibiting in classical drapery the exquisite gifts of Nature touched up for Stage purposes by theatrical Art, is in her private life a model of all the virtues, and this will serve as an attractive advertisement to many goody-goody people who might otherwise have avoided what would have appeared to them, when forming their opinion of the piece and Actress from the photographs, to be merely the assumption of a certain character on account of the opportunity afforded by it for suggestive display. Then let it be bruited about that she has refused offers of marriage from a Lord Chancellor, a Lord Chief Justice, two or three Dukes, and Archbishop, and half-a-score or so of Lordlings, and all the best parts of the theatre will be crowded for weeks.[80]

Architecturally, the opportunity to fantasize in public came atop Stanford White's Madison Square Garden, an extensive recreational

3.41

FIG. 3.40 Edward William Godwin (1833–1886), *costumes and set design* for John Todhunter's play *Helena in Troas*, 1886. Victoria & Albert Museum, London.

FIG. 3.41 Napoleon Sarony (1821–1896), *Mary Anderson* as Galatea in *Pygmalion and Galatea*, ca. 1883, photograph. Library of Congress, Washington, D.C.

complex erected in turn-of-the-century New York. On November 2, 1891, a blaze of white light inaugurated the building's 341-foot tower, where the architect kept one of several private apartments for his assignations.[81] The blinding glare revealed the colossal figure of a young Diana with her bow and arrow, wearing nothing by a thin layer of gold leaf. The controversial nude, created by Augustus Saint-Gaudens at White's personal expense, was thought to be inspired by La Giralda, a weathervane in the form of a draped female figure crowning the Cathedral of Seville.[82] This chaste Spanish statue was *Fe* (faith), but Saint-Gaudens's *Diana* had more in common with an Italian, *La Fortuna*, a similarly posed nude that embellishes the Dogana di Mare (customs house), projecting into the lagoon at Venice.[83] Henry James described her in *Italian Hours*:

> The charming architectural promontory of the Dogana stretches out the most graceful of arms, balancing in its hand the gilded globe on which revolves the delightful satirical figure of a little weathercock of a woman. This Fortune…catches the wind in the bit of drapery of which she has divested her rotary bronze loveliness. On the other side of the Canal twinkles and glitters the long row of the happy palaces which are mainly expensive hotels. There is a little of everything every-where, in the bright Venetian air, but to these houses belongs especially the appearance of sitting, across the water, at the receipt of custom, of watching in their hypocritical loveliness for the stranger and victim.[84]

The *Diana* looked down on the roof garden where architect White would be murdered fifteen years later. The original statue, on its crescent moon of plate glass lit from within, proved too large and cumbersome to function as a weathervane.[85] When a smaller, second version was designed, Dudie Baird later claimed in press reports that the sculptor made casts from her body to design the graceful statue, which was also made available to the public in reduced statuettes of various sizes [fig. 3.42]. There was no drapery at all on the second statue or on the reduced versions. O. Henry subsequently mocked the public fuss with a short story in which the Statue of Liberty chats with Diana about fashion. Diana tells Lady Liberty:

3.42

FIG. 3.42 Augustus Saint-Gaudens (1848–1907), *Diana of the Tower*, 1899, bronze, height 39 inches. VMFA, The Adolph D. and Wilkins C. Williams Fund.

that Mother Hubbard you are wearing went out ten years ago. I think those sculptor guys ought to be held for damages for putting iron or marble clothes on a lady. That's where Mr. St. Gaudens was wise. I'm always a little ahead of the styles; but they're coming my way pretty fast.[86]

At a time when naive innocence was changing to worldly wisdom, O. Henry managed to slip an undetected salacious pun into the text of his story, which first appeared in a newspaper.[87]

Lily Bart, the tragic heroine of Edith Wharton's *House of Mirth*, participates in some tableaux vivants at a fashionable party, and the scenes are taken from old paintings. Lily, having considered "representing Tiepolo's Cleopatra— had yielded to the truer instinct of trusting to her unassisted beauty, and she had purposely chosen a picture without distracting accessories of dress or surroundings." She posed as an eighteenth-century portrait:

> The unanimous "oh!" of the spectators was a tribute, not to the brush-work of Reynolds's "Mrs. Lloyd" [fig. 3.43] but to the flesh and blood loveliness of Lily Bart. She had shown her artistic intelligence in selecting a type so like her own that she could embody the person represented without ceasing to be herself....her pale draperies, and the background of foliage against which she stood served only to relieve the long dryad-like curves that swept upward from her poised foot to her lifted arm. The noble buoyancy of her attitude, its suggestion of soaring grace, revealed the touch of poetry in her beauty.

While one male character caught "for a moment a note of the eternal harmony of which her beauty was a part," another gasped, "Deuced bold thing to show herself in that get-up, but gad, there isn't a break in the lines anywhere, and I suppose she wanted us to know it!"[88]

Like the interweaving of high-style format and lowlife subject in Whistler's *Symphony in White, No. 1*, or the blend of legitimate theater and the burlesque in Anderson's *Pygmalion and Galatea*, or the mixed messages of art and titillation in Saint-

3.43

Gaudens's *Diana* and Wharton's *House of Mirth*, the consumption of art and more mundane goods meet frequently in art and literature. Émile Zola must have contemplated Whistler's "White Girls" before penning one of the most breathless passages in his lengthy, highly detailed story of a fictive department store based on Au Bon Marché, the opulent emporium in Second Empire Paris that inspired numerous American and British counterparts.[89] Available in English translation only a year after it was serialized in a French periodical, Zola's book celebrated a "great exhibition of household linen" in a multipage paean not to a symphony but to an orgy of white.[90] Distinctions between fine art and frankly commercial products—between art and entertainment; between the staged and the real—had become blurred in the elaborate installations mounted at countless world's fairs. These were quickly imitated by the great department stores, where fanciful, often exotic environments romanticized the task of purchasing goods, making it more a tempting entertainment than a chore. In the hands of a clever window dresser, a popular tourist destination like Venice could be conjured up in an elaborate display of folded white napkins.

Whistler's continuous performance as an artistic self-promoter served as an important model for American painters of subsequent generations. Simultaneously, advertising as practiced by department stores and other businesses was as fresh a form of showmanship as vaudeville and the five-cent movie. Yet this particular staging moved merchandise, whether housewares or paintings. Just as Whistler's artistic advances became a fixed reference point in American art circles, January white sales became a feature in American department stores. One journalist told shoppers in 1900, "It would be a bold concern which would dare to ignore it."[91]

In *The Shoppers* (1907) [fig. 3.44] by William Glackens, the artist's fur-coated wife and her luxuriously garbed friends flock to an alluring white negligee that centers the monumental canvas.

3.44

FIG. 3.44 William Glackens (1870–1938), *The Shoppers*, 1907, oil on canvas, 60 x 60 inches. The Chrysler Museum, Norfolk, Virginia, Gift of Walter P. Chrysler, Jr., 71.651.

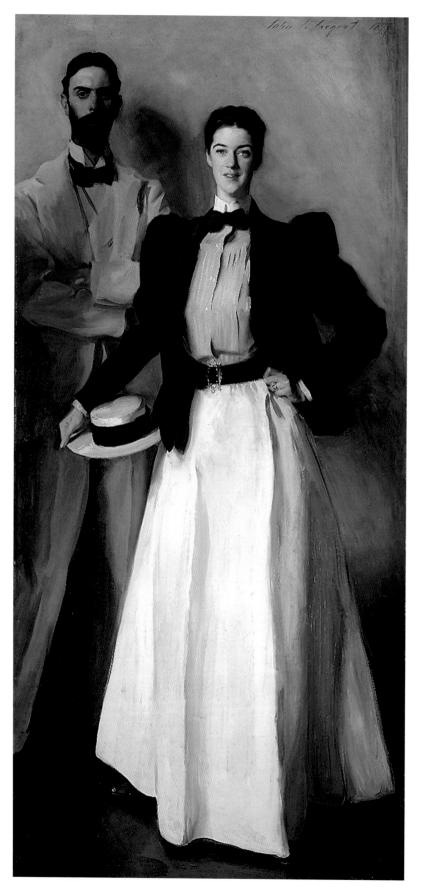

Pressed against the outermost edge of the picture, a shop girl, wearing the standard white shirtwaist of her profession, assists these affluent customers. As Glackens's shoppers were well aware, being perfectly dressed was a great deal of work, and changing fashion ensured continuing consumption.

A man's success could be gauged in part by the appearance of his lady, putting a certain amount of pressure upon her to choose well. Wharton's Lily Bart complained:

> If I were shabby no one would have me: a woman is asked out as much for her clothes as for herself. The clothes are the background, the frame if you like: they don't make success but they are a part of it. Who wants a dingy woman? We are expected to be pretty and well dressed till we drop.[92]

An illustration for "The World's Best Dressed Women" in 1909 exalted "the clinging, trailing gown, like a beautiful vase holding a perfect flower."[93] A real New Yorker, a woman who felt she did little but shop, confided in her diary, "I am so sick of the stores and the clothes...would rather the clothes grew on like feathers!"[94]

As Winslow Homer's brash image of Long Branch indicated early on, personal attire and possessions sent important signals, a social dynamic still operant in our own day. In 1897, John Singer Sargent painted Mr. and Mrs. Isaac Newton Phelps-Stokes wearing casual dress [fig. 3.45]. Having selected a fashionable painter the couple accepted an unconventional composition, with Isaac in the background and Edith out front in sports clothes that would be popularized in the Gibson Girl image. These choices reflect a significant shift in permissible behavior for polite society. The Phelps-Stokes family was highly enough placed to make such choices with some confidence. But what did the simple folk do? Facing her wealthy customers, the shop girl in Glackens's picture wears a modest brooch, a signal of upward mobility, on her requisite white shirtwaist. She is a woman earning her own income—a sign of opportunity as well as necessity. Yet there were too many choices—both material and moral—a fact often recorded in both paint-ing and documentary photography [figs. 3.46, 3.47].

How were the newly affluent—a key audience for painters—supposed to know what was tasteful? Beginning in the nineteenth century, various paradigms were avail-able in the form of self-help books and decorating guides. The prime target audience is clearly revealed by two British authors who asserted in 1876, "It is middle-class people

FIG. 3.45 John Singer Sargent, *Mr. and Mrs. Isaac Newton Phelps Stokes*, 1897, oil on canvas, 85¼ x 39¾ inches, signed and dated u.r.: "John S. Sargent 1897".
The Metropolitan Museum of Art, New York. Bequest of Edith Minturn Phelps Stokes (Mrs. I. N.), 1938, 38.104.

specially who require the aid of a cultivated and yet not extravagant decorator who may help them to blend the fittings of their now incongruous rooms into a pleasant and harmonious habitation."[95] As often as not, such texts were closely tied to marketing, as exemplified in Clarence Cook's plaintive title, *What Shall We Do With Our Walls?* (1880), published by a wallpaper manufacturer. By the early twentieth century a definite move to lighter, less cluttered interiors had been incorporated into the gospel of Elsie de Wolfe. In *The House in Good Taste* (1913) the actress-turned-author expounded, "I believe in plenty of optimism and white paint."[96]

For the best-seller's frontispiece photograph, de Wolfe leans casually on the mantel, draped in a drop-dead fur. Nonetheless, her book was purposefully matter-of-fact. Earlier, her stage performances, coupled with the power of modern journalism, went beyond other urban entertainments by reinforcing role modeling with passive window-shopping — product endorsement was part of the show and haute couture French clothing was the most important product that Elsie de Wolfe animated for her theater audiences. She made flowing gowns by Paquin and Worth as desirable as *The Black Hat* [see fig. 3.26], rendered by Frank Benson in seductive layers of rich, thick pigment. Lavish, if not to say worshipful, descriptions of individual gowns in the fashion press inventoried the details of her costumes, noting, "Their wearer may, it is safe to assert, step from the stage to a ball-room or drawing-room with perfect impunity. Nothing in the style or color or general effect of her gowns is dependent upon the footlights."[97]

For New Yorkers, not only opulent gowns but also elaborate stage sets offered models for emulation. A society columnist, hoping de Wolfe's approach to interior scenery would spread, praised *The Way of the World*, the actress's most ambitious play:

> We would do away with "props" and have people act in real scenes from life — in rooms that might really be lived in, with hangings of velvet, not of paint; with statuary of marble, not of plaster; with carpets into which correctly slippered feet may sink instead of painted boards; with desks and tables that are real, not made of papier-mache, and with flowers not made of paper or wax, but fresh-cut and dewy, whose scent gets over the footlights and helps make a real illusion real.... Miss de Wolfe's Mrs. Croyden is a character with whom we are all familiar, and Miss de Wolfe presents her to us just like the Mrs. Croydon on our visiting lists.[98]

Unfortunately, like Mary Anderson, de Wolfe wasn't much of an actress— "she was splendid in the second dress" typifies critical response. Nor was she a beauty. Sensible to the core, she ended her professional stage career in 1904, taking with her an avid following and a salable skill. Although withdrawing from the stage, she continued her concern with comfort and visual effect at a time when both the excesses of the Gilded Age and the moralizing of the Aesthetic movement were being called into question. Nonetheless her "look" evolved quickly into

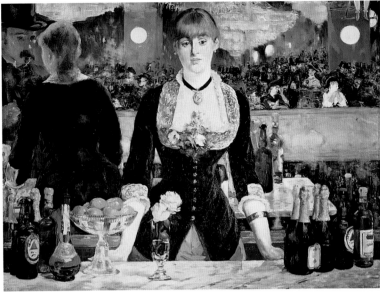

3.46

what we might call a "celebrity style" associated with glamorous gatherings in New York, Versailles, and Paris, where pillars of society— the Astors, the Hewitts, the Morgans, even Isabella Stewart Gardner— mingled with glittering opera stars Emma Calve and Nellie Melba; actresses Sarah Bernhardt, Ellen Terry, Ethel Barrymore, and Maxine Elliott; aesthete Oscar Wilde; historian Henry Adams; and others. "I went to the Marbury salon," wrote Henry Adams,

3.47

and found myself in a mad cyclone of people. Miss Marbury and Miss de Wolfe received me with tender embraces, but I was struck blind by the brilliancy of their world. They are grand and universal…I had to chat as one of the wicked, and got barely a whisper of business.[99]

As Whistler and others of his generation had already demonstrated, in the volatile world of continuing press coverage, scandal *was* business. In the spring of 1894, Oscar Wilde introduced Aubrey Beardsley to the actress Mrs. Patrick Campbell, who was playing the part of a woman with a past in *The Second Mrs. Tanqueray* at the St. James Theatre in London. In this tale of gender-based double standards, prudish neighbors snub Paula Tanqueray, so she invites Lord George Orreyed and his wife, a former chorus girl, for a country house visit. As matters go from bad to worse, Paula is driven to confess to

FIG. 3.46 Édouard Manet, *A Bar at the Folies-Bergère*, 1881–82, oil on canvas, 38 x 51 inches. Courtauld Institute Gallery, London.

FIG. 3.47 *Food counter at R. H. Macy & Company department store*, Herald Square, New York City, 1902, photograph. Museum of the City of New York, Byron Collection.

her new husband that the man his convent-raised stepdaughter Ellean wants to marry was once her own lover. Ellean discovers this and taunts her stepmother, although she accepts such behavior on the part of her fiancé. Sending the message that a woman with a past has no future, the play ends with Paula Tanqueray's suicide.[100] Beardsley's elegant caricature, rendering homage to the stark composition of Whistler's *Symphony in White, No. 1*, caused indignation when it was published that April in the first volume of *The Yellow Book*, an avant-garde periodical [fig. 3.48].[101] Both actress and playwright must have felt the discomfort. Mrs. Campbell, credited with the cautionary remark that it didn't matter what one did in private so long as one didn't do it in the streets and frighten the horses, was just launching her career. The play was written by a dramatist trying to strike just the right note to win middlebrow critical approval for his social-problem dramas. His caution eventually denied him the acclaim of the British avant-garde, who embraced Ibsen's work instead.[102]

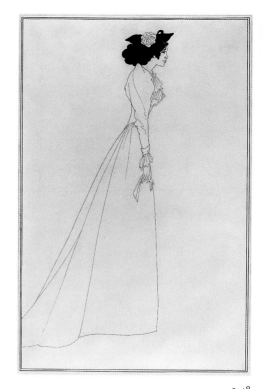

3.48

Elsie de Wolfe, on the other hand, maintained her precarious balance. An early photograph captures her lounging — *Symphony*-like — in the Turkish Corner at Irving House, the home she and her lover, theatrical agent and political activist Elizabeth Marbury, shared in New York City [fig. 3.49]. Known to their friends as "The Bachelors," the couple lived outside the bounds of convention, but de Wolfe countered overt decadence with energetic (and profitable) practicality, as had Whistler before her. Her lengthy career as both amateur and professional actress, art adviser, interior decorator, and high-flying socialite can be seen as a nexus, linking complex cultural hungers familiar to artists like Whistler. These longings continued to be expressed in turn-of-the-century literature and painting. In de Wolfe's work and in her conduct we see the blurring of boundaries between public and private space coupled with an expanding definition of decorum. These issues were already in flux with the sudden intrusion of Whistler's "White Girls" in the early 1860s. The radically simplified detail seen on canvas with the first *Symphony in White* elides neatly into de Wolfe's credo of "simplicity, suitability, proportion," as she promised that her readers would "never again be guilty of the errors of meaningless magnificence."[103] Describing her drawing room, a space visually expanded

FIG. 3.48 Aubrey Beardsley, *Mrs. Patrick Campbell as Paula Tanqueray*, 1894, lithograph, 6½ x 4 inches. Staatliche Museen zu Berlin.

with mirrors set into the woodwork in the unorthodox manner of British Regency architect Sir John Soane (1753–1837),[104] she told her readers:

> I think we can carry the white paint idea too far: I have grown a little tired of over-careful decorations, of plain white walls and white woodwork, of carefully matched furniture and over-cautious color-schemes. Somehow the feeling of homey-ness is lost when the decorator is too careful. In this drawing room there is furniture of many woods, there are stuffs of many weaves, there are candles and chandeliers and reading-lamps, but there is harmony of purpose and therefore harmony of effect.[105]

De Wolfe's still-recognizable look—a judicious blend of light colors, antique furniture, modern reproductions, and yards of chintz—was as richly scored a "symphony" as those of Whistler himself.[106] Interestingly, her servants' rooms were essentially all white, calling to mind again the women in white by Whistler as well as Collins's Miss Fairlie—their dresses "spotlessly pure" but of a type "the wife or daughter of a poor man might have worn."[107]

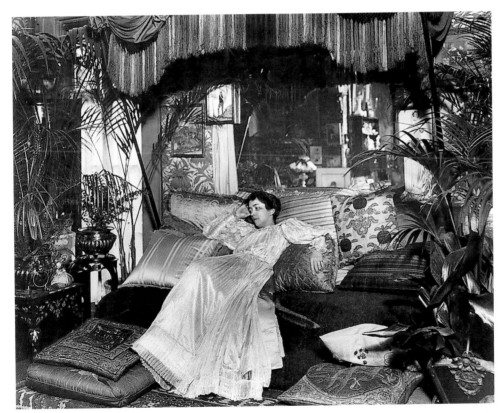

3.49

FIG. 3.49 *Elsie de Wolfe in a Turkish Corner in the Irving House,* New York City, 1896, photograph. Museum of the City of New York, Byron Collection.

As aestheticism devolved into symbolism, images such as John White Alexander's *Repose* (1895) carry on Whistler's elegant manipulation of line and color [fig. 3.50]. A supporter of Whistler's ideas after the two met in Venice in 1879, Alexander spent his brief time abroad cultivating friendships not only with Whistler but also with Henry James, Octave Mirbeau, Auguste Rodin, and Oscar Wilde. However, on his return to the United States in 1881, Alexander was no spokesman for radicalism. Rather, he became a respected arts advocate who later served as president of the National Academy in New York.[108]

Sinuous, nonnarrative images of women in white could become positive agents of change, if the collaboration between Glasgow entrepreneur Kate Cranston and the young architect Charles Rennie Mackintosh and his wife, Margaret MacDonald, are any indication. Starting with the Buchanan Street Tearooms (1897), where murals of statuesque women in white hedged by a tangle of flowering rosebushes provided a dramatic background for middle-class Glaswegians lunching out, Miss Cranston sponsored a series of increasingly elaborate tearooms decorated in white and silver, touched with pale shades of purple, green, and rose—all colors abundant in the Scottish landscape. Following a visit to Glasgow, English architect Edward Lutyens described Miss Cranston's Buchanan Street rooms as the rather arresting project of "a Miss Somebody's who is really a Mrs. Somebody else." He went on:

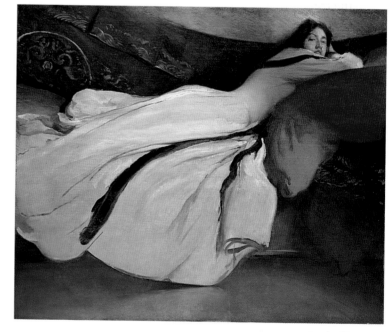

> She has started a large Restaurant, all very elaborately simple on very new school High Art Lines. The result is gorgeous! And a wee bit vulgar! She has nothing but green handled knives and all is curiously painted and coloured.... Some of the knives are purple and are put as spots of colour! It is all quite good, all just a little outré, a thing we must avoid.[109]

Miss Cranston developed a formula of good food, reasonable prices, and unusual artistic surroundings where, as Lutyens put

3.50

FIG. 3.50 John White Alexander (1856–1915), *Repose*, 1895, oil on canvas, 52¼ x 63⅝ inches. The Metropolitan Museum of Art, anonymous gift, 1980 (1980.224).

3.51

3.52

it, "cheap clean food" was served in "white rooms with black furniture [and] black rooms with white furniture, where Whistler is worshipped and Degas tolerated."[110] With the ladies' lunch room at the Ingram Street Tearooms (1900) [fig. 3.51] and the Salon de Luxe at the Willow Tearooms (1903), Mackintosh occupied (albeit briefly) the cutting edge, enjoying a noticeable impact in modernist circles as widespread as Vienna and Chicago. As we have come to expect, fashion and theatricality played a role in the success of the tearooms. The Salon de Luxe was quickly nicknamed the "Room of Good Looks." Miss Cranston specially selected her waitresses for their beauty, clothing them in white dresses topped by a prominent bow and chokers of large pink beads [fig. 3.52]. The picturesque costume was designed by Mackintosh himself.

In contrast to the success enjoyed by John White Alexander and Charles Rennie Mackintosh, endless accounts document how Oscar Wilde's fortunes fell. Writing *Salomé* in Paris late in 1891, Wilde was disappointed when the Lord Chamberlain banned a London production with Sarah Bernhardt in the title role. In 1893 Wilde found a French publisher, but in 1894 the play came out in English with Aubrey Beardsley's accomplished yet disturbing drawings. The published work seems a harbinger of Wilde's coming misfortunes over his affair with Lord Alfred Douglas. By the time *Salomé* was finally produced (in Paris at the Theatre de l'Oeuvre in February 1896) Wilde was already serving his years at hard labor, his name permanently associated with decadence.

FIG. 3.51 Charles Rennie Mackintosh (1868–1928), *The Wassail* (detail), 1900, gesso, panel, for the Ladies' Luncheon Room, Ingram Street Tearooms, Glasgow. Glasgow Museums.

FIG. 3.52 *Waitresses in the Salon de Luxe*, Willow Tearooms, Sauchiehall Street, Glasgow, ca. 1910, photograph. Charles Rennie Mackintosh Society, Glasgow.

Coeval with Alexander's sensual *Repose*, the far more graphically decadent "J'ai baisé ta bouche, Iokanaan" from *Salomé* [fig. 3.53] further developed formal tenets of elegant line and surface.

3.53

As previously noted, Whistler's first *White Girl* stands in a dominant position upon a sprawling bearskin rug, her wilted pansies, symbolic of thoughts but not necessarily regrets, splash a bright note of color just behind the animal's gaping head. The bear carried marked connotations of sexuality, figuring in nineteenth-century plays, carnival costumes, and popular prints.[111] Just how artfully Whistler stretched, but did not break, artistic boundaries is made clear when we compare his painting to Beardsley's *Salomé*. The dancer in the latter leaves us no doubt about her priorities. As she holds John the Baptist's severed head, snaky trails of blood pool at the bottom of the composition, from which grows an upright, doubtless malodorous lily.

In a photograph of a deceptively kittenish Evelyn Nesbit [fig. 3.54], we have not a woman *in* white, but a woman *on* white. The mistress of Stanford White sprawls seductively on a bearskin rug, wrapped in one of the ill-fated architect's kimonos. She rests her head on the bear's; his mouth opens in a silent roar. Roughly coincident with several Whistler pastels of nubile young models in colorful silken robes [see fig. 7.4], the photograph, trenchantly titled *In My Studio (Tired Butterfly)*, was snapped in one of White's numerous urban hideaways, this one occupying two upper floors above F. A. O. Schwarz's toy store on West 24th Street.[112]

Evelyn, who began her working life in the stock room at Wanamaker's department store in Philadelphia, made her way up the now-familiar path as an artist's model and actress, including a run as the youngest dancer in *Flora Dora*, before starring in *The Wild Rose*, a musical named for her. In another peekaboo photograph indebted to Greuze's *La Cruche Cassée* [see fig. 3.12], she leans seductively into the camera in a flimsy, white, off-the-shoulder chemise, holding a pitcher. Evelyn's well-documented rise, her notorious affair with White, and her marriage of convenience to the mentally unstable millionaire playboy Harry Thaw in 1905 all seem a palimpsest of conflicting mores and desires at the turn of the nineteenth century.[113] Her story reached an explosive climax during the opening performance of *Mamzelle Champagne* on the roof of Madison Square

FIG. 3.53 Aubrey Beardsley, *The Climax*, in *Salomé*, by Oscar Wilde, London, 1894. VMFA Library.

Garden. As the tenor sang "I Could Love a Thousand Girls," Evelyn's jealous husband shot and killed the architect of the "amusement palace in which all classes of the public can meet in harmony upon a common ground…a permanent ornament to the city, one designed to serve an important purpose in the amusement and instruction of the public."[114] Mrs. Thaw was wearing a white dinner dress.[115] After the scandalous murder, the sculptor Saint-Gaudens remarked that Evelyn had "the face of an angel and the heart of a snake."[116] Whistler's discreet liaisons seem tame in comparison.

At the end of *The Woman in White*, the lovers are united after several hundred pages of harrowing experiences. The evil genius Count Fosco winds up on a marble slab at the morgue in Paris. A passage from Wilde's *The Importance of Being Earnest* wryly spoofs the type of potboiler novel that Whistler, for one, denied he'd read. The governess, Miss Prism, warns her ward, "Do not speak slightingly of the three-volume novel, Cecily. I wrote one myself in earlier days." Her ward responds, "Did you really, Miss Prism? How wonderfully clever you are! I hope it did not end happily? I don't like novels that end happily. They depress me so much." Miss Prism replies, "The good ended happily, and the bad unhappily. That is what fiction means."[117] Jo Hiffernan, Whistler's original woman in white, was supplanted by Maud Franklin, who posed for the *Arrangement in White and Black*, ca. 1876, the last of the "White Girls" and the last of Whistler's string of mistresses as well [fig. 3.55]. She appears in a chic black-and-white costume firmly wedded to contemporary fashion; yet despite bearing several of his children, she could not hold on to the artist. Following Whistler's marriage to Trixie Godwin, Maud moved to Paris. In later years she would not speak to biographers about Whistler.

After Whistler, white-on-white paintings had great staying power—in the hands of Malevich, of Charles Sheeler, of Ad Reinhardt. By the twenty-first century, the notion of a white-on-white picture had become such a cliché that it could serve as the defining metaphor for Yasmina Reza's play, simply titled *Art*. The staging notes specify a "canvas about five foot by four: white. The background is white and if you screw up your eyes, you can make out some fine white

3.54

FIG. 3.54 Rudolf Eickemeyer, Jr. (1831–1895), *In My Studio (Tired Butterfly)*, portrait of Evelyn Nesbit, 1902, carbon print photograph, 19 x 24 inches. Hudson River Museum, Yonkers, NY (76.0.26).

112

diagonal lines." Quarreling over the picture—what style it represents, what the ownership of such a work implies—drives a trio of characters in a comic play about multiple meanings and open-ended interpretation.[118] Whistler would not have minded being in the midst of such a dilemma. The layered complexities of his women in white place them simultaneously inside and outside of his own time. Each representation of Jo in her white muslin dress hovers at the intersection of multiple contingencies—aesthetic, political, social, economic.

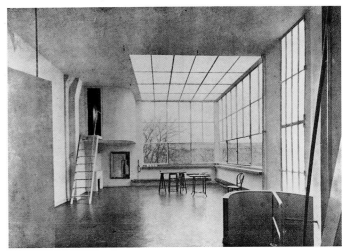

3.56

The stark set of the original London production of *Art* brings to mind the spare simplicity of Amédée Ozenfant's Paris studio [fig. 3.56]. Designed by Le Corbusier and Pierre Jeanneret, it was a room where Whistler might have felt quite at home. Assessing Whistler's interest in interior decoration, his student Mortimer Menpes wrote:

> There was nothing that Whistler loved more than a plain white room. White appealed to him. He loved the silvery greys that one sees in the interior of large white rooms. I have often heard him say that the apartment which attracted him most of all in people's houses was the pantry, which had "nice whitewashed walls." The woodwork of a room he generally liked to have all white: a true white—no subtleties, no cream or ivory tones, but—a clean flake white with nothing added.[119]

Le Corbusier and others would establish white walls as the very essence of modern architecture. In advance of that development, Whistler's "White Girls" demonstrate the dynamic of fashion in a world of change. At the same time, as we will see in the following chapter, these women in white heralded even more reductive simplicities to come.

113

FIG. 3.55 Whistler, *Arrangement in White and Black*, ca. 1876, oil on canvas, 75⅛ x 35¾ inches, inscribed with butterfly. Freer Gallery of Art, Smithsonian Institution, Washington, D.C., Gift of Charles Lang Freer, F1904.78.

FIG. 3.56 "Studio of M. Ozenfant," from Le Corbusier, *L'art décoratif d'aujourd'hui*, Paris, 1925. VMFA Library.

4. Houses Beautiful

All the world's a stage...

—"Jaques" in Shakespeare's *As You Like It* (1598–99)

Now my...rooms. They are pictures in themselves.

—James McNeill Whistler (1881)

In an era of exceptional clutter, Whistler pictured plain walls, spare furnishings, and unpatterned upholstery in an elegant sketch of his studio at No. 7 Lindsey Row in Chelsea [fig. 4.1]. These elements exemplify the importance Whistler attached to his surroundings. The artist also took care to record his own presence, directing his gaze outward, toward his audience. If, as Whistler eventually asserted, his rooms were "pictures in themselves," they were also carefully orchestrated stage sets showcasing a leading light of the avant-garde.

The oil sketch was one of two preliminary efforts toward a never executed picture intended for the Salon of 1866. Whistler meant, not surprisingly, to provoke controversy.[1] Slyly quoting his own paintings—specifically *Symphony in White, No. 3* and *Princess of the Porcelain Country* [see figs. 3.1, 4.45]—Whistler costumed one of his companions in a filmy white at-home dress while the other is draped in a pale peach Japanese kimono.[2] Along with the faintly domestic air and understated decorative details, the theatrical foregrounding of the artist himself and even the eventual abandonment of his larger Salon project predict topical and behavioral threads that would tie Whistler to E. W. Godwin (1833–1886), an avant-garde architect and theater designer whose career garnered him praise as a pioneer of aestheticism.[3] Their careers intersect on the grounds of presentation as well as content.

Opposite: Detail from fig. 4.20

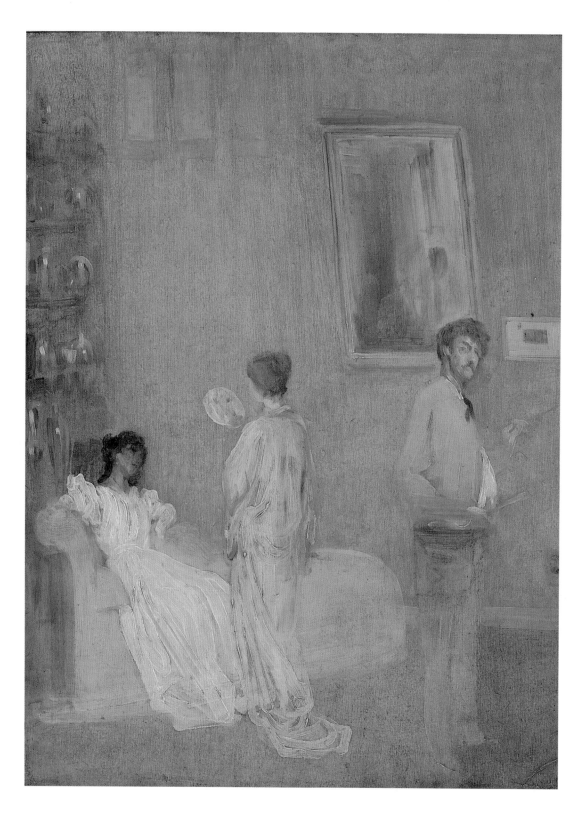

FIG. 4.1 Whistler, *The Artist in His Studio*, 1865–66, oil on paper mounted on panel, 24 x 18 inches.

The Art Institute of Chicago, Friends of American Art Collection, 1912.141.

The role that Godwin shared with Whistler—as influential paradigm for modern artistic behavior[4]—proves largely a matter of staging. The houses, exhibition interiors, and display stands where the ideas of artist and architect conjoin offer backdrops or arenas for public performance [fig. 4.2]. An obsessive desire for total control over the works of art they created is their most significant common trait; their dedication to the beautiful in modern life is their most important legacy. If their bohemian antics no longer have the power to shock, the strength and beauty of the objects they left behind remain palpable.

It is little wonder that Godwin and Whistler were assessed as monolithic prototypes of twentieth-century modernism given the relative simplicity of their interiors, known chiefly through press descriptions. But their legacy continues to prove far more complex than a cheeky artist-as-self-publicist, a worshipful biographer, or a doctrinaire theorist might lead us to believe. Whistler has emerged as a highly skilled manipulator of the press, while Godwin's impact on architecture and design is amplified by his journalistic and theatrical skills.

Separate in age by scarcely more than a year, Godwin and Whistler eventually shared a great deal, including successive marriages to the same woman young enough to be the daughter of either one.[5] Multitalented, prolific, charming, exacting, sometimes irascible, they were witty polemicists publicly active on numerous fronts. Never entirely with the procession, each of these creative aesthetes proved difficult to pin down in the Victorian cultural climate of increasing specialization. Each, resisting early pressure to enter the conventional haven of professional engineering, used his career as an artist to sidestep the bounds of Victorian respectability. Eventually, a little like Jaques, the libertine-turned-philosopher in Shakespeare's *As You Like It*, they became spokesmen for the changing art world in which they lived and worked. Their very language is often similar. "As music is the poetry of sound, so painting is the poetry of sight," said Whistler. "A building is to me as a picture to a painter or a poem to a poet," wrote Godwin.[6]

Shopping and collecting were foremost among their mutual interests. In the wake of the Japanese Court at the London International Exhibition of 1862, the craze for

4.2

FIG. 4.2 *The William Watt stand at the Exposition Universelle*, Paris, 1878, designed by Godwin, painted by Whistler. Victoria & Albert Museum, London.

4.3

gathering up Japanese decorative arts, already hot commodities in Paris, swept London's artistic circles as well [fig. 4.3].[7] Such trendy home accessories were featured in the apartments and studios of both Whistler and Godwin in the 1860s, as recorded in numerous descriptions and captured in a few rare photographs.[8]

The two men found common ground at the time when the private artist's studio, with its multifaceted historicism, merged into the sphere of public display. Reminiscent of a baroque porcelain cabinet in some royal European household, blue-and-white pots fill a corner whatnot in Whistler's studio sketch.[9] A shadowy trio of kakemonos (Japanese scrolls) hangs nearby. Fantin-Latour could write of Whistler's studio, "We might be at Nagasaki, or in the Summer Palace."[10]

Carefully decorated studio-houses were filled with backward-looking bric-a-brac as well as the latest, self-consciously designed "art furniture" to create reassuringly furnished points of sale where commercial transactions could transpire amidst aesthetic surroundings.[11] One might easily have encountered women during a studio visit. The women in Whistler's oil study are models, but they remind us that conventional popular imagery recorded the artist's studio as a destination frequented by ladies enjoying new forms of urban leisure [fig. 4.4]. Gradually, the domestic ethos of studio-houses overlapped with similarly embellished temporary installations for commercial galleries and art associations, and also

118

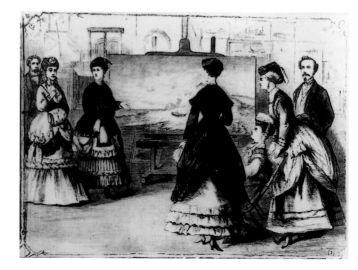

4.4

FIG. 4.3 James Tissot (1836–1902), *Young Women Looking at Japanese Articles*, 1869, oil on canvas, 27¾ x 19¾ inches.
Cincinnati Art Museum, Gift of Henry M. Goodyear, M.D.

FIG. 4.4 *Reception at the Tenth Street Studios, New York City* (detail), wood engraving, from *Frank Leslie's Illustrated Newspaper*, 29 January 1869.
Library of Virginia, Richmond.

4.5

crept into permanent decor at prestigious Bond Street dealerships such as Agnew's and the Fine Art Society [fig. 4.5].

This fresh domestic air, making well-heeled middle-class customers (particularly women) feel at home, had its predecessors, albeit at a much higher social level, in the art-filled country houses of Britain. Moreover, when Britain's National Gallery first opened its doors in May 1824, it did so at 100 Pall Mall, the town house of financier John Julius Angerstein. Having acquired his art collection for the nation, the government presented it to the public in this previously private space. Angerstein's modest dwelling was contrasted with the grandeur of the Louvre in an engraving made about 1825 [fig. 4.6], reminding us yet again how often public collecting is driven by national pride.

The proliferation of artists' studios in Europe and America follows this domesticated formula for an affective, effective business environment. Like the department store, the decorated studio was an international development connected to fashion and the theater. "Many a hat or gown or painting that would have been comparatively inconspicuous amid ordinary surroundings assumes a new charm when viewed in the restful atmosphere of a well ordered, well lighted, and richly furnished gallery," asserted a merchandising strategist in 1909.[12]

As Zola's department-store novel, *Au bonheur des dames*, made so abundantly clear, theatrical packaging was intended to stimulate material desire.

4.6

FIG. 4.5 Edward Salomons (1827–1906), *William Agnew in His Gallery*, ca. 1880, pen and ink with watercolor, 12¼ x 23 inches. Thomas Agnew & Sons Ltd.

FIG. 4.6 Charles Joseph Hullmandel (1789–1850), *The Louvre* and *No. 100 Pall Mall*, ca. 1825, lithograph, 13 x 9 inches. Guildhall Library, Corporation of London.

4·7

4.8

Newspapers and magazines on both sides of the Atlantic retailed heady accounts of suggestive surroundings, stimulating a vogue for collecting old and new decorative arts. Pictures of bric-a-brac assemblages also became popular [fig. 4.7].[13] A journalist's breathless inventory of Charles Caryl Coleman's Roman studio—which he described as being filled with everything from "a curious bit of hammered work from the home of Titian" to "a lute that Romeo might have played upon, and a poison-bearing poniard that Caesar Borgia may have owned, yes, and used"—typifies the associative historicizing atmosphere that encouraged sales of contemporary art. A call to lunch from Coleman as "artist-host" featured "luscious figs from Albano served upon Gubbio ware" and "delicious wine in rock crystal jugs" sipped from "Venetian glasses three hundred years old." Less than a decade after Mark Twain and Charles Dudley Warner pilloried materialism in their novel *The Gilded Age*, the same journalist emphasized that Coleman's "very knives and forks" were "historical and artistic." He then ended with a telling query:

> After all, in this busy age of ours, with its hurry and greed, its ostentation and petty
> ambition, its standard of gold by which it measures all things, what life is best to live?
> One in which there are high ideals—the life of an artist—in a Roman studio.[14]

Whistler's relatively austere London studios were considerably more rarefied than the usual tchotchke-choked interior. Ordinarily a welter of bric-a-brac drew heavy-handed parallels between the artist-occupant and the old masters [fig. 4.8]. Whistler relied on more subtle references. In *The Artist's Studio*, [see fig. 4.1] a Rembrandtian print adorns the wall next to him but we can't really tell if it is one of Whistler's own etchings or an object he had acquired. He not only quoted his own works but also related the picture's composition to *Las Meninas* by Velázquez.

Whistler's activities as aesthetic host for Sunday breakfasts and dinner parties are well documented by his contemporaries. He would later inquire, "Wasn't I the first to

FIG. 4.7 Charles Caryl Coleman (1840–1928), *Quince Blossoms*, 1878, oil on canvas, 31¾ x 43⅝ inches, inscribed m.r.: "Roma 1878/CCC" (in monogram). VMFA, The J. Harwood and Louise B. Cochrane Fund for American Art.

FIG. 4.8 William Merritt Chase, *In the Studio*, ca. 1880, oil on canvas, 28⅛ x 40 1/16 inches, signed: "Wm. M. Chase". Brooklyn Museum of Art, Gift of Mrs. Carll H. De Silver in memory of her husband.

FIG. 4.9 *Whistler's drawing room*, 7 Lindsey Row, Chelsea, ca. 1865, from *The Whistler Journal*, by Elizabeth Robins Pennell and Joseph Pennell, Philadelphia, 1921. VMFA Library.

give white and yellow lunches, an idea copied everywhere afterward with great pretense of originality?"[15] Yet the contrast between Whistler's reliance on a color scheme and Coleman's use of storied objets d'art underscores Whistler's less literal approach.

By 1870 Whistler had already twice transformed extant rooms into studios at Lindsey House, a late baroque building later subdivided into apartments.[16] Unlike his first parlor, with its assortment of hanging kakemonos, fans, and a folding screen [fig. 4.9], both studios were quite plain. Their gray walls and black oak woodwork are visible in works such as the *Mother* and the *Carlyle* portraits [see figs. 6.15, 2.10]. Evidence of what Whistler's rooms looked like can be found in the backgrounds of certain surviving portraits. In general, these settings mirror the artist's overarching progression toward simplicity, a gradual process surely reinforced by his contact with Godwin.[17] But Whistler was eager to build a studio from the ground up. His mother reported, "Jemmie says all the Studios now being built when he had hoped to have one, are totally wrong."[18]

The first privately built London studio-house coincides with Whistler's arrival in the British capital to launch his public career. Commissioned by James Swinton for a site in Pimlico, the structure included two studios, a picture gallery, and a ballroom, intermingling social and commercial concerns.[19] The world of studio-houses in London was a small one. Other elaborate structures of a similar nature followed during the 1860s and '70s, including Philip Webb's house [fig. 4.10] for Valentine Prinsep, who eventually married Florence Leyland, daughter of Whistler's first important patron, Frederick Richards Leyland. Costly, high-profile escapism characterized such houses, which were created by architects working with wealthy painter-clients situated for the most part in Kensington, Hampstead, and Bedford Park. For example, Leighton House, designed in 1865 by George Aitchison in collaboration with Lord Leighton, a prominent Royal Academician, masked lavish rooms of Near Eastern splendor under a relatively plain red brick facade. Added to Leighton's property in 1877–79 (during the brief existence of the reductively plain "White House" as Whistler knew it), a flamboyant

4.10

FIG. 4.10 Philip Webb (1831–1915), *garden front of Valentine Prinsep's House*, Holland Park Road, London, 1864–76, from Maurice Bingham Adams, *Artists' Homes*, London, 1883. British Library.

tiled "Arab Hall" featured a mosaic floor and stained-glass lighting [fig. 4.11].[20]
Among the friends gathering up old floral-patterned tiles from Cairo,
Damascus, and Rhodes to decorate Leighton's hall was the adventurous explorer
Sir Richard Francis Burton, another Victorian whose larger-than-life persona
was, like Whistler's, constructed in the public press.[21]

Whistler's mother emphasized that her son must have a studio "as soon
as possible, built according to his own views."[22] As is the case with so many
aspects of his career, Whistler commissioned a studio as a way of exercising
his personal brand of aestheticism to address a larger trend and make it his
own. The result of his ambitious collaboration with Godwin was the "White
House" [fig. 4.12]. Sheridan Ford later recalled a "memorable dinner" there
when Whistler "revealed the House Beautiful in its completeness—from
the delicate turquoise blue door to the slender flower in the vase of Japan."[23]
This radical building in Tite Street became the inspiration for subsequent versions of the
"House Beautiful" popularized by Oscar Wilde during the 1880s.

Many of the details that made the "White House" unusual had already been
tried as part of Whistler's initial collaboration with Godwin, one that resulted in his first
single-artist exhibition with its "pleasant 'artist's studio' appearance." Held in June 1874
at the Flemish Gallery, 48 Pall Mall, the show presented a full range of Whistler's work,
packaged in what would become characteristic elements of Whistlerian exhibition design:
a carefully orchestrated color scheme, special seating, floor covering, pottery, plants,
consciously coordinated framing, and attention to the source of lighting and its effect
upon the artworks.[24]

The hanging surface probably resembled a later, delicately tinted scheme for an
unidentified interior with the kind of Venetian red walls often seen in public picture
galleries [fig. 4.13].[25] During Whistler's lifetime, a New York dealer annotated the back of
the Venetian red color scheme: "Design for the coloring of a room—A Symphony in
red, white and yellow!"[26] The inscription serves to underscore how Whistler's paintings
and his interior decorations were seen to interrelate at the time of their execution.

Surviving designs for other projects give us some notion of the Flemish Gallery's
appearance. On the floor "glaring yellow matting striped in 2 shades" was seen by a
reporter who admired the "finely formed couches" covered with "rich light maroon cloth."

FIG. 4.11 George Aitchison (1825–1910), *Design for the Arab Hall, Leighton House*, 1880, watercolor and gold heightened with white on paper,
25 x 17¼ inches. RIBA Library Drawings Collection, London.

4.12

4.13

FIG. 4.12 E. W. Godwin, *Front Elevation of the "White House,"* 35 Tite Street, Chelsea, 1877, watercolor, pen and ink, Chinese white, 15 x 21⅞ inches
(design rejected by the Metropolitan Board of Works). Victoria & Albert Museum, London.

FIG. 4.13 Whistler, *design for the coloring of a room,* 1883–84, watercolor, 9⅞ x 7 inches. Freer Gallery of Art, Smithsonian Institution, Washington, D.C.,
Gift of Charles Lang Freer, F1901.168.

4.14

4.15

FIG. 4.14 E. W. Godwin, *revised design for the "White House"* (detail), 35 Tite Street, Chelsea, ca. 1877–78, pen and ink, 13 x 19¾ inches (design accepted by the Metropolitan Board of Works). Victoria & Albert Museum, London.

FIG. 4.15 W. Edward Gray (active, late 19th century), *The "White House,"* Tite Street, Chelsea, photograph showing Quilter's modifications, after 1878.

Pennell Collection, Library of Congress, Washington, D.C.

Whistler's first recorded exhibition installation also included blue-and-white pots with yellow calceolaria, and simple wood frames gilded in various shades of gold. The light from the roof was "subdued and mellowed by passing through thin white blinds."[27]

Mesmerizing journalists and readers alike, Whistler's quarrel with his first major patron, as well as his libel suit against Ruskin for intemperate criticism, were already in full spate when the self-confident artist engaged Godwin to design a brand-new studio for him. On 14 August 1877 Whistler requested a studio "50 x 50; or thereabouts." In less than a month Godwin was already working on a fourth, expanded design.[28] The project developed rapidly. According to Whistler, "the whole scaffolding of the roof [was] already up" by late January 1878.[29] The building was essentially complete seven months later. Godwin's final statement of account to Whistler suggests that artistic ambition had gotten the upper hand over fiscal prudence:

> It has distressed me to find that the Contract should have been so much exceeded but then of course you have greater accommodation and more fittings than we contemplated. When you have completed your internal painting and have put one or two of those final touches that used to be such eye openers to Watt I have little doubt that you would be able to sell the house for £3000…as a house plus a work of art of the original Whistler and yours sincerely, EWG[30]

Alan Cole reported that Whistler "was in the midst of decorating the 'White House' when, at the end of November, the Ruskin libel case came to trial."[31] The devastating award of a single farthing in damages tarnished the painter's adjudicated moral victory. Echoing the experience of Rembrandt, whose artistic house filled with extravagant treasures contributed to his bankruptcy in 1656, Whistler was forced to sell in the aftermath of the trial. By early May 1879, Godwin—himself familiar with the invasion of bailiffs seeking to recoup unpaid debts—"saw placards of sale stuck on Whistler's house."[32] Whistler occupied it for less than a year.

In a sense, this most intricate collaboration between Whistler and Godwin scarcely existed, given the architect's immediate alterations to the facade [fig. 4.14], deemed overly stark by the Metropolitan Board of Works. Moreover, Whistler was unable to furnish the house completely in the face of his financial difficulties before the bankruptcy-forced sale. In September 1879 the house was auctioned off to the art critic Harry Quilter for

£2,700, a little less than it had cost to build.[33] Quilter's space-gaining but aesthetically inept alterations to the second story compromised the house as a work of art long before its complete demolition in 1965 [fig. 4.15].[34]

When the Metropolitan Board of Works rejected his original design, demanding supplemental ornamentation, Godwin complained:

> That it was not *Gothic*, nor *Queen Anne*, nor *Palladian*, was probably its crime before the Board of Works. It is unhappily of white brick and is covered with green slates—two heresies in the last modern faith, that believes only in red brick and red tile…. Mr. Whistler as owner and Mr. Godwin as author of the work must be prepared to be misunderstood in days devoid alike of simplicity and originality.[35]

Godwin's suggested sculptural embellishments are none of these, but closely resemble a drawing from one of his sketchbooks showing the Hôtel de Ville in La Rochelle, on the mid-Atlantic coast of France [fig. 4.16]. A strong supporter of sixteenth-century French architecture from the reign of Francis I, Godwin found such buildings as "thoroughly healthy and strong in idea and in mass as they are refined and tender in detail."[36] La Rochelle's vivid history as a stronghold of Protestant rebellion in Catholic France during the days of Cardinal Richelieu adds a contextual measure of defiance to such a choice for ornamenting the controversial "White House" under duress from the Board of Works.

4.16

Whistler also couched his vociferous protests in aesthetic terms, telling the Board of Works, "In proportion as you estimate the importance and beauty of the decorations you insist upon, so must you recognize the necessity of these being executed by a sculptor of distinction." At this point, Whistler could hardly afford such a course of action, yet he manned his aesthetic guns, warning the board not "to stultify itself by accepting any kind of work that could be done by the nearest stone-cutter in a couple of hours."[37]

FIG. 4.16 E. W. Godwin, "*Hôtel de Ville de la Rochelle*," mid-1870s, ink on paper, from sketchbook. Victoria & Albert Museum, London.

Looking backward, it is difficult to share the outrage expressed by the Board of Works over the initial design for the street facade of the "White House," with its stone-trimmed white brick walls, enlivened by pale blue-gray woodwork and topped with a large expanse of green tile roof.[38] As is evident from Godwin's remark, the house's greatest aesthetic crime was its whiteness. The Board of Works likened the blank facade to a death house, as abrupt and unsettling in the late 1870s as the white dress worn by Jo for *Symphony in White, No. 1* had been almost two decades earlier.

Godwin credited Whistler with the choice of colors and materials for the "White House," both inside and out.[39] Their exterior aesthetic program, described by the architect as "simple, unpretending, almost cottage-like in design," may have been partly motivated by the painter's roots. In America, white facades with green trim were an architectural commonplace — particularly in New England at the time Whistler spent part of his childhood there. Social historian Richard Bushman writes:

> In the first four decades of the nineteenth century, white frame houses with green shutters… came to characterize New England townscapes and to appear nearly as commonly in other sections of the country.… By the middle of the nineteenth century, the white-and-green combination had become almost a cliché…and men of advanced taste were beginning to disparage it.[40]

Bushman highlights the power of pretension offered by a white facade:

> White houses gleamed from amidst the trees as once only mansions had done, when most dwellings huddled against the ground, lost in the landscape, garbed in colors not much different from those of the fields and forests themselves. By mid-century the middling house stood its ground, rose up and spoke out in brisk white as once only mansions dared do. The picturesque architects, in fact, felt that white spoke too loudly. They wanted houses to blend with the countryside, to be an element in the picture, not to stand alone in the spotlight.[41]

Whistler, never one to blend in, engaged in a New Englander's effort at social elevation by spotlighting himself as the proprietor of a visually striking studio-house, shining white amidst its redbrick neighbors, which set it off as sharply as an empty green countryside would have done.

FIG. 4.17 William Cooke (active early nineteeth century), *Sandycombe Lodge, Twickenham*, 1814, lithograph after William Havell. Private collection.

FIG. 4.18 Nicholas Revett (ca. 1720–1804), *The Temple of Music*, West Wycombe Park, Buckinghamshire, built late 1770s, archival photograph. National Trust Photographic Library.

Although white frame houses never held sway in domestic British architecture, the impetus for white facades did. By 1813, J. M.W. Turner, who eventually became one of the most famous of Chelsea's artistic residents, had designed for himself a small, stripped-down neoclassical sketching lodge in Twickenham [fig. 4.17]. Unornamented save for a bold row of dentils just below the pedimented roof, along with recessed niches similar to those later employed by Godwin, Turner's templelike rural retreat anticipates the modest scale, simplified ornament, and pale facade of the Whistler-Godwin project.

Like the small white buildings of the New England countryside, Turner's sketching lodge would have stood out in the landscape just like any neoclassical garden folly from the preceding century [fig. 4.18]. Enhancing the pastoral ideal, these eye-catching features were often raised on a projecting bank near the water's edge to cast an evocative reflection. Interpreting Whistler's house, or indeed any elaborate studio-house of the period, as a "temple of the muses" is a logical extension of the picturesque.

4.17

It is important to recall that the village of Chelsea was one of the last parts of greater London to urbanize. By the time Whistler's "White House" was under construction, this semirural riverside haven had sheltered artists and writers for well over a century.[42] Chelsea's development initially took place in the squares and streets on both sides of King's Road. When South Kensington was built over in the aftermath of the Crystal Palace Exhibition at mid-century, then-fashionable stucco buildings[43] overflowed into Chelsea, where the population more than doubled between 1841 and 1881.[44] While Chelsea partakes of a pattern of ongoing urbanization stretching back to the reign of Henry VIII, the shock was all the greater in the riverside neighborhood of Whistler's day because it had taken so long to get there. Indeed, at the end of the 1800s, arguments for the preservation of Chelsea, compromised by widening streets and the extension of the riverside embankment, revolved almost completely around saving

4.18

FIG. 4.19 Thomas Rowlandson (1756–1827), *Cheyne Walk, Chelsea*, ca. 1805–10, pen and brown, vermilion, and India ink, and watercolor over graphite on wove paper, 11 x 17 inches. Art Gallery of Ontario, Toronto, Gift of Reuben Wells Leonard Estate, 1936 (acc. no. 2367).

picturesque elements celebrated in earlier graphics [fig. 4.19]. By the late 1890s, Whistler's name was regularly invoked as an argument against further development.[45]

Godwin was careful to emphasize modern architecture's debt to the past—specifically to principles of Greek and Gothic predecessors—when implying that his studio designs were the first step in an "architecture of the future."[46] Shortly after he completed the "White House," Godwin wrote about the influence of Greek antiquities on his design:

> [W]hen we talk about architecture as a fine art we mean refinement, finesse, gentleness; and these qualities we can always trace in Greek mouldings. At Whistler's house there is an entrance doorway in Portland stone, in which I have endeavoured to express these ideas [fig. 4.20].[47]

Similarly convinced of the artist's responsibility to carry on tradition, Whistler drew on the past for his often controversial portraits. But the painter shifted the centuries-old visual dialogue with a facture that deemphasized the sitter's actual visage in favor of an overall decorative scheme.

Isolated amidst its ornate redbrick neighbors, the stark Whistler-Godwin facade stood out as a radical work of art. However, despite its reception in the late 1870s, the "White House" seems less radical when we recall that pale, classicizing facades invaded London during the Georgian building boom of the late eighteenth and early nineteenth centuries. Four imposing white stucco facades, one at the center of each row, enliven the severe brick town houses making up the uniform Bedford Square (1775–80).[48] Rusticated bases and colossal ionic pilasters brought to town the memory of earlier artistic neo-Palladian country retreats such as Chiswick House (1725–29) for Lord Burlington or grand country estates like Kenwood House, remodeled at Hampstead by Robert Adam for the first earl of Mansfield in the 1760s. A white facade interrupting a block-long row of urban brick walls is as visually arresting as a white *tempietto* set out in a verdant rural landscape.

Less than two weeks after the bankruptcy sale of Whistler's home and its contents, Godwin predicted more than he knew, telling readers of *British Architect and Northern Engineer*, "Perhaps no house of its size and age has been the subject of so many notes as 'the White House,' Chelsea."[49] Stark, white facades would continue to carry a potent charge well into the twentieth century,

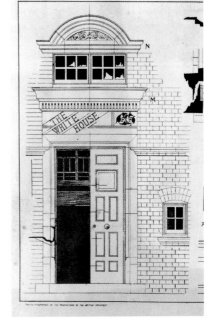

4.20

IG. 4.20 E.W. Godwin, *The "White House," Chelsea* (detail), lithograph, from *British Architect and Northern Engineer*, 24 October 1879. Library of Congress, Washington, D.C.

4.21

from a Glasgow tenement reconfigured by Charles Rennie Mackintosh as the stylish yet homey Willow Tearooms for Miss Cranston in 1903 to the *Weissenhofseidlung*, a 1927 exhibition of predominantly white show houses organized at Stuttgart by the German Werkbund under the leadership of Mies van der Rohe.[50] Comforting association with past vernacular architecture also ties Whistler's "White House" to Charles Sheeler's severely cropped and flattened 1915 photograph of an old barn in Bucks County, Pennsylvania [fig. 4.21]. Tight framing eliminates all vernacular context, resulting in a formal, textured orchestration of vertical and horizontal elements hailed as a groundbreaking artwork of its time.[51]

Godwin's tiny notebook sketch of Whistler at work on a studio portrait is one of the most direct visual interchanges between artist and architect [fig. 4.22]. However personal, this quickly executed drawing easily elided into a staffage figure placed in front of a tiled fireplace in the lower-level studio drawing room of the "White House," giving human scale to Godwin's architectural rendering. Finally approved by the Board of Works, the revised design was later published in *British Architect and Northern Engineer* [fig. 4.23].

Free from the meddlesome Board of Works, Godwin and Whistler did retain control inside the house, where simplicity and originality certainly reigned. Many of their domestic decorative details would reappear in a trio of special exhibitions designed to showcase Whistler's work at the Fine Art Society during the early 1880s.

Multiple vintage descriptions of the "White House" interiors share an impression of an overarching japanesque aesthetic, tempered, as in the architect's description of the Portland stone doorway, with elements of Western classicism. The lower studio's terracotta-red wall color was Pompeian, while the proportions of the space—29 x 17 x 18 feet —made it virtually a Double Cube, the type of room beloved of British neo-Palladian and neoclassical architects.[52] A cornice ornamented with classical dentils crowned the wide, shallow arch over the tiled fireplace.[53]

FIG. 4.21 Charles Sheeler (1883–1965), *Side of White Barn, Bucks County*, 1915, gelatin silver print, 8 x 10 inches, inscribed on mount l.l.: "Bucks County Barn / photographed by Charles Sheeler / 1915". The Lane Collection, Museum of Fine Arts, Boston.

4.22

4.23

Although the "White House" no longer exists, details of the building inform other surviving Godwin designs. The fireplace arch resonates not only with other interiors for private artistic houses conceived by Godwin from the late 1870s through the early 1880s, but also with a range of additional projects that emphasize how both art and nature had been commodified. Godwin's designs for conservatories and verandas invited nature indoors [fig. 4.24]. His fresh public facade for the Fine Art Society in New Bond Street aimed to attract customers through the portal and into the galleries [fig. 4.25].

Later Godwin projects reprise small square windowpanes used at the "White House." Walter Dowdeswell, another art dealer, described them on his visit to Tite Street to consult Whistler about framing:

> The front door opened on to the pavement, and upon entering one found oneself at once midway upon a flight of stairs—I was directed to descend, and found myself in a large terra cotta coloured room with white woodwork—very plainly furnished and very unusual. There were two long side windows about sixteen feet high on one side of the room, looking upon a little bit of garden. They had small square panes of about a foot square.

Dowdeswell went on:

> The furniture consisted of a table and some large low chairs and a couch, covered to the ground in terra cotta serge. I had expected to find the furniture very severe in design, but to my surprise found no design at all save what was necessary for comfort. Upon the couch was an Etching framed in a black fillet and reed 1¼ no gold.[54]

The aesthetic of simplicity stems in part from concern for cleanliness. Several sources tell us that the floors were covered in straw matting, a decorative, inexpensive, and hygienic survival from early-nineteenth-century bedchambers.[55] Such mats had already been seen in Whistler's Chelsea apartment at Lindsey Row (1860s) and at Fallows Green (1871–72), Godwin's house for Ellen Terry in Hertfordshire, as well as the rooms they

FIG. 4.24 E. W. Godwin, "Verandahs" from Messenger and Company, *Artistic Conservatories*, London, 1880. British Library, 1734.a.4.

FIG. 4.25 E. W. Godwin, *design for new entrance of Fine Art Society, London,* 1881, India ink and red ink with colored washes, 19¼ x 27 inches. RIBA Library Drawings Collection, London.

: Elevation :

shared at 20 Taviton Street, Gordon Square, London (1874). In Whistler's day, available materials included traditional British rush matting, long used in important English country houses such as Hardwick Hall (1590–98); sturdy "Indian" matting of coir, sisal, or jute, imported from British colonies in the East Indies; and Japanese tatami mats, the cheapest and least durable option.[56] One scholar has recently speculated that the staircase walls might have been covered in felt, which Godwin intended to use in the Frank Miles house, built shortly after Whistler's "White House" and closely related to it.[57]

Whistler had marked opinions about the yellow tiles that surrounded the metal fireplace, a cast-iron Anglo-japanesque design by his erstwhile colleague Thomas Jeckyll.[58] The artist wrote to Godwin:

> I suppose you are not well enough to get down there on Monday or Tuesday and see West about the Jeckyll stoves for the rooms—Some of them have come and he doesn't know where they are to go—Also what about tiles to go round them…I want those plain simple yellow ones that Watt has from Doultons—I cannot [abide] any of the other abominations—[59]

Tiled fireplaces were quite common, but what made this one different was its utter simplicity. A few years later, at the Fine Art Society, plain tiles, both green and cream, were part of the renovation. A look at more elaborate contemporaneous Victorian tiles tells us not only what it was Whistler could not abide [fig. 4.26], but also that as designers he and Godwin did not reinvent the wheel.

Like Godwin, Whistler took a holistic approach to his entire oeuvre, marking another confluence between the two men. We need only compare one of Whistler's schemes for a dining room wall with a rug design and an independent seascape to see what a consistent design sensibility he applied to a flat surface, whatever its size or purpose. In these, carefully proportioned horizontal bands carry a variety of color combinations but otherwise change very little from one to the next [figs. 4.27, 4.28, 4.29].

4.26

FIG. 4.26 William de Morgan (1839–1917), *"Persian Tulip" tile*, 1872–81, glazed earthenware, 6⅛ x 6⅛ x ⅜ inches; Impressed, verso, "W De Morgan". Private collection.

4.27

4.28

4.29

FIG. 4.27 Whistler, *color scheme for a dining room at Aubrey House*, ca. 1873–74, gouache on brown paper, 7⅛ x 5 inches. Hunterian Art Gallery, Glasgow University, Birnie Philip Bequest.

FIG. 4.28 Whistler, *Southend: Sunset*, ca. 1880s, watercolor, 10 x 7 inches. Freer Gallery of Art, Smithsonian Institution, Washington, D.C., Gift of Charles Lang Freer, F1905.119.

FIG. 4.29 Whistler, *design for matting*, 1873–75, pastel on brown wove paper, 11⅛ x 7¼ inches. Fogg Art Museum, Harvard University, Bequest of Grenville L. Winthrop.

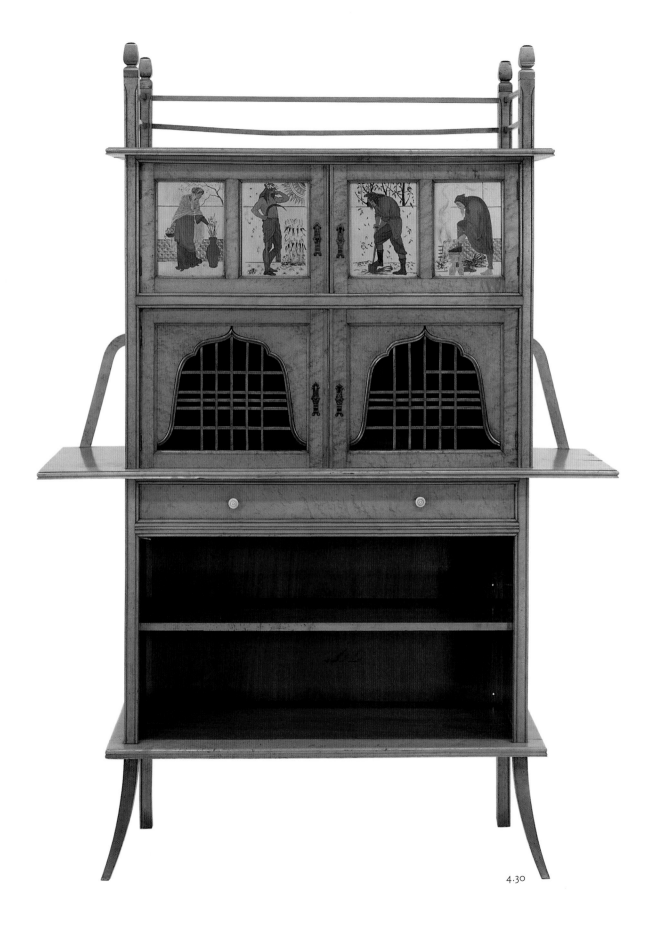

4.30

Similarly, several pieces of Godwin's furniture—contemporary with the "White House," although not clearly intended for it—resonate with that now-destroyed structure. Brass, mahogany, and gilding are featured in one of the most beautiful of all Godwin's case pieces, the *Four Seasons Cabinet* of 1877 [fig. 4.30]. Godwin himself published drawings showing his debt to Japan [fig. 4.31]. The bell-shaped brass-grilled openings in the center doors directly quote Japanese architecture, but the cabinet serves as a sharp visual reminder that the works we are discussing cannot easily be categorized. The chaste saber-legged form of yellow satinwood veneer derives from Georgian prototypes.[60]

Whistler's future bride—the architect's wife—provided painted decoration for the cabinet.[61] By representing the seasons—here, four figures wearing medieval dress and working in a garden—Beatrice Godwin contributed to one of the oldest cross-cultural visual traditions in the world, as important in Asia as in the West. The seasonal theme strikes deeply into the rich soil of much earlier European art—the first books of hours decorated with the labors of the months and the more ambitious cycles of seasonal paintings that followed. For three centuries (1250–1550) books of hours were medieval "best-sellers," marking time with their series of prayers and illuminated calendars. But they also shaped time, encouraging meditation that transported the user from the distracting cares of this world to the divine pleasures of the next.[62] In the more secular, industrialized milieu of Victorian Britain, the desire for mental travels—to other times as well as other places—formed a significant stimulus in the arts and found frequent expression in paintings, sculpture, and interior decoration.

4.31

Also contemporary with the "White House" is another joint Whistler-Godwin project: *Harmony in Yellow and Gold: The Butterfly Cabinet* (1877–78) [fig. 4.32]. It began as a fireplace surround designed by Godwin and painted by Whistler for William Watt's furniture display at the 1878 Exposition Universelle in Paris [see fig. 4.2].[63] Yellow tiles duplicate those used in the ill-fated Tite Street property. Although now in a somewhat compromised state, the cabinet remains an instructive witness to the fruitful collaboration between artist and architect.[64]

A traveling correspondent for the *New York Tribune* described the subtle orchestration of yellows that Whistler and Godwin achieved in Paris:

FIG. 4.30 E. W. Godwin, designer; Beatrice Godwin (1857–1896), decorator; William Watt, manufacturer, *Four Seasons Cabinet*, ca. 1877, satinwood with painted and gilt panels, ivory handles, brass fittings, 70 x 16 x 50 inches. Victoria & Albert Museum, London.

FIG. 4.31 E. W. Godwin, *Japanese Wood Construction* (detail), from *Building News and Engineering Journal*, 12 February 1875. British Library.

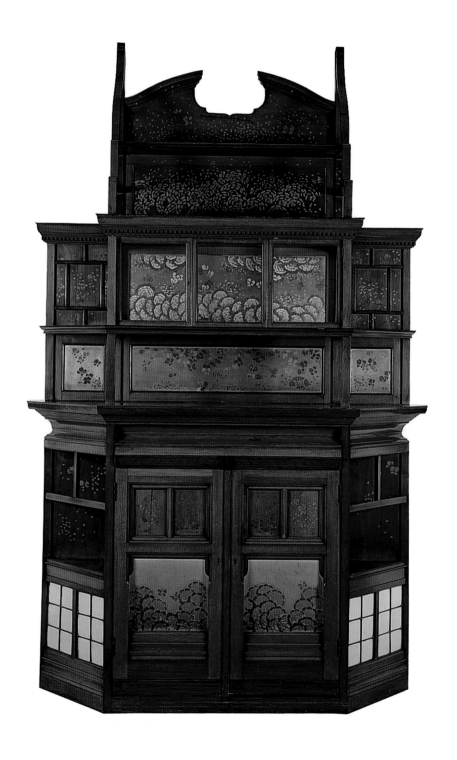

FIG. 4.32 E. W. Godwin, designer; Whistler, decorator; William Watt, manufacturer, *Harmony in Yellow and Gold: The Butterfly Cabinet*, 1877–78, mahogany with oil-painted decoration, yellow tiles, brass moldings, glass, 119 x 74 x 18 inches. Hunterian Art Gallery, Glasgow University.

Against a yellow wall is built up a chimney-piece and cabinet in one; of which the wood, like all the wood in the room, is a curiously light yellow mahogany.... The fireplace is flush with the front of the cabinet; the front paneled in gilt bars below the shelf and the cornice, inclosing tiles of pale sulphur, above the shelf a cupboard with clear glass and triangular open niches at either side, holding bits of Kaga porcelain, chosen for the yellow-ishness of the red, which is characteristic of that ware; the frame of the grate brass; the rails in polished steel; the fender the same. Yellow on yellow, gold on gold everywhere.[65]

The journalist tallied the effect of a closely related color range sparked by textural variations typical of Whistler-Godwin collaborations at their best. He also perceived Whistler's effort to distance himself from commercialism through aesthetic decoration: "The exhibitor is Mr. Wm. Watt, of London, whose sign stares you in the face at the top in a way which would drive Mr. Whistler mad if he saw it, for in his fancies below, there is certainly no suggestion of the shop."[66] Of course, the stand was precisely that—a commercial undertaking—reminding us that economic ambivalence colors Whistler's aesthetic strategies.

Seeing the cabinet helps us to imagine one of the rooms in the "White House" described by turn-of-the-century critic Edward Lucas:

> There was no other color beside yellow. But it would be impossible to describe
> the subtle variations which had been played upon it; how the mouldings, the
> ceiling, the mantelpiece, the curtains, and the matting on the floor enhanced
> and beautified the general harmony.... This was picked out with yellow in the
> mouldings, cornice, etc., with a result extremely satisfactory and charming. All
> the decoration was entirely free from anything in the way of pattern or diaper;
> the color was laid smoothly and broadly on the hard finished plaster, and the
> effect depended solely upon the contrast and disposition of the tints.[67]

Godwin also designed a delicate mahogany side chair [fig. 4.33] for the Watts display stand. It retains some of its original split cane in a complex weave that recalls the embellishment of the panels flanking the fireplace in Whistler's front hall and downstairs studio at the "White House." Godwin specified "scratches in wet plaster" to complement the straw matting laid on Whistler's

141

4.33

FIG. 4.33 E. W. Godwin, designer; William Watt, manufacturer, *side chair from the Butterfly Suite*, 1878, mahogany with split cane back panel and seat, height 38⅛ inches. VMFA.

4.34

floors. The look may ultimately have derived from fences reproduced in the *Manga*, an important Japanese source familiar to both Whistler and Godwin.[68] However, closer to home, pargetting offered a Western precedent. This long-established method for covering half-timbered buildings with a mixture of plaster and animal hair often featured surfaces incised with a comb to form decorative patterns. Numerous examples still survive in rural England.[69] The rectilinear battens enclosing Godwin's plaster panels offer an abstract evocation of Elizabethan oak paneling, serving to remind us that the architect was an accomplished medievalist as well as a lover of Japanese art.

The plaster-scratching technique is also indicated on a detail drawing for the staircase in Whistler's "White House," where precise instructions call for a railing of "polished hard white wood" punctuated by a newel post inlaid with bands of ivory [fig. 4.34]. The choice of decorative ivory underscores the austere luxury of the project as a whole, but it too has an American vernacular resonance. In historic houses as far apart as Nantucket and Charleston, tales are told of the ivory "mortgage button" inlaid in the newel post of a front staircase to celebrate the discharge of debt on the building, an accomplishment denied Whistler himself.[70] The drawing gives us some notion as to why. Godwin and his client lavished attention (necessitating expenditure) on the least detail, whether of interior architecture or of furniture design.

Another Godwin chair, produced commercially by Watt and then copied by other manufacturers, is known as the "Old English" or "Jacobean" armchair [fig. 4.35]. The design echoes Regency stick chairs but also rests on circular "burgomaster" prototypes associated with Dutch East India.[71] The cane seat reprises a material fashionable in London during the days of Samuel Pepys as Britain's trade with the Near East expanded in the late 1600s. The geometric back splat echoes japanesque elements

FIG. 4.34 E. W. Godwin, *elevation for the "White House" staircase*, 7 November 1877. Victoria & Albert Museum, London.

again connected with empire and trade. Godwin exploited similar elements for stair railings and balustrades in the "White House" and another studio-house built across the street for Frank Miles [fig. 4.36]. Godwin, who once more had trouble gaining approval for a stylistically advanced facade, dubbed the conservative Board of Works a group of "retired farriers and cheesemongers who never drew a line nor saw a drawing until yesterday." Still, the architect's choice to modify the Miles exterior with "a number of reminiscences of a visit to Holland" while maintaining a japanesque aesthetic within is consistent with his approach to designing the "Jacobean" armchair.[72]

4.35

The *Building News* remarked that Godwin took "Japanese forms as the basis of his productions, which have been prepared with a care for English wants," reminding us that Godwin, like Whistler, needed to tailor his *japonisme* to the British market.[73] In Whistler's decorative work, this skill is perhaps best exemplified in his floral panels for the imposing main staircase in Leyland's art-filled mansion on the south side of Hyde Park.

The eclectic stair hall at 49 Prince's Gate became a showcase that featured works from the family's important collection of Italian primitive and English Pre-Raphaelite paintings. The dado was commissioned to enhance Leyland's collection, but Whistler also managed to inject his own art into the mix, for he made no hierarchical division between painting and decoration.

Like a trophy, the eighteenth-century balustrade was plucked from the recently demolished Northumberland House at Charing Cross and inserted into the self-made

4.36

143

FIG. 4.35 E. W. Godwin, designer; William Watt, manufacturer, *"Old English" or "Jacobean" armchair*, ca. 1867, ebonized wood, cane seat, height 34½ inches. Private collection.

FIG. 4.36 *Staircase in "Keats House,"* 44 Tite Street, Chelsea, London, designed by Godwin for Frank Miles, 1879, photograph, 1972. Country Life Picture Library.

shipping magnate's mansion.[74] The gilt-bronze is characterized by flowing curves and much open space, punctuated by flat flower heads. Whistler avoided stylistic imitation of the already present elements of the stair hall in order to bring the whole into spatial harmony. Balustrade and dado were in taut and perfect balance.

Whistler did not rely upon style to coordinate his dado decorations with the staircase [fig. 4.37]. Instead, he complemented its sense of openness, using spriggy flowers that echo the linear quality of the balustrade while floating on the surface of each panel.[75] He chose japanesque morning glories, rendered according to then-current theories advocating stylized decorative art.[76] Fine lines tie the flowers to the suggestion of a trellis [fig. 4.38]. The flower heads picked up on the floral forms in the balustrade as well as those in the mosaic floor at the foot of the stairs. Heavy moldings, painted the dark green of Jacobean England, act as "windows" through which we see the morning glories on their trellis. Infinite, dark, unarticulated space is suggested behind them. By evoking abstract space beyond the wall, Whistler brought into tension the actual space glimpsed through the balustrade. As one ascended the steps, heavy moldings repeated the rhythmic

4·37

FIG. 4.37 Henry Dixon & Son, *staircase*, from *No. 49 Prince's Gate, S.W., for Sale by Auction by Mssrs. Osborne & Mercer*, London, 1893.
Charles Lang Freer Papers, Freer Gallery of Art, Smithsonian Institution, Washington, D.C.

<div align="center">4.38 4.39</div>

element of the stair treads, while glints reflecting off the bronze were echoed by similar glints from the metallic foil only partially obscured by layers of paint.

Experienced sequentially, the panels demonstrate Whistler's masterful grasp of the subtleties of Japanese screens decorated with gold leaf:

> In the darkness of the innermost rooms...the gold leaf of a sliding door or screen will
> pick up a distant glimmer...then suddenly send forth an ethereal glow, a faint golden light
> cast into the enveloping darkness, like the glow upon the horizon at sunset...you may
> find that the gold dust of the background, which until that moment had only a dull, sleepy
> luster, will, as you move past, suddenly gleam forth as if it had burst into flame.[77]

Whistler here took a motif found in other works of the period. But while the "Trellis" wallpaper by William Morris and Philip Webb *tells* [fig. 4.39], Whistler's trellis panels *suggest*.

IG. 4.38 Whistler, *staircase dado panel for entrance hall at 49 Prince's Gate, London*, 1876, oil and metal leaf on wood, 20 x 14½ inches. Freer Gallery of Art, Smithsonian Institution, Washington, D.C., Gift of Charles Lang Freer, F1904.461.

IG. 4.39 William Morris, *"Trellis" wallpaper*, 1862, birds designed by Philip Webb (1831–1915), block print, distemper colors, printed by Jeffrey & Co., for Morris, Marshall, Faulkner & Co., London. Victoria & Albert Museum, London.

FIG. 4.40 Whistler, *design for wall decoration at Aubrey House*, ca. 1873–74, charcoal and gouache on brown paper, 5 ¹⁵/₁₆ x 4 inches, inscribed with butterfly.
Hunterian Art Gallery, Glasgow University, Birnie Philip Bequest.

This degree of sophistication grew out of earlier experiments, including Whistler's decorations for his own staircase at No. 2 Lindsey Row. Cecily Alexander, who sat for Whistler there in 1872–73, later recalled the tinted lemon walls with a gilt dado below. Only a rough sketch is left now; it records his scheme delicately flecked with chrysanthemum petals in pink and white, accented with butterflies.[78]

Whistler conceived a number of elegant decorative options for W. C. Alexander, Cecily's father, shortly after the London banker acquired Aubrey House in Camden Hill, Kensington.[79] Once a country house, the dwelling dates back to the late 1690s. It now stands on Aubrey Road (built in 1859), a witness to changing tastes hedged by urban expansion.[80]

During the eighteenth century, James Wyatt redecorated the house for the eccentric and imperious Lady Mary Coke (1726–1811).[81] Almost a hundred years later Alexander asked Whistler to suggest ideas for redecorating a suite of three interconnected Georgian rooms on the south front of the house dating to the 1750s. Whistler worked on the paneling of the "White Room" and also painted a drawing room known as Lady Mary's "Red Room."[82] Critic Roger Fry later asserted that the Victorian banker's prescient, uninhibited taste let him "save England from the disgrace of leaving Whistler unrecognized."[83]

Whistler's proposed treatments for Aubrey House, most of them apparently unexecuted, clearly indicate how he prepared his walls as he would a canvas, in layers of color that broke through one another to give life and interest to a seemingly blank wall. In one Aubrey House scheme, old-fashioned picture rail, dado, and paneling are all picked out in shades of pale yellow, blue, lavender, and cream, a color combination favored by Impressionist landscape painters [fig. 4.40].[84] Extant pen sketches further reinforce this balance between Whistler's present and his past—for example, a sketchy indication of symmetrical jars on pedestals recalls arrangements of pier tables and mirrors from previous centuries, such as he would have seen in Russian palaces during his youthful days in Saint Petersburg.[85] The attenuated furniture in these little drawings may also be evidence of Godwin's impact on Whistler's thinking.

Whistler's advice to his sister-in-law, Nellie, who was disappointed in a room redecorated by commercial painters, is one of several documents shedding a great deal of light on Whistler's working method:

My dear Nellie. It all comes of not doing *exactly* as I understood it should be—If the first coat had been as I *directed* grey brown—This too crude and glaring condition of the yellow would not have occurred—It is just because of the horrid white ground—Also why on earth should the workmen think for themselves that after all *two* coats of the yellow upon *white* would do just as well as *one* coat of yellow on grey!—This was so ordered by me because in my experience the result would have been fair and at the same time soft and sweet.... Now listen—See that the man gets a tube of "Ivory black" from any colorman's and a tube of "raw Sienna." Let him put first about a salt spoonful of the Ivory black into his pot of yellow paint, "mix well—and stir"—this will lower the moral tone of that yellow!—but you must not be alarmed if to your over anxious eyes it even looks a little *green*—all the better—Then mix and stir in say half of the tube of raw Sienna—and I should think you would bring things to their natural harmony—If not quite satisfied—try then another salt spoon of black—and the other half of the tube of Raw Sienna—"mix to taste"—Don't be afraid—you are well started—and don't be shocked if the *first little daub* of this new mixture looks dirty on the bright yellow coat already on the wall—of course it will—but remember that brightness is what you wish to be rid of—also remember that when the second coat is all over the wall you will *only see the second coat!* You can't make any mistake—it is not like the distemper business, because here you see exactly what you are about in the pot![86]

Similarly, Whistler gave his friend Ernest Brown, a dealer working with the Fine Art Society, specific advice on the use of specially mixed distemper (tinted whitewash) in colors far more subtle than harsh, commercially available tints.[87] A surviving proposal for a lavatory shows that Whistler was willing to apply his considerable skills even to the most humble chamber [fig. 4.41].

Such recipes were valued by the relatively few clients having access to them. Mrs. D'Oyly Carte (whose husband, Richard, produced the Savoy Operas, orchestrated Oscar Wilde's lecture tour in America, and hoped Whistler would make a similar voyage) related how Whistler designed a color scheme for her house at Adelphi Terrace, part of an impressive riverside development erected by the brothers Adam beginning in 1772.[88] Whistler was in good historical company there. Prominent artists who had gone before him as decorators at Adelphi Terrace included Angelica Kauffmann, a founding member of the Royal Academy, as well as her husband, Antonio Zucchi, and Giovanni Battista

4.41 Whistler, *lavatory color scheme for Ernest Brown*, 1886, watercolor on cream wove paper, 5 15⁄$_{16}$ x 4½ inches, inscribed with butterfly.
Glasgow University Library, Department of Special Collections.

Cipriani. Kauffmann and Cipriani were also involved in designing for the Theatre Royal, Drury Lane, reinforcing again the complex interweaving of domestic and public decoration with social performance.[89] Mrs. D'Oyly Carte was later instrumental in arranging Whistler's "Ten o'Clock" lecture in 1885.

Recalling Whistler's contribution, the theater entrepreneur's wife scrupulously noted, "It would not be quite correct to say that Mr. Whistler designed the decorations of my house, because it is one of the old Adam houses in Adelphi Terrace, and it contained the original Adam ceiling in the drawing-room and a number of old Adam mantelpieces, which Mr. Whistler much admired, as he did also some of the cornices, doors and other things."[90]

Rather, she later reported, Whistler

> mixed the colours for distempering the walls in each case, leaving only the painters to apply them. In this way he got the exact shade he wanted, which made all the difference.... Painters simply have their stock shades which they show you to choose from, and none of these seem to be the kind of shades that Mr. Whistler managed to achieve by the mixing of his ingredients. He distempered the whole of the staircase light pink; the dining room a different and deeper shade; the library he made one of those yellows he had in his drawing room at The Vale [in Chelsea], a sort of primrose which seemed as if the sun was shining, however dark the day, and he painted the woodwork with it green, but not the ordinary painters' green at all. He followed the same scheme in the other rooms. His idea was to make the house gay and delicate in colour.[91]

Mortimer Menpes reported that Whistler's favorite tones for distempering rooms were "lemon yellow, Antwerp blue and apple green."[92] Whistler captured one such room in an intimate watercolor of his mistress Maud Franklin, painted at 13 Tite Street [fig. 4.42]. The apartment was in a building designed by Robert W. Edis, author of *Furniture and Decoration of Town Houses*. The two men shared friendship with Godwin, whose furniture could be seen in Edis's own sitting room.[93] But Whistler stayed only until he was able to get into another Godwin-designed set of rooms in the architect's Tower House, which still stands in Tite Street. Meanwhile yellow distemper mixed to his exacting specifications proved an inexpensive way to enliven rooms Whistler disliked.

Yellow rooms, sometimes accented with white, have since become associated particularly with Whistler, but it is worth pointing out that yellow and white was a

G. 4.42 Whistler, *The Yellow Room*, 1883–84, watercolor on white paper, laid down on card, 9½ x 6¼ inches, inscribed with butterfly. Private collection.

152

Regency color scheme, seen by 1825 in Sir John Soane's patent-yellow and white south drawing room at Lincoln's Inn Fields, London. The color scheme was perhaps most grandly realized at Apsley House, remodeled for the duke of Wellington in the late 1820s, following the military hero's travels in Russia where he, like Whistler after him, encountered the soft yellow and white palette common in the architecture of Saint Petersburg. As Whistler would later do in his work for the D'Oyly Cartes at Adelphi Terrace, Benjamin Dean Wyatt retained original Adam elements at Apsley House, including the elaborate ceilings and some of the moldings and door cases in the main suite of reception rooms. However, he changed the color scheme completely. The ceiling went from green and terra-cotta to white picked out with gold, and the walls were covered with "tabaret," a rich yellow fabric of alternating watered silk and satin stripes. The white-painted neoclassical furniture was upholstered to match [fig. 4.43]. The three rooms were remodeled to better display Wellington's art collection. A similar motive governed Whistler's choices for interior decoration a half century later.[94]

4.44

The Pennells thought Whistler got the idea of using distemper from houses in New England. Menpes noted that Whistler favored it as "the very best medium of all for coating walls" because it was "clean and easily renewed, and with it one procured a finer quality of colour."[95] Much later modernists, such as Le Corbusier, were quick to cite the ancient roots of whitewash as a decorative choice—"I found whitewash wherever the twentieth century had not arrived."[96]

Menpes stressed the unity of color Whistler regularly sought, and tied his technique directly to fine art:

> Whistler's method of procuring a fine quality in distemper was almost exactly the same as that which he used when painting his pictures. Before putting it upon the walls he prepared a groundwork of black and white, forming a neutral grey which broke through and gave to the colour a pearly quality.[97]

While these descriptions predict the color field paintings of artists like Mark Rothko [fig. 4.44], Whistler's remodeling at Aubrey House and Adelphi Terrace again

FIG. 4.44 Mark Rothko (1903–1970), *No. 10*, 1957, oil on canvas, 69¼ x 61½ inches. Menil Collection, Houston.

FIG. 4.45 Whistler, *Harmony in Blue and Gold: The Peacock Room*, detail of north wall, featuring his *Princess of the Porcelain Country* (1864–65), 1876–77, oil paint and gold leaf on canvas, leather, and wood. Freer Gallery of Art, Smithsonian Institution, Washington, D.C., Gift of Charles Lang Freer, F1904.61.

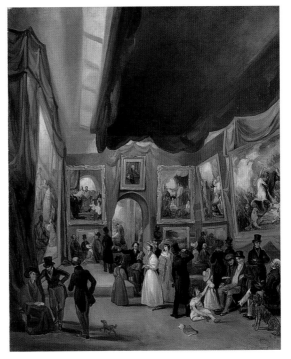

4.46 4.47

shows us how seamlessly he could accommodate his work to an already extant interior.
His greatest triumph of this nature, and the only Whistler interior known to survive,
is the often-published Peacock Room, once at 49 Prince's Gate and now in the Freer
Gallery of Art. Suffice it to say here that the room was, in essence, a modern version of
a baroque porcelain chamber, with the chief purpose of displaying an extensive collection
of blue-and-white china along with Whistler's *Princess of the Porcelain Country* (1864–65)
[fig. 4.45]. Whistler's adaptive skills, seen here, would serve him well when he found
himself creating public exhibition installations relying on color, texture, and drapery to
change the visitor's perception of the space. As we have come to expect, Whistler's contri-
bution was to take something ordinary and make it highly aesthetic. Even his much-
vaunted velarium, or light scrim, visible in the image of the Society of British Artists
exhibition [fig. 4.46], had prominent historic precedents. Fabric covering the skylight
in Benjamin West's London studio was prosaic, practical [fig. 4.47]. Whistler's version was
beautiful. That was enough to confound a journalist, entranced by the seeming novelty
of the velarium: "In the center of the room, subduing the light which enters from

FIG. 4.46 Whistler, *Interior of the British Artists Exhibition*, 1887, pen and ink, 7⅞ x 6¼ inches. Ashmolean Museum, Oxford.

FIG. 4.47 John Pasmore (fl. 1831–1845), *Benjamin West's Gallery*, ca. 1821, oil on canvas, 29½ x 24¾ inches. Wadsworth Athaeneum, Hartford,
The Ella Gallup Sumner and Mary Catlin Sumner Collection Fund.

above, floats a cloud of yellow merino, forming a series of exquisite curves. Eccentric it certainly is, if this term may be taken to mean that Mr. Whistler's art is altogether outside that academical art circle, which always revolves on its own axis of common-place and dull mediocrity."[98]

As Whistler rejuvenated his career with specially designed shows at the Fine Art Society in 1880, 1881, and 1883, standard Whistlerian elements of decoration would become more and more familiar to London gallery goers. Even though the "White House" was short-lived, the artist's bid for the perfect personal stage set (combining living quarters, teaching facilities, and sales room) is bracketed by a series of innovative exhibition designs that would have a lasting impact on the way we present art to the public.

Whistler had an excellent reason for fine-tuning his decorations, as each carefully selected color harmony drew attention to his art. Making the art easier to see made it easier to sell. If Whistler could control the overall appearance of a single work of art by judicious framing, so could he design exhibition settings in order to maintain maximum control over the visitor's perception of the art. At least one writer clearly discerned this intention: "[Whistler], feeling probably, that his works were not seen to advantage when placed in juxtaposition with those of an essentially different kind, has determined to have an exhibition of his own, where no discordant elements should distract the spectator's attention."[99] Gradually it became clear to reviewers that Whistlerian installations actually influenced perception of the works of art.[100] By the time Whistler created a flesh color and gray installation for "Notes"—"Harmonies"—"Nocturnes" at the Dowdeswell Gallery in 1884, the "White House" as Whistler knew it had come and gone, but Godwin still could comment that Whistler's interior decor "might be in itself an exhibition if the people could enjoy colour."[101] Whistler's palette at the Dowdeswell Gallery recalled numerous earlier paintings such as *Variations in Pink and Grey: Chelsea* (1871–72) [see fig. 5.28] and *Arrangement en chair et noir: Portrait of Théodore Duret* (1884, Metropolitan Museum of Art, New York). Shortly after he painted Duret, Whistler told the French critic, "I attach just as much importance to my interior decorations as to my paintings."[102]

An expanding body of literature on cultural consumerism illuminates the strategies Whistler, Godwin, and others employed in their efforts to reach female consumers—some of them as professionally, fiscally, or socially prominent as Lillie Langtry, Mrs. Leyland, the daughters of W. C. Alexander, and Princess Louise.[103]

Raffles Davison pictures women at the Fine Art Society in a somewhat fanciful engraving of its still-extant entrance vestibule and gallery [see fig. 4.49]. Some of the women are escorted (on the balcony); others are out in public on their own (at curbside). For more than a century, this eclectic stone facade, commissioned during the summer of 1881 by the society's director, Marcus B. Huish, has stood as one of Godwin's best-known surviving works. Whistler, who staged controversial exhibitions at the Fine Art Society in the early 1880s, may have had a hand in Godwin's receiving the commission.[104] By then, artist and architect had known each other for nearly two decades.

Well aware of the Regency-period glass display windows that characterized New Bond Street as well as other fashionable shopping areas in London, Huish asked Godwin to change the facade at 148 New Bond Street in order to "make it rather less of a shop front."[105] Later interior changes were also made to create a more domestic atmosphere within the galleries.[106] Nonetheless, in 1899, Walter Sickert told Jacques-Emile Blanche that the society was still the "best *shop* in London."[107]

In Davison's etching of the Fine Art Society, Godwin's presence is suggested by the architecture itself, but the drawing is layered with further associations. Below the balcony, near one of the very plain engaged classical columns, a somewhat menacing figure in a tall silk hat and frock coat seems to confront a slighter man wearing a slouch hat. To a degree, they resemble Whistler and the influential critic John Ruskin. However unlikely it is that such an exchange took place in front of 148 New Bond Street, both Whistler and Ruskin had exhibited at the Fine Art Society by the time the etching was made.[108] Readers of *British Architect and Northern Engineer*, where the image was first published in 1881, knew that Whistler and Ruskin had recently conducted their chief confrontation in court. Published only a few short years after the *Whistler v. Ruskin* libel suit, this pair of opposed figures, standing in front of a commercial gallery with its new proscenium-like arch, conjures up one of the most notorious but significant dramas in the art world of the late nineteenth century, the moment when the rights of the artist were forever pushed into the limelight.[109]

Other confrontations continue to expand our perception of the works of art we study. As difficult to classify as one of Whistler's paintings, the facade of the Fine Art Society has been described variously as "japoniste" and "Free Renaissance," but it embodies Gothic and Old English ideas as well.[110] The arch also has been associated with

the loggia of a sixteenth-century building near Dieppe, published by Godwin in 1874.[111]

Among the circumstances shared by Whistler and Godwin were overexpenditure on an artistic house followed by an effort to replenish tottering fortunes through a project involving Venice. With the bailiffs at the door to repossess his furniture at Fallows Green, Godwin agreed to serve as historical consultant for a production of *The Merchant of Venice* starring his soon-to-be-former mistress, Ellen Terry.[112] This project of 1875 predates Whistler's mid-career Venetian sojourn with his mistress Maud Franklin in 1879–80, following his loss of the "White House" through bankruptcy.

The Whistler-Godwin correspondence includes a letter that very likely has to do with Whistler's third Venetian exhibition at the Fine Art Society. It reminds us how straitened circumstances led both painter and architect to practice "elegant economy" like the ladies of Cranford in Elizabeth Gaskell's novel.[113] We also see how very close the worlds of theater and art exhibition were then, as they are now. With his usual imperious excitement, Whistler wrote:

> I wonder if you could find out for me from one of the theatre swells, one of the scene painters you know, whether in any pantomime or fairy piece they ever have such a thing as a gilded net!—a sort of fisherman's golden net—and if so how can one get one?—
>
> "What I mean," as Albert says, is this—I want a net—a fishing net made of what shall look like gold thread—I think I have seen something of the kind in festivals on the Grand Canal in Venice—where the Fishermen of the Adriatic have been paraded about in wonderful painted barges with gold and silver nets hanging from the mast or jiboom or yard or whatever it may be—
>
> In any case I am sure you might readily know if something of the kind is done at the theatres—
>
> If so do let [me] hear all about it—there must be some pinchbeck way of getting a gold netting—[114]

Whistler's design for his celebrated yellow velarium, a light silken scrim "looped up with promiscuous strings," was still a few years in the future [fig. 4.48].[115] Had Godwin managed to locate one, however, a voluptuously draped golden net could only have enhanced the elaborate appointments of Whistler's exhibition *Arrangement in White and Yellow* during the late winter of 1883.

G. 4.48 Whistler, *design for a velarium*, ca. 1887–88, watercolor on paper, 10 x 7 inches, inscribed with butterfly and "J. McNeill Whistler".
Hunterian Art Gallery, Glasgow University.

Even without the net, the mis-en-scène was wildly theatrical with its white felt walls picked out with stenciled yellow lines and butterflies, canary-yellow ledge and skirting board, "perilous little cane bottom chairs" on straw-colored matting, various potted yellow flowers including, appropriately for Whistler, narcissi—not to mention "the poached egg," an attendant clad in a rented yellow-and-white costume that one suspects was derived from Regency clothing. Displaying the complexity we have come to expect of him, Whistler revisited a familiar Regency-period interior palette, giving it a late Victorian twist. White—still associated with purity, cleanliness, and innocence—was twinned with yellow, which signalled decadence as the century drew to a close.

Renovation of the Fine Art Society facade was complete by the time *Arrangement in White and Yellow* opened (17 February 1883), so "gallery trotters," as they were then called, would have passed under Godwin's elegant new archway [fig. 4.49] to see Whistler's exhibition. The air of domesticity, gradually transferred from artist's studio to commercial art gallery, can be found not only in architectural spaces but also in some of the artworks displayed. Among the white-framed etchings on view, *The Balcony* [fig. 4.50], peopled with languid figures standing below arched windows, shares elements with Davison's image of the Fine Art Society, in which a leisurely couple pauses on the balcony, high above the crowded sidewalk. Near them, the oriental rug's heavy folds cascade sensuously over the stone balustrade. The domestic air of the couple on the Fine Art Society balcony resonates with the figures and drapery in Whistler's etching. His Venetian site, too, proved domestic— not a grand palace but a small Renaissance house on the Rio de San Pantalon, which divides the Venetian quarters (*sestieri*) of Santa Croce and Dorsoduro.[16]

The year Whistler and Godwin first collaborated on an exhibition (1874) was also the year in which Godwin began publishing a series of thirty-three articles on Shakespeare's plays for the *Architect*.[17] Shakespeare had more significance in Godwin's career than in Whistler's, but the bard is by no

160

4.49

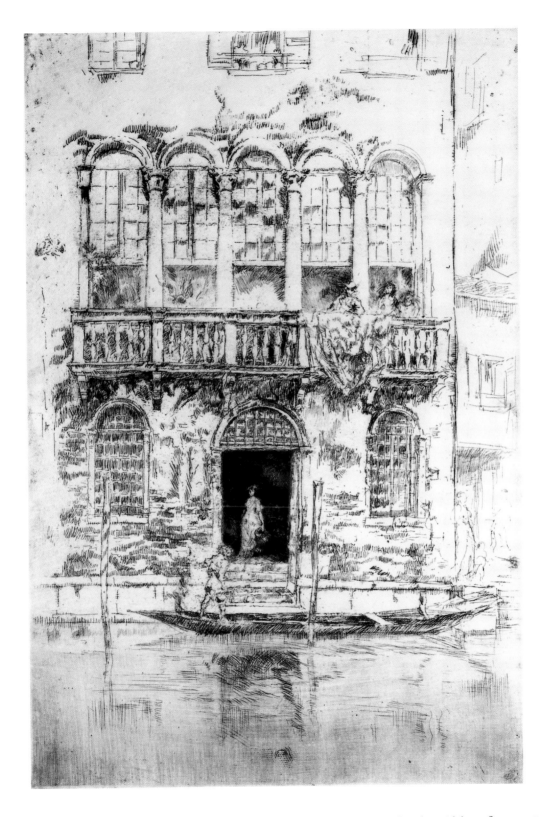

FIG. 4.50 Whistler, *The Balcony*, 1879–80, etching and drypoint, 9th state, K207, 11¾ x 8 inches, inscribed in plate with butterfly. Freer Gallery of Art,

Smithsonian Institution, Washington, D.C., Gift of Charles Lang Freer, F1898.398.

means absent from the latter's thinking. The continuing performance of Shakespearean plays from the sixteenth century through the nineteenth forms a cornerstone supporting narrative traditions in British painting that Whistler both combated and exploited.[118]

Godwin was more comfortable than Whistler was with Shakespeare's ongoing commercial viability. The architect's "Shakespeare" dining room set (1881) was lauded in *Building News* for its putative "Washington-slept-here" tie to the famous playwright. Supposedly, the designs derived from "original furniture, which is said to be either in the possession of Shakespeare's family at the present, or known to have belonged to him."[119]

By 1884, the year after the *Arrangement in White and Yellow* exhibition, Whistler had introduced Godwin to Lady Archibald Campbell, an aesthetic socialite with royal connections conducive to professional artistic success in Victorian Britain.[120] Under Lady Archie's aegis and with her starring as Orlando, Godwin designed and produced Shakespeare's *As You Like It*, the first of several open-air performances in the woods near the Campbell family's country retreat at Coombe House, New Malden, Surrey.

At the beginning of the play, Orlando—seemingly at a disadvantage—wrestles with Charles and, to everyone's surprise, wins. Similarly, Godwin and Whistler struggled in what might have seemed to them an uphill battle against establishment notions of what fine art can be. Scholars continue to affirm that for both Whistler and Godwin, the game was worth the candle.

Whistler's *Note in Green and Brown: Orlando at Coombe* (1884) [fig. 4.51] falls under the rubric of the English theatrical portrait, a genre stretching back to William Hogarth, Joshua Reynolds, and Thomas Lawrence. Whistler created examples as resplendent as *Arrangement in Black, No. 3: Sir Henry Irving as Philip II of Spain* [see fig. 2.31], which hung briefly in the drawing room at the "White House" in Tite Street.[121] But the tiny *Orlando* panel, only a fraction of the size of Irving's portrait, has some of the intimacy of a snapshot.

4.51

FIG. 4.51 Whistler, *Note in Green and Brown: Orlando at Coombe*, 1884, oil on wood, 5⅞ x 3 inches, inscribed with butterfly. Hunterian Art Gallery, Glasgow University, Birnie Philip Bequest.

4.52

Taken at about the same time, a photograph of cast members clad in authentic costumes designed by Godwin includes the architect himself, hooded in a monk's robe [fig. 4.52].

If Shakespeare was right to suggest that "all the world's a stage," Whistler and Godwin seem to be yet treading the boards in continuous performance. Long after their deaths, they seem still to touch Whistler's "multitude"—the popular mass they affected to scorn in life. Perhaps for all the wrong reasons, Whistler's *Mother* is one of the most famous pictures in the world, while the artist's endlessly quotable aphorisms can inspire even a latter-day novel that closes with a young footman, about to usher the artist into dinner, whispering of him to the parlor maid, "There's a strange old actor out there in the hall...arrangin' his dyed black curls in front of the mirror, primpin' up proper." Whistler, undaunted, comments, "The younger generation...should not be expected to understand the older's sense of social responsibility. How can they know...what my hostess expects of Jimmy Whistler?" He then confides to the reader the novel's last word: "My dealer told me...that there exists today a widespread and most profitable underground traffic in fake 'Whistlers.' Ha-*ha!*"[122] Godwin might be equally amused to read this on the dust jacket of a recent crime novel: "Tim Simpson never guessed that his wish to buy a Godwin sideboard would lead to murder."[123]

163

FIG. 4.52 Cast members of *As You Like It*, with Godwin (third from the right) dressed as the friar, 1884, photograph on card, 6 x 11⅝ inches. Victoria & Albert Museum, London.

5. Style Wars

> We live, I regret to say, in an age of surfaces.
>
> —Lady Bracknell, in *The Importance of Being Earnest* (1895)

The redoubtable Lady Bracknell's pronouncement in the comedy of manners by Oscar Wilde sets the tone for an assessment of Whistler's synthetic style.[1] In his tireless efforts to avoid being typecast, the artist dissociated himself not only from Realism but also from Aestheticism and Impressionism, yet he synthesized all three in a matrix of subtle references to the arts of the past. Despite Whistler's anguished, often misleading comments about art, his work actually served as a nexus linking movements ordinarily considered distinct.

Looking Backward

Whistler's hawkish rhetoric and his disinterest in acknowledging sources make sense in a post-Goya world where, as Michael Levy has eloquently written, "European affairs are conducted like a symphony of artillery; old ideals, old regimes, old confidence, and old art forms too, disappear in the smoke of battle."[2] Fighting throughout his career to privilege aesthetics over content, Whistler used personal correspondence and well-placed press contacts to fan the flames of controversy. The standard text for his best-known publication, *The Gentle Art of Making Enemies*, begins with "The Exploded Plot," a triumphant—if not completely accurate—account of Whistler's efforts to thwart an unauthorized compilation of his correspondence.[3] Thanks to the power of his pen, Whistler's smoke has never entirely cleared.

Nonetheless, the evolution of his style seems less embattled when evaluated against the emergence of middle-class prosperity, popular entertainment, and a

Opposite: Detail from fig. 5.1

romanticized urban picturesque that mitigated London's haphazard expansion during the second half of the nineteenth century. Whistler witnessed Queen Victoria's capital expand in quite a different manner from that during the rebuilding of Paris under autocratic French rule. Shuttling back and forth over the English Channel, Whistler saw how keenly Britain competed, both economically and artistically, with its French neighbor. The American expatriate was strategically positioned to profit from the practice of aesthetic synthesis.

Graceful, a bit aloof, the *Symphony in Flesh Colour and Pink* (1871–74) [fig. 5.1] eludes precise stylistic definition although it numbers among the memorable works marking Whistler's achievement of artistic maturity during the 1870s and 1880s. Using a light, Impressionist palette, Whistler blended elements of old master portraiture, Japanese pillar prints, Aesthetic movement interior decoration, and Rococo-revival fashion to transform Frances Leyland, the wife of a self-made shipping magnate, into an elegant, ethereal being. The surface of the canvas is charged with shimmering color and pattern— hallmarks of Whistler's emphatic aestheticism. A well-proportioned artist-designed frame amplifies this aesthetic approach. Incised rhythmic lines break the soft gilt surface of the wood, reiterating patterns found on the canvas.

An amalgam of performance, fashion, and display—not a readily defined style— governs this portrait. Numerous pastel sketches chronicle the evolution of Mrs. Leyland's tea gown—the latest in at-home wear, tinged with a whiff of sexual freedom. The gown changed in color and detail on paper even as the artist was scraping down his canvas and repainting it over and over during a four-year period. The finished canvas bears no trace of such intense labor. Yet even with the sketches, it is impossible to tell precisely how the tea gown—or indeed any dress worn by a woman he depicted—was actually constructed.[4] Whistler elides, edits, changes, obscures, seemingly reluctant—unlike the creator of a commercial paper dress pattern—to let us pin down his fashion secrets. Rather, as Baudelaire proposed, he fuses the temporal with the eternal. Through fashion, Whistler invested his portraiture with a timelessness that has long outlived his elegant

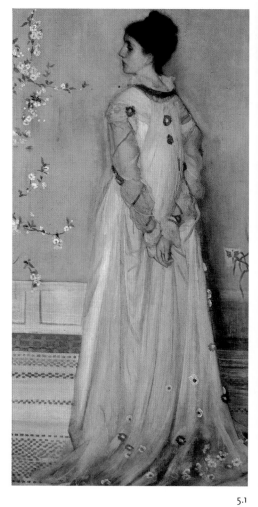

5.1

166

FIG. 5.1 Whistler, *Symphony in Flesh Colour and Pink: Portrait of Mrs. Frances Leyland*, 1871–74, oil on canvas, 77⅛ x 40½ inches, inscribed with butterfly. The Frick Collection, New York.

sitters. Whistler leaves us with susurrations of color and line on canvas or paper, seductive as the rustle of a silken tea gown in a dimly lit drawing room.

"Oh, Atlas," Whistler wrote to one of the London newspapers, "they say I cannot keep a friend. My dear, I cannot afford it."[5] Present-day Whistler scholars continue to use the artist's rancorous falling-out with Frederick Richards Leyland, the husband of the beautifully gowned woman in *Flesh Colour and Pink*, as a watershed when charting his fiercely independent career. But despite Whistler's unassailable position in the pantheon of modernity, Mrs. Leyland's gossamer costume signals the presence of the past. Designed by the artist, the dress is indebted to the eighteenth-century French *sacque* [fig. 5.2]. Such loose flowing gowns foreshadowed the Aesthetic movement's interest in "rational" (i.e., comfortable) dress by 150 years.[6] Pictured constantly in the works of Watteau, the distinctive box-pleated back of the dress eventually acquired a popular name: the "Watteau pleat."

5.2

Long before Whistler crafted his reputation as a leading art guerrilla, Jean-Antoine Watteau was a rebel in the realms of high art. Like his French predecessor, the American expatriate stood out by offering a distinctive alternative to mainstream artistic thinking. Evaluating Watteau's importance as the painter who "created, unwittingly, the concept of the individualistic artist loyal to himself, and alone," Levy writes:

> Almost under cover of [the Rococo] Watteau comes forward,
> first as a decorator, then as a creator of *fêtes galantes*, and finally
> as the topical painter of the enchanted genre scene that is the
> *Ensigne de Gersaint* [fig. 5.3]. Watteau's ideas of nature and reality
> retained until the end their decorative aspect; that aspect, like
> the marvelous glaze over finest porcelain, sometimes makes us
> forget the common materials which are the basic element.[7]

Like Watteau, Whistler masked the common materials on which his work was based, as well as the commercial side of his artistic ambitions, under the cover of aestheticism. Whistler's credo that art "is withal selfishly occupied with her own perfection"[8]

5.3

FIG. 5.2 *Costumes for a lady and her maid* (detail), ca. 1750, wood engraving from *La Couturiere*, by Felix-Auguste Duvert, Paris, 1829. University of Maryland Libraries.

FIG. 5.3 Jean-Antoine Watteau, *L'Enseigne de Gersaint* (detail), 1720, oil on canvas, 64 x 121¼ inches. Louvre, Paris.

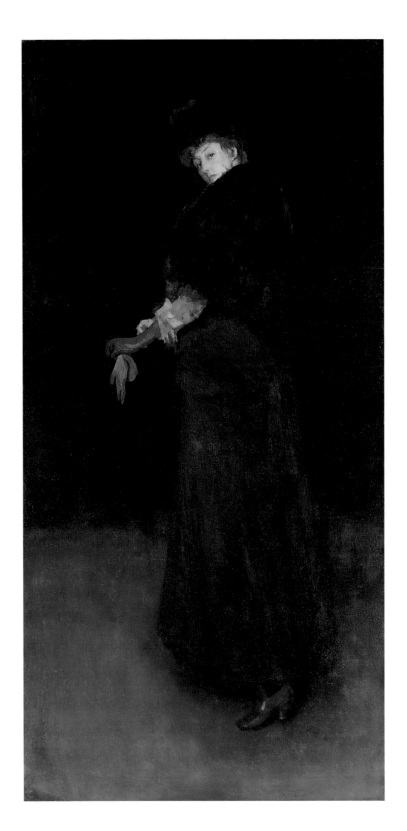

FIG. 5.4 Whistler, *Arrangement in Black: La Dame au brodequin jaune*, portrait of Lady Archibald Campbell, 1882–84, oil on canvas, 86 x 43½ inches.
Philadelphia Museum of Art, purchased with The W. P. Wilstach Fund.

bridges the centuries between Watteau's independence and that of artists who work in today's commercialized culture yet aspire to do as they please.

Before being acquired for Frederick the Great in Berlin in about 1744, Watteau's trompe l'oeil decoration actually served (albeit briefly) as a signboard advertising—even aggrandizing—the merchandise for sale in Edme-François Gersaint's bric-a-brac shop, Au Grand Monarque, on the Pont Notre-Dame.[9] Watteau's masterful illusion transforms what was probably a mundane commercial space into a magical stage set, entered by a fashionable young woman in pink. She takes the hand of an advancing gallant and, unaware, entices us to follow by permitting a glimpse of ankle as she steps up from the pavement. Levy writes that the paint itself "communicates an almost feverish excitement, a hectic vitality, to the society assembled here in autumn colors, chrysanthemum tones of bronze and yellow and pink, set off by black and silver-grey." He adds, "There is nothing so concrete as a story, but all these people, themselves objects of *grande luxe*—seem looking for more than works of art; and the picture becomes concerned with the shop of the human heart."[10]

A century and a half later, in Whistler's *Arrangement in Black: La Dame au brodequin jaune* (1882–84) [fig. 5.4], Lady Archibald Campbell steps away from the viewer, whose glance she acknowledges so boldly that one contemporary critic compared her to a streetwalker. Whistler used a subtitle to draw attention to her well-turned ankle clad in a *brodequin jaune,* or half-boot of yellow leather. Called "buskins" in English, such high-heeled, thick-soled footgear had erotic connotations, intensifying the portrait's rich set of references to past art and contemporary fashion.[11]

Despite the wealth of such verifiable contemporary data embedded in his pictures, Whistler himself generated the notion that he had repudiated French Realism as practiced by Courbet, Bonvin, Ribot, Legros, and others. Writing to Henri Fantin-Latour in 1867, he denied any possible influence on his work on the part of "poor Courbet," going on to curse

that damned Realism which made an *immediate* appeal to my vanity as a painter! And mocking tradition cried out loud, with all the confidence of ignorance, "Long live Nature!!" Nature!…that cry has been a big mistake for me!—Where could you find an apostle more ready to accept so appealing an idea! That panacea for all ills—What? All he had to do was open his eyes and paint what he found in front of him![12]

Eventually, Whistler's correspondence with Fantin-Latour helped to muddy the art-historical waters. Trenchant excerpts were published in the *Gazette des Beaux-Arts* in 1905 at a point when Cubism was radically changing ideas of modern art in France.[13] Meanwhile, frankly partisan biographers had just begun to chronicle the recently deceased Whistler's life, even as American Realist painters jettisoned the bucolic beauties of Impressionism in favor of dark urban scenes indebted to mid-nineteenth-century French Realism and the brooding works of Manet and Degas. However, a variety of American painters admired Whistler. For works as seemingly disparate as Childe Hassam's *The West Wind, Isles of Shoals* and George Bellows's *Pennsylvania Station Excavation*, Whistler's earlier aestheticism provides a common denominator [figs. 5.5, 5.6]. As far as Whistler's oeuvre is concerned, the style wars were in full cry.[14]

The battle was joined in earnest when Whistler marshaled his thoughts for the "Ten o'Clock" lecture in 1885. Delivered by London's ur-Impressionist, the "Ten o'Clock" began with a diatribe:

> Art is upon the Town!—to be chucked under the chin by the passing gallant!—to be enticed within the gates of the householder—to be coaxed into company, as a proof of culture and refinement! If familiarity can breed contempt, certainly Art, or what is currently taken for it, has been brought to its lowest stage of intimacy![15]

Whistler's unabashed denouncement of the Aesthetic movement in the lecture did much to foster a sense of opposition between Aestheticism and Impressionism, but his deft maneuvering hints that we should be reading between the lines.

5.5 5.6

FIG. 5.5 Childe Hassam, *The West Wind, Isles of Shoals*, 1904, oil on canvas, 15 x 22 inches. Yale University Art Gallery, New Haven; Bequest of Sinclair Lewis to the Collection of American Literature, Beinecke Rare Book and Manuscript Library.

FIG. 5.6 George Bellows (1882–1925), *Pennsylvania Station Excavation*, 1909, oil on canvas, 31¼ x 38¼ inches. Brooklyn Museum of Art; A. Augustus Healy Fund, B67.205.1.

5.7 5.8

Dominating the art world of the 1870s and '80s, the Aesthetic movement began
in England, touting art as a matter of uplifting beauty. Simultaneously, Impressionism was
born in France, but it was initially received as harsh and ugly. Aestheticism became a
matter of lifestyle, concerned chiefly with decoration. Impressionists were more interested
in how and what to paint. The charming domesticity of "My Lady's Chamber" [fig. 5.7],
Walter Crane's frontispiece to a popular book on decoration, contrasts sharply with the
chilling realities of Parisian street life in *Absinthe Drinkers* [fig. 5.8] by Edgar Degas. These
contemporaneous images sum up the differences between the two art movements.[16]

Fueled by reformist zeal equivalent to Whistler's own, the Aesthetic movement
was a frankly commercial manifestation of the cult of the beautiful. It flourished during
the period when Whistler established himself as a leading international artist. Gratifying
materialism was rationalized by positing twin goals for the arts—evoking pleasure and
enhancing spirituality, or the "higher education of the soul," as critic Francis Palgrave
put it in his *Handbook to the International Exhibition* of 1862.[17] Fairs and exhibitions brought
the movement's products to wide public attention. Earnestly written books, sometimes
lavishly ornamented, embodied its principles even as they spread them to an international

5.7 Walter Crane (1845–1915), *My Lady's Chamber,* wood engraving, frontispiece from *The House Beautiful,* by Clarence Cook, New York, 1881. VMFA Library.

5.8 Edgar Degas, *The Absinthe Drinkers (Dans un Café–L'absinthe),* ca. 1875–76, oil on canvas, 36¼ x 26¾ inches. Musée d'Orsay, Paris.

audience. The expatriate Whistler's own countrymen would eventually number among the most avid consumers of Aesthetic movement principles and products. By the 1880s, aesthetic taste could be found everywhere from the bourgeois parlors of Back Bay Boston to the stately reception rooms of President Chester Arthur's White House in Washington, D.C.[18]

Aestheticism signaled an awareness of beauty so self-conscious that it was a ready target for ridicule, while Impressionism has come to represent the epitome of spontaneity with a paintbrush—a conventional wisdom modified if not dismantled by scholars demonstrating just how carefully Impressionist artists built up incredibly complex paint surfaces.[19] Eventually the two movements progressed in different directions. Aestheticism devolved into ever more decadent symbolism; Impressionism gradually became an arguably debased mainstream style. But before then, in the quest for wider patronage, artists of both movements shared moments of intersection. These include theoretical sources, similar subject matter, the impact of *japonisme*, and recognition of the need to package the arts and pose the artist. All are exemplified in Whistler's career.

From the mid-1860s onward, in works like *The Balcony* [fig. 5.9], Whistler asserted that the creative act held precedence over the artist's chosen subject matter. This strategy had been taken at face value by the time of Whistler's death, and the beauty of his work, seen as "aesthetic" and "abstract," was completely separated from subject.[20] Whistler boldly stated his position as an apostle of the beautiful at the expense of narrative pictorial content, yet he engaged then-current topics, themes, and issues—including the street, the theater, fashion, and the decorative arts. By focusing his artistic lens on these overlapping and somewhat volatile spheres of urban life and leisure, Whistler practiced what Wilde preached in "The Decay of Lying." When "Art takes life as part of her rough material," Wilde wrote, she must refashion it "in fresh forms." Art "keeps between herself and reality the impenetrable barrier of beautiful style, of decorative or ideal treatment."[21] That such an approach stems from architectural ornamentation, not easel painting, was no more problematic for Whistler than observing another culture, such as Japan, and applying the lessons of its arts to his own.

Divided by a literal barrier between the real and the ideal, *The Balcony* serves as a palimpsest recording Whistler's negotiations with Courbet's Realism. Begun in 1864, the picture underwent numerous changes over the years, changes that mark the artist's growing tendency to distance himself from the subject matter of modern life. As Whistler

IG. 5.9 Whistler, *Variation in Flesh Colour and Green: The Balcony*, 1864–70, oil on wood panel, 24¼ x 19¼ inches, inscribed with butterfly.

Freer Gallery of Art, Smithsonian Institution, Washington, D.C., Gift of Charles Lang Freer, F1892.23.

left it, a thin iron railing bars the bleak riverside factory scene from the picture's visual wealth—the domestic space where kimono-clad women are at leisure. The railing itself bespeaks an industrial age, while the monochrome south bank of the Thames is counterbalanced by a mass of luscious pink, peach, and white flowers. At some point, Whistler eradicated his prominent signature "Whistler 1865" in favor of a new one, self-consciously associating himself with the beautiful. His butterfly in a japanesque signature block is rendered in the same shades as the voluptuous flowers.[22] Separating industry from leisure, *The Balcony* pictures a division between work and play that came to be associated with the artist's very persona.

Here, Whistler makes his strongest positive link to modern life through music. Fenced in yet protected by their iron railing, several indolent figures fill the colorful foreground. The most brightly dressed among them plays a Japanese stringed instrument. The vivid red edging on her robe draws the eye to a red sash worn by the single standing figure. Ignoring us, she leans gracefully on the railing, looking upriver. There, out of sight but not out of earshot, the orchestra at Cremorne Gardens played every afternoon and evening. Whistler's Chelsea lodgings were far enough removed from Victorian London's preeminent outdoor pleasure resort that a popular tune wafting out over the water might sound as otherworldly as the thin sharp notes of a lacquered shamisen.

5.10

FIG. 5.10 Robert Pollard (1755–1838) and Francis Jukes (1747–1812) after Rowlandson, *Vaux-hall*, 1785, hand-colored etching and aquatint on laid paper, 21 x 29¾ inches. Guildhall Library, Corporation of London.

Wilde warned, "When Life gets the upper hand [it] drives Art out into the wilderness."[23] But life had already threatened to overwhelm traditionally exclusive aesthetic echelons during the previous century, as Britain gradually acquired the components of a modern art world. The commercialization of leisure during the eighteenth century depended upon an expanded, materially successful audience of consumers who challenged the rule of taste long sanctioned by an aristocratic elite.[24]

While art was not exactly driven into the wilderness, some of the first works made specifically for the new urban audience were positioned outdoors at Vauxhall Gardens, located across the river to the left of Whistler's bleak Surreyside industrial view. A 1780s balcony scene by Thomas Rowlandson captures part of Vauxhall's structured landscape, carefully contrived to facilitate the public consumption of entertainment [fig. 5.10].[25] The garden's amenities included elaborate structures dedicated to musical performances, a royal pavilion, and numerous smaller supper boxes (booths) decorated with paintings.[26] Among the revelers mingling to take advantage of these offerings, Rowlandson pictured the prince of Wales; his mistress, Mary Robinson [see fig. 2.29]; and her cuckold husband in the foreground. The racy duchess of Devonshire [see fig. 3.8] and her sister, Lady Duncannon, stand at the center of the image.[27] Dr. Johnson and his Boswell, along with Mrs. Thrale and Oliver Goldsmith, occupy the box beneath the musicians, while Mrs. Weichsel sings.[28]

Whistler's Chelsea balcony was actually situated between two gardens, past and present.[29] In 1859, the year the American expatriate moved from Paris to London, Vauxhall closed after more than a century as the British capital's leading semirural resort. Vauxhall had once stood downriver, east of the somber factories and slag heaps painted by Whistler. Upriver, new Victorian pleasure grounds covered part of the Cremorne estate. It lay farther west along the bank where Whistler's women lounged. During the mid-nineteenth century, Cremorne Gardens gradually eclipsed the shabby old Vauxhall grounds, which had "long lost all chance of rivaling the 'Chelsea Elysium.'" Succumbing to the pressures of urban development, Vauxhall's grounds were built over as Whistler worked at his panel painting. Eventually some of the decorations that once embellished eighteenth-century Vauxhall found their way to nineteenth-century Cremorne.[30]

Although Whistler's standing figure looks away from the past toward the present, the artist did not turn his back on the lessons of the old pleasure garden. As urban

FIG. 5.11 Whistler, *Caprice in Purple and Gold: The Golden Screen*, 1864, oil on wood panel, 19¾ x 27 inches, signed and dated l.l.: "Whistler. 1864".

Freer Gallery of Art, Smithsonian Institution, Washington, D.C., Gift of Charles Lang Freer, F1904.75.

London continued to expand all around him, Whistler regularly resorted to artistic admix-
tures first seen at Vauxhall. Like a garden supper box from the previous century, *The
Balcony* is a partially enclosed space with adjustable shades where luxuriating figures in
exotic costumes enjoy tea, music, and flowers. These elements resonate with attractions
regularly offered at London's first public resorts, where fanciful chinoiserie follies
conjured up the far reaches of the British Empire.[31]

 The Balcony remains an awkward image in Whistler's work, incorporating
elements as capricious as an Asian pagoda in an English garden. Eventually Whistler
adapted the spatial configurations and low-toned color harmonies of Japanese art to his
own purposes. However, his first efforts at *japonerie*—the wholesale incorporation of
Japanese trappings in figure paintings such as the aptly titled *Caprice in Purple and Gold:
The Golden Screen* (1864) [fig. 5.11]—have more to do with romanticized escapism. His
work recalls seventeenth- and eighteenth-century portraits that relied upon exotic costum-
ing "à la Turque" in order to allow the sitter to project an alternate persona. The models
in *The Balcony* remain unidentified, although several related paintings, including *The
Golden Screen*, feature Jo Hiffernan, Whistler's fiery-tempered Irish mistress. Here, she
sits before a painted screen illustrated with scenes from *The Tale of Genji*, an ancient
Japanese love story. Captured on canvas, her coppery tresses (beautiful as a Venetian dream
for the artist himself) secure her image in the long literary and artistic procession of
red-haired scarlet women from Mary Magdalene to Celia Madden.[32] The latter seductress,
from Harold Frederic's *Damnation of Theron Ware* (1896), plays passages from Chopin
while informing her hapless suitor that her red hair completed the color scheme of the
room: "We make up what Whistler would call a symphony."[33]

 Long associated with licentious behavior, pleasure gardens took a brief upward
turn when Jonathan Tyers acquired Vauxhall's lease in 1728. Tyers endeavored to make
the grounds a backdrop for more genteel deportment. He would later boast that he had
transformed "a much frequented rural Brothel (as it once was)" into a scene of "the most
rational, elegant and innocent kind."[34] Both music and art were pressed into the service
of refinement, prefiguring a central tenet of the Aesthetic movement: art uplifts. At
Vauxhall, musical performances signaled not only the gradual independence of what is
now called "classical" music from exclusively royal patronage, but also the recognition
that certain types of music—George Frederic Handel's orchestra as opposed to the fiddle
and Jew's harp of the itinerant busker—could help foster gentility. When the Royal

Fireworks Music was rehearsed at Vauxhall in 1749, upwards of twelve thousand visitors paid two shillings and six pence each to hear it.[35]

Whistler, too, realized the refining power of music, exploiting it as a metaphor for nonnarrative painting. In an 1878 interview with *The World*, Whistler referred to "the great musicians" as he attempted to clarify his use of musical titles:

> Beethoven and the rest wrote music—simply music: symphony in this key, concert or sonata in that. On F or G they constructed celestial harmonies—as harmonies—as combinations, evolved from the chords of F or G and their minor correlatives. This is pure music as distinguished from airs—commonplace and vulgar in themselves, but interesting from their associations, as, for instance, "Yankee Doodle," or "Partant pour la Syrie."[36]

5.12

Only a few years earlier, in an essay on Venetian art, Walter Pater had asserted that all art constantly aspires toward the condition of music.[37]

In 1738, Jonathan Tyers embellished the gardens with a white marble statue of Handel carved by a French sculptor working in London [fig. 5.12].[38] Like Whistler's balcony picture, the first work of art encountered by Vauxhall visitors offered a juxtaposition of both real and fantasy elements. Created for an outdoor public space, the figure represents a private moment *en dishabille*, unusual at a time when portrait statuary was traditionally carved in neoclassical dress.[39] Casually seated, Handel wears a flowing banyan and floppy turban appropriate only at home. The banyan, or morning gown, was a popular article of men's domestic clothing based on an Indian garment regularly imported from Asia by the East India Company.[40] While the musi-

FIG. 5.12 Louis-François Roubiliac (1705–1762), *George Frederick Handel*, 1738, marble, height 53¼ inches. Victoria & Albert Museum, London.

cian's hose are wrinkled, and one slipper
dangles precariously from his toes, an other-
worldly putto sits at his feet, toying with
various musical instruments. Tyers thought it
appropriate that the beguilingly offhand statue
should "preside [where Handel's] Harmony
has so often charmed even the greatest Crouds
into the profoundest Calm and most decent
Behaviour." Presaging Whistler's reliance on
the press, the garden manager employed a
publicist to broadcast his purpose in commissioning this piece.[41]

Eventually, "Harmony" appeared in Whistler's lexicon of musical titles, but
"profoundest Calm" was hardly the result of his manipulative musical analogies. Like
the banyan-wearing, harp-strumming composer immortalized in stone for Vauxhall
Gardens, the anonymous kimono-clad musician on Whistler's balcony plucks her
Japanese shamisen. Lyrics to Handel's *Sampson* associate the harp with celestial
spheres.[42] For a combative secular artist like Whistler, caught in and part of the
inescapable posturing of the Victorian art scene, far-off Japan must have seemed as
otherworldly as heaven.

In 1878, the year Whistler's interview about musical nomenclature appeared,
the balcony picture was featured in the aesthetic hothouse atmosphere of the recently
opened Grosvenor Gallery as *Variations in Flesh Colour and Green: The Balcony.* As in the
case of the retroactively titled *White Girls*, an extended musical association is consider-
ably more evocative than Whistler's earlier matter-of-fact designation. By reminding
viewers that the panel is one of several related works that play with exquisite color, he
reinforced the abstract, interdependent conceits of his work.[43]

The strategic placement of Handel's statue at the entrance to Vauxhall Gardens
as part of Tyers's entrepreneurial regime for refinement marks a shift in the balance
of commercialized attractions, from music toward the visual arts. During the 1740s,
apparently at Hogarth's suggestion, paintings such as *The Milkmaid's Garland* [fig. 5.13]
were added to the garden's amenities, providing an early venue for the public display of
then-contemporary British art. Commissioned to decorate the supper boxes at Vauxhall,

FIG. 5.13 Francis Hayman (1708–1776), *The Milkmaid's Garland, or Humours of Mayday*, ca. 1741–42, oil on canvas, 54½ x 94½ inches.
Victoria & Albert Museum, London.

Francis Hayman appropriated coarse, awkward, sometimes bawdy subjects and then refined them—a testament to spreading interest in the French Rococo style in England. However, the art displayed on the grounds worked with other forms of sensual bombardment derived from carnival culture and promoted by the garden's proprietors, including excessive eating, drinking, noise, and bright lights.

Both familiar and distanced, popular themes including not only "The Milkmaid's Garland," but also "Country Dances Round the Maypole" and "The Play of Skittles" were lifted from a low-life context and symbolically recast into high art. Once installed, the supper-box paintings—for the most part sentimentalized images of children's games or scenes where bumpkins behaved in a childish manner—allowed Vauxhall's well-heeled clients to identify themselves as refined seekers of elevated pleasures in contrast to the noisome characters present only on canvas.

The style of the pictures helped to separate Hayman's subjects from their humble origins.[44] David Solkin writes:

> From the small amount of contemporary commentary that survives, it seems clear that no one regarded the *paintings* as offensive to refined tastes, and indeed there is no reason why they should have caused any affront. These were, after all, only symbols of repudiated social rituals, cleaned up and re-presented as refined aesthetic objects; a glance at the crude caricature prints of which the period was so fond underlines just how polished the Haymans must have looked.[45]

However sharp, the aesthetic sword was double-edged: the process of refinement worked because the upwardly mobile visitors assembling at Vauxhall could not escape their vulgar heritage. Solkin concludes that when wealthy bon vivants tried to "draw the boundaries between their own sites of assembly and the debased haunts of the poor, this attempt at purification gave rise to fantasies focused on an intermingling of the two."[46] We have seen this already in the co-option of workers' garments into high fashion, exemplified by Whistler's frock coat. We will see it again in Whistler's use of a full-scale, high-style portrait format to depict a street urchin [see fig. 7.27]. These are all instances of the tension between accommodation and resistance that characterizes social change.

The heady contrast between vulgar pastimes and refined pleasures offered at Vauxhall survived into the nineteenth century. Victorians took delight in vicarious visits to the lowest parts of London via picturesque descriptive literature or sentimentalized

imagery. Works that bracket Whistler's transitional balcony scene—from his early Thames etchings to the later series of shop-front paintings, drawings, and prints—demonstrate how thoroughly he understood the benefits of slumming.

Freshly arrived from Paris in 1859, Whistler continued his bohemian habits of visiting squalid haunts—as his well-received Thames etchings attest.[47] But such topics were not suitable for realistic treatment in oil, at least not in Victorian London. Nonetheless Whistler soon was laboring over a complex canvas begun the following year. *Wapping* [fig. 5.14] is a determinedly realist composition, yet it reveals an artist already employing conscious artifice to distance his subject matter from his audience.[48]

The Wapping environs Whistler knew in the 1860s were just as noxious as those captured by Francis Hayman in a 1740s Vauxhall supper-box scene crowded with hoi polloi.[49] Amorous intrigue and strong drink—among the chief entertainments of the pleasure grounds—were relocated on canvas as Hayman transported viewers to an

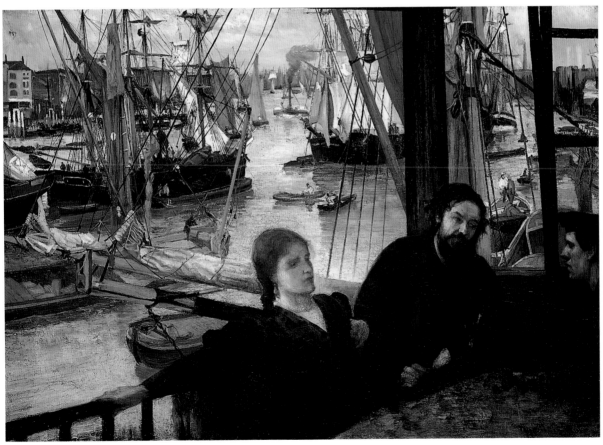

5.14

FIG. 5.14 Whistler, *Wapping*, 1860–64, oil on canvas, 28⅜ x 40 1/16 inches. John Hay Whitney Collection, National Gallery of Art, Washington, D.C.

alehouse in one of the most disreputable parts of London. *The Wapping Landlady, and the Tars Who Are Just Come Ashore* survives as a fragment (in the Victoria and Albert Museum, London) and is also known in an engraving [fig. 5.15], accompanied by a poem:

> From Ship dismissed, their Pockets full of Pay
>
> Thus the Tars squander Years of toil away
>
> And with the frantick Mirth her Chalks advance
>
> Joyous to tread their native Land again
>
> On past and present Ills they think no more
>
> Nor heed the greater Dangers of the Shore[50]

Whistler wasted little time in discovering this louche maritime neighborhood to explore "the greater Dangers of the shore." His *Wapping* depicts a view of the Thames seen from a first-floor balcony at the still-extant Angel Inn, near Cherry Gardens in Rotherhithe. The inn is situated on the south bank at the bottom of a wide curve in the river, which turns northwest toward the Tower of London and northeast toward a deep part of the river, the Pool of London, where heavy shipping traffic was frequent.

FIG. 5.15 Louis Truchy, *The Wapping Landlady*, 1743, engraving after Francis Hayman, 9 x 12½ inches. The New York Public Library for the Performing Arts.

In Whistler's ambitious canvas, the narrative details of Hayman's eighteenth-century tavern scene are absent, but the import of this unsavory riverside gathering is much the same. Anticipating the divided composition of *The Balcony*, Whistler here created a space that separates its occupants from the view beyond. Again, the space works like a garden supper box, providing the seclusion that enabled occupants to conduct their assignations. Whistler himself referred to the painting's "jolly gal," actually his mistress Jo, as having a superlatively whorish air. The bearded man with her is the artist Alphonse Legros, his portrait overlayed on a no-longer-visible "old man in a white shirt." They confront an unidentified "sailor in a cap and blue shirt," who is possibly a customer for the woman's favors.[51]

In favor of issues explored by much earlier artists, Whistler—the son of an accomplished engineer—sidestepped picturing certain large-scale feats of modern development near this site. Wapping lay across the river from Rotherhithe. By 1843 the two were connected via the first underwater tunnel in the world, dug under the Pool of London, just to the east of the Angel Inn.[52] Whistler was not attracted to the distinctive circular redbrick and white stone buildings erected to shelter and announce the entrances to one of the great engineering accomplishments of Victorian Britain.[53] Moreover, in Whistler's painting, a visual tangle—rigging, masts, and sails—conveniently obscures any glimpse of the large commercial docks that stretched east for ten miles on the bank opposite the inn, from the Tower of London to Gallion's Creek. Left of Whistler's view, near the Tower of London, St. Katherine's Dock had been finished in 1828. To the right was the Royal Victoria Dock, completed only five years before Whistler started to paint *Wapping*. The Victoria was the first in a group of three colossal "Royal Docks" built on the eastern reaches of the Thames to accommodate the empire's constant stream of lucrative shipping traffic.[54]

Whistler was excited when he tackled this topic, but criticism from his friends induced the increasingly discouraged artist to make changes. By the time he exhibited the overworked canvas at the Royal Academy in 1864, Jo's buttoned-up figure, awkwardly pinned against the wooden railing, had lost any jollity that it might once have possessed.[55] There is no vestige of "frantik Mirth" here. Even so, Whistler was taken to task in the *Times* for his "defiance of taste and propriety."[56] Whistler's defiance quickly receded further behind the mask of style as he continued to draw upon artistic tradition to create pictures that expressed the times in which he lived.

Walter Benjamin's discourses on Second Empire Paris established the French capital as the locus for modernism for many twentieth-century scholars. Recently, however, Lynda Nead has shown that modernity is really a tale of *two* cities:

> London's engagement with the new was equivocal and piecemeal. Confronted with the apparent spectacle of the total transformation of central Paris in this period, London offered a different model of urban planning; one that its supporters argued reflected principles of democratic government rather than the autocratic rule that governed Paris. The conventions of the picturesque were reinvented to represent the contingencies of the modern metropolis, and through these cultural forms London produced a pictorial lexicon of modernity based on the conjunction of the old and the new; destruction and construction; antiquarianism and technology.[57]

It is easy to find such dichotomies, such piecemeal engagement, in many of Whistler's paintings, drawings, and prints. Although he self-consciously distanced himself from Impressionism, Whistler's nonnarrative urban subjects from modern life are essentially those of his French contemporaries. However, Whistler's brand of modernism, with its constant echoes of the past, is also an artistic response to the rapid, haphazard urbanization of London during the Victorian era. His images—for which Whistler always claimed unique status—are in truth a judicious visual mix of the old and the new.

Among the most modern works of its time, *Nocturne in Black and Gold: The Falling Rocket* (1875) [fig. 5.16] was more than a pot of paint flung in the face of an unreceptive public. It was an incendiary cocktail tossed by an aesthetic terrorist. The appropriate musical reference might have been not a "harmony" but a *battaglia*. This baroque form of programmatic music, popular during the sixteenth and seventeenth centuries, was intended to conjure up the turmoil of the battlefield, with sounds imitating cannon shots and clashing swords, braying trumpets and beating drums.[58] Whistler's picture is tempered by layered references to public gardens of the past, as well as with the traditional meanings behind displays of fireworks, which had for centuries been connected to battle.[59] Behind brilliant passages of orange and yellow, bracketed by dark trees and myriad individual colored sparks, we see the dim turrets of the "firework temple"—a cast-iron Victorian version of a picturesque Gothic garden folly [fig. 5.17]. In *Nocturne in Black and Gold* the tawdry fixture is made beautiful

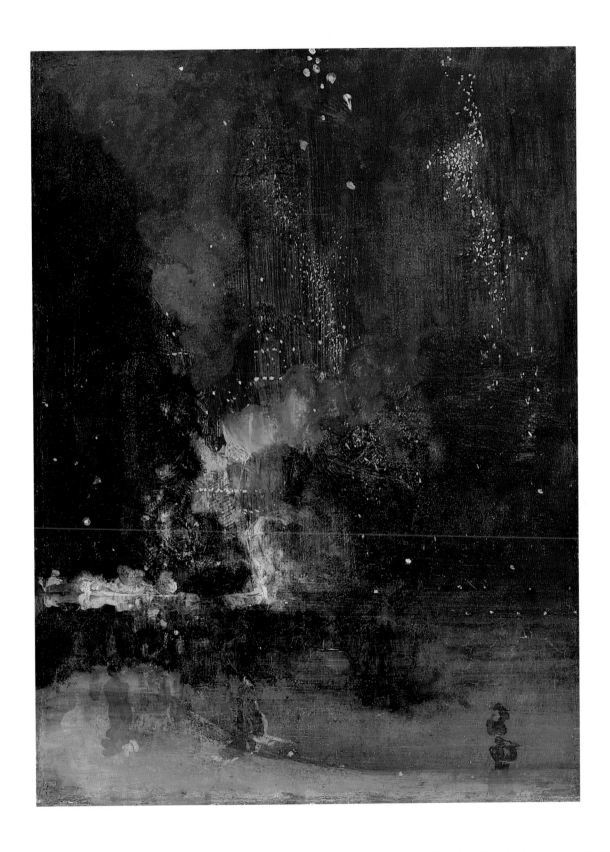

IG. 5.16 Whistler, *Nocturne in Black and Gold: The Falling Rocket*, 1875, oil on wood panel, 23¾ x 18⅜ inches. The Detroit Institute of Arts, Gift of Dexter Ferry Jr.

5.17

through an exquisite shower of fireworks, which derive, ultimately, from Asia. Like fog and rain in Whistler's Thames *Nocturnes*, smoke and fire here obscure mundane reality.

The Falling Rocket and related Cremorne Garden pictures offer evidence that the libidinous and dramatic nocturnal atmosphere associated with the public pleasure garden made it an appropriate trysting place for Whistler and his muse. The entire series is governed by the contemporary meaning of the actual site, noted for its nightly pyrotechnic programs, raucous music, theatrical performances, and habitués from the demimonde—all of them entertainment holdovers from earlier resorts.

Near the fireworks pavilion at Cremorne stood another structure whose nocturnal allure for Whistler depended on darkness punctuated by brilliant—in this case, modern gas—light.[60] The dancing platform is nothing but a couple of graceful arcs of light illuminating white dresses of whirling dancers who stand out from the stygian depths of *Nocturne in Black and Gold: The Gardens* (1876) [Metropolitan Museum of Art, New York]. However, Phoebus Levin's 1864 *Dancing Platform at Cremorne Gardens* [fig. 5.18] reveals that in broad daylight the structure is yet another iron-and-glass Victorian reprise of picturesque structures that had ornamented eighteenth-century gardens, as we see on the Vauxhall fan [fig. 5.19].[61]

Levin shows clearly what Whistler only hints at: the province of the demimonde. In Levin's picture, a sturdy Scot, clad in traditional garb and probably fresh from the country, looks on while a young woman of impeccable dress but questionable morals accosts a dandified potential escort. The dancing platform glitters in the mid-ground while supper boxes, promising seclusion, can be seen in the distance. Lest the viewer miss the message, Levin includes a number of dogs and monkeys—long-established sexual symbols in the history of art.

Following his visit to Cremorne, the French philosopher and art historian Hippolyte Taine asserted that the women he saw were prostitutes, albeit of a higher

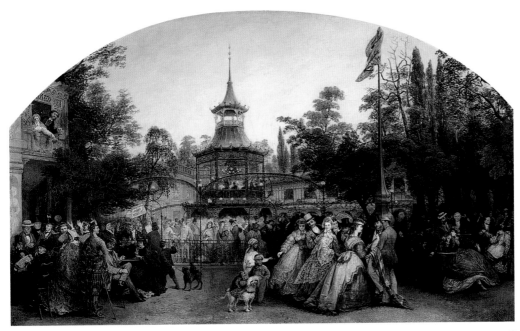

5.18

rank than those to be found in the Strand, one of London's major thoroughfares. Taine
went on to describe their clothing with a Frenchman's eye for fashion, cataloguing
"light coloured shawls over white gauze, or tulle dresses, red *mantelets*, new hats. Some
of their dresses may have cost as much as £12." He concluded, however, that "the faces
are rather faded and sometimes, in the crowd, they utter shocking screams, shrill as
a screech-owl."[62]

Similar confrontations with impropriety had been retailed in British literature
since the time of Samuel Pepys. In 1712 Joseph Addison wrote of Mr. Spectator
strolling by moonlight at Vauxhall while discussing nightingales with Sir Roger de
Coverly. Sir Roger's musings are suddenly interrupted by
a woman wearing a mask:

> [She] came behind him, gave him a gentle tap
> on the shoulder, and asked him if he
> would drink a bottle of mead with her?
> But the knight being startled at so
> unexpected a familiarity, and displeased to be
> interrupted…told her "she was a wanton baggage"
> and bid her go about her business.

5.19

IG. 5.18 Phoebus Levin (fl. 1855–1878), *The Dancing Platform at Cremorne Gardens*, 1864, oil on canvas, 26 x 42 ⅜ inches. Museum of London.

IG. 5.19 M. Harris, *The Vauxhall Fan*, showing the Grove at Vauxhall Gardens, 1736, etching printed in blue. The Royal Collection, London.

As they depart, Sir Roger tells the management "that he should be a better customer to [the] garden if there were more nightingales, and fewer strumpets."[63]

Against such blatant anecdote, Whistler used an abstract language of form and color to whisk us incognito into the gardens. The artist maintained an almost voyeuristic distance from the enticements on offer, inscribing nothing directly judgmental onto his canvas. Through his dense, veiled atmosphere the viewer absorbs the mood of the place. Degas and Manet painted pictures of Parisian nightlife that focus upon implied relationships glimpsed at close hand, as individuals arrange their assignations. But Whistler expressed the darker side of the pleasure garden with palpable, painted darkness itself. He used a sinister palette of bituminous blacks, browns, and yellow-whites, occasionally relieved by harsh spots of color. Enough detail is provided to inform the viewer of his location, but that is all.

Shortly after Whistler painted nocturnes at Cremorne, a moral intolerance for racy nightlife that echoed censures leveled against earlier Georgian pleasure grounds contributed to the disappearance of the Victorian resort. But in her perceptive study of Cremorne, Nead reminds us that the garden "was a mutable social space. To an extent, it gave people what they wanted to find." She notes that William Acton, whose medical career was devoted to understanding and regulating prostitution in Victorian England, left an inconclusive account of this place where, as he put it, "calico and merry respectability tailed off eastward by penny steamers [as] the setting sun brought westward Hansoms freighted with demure immorality in silk and fine linen."[64] Whistler distilled art from ambiguity.

On the Cremorne platform, brief street encounters between strangers were replicated during set dances such as the quadrille, when the men moved round the floor, from one female partner to the next.[65] Alfred Concanen's lithographed sheet music for *Marriott's Cremorne Quadrilles* captures such a moment [fig. 5.20]. Analyzing the image, Nead describes "The Flirtation," one of the most popular finales to these set dances.

> At the centre, a man and a woman are stopped dead during the moment in which
> they pass each other and look over their shoulders to exchange a glance. The quadrille
> encodes the fleeting moment of the street encounter, the flirtatious exchange of looks
> with a stranger, into the moves of a fashionable dance; the music cover then completes the
> process and fixes this ephemeral experience into the permanent form of the printed

illustration. Dancing at Cremorne choreographed a performance of modern street behaviour; sheet music turned this play-acting into an icon of contemporary gender relations.[66]

Just as the lithographed sheet music with its encoded image of "fast" London might be destined to sit on a new upright piano in a perfectly respectable middle-class parlor,[67] ambiguity sets the tone for Whistler's Cremorne series, which provides no clear narrative.

A number of the canvases feature unaccompanied women. One, as elegantly clad as the ladies of the evening described by Taine, stands isolated at the edge of the path in *The Falling Rocket*. The light-colored trim on the train of her dark red gown trails behind her in a sensuous curve that echoes the pattern made by showers of sparkling light falling from above. In *Cremorne Gardens, No. 2* (1872–77) [fig. 5.21], several well-dressed women encircle the central male figure, who tips his hat but stands with legs apart. Arbiters of social propriety considered such a stance to be inappropriate for introductions made in polite society. This confrontational pose—pulled by the painter from an old master, Velázquez, and clad in modern dress—appears over and over in Whistler's work, irrespective of medium, subject, or scale.

The Pennells conjectured that the elegant figure seated on a bench at the right in this picture was the artist himself. Whether or not this is the case, Whistler fits the Baudelairean paradigm of the sophisticated *flâneur*—detached, alienated, keenly observing the interchanges of the urban crowd. In that essentially Second Empire French paradigm, the prostitute is the *flâneur's* transgressive female counterpart.[68]

Whistler implies that an assignation is in progress in *Nocturne: Cremorne Gardens, No. 3* (1872–77) [fig. 5.22]. We glimpse a couple swiftly departing one of the theaters or restaurants. A man in his top hat and domino, or evening cape, escorts a woman in her fashionable white evening dress, a mark of affluence in soot-ridden London. The darkness is about to swallow them, but like Poe's "man of the crowd," Whistler figuratively follows "in pursuit of an unknown, half-glimpsed countenance that has, on an instant, bewitched him."[69] These tantalizing impressions are understated, anonymous, as clandestine as the types of relationships initiated at Cremorne Gardens.[70]

5.20 Alfred Concanen (1835–1886), *sheet music cover for Marriott's Cremorne Quadrilles*, ca. 1865, chromolithograph, 13½ x 10 inches. Spellman Collection, University of Reading.

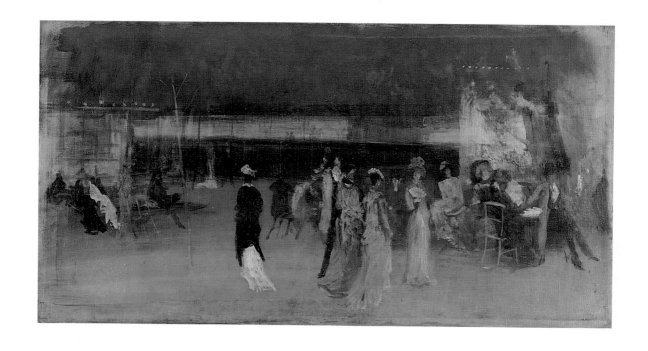

FIG. 5.21 Whistler, *Cremorne Gardens, No. 2*, 1872–77, oil on canvas, 27 x 53⅛ inches. The Metropolitan Museum of Art, John Stewart Kennedy Fund, 1912, 12.32.

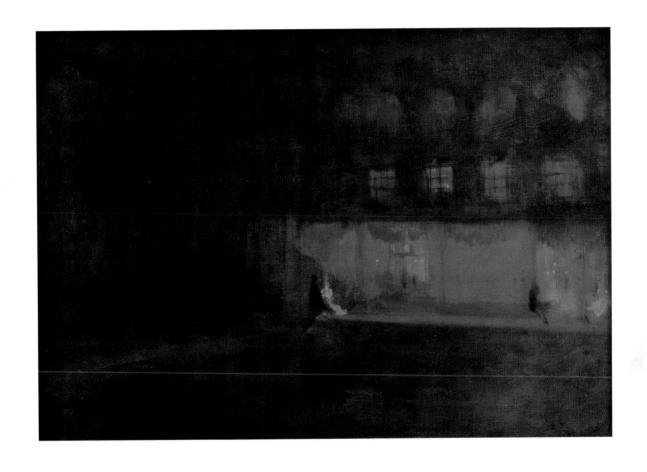

FIG. 5.22 Whistler, *Nocturne: Cremorne Gardens, No. 3*, 1872–77, oil on canvas, 17⅝ x 24⅞ inches. Freer Gallery of Art, Smithsonian Institution, Washington, D.C.,
Gift of Charles Lang Freer, F1919.12.

Whistler's veiled treatment of the topic, just as the gardens were about to close, contrasts sharply with the host of surviving anecdotal graphics depicting rowdy aspects of Cremorne [fig. 5.23].[71] The garden's eventual demise under the twin pressures of Victorian morality and urban development was well documented in the contemporary press. Yet just as the physical layout of the grounds, the entertainment on offer, and the questionable behavior of certain guests hark back to the eighteenth century, Whistler tempered his firsthand observation of an actual site with art from the past.

Gainsborough's painting *The Mall in St. James's Park* [fig. 5.24] has been proposed as a possible stylistic precursor of Whistler's suggestive *Cremorne Gardens, No. 2*.[72] In each painting, flirtation is elegant, refined, subdued. Yet the parallel is more than stylistic. The Mall, London's oldest royal park, was the setting for the kind of untoward associations we have found as well at Vauxhall and Cremorne. Once part of a chase where Henry VIII and Queen Elizabeth I hunted deer, St. James's Park was the site for a different kind of game by the time of Queen Anne's reign, when the grounds became notorious for prostitution. Despite its locked gates, the park remained "a recognized haunt of whores" throughout the eighteenth century.[73] Like the spirit of the Wapping landlady in Whistler's unexplained gathering at the Angel Inn, the artist's hint of dubious pleasures conveyed in the Cremorne series is a response to earlier history and art as well as to modern manners and circumstances.

Looking Forward

By the time Whistler took up etching needle and paintbrush, cultural dilemmas reminiscent of eighteenth-century problems haunted Victorian London.[74] In Britain, entrepreneurial efforts to blend amelioration of modern life with profitable returns on carefully designed merchandise led to the Aesthetic movement, a prime middle-class anodyne to the disturbing social and economic developments of the previous decades.[75]

Architects as well as designers of the 1860s fostered the movement in Britain, a fact germane to its eventual link

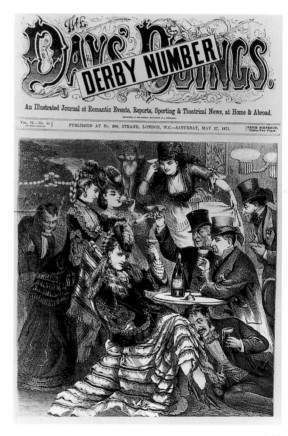

5.23

FIG. 5.23 *"The Derby Night at Cremorne—Keeping It Up,"* in *Days' Doings*, 27 May 1871, London. Chelsea Public Library.

5.24

with Impressionism. As the Aesthetic movement gathered force, by the 1880s

it embraced every art form from the greetings card to domestic architecture. It introduced Japanese art to children's story books and red brick Queen Anne architecture to the streets of London; it led to changes in fashionable dress, to the first garden suburb and to the vogue for painted dark green or Venetian red front doors and railings which lasted for half a century in England. People described themselves as "going in" for "High Art," for Art Decoration, Art Embroidery or Art Furniture, this last expression becoming so general that by the mid 'seventies the *London Trades Directory* lists "Art Furniture Manufacturers" quite separately from ordinary cabinet-makers and furnishers.[76]

Populist commercialism, scorned in Whistler's "Ten o'Clock" lecture, resounds in Elizabeth Aslin's summary above. She notes that insofar as architecture and the applied arts were concerned, the movement was confined to Britain and the United States,

FIG. 5.24 Thomas Gainsborough, *The Mall in St. James's Park*, ca. 1783, oil on canvas, 47½ x 57⅛ inches. The Frick Collection, New York.

although aesthetic clothing enjoyed a brief vogue in France during the early 1880s. She concludes that by then, the term "aesthetic" had risen from obscurity to become an overworked adjective applied indiscriminately to anything fashionable.[77] The Philadelphia Centennial Exposition of 1876 is credited with popularizing the Aesthetic movement in the United States.[78] In America, studies of the movement focus almost entirely on interior decoration, emphasizing the application of art principles to the production of furniture, metalwork, ceramics, stained glass, textiles, wallpaper, and books.

Painting does not play much of a role in these boilerplate definitions, but painters — Whistler key among them — furthered the aims of the Aesthetic movement by creating pictures reliant on formal pattern, texture, and color.[79] Moreover, portraits, figure paintings, interiors, and still lifes were filled with images of delicate decorative arts, often Asian or in the Asian taste. In *Roses on a Tray*, an early and extreme example, John La Farge painted a Japanese tray literally as well as figuratively, using a piece of lacquer as a support [fig. 5.25]. He placed his flowers before a curtain. Its white-on-white passages remind us that La Farge's picture is coeval with Whistler's "White Girls".[80]

In the work of many painters — not only Whistler and La Farge, but also the French Impressionists and international expatriates such as John Singer Sargent — nonnarrative images reached the public with increasing frequency during the years that the commercial Aesthetic movement held sway, amplifying the aesthetic message of "art for art's sake." A paper Japanese export fan, a carved red lacquer box, and a slender blue-and-white vase embellish Whistler's *Symphony in White, No. 2: The Little White Girl* [fig. 5.26; see fig. 7.41]. William Michael Rossetti, the chronicler of the Pre-Raphaelites, perceptively assessed the picture's "delicious harmony" of whites, flame-yellow, black, and crimson-pink. While recognizing Whistler's sketchy style as "exceptionally gifted," he nonetheless warned that such "peculiarities of slight execution" should not become "a model for general adoption."[81] Alarmed by publicity surrounding the Whistler-Ruskin trial, James Jackson Jarves, author of *The Art-Idea* (1864), issued a similar warning against "art of the Whistler sort" to American painters in 1879.[82] However, by the time of the Exposition Universelle in Paris in 1900, Whistler's once "dangerous" canvas had been co-opted as a prime example of "American" art for the United States pavilion.

If *The Little White Girl* creates any sensation, it is that of distilled beauty. Subjects lacking clear story lines permitted viewers to project any number of inter-

FIG. 5.25 John La Farge (1835–1910), *Roses on a Tray*, 1861, oil on Japanese lacquer panel, 20 x 11 ¹⁵⁄₁₆ inches. Carnegie Museum of Art, Pittsburgh, Katherine M. McKenna Fund.

pretations upon the image. While intending that this picture be seen as a wistful reverie, Whistler sensed the potential interpretive challenge facing his 1865 audience, corroborated by his decision to affix an equally wistful poem to the frame of the painting for its exhibition at the Royal Academy that year.[83] A more specific reading requires access to information neither on the canvas nor in the poem. The model before the mirror had a good reason for looking forlorn. Although Whistler furnished Joanna Hiffernan with a wedding band in the painting, she was only his mistress. Their stormy relationship ended in 1867, not long after the picture was completed.

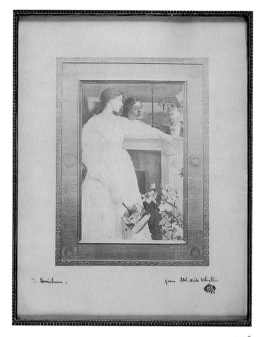

5.26

As we have seen, after Jo had posed in front of a white curtain for *Symphony in White, No. 1* [see fig. 3.11] and the resulting canvas was exhibited at the Salon des Refusés in 1863, some inventive journalists tried to read a story into Whistler's image—the morning after the wedding night, to be precise. Such projections by viewers forced to navigate without many signals would become regular fodder for the art press as the century progressed. Given that few of these painted ladies were considered quite proper, it should be noted that adverse reaction to such images, and also to the posturing of the Aesthetic movement, had to do not only with fine arts issues but also with the expansion of scientific theory and with changing class and gender roles in society. These concerns are clearly revealed in many period cartoons, as well as in James Hadley's androgynous teapot [see fig. 6.26], with its facetious warning of the dreadful impact of "the laws of Natural Selection and Evolution" awaiting aesthetes who indulged in affected behavior. At the turn of the century, continuing cultural discomfort would fuel the shift from the beauties of Impressionism toward the harsher viewpoint of American Realist painters, giving further evidence as to how the stylistic comedy of aesthetic manners and mannerisms was indiscriminately lumped together with more dangerous issues.

In his sumptuous *Portrait of Miss Dora Wheeler* [fig. 5.27] William Merritt Chase presents a single figure, clad in a resplendent fur-trimmed sapphirine-blue gown, isolated against a deep yellow background. Although she lounges in a turned Elizabethan revival armchair, her pot of daffodils sits on a Chinese drum table, while the silk hanging is embroidered with butterflies in the Asian taste. Again, information

196

FIG. 5.26 *Whistler's Symphony in White, No. 2: The Little White Girl*, 1864, photograph in original frame. Courtesy of Mark Samuels Lasner.

not available to the casual viewer is necessary for a full reading. The sitter was an aspiring painter, the pupil of the artist. The magnificent hanging behind her was probably produced by Associated Artists, in which her mother, Candace Wheeler, was a partner. A prominent circular element embroidered into the material depicts a kitten chasing its reflection in a pool, perhaps a pun on the artist's name. But the endless pursuit sustains more poignant interpretation. Like her mother, Dora Wheeler wound up with a career in the decorative arts, for it was more difficult then for a woman than for a man to achieve success as an easel painter.

Equally as disturbing as the plight of educated women with artistic talents and aspirations is this paradox: the popularity of the Aesthetic movement, with its Asian trappings, coincided with anti-Chinese sentiment in America. Particularly after the Panic of 1873, economically driven fears of cheap labor—a perceived "yellow peril"—led to the passage of the Chinese Exclusion Act, closing the doors to the "land of opportunity" for the first time in its history. The United States Congress, bowing to political pressure in California, New England, and elsewhere, passed this shameful piece of legislation in 1882, the year before Chase painted Miss Wheeler.[84] That same year, Whistler's *Arrangement in White and Yellow* was staged in London before traveling to cities in the artist's homeland. By the end of the century, the color yellow in the arts would be associated with decadence, and in 1902 Congress enacted a permanent ban against Chinese immigration.

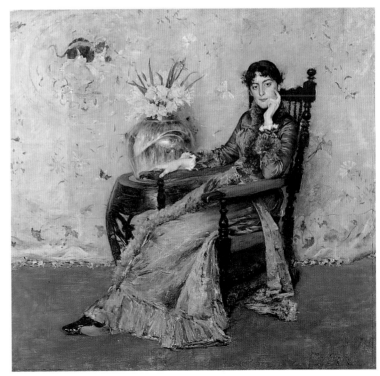

5.27

The props surrounding Dora Wheeler would have been at home in any Aesthetic movement drawing room, but Chase's handling of the paint parallels the vigorous brushwork Impressionists used to combine optical observation with personal sensation. Despite their readily distinguishable stylistic differences, the many artists associated with Impressionism were searching for a technical means to express individual feelings—not to record the thing

FIG. 5.27 William Merritt Chase, *Portrait of Miss Dora Wheeler*, 1883, oil on canvas, 62½ x 65¼ inches. The Cleveland Museum of Art, Gift of Mrs. Boudinot Keith, in memory of Mr. and Mrs. J. H. Wade, 1921.1239.

5.29

5.30

5.28 Whistler, *Variations in Pink and Grey: Chelsea*, 1871–72, oil on canvas, 24 ⅝ x 16 inches. Freer Gallery of Art, Smithsonian Institution, Washington, D.C.,
Gift of Charles Lang Freer, F1902.249.

5.29 Claude Monet (1840–1926), *Impression Sunrise*, 1873, oil on canvas, 48 x 63 inches [signed and later dated: "Claude Monet.72" at lower left].
Musée Marmottan—Claude Monet, Paris.

5.30 William Merritt Chase, *At the Seaside*, ca. 1892, oil on canvas, 20 x 34 inches, signed l.l.: "Wm M. Chase". Metropolitan Museum of Art,
Bequest of Miss Adelaide Milton de Groot, 1967, 67.186.123.

they saw but to capture the sensation it produced in them.[85] The bright, patterned surface of an Impressionist painting is evidence of the demands of subjective truth. As Zola put it, art is "a corner of nature seen through a temperament." At the same time that artists were filtering nature through their own sensibilities, denizens of the typical Aesthetic movement parlor were asking one another, "Are you SENsitive?" suggesting a parallel vogue for a heightened personal response to one's surroundings.[86]

However mannered the attitude toward beauty for its own sake was within the Aesthetic movement—and however hard Impressionist painters tried to link their method to then-current scientific theories of vision—these artists were grounded by a much earlier tradition of the romanticized picturesque landscape garden. In that tradition, stock elements such as neoclassical temples, artificial Gothic ruins, or rocky grottoes called forth conventional responses from viewers. What painters and designers of the 1870s and '80s left out was the singular narrative trigger. What they left open was the greatly expanded range of possible response.

Whistler's images of Victorian London from the late 1860s and early 1870s are among the earliest pictures to blur the boundaries between Aestheticism and Impressionism.[87] *Variations in Pink and Grey: Chelsea*, of 1871–72 [fig. 5.28], has much in common with Claude Monet's *Impression, Sunrise* of 1873 [fig. 5.29], the canvas that gave Impressionism its name when it was shown at the first group exhibition in Paris two years later.[88] With a frame decorated by Whistler to harmonize with his picture, *Variations in Pink and Grey* is intended to exist as a fantasy apart from the Chelsea scene on which it was based. Whistler rendered the Thames in a color harmony common to eighteenth-century Japanese prints, although since the days of Henry VIII (r. 1509–47), the crowded waterway had served as one of London's central thoroughfares. Across the English Channel, Monet's work captured a shimmering glimpse of the industrialized harbor at Le Havre. The canvas is far more summary than finished works he was making at the same time. Monet later noted that he called it an "impression" because "it really couldn't pass as a view of Le Havre." Whistler made similar comments about several *Nocturnes* during testimony at the Whistler-Ruskin libel suit in 1878.[89]

Impressionist landscapes and scenes from modern life, particularly urban views and images of bourgeois recreation, continued to appear well after the heyday of Impressionism as a cutting-edge style. We see this in Chase's *At the Seaside* (ca. 1892),

with its horizontal divisions, vigorous brushwork, and light-filled palette [fig. 5.30]. Significantly for the link between Aestheticism and Impressionism, enormous Japanese parasols punctuate the patriotic color scheme of red, white, and blue sparked with yellow.

Until contextual studies gained ground in the late twentieth century, the art of Whistler, whether admired or damned, remained of interest primarily for its refined aesthetic beauty. And the history of Impressionism once revolved almost completely around nontopical issues of light and atmosphere captured on canvas. Originally, however, both movements were profound responses to their own time, as proposed by Charles Baudelaire. The critic's challenge to "distill the eternal from the transitory" in "La Peintre de la vie moderne," a series written in 1863 for the French periodical *Figaro*, offered an agenda for young contemporary artists.[90] As early as 1845 Baudelaire had warned, "No one is cocking his ear to tomorrow's wind; and yet the heroism of *modern life* surrounds and presses upon us." He sought the painter who "can snatch its epic quality from the life of today and can make us see and understand, with brush or with pencil, how great and poetic we are in our cravats and our patent-leather boots."[91] Not content with the transitory, however, Baudelaire believed that art had an eternal element, providing stability in the flux of modern life.

In *Variations in Pink and Grey* and in *Impression, Sunrise,* both Whistler and Monet exercised artistic agency, distancing viewer from subject to provide a measure of reassurance. Technological progress seems always a mixed blessing, accompanied by confidence and doubt, courage and trepidation. For his image of the Thames, Whistler aestheticized extant wooden hoardings, folding them into a gray zigzag like a Japanese screen to hide extensive excavations for the Chelsea Embankment—a construction project as disruptive as large-scale present-day projects from Boston to Beijing. Monet deploys a lively complementary color palette of blue and orange to soften and cheer the smoking towers and angular derricks of the prosaic French port, seen only dimly through the haze.

Masking technology through artistry became a nineteenth-century commonplace. We can peer past the mask of style to detect shared concerns not only in avant-garde easel painting but also in mechanically produced decorative arts. A mid-century parlor chair perched on graceful cabriole legs makes retroactive use of a French Rococo decorative vocabulary to cushion the impact of technological advances [fig. 5.31]. The original

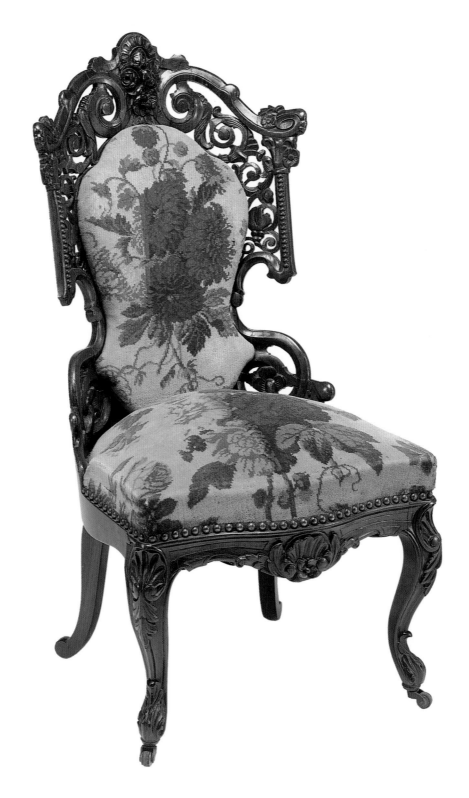

FIG. 5.31 Charles A. Baudouine (1808–1895) for the Baudouine Firm, New York, *side chair*, 1849–54, laminated rosewood, original Brussels carpet upholstery, height 37¼ inches. VMFA, Mary Morton Parsons Fund for American Decorative Arts.

Brussels carpet upholstery, ablaze in oversize roses and chrysanthemums, complements flowers carved into the steam-bent rosewood chair back. While the chair frame is made of an early version of plywood, hand-carving was required to finish the piece, imparting a sense of naturalism to the decoration.

Driven by their avidity for market share, British design reformers discredited such naturalism in the decorative arts—flat patterns were far easier to produce efficiently by machine. Stylistic masking continued with objects dependent on industrial technology, but Aesthetic movement patterning, governed by architecture, became increasingly conventionalized, for a time dominating interior appointments and accessories.

The English design reformer Owen Jones's influential *Grammar of Ornament* (1856) underscores the significance of flat patterning during the years preceding the emergence of both Aestheticism and Impressionism.[92] The majority of the plates compile decorative motifs from various times and cultures, but a final group of ten is particularly instructive in linking the two movements. Christopher Dresser, botanist and industrial design reformer, was responsible for these. One of Dresser's "Leaves and Flowers from Nature" is trenchantly subtitled "Plans and Elevations of Flowers" [fig. 5.32]. Like a Victorian plantsman forcing hothouse bulbs for the holiday market, Dresser did indeed force familiar blossoms into formal architectural planes, reducing nature to architecture. From this mind-set emerged not only the conventionalized flat floral patterns of Aesthetic movement decoration but also Impressionist emphasis on the use of broken brushstrokes to hold the eye to the flat canvas surface.[93]

Examples abound in the decorative arts, from small accessories like a silver gilt vase with rigid daisylike flowers marching relentlessly around its center panel [fig. 5.33] to functional furniture, such as an angular plant stand with a tile top [figs. 5.34, 5.35]. Close in date to Charles Caryl Coleman's aesthetic still life [see fig. 4.7], the stand prac-

5.32

203

5.32 Christopher Dresser (1834–1904), *"Leaves and Flowers from Nature, No. 8,"* color lithograph, from *The Grammar of Ornament* by Owen Jones (1809–1874), London, 1856. VMFA Library, Gift of Sally Todd.

tices a similarly international eclecticism, combining ornament from various countries and periods. The tile used for a top is stamped "Japon," but it was made in Gien, a French ceramic-producing center. The design on the tile quotes a plate from *The Grammar of Chinese Ornament* by Jones.[94] The stand was created to bring nature indoors, and one might draw a parallel between a hothouse plant and a landscape painting—each is an aspect of commodified nature.

5.33

Separating the decorative from the natural in Monet's Rouen Cathedral paintings [fig. 5.36], Robert Herbert detects "an aesthetic concentration on surface effects, such as color and pattern, that seem to attach as much to architectural ornamentation as to traditional concepts of easel painting."[95] Given that Monet's renowned series focuses on a Gothic cathedral, it seems worth pointing out how easily the principle of repeating decorative surface pattern translated from the Gothic revival to the Aesthetic movement. For example, mid-century mass-produced encaustic floor tiles covered with Gothic ornament create a visual impact similar to endless repeated sunflowers on tiles hand-painted by William de Morgan three decades later.[96] The style has changed, but while the Gothic tiles revive ancient ornament using a modern manufacturing process, the de Morgan tiles reverse the equation, carrying on a medieval tradition of handmade tiles but covering them with modern ornamentation.

204

This confusing back-and-forth between present and past also cloaks Whistler's hand-decorated gilt frames in apparent modernity. In competition with Impressionist colleagues just as surely as the British economy in general rivaled that of the French, Whistler claimed more credit than he should have, telling George Lucas, an American dealer in Paris, that he wanted it "clearly stated in Paris that I am the inventor of all this kind of decoration in colour in the frames; that I may not have a lot of clever little Frenchmen trespassing on my ground."[97] Using blue pigment, the artist enriched gilt surfaces with patterns ranging from delicate fallen blossoms to japanesque waves to proto-secessionist

5.34

FIG. 5.33 *Silver gilt vase*, 1877, Gorham Manufacturing Company, Providence, Rhode Island, silver, gold, polychrome enamel, height 5½ inches. The Newark Museum, Sophronia Anderson Bequest Fund (1984).

FIG. 5.34 *Top of plant stand*, cast brass with French painted and glazed earthenware, stamped on underside: "Japonais No 3" and impressed "Gien". VMFA, Museum Purchase with funds provided by anonymous donor.

ɢ. 5.35 *Plant stand*, 1880–85, possibly Meriden, Connecticut, cast brass with French painted and glazed earthenware, height 32½ inches.

VMFA, Museum Purchase with funds provided by anonymous donor.

5.37

5.39

5.38

5.40

FIG. 5.37 Whistler, detail of frame for *Blue and Silver: Screen, with Old Battersea Bridge*, 1872, blue paint over gilded wood. Hunterian Art Gallery, Glasgow Universit

FIG. 5.38 Whistler, detail of frame for *Nocturne*, 1875–77, blue paint over gilded wood. Hunterian Art Gallery, Glasgow University.

FIG. 5.39 Whistler, detail of frame for *Harmony in Blue and Gold: The Little Blue Girl*, 1894–1903, blue paint over gilded wood. Freer Gallery of Art, Smithsonian
Institution, Washington, D.C., Gift of Charles Lang Freer, F1903.89.

FIG. 5.40 Detail, reverse profile cassetta frame, Italian, late 16th– early 17th century, blue paint over gilded wood. Collection of Paul Mitchell Ltd., London.

checked borders [figs. 5.37–5.39]. By using an old-fashioned decorative technique to create fashionable stylized patterns, Whistler masked his unacknowledged debt to the blue and gold frames of Renaissance Italy [fig. 5.40].[98]

During the nineteenth century, responses to modern life varied. If the Impressionists embraced subject matter drawn from modern life, Victorian aesthetes—the Pre-Raphaelite painters, designers such as Morris or Philip Webb, and even unknown artisans working for the popular market—shielded themselves with evocations of Renaissance and medieval times. Venetian Gothic architecture inspired the Connecticut plant stand's overall columnar form, despite the misleading "Japon" stamped on its tile top.[99] Gothic architecture also inspired an imposing architectural case piece designed by Bruce Talbert for the 1867 Exposition Universelle [fig. 5.41]. Named after the Greek statesman, the "Pericles" cabinet garnered a Grand Prix in Paris as "the most distinguished amongst competing Gothic works."[100] There is nothing Greek about this well-orchestrated series of columns, arches, buttresses, pediments, and pinnacles. The cabinet has the air of a mini-cathedral, but when we recall that in ancient Greece Pericles served as a general in the Athenian war against Sparta, the title makes sense. In modern Europe, world's fairs were actually international battlegrounds for market share. Beautifully crafted by Holland and Sons to Talbert's design, the richly inlaid cabinet is not only a work of art but also a commercial victory.

As nature took a backseat to art, independent works simultaneously expressed similar ideas. As we have seen, Whistler's *Nocturne in Black and Gold: The Falling Rocket* translated the realities of a tawdry pleasure ground into a dark, mysterious canvas, its thin layers of pigment sparked by a shower of gold, red, and green. The same year, a dark glass goblet made in Venice imitated aventurine quartz, a natural material, by using flecks of silver foil covered with thin films of yellow, green, and red glass sealed with a final colorless overlay like a varnish on a picture

5.36

5.41

5.36 Claude Monet, *Rouen Cathedral, West Facade, Sunlight*, 1894, oil on canvas, 50¼ x 36 inches, signed and dated: "Claude Monet '94". National Gallery of Art, Washington, D.C., Chester Dale Collection.

5.41 Bruce James Talbert (1838–1881), designer; Holland and Sons, London (1803–1942), manufacturer, *Pericles*, cabinet, ca. 1867, oak and fruitwood with marquetry inlay and brass hinges. Private collection.

[fig. 5.42].[101] In fully assessing *The Falling Rocket*, trivialized by Ruskin as the "pot of paint" that triggered the infamous Whistler-Ruskin libel suit, we might recall that "black and gold" was not only part of a runic title for this highly abstract painting, but also a favored color scheme for ebonized Aesthetic movement furniture enriched with stylized parcel gilt patterns [fig. 5.43]. Moreover, Aesthetic movement commercial decoration illuminates a charge leveled during the trial—that pictures like *Nocturne in Black and Gold* were little more than delicately tinted wallpaper.[102]

5.42

At the market's highest end, in the hands of the Morris firm or the Herter Brothers or Louis Comfort Tiffany, surface is all. Despite their richness, individual objects were subsumed into the overall patterning typical of Aesthetic movement interiors. Describing Stanmore Hall, a Midlands mansion decorated by Morris and Company in the early 1890s, one critic noted, "The large ornament and bold forms Mr. Morris delights in prove their power to blend into a perfect whole, elaborate but in no way overwhelming."[103] We can find a similar balance between patterning and the "perfect whole" in many an Impressionist canvas, not only in ambitious serial cycles such as Monet's intentionally decorative water lilies but also in myriad individual canvases by him, Whistler, and many others.

Painters with differing viewpoints found common ground in the decorative surface, as did various designers whose work is otherwise quite distinctive. While some Aesthetic movement design reformers insisted on costly handmade objects, others like Christopher Dresser chose mass production, accepting technology and executing designs for industrial manufacture. His toast and letter racks [fig. 5.44] look like tiny Japanese bridges. Dresser realized his ideas for these handy home accessories in 1881, shortly after Whistler's *Nocturne: Blue and Gold—Old Battersea Bridge* [fig. 5.45] achieved

5.43

FIG. 5.42 Venezia-Murano Glass Company, Venice (1877–1910), *goblet*, ca. 1875, glass enclosing silver foil flakes with a clear overlay, height 6⅛ inches. The Metropolitan Museum of Art, Gift of James Jackson Jarves, 1881 (81.81.74).

FIG. 5.43 Herter Brothers, New York (1865–1905), detail, *center table for reception room of Mark Hopkins residence*, San Francisco, ca. 1878–80, ebonized maple, marquetry of various woods; brass, gilding, paint, 30¾ x 56 x 35 inches, branded underside of stretcher: "Herter Bro's". VMFA, The Adolph D. and Wilkins C. Williams Fund.

5.44

FIG. 5.44 Christopher Dresser (1834–1904), designer; Hukin and Heath (1855–1953), Birmingham, England, manufacturer, *letter rack*, 1881, silver plate, height 5 inches, inscribed on underside: "H&H, 2555" and registration mark for October 9, 1881. Private collection.

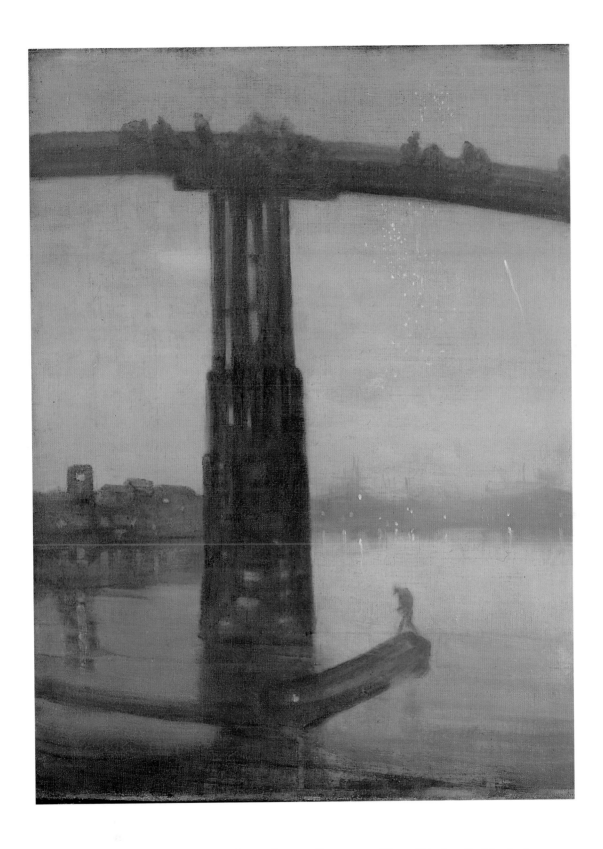

FIG. 5.45 Whistler, *Nocturne: Blue and Gold—Old Battersea Bridge*, ca. 1872–77, oil on canvas, 26⅞ x 20⅛ inches. Tate Gallery, London.

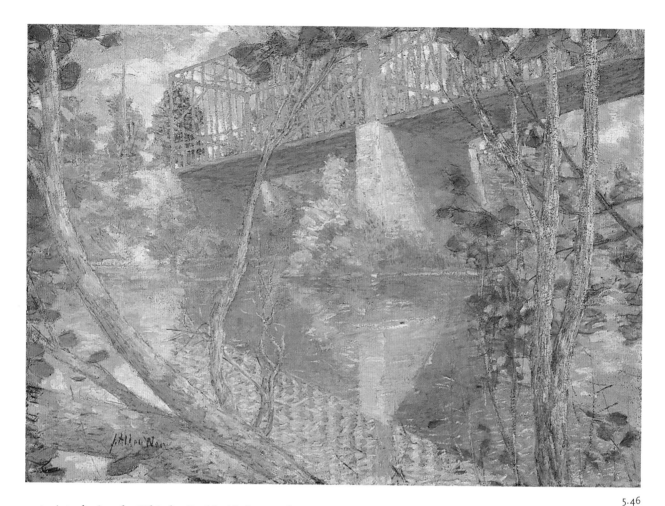

5.46

notoriety during the Whistler-Ruskin libel suit. The evocative painting frankly stems from Japanese woodblock prints—its composition is as japanesque as Dresser's toast rack. Whistler's palette is equally indebted to woodblocks, but such brilliant blue color, interpreted by the influential French critic Théodore Duret as characteristically Japanese,[104] was actually a commercial product sold by Europeans to printmakers in Japan.[105]

Whistler would probably have refuted any association between his picture and Dresser's similarly arched (and similarly arch) toast rack. However, the two have more in common than the traditional Western separation of fine and decorative arts, let alone Whistler's elitist pronouncements, might lead one to believe. The atmosphere of publicity and commerce in which all artists labored invites us to consider how the two works resonate with each other. We can find picturesque bridges in the Asian taste among the follies in eighteenth-century gardens, and a japanesque bridge in Monet's

FIG. 5.46 Julian Alden Weir (1852–1919), *The Red Bridge*, 1895, oil on canvas, 24¼ x 33¾ inches, signed l.l.: "J. Alden Weir". The Metropolitan Museum of Art, Gift of Mrs. John A. Rutherfurd, 1914 (14.141).

5.47 5.48

garden at Giverny became one of that leading Impressionist's favorite motifs. Even
J. Alden Weir's asymmetrical, textured image of a modern steel bridge near his Connecticut
farm takes on added interest in this connection [fig. 5.46]. Weir's canvas is considerably
more distanced through decorative patterning than are such obvious sources as Monet's
series of the railroad bridge crossing the Seine at Argenteuil, painted twenty years earlier.[106]

One need look no further than various domestic and semipublic spaces
to find a staging ground where stylistically impure admixtures of Impressionism and
Aestheticism readily occurred. We know they coincided in Whistler's studio [see fig. 4.1],
where his display of blue-and-white pots, reminiscent of a Baroque *porzellanzimmer*,
kept company with women in vaguely Japanese dress. Whistler lost his first collection
of blue-and-white during his bankruptcy, but after marrying Beatrice Godwin in 1888,
he reprised the "chinamania" of the Aesthetic movement, gathering up a new supply
[fig. 5.47]. He also acquired delicate pieces of Dutch, French, English, and Irish Georgian
silver and silver plate—each piece "aestheticized" with a delicate engraving of his
butterfly monogram, always positioned carefully to complement the shape of the piece.[107]
On one little flask, Whistler exploited a row of tiny hallmarks as if they were chops or
seals. He placed his engraved butterfly below and to the right, creating an asymmetrical
japanesque composition on the reflective silver surface [fig. 5.48].

Many other artists were similarly acquisitive. Visitors to Chase's studio [see fig. 4.8]
encountered a mixture of objects as eclectic as the design sources that fed the Aesthetic

IG. 5.47 *Quing-period Chinese blue-and-white charger,* Kangxi reign period 1662–1722, porcelain with cobalt blue underglaze, diameter 18 inches,
from Whistler's collection. Hunterian Art Gallery, Glasgow University.

IG. 5.48 *Flask,* silver, English, ca. 1800, height 3 inches, later engraved with butterfly by Robert Dicker, London, from Whistler's collection.
Hunterian Art Gallery, Glasgow University.

movement. Meanwhile, in Monet's dining room blue-and-white plates manufactured by the French pottery works at Creil imitated authentic Imari wares [figs. 5.49, 5.50]. The ceramics complemented genuine Japanese prints as well as bright yellow rush-seated chairs that descend from a commercially produced William Morris rush-seated chair of the early 1860s. The Pre-Raphaelite painter Dante Gabriel Rossetti was responsible for the chair design.[108]

Particularly in the homes of the great collectors of the period, such as Americans Charles Lang Freer in Detroit or Mr. and Mrs. H. O. Havemeyer in New York, Impressionist and Aesthetic elements dwelt in harmony. Freer had his delicate rush-seated oak chairs thinly glazed with silver lacquer so that the oak grain showed through, as does the canvas in Whistler's thinly painted *Symphony in Grey: Early Morning, Thames* (1871), a work acquired by Freer in 1904 [figs. 5.51, 5.52]. We see this most clearly on parts of the chair where the original lacquer has suffered little wear. The collector characterized a Satsuma water bottle purchased in 1892 as "Hexagonal. White cracked glaze; Whistlerian landscape in blackish blue underglaze" [fig. 5.53].[109] Among her many important Impressionist canvases, Louisine Havemeyer counted a Japanese bridge picture by Monet and an elegant aesthetic still life by Chase. Her sixty-two-piece flatware service was made of mixed metals in the japanesque taste by Tiffany, while her hoard of "sober dark brown" eighteenth-century Edo tea jars, "so soft you want to hold them in your hand," brought Mrs. Havemeyer the pleasure of "a child with a toy."[110]

The profoundly entrepreneurial Havemeyers, whose holdings enrich the Metropolitan Museum in New York and other institutions, had contemporary counterparts in Japan. There, from the late nineteenth century up to World War I, many businessmen, for whom the tea ceremony and the appreciation of art objects offered a cultivated form of relaxation, formed extensive collections now held by private museums.[111] In seeking uplift through art, their collecting patterns parallel those of their Western contemporaries.

In Mary Cassatt's *Lady at the Tea Table* (1885) [fig. 5.54] the sitter lays a possessive hand on a piece of china. This canvas is one of many Impressionist paintings in which still-life elements help to establish the sitter's status by emphasizing luxurious material possessions.[112] In Joseph DeCamp's *Blue Cup* (1909) [fig. 5.55] a single piece of fragile blue-and-white china carries as much weight as the entire porcelain service in Cassatt's earlier portrait. After seeing DeCamp's work at a group exhibition of The Ten, a critic

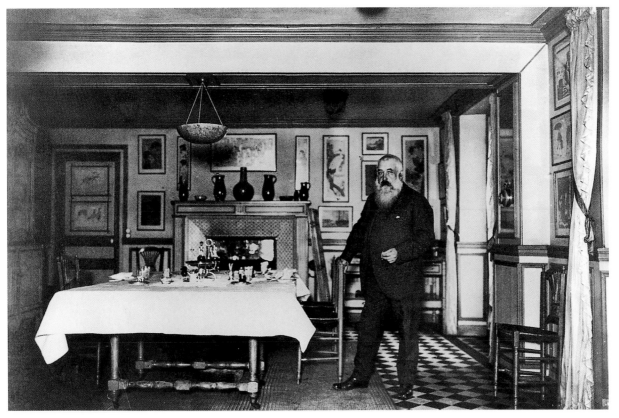

5.50

5.49 *Monet in his dining room at Giverny*, ca. 1910, photograph. Private collection.

5.50 Creil-Montreau, Seine-et-Marne, France (1819–1895), *luncheon plate*, ca. 1880, earthenware with blue transfer pattern, diameter 8⅝ inches, stamped verso: "deposé Creil/Montereau/Japon". Private collection.

5.51

FIG. 5.51 Whistler, *Symphony in Grey: Early Morning, Thames*, 1871, oil on canvas, 18 x 26½ inches.
Freer Gallery of Art, Smithsonian Institution, Washington, D.C., Gift of Charles Lang Freer, F1904.50.

FIG. 5.52 Davenport & Company, Boston (1889–1914), *armchair*, 1892, oak frame with silver glaze,
rush seat, height 36 inches. Study Collection, Freer Gallery of Art, Smithsonian Institution,
Washington, D.C., Gift of Charles Lang Freer.

FIG. 5.53 *Satsuma water bottle*, ca. 1725–50, Japan, landscape painted in underglaze blue by Tangen
(1679–1767), height 8 9/16 inches. Freer Gallery of Art, Smithsonian Institution, Washington, D.C.,
Gift of Charles Lang Freer.

5.53

5.52

for the *Globe and Commercial Advertiser* remarked on the woman's intellectual curiosity as she examines the mark on the cup's bottom. DeCamp's model was taken for a maid when the picture was first exhibited, but her status remains ambiguous. A surviving study reveals that she has given up her dust rag, once draped on the edge of the table, in favor of a gold bracelet, worn on her left arm to help draw the viewer's eye to the cup she holds.[13]

Whether she is mistress or maid, the painting reinforces connections between hard work, education, and material reward. With the rising tide of immigrants at the turn of the twentieth century came efforts to socialize the worker through art education, giving rise to a host of American public art museums modeled after London's Victoria and Albert.[14] These civic enterprises institutionalized the Aesthetic movement

5.54

FIG. 5.54 Mary Cassatt, *Lady at the Tea Table*, 1885, oil on canvas, 29 x 24 inches, signed and dated l.l.: "Mary Cassatt/1885". The Metropolitan Museum of Art, Gift of the artist, 1923 (23.101).

FIG. 5.55 Joseph Rodefer DeCamp (1858–1923), *The Blue Cup*, 1909, oil on canvas, 49⅞ x 41⅛ inches. Museum of Fine Arts, Boston, Gift of Edwin S. Webster, Lawrence J. Webster, and Mary S. Sampson in memory of their father, Frank G. Webster.

FIG. 5.56 Theodore Robinson (1852–1896), *Low Tide*, 1894, oil on canvas, 16 x 22¼ inches. The Manoogian Collection.

notion that fine art uplifts, satirized in a trenchant George du Maurier cartoon for *Punch* [see fig. 6.22]. Although a parody of Oscar Wilde's famous anecdote for aesthetic behavior, the cartoon is art about looking at art, a topic freighted with intimations of both pleasure and self-improvement also expressed in easel paintings such as the one cited above by DeCamp.

"Knowledge is power," Dresser asserted in 1862 as new audiences began to incorporate the arts into their everyday lives.[115] Particularly in the commercialized societies of Europe and the United States, material things remain a cornerstone in the edifice of social status. The awareness of an object's aesthetics, incorporated into Whistler's paintings while strongly fostered by the Aesthetic movement of the 1870s and '80s, played a substantial role in creating a climate of acceptance for pictures such as Theodore Robinson's *Low Tide* (1894) [fig. 5.56]. Such paintings might otherwise still be considered unfinished had not the radicalism of Whistler's earlier abstraction gradually been disarmed by commerce.

Today the legacy of the Aesthetic movement can be mistaken for awkward, fey evidence of a tempest in a teapot [see fig. 6.26], while investors and scholars revere Impressionist paintings. But contemporary museumgoers flocking to Impressionist exhibitions have their nineteenth-century counterparts in the primary audience targeted by proponents of Aestheticism. Moreover, the majority of artists involved were not independently wealthy themselves but members of the middle class, and thus obliged to sell their work. It would be difficult to sustain the argument initially mounted by Whistler in the "Ten o'Clock" lecture that one movement was more commercialized than the other. His work tells a different story. In demonstrating the advantages of aesthetic synthesis subtly yet clearly indebted to arts of the past, Whistler offered a rich, complex, and durable legacy to his countrymen.[116] Traveling back for the future, Whistler was nurtured by aesthetic continuities from previous centuries as he explored new territories, gradually discovering how fresh modes of seeing—the Aesthetic movement and Impressionism, each rooted in French Realism—complemented each other, establishing works of art as visual experiences whose surfaces are as important as the subjects they depict.

6. Punch and Jimmy

What is a Nocturne, Mr. B.?

—*Punch*, 1881

Thanks to cartoonists, Whistler's was the name most closely identified with
aesthetics as visual mystification in the popular mind after the early 1870s.
He would hold this dubious distinction until the end of his life and for decades
thereafter. A selection from the abundant caricatures published in late-nineteenth-
century periodicals demonstrates how Whistler's personal appearance, intertwined with
his art and aesthetic ideas, was transmitted, albeit tongue in cheek, to a broad audi-
ence [fig. 6.1].

Visual jokes about Whistler and his work form a significant element in a much
larger international body of nineteenth-century material indicating that the general
public was uncomfortable about directions the arts were taking. Further, links to class,
gender, and economic change made art seem far more dangerous than radical aesthetics
alone could have done. Using the common visual denominator of people engaged
in looking, sardonic images regularly tell a story of ignorance that bred distrust in the
commercialized world of fine art. In all sorts of situations "high art" intended for an
elite audience commingles with Aesthetic movement decoration for the middle class.
Dilemmas specifically associated with Whistler's career—how to assess the fiscal value
of an artwork, how it should be framed, how presented, how responded to—all appear
over and over in the pages of *Punch*, staged against a background of shifting social
status and unstable gender roles that are regularly emphasized through details of costume,
manners, and speech. In some cartoons, the personas of Whistler and Wilde seem to
be fungible, offering a deprecatory testament to the dangers posed by satire when it
addresses an ultimately serious agenda such as Whistler, at bottom, wished to present.
Given Wilde's later fall from grace, the already published cartoon cocktails of the 1870s
and '80s, mixing artist and writer, helped to trivialize Whistler's work for later gener-
ations. Moreover, generic jokes were applied to all kinds of new art and artists, from the

FIG. 6.1 Detail from *"Note of a recently 'Established President,'"* wood engraving from *Punch, or the London Charivari,* June 1886. Library of Virginia, Richmond.

Impressionists to Sargent to the American Realists. That conversation continues to flow in journals such as *The New Yorker*, where any new art trend is fair game.

Issues raised by cartoonists using humor to defuse potentially explosive issues in Europe and the United States more than a century ago continue to haunt the international museum world. These old cartoons address problems that remain familiar to today's curators and museum administrators seeking to woo uneasy viewers. The struggle to strike a balance between artistic freedom and commercial viability is far from over.

William Michael Rossetti's early supportive commentary on various pictures by Whistler stressed aesthetics. Whistler's "aim is not so much to reproduce facts, or present a story of any kind, as to execute a work of art in which the conception and sentiment of the art itself shall be paramount," Rossetti informed readers of the *Chronicle* in 1867.[1] A few years later, in private correspondence with Frederick Richards Leyland, Whistler thanked his piano-playing patron "for the name 'Nocturne' as a title for my moonlights!" The artist chirped, "You have no idea what an irritation it proves to the critics and consequent pleasure to me—besides it is really so charming and does so poetically say all I want to say and *no more* than I wish."[2] Leyland would have known the nocturne as a musical form invented by John Field, an Irish-born composer working in Saint Petersburg and Moscow during the early nineteenth century. Field's nocturnes—precursors of romantic music by Chopin, Liszt, and Mendelssohn—were the first "songs without words."[3] Field sidestepped earlier programmatic music with literary underpinnings in favor of mood and atmosphere, and his piano compositions anticipate Whistler's nonnarrative focus. Moreover, critics used musical terminology to describe Whistler's work before he himself took it up.[4]

"The Diffusion of Aesthetic Taste" is but one of many cartoons advancing Whistler's position as an apostle of the beautiful in the pages of *Punch*, the humorous British magazine that most often satirized the American expatriate artist [fig. 6.2].[5] *Punch* published the image shortly after paintings shown at the Whistler-Ruskin trial, particularly *Nocturne in Black and Gold: The Falling Rocket* [see fig. 5.16], made Whistler's a household name. Typically, "Diffusion" admixes audience anxiety, misinformation, and the constant association of painting

222

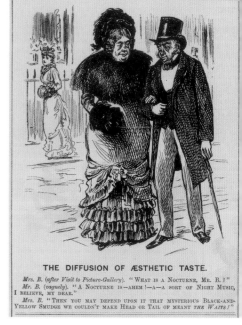

THE DIFFUSION OF ÆSTHETIC TASTE.

Mrs. B. (*after Visit to Picture-Gallery*). "WHAT IS A NOCTURNE, MR. B.?"
Mr. B. (*vaguely*). "A NOCTURNE IS—AHEM!—A—A SORT OF NIGHT MUSIC, I BELIEVE, MY DEAR."
Mrs. B. "THEN YOU MAY DEPEND UPON IT THAT MYSTERIOUS BLACK-AND-YELLOW SMUDGE WE COULDN'T MAKE HEAD OR TAIL OF MEANT *THE WAITS!*"

6.2

FIG. 6.2 *"The Diffusion of Aesthetic Taste,"* wood engraving from *Punch*, 16 April 1881. Library of Virginia, Richmond.

with performance. The cartoon features a well-dressed elderly couple discussing their recent visit to a picture gallery. "What is a Nocturne, Mr. B.?" the wife inquires. Her husband answers her ("vaguely"), "A Nocturne is—Ahem!— A—A sort of Night Music, I believe, my dear." She replies, "Then you may depend upon it that mysterious black-and-yellow smudge we couldn't make head or tail of meant *the Waits!*" (Waits were groups of strolling musicians, who performed Christmas carols in the streets of Victorian cities and towns.)

6.3

Whistler did not admit to literary inspirations—hardly a surprise given his battle against Victorian narrative painting and his hatred of the art critic as misguided storyteller. Yet we know that Whistler's initial bohemian stance was based on a literary model, Henry Murger's *Scenes de la Bohème* [fig. 6.3].[6] At the end of Murger's story, the bohemian characters, like Murger himself, succumb to the financial lure of respectable conformity. Marcel, the painter in the story, finally breaks into the Salon, averring,

> One can be a poet or a true artist, and still keep one's feet warm and eat three meals a day. Whatever we may say or do, if one wishes to arrive at any destination, one must take the common road.[7]

No one would ever accuse Whistler of taking the common road but, like Marcel, he did make adequate accommodation to Victorian mores, particularly after his marriage in 1888. During the 1890s he achieved material success coupled with public acknowledgment of his art.

Meanwhile, Whistler's willingness to exploit not only the painted canvas but also the written word in advancing his self-described "story of the beautiful" made him a tempting target for humorous parody in the popular press. As the century wore on, Whistler's aesthetic terminology would become a sort of lingua franca for aesthetic change, and some of his works were satirized years after they had been painted. Whistler's aesthetic agenda was mocked even when the article or cartoon did not focus specifically on his work.

As a satirical column on Whistler's exhibition of Venetian pastels at the Fine Art Society makes clear, Victorian cartoons tend toward sophomoric humor and

FIG. 6.3 Whistler, *An Artist in His Studio*, ca. 1856, ink and pencil on paper, diameter 9¼ inches, inscribed: "J. Whistler Au 5me No. 7 Rue Galeres, Quartier Latin/Fuseli". Freer Gallery of Art, Smithsonian Institution, Washington, D.C., Gift of Charles Lang Freer, F1906.104.

WHISTLER'S WENICE; OR, PASTELS BY PASTELTHWAITE.

MR. WHISTLER is the artful Doger of Venice. TURNER made "studies" from which he subsequently developed his pictures: but Mr. WHISTLER is the "Chiel amang ye taking notes"—in colour, and, unable to keep them to himself, he exhibits them in the most generous and self-effacing way to the public generally. It is very kind of him; perhaps it is very deep of him. Does he want to discourage his brother artists from going to Venice? He may have conceived a violent animosity to Mr. COOK, and has hit upon this method of deterring intending tourists from visiting the "Pride of the Sea."

Whatever the motive for the exhibition, the artist seems to speak for himself, and say—"Well, Sir, I'm Master JIMMY WHISTLER I am, and if I can do this sort o' thing with a shilling box o' paints from the Lowther Arcade, a few sheets of blotting paper, and some brown-paper covers off the family jam-pots, I could do bigger work with improved materials, you bet!"

This address evidently conveys the suggestion that he should be forthwith presented by his friends and admirers with a real colour-box and the entire artistic paraphernalia. In furtherance of this design, we place before our readers our own "Notes" in black and white, suggested by those of Master WHISTLER.

N.B.—Visitors are requested to observe the principal figures, on which we only allow ourselves to touch lightly, and compare them with those in the brown-paper Catalogue. These notes being intended for practical guidance, every visitor should take them to the Gallery as a suggestive commentary which will be of the greatest assistance to him in appreciating the collection in detail.

No. 1. *Sotto Portico, San Giacomo.* A sort o' portico. Pretty clear so far.

No. 7. *The Little Back Canal.* Subject from the celebrated Triumviretta, *Coxio e Boxio.*

Sergento Bouncero. Don't be angry, Gentlemen. There used to be a Little Back Canal here.

Boxio e Coxio (together). Then put it up! [*Exit* BOUNCERO.

No. 10.

No. 10. *Nocturne—The Riva.* A Mud-bank note. "First Impression of Venice on a piece of Blotting-Paper."

No. 13. *The Giudecca: note in flesh-colour.* Suggestion for a Picture to represent Mr. IRVING as *Shylock* on a river—somewhere. Note for Jewdecca-rative Art.

No. 14. *The Bridge—flesh-colour and brown.* Suggestion for Sir WILLIAM TITE's pantaloons—say a pair of Tite's.

No. 18. *Nocturne at a Hotel.* Curious specimens of shoes left outside the bedroom doors to be cleaned. Suggestion for the Boots.

No. 21. *Fish Market, San Barnabo.* Suggestion of trade being very dull.

No. 22. *The Old Marble Palace.* We "dreamt that we dwelt in marble halls," and awoke with a severe cold. About this period we came to the conclusion, that if we wisited Wenice —WHISTLER's Wenice—we should soon become what Mr. MANTALINI described as a "demm'd moist uncomfortable body."

No. 18.

No. 27. *Campanile at Lido.* Suggestion for a camp in ile—this isn't in ile. *Note*—it's out in the desolate country, a truly-rural-Lido sort of place.

No. 28. "*Boat Ahoy!*" Suggestion for a picture of "there were three sailors of Bristol City, Who took a boat and went to sea."

No. 29. *The Giudecca—Winter: grey and blue.* Uncomfortably suggestive of a nervous man bent on taking a header.

No. 35. *The Staircase: note in red.* Suggestion that this note "should be taken as red."

No. 36. *The Cemetery.* This is what Master JAMES calls it. We prefer to consider it as suggestion for a dark scene in some

No. 29.

Pantomime of *Gulliver*, representing *Gulliver's* cocked-hat adrift off Lilliput or Water-Lilliput.

No. 37. *Swamped Buttercups.*

No. 36.

No. 38. *The Red Doorway.* Suggestion for the Home of SMUDGE, R.A.

No. 39. Suggestion for a view of the Polar Regions "from the steps of the Piazetta."

No. 43. *A Red Note.* Suggestive that bearer waits answer.

No. 47. *Awfully Cow'd!* Suggestion for a picture representing three unfortunate Pierrots who, returning from a fancy ball in the country, have lost their way and stuck in a peat-bog.

No. 47.

No. 51. *Campo Sta. Martin—Winter Evening.* Note in Real Jam, or "Venice Preserved."

No. 53. *The Brown Morning—Winter.* Master JAMES means the Brown-paper Morning. And lastly, what in nature is this curious specimen that appears in every picture? It's not a Gnat: it's not a Mosquito. Can it be a—but this suggestion of Venice is unpleasant for travellers. Did Master JAMES stay in the Palace of the Doges, and at midnight was he aroused from his harmony in snores, and compelled to rise from the ancient bed, light a candle, and—but we will not pursue the subject further.

[Beautiful Venice! "When found make a note of." *Mem.* by J.W.]

IO TRIUMPHE!

(*A Circumspect Pæan.*)

"SEE, they number thirty-six—
 Thirty-six, and I but one!
I'll confound their knavish tricks!
 Never yet did GOSSETT run!"
Thus—the hero to the Chair.
 BRAND replied, "The iron's hot:
Strike you shall; and,—time to spare,
 Shall I lump and *name* the lot?
Come, how will you have it done?"
Whispered GOSSETT, "One by one."

Then grew fierce the deadly strife,
 And full thirty-five at bay
Fought for dear obstructive life,—
 Fought,—MOLLOY though ran away.
And from rafter, roof, and floor
 Rang the cheer, as GOSSETT's band,—
Six attendants from the door,—
 Cleared the House. Then, up spake BRAND,
"What—cleared! Bless *me*, how *was* it done?"
Quoth GOSSETT, smiling, "*One by one!*"

Kurds and their Ways.

IT appears from an advertisement in the daily papers that the "wild and terrible" Kurds, as they are called, in the intervals of their wildness and terror, are in the habit of making Persian carpets for the English market at very low prices. Perhaps if they were less wild and terrible, they would make worse carpets and charge higher prices. Civilisation is sometimes a great demoraliser.

Thrue for You!

TALK of unparliamentary speech, Sorr?
 Bad example? Bedad, Sorr, who gave it?
Very fine at *our* swearing to screech, Sorr,—
 When *you're* just after taking our *Davitt!*

Perfect Agreement.

"I FIND it so difficult to pay calls," said a busy Lady, the mother of a large family, to her husband.

"So do I," he replied, as he thought of his large investment in the shares of the Minimum Under-Mining Company which hasn't yielded anything except a half-yearly report of their "Doings."

6.5

labor-intensive puns [fig. 6.4]. The delicate *Nocturne: San Giorgio* [fig. 6.5] is reduced to "*Nocturne at a Hotel.* Curious specimens of shoes left outside the bedroom doors to be cleaned. Suggestion for the Boots." (The Boots was a servant whose menial tasks included blacking and polishing footwear.)

Cartoons from Whistler's era carry on a well-established tradition of social and political caricature, one that waxed particularly strong in Georgian England.[8] A satire on aesthetic costume and hairstyles, "Mr. Punch's Designs After Nature. Grand Back-Hair Sensation for the Coming Season" [fig. 6.6], snipes at the peacock, a trendy decorative motif of the 1860s and '70s that would, by the 1880s, devolve into a cliché.[9] Linley Sambourne's facetious image of a woman with a bird on her head appeared just before Whistler decorated Leyland's dining room with blue, green, and gold patterns abstracted from such regal plumage. Sambourne used text along with image to pillory not only female fashion but also the then-current debate over British design reform and the appropriate relationship of ornament to the natural world. Worn by a woman, the male peacock's fine feathers suggest gender tensions as well.[10] Such a cartoon descends from eighteenth-century lampoons of the extravagant clothing, hairstyles, and — by extension — political or social agendas of the Regency. Elaborate dress and zealous politics were particularly associated with prominent Whig socialites such as Georgianna, duchess of Devonshire [fig. 6.7].[11]

Following long-established practice, cartoonists regularly targeted works Whistler chose for public exhibition.[12] Whistler's "Projects" — delicate oil sketches of Anglo-japanesque figures by the sea — reveal the artist as a masterful colorist.[13] In June 1874, he featured several panels from the series in his first one-man exhibition staged at the Flemish Gallery, Pall Mall.[14] Shortly after the exhibition, George du Maurier parodied one of them, *Symphony in Blue and Pink* [fig. 6.8]. While borrowing Whistler's composition for "Women and Their Garments Artistically Described," du Maurier reduced it to more tradi-tional satiric commentary on women's fashion [fig. 6.9]. He applied Whistler's musical nomenclature to garish color schemes including a "Symphony in Orange, Blue, and Crimson." In the same vein *Punch*

6.6

6.7

6.8

IG. 6.6 Linley Sambourne (1844–1910), *"Mr. Punch's Designs after Nature: Grand Back-Hair Sensation for the Coming Season,"* wood engraving from *Punch*, 1 January 1871. Library of Virginia, Richmond.

IG. 6.7 P. Dawe (fl. ca. 1760–1800), *"A Hint to the Ladies to Take Care of their Heads,"* 1776, mezzotint, 13¾ x 10¼ inches. The British Museum, London.

IG. 6.8 Whistler, *Symphony in Blue and Pink*, ca. 1868, oil on millboard mounted on panel, 18⅜ x 24⅜ inches. Freer Gallery of Art, Smithsonian Institution, Washington, D.C., Gift of Charles Lang Freer, F1903.179.

made fun of "High Art Colours" in a bit of doggerel, again about fashion.[15] By the time Whistler's work became notorious through the highly publicized *Whistler v. Ruskin* lawsuit, du Maurier's colleague Sambourne could conflate art, music, and women's fashion to dismiss the entire Whistlerian enterprise as "An Arrangement in 'Fiddle-de-dee'" [fig. 6.10].

6.9

However puerile they may seem today, cartoonists used Whistler's art to explore larger dilemmas. As an avant-garde statement of "art for art's sake," *At the Piano* [see fig. 1.1] intersects with mass culture in the pages of *Punch*. The first of several cartoons by George du Maurier based on *At the Piano* shows "Queen Prima-Donna at Home" [fig. 6.11]. She plies the keys with the intensity Whistler himself brought to the cause of high art. But her daughters beg, "O, Mamma!—Dear Mamma! Darling Mamma!! DO leave off!!" Du Maurier sardonically concludes that "no one is a Prophet in his own Country." Two more du Maurier riffs on the piano picture poke fun at non-English musicians. In "Appreciative Sympathy," a heavily mustachioed "Herr Bugoluboffski," who looks suspiciously like Whistler, has just finished playing "a lovely Nocturne," doubtless referring not only to Whistler's pictorial titles but also to his personal history as a youth in Russia [fig. 6.12].[16] Another parody, titled "Musical Egotism," features a self-centered Germanic pianist whose heavy accent reminds us that Whistler's expatriate status was a further strike against him as he battled for the acceptance of advanced French ideas about beauty in jingoistic Victorian Britain.[17] Although du Maurier moved further and further away from his source, in each piano parody he tuned the humor to a dissonant sense of opposition and misunderstanding.[18]

Misunderstanding was a familiar air, for of course the art world was not changing in a vacuum. The year 1859, when Whistler moved to London, witnessed a disturbing number of publications capable of undermining the fragile equipoise of the all too recently established Victorian middle class. Issues of politics (John Stuart Mill's *On Liberty*), science and religion (Charles Darwin's *Origin of Species*), even sensuality (Edward Fitzgerald's *Rubaiyat of Omar Khayyam*;

AN ARRANGEMENT IN "FIDDLE-DE-DEE."

6.10

FIG. 6.9 George du Maurier (1834–1896), *"Women and Their Garments Artistically Described,"* wood engraving from *Punch*, 28 November 1874. Library of Virginia, Richmond.

FIG. 6.10 Linley Sambourne, *"An Arrangement in 'Fiddle-de-dee,'"* wood engraving from *Punch*, 6 October 1877. Library of Virginia, Richmond.

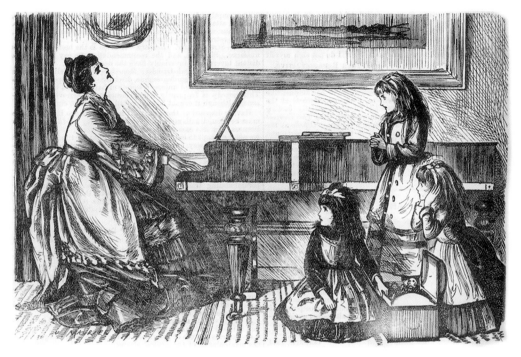

QUEEN PRIMA-DONNA AT HOME.

APPRECIATIVE SYMPATHY.

FIG. 6.11 George du Maurier, *"Queen Prima-Donna at Home,"* wood engraving from *Punch*, 7 November 1874. Library of Virginia, Richmond.

FIG. 6.12 George du Maurier, *"Appreciative Sympathy,"* wood engraving from *Punch*, 20 November 1880. Library of Virginia, Richmond.

BROTHERS IN ART.

6.13

Alfred Lord Tennyson's *Idylls of the King*) were among the unsettling subjects discussed that seminal year.[19] The potential dangers inherent in Whistler's art went well beyond aesthetics. Over time he would be condemned in part by association with other concurrent subversions of the Victorian status quo.

Initially, however, Whistler's timing was good. He launched his career on a tide of stylistically advanced etchings of the Thames that were well received, even though the art itself was somewhat provocative. Yet Whistler, a practicing bohemian, could not avoid being associated with the market. From the outset, journalists and critics perceived that Whistler had firmly moored his fragile aesthetic craft to a commercial dock. Comparing Whistler to Rembrandt at brother-in-law and fellow etcher Seymour Haden's expense, a positive review of the Thames etchings in *Punch* began with the phrase "English Etching is up in the market just now," linking Whistler not only to the etching revival, with its worthy Rembrandtian legacy, but also to the nonaristocracy of tradesmen.[20]

Just as clearly the review associates Whistler's subject matter with economically driven urban change:

FIG. 6.13 George du Maurier, *"Brothers in Art,"* wood engraving from *Punch*, 12 December 1874. Library of Virginia, Richmond.

Such etchings of this queer long-shore reach and marine-store dealers, and ship-chandlers, bonded warehousemen, and boatbuilders, ancient mariners, and corn-porters, wherry-men, and wharfingers, Thames-police, and mud-larks, are all the more precious because the beauties they perpetuate are dying out—what with embankments and improve-ments, [and] increased value of river frontage…

The article concludes by assuring readers that Whistler's portfolio will surely prove a good investment.[21]

Not even his own family members could be assured of a courtesy discount from Whistler. While remaining jocular, he wrote to his brother George asking for the return of six etchings rather than lower their price:

My dear George, you are quite right—two guineas a-piece is a large price for my etchings! Unfortunately though it *is* their price, and they *are* devilish dear—they are expensive objects of luxury, and an extravagance that not everyone ought to permit himself.[22]

Whistler, like his colleagues, was indeed the purveyor of luxury goods. However, another cartoon, "Brothers in Art" [fig. 6.13], exposes the precarious social niche that the majority of Victorian artists occupied. Du Maurier confronts a "playful" Royal Academician with his model, "who has been expiating on the dignity of the working man," to point out the dangerous leveling power of an aesthetic life. In response to the smug artist's patronizing comment, "I am pleased to perceive, Jakes, that you are content with your humble condition, and do not envy the lot of the superior classes!" the model replies, "Henvy 'em! Why, bless yer, them as belongs to them classes as you alludes to ain't 'alf so much to be henvied as them as belongs to the class as Me and YOU belongs to."

In a similarly unsettling juxtaposition, Whistler hung a proof of *Black Lion Wharf*, filled with unsavory low-life details, over the saintly image of Anna Whistler in *Arrangement in Grey and Black: Portrait of the Painter's Mother* [figs. 6.14, 6.15]. Anna's head is bracketed by her white lace cap, cuffs, and handkerchief. She averts her eyes from the starkly framed, white-matted print of a gritty dock worker, whose profile faces hers in a perfectly balanced graphic confrontation between high and low culture.

Painted in 1871, this compelling canvas had been exhibited in London twice and Paris once by the time a cartoon titled "A Vocation" graced the pages of *Punch*

FIG. 6.14 Whistler, *Black Lion Wharf*, 1859, etching, 2nd state, K 42, 5⁷⁄₁₆ x 8⅛ inches, signed l.r.: "Whistler 1895". VMFA, Bequest of John Barton Payne.

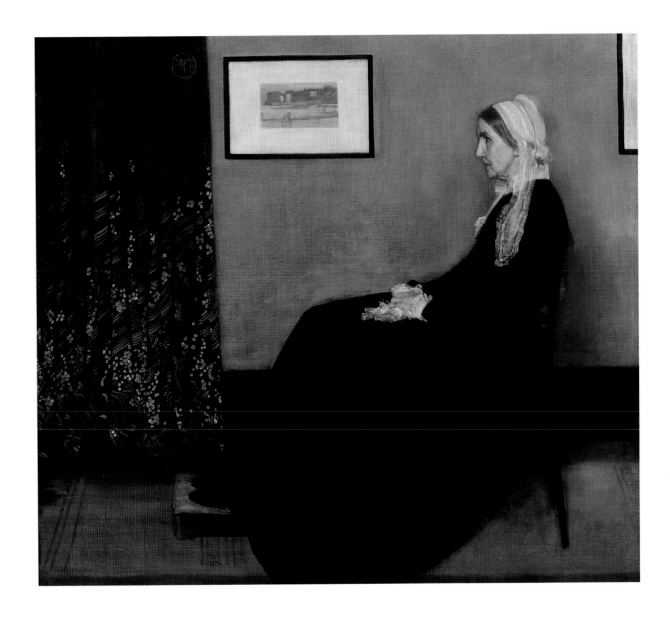

IG. 6.15 Whistler, *Arrangement in Grey and Black: Portrait of the Painter's Mother*, 1871, oil on canvas, 56¾ x 64 inches, inscribed with butterfly.

Musée d'Orsay, Paris.

[fig. 6.16].²³ As he gazes "with complacency" at his mother's portrait, the "Young Genius" avers, "What we really want, Mother, to regenerate art and restore it to its former high position, is that a Man should arise amongst us who should combine the *Loftiest Aims* with absolutely *unlimited Power!*—and I must say, Mother, I can't see why I should not be that Man!" His "fond and foolish Mamma" assures him, "I'm sure you might, Algernon, if you *Tried.*" Whistler left reams of evidence— paintings, drawings, prints, photographs, letters, pamphlets—that he tried very hard indeed.

A VOCATION.

6.16

Even his autocratic behavior as president of the Society of British Artists wavered between the unstable twin peaks of lofty aims and unlimited power. During a brief and stormy tenure, from June 1886 to June 1888, Whistler translated his commercial gallery display techniques to a more public venue, much to the dismay of conservative society members. A few months after his election as president, Whistler was caricatured in *Fun*, a rival publication to *Punch*, as a walking self-advertisement [fig. 6.17]. He wears a painter's palette enlarged into a sandwich board. Emblazoned on the palette we read, "Society of British Artists. Whistler. New Scenery & Decorations. Real Canopy. Bed Hangings. Sensation. Frames."²⁴

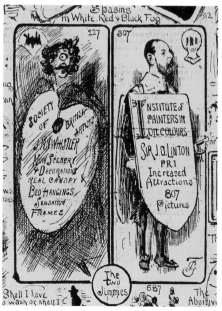

6.17

The text reminds us that Whistler's approach to the public presentation of art derives from the theater on one hand and domesticity on the other. We are further reminded by yet another du Maurier cartoon about how perceived eccentricities of interior decoration were the perfect topic for satire in an era that so concerned itself with domestic comforts. "Art in Excelsis" shows a gathering at the home of the Montgomery Spiffinses [fig. 6.18]. Nearly prone on a circular settee,

FIG. 6.16 George du Maurier (attributed to), *"A Vocation,"* wood engraving from *Punch*, 11 November 1876. Library of Virginia, Richmond.

FIG. 6.17 *"A Little Mixed,"* wood engraving from *Fun*, 8 December 1886. Library of Virginia, Richmond.

a group of guests are looking at the "drawing room ceiling elaborately decorated by artistic hands." As both press clippings and private papers tell us, Whistler's interiors were equally riveting.

With its austere yet glowing gray wall, its portiere of softly shirred japanesque cretonne, and its patterned straw floor covering, the *Arrangement in Grey and Black* presages concerns with interior decor that would later emerge in Whistler's attempts to reform displays at the Society of British Artists. We have already seen how these concerns mediate between the realms of high art—such as the work of avant-garde architect E. W. Godwin—and low, embodied in frankly commercial products of the Aesthetic movement. Striking a hieratic pose akin to an ancient Tanagra statuette from the Ionides collection, Whistler's mother sits on a new rush-seated stick chair of the type produced and retailed by Morris and Company after 1865 [fig. 6.19].[25] A coordinated rush-covered foot stool supports her feet. Used by both domestic and institutional clients, such furniture was fresh and fashionable at the time Whistler was painting *Arrangement in Grey and Black*. "Sussex" furniture remained in production throughout the Morris firm's long existence.[26] Years after the line was introduced, advertising copy continued to promise urban shoppers that reform aesthetics were tempered by a respect for the rural past:

ART IN EXCELSIS.

6.18

6.19

Of all the specific minor improvements in common household objects due to Morris, the rush-bottomed Sussex chair perhaps takes the first place. It was not his own invention, but was copied with trifling improvements from an old chair of village manufacture picked up in Sussex. With or without modification it has been taken up by all the modern furniture manufacturers, and is in almost universal use. But the Morris pattern …still excels all others in simplicity and elegance of proportion.[27]

6.18 George du Maurier, *"Art in Excelsis,"* wood engraving from *Punch*, 5 December 1874. Library of Virginia, Richmond.

6.19 *"The Sussex Rush-Seated Chairs,"* in Morris and Company catalogue, London, early twentieth century. Victoria & Albert Museum, London.

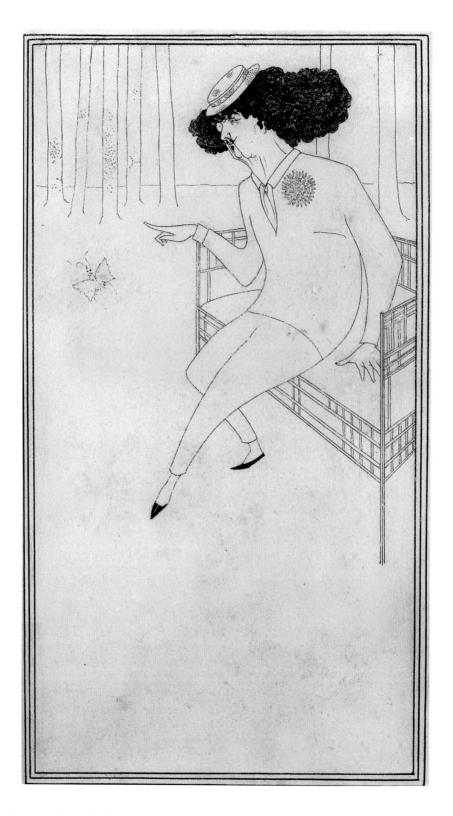

FIG. 6.20 Aubrey Beardsley, *Caricature of J. M. Whistler*, ca. 1893–94, pen and black ink on wove paper, 8 5/16 x 4¾ inches. Rosenwald Collection, National Gallery of Art, Washington, D.C.

Whatever its reassuring links to the past, such attenuated furniture quickly became another signal for the discomforts (both psychic and physical) of the new "art-for-art's-sake" campaign.[28] Beardsley seated Whistler unsympathetically on an attenuated settee [fig. 6.20], while *Punch* provided this "Song for a High-Art hostess":

ÆSTHETIC LOVE IN A COTTAGE.

6.21

> Come, rest on this gridiron, my own dear aesthete,
> Though the herd may contemn, 'tis a true High-Art seat:
> These, these the contours that Art yearns to create,
> A leg that is spindly, a back that is straight.

The song concludes, "In furnishing, firmly High Art I'll pursue, and I'll crouch on my gridiron couch till all's blue."[29] Lounging awkwardly on what can only be described as a bitterly uncomfortable bench, Mariana Bilderbogie assures Mrs. Cimabue Brown that following her marriage she will live in Kensington, where "everything is so cheap...Peacock feathers only a Penny a-piece!" [fig. 6.21] Similar furniture, including a side chair not unlike the one Mrs. Whistler occupies in the portrait by her son, appears in the background of this sardonic glimpse of "Aesthetic Love in a Cottage."

Meanwhile, the "china-mania" craze that Whistler and other artists had helped to legitimize during the 1860s became the target of relentless satire. Set in an aesthetic drawing room with the requisite rush and ebonized stick furniture, folding screen, and fans, du Maurier's "Six-mark Tea-pot" skewers the intentionally runic, somewhat affected title given one of Whistler's earliest japanesque compositions, *Purple and Rose: The Lange Leizen of the Six Marks* (1864) [figs. 6.22, 6.23]. The painting was made fourteen years before the cartoon, but each focuses on a piece of blue-and-white china. In the cartoon, an "aesthetic bridegroom" leans sensuously on the back of a fragile chair. His wife's languid stance derives from another of Whistler's early efforts at *japonerie*, the *Princesse du Pays de la Porcelaine* [see fig. 4.45].[30] Heavy-lidded, almost drugged, the man gazes at a teapot so dreamily that it might be his first child. "It is quite consum-

THE SIX MARK TEA-POT

6.22

6.21 George du Maurier, *"Aesthetic Love in a Cottage,"* wood engraving from *Punch*, 19 February 1881. Library of Virginia, Richmond.

6.22 George du Maurier, *"The Six-Mark Tea-Pot,"* wood engraving from *Punch*, 30 October 1880. Library of Virginia, Richmond.

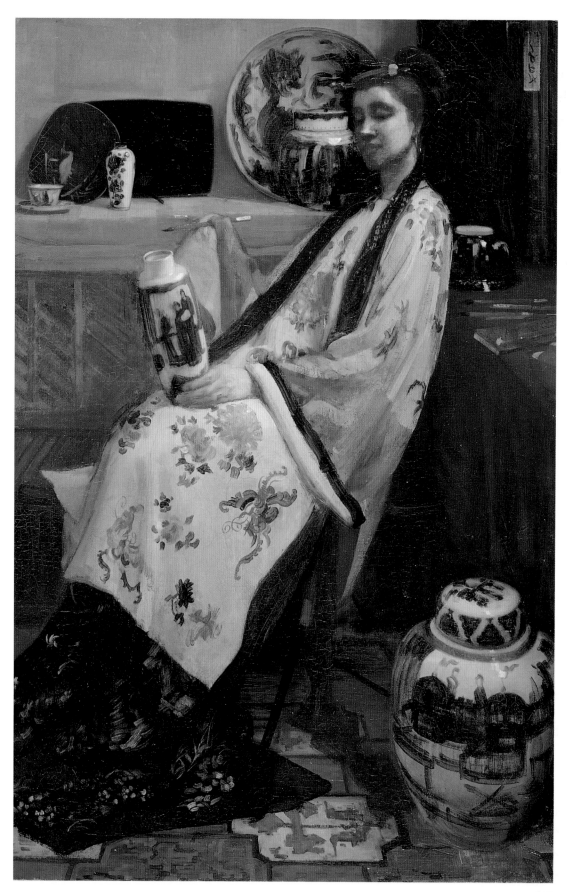

mate, is it not?" he inquires. His "intense bride" answers, "It is, indeed! Oh, Algernon, let us live up to it!" The one-liner proved so catching that another cartoon, titled "Let Us Live up to It!," appeared the following year as a "Design for an Aesthetic Theatrical Poster" [fig. 6.24]. This image obscures any differentiation between self-conscious social performance—as practiced by Oscar Wilde, who originally made the comment during his Oxford student days in the mid-1870s—and public entertainment presented in London shortly thereafter.[31]

Cartoons ostensibly aimed at a fashionable movement cloak deeper concerns. "What It Has Come To" echoes the composition of Whistler's *Lange Leizen* while revealing a class-bound society in the early stages of inexorable social change [fig. 6.25]. Here, Whistler and Wilde are tarred with the same brush. A patently coarse parlor maid moons at a piece of blue-and-white china while the housekeeper consults a physician: "Well, Doctor, I don't know as what's the matter with Marier since she come from her last siterwation in Lunnon. There she sits all day a-staring at an old chiney dish, which she calls a-going in for *Astheletix!*" The cartoon is accompanied by a story, "High Art Below Stairs," in which servants form a new

WHAT IT HAS COME TO.

6.25

"Society for bringing Beauty 'ome to the Pantry." Using lower-class dialect brimming with malapropisms, the accompanying text sends up public lectures on taste, most pointedly those given by Oscar Wilde:

Secret love of the Lily, or privit kontemplation of fragments of Blue Crockery, is not enuff. Aving to sweep a huneasthetick carpet, dust Philistian furniture, or lay hout a dinner wiolating all the most sacred cannons of Igh Art, is triles to wich no suvvink should be subjeck.

6.24

G. 6.23 Whistler, *Purple and Rose: The Lange Leizen of the Six Marks*, 1864, oil on canvas, 36¼ x 24¼ inches, signed and dated: "Whistler 1864". Philadelphia Museum of Art, John G. Johnson Collection.

G. 6.24 Sambourne, *"'Let Us Live up to It!' (Design for an Aesthetic Theatrical Poster),"* wood engraving from *Punch*, 7 May 1881. Library of Virginia, Richmond.

G. 6.25 Harry Furniss (1854–1925), *"What It Has Come To,"* wood engraving from *Punch*, 16 April 1881. Library of Virginia, Richmond.

Among the servants in attendance is "Melinder Jane," got up in "a spideresk kostume, like a Nockturn in drab and dust colour" and striking "a dekkerative hattitood of... Medoosa-like wo."[32] Many other cartoons mock social situations where class divisions are disconcertingly fluid.[33]

Inspired by a Gilbert and Sullivan operetta, a piece of Worcester porcelain sets anthropomorphic satire firmly on the tea table, that bastion of ritualized social propriety [fig. 6.26]. As mentioned, the teapot pairs male and female aesthetes as affected as the poseurs in du Maurier's cartoons. Their postures derive directly from the awkward attitudes struck by actors onstage in *Patience*, a satirical comedy of manners [fig. 6.27]. However, acceptable gender roles blur here—the woman not only has an unflatter-ingly flat-chested physique, but she also wears a calla lily, long established as a signal of sexual decadence.[34] The limp-wristed man, sporting a large sunflower as his bouton-niere, is pointedly effete. The bottom of the vessel is inscribed: "Fearful consequences through the laws of natural selection and evolution of living up to one's teapot," under-scoring how a stylized comedy of aesthetic manners and mannerisms could be indis-criminately lumped together with profoundly vexed issues such as evolution and gender relations.[35]

Not until the turn of the nineteenth century did American realist painters counter "the story of the beautiful" with a self-consciously robust program of brash urban themes, bravura brushwork, and manly public posturing. Their work, in concert with Theodore Roosevelt's aggressive American imperialism and a growing international oppo-sition to women's rights, signals the end of delicate-looking aestheticism.[36] But the ground for rejection was well prepared during the height of the movement itself, and cartoons not directly focused upon Whistler still chronicle the uphill battle that he waged for acceptance of his aesthetic principles. Paralleling Whistler's use of the past, du Maurier's "Line of Beauty" subverts and literally recycles an eighteenth-century design ideal. Here, the S curve trivializes the aesthetic male as someone who avoids the exercise of bicycling because "it develops the calves of the legs so! Makes 'em stick out, you know! So coarse! Positive deformity!!" [fig. 6.28][37] A story titled "Athlete and Aesthete" pits the muscular Jack Beamish against the sensitive Tristram Moldwarp. They com-pete for the love of Lily. Not surprisingly, Beamish emerges the victor, having bested Moldwarp: "Told him the passion for Blue China was an effeminate craze.... Straight tip,

6.27

CHAPTER 6 | PUNCH AND JIMMY

241

FIG. 6.26 James Hadley (1837–1903), for the Worcester Royal Porcelain Company (1862–present), *double-sided teapot*, 1882, enameled porcelain, height 6¼ inches, inscribed on underside: "Fearful consequences through the Laws of Natural Selection and Evolution of living up to one's teapot" and with the firm's mark for 1882. VMFA, Gift of The Council of the VMFA.

FIG. 6.27 *Actors Richard Temple, Frank Thornton, and Dorward Lely* in *Patience* by William Schwenck Gilbert and Arthur Sullivan, photograph, ca. 1881.

THE LINE OF BEAUTY.

FIG. 6.28 George du Maurier, *"The Line of Beauty,"* wood engraving from *Punch*, 6 December 1879. Library of Virginia, Richmond.

"MAN OR WOMAN?" — A TOSS UP.

G. 6.29 Linley Sambourne, *"Man or Woman?"—A Toss Up,"* wood engraving from *Punch,* 10 April 1880. Library of Virginia, Richmond.

THE "NIMBLE NINEPENCE."

6.30

SIC VOS NON VOBIS

6.31

LIGHTS AND SHADOWS OF PORTRAIT PAINTING.— THE FINISHING TOUCH.

6.32

FIG. 6.30 Charles Keene (1823–1896), *"The 'Nimble Ninepence,'"* wood engraving from *Punch*, 2 March 1872. Library of Virginia, Richmond.

FIG. 6.31 W. M., *"Sic Vos Non Vobis,"* wood engraving from *Punch*, 18 November 1871. Library of Virginia, Richmond.

FIG. 6.32 George du Maurier, *"Lights and Shadows of Portrait Painting—The Finishing Touch,"* wood engraving from *Punch*, 15 July 1882. Library of Virginia, Richm⬤

that!"[38] A Wilde-like cartoon character such as Jellaby Postlethwaite, satisfied with contemplating a freshly cut lily rather than a human one of flesh and blood, was worthy only of scorn.[39] In "Nincompoopiana," when Mrs. Cimabue Brown admires Jellaby's "grand head and poetic face, with those flowerlike eyes, and that exquisite sad smile"—not to mention "his slender willowy frame, as yielding and fragile as a woman's"—it takes the sturdily built no-nonsense Colonel to snort, "Why, what's there *beautiful* about him?"[40] We might bear this in mind when recalling that the aesthetic Whistler was also pointedly athletic. Prone to pugilistic language, he even once heaved his brother-in-law through a plate glass window. Caricatures addressing this issue could be disconcertingly forthright, as Sambourne's "'Man or Woman?'—A Toss Up" attests [fig. 6.29]. The text is an out-of-context snippet from a fashion journal regarding evening dresses cut "en habit d'homme," but the heavy-jawed women in the cartoon, based on Jane Morris and other Pre-Raphaelite beauties, would have been forbidding to conservative Victorian readers.[41]

These cartoons comprise a visual testament to a social structure of class and gender that was simultaneously rigid and permeable. Jokes frequently pivot on audience gullibility set against cupidity on the part of the art provider, be he an artist, a dealer, an auctioneer, or a critic. In the "Nimble Ninepence" a "city gent" bargains with a sidewalk "picture-dealer" over a "Moonlight" [fig. 6.30].[42] The dealer's slouchy appearance and slurred language suggest inebriation. The dealer offers framed pictures—all "undoubted Smethers"—at 75 guineas each, but settles "with alacrity" for 35 shillings the pair. Echoing the outcome of *Whistler v. Ruskin*, with its one-farthing damages, the cartoon implies that the art is worthless anyway, ending with a snide aside, "City Gent is in for 'em!"[43] In a similar vein, an auctioneer knocks down a "Titian" oil for 30 guineas as two artists in the back converse [fig. 6.31]. Brush complains to Badger, "Downright dishonest, I call it! Old Aaron's got thirty for that Titian, and he only gave me three for painting it!" Here taken for granted, anti-Semitism in the Victorian art marketplace further darkens the humor.[44]

In a studio image, a handsome young artist presents a portrait to the "fair sitter's" family [fig. 6.32]. The mother is "sure the nose is not aquiline enough," and the artist gives the canvas "one dexterous sweep of his brush" while inquiring solicitously, "Is that better?" The mother is now happy, but the father, "who is always so contradictory," mutters, "Hum! Now I consider that last touch has spoilt the likeness altogether." The reader

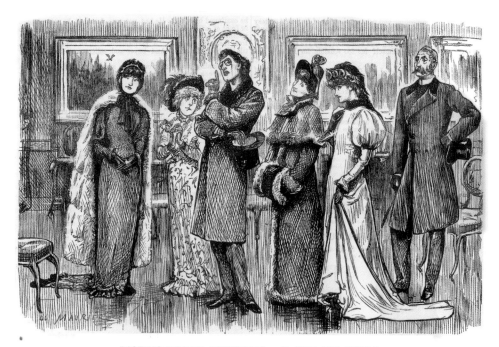

DISTINGUISHED AMATEURS.— 2. THE ART-CRITIC.

6.33

CHAPTER 6 | PUNCH AND JIMMY

may or may not be reassured to learn that "Sopley's brush was perfectly dry—and so was his canvas!" Whistler's seemingly eccentric quarrels with sitters take on a more comprehensible nature given the general trials of the professional portrait painter.

Cartoonists show audiences ignorant not only about the art they are acquiring but also about the art displayed in public museums.[45] As viewers became more and more dependent on professionals for the interpretation of art, Whistler carped unreservedly at critics and curators. In his view the critic was merely a "middleman" who "widened the gulf between the people and the painter" by misconstruing painting as "a method of bringing about a literary climax." Curators were nothing more than "true clerks of the collection [who] mix memoranda with ambition." Reducing "Art to Statistics, they 'file' the Fifteenth Century and pigeonhole the Antique."[46] Such characters fare poorly in images that raise doubts about their competence and sincerity. Whistler would have applauded a cartoon indebted to Frith's *Private View Day at the Royal Academy* (1881). In it du Maurier presents an art critic based on Oscar Wilde, surrounded by eager listeners [fig. 6.33]. Occupying center stage, "Prigsby" holds forth at length on a head painted by his friend "Maudle" and draws a flowery analogy to the *Ilyssus* from the Elgin marbles at the British Museum.[47] The women in attendance chime in with rapturous agreement, but

246

6FIG. 6.33 George du Maurier, *"Distinguished Amateurs—2. The Art-Critic,"* wood engraving from *Punch*, 13 March 1880. Library of Virginia, Richmond.

the Colonel standing at the edge of the group looks doubtful. This masculine representative of common sense later pays a visit to the British Museum, where he finds that the *Ilyssus* is headless.[48] Frith's *Private View* had already been lampooned by *Punch* when it was exhibited at the Royal Academy in 1883. Then, a cartoonist translated the composition into "members of the Salvation Army, led by General Oscar Wilde, joining in a hymn." Once more we see art used as a vehicle to question not only aesthetics but also efforts at social reform.[49]

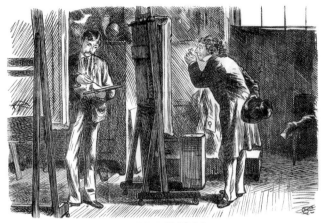

"PRAVE 'ORDS."

Another cartoon, "Prave 'Ords," suggests that more artists than just Whistler shared the purchasing public's skepticism about the gobbledygook of critics [fig. 6.34]. A young painter looks askance as an art critic peers through spectacles, scrutinizing a canvas on an easel. The critic coos, "Dear Boy, how exquisitely you've introduced your cool tertiaries!" Such pretentious language anticipates by a century and a quarter the market-driven mysticism too often encountered in current art journalism. In yet another cartoon, "The Philosophy of Criticism," a heavily accented critic shares a café table with a layman, telling him, "It's by taychin' the ignorant public what is good or bad, accordin' to me lights, that I get me livin' intoierely!" When the layman inquires, "And how's the ignorant public to know whether *you* are right or wrong?" the critic "innocently" replies, "By the coincidence of the popular verdict with moine, sorr, or the reverse! But eithorr way I turn an honest penny!"[50] Meanwhile, a group gathers around a curator at the "Shoddyville Art Gallery," a snobbish slam at new efforts toward middle-class culture in the industrial midlands.[51] When one of the visitors asks who painted one of the portraits, the curator replies, "I believe by some London firm, sir!!"[52]

Whether fine art or decoration, beauty was wasted on the commercial mind, the cartoons often imply.[53] Satire jabbing at the overtly art-sensitive can also wound the hopelessly art-obtuse. Clearly, as at glamorous exhibition openings today, some visitors frequented Victorian galleries for other reasons than the uplift art could provide. A modishly dressed young woman speaks petulantly to her father "At the Academy": "Now, I told you, Papa, this wasn't the fashionable hour. We'll have nothing but these horrid pictures to look at until the people come!"[54] A dignified matron, looking to

FIG. 6.34 Charles Keene, *"Prave 'Ords,"* wood engraving from *Punch*, 1 May 1875. Library of Virginia, Richmond.

broker a marriage before "The Last of the Season," responds to her daughter's enthusi-astic, "O, Ma! Do look at this beautiful sunset!" with a chilly, "Nonsense, Madeline, don't be absurd! We haven't time to look at anything! We must just run through and be able to say we have been here" [fig. 6.35].[55] The aesthetic demands of fine art are no match for the older, more compelling social wish to see and be seen.

Already beleaguered by ignorant viewers and self-aggrandizing critics, artists were equally ill advised to trust their studio help, if we can believe the cartoons. In "A Model Model," a bumptious character holds forth in the studio of an absent artist, undercutting the value of his master's work [fig. 6.36]. A woman visitor asks, "From whom did Mr. M'Gilip paint that head?" "From yours obediently, Madam. I sit for the 'eds of all 'is 'oly men," the model answers. "He must find you a very useful person," she says. "Yes, Madam. I order his frames, stretch his canvasses, wash his brushes, set his palette, and colours. All *he*'s got to do is just to *shove 'em on!*" Whistler would later counter this cavil at the *Whistler v. Ruskin* trial when he said he did not charge for the labor of a moment but for the knowledge of a lifetime.[56]

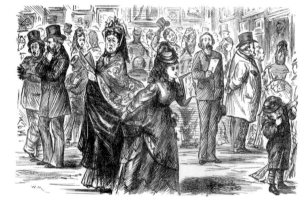

"THE LAST OF THE SEASON."

6.35

Two men converse at a crowded exhibition in "Academy Pencillings" [fig. 6.37]. Hands in pockets, wearing a derby hat, an "affable stranger" says, "There, sir, my work 'ung on the line again!"[57] The "astonished stranger" in a top hat replies, "Eh? What? I thought Millais painted this—" He receives a contemptuous response. "Pooh! 'E may have painted it, but I made the frame!"[58] Until recently, Whistler could pass for an isolated figure unusually concerned with the framing and presentation of his paintings, prints, and drawings. However, long before Whistler began pack-aging his art in unique moldings that would be specially associated with his work, earlier artists sought to develop distinctive framing styles to help their works stand out from others in group exhibitions. These designs were executed by numerous frame makers in London and elsewhere. Like the "Whistlerian" frame, earlier types bear the names of artists (Maratti, Hogarth, Hoare), architects (Kent), even

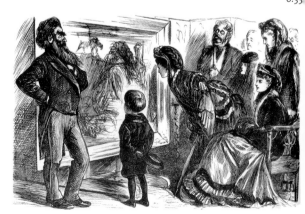

A MODEL MODEL.

6.36

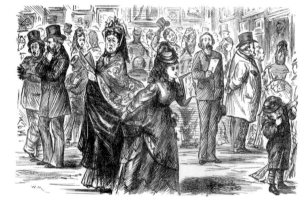

248

FIG. 6.35 W. M., *"The Last of the Season,"* wood engraving from *Punch*, 1 August 1874. Library of Virginia, Richmond.

FIG. 6.36 *"A Model Model,"* wood engraving from *Punch*, 2 April 1870. Library of Virginia, Richmond.

patrons (Medici, Sunderland). To suit his own ends, Whistler drew attention to his own self-conscious, aesthetically driven framing, but he was actually addressing a market-driven issue that has engaged artists and their patrons for five hundred years.[59]

That so many pictures were *not* hung "on the line"—that is, at optimal height for the audience to see them—had vexed not only artists but also critics and gallerygoers for decades. Eventually Whistler took special measures to avoid having to read in a newspaper, "Below the line and where the crinolines scour its surface hangs Mr. Whistler's artistic and able picture…"[60] Whistler achieved total control over the placement of his art in his one-man shows while visually enhancing the paintings, drawings, and prints with personally designed frames and revolutionary installations. His aim was not merely to shock and surprise power brokers in the art world. He wished also to facilitate the potential customer's ease of perception.

Such choices countered the challenge of seeing Whistler's work at its best advantage, a problem that plagued all but the most important members of the Victorian art establishment, who were powerful enough to avoid having their work "skied" or hung at "the crinoline line" in large group exhibitions.[61] Old-fashioned hanging methods also made it virtually impossible for journalists to examine much of the work on display.

As regular gallerygoers, cartoonists did not miss the opportunity for comment. Scribbling, top-hatted critics are hoisted up gallery walls in "High Art," one such indictment of both art criticism and art display [fig. 6.38]:

> Mr. Punch offers the above suggestion to the committee of the Royal
> Academy, for the use of critics visiting their exhibition. With the aid of this
> little machine, they will be in a position to study every picture, from the highest to the
> lowest, with equal comfort, thereby enabling them to impart to their criticisms that &c.
> and &c. which should ever be the &c. and &c. of the British press.

Salon visitors were at a similar disadvantage in traditionally hung galleries. In a surreal vision of the annual exhibition at Royal Academy, its walls jammed with

ACADEMY PENCILLINGS.

6.37

HIGH ART.

6.38

G. 6.37 *"Academy Pencillings,"* wood engraving from *Punch*, 12 July 1873. Library of Virginia, Richmond.

G. 6.38 W. M., *"High Art,"* wood engraving from *Punch*, 13 July 1872. Library of Virginia, Richmond.

FIG. 6.39 George du Maurier, *"Edison's Anti-Gravitation Under-Clothing,"* wood engraving from *Punch's Almanack for 1879*, 9 December 1878. Library of Virginia, Richmond.

pictures hung cheek by jowl from floor to ceiling, visitors enjoy "anti-gravitation under-clothing," which "enables the wearers thereof to suspend at will the force of gravity" while they maneuver themselves "gracefully" about the gallery [fig. 6.39], using Japanese paper fans like the one held by Jo in *The Little White Girl* [see fig. 7.41].

6.40

Even if they wanted to look at the art, audiences found it hard to know just what to say. Social affectations mocked earlier by novelists such as Jane Austen carry forward into Whistler's era.[62] In "Round of the Studios" a group of dilettantes gesture in front of a large canvas:

> *Male Dilettante, No. 1 (making a telescope of his hand).* "What I like so much is that—er that—" *Ditto No. 2 (with his nose almost touching the canvas).* "I know what you mean—that broad—er—" *Female Dilettante, No. 1 (waving her hand gently from right to left).* "Precisely. That sort of—er—of—er—of—er" *Ditto No. 2.* "Just so. That general sort of—er—of—er" *Ditto No. 3.* "O yes—quite too lovely—that particular kind of er—of—er"[63]

Well-meaning viewers were flummoxed by their lack of aesthetic vocabulary. A cartoon showing an artist receiving praise from a pretty girl in his studio on "Picture Sunday" advised, "It is very difficult to know exactly the right thing to say to an Artist about his Pictures. We recommend unlimited praise; but do not enter into details."[64] The wisdom of such counsel is seen in another cartoon [fig. 6.40]. A prominent amateur etcher, noted more for his "dinners, his pretty daughters, and his exquisitely-appointed studio" than for his prints, says proudly, "There! It's easy enough to *draw* my friend! I etched that study in *five minutes*! But the '*biting-in*' has taken me *two years! That's the seventeenth state of the plate!*" Poring over the tiny impression in its vast mat, a graceful young man identified as "our artist" (who is "naturally anxious to make himself agreeable") responds, "Excellent! Awfully good! That black kitten pawing the air in front of the parlour grate is most life-like, and the texture of your Persian hearthrug is simply admirable!—I should know it anywhere!" The amateur etcher's horrified response— "Why that's a windmill on a heath, man—against an evening sky!"—leads to general

FIG. 6.40 George du Maurier, "'*Distinguished Amateurs'*—*1. The Etcher,*" wood engraving from *Punch,* 17 January 1880. Library of Virginia, Richmond.

embarrassment and "collapse of everybody except Distinguished Amateur."[65] Tinged by bitterness against Seymour Haden and other amateur artists, Whistler's own commentary adopted a similar tone. Taking issue with an article on Haden by P. G. Hamerton in *Scribner's Magazine* (September 1880), Whistler wrote to the *New York Tribune*, dismissing his brother-in-law as "the eminent surgeon etcher."[66]

In Whistler's day, the gallery experience was facilitated by printed guidebooks rather than wall labels. Then as now, without some kind of didactic information many viewers were helpless. In "Oil and Water," an old gentleman from the country is puzzled because "his friends have carelessly sent him to the Royal Academy exhibition carrying a catalogue for the water-colors, and he cannot make sense of the oil paintings on the walls."[67] In another cartoon, a quick-thinking young gallant saves himself the embarrassment of not knowing anything about the art on view, with a "Happy thought—division of labor." Taking the catalogue from his lady friend, he says, "A—look here, Miss Bonamy! S'pose *you* look at the pictures, while I confine my attention to the catalogue! Get through the job in half the time, you know!"[68] When it came to what James Jackson Jarves dismissed as "art of the Whistler sort," even viewers with catalogues received little help from the artist's runic titles. Billed as a pleasant choice to fill leisure time, looking at art is still perceived by many as hard work, particularly when the art is abstract.

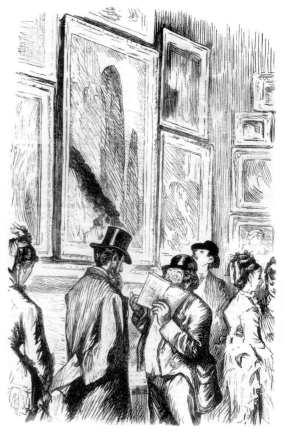

A NOTE AND QUERY.

6.41

Even a picture with uplifing subject matter could stump the uninformed. In "A Note and Query," Farmer Drennidge converses with his rector at the Royal Academy exhibition [fig. 6.41]. They are standing in front of a large allegorical painting. Drennidge clutches his gallery guide, which in actual fact would have contained the following entry:

> Valentine Cameron Prinsep, R.A.
>
> 988. *The Gadarene swine.*
>
> "And the unclean spirits went out and entered into the swine, etc."[69]

FIG. 6.41 *"A Note and Query,"* wood engraving from *Punch,* 21 June 1873. Library of Virginia, Richmond.

Prinsep's allegory refers to Christ's miracle of driving unclean spirits out of the Gadarene people into a herd of swine feeding on a nearby mountaintop. Once possessed, the herd stampeded into the sea and drowned.[70] Despite the information in his gallery guide, Drennidge remains puzzled. "Have you noticed this beautiful pictur', sir, No. 988, by Mr. Wee Prinsep, o' the evil sperits that entered the herd o' swine, and they rushed wiolently down the precipice, and perished in the sea! Tha's the pictur' I'd like to hev, sir. But there's one p'int about that 'strordinary ewent, sir, as has allus weighed on my mind, and I've often thought o' astin' o' you!" Graciously inclining his head, the rector responds, "O, I shall be most happy, Mr. Drennidge, at any time to explain—" but the farmer interrupts to whisper, "Well, it's this 'ere, sir. Whew paid for they drownded pigs, sir?!!"[71] In our own time, hosts of museum-audience studies suggest that the questions visitors have about pictures do not necessarily relate to the finer points of art history.

Audience anxiety reigns in a rubric called "Study for the Academy":

> Visitors to that delightful annual, the Winter Exhibition of the Royal Academy, will save themselves much helplessness, confusion and prevarication—particularly those to whom their companions may turn for information about such of the pictures as need explanation— by learning beforehand a few facts, historical, biographical, mythological, topographical, poetical, literary, and dramatic, bearing on the various paintings which have not the advantage of telling their own story in titles as beautifully brief and simple as *"A Thistle"* [or] *"Two Sheep."* Indeed, no one should dream of visiting the Exhibition now open at Burlington House, and plunging into the expense of a Catalogue (bound, with pencil), unless competent to answer such a proportion of the following questions as would satisfy the Civil Service Commissioners.

A series of daunting queries follows, such as "Who wrote *Orlando furioso*, and what scene in that successful burlesque is portrayed in Dosso Dossi's picture?" or "Give the correct pronunciation of Fra Bartolommeo, Hobbema, Ruysdael, Mierevelt, Jan Claasze, Rietschoof, Brauwer, Mieris, Mantegna, Vandevelde, Velázquez, Zegers, and Zurburán; and explain Lo Spagnoletto, Andrea del Sarto, and the origin of the names of Ghirlandaio, and Tintoretto." The column concludes with an early call for didactic gallery labeling as we know it today: "Are you not of [the] opinion that descriptive tablets on *all* the frames would be highly desirable?"[72]

Descriptive labels never played a role in Whistler's presentation of his art, but on occasion he did adapt the concept of the trophy frame—an old-fashioned narrative framing device that extended the meaning of the picture it housed through carved elements ranging from the literal (weapons on a general's portrait or a battle scene) to the symbolic (a Herculean lion's skin on the portrait of a king). The tradition was alive in Victorian times. For example, close in conception to baroque and rococo trophy frames from previous centuries, carved shovels, picks, and gold pans surround Charles Christian Nahl's *Sunday Morning in the Mines* (1872).[73]

In contrast, as we have come to expect, a Whistlerian version of a trophy frame deploys a far more subtle approach to ornamentation than the high-relief embellishments typical of thematic moldings. For example, a shallow frame with incised decorations [fig. 6.42] surrounds *The Princess of the Porcelain Country* [see fig. 4.45]. Borrowed from a pattern book, two types of Chinese fret sandwich an Egyptian spiral to ornament this dramatic molding.[74] The exotic assemblage of objects on canvas—Japanese kimono worn by a model of Greek descent carrying a Japanese export fan and standing on a Chinese rug—is complemented by Whistler's eclectic mixture of patterns from Eastern cultures distant in space and time. Created in an age of stylized decoration, the *Princess*'s frame is as helpful in reading the picture as the confusion of titles under which the canvas was exhibited.[75]

Whistler designed another variation on the trophy frame by painting notes from Schubert's *Moments musicaux* on a gilt molding originally intended for *The Three Girls* (ca. 1876).[76] Commissioned by Frederick Richards Leyland, that lyrical work remained unfinished and is now partially destroyed.[77] Whistler maliciously transferred the frame to a savage portrait caricature of his luckless former patron [fig. 6.43].[78] *The Gold Scab: Eruption in Frilthy Lucre* (1879) is a thinly painted oil sketch structured around direct quotations from the Peacock Room, including the turquoise color palette and serial feather motifs. Leyland is shown wearing starched shirt frills and playing the piano. His sheet music is emblazoned with a base note embellished with feathers. These repeat the shape

FIG. 6.42 Whistler, detail of frame for *Princess of the Porcelain Country*, 1864–65, cast and gilt ornament on wood. Freer Gallery of Art, Smithsonian Institution, Washington, D.C., Gift of Charles Lang Freer, F1903.91.

of the angry bird's neck in the Peacock Room's central panel. Any viewer unable to make the connection was assisted by additional feathers fringing the capital F of "Frilthy" on the musical score. Known for his frilled shirts and his skill as an amateur pianist, Leyland is here graphically identified with greed. His face and the nearest money bag are rendered in odious ocher pigment. Accustomed by now to being lampooned in the press, Whistler used familiar cartoon techniques—exaggerated pose, distorted features, heavy-handed punning, and references to fine art—to pillory the man he had earlier so daintily thanked for the term "nocturne." In lieu of a piano bench Leyland sits on the "White House," Whistler's new residence forfeited to bankruptcy in 1879. Prior to the forced sale of the artist's possessions, this vitriolic caricature was available for public view at the studio-house in Tite Street.[79] The formal beauty of the canvas "exudes like the scent of a poisonous flower," according to one contemporary report.[80]

In villifying his former patron, Whistler effectively deployed the conventions of the rococo *portrait déguisé*, exhibiting some of the nastiness expressed earlier in another record of an ugly quarrel between artist and patron—Anne-Louis Girodet's *Mlle. Lange as Danaë* [fig. 6.44].[81] In 1799 an actress insulted Girodet by demanding that he withdraw her commissioned portrait from the Salon as it "compromises my reputation as a beauty." When Anne-Françoise-Elizabeth Lange offered to pay only half the cost of her likeness, the outraged Girodet not only withdrew it from the Salon but also returned it to her in shreds. In its place he hung a wicked satire attacking her vanity and greed:

> Girodet chose to evoke the myth of Danaë, who was visited by the amorous Zeus in the form of a shower of gold. The modern Danaë hastens to catch this rain of gold coins in her flimsy draperies, but one escapes and mortally wounds a dove, symbol of fidelity, who perishes at her side. She is attended by an amor who (like her mistress Danaë, the putto at left, and the laughing turkey) wears peacock feathers, symbols of vanity.[82]

To make things worse, the turkey cock, a caricature of Mlle. Lange's husband, drops a torch that is about to burn a scroll inscribed *Asinaria*. This classical Roman comedy by Plautus relates the story of a courtesan patronized by both father and son.

Although it attracted very little attention when auctioned at Sotheby's in 1880, *The Gold Scab* did not go unnoticed by *Punch*. In graphic form, Whistler's visual satire was satirized yet again. In July 1881, as Whistler was attempting to rejuvenate his

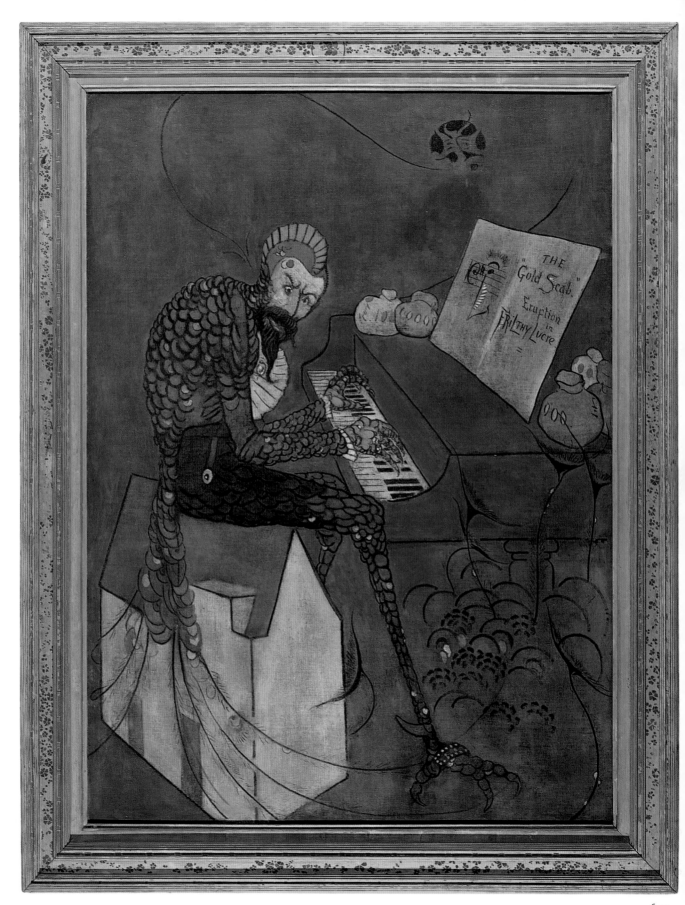

6.43

257

6.44

6.43 Whistler, *The Gold Scab: Eruption in Frilthy Lucre*, oil and canvas, 73½ x 55 inches; Whistler-designed frame made by Foord & Dickinson, London.
Fine Arts Museums of San Francisco, Gift of Mrs. Alma de Bretteville Spreckels through the Patrons of Art and Music, 1977.11.

6.44 Anne-Louis Girodet de Roucy Trioson (1767–1824), *Portrait of Mlle. Lange as Danae*, 1799, oil on canvas, 25¼ x 21¼ inches, with original frame.
The Minneapolis Institute of Arts, the William Hood Dunwoody Fund.

career following his return from Venice, *The Gold Scab* reappeared as the basis for one of "Punch's Fancy Portraits"—the Russian pianist Anton Grigorevich Rubinstein as "'Il Demonio' Rubinstein-O' [fig. 6.45].[83] The text—conflating cultural events and figures—reads, "As this accomplished but somewhat eccentric foreigner is said to have taken away about ten thousand pounds English coin this season, he may be considered as not only having composed *Demonio*, but having also made de-Money-o." "Rubinstein-O's" long barbed tail reminds us that, after the traumas of 1878, Whistler began adding a barbed sting to the tail of his anthropomorphic signature butterflies, particularly when he wished to make a point in print. In Sambourne's cartoon, Whistler is guilty by association—for being a foreigner in Britain, for using mystifying musical titles, for daring to charge high prices, for immodest self-promotion. Such conduct was looked on askance. When George Eliot based a character on Rubinstein a few years earlier, she'd written that, "he had not yet that supreme world-wide celebrity which makes an artist great to the most ordinary people by their knowledge of his great expensiveness."[84]

The cartoonist's exploitation of *The Gold Scab* might have warned Whistler that publicity seeking could be either a gold mine or a minefield. By cultivating the socially prominent, Whistler was playing with fire. Many other cartoons parody the social-climbing practices of middle-class hostesses, anxious to lionize currently famous or well-born cultural leaders. Cartoons such as "The Profession of Beauty" show that self-seeking publicity was neither uncommon nor limited to fine art [fig. 6.46]. In this cartoon, a "Business-like Mama" visits a hosier's shop in London's chic West End, seeking to have photographs of her daughter displayed in the window "with her name in full." By framing the daughter in question against the shop window as if she were a dress dummy, the cartoonist underscores the crass pragmatism of such a transaction. While "Mama" is willing to pay for her daughter's expo-sure, Lillie Langtry and other notable professional beauties enjoyed such publicity gratis, joining professional actresses like Sarah Bernhardt who advanced their careers through this very means. Again, fashion, performance, and display provide durable constants for interpreting these images of self-commodification.

"IL DEMONIO" RUBINSTEIN-O.

6.45

FIG. 6.45 Linley Sambourne, *"Punch's Fancy Portraits—No. 41. 'Il Demonio' Rubinstein-O,"* wood engraving from *Punch*, 23 July 1881. Library of Virginia, Richmond

Like a controversial actress, a notorious artist did not have to pay for publicity. Whistler's feisty exchanges with the press, initiated during the 1860s, became a modus operandi throughout his long career. At first, Whistler tried gentle means to counter feeble jokes about his work. In 1878 he gave an interview for the "Celebrities at Home" series in *The World*:

> "Why not?" exclaims the artist, with true southern vivacity, his bright grey eyes sparkling with excitement; "why should not I call my works symphonies, arrangements, harmonies, nocturnes, and so forth? I know that many good people whose sense of humour is not very capacious think my nomenclature funny and myself eccentric.... But why do not they give me credit for meaning something, and knowing what I mean."[85]

THE PROFESSION OF BEAUTY.

6.46

Understandably, over the years his voice became ever more shrill. By 1890, when he printed an edited version of this interview in *The Gentle Art of Making Enemies*, he had lost the sense of humor that leavens the earlier exchange. His book of carefully selected correspondence and commentary was anything but gentle, and Whistler gave the revised interview a provocative title — "The Red Rag." Little wonder. Rebarbative articles and cartoons constantly linked him and his work with frivolity. As we have seen, Whistler figures in several types of cartoon prevalent during the last third of the nineteenth century, the years when new audiences for art were of special interest to journalists and their expanding circle of readers. Whistler was personally caricatured, specific works were lampooned, and his radical ideas lent themselves not only to parodies questioning aesthetic change, but also to cartoons exploring broader disruptions in the cultural status quo.

In *Harmony in Green and Rose: The Music Room* [see fig. 3.30], an early harbinger of changing women's roles, Whistler's niece Annie holds a large-format art book on her lap. As publishers took advantage of new technologies for reproducing images, lavishly

6.46 George du Maurier, *"The Profession of Beauty,"* wood engraving from *Punch*, 23 July 1881. Library of Virginia, Richmond.

FIG. 6.47 George du Maurier, *"The 'Édition de Luxe,'"* wood engraving from *Punch's Almanack for 1883*, 7 December 1882. Library of Virginia, Richmond.

illustrated tomes—forerunners to the "coffee table" books of our own time—played an important role in stimulating art consumers' appetites. Yet mishaps befall the eager reader of an unwieldy "Édition de Luxe" in a cartoon from *Punch* [fig. 6.47].

In 1885, responding to years of criticism and caricature, Whistler issued the "Ten o'Clock" lecture as a manifesto in which he declared his independence from the "vulgarity" of the common man. Like "The Red Rag," the "Ten o'Clock" would reach generations of readers via the exquisitely laid out pages of *The Gentle Art of Making Enemies*. Yet the book's last rubric, "Final Acknowledgments," ends on rather a sad note: "It was our amusement to convict—they thought we cared to convince!"[86] Clearly, the power of the press, which played a significant part in establishing the mythical Whistler, proved a mixed blessing, as the artist himself was only too aware.

7. A Little White Paper

The story of the beautiful is already complete—hewn in the marbles of the
Parthenon, and broidered, with the birds, upon the fan of Hokusai…

—James McNeill Whistler, "Ten o'Clock" (1885)

Permitted to inhabit neither the realm of the ideal nor the realm of the real,
to be neither aspiration nor companion, beauty comes to us like a fugitive bird
unable to fly, unable to land.

—Elaine Scarry, *On Beauty and Being Just* (1999)

On February 14, 1885, *The World* sent Whistler a cheering little valentine, promising readers that the American expatriate artist's forthcoming lecture at Prince's Hall, Piccadilly, would be well worth "an attentive hearing":

Those who have met Mr. Whistler in society know that he is one of the most amusing of companions, and that his bons mots are unique. The artistic event of the opening season will, of course, be Mr. Whistler's "Ten o'Clock."[1]

Six days later, clad in dark evening dress and sporting his "historical White Lock well to the forefront," Whistler delivered what would become his most famous theoretical statement on art [fig. 7.1].[2] The hall seated about eight hundred and was well filled with "as fashionable, as literary, and as artistic an audience as London could muster." One critic noted, "Had [Whistler] been on a stage all his life he could not with more coolness meet a greater audience."[3]

Journalists providing initial coverage were equally riveted by the extravagant jewels flashing in the audience and the sparkling witticisms emanating from the stage. Whistler studded his prose with colorful metaphors, sprinkling clever puns on the script just as he touched bits of color to pastel drawings structured in black and white. His verbal fireworks included scintillating passages fueled by deep antipathy toward

OPPOSITE: Detail from fig. 7.26.

mainstream Victorian art, particularly the Ruskinian obsession with "truth" divined from nature:

> [The artist] looks at [nature's] flower, not with the enlarging lens, that he may gather facts for the botanist, but with the light of the one who sees in her choice selection of brilliant tones and delicate tints, suggestions of future harmonies—He does not confine himself to purposeless copying, without thought, each blade of grass, as commended by the inconsequent—but in the long curve of the narrow leaf, corrected by the straight tall stem, he learns how grace is wedded to dignity, how strength enhances sweetness, that elegance shall be the result.…In all that is dainty and lovable he finds hints for his own combinations, and *thus* is Nature ever his resource and always at his service.[4]

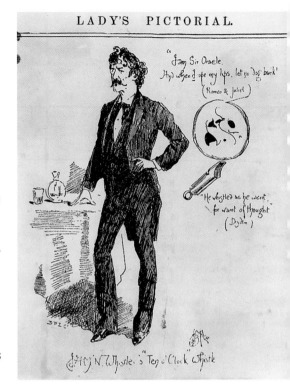

7.1

Evaluating the natural world as a trigger for the artist's imagination, a view that stems from the Rococo,[5] Whistler also flatly denied Ruskin's pious equation of morality and art, insisting that laxity could not limit creativity. The artist whose mistresses of the 1850s, '60s, and '70s appear frequently in his work denigrated as "sublimely vain" the belief that a nation "shall live nobly or art perish." He went on, "At our own option is our virtue. Art in no way we affect."[6]

The lecture stands as a modern moment in the theatrical performance of the artistic self, but the past was a constant presence. Whistler cited numerous great artists—Rembrandt, Tintoretto, Veronese, Velázquez. He also delivered his thoughts using an old-fashioned format. As one journalist noted, "The ten-and-sixpence per seat function… has rehabilitated and made fashionable the ancient lecture, and added a new amusement to a world by no means full of fun after dinner."[7] Repeating his talk at both Oxford and Cambridge, Whistler published various versions before he incorporated the "Ten o'Clock" into the pages of *The Gentle Art of Making Enemies* in 1890.[8] The text has remained widely available ever since.

Along with glamour-stricken accounts in the fashionable press, the "Ten o'Clock" received more thoughtful commentary from Oscar Wilde and Algernon Swinburne, each a target for potshots from Whistler's pulpit. Their responses were not entirely

FIG. 7.1 *"J. A. McN. Whistler's 'Ten o'Clock' Whistle,"* from *Lady's Pictorial,* February 1885. Glasgow University Library, Department of Special Collections.

negative, but Wilde went too far, claiming that "the poet is the supreme artist, for he is lord and master of colour and of form, and the real musician besides, and is lord over all life and all arts." Swinburne characterized the lecture itself as a "light and glittering bark" captained by a "brilliant amateur in the art of letters," warning that so fragile a craft required careful steering between "the Scylla and Charybdis of paradox and platitude." Whistler's negative reaction to these soon-to-be-former colleagues reinforces our sense of the "Ten o'Clock" as a white paper, the artistic analogue to an official position paper on some matter of international import.[9] For proclaiming his aesthetic agenda with consistency, strength, and conviction, Whistler would become an acknowledged precursor of twentieth-century formal abstraction.

The "Ten o'Clock" lecture solidified Whistler's aesthetic boundaries even as its author scorned any pretense of tasteful refinement. At the same time, Whistler defended popular taste:

> It is…no reproach to the most finished scholar or greatest gentleman in the land that he be absolutely without eye for painting, or ear for music—that in his heart he prefer the popular print to the scratch of Rembrandt's needle—or the songs of the [Music] Hall to Beethoven's "C minor Symphony"—if he but have the wit to say so—and do not feel the admission a proof of inferiority.[10]

Class discord had been escalating for more than a century by the time Whistler took the podium at Prince's Hall. As we have seen, in earlier pleasure gardens, art helped establish social divisions as surely as clothing and speech patterns did. Given his precarious poise between artistic bohemianism and Victorian respectability, Whistler had little choice but to accommodate this general schism within his cultural milieu. His consistent lowering of an aesthetic veil between subject and viewer supported his rhetoric; yet, as we will shortly see, in the choice of subject matter itself, Whistler might seem to find himself at sixes and sevens.[11]

From the outset, the "Ten o'Clock" has been interpreted as Whistler's manifesto of aesthetic isolationism. The same detached air governs the barely ruffled surfaces that Whistler achieved in oil, watercolor, ink, pastel. An inverted rainbow of diaphanous blue-green and turquoise separates us from the space occupied by *Annabel Lee* (1885–87) [fig. 7.2].[12] Head cast down and back turned, the figure is as inaccessible as she is

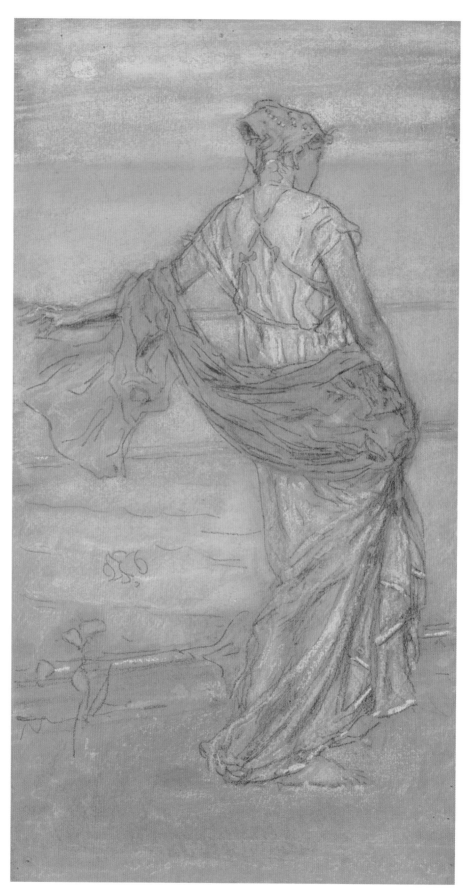

beautiful. Similarly, Whistler stood firm on the *painter*'s exalted, if lonely, position as one chosen, with "the mark of the Gods upon him."[13] Art—herself "a goddess of dainty thought"—proposed "in no way to better others," he told his audience. She sought "the artist alone." According to Whistler, the artist's brain was "the last alembic" through which "is distilled the refined essence of that thought which began with the Gods, and which they left him to carry out."[14]

Whistler's mother had done her level best to ground her son with a firm religious foundation. However, he built upon it after her death in 1881 in ways that might have shocked her. Like the Reverend William John Loftie, author of *A Plea for Art in the House, with special reference to the economy of collecting works of art, and the importance of taste in education and morals* (1876), Whistler cast himself in "the character of the Preacher," going so far as to paraphrase verses from the Bible almost verbatim in the "Ten o'Clock."[15] Despite his "great hesitation and much misgiving," Whistler's lecture, larded with biblical language, was as proscriptive as any Aesthetic movement taste-making text. "Art," said Whistler, "is limited to the infinite, and beginning there cannot progress."[16] Such determinist pronouncements recall predestination—the "Doctrine of the Elect"—thundered from the pulpits of Puritan New England a century and more before Whistler was born in Lowell, Massachusetts.[17]

At this time, audiences were quite used to aesthetic exhortation—whether in lectures, essays, articles, or household manuals. As Whistler himself complained,

> The people have been harassed with Art in every guise, and vexed with many methods as to its endurance. They have been told how they shall love Art, and live with it. Their homes have been invaded, their walls covered with paper, their very dress taken to task—until, roused at last, bewildered and filled with the doubts and discomforts of senseless suggestion, they resent such intrusion, and cast forth the false prophets, who have brought the very name of the beautiful into disrepute.[18]

However, Whistler's message—received as elitist—wasn't any more reassuring than others delivered to an audience troubled by commingled faith and doubt on questions of scientific, industrial, social, and cultural progress.

Reverend Loftie warned of forgery, imitation, condition problems, and fluctuations of taste in the art market. He steered his readers away from collecting anything

FIG. 7.2 Whistler, *Annabel Lee*, ca. 1885–87, pastel on brown paper, 13 x 7⅛ inches. Freer Gallery of Art, Smithsonian Institution, Washington, D.C., Gift of Charles Lang Freer, F1905.129.

but narrative pictures. He added, "The first advice I should give anyone who proposed to embark in old masters would be, 'Don't.'" Modern prints were a safer bet, but Loftie averred, "To the general taste Mr. Whistler's ragged style of rapid execution is absolutely without meaning."[19] In the "Ten o'Clock," Whistler countered by rejecting invidious distinctions between "the painting that elevates" and "the panel that merely decorates," reversing the argument that art and uplift could be linked. He told his genteel listeners that "polish, refinement, culture and breeding, are, in no way, arguments for artistic result."[20] This both amused and confounded his society audience, but at least for the moment it didn't stimulate many to collect contemporary art by Whistler or his followers, as a sluggish secondary market for Whistler's work into the 1890s indicates.[21]

The original manuscript for the "Ten o'Clock" offers ample evidence that Whistler's pen captured the verbal equivalent of his painting style, marked by the primacy of tenebrous color:

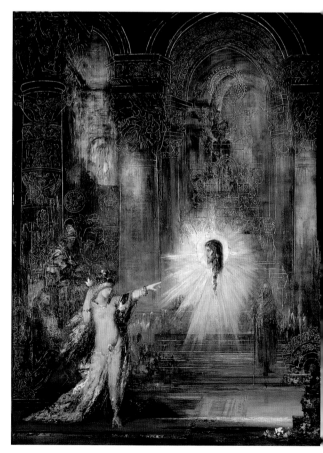

> In the citron wing of the pale butterfly, with its dainty spots of orange, he sees before him the stately halls of fair gold, with their slender saffron pillars, and is taught how the delicate drawing high upon the walls shall be traced in tender tones of orpiment, and repeated by the base in notes of graver hue.[22]

Vivid descriptions of art or architecture intended to conjure the subject in the mind's eye are as old as ancient Greek rhetoric passed down through both Byzantine and Western traditions. Among the historic examples are Lucian of Samosata's *The Hall*, describing an opulent chamber decorated with scenes from mythology, and Paulus Silentiarius's text celebrating Emperor Justinian's rebuilt dome of Hagia Sophia—a marvel of light and space, arched over a resplendent multi-colored marble interior.[23]

Whistler's language carries not only overtones of the King James Bible but also Shakespearean rhetorical

268

7.3

FIG. 7.3 Gustave Moreau (1826–1898), *The Apparition (L'apparition)*, ca. 1876, oil. Musée Gustave Moreau, Paris.

flourishes, as "oh, fie!" One of his slings and arrows for Ruskin was that the "Sage of the Universities" just "babbles of green fields," a quote from Falstaff's death scene in *Henry V.*[24] However, tradition aside, Whistler's extravagant prose also expresses isolationism, prompting us to consider another rejection of unadorned naturalism contained in a text much closer to him. The year before Whistler delivered his lecture, Joris-Karl Huysmans, a French critic and novelist, published *À rebours* (*Against Nature*). To create his central character, named Des Esseintes, Huysmans distilled an amalgam of several contemporary and historic aesthetes known to Whistler.[25] In a passage Whistler must have read, Huysmans's vaguely aristocratic gentleman of refined tastes waxes eloquent on Herod's palace, how it

> soared up, like an Alhambra, on slender columns iridescent with Moorish tiles that seemed to be embedded in silver and cemented in gold; arabesques, beginning at diamonds of lapis lazuli, swooped along the length of the cupolas whose surfaces of mother-of-pearl marquetry were criss-crossed by iridescent lights, by flashes of prismatic colour.[26]

The sumptuous but sinister edifice described by Huysmans's fictional character is based on an actual watercolor, *The Apparition,* exhibited at the Salon of 1876 and now in the Louvre. Numerous related versions also survive [fig.7.3]. In the novel, des Esseintes "collects" *The Apparition* along with a number of other know works of art.[27] Through the eyes of a fictive collector of old masters, rare books, and riveting experiences, Huysmans portrayed an antagonistic vision of contemporary society. Whistler's similar verbiage backfired to some extent. By commenting on "stately halls" in the "Ten o'Clock" Whistler hoped his audience would—through extended metaphor—begin to grasp his general approach to painting and decoration. However, Wilde, Swinburne, and other critics felt the antagonism that Whistler failed to eliminate from his text.

Analyzing *Against Nature*, Nicholas White fixes the book's stylistic niche at "the very edge of readability." He contrasts its affected text, marked by "neologisms, improprieties, solecisms, and barbarisms" with the "simplicity of Naturalist immediacy" characteristic of Huysmans's earlier writing. With its mannered prose, *Against Nature* "sits on the difficult boundary between illumination and alienation."[28] Whistler had occupied a similar shadowland since the late 1860s. Huysmans's letter to Stéphane Mallarmé in 1882 on substituting "the pleasures of artifice for the banalities of Nature"

has its precursor in Whistler's earlier letter to Fantin-Latour rejecting Courbet's Realism.[29] Now, reinforcing his firm aesthetic commitment with passionately aesthetic phrasing, Whistler dismissed "vulgarity" in no uncertain terms. In light of modern culture's fascination with self-styled outsiders, Whistler's public "otherness" might well remind us of later cinema celebrities such as Greta Garbo. In the annals of art history, Whistler wanted to be alone.

Huysmans and Whistler shared an inspiration for luxuriant language. During the mid-nineteenth century Edmond and Jules de Goncourt tried to synthesize the vocations of artist and writer. In projects such as *L'Art du XVIIIe siècle* (published 1859–75), they blurred distinctions separating historian, art critic, and artist. (Jules was an etcher whose work illustrated their writing on eighteenth-century French artists from Watteau and Boucher to minor painters.) The Goncourt brothers created an *écriture artiste* based on two central concepts—color and the value of suggestive fragments. Sketches or drawings were worth more to them than finished literary or academic painting. David Scott notes, "This new desire for identity or synthesis was reflected in their concern with developments in precisely those areas that were fundamental to both literature and painting: style, technique, and taste."[30] Whistler's cavil against Victorian narrative painting coincides with the Goncourt brothers' belief that all traces of narrative literature should be banished from painting in order to allow its sensual physicality to shine forth. Whether on canvas or paper, Whistler's images often are only suggestive fragments of what the artist actually observed.

As we have seen, Whistler's rarefied color harmonies were prized examples of artful, avant-garde interior decoration. Obsessively concerned with aestheticized domestic space, Whistler joined others in providing real-life exemplars of recherché interior decoration ranging from the deceptively simple (Godwin) to the frankly florid (King Ludwig II of Bavaria). Again, a link to the Goncourts and Huysmans can be discerned. Following Edmond de Goncourt's descriptions of his art-filled home in Auteuil, fictionalized in the pages of *La Maison d'un Artiste* (1881), Huysmans celebrated over-the-top aestheticism, liberally splashing *Against Nature* with highly mannered interior schemes combining luxurious objects with multihued backgrounds. Above all other possibilities Des Esseintes preferred the "deceptive splendours" and "febrile sourness" of orange. The color was "irritating, morbid"—properties Edmond de Goncourt claimed to have discovered earlier

in Auteuil.[31] In the "Ten o'Clock," Whistler's citron butterfly fluttered its orange-spotted wings against walls tinted with orpiment, a brilliant yellow pigment made with arsenic trisulfide. The audience might more easily have recognized a vernacular trade name such as patent yellow, used earlier by Sir John Soane, or Turner's yellow, but Whistler practiced his own preciously worded version of *l'écriture artiste*, taking his audience to the limits of their comprehension.[32]

Huysmans's description of another painting by Moreau, *Salomé Dancing Before Herod* (1876), is determinedly decadent, leaving little to the imagination—a tactical error that later ruined Oscar Wilde:

> A pensive, solemn, almost august expression on her face, [Salomé] begins the lubricious dance which is to awaken the slumbering senses of the aging Herod; her breasts rise and fall, their nipples hardening under the friction of her whirling necklaces; the diamonds adhering to her moist skin glitter; her bracelets, her belts, her rings flash and sparkle; on her triumphal gown—pearl-seamed, silver-flowered, gold-spangled—the breastplate of jewelry, each of its links a precious stone, bursts into flame, sending out sinuous, intersecting jets of fire, moving over the lustreless flesh, the tea-rose skin, like a swarm of splendid insects whose dazzling wing-sheaths are marbled with carmine, spotted with saffron yellow, dappled with steely blue, striped with peacock green.[33]

For Des Esseintes, Salomé becomes "the accursed Beauty," a creature at once "monstrous, indiscriminate, irresponsible, unfeeling," who "poisons everything that comes near her."[34]

Huysmans's difficult masterwork soon achieved cult status, reinforced in Britain by its identification with the yellow book of unpleasantries prized by the protagonist in *The Picture of Dorian Gray*, Wilde's novel of 1891, as well as the controversial English publication of Wilde's *Salomé*, with illustrations by Aubrey Beardsley, in 1894.[35]

Hyperaesthetic narcissism heralds the advent of fin de siècle literary and artistic decadence. How gentle and sedate, by contrast, is Whistler's *Annabel Lee*, despite the drawing's connection to Edgar Allan Poe, beloved writer of French Symbolists. In such works, Whistler maintained a delicate balance, skirting but not permanently overstepping acceptable boundaries.

Although Whistler regularly cast art in the role of the capricious yet generous mistress, she was far from unfeeling. She appears in the "Ten o'Clock" like the conventional

literary harlot with a heart of gold. Art—"the cruel jade"—denied her favors to many a supplicant but lavished treasures upon her artist-lover, he told the bejeweled ladies and gentlemen in his audience.

Even in the most forward of his late pastels Whistler's ideal of beauty remains positive. Backed by the old master tradition of orientalisme, Whistler presents *The Arabian* (1890–92) [fig. 7.4], a pretext not only for the nude but also for an extravaganza of richly colored draped fabrics. The viewer can contemplate this image for its beauty alone, without Moreau's narrative pictorial counterpart in the guise of a leering old king. Nor is *The Arabian*'s beauty compromised by the thought that Whistler surrounded his subject with draperies he probably picked up in a rag shop. Whistler depicted similar trappings in a number of urban images where draperies are either for sale or used to shade other goods on offer.

Against Nature dramatizes "the apparent incompatibility of elite aesthetic taste, on the one hand, and social and political engagement on the other."[36] Having already generated the notion that he had repudiated French Realism, Whistler worked overtime on the "Ten o'Clock," using poetic, even flowery language to codify that sense of separation by erecting a semipermeable barrier of beautiful style. Yet he continued to seek a gentle, genteel synthesis of seemingly opposite poles. Familiar subjects drawn from

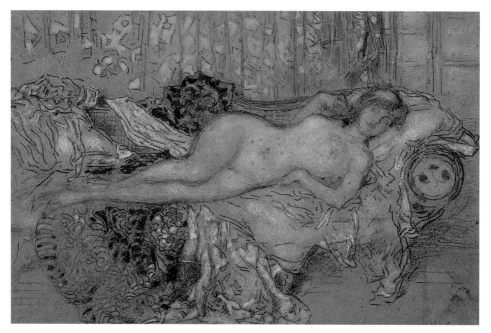

7.4

FIG. 7.4 Whistler, *The Arabian*, ca. 1890–92, pastel, 7 x 11 inches, inscribed with butterfly. Hunterian Art Gallery, Glasgow University, Birnie Philip Bequest.

modern life are layered with formal choices that distance the final image from any clear narrative or social commentary. Nowhere is this more evident than in Whistler's pictures of shop fronts.

Undistinguished architectural subjects made beautiful through formal choices appear in some of Whistler's earliest work. At the 1859 Paris Salon, *La Marchande de Moutarde* offered visitors an outsider's glimpse of daily life framed in a doorway [fig. 7.5]. This convention would become standard fare in Whistler's oeuvre. He summed up in the "Ten o'Clock" that the beautiful could be sought and found "in all conditions and in all times, as did her high priest, Rembrandt, when he saw picturesque grandeur and noble dignity in the Jew's quarter of Amsterdam and lamented not that its inhabitants were not Greeks."[37]

Whistler's interest in shop fronts gained strength during his Venetian sojourn in the late 1870s [fig. 7.6]. In the midst of his commission to create new etchings of Venice for the Fine Art Society, Whistler assured its director, Marcus Huish, that he had "learned to know a Venice in Venice that the others never seem to have perceived."[38] However, American author and editor William Dean Howells used the phrase "Venice in Venice" in the very first chapter of *Venetian Life* (1866). Indeed, a vast body of tourist literature precedes Whistler's discovery of Venetian byways. We may safely presume that some of those books guided Whistler, like the traditional Italian cicerone hired for the eighteenth-century gentleman's grand tour, prompting decisions to forgo tourist spots in favor of obscure courtyards and canals.

7.5

273

Howells—and Whistler after him, no doubt—frequently found himself ensnared by "the intricacies of the narrowest, crookedest, and most inconsequent little streets in the world" or "cast away upon the unfamiliar waters of some canal as far as possible from the point aimed at." Regularly lost, he found

> all places had something rare and worthy to be seen: if not liveliness of sculpture or architecture, at least interesting squalor and picturesque wretchedness; and I believe I had less delight in proper Objects of Interest than in frowzy heads and beautiful eyes from the high, heavy-shuttered casements above. Every court had its carven well to show me, in the noisy keeping of the water-carriers and the slatternly, statuesque gossips of the place. The remote and

FIG. 7.5　Whistler, *La Marchande de Moutarde*, 1858, etching, 5th state, K22, 6⅛ x 3½ inches.　VMFA, Gift of Mr. and Mrs. Helmut Wakeham.

274

7.6

FIG. 7.6 Whistler, *Fruit Stall*, 1879–80, etching, 6th state, κ200, 8 ¹³⁄₁₆ x 5 ¹⁵⁄₁₆ inches. Freer Gallery of Art, Smithsonian Institution, Washington, D.C.,
Gift of Charles Lang Freer, F1887.7.

FIG. 7.7 Whistler, *The Marble Palace*, 1879–80, chalk and pastels on brown paper, 12 x 6 inches. Freer Gallery of Art, Smithsonian Institution, Washington, D.C.,
Gift of Charles Lang Freer, F1905.123.

CHAPTER 7 | A LITTLE WHITE PAPER

7.7

noisome canals were pathetic with empty old palaces peopled by herds
of poor, that decorated the sculptured balconies with the tatters of epicene
linen, and patched the lofty windows with obsolete hats.[39]

Howells quoted Ruskin's observation that "The Venice of modern
fiction and drama is a thing of yesterday, a mere efflorescence of decay,
a stage dream."[40] This notion might have comforted Whistler when
one of his etchings, *Little Venice*, was disparaged in 1881 as "not the
Venice of a maiden's fancy."

Shortly after both content and packaging of Whistler's Venetian
material at the Fine Art Society startled Londoners in 1880 and '81,
Henry James introduced his 1882 paean to Venice by acknowledging
that, "of all the cities of the world it is the easiest to visit without
going there."[41] James verbalized Whistler's elegant visual evocation of remote spots in
Venice [fig. 7.7]:

> It is not of the great Square that I think, with its strange basilica and its high arcades, nor
> of the wide mouth of the Grand Canal, with the stately steps and the well-poised dome
> of the Salute; it is not of the low lagoon, or the sweet Piazzetta, nor the dark chambers of
> St. Mark's. I simply see a narrow canal in the heart of the city, — a patch of green water
> and a surface of pink wall.…The pink of the old wall seems to fill the whole place; it sinks
> even into the opaque water.…On the other side of this small water-way is a great, shabby
> facade of gothic windows and balconies…on which dirty clothes are hung, and under which
> a cavernous-looking doorway opens from a low flight of slimy water-steps. It is very hot
> and still, the canal has a queer smell, and the whole place is enchanting.[42]

By the end of his life, Whistler's "Venice in Venice"—his focus on humble
scenes—had become as much an art market cliché as the romanticized "maiden's fancy"
of previous decades.[43]

Before, during, and after Whistler's Venetian shows (1880, 1881, 1883) London
galleries regularly brokered images of Venice by a wide variety of artists. A painting
of a doge owned by Ruskin and brought into court during the libel suit that bankrupted
Whistler, sending him to Italy, sheds light on the commercial viability of art related to
the Serenissima. Then thought to be by Titian, this portrait was part of the evidence intro-
duced to argue against Whistler's "lack of finish" [fig. 7.8]. But aesthetic considerations—

276

7.8

FIG. 7.8 Vincenzo Catena (fl. 1506–1531), *Portrait of the Doge Andrea Gritti*, ca. 1523, oil on canvas, 38¼ x 31¼ inches. National Gallery, London.

not to mention the reputation of its purported maker—account only partially for Ruskin's attraction to the portrait. A. N. Wilson notes:

> One of [Ruskin's] reasons for wanting the portrait of a Doge…was not merely the beauty of this picture as an object. For Ruskin, the mercantile, sea-faring city-state and empire was an emblem of Britain. The good Doge was, like Ruskin's father…, a merchant. Everyone in Venice was "in trade." The Merchant King was the symbol in fact of Ruskin's own class which now rose to prominence in Britain.[44]

Many picturesque Venetian enterprises had counterparts in Whistler's adopted "nation of shop-keepers." On returning to London in November 1880, he began to create fresh images of shop fronts and urban streets [fig. 7.9]. Characterized by strict geometries, suppressed detail, flattened spaces, and close cropping, these have been numbered among his most advanced compositions. The work ignores the concept of the shop window as a locus for consumerism, yet the objects Whistler made were for sale.

Painted at about the time of the "Ten o'Clock" lecture, *A Chelsea Street* melts into a dream of soft color [fig. 7.10]. The picture probably represents a tobacconist and news agent on the right, but the business of the shop to the left, shaded by a white awning, is open for interpretation. Arbitrarily partial lettering in a large window—"icholas importers of"—provides a tantalizing clue to the precise location of the image, but ultimately Whistler has frustrated later scholars.[45] At once mundane and mesmerizing, *A Chelsea Street* amplifies Wilde's general perception that "lying and poetry are arts."[46]

Whistler's cropped compositions recall abbreviated urban vignettes by various illustrators and photographers embellishing popular fiction, travel literature, and social commentary of the early and mid-nineteenth century. However, Whistler's neutral stance brings to mind not Victorian purple prose but the work of reformist Henry Mayhew. His *London Labour and the London Poor* (1851–52) pioneered a straightforward treatment of the city's most impoverished inhabitants. Remarkable for its

7.9

7.9 Whistler, *T. A. Nash's Fruit Shop*, ca. 1886, etching, 2nd state, K263, 6⅞ x 4⅞ inches. Freer Gallery of Art, Smithsonian Institution, Washington, D.C., Gift of Charles Lang Freer, F1903.42.

avoidance of cheap sentiment, Mayhew's work was based on actual contact with the men and women he wrote about. For example, after interviewing several costermongers Mayhew reported that they "almost universally treat their donkeys [as] not only favourites, but pets."[47] This is a far cry from more harrowing accounts of starved and beaten urban animals typical of sensationalist Victorian literature.[48] The placid donkey pulling a cart in *A Chelsea Street* offers a similarly restrained approach, one we often witness in Whistler's city scenes.

As the eighteenth century waned, centralized commerce gained ground. Earlier customs began to disappear, but a continuing stream of images—from crude wood-cuts to sophisticated engravings by William Hogarth and George Cruikshank—kept the old ways alive in the urban imagination. These images, gathered into books aimed at both children and adults, often featured the gradually vanishing street vendors.[49] One such compendium, titled *Old London Cries and the Cries of To-day with Heaps of Quaint Cuts*, noted, "Many of the old cries, dying out elsewhere, may still be familiar…in the back streets of second- and third-rate neighborhoods."[50] The book was published in 1885, the year Whistler delivered his "Ten o'Clock" lecture.

Often Whistler chose to work in just such marginal neighborhoods—the run-down sections of a city rapidly changing at the hands of developers.[51] He never discussed a "London in London," but the old cries echo in his otherwise innocuous pictures of stalls selling birdcages, nuts, oranges, melons, fish, old clothes, and used furniture. While so subtly deployed as not to become a bore, Whistler's stock elements—the babe in arms, the defiant little figure with outspread legs, the costermonger's cart at rest—become as familiar as the sound of vendors in the city's streets.

For his controversial 1883 white and yellow exhibition at the Fine Art Society, Whistler carefully placed a few London plates among the Venetian etchings that dominated the gallery walls. Half a dozen views of London were incorporated into his portfolio issued by the Dowdeswells brothers in 1886 and popularly known as the "Second Venice Set." Apparently Whistler even considered creating another portfolio devoted to London. While it did not materialize, shop-front scenes would continue to engage his attention for the next two decades.[52]

For a number of urban scenes, including *Drury Lane*, a print that figured in both the white and yellow exhibition and the Second Venice Set, Whistler chose a

FIG. 7.10 Whistler, *A Chelsea Street*, 1883–86, watercolor on white paper, 4 ¹⁵⁄₁₆ x 8 ⁹⁄₁₆ inches. Yale Center for British Art, Paul Mellon Collection.

fundamentally narrative device—the title—to trigger a response to his image [fig. 7.11]. The etching is devoid of signage but the street and the neighborhood were fraught with unsavory associations for the Londoners of his day. For art-literate viewers, the name alone would have conjured up *A Harlot's Progress* (1732). Hogarth's set of six engraved vignettes chronicles a country girl's brief career as an urban prostitute who comes to grief in Drury Lane [fig. 7.12], a quarter dating back to Elizabethan times.[53] By the time Whistler worked there, it numbered among the most notorious of Victorian London's many slums.[54]

Earlier, Dickens described Drury Lane and Covent Garden as

essentially a theatrical neighborhood. There is not a potboy in the vicinity who is not, to a greater or less extent, a dramatic character. The errand-boys and chandler's-shop-keepers' sons are all stage struck; they "get up" plays in back kitchens hired for the purpose and will stand before a shop-window for hours, contemplating a great staring portrait of Mr. Somebody or other, of the Royal Coburg Theatre.[55]

Whistler was not alone in combing back streets and alleys for subject matter. In fact, he stepped up the production of his formulaic shop-front imagery at a time when more conventional Victorian artists were elevating contemporary urban scenes from popular culture to high art.[56] Simultaneously, the nation's growing sense of architectural loss encouraged movements aimed at saving or at least recording historic buildings in decaying neighborhoods.[57]

280

7.11

7.12

FIG. 7.11 Whistler, *Drury Lane*, ca. 1880–81, etching, only state, K237, 6⅜ x 4 inches. Freer Gallery of Art, Smithsonian Institution, Washington, D.C., Gift of Charles Lang Freer, F1887.17.

FIG. 7.12 William Hogarth (1697–1764), *A Harlot's Progress*, plate 3, 1732, engraving and etching, 11¹³⁄₁₆ x 14⅞ inches. Elvehjem Museum of Art, University of Wisconsin, Madison, University Fund purchase, 66.8.4.

Nostalgia stimulated demand, as is evident in Augustus Edwin Mulready's *Remembering Joys That Have Passed Away* (1873) [fig. 7.13]. Various inscriptions on the canvas guarantee maximum sentiment— not surprisingly cast in the language of urban performance. Emblazoned with an awkward harlequin resembling famous entertainers from Regency and early Victorian times, a tattered Drury Lane Theater poster engages a little boy and girl.[58] The lidded wooden tray marked "pipe lights" and a coarse broom pinpoint the children as standard types associated with

the working poor: the match seller and the street-crossing sweeper. A notice hastily slapped onto the larger poster warns "the last night." The boy's broom rests on this flyer, injecting a melodramatic possibility that the children just might freeze to death in the falling snow.

Whistler had sent his mother a sketch of a picturesque London street-crossing sweeper as early as 1849.[59] He included one of these familiar urchins at the center of *Little Court*, another London etching added to the Second Venice Set [fig. 7.14]. The figure is so tiny you must hunt for him across the empty foreground that occupies a third of the pictorial space, swept clean of any detail whatsoever. Aesthetic remoteness serves the same function as poignant sentimentality, distancing this icon of urban poverty from the viewer. Humor could also be employed, as we see in a comic song called "Buy a Broom," originally performed at the Theatre Royal, Haymarket [fig. 7.15].[60]

As a young man, Whistler was especially fond of *The Pickwick Papers* by Charles Dickens.[61] He must have known the author's slightly earlier *Sketches by Boz* as well. Dennis Walder finds "the writer's imaginative fancy is often most persuasive when it is not attempting a consciously fictional tale, but when it is engaged with the surface of the city."[62] In "The Streets—Night" Dickens himself evoked London's sinister atmosphere:

FIG. 7.13 Augustus Edwin Mulready (fl. 1863–1905), *Remembering Joys That Have Passed Away*, 1873, oil on canvas, 15 x 20 inches. Guildhall Library, Corporation of London.

7.14

To be beheld in the very height of their glory [the streets] should be seen on a dark, dull, murky winter's night, when there is just enough damp gently stealing down to make the pavement greasy, without cleansing it of any of its impurities; and when the heavy lazy mist, which hangs over every object, makes the gas-lamps look brighter, and the brilliantly-lighted shops more splendid, from the contrast they present to the darkness around.[63]

The year before he delivered the "Ten o'Clock" lecture, Whistler selected *Nocturne: Black and Gold—Rag Shop, Chelsea* for his one-man exhibition at the Dowdeswell Gallery [fig. 7.16].[64] The painting incorporates the stygian darkness of the Cremorne series, broken by little squares of light and populated by a tiny white-clad figure dwarfed by the open doorway that frames her. Whistler's subject—a junk shop stocked with used clothing and bric-a-brac—offers a pointed contrast to the customary haunts of the elegantly dressed audience attending the 1885 evening lecture. In the wake of mass production, as "Birmingham and Manchester arose in their might," Whistler scolded, "Art was relegated to the curiosity shop."[65]

In "Meditations in Monmouth-street" Dickens described the wares of a famous used-clothing market in London's East End:

282

FIG. 7.14 Whistler, *Little Court*, ca. 1880–81, etching, only state, K236, 4 13/16 x 6¾ inches. Freer Gallery of Art, Smithsonian Institution, Washington, D.C., Gift of Charles Lang Freer, F1905.188.

A "Monmouth-street laced coat" was a by-word a century ago; and still we find Monmouth-street the same. Pilot great-coats with wooden buttons have usurped the place of the ponderous laced coats with full skirts; embroidered waistcoats with large flaps, have yielded to double-breasted checks with roll-collars; and three-cornered hats of quaint appearance, have given place to the low crowns and broad brims of the coachman school; but it is the times that have changed, not Monmouth-street.

Dickens went on, "Through every alteration and every change, Monmouth-street has still remained the burial-place of the fashions; and such, to judge from all present appearances, it will remain until there are no more fashions to bury."[66] In mid-century London, the term "Monmouth-street finery" was synonymous with tawdry pretense.[67]

Whistler did picture the sort of high-end shopping area familiar to his listeners in *Regent's Quadrant* (1880–81) [fig. 7.17].[68] However, this etching, peopled with minuscule, partially completed figures that conjure the ghosts of Regency bucks in cutaway coats, is far outnumbered by his prints and paintings of squalid shops selling cast-off garments. These images take us across the city, from the west, where Whistler captured glimpses of Milman's Row, a Chelsea back street, to St. Martin's Lane in the theater district, to Houndsditch in the East End.[69]

Art and life were never completely compartmentalized for Whistler. His shop-front images are contemporary with the rise of modern merchandising in Europe and the United States. Recall the vernacular roots and multifunctional nature of Whistler's "White House." Despite its architectural modernity, the building was intended to serve as home and studio—and shop—a very old-fashioned point of sale. Little by little commercial art dealers took over negotiations that once transpired almost exclusively in the studio. Simultaneously, individual shops purveying all manner of goods were gradually crushed by department stores that drove down their prices, bought up their premises, and homogenized their facades into single entities. Enormous plate-glass display windows obviated the old negotiations between individual buyers and sellers by encouraging impersonal browsing—literally—"window-shopping." As late as the 1890s, when Whistler tried again to establish his own sales gallery, this time

7.15

FIG. 7.16 Whistler, *Nocturne: Black and Gold—Rag Shop, Chelsea*, ca. 1878, oil on canvas, 14¼ x 20 inches. Fogg Art Museum, Harvard University,
Bequest of Grenville L. Winthrop.

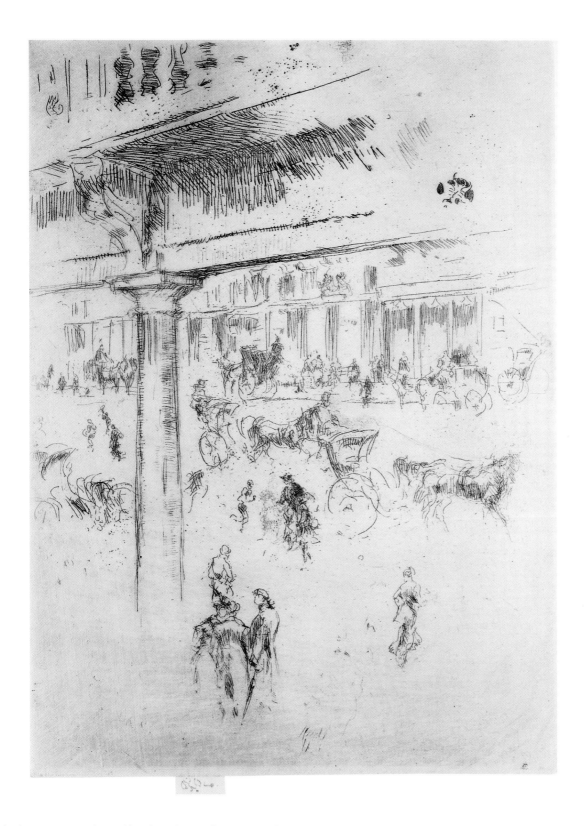

. 7.17 Whistler, *Regent's Quadrant*, 1880–81, etching, 3rd state, K239, 6⅚6 x 4¹¹⁄₁₆ inches. Freer Gallery of Art, Smithsonian Institution, Washington, D.C.,

Gift of Charles Lang Freer, F1903.

outside his home and studio, he looked to the past. The architectural format he chose for *The Blue Butterfly* reprised a Regency shop front punctuated by tiny windowpanes, the type of establishment being absorbed by the department stores [figs. 7.18, 7.19].

Ruthless commercial battles drive Émile Zola's *Au bonheur des dames* (1882), his first novel to be translated into English.[70] The cast of characters is dominated not by a person but by a building — the "Ladies' Paradise." This fictive edifice derived from several department stores actually built in Paris over a thirty-year period. Zola's retail colossus finally defeats the last neighborhood specialty shop holding out across the street:

> The Old Elbeuf, on the other side of the way, had been closed, walled up like a tomb, behind the shutters that were never now taken down; little by little the cab-wheels had splashed them, posters covered them up and pasted them together like a rising tide of advertising, which seemed like the last shovelful of earth thrown over the old-fashioned commerce; and, in the middle of this dead frontage, dirtied by the mud from the street, discoloured by the refuse of Paris, was displayed, like a flag planted over a conquered empire, an immense yellow poster, quite wet, announcing in letters two feet high the great sale at The Ladies' Paradise.[71]

In contrast to the new department store, Zola's description of the failing boutique evokes some of Whistler's shop images:

> A single window opened on a small back-yard, which communicated with the street by a dark alley along the side of the house. And this yard, sodden and filthy, was like the bottom of a well into which a glimmer of light had fallen.[72]

7.18

7.19

FIG. 7.18 *Harrods Ltd., original store*, Knightsbridge, London, photograph, 1901. Company Archive, Harrods Ltd., London.

FIG. 7.19 Whistler, *The Blue Butterfly*, ca. 1896, pen and black ink on off-white laid paper, 3⅞ x 6 inches. Hunterian Art Gallery, Glasgow University, Birnie Philip Beques

286

7.20

7.21

7.20 George Cruikshank (1792–1878), *Monmouth Street*, wood engraving, from *Sketches by Boz* by Charles Dickens, London, 1873.
Library of Virginia, Richmond.

7.21 Whistler, *Cutler Street, Houndsditch*, ca. 1886–88, etching, lst state, κ292, 7 x 5 inches. Freer Gallery of Art, Smithsonian Institution, Washington, D.C.,
Gift of Charles Lang Freer, f1903.153.

Often, Whistler's London street scenes are static, almost suspended in time. Inactivity also marks the Old Elbeuf.

> Now and again a few customers came in; a lady, then two others appeared, the shop retaining its musty odour, its half light, by which the old-fashioned business, good-natured and simple, seemed to be weeping at its desertion.[73]

7.22

An illustration of Monmouth Street by Cruikshank provides the kind of detail implied, but not fully stated, in Whistler's view of a similar street market nearby [figs. 7.20, 7.21]. By including a sign over the door reading "B. Abrahams," Whistler touches lightly on an issue that exercised several writers of the period—often the proprietors of used-clothing shops, particularly in the East End, were Jewish.[74]

Occasionally, Whistler included partial or complete words or phrases in an image, reinforcing information carried by his titles. In *Rag-Shop, St. Martin's Lane*, the word "RAG" etched in a window helps identify the goods purveyed from a Regency shop gone to seed, but when Whistler etched the notorious Petticoat Lane, famous not only for old clothes but also for pickpockets and thieves, his image is so neutral that only a place-name title conveys the specific nature of the site [fig. 7.22]. An anonymous narrative illustration from 1889 captures the squalid hubbub that Whistler entirely suppressed [fig. 7.23].

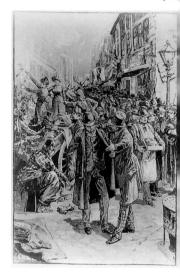

7.23

Whistler's focus on shop fronts coincides with urban street photographs published as *Street Life in London* by John Thomson in 1878.[75] Whistler's small panel painting *Old Clothes Shop, Houndsditch* bears similarities of composition and scale to photographs such as *An Old Clothes Shop, Seven Dials* [figs. 7.24, 7.25]. Thomson drew near to individual inhabitants of the narrow streets, seeking insight into the inchoate mass of the urban poor. As he did so, his camera cut off many details of the dilapidated buildings that form the backgrounds of his images. Whistler, too, regularly omitted architectural detail

FIG. 7.22 Whistler, *Petticoat Lane*, ca. 1886–88, etching, 1st state, K285, 3 ¹¹⁄₁₆ x 5¼ inches. Freer Gallery of Art, Smithsonian Institution, Washington, D.C., Gift of Charles Lang Freer, F1903.305.

FIG. 7.23 *Petticoat Lane Market*, 1889, lithograph, location unknown.

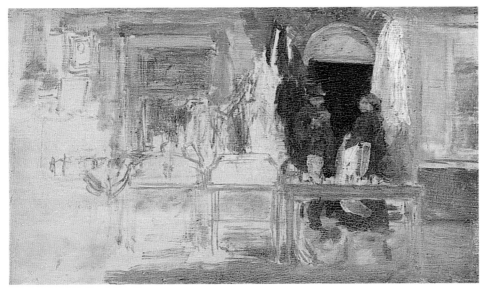

7.25

7.24

above the ground floor, enhancing the sense of strict geometries in these little works. Not only past illustration but also contemporary photography may have had some impact on the artist's thinking.

Marked by measured restraint, Thomson's approach to his subject follows Mayhew's earlier example, avoiding the lurid prose offered by popular Victorian writers on the urban poor. Thomson and his collaborator, Adolphe Smith, particularly cite James Greenwood for having "created considerable sensation by his sketches of low life." However,

> the subject is so vast and undergoes such rapid variations that it can never be exhausted; nor, as our national wealth increases, can we be too frequently reminded of the poverty that nevertheless still exists in our midst. And now we also have sought to portray these harder phases of life, bringing to bear the precision of photography in illustration of our subject. The unquestionable accuracy of this testimony will enable us to present true types of the London Poor and shield us from the accusation of either underrating or exaggerating individual peculiarities of appearance.[76]

If Thomson's aim was proximity, Whistler sought distance. His own demonstrable comfort with slumming was not entirely shared by his primary market audience, and aesthetics provided a buffer between his images and their modern-life sources.

7.24 Whistler, *Old Clothes Shop, Houndsditch*, 1885–90, oil on panel, 5 x 8½ inches. Hunterian Art Gallery, Glasgow University, Birnie Philip Bequest.

7.25 John Thomson (1837–1921), *An Old Clothes Shop, Seven Dials*, woodburytype, from *Street Life in London*, by Thomson and Adolphe Smith, London, 1878.

FIG. 7.26 Whistler, *Chelsea Children*, ca. 1897, watercolor, 5 x 8½ inches, inscribed with butterfly. Freer Gallery of Art, Smithsonian Institution, Washington, D.C., Gift of Charles Lang Freer, F1902.116.

Lacking the "precision of photography" as a strategy for avoiding sentimentality, Whistler resorted to a much older artistic device for sanitizing the threat represented by the urban poor, one already witnessed in the eighteenth-century supper-box paintings at Vauxhall Gardens as well as in later Victorian genre painting. Many of Whistler's shop-front images are populated by appealing youngsters.[77] One typical watercolor has *Chelsea Children* for its upbeat title [fig. 7.26]. Whistler shows an innocuous group intent on a window filled with works of art. Only one child stands alone, gazing into a neighboring fish-monger's shop under a sign reading "Stewed Eels," a food associated with the London poor.[78] When Whistler chose a more dangerous site in Drury Lane or the East End, children regularly temper the potentially off-putting subjects.[79] Like genteel Georgian garden-goers who contemplated their vulgar counterparts in supper-box paintings of children's games and peasants' pastimes, Whistler's privileged Victorian audience did not confront patently down-and-out street types. But by owning such works, they could experience the same sort of familiarity and distance enjoyed by visitors to Vauxhall a hundred years earlier, as discussed in connection with *The Balcony* and its links to public entertainment.

However, at the same time that he was painting, etching, and lithographing small-scale images of shop fronts, Whistler chose a full-size high-style portrait format to present a lowlife urchin in *The Chelsea Girl* [fig. 7.27]. Painted in 1884, the canvas was soon dispatched to Mary Cassatt's brother in Philadelphia. Hands on hips, Whistler's little costermonger stared out defiantly at passing throngs of middle- and upper-class spec-tators visiting the Chicago World's Fair in 1893, long before urban scenes dominated the work of the American realists or those of the so-called Ashcan school.[80] Feet wide apart, she strikes a pose similar to that of a child etched by Whistler amid the cacophony of the London's Clothes Exchange [fig. 7.28]. We encounter a similar confrontational stance throughout Whistler's work, from the unidentified man meeting ladies of the evening at Cremorne to Lady Archibald Campbell in male attire, costumed as Orlando in Shakespeare's *As You Like It*. Borrowed from Velázquez [see fig. 2.32], with echoes of Holbein's *Henry VIII* (after 1537, Walker Art Gallery, Liverpool) as well, this aggressive compositional element reminds us of Whistler's central role in modernism, of the theatrical nature of his work, and of the constant reliance upon old masters that give his pictures such rich resonance.[81]

Swinburne's criticism of the "Ten o'Clock" lecture, taking Whistler to task for the presence of subject matter, offers further insight into Whistler's complex artistic position:

293

7.28

G. 7.27 Whistler, *The Chelsea Girl*, 1884, oil on canvas, 65 x 35 inches. Private collection.

G. 7.28 Whistler, *Clothes Exchange, No. 2*, ca. 1886–88, etching, 1st state, κ288, 9 x 6 inches. Freer Gallery of Art, Smithsonian Institution, Washington, D.C.,
Gift of Charles Lang Freer, F1889.4.

Mr. Whistler's own merest "arrangements" in colour are lovely and effective; but his portraits, to speak of these alone, are liable to the damning and intolerable imputation of possessing not merely other qualities than these; but qualities which actually appeal…to the intelligence and the emotions, to the mind and heart of the spectator.[82]

Earlier, Swinburne had detected in Whistler's *Mother* "an expression of living character, an intensity of pathetic power, which gives to that noble work something of the impressiveness proper to a tragic or elegiac poem."[83] Swinburne would come to embody Whistler's dread "middle-man" or "unattached writer," the professional critic who is lambasted in the "Ten o'Clock" for causing "the most complete misunderstanding as to the aim of the picture," even though it was Swinburne who translated Whistler's aesthetic intentions into words by writing about the *Projects*, an early decorative series, during the 1860s.[84]

Journalists regularly drew analogies between painting and writing. Efforts to help readers accustomed to receiving information through print rather than nonnarrative

7.29

FIG. 7.29 Whistler, *Nocturne: Grey and Gold—Chelsea Snow*, 1876, 18⅝ x 24⅝ inches. Fogg Art Museum, Harvard University, Bequest of Grenville L. Winthrop.

visual images led to crimes most heinous in Whistler's eyes—appropriating and recycling aspects of an artwork so that its aesthetic mission became secondary:

...as [the critic] goes on, with his translation, from canvas to paper, the work becomes his own—He finds poetry, where he would feel it, were he himself transcribing the event—invention, in the intricacy of the mise en scène—and noble philosophy in some detail of philanthropy—courage, modesty, or virtue suggested to him by the occurrence—[85]

Whistler might have objected to a writer's co-option of a painting, but he himself operated like a postmodern architect, borrowing and mixing at will. His omnivorous synthesis is a not a case of "either/or" but of "both/and."[86] Whistler was not above putting out a smoke screen to cover this approach. He said his *Nocturne: Grey and Gold—Chelsea Snow* [fig. 7.29] was just "a snow scene with a single black figure and a lighted tavern," but then averred,

I care nothing for the past, present, or future of the black figure, placed there because the black was wanted at that spot. All that I know is that my combination of grey and gold is the basis of the picture. Now this is precisely what my friends cannot grasp. They say, "Why not call it 'Trotty Veck,' and sell it for a round harmony of golden guineas?"—naively acknowledging that, without baptism, there is no...market! But even commercially this stocking of your shop with the goods of another would be indecent—custom alone has made it dignified. Not even the popularity of Dickens should be invoked to lend an adventitious aid to art of another kind from his. I should hold it a vulgar and meretricious trick to excite people about Trotty Veck when, if they really could care for pictorial art at all, they would know that the picture should have its own merit, and not depend upon dramatic, or legendary, or local interest.[87]

Whistler's own use of narrative devices, from the poem affixed to the frame on *The Little White Girl* at the Royal Academy in 1865 to the canvas *Effie Deans* (1876), inscribed with a passage from *The Heart of Midlothian* by Sir Walter Scott, to the local interest he slyly conjured by "baptizing" some of his etchings with such leading titles as *Drury Lane*, suggests that we simply need not take him at his word. Certainly the *Chelsea Girl*, with her distinctive costume, would prompt a reaction. A press clipping

from the *Whitehall Review* reporting that Whistler was painting "a veritable daughter of the people, with all the defiance of an offspring of the *proletaire* in her attitude" probably refers to this canvas.[88] Her bright yellow scarf, called a "kingsman," was the signature neckwear of men and women who sold fruit and vegetables from street barrows. She also sports a man's hat, perhaps a hand-me-down from an older relative.[89]

In the "Ten o'Clock," Whistler lumped Swinburne together with "the bagman" or street dealer in old clothes, leveling him in the language of the urban picturesque.[90] Wilde, who of course was heavily involved in dress reform, was similarly dispatched when Whistler asked his chic, bejeweled audience if they would "up and follow the first piper that leads you down Petticoat Lane, there, on a Sabbath, to gather, for the week, from the dull rags of ages wherewith to bedeck yourselves."[91] Whistler's listeners, not to mention his targets, would have been fully aware of such an insulting link between art critics and the types described by Greenwood in *Low-Life Deeps* (1876) as "dealers...who collect old wearing apparel—the 'bagmen' who are of the lingering race of London street criers." They could be found in the shabbiest quarter of London, "screeching out with all the strength of their lungs what it is they have got to dispose of, and what the price of it is."[92] Mayhew included a woodcut of a rather threatening bagman in *London Labour and the London Poor* [fig. 7.30]. Similar types frequent books on the London cries.[93]

Street Life in London comments on the old-clothes trade at some length, noting that "disgusting rags" often became "the devil's dust" of woolen manufacturers in Yorkshire. While they knew all about Petticoat Lane, surely Whistler's well-dressed "Ten o'Clock" audience would prefer not to ponder how recycled material "mixed with a certain amount of new wool" might finally "reappear as new cloth, woven according to the latest pattern, and resplendent in the dye of the most fashionable colours. Thus the cloth of our newest coat is, after all, probably made from the cast-off garment of some street beggar."[94]

In 1867, not quite twenty years before Whistler spoke at Prince's Hall, the second Reform Act granted the vote to many workingmen in towns and cities.[95] The act was largely the work of Benjamin Disraeli, the Tory politician Whistler hoped to paint after

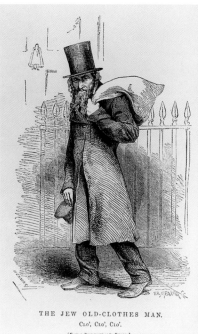

THE JEW OLD-CLOTHES MAN.
Clo', Clo', Clo'.
[From a Daguerreotype by Beard.]

7.30

FIG. 7.30 *"The Jew Old Clothes-Man,"* woodcut, from *London Labour and the London Poor,* by Henry Mayhew, London, 1881–82. VMFA Library.

finishing his *Carlyle* portrait (1873). In her recent study of Victorian culture, Lynda Nead assesses the impact of the second Reform Act:

> The extension of the franchise not only signaled an initial triumph of democracy over
> refined patronage, but, at a cultural level, it also threatened to produce a dangerous leveling
> out; an inclusion of new sections of society in cultural consumption and an unhealthy
> commingling of classes in the new forms such as the music-halls and through commercial
> street culture. After 1867 the anxiety that cheap, commercial culture created a criminalised
> working-class population became fully installed in the Victorian imaginary.[96]

Whistler's aesthetic distance was in part a response to audience attitudes toward these social changes.

As we have seen, leveling had begun with statuary and supper-box paintings at Vauxhall Gardens more than a century earlier. Moreover, the works of Shakespeare were subsumed for decorations in the Prince of Wales Pavilion on the grounds. By giving Vauxhall revelers something familiar to "read," Francis Hayman tacitly acknowledged that the London theater was the province of the layman. David Solkin notes:

> In selecting his subjects from Shakespeare, whose plays dominated the repertoire of the
> contemporary London theatre, and in deploying his figures in accordance with current
> stage conventions, [Hayman] did more than put his audience at ease with the unfamiliar;
> he also placed them in [a] position of critical authority.... In the playhouses it was the
> customers—especially the tradesmen in the pit and the plebeians in the gallery—who
> called the tune, as any theatrical manager who tried to "improve" the tastes of his public
> quickly learned to his cost.[97]

Memoirs by prominent Victorian thespians such as Henry Irving suggest that these issues still confronted actors and managers in Whistler's day.

In the "Ten o'Clock" lecture, Whistler turned the long-standing connection between popular taste and Shakespeare's plays on his listeners. Specifically citing *Troilus and Cressida*, Whistler scorned Shakespeare's "one touch of Nature" that "makes the whole world kin."[98] He admonished would-be aspirants to the realms of art:

Let not the unwary jauntily suppose that Shakespeare herewith hands him his passport to Paradise, and thus permits *him* speech among the chosen. Rather, learn that, in this very sentence, he is condemned to remain without—to continue with the common.

Whistler further asserted,

This one chord that vibrates with all—this "one touch of Nature" that calls aloud to the response of each…this one unspoken sympathy that pervades humanity, is—Vulgarity![99]

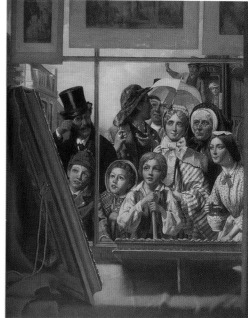

Troilus, the son of Priam, king of Troy, gave his name to a butterfly, *Papilio troilus.* Its yellow-spotted wings recall Whistler's reference to the dainty butterfly that let the artist's imagination take flight, suggesting to him "stately halls" with "slender saffron pillars." But in the twelfth-century tale, told and retold by Boccaccio, Chaucer, and others long before Shakespeare, Cressida was at best a fickle woman—at worst a leprous prostitute.[100]

Whistler was at pains to distance himself and his images from "Vulgarity—under whose fascinating influence 'the many' have elbowed 'the few'—[so] the gentle circle of Art swarms with the intoxicated mob of mediocrity."[101] This comment would seem to set him apart not only from the affected aesthetes who were his main target here, but also from a host of Victorian narrative painters whose storytelling appeal to the masses he deplored. Yet, as his own shop-front pictures lead us to suspect, narrative undertones sometimes lurk behind Whistlerian facades.

Nearly twenty years before Whistler used Shakespeare's kinship phrase in the "Ten o'Clock," the narrative painter Thomas P. Hall chose it for a title. In *One Touch of Nature Makes the Whole World Kin* (1867), Hall depicts a dense crowd of "the many" gathered in front of a plate-glass picture-shop window [fig. 7.31]. Art displayed in the window establishes the central enterprise—looking—just as it does in *Chelsea Children,* Whistler's watercolor of the mid-1880s. Propped up in Hall's window, a heavily framed canvas with its back to us—certainly not "art of the Whistler type"—has attracted the rapt attention of assorted Victorian stock characters, differentiated by clothing and

FIG. 7.31 Thomas P. Hall (fl. 1837–1867), *One Touch of Nature Makes the Whole World Kin,* 1867, oil on canvas, 30 x 25 inches. Location unknown.

accessories. A working-class man wearing a sou'wester vigorously gestures toward the window as he turns back into the street, where a prosperous-looking couple peers out from a passing omnibus to see what all the fuss is about. The crowd includes two young laborers who have interrupted their daily toils for a presumably uplifting look at art— a street-crossing sweeper leaning on his broom and a housemaid holding a large pottery jug. Mustachioed and top-hatted, a well-dressed man on the edge of the crowd takes this opportunity to raise his monocle and ogle the enraptured maid. Her pottery pitcher— as yet unbroken—calls to mind erotically charged French peasant paintings such as *La Cruche Cassée* [see fig. 3.12] and *La Laitière* by Jean-Baptiste Greuze, well known in Victorian Britain through reproductive engravings.[102]

A sign on the omnibus in Hall's picture reads "Bank," telling us it is bound for the city's financial district. As it gained economic power, the middle class increased its emphasis on conventional morality. At this point, "the father's curse"—an eighteenth-century French theme of moral turpitude that formed part of Greuze's thematic lexicon— changed genders. Anita Brookner observes,

> Generally speaking, whereas the ungrateful son was the stock figure of the eighteenth
> century, the nineteenth preferred the fallen girl who eventually became embellished with
> an illegitimate child and a blinding snowstorm outside the window.[103]

In 1851 Richard Redgrave used the reworked moral theme for *The Outcast*, his Royal Academy diploma painting [fig. 7.32]. Three years later, Redgrave found the conceit still serviceable to illustrate "Blow, Blow, Thou Winter Wind" for the Etching Club's publication of *Songs and Ballads of Shakespeare*.[104] The song came from *As You Like It*, a play that would soon interest Whistler's friend the architect Godwin [see fig. 4.52].[105]

Meanwhile, in Hall's painting of Victorian types gathered before a shop window, nothing has yet come of the top-hatted

7.32

7.32 Richard Redgrave (1804–1888), *The Outcast*, 1851, oil on canvas, 31 x 31 inches. The Royal Academy of Arts, London.

7.33

gentleman's hungry stare. But a title drawn from Shakespeare might, for followers of the London stage, imply another level of meaning. Given not only Cressida's faithlessness, but also turpitude's segue from errant son to fallen daughter, we may presume that the young woman now carrying the pitcher may soon be left holding the bag.

Respectable women, emerging unescorted from private spaces to enjoy urban amenities, were considered particularly at risk. Some Victorian journalists associated the opportunity for transgressive behavior with print shops as well as public gardens, a carry-over from the Regency. For example, a warning against shops selling secondhand books and prints as "a great temptation when in a sauntering humor in the London streets" appeared in an article on London shops for the *Builder* in 1857.[106]

Thirty years and many examples later, the subject retained its ominous overtone, resonant in the bold prospectus designed by Beardsley for *The Yellow Book*, London's leading avant-garde journal of the 1890s [fig. 7.33]. The ambiguous status of the elegantly clad woman staring into a bookshop window is underscored by the surreal presence of an aged Pierrot within. Certainly the image was meant to shock. A. N. Wilson detects "an emblem of new womanhood, and of erotic power."[107] Such currents eventually seeped into American Realist art. In John Sloan's *Picture Shop Window* (1907), the only distinguishable work of art on sale shows an actress in a short costume with pink tights [fig. 7.34]. The relationships and social classes of the viewers outside are left unclear, although we do know that Sloan associated red-feathered hats with hookers. Beckoning displays of framed prints continue commercial practices of the Regency when a brisk trade in woodcuts and engravings brought street cries, ballads, and cartoons as well as portraits of prominent politicians, religious leaders, and socialites to a wide audience [fig. 7.35].

FIG. 7.33 Aubrey Beardsley, cover for prospectus of *The Yellow Book*, 1894, pen and ink, 9½ x 6⅛ inches. Victoria & Albert Museum, London.

.7.34 John Sloan, *Picture Shop Window,* 1907, oil on canvas, 32 x 26 inches. The Newark Museum, Gift of Mrs. Felix Fuld, 1925.

Whistler's divisive strategies in the "Ten o'Clock" lecture work to sever any sense of his connection to traditional narrative painting as well as to other early manifestations of modernism. During the twentieth century, Joseph Paxton's contribution to modern architecture would become as apparent as Whistler's impact on painterly abstraction. However, when advancing his aesthetic agenda in his own time, Whistler mocked Paxton's Crystal Palace:

7.35

> The sun blares—and the wind blows from the East—the sky is bereft of cloud—and without, all is made of iron—The windows of the Crystal Palace are seen from all points of London—the holiday maker rejoices in the glorious day—and the painter turns aside to shut his eyes—[108]

Paxton's innovative structure housing the Great Exhibition also played an important role in fostering the public's growing appetite for looking—at fine art, at displays of technology or consumer goods, at public performances, and, of course, at one another. Three times the length of St. Paul's, the Crystal Palace was among other things a forerunner of modern department stores, later interpreted as "cathedrals of consumption."[109] Although Whistler carped at Paxton's architectural achievement in the "Ten o'Clock," he would take advantage of several world's fairs to exhibit his own pictures in such structures, exposing the work to thousands of cultural tourists.[110]

In 1850, hoping to gain public support. Paxton published his proposed design for the building in a recently founded pictorial journal. Having carried the story, the *Illustrated London News* later became a staunch supporter of the Great Exhibition itself. *Punch*, the periodical that figured largely in Whistler's career as well, supplied the building's still-recognized nickname, the "Crystal Palace."[111] Paxton's bid for publicity anticipates Whistler's manipulation of the popular press by only a decade.

Like the composition of *The Balcony* that divided magical from mundane space, or the fanciful rhetoric clothing the purposeful message of the "Ten o'Clock" lecture, the pragmatic Crystal Palace also had its otherworldly side. Drawings and engravings of the building exaggerated its scale and provided "views" that were actually impossible to

FIG. 7.35 *Spectators at a Print Shop in St. Pauls Church Yard*, ca. 1770, mezzotint, by anonymous artist, 13¾ x 9¾ inches. Guildhall Library, Corporation of London.

see in urban London. There was even "one touch of nature" in this glittering monument to industrial progress. Concerned by the controversy aroused by clearing nineteen acres of ground for construction on the south side of Hyde Park—a place where Whistler, for one, would anticipate finding that "Nature was usually wrong"[112]—the exhibition commissioners left a few large trees standing under the 108-foot-high central vault. Flanked by statuary, several elms rise majestically above the "Fountain of Glass" in the north transept [fig. 7.36]. A contemporary visitor commented that

> The glitter of the falling waters in the gleaming light which pours down unobscured in this part of the building, and the artistic arrangement of the groups of the objects of art and industry in the immense vicinity of the Transept, renders this a peculiarly attractive part of this immense structure.[113]

Each tree was selected from nature and repackaged as a commodified work of art, not unlike a flower in a still life painting or a feature in a public garden. The commissioners' highly publicized decision served as a partial palliative against the invasion of architecture into the park, considered the "lungs of London" by city residents.[114]

Paxton's structure for sheltering the wares of nearly 14,000 exhibitors and the surging crowds who came to view them proved practical and affordable. His inventive ideas for lightweight, efficient buildings had visionary applications as well. In 1855 Paxton proposed to the Select Committee on Metropolitan Communications that London be encircled by a "Great Victorian Way," a colossal, multilevel iron-and-glass arcade sheltering roads, shops, apartments, even pneumatic railways—in short, an artificial environment that screened its occupants from the smoke, noise, and dirt of urban London.[115] This unexecuted scheme for screening the "few" from "the many" with see-through walls of iron and glass gains poignancy in light of Queen Victoria's journal entry listing the key persons to be knighted for their efforts after the Great Exhibition. She included Paxton, "for whom this is indeed an immense, though deserved distinction, and very striking as to the possibility of the lowest being

7.36

7.36 Louis Haghe (1806–1885), *The Transept of the Crystal Palace*, 1851, color lithograph. Victoria & Albert Museum, London.

able, by their own merits, to rise to the highest grade of society—he was only a gardener's boy."[116]

Whistler, too, was an outsider who proved adept at courting royalty, and his desires to distance his viewers from urban London while allowing them to see it in his works is less radical and individualistic than he would have had us believe. Rather, in a commercial age driven by specialization, statistical measurement, and faith in progress, its brash self-confidence increasingly compromised by self-doubt, Whistler privileged the nonquantifiable, the mythological, the magical. Clearly, for Whistler, beauty made life worth living.

Wilde correctly perceived the artist's veiling of subject through style, citing a passage from "Ten o'Clock" that he found "of singular beauty, not unlike one that occurs in Corot's letters, [in which Whistler] spoke of the artistic value of dim dawns and dusks, when the mean facts of life are lost in exquisite and evanescent effects."[117] Often quoted, this passage has come to stand for Whistler's evocative skills as a writer, his determination to find beauty in the squalor of modern life, and his declared intention to drop a veil of artistry between the viewer and subjects drawn from the world around him:

> When the evening mist clothes the riverside with poetry, as with a veil—and the poor
> buildings lose themselves in the dim sky—and the tall chimneys become campanile—and
> the warehouses are palaces in the night—and the whole city hangs in the heavens, and
> fairyland is before us—then the wayfarer hastens home—and the working man and the
> cultured one—the wise man and the one of pleasure—cease to understand, as they have
> ceased to see—and Nature, who for once has sung in tune, sings her exquisite song to the
> Artist alone.[118]

Whistler was not the first to perceive the aesthetic possibilities of an industrialized riverbank.[119] Scrutinizing London at midcentury, Charles Knight declared, "Churches, warehouses, steam-chimneys, shot-towers, wharves, bridges—the noblest and humblest things—all are picturesque." Benjamin Robert Haydon, a painter who railed against the Royal Academy long before Whistler took up that cudgel, also found London's polluted atmosphere compelling:

> So far from the smoke of London being offensive to me, it has always been to my imagination
> the sublime canopy that shrouds the City of the World. Drifted by the wind or hanging

in gloomy grandeur over the vastness of our Babylon, the sight of it always filled my mind with feelings of energy such as no other spectacle could inspire.[120]

This was not the usual response. Since the late eighteenth century, Hades was the usual image conjured up by frightening yet exhilarating technologies of the industrial revolution, producing coal, steam, iron, and steel.[121] As Whistler established himself in London, William Blake's "dark satanic mills" were no longer confined to the British Midlands. Large-scale noxious enterprises besieged the very seat of the British empire. By the early 1860s, the gas industry alone had generated twenty-three manufacturing works and six stations in London. The journalist John Hollingshead observed how bold cylindrical gas-storage structures stood out "like gigantic iron vats, towering above the walls of the gas-yards."[122] Gas lighting—a significant manifestation of Victorian progress— depended upon Britain's seemingly endless supply of coal. Yet Hollingshead's comment on urban gasworks shares an ominous air of pandemonium with an earlier text describing a descent into a Lancashire mine pit.[123]

Whistler's poetic vision of the Thames River in the "Ten o'Clock" comes remarkably close to that of Théophile Gautier, whose advocacy of "art for art's sake" was a keystone in the American expatriate's theoretical education. In 1842 Gautier quit a masked ball in Paris to cross the English Channel in a steamer called *le Harlequin*. As he approached London, Gautier scrutinized the built-up banks of the Thames, discovering an urban poetry in which nature counted for nothing.[124] Day or night, harsh industrial structures could appear exotic—distanced in both time and place—thanks to the softening, romantic cloak of fog and smoke that transformed mundane factories into Babylonian terraces and factory chimneys into the gates of Palmyra.[125]

During the 1860s, Whistler introduced the London art world to detached, dispassionate impressions of the busy commercial river where modern industrial structures like gasworks are suppressed or eliminated. In his elegant *Symphony in Grey: Early Morning, Thames* [see fig. 5.52], the artist's lyrical monochromatic palette presages his own comment in the "Ten o'Clock" that "colours are not more since the heavy hangings of night were first drawn aside, and the loveliness of light revealed."[126] Here Whistler paints light rather than color. Wintry fog mutes the hues and tones of nature. Barely illuminated at daybreak, the awkward smokestacks and slag heaps of Battersea, across the river from

FIG. 7.37 Whistler, *A Masked Woman*, ca. 1888–89, chalk and pastel on brown paper laid down on card, 11 x 7 1⁄16 inches.
Hunterian Art Gallery, Glasgow University, Birnie Philip Bequest.

Whistler's balcony in Chelsea, are reduced to timeless towers and elemental pyramids. Whistler needed some kind of subject, a place from which he could embark on his aesthetic explorations.[127]

In a recent and eloquently argued discourse on the concept of beauty, Elaine Scarry observes that "beauty always takes place in the particular, and if there are no particulars, the chances of seeing it go down." She notes that while it is very difficult to say what "beauty" unattached to an object is, "there are attributes that are, without exception, present across different objects (faces, flowers, bird-songs, men, horses, pots and poems)." Among the most significant of these is the impulse toward begetting.[128] The idea of replication is her departure point:

> What is the felt experience of cognition at the moment one stands in the presence of a
> beautiful boy or flower or bird? It seems to incite, even to require, the act of replication…
> when the eye sees something beautiful, the hand wants to draw it. Beauty brings copies
> of itself into being. It makes us draw it, take photographs of it, or describe it to other people.
> Sometimes it gives rise to exact replication and other times to resemblances and still
> other times to things whose connection to the original site of inspiration is unrecognizable.[129]

Scarry uses the word "replication" to remind us "that the benign impulse toward creation results not just in famous paintings but in everyday acts of staring."[130] One wishes to keep looking as long as possible at something perceived as beautiful in order to prolong the experience. By collating Scarry's observations with Whistler's aesthetic agenda, we can understand how his serial images — of the river, of Cremorne Gardens, of Anglo-japanesque women, of Venetian canals and London streets — might stem from a different impulse than, say, Monet's time-based serial paintings of grain stacks, water lilies, or cathedrals.

About two years after staging the "Ten o'Clock" lecture, Whistler drew *A Masked Woman* [fig. 7.37]. This exquisite pastel concretizes the invitation to stare — extended to artist and viewer alike.[131] Among the most skilled of all colorists, Whistler had earlier written at some length to Fantin-Latour that

> with the canvas as given, the colours should be so to speak *embroidered* on it — in other
> words the same colour reappearing continually here and there like the same thread in an
> embroidery…the whole forming in this way an harmonious *pattern* — Look how the

Japanese understand this!—They never search for contrast, but on the contrary for repetition.[132]

Here, tiny touches of icy blue and dusky pink "embroider" and empower the otherwise monochromatic image, bracketed on either side by a lilac haze. Instead of a canvas showing through, as in the *Symphony in Grey*, Whistler chose a rough sheet of paper, leaving golden flecks of fiber still visible. Thinly covered by a nearly transparent shift, the young woman's beauty is set off by her open robe. She is as brazen as a fashion-show manne-quin on a catwalk or a burlesque performer before the footlights.

Whistler uses costume—a domino mask, a semifolded fan, and a richly embroidered robe—to achieve a dramatic visual effect in his beautiful pastel. Centered in the particular—one of the Pettigrew sisters probably posed—the drawing puns upon both the studio model, whose mask preserved her identity, and the costume ball, where masks and costumes protected the reputation of the wearer. The anonymity conferred by fancy dress was a source of lasting fascination for Whistler and his contemporaries.

In "The Truth of Masks," an essay about authentic costume in the Victorian theater, Wilde discussed the work of E. W. Godwin, the architect and stage designer who had previously designed the "White House," Whistler's Tite Street studio dwelling. From this perfect avant-garde stage set, the artist would have conducted his campaign for the beautiful had he not quarreled over the Peacock Room and been bankrupted by the *Whistler v. Ruskin* trial. Assessing Godwin's designs for the theater, Wilde made refer-ence to Shakespeare, who constantly introduced masques and dances into his plays "purely for the sake of the pleasure which they give the eye." But Wilde went on to under-score that the Elizabethan dramatist realized "how important costume is as a means of producing certain dramatic effects."[133]

Fans like the one held by Whistler's masked gamine appear regularly in Whistler's work. A clever visual pun, his watercolor design for a decorated fan blade incorporates a sprightly nude dancer related to the figure in the pastel [fig. 7.38]. She not only holds a fan but also decorates one [fig. 7.39]. Fans were generally understood to be eloquent accessories for the game of flirtation.

7.38

FIG. 7.38 Whistler, *design for a decorated fan*, 1895, watercolor and pencil, 7 x 4½ inches, inscribed verso: "Sketch for Fan, Given to me by Mr. Whistler, August 1899 C.L.F." Freer Gallery of Art, Smithsonian Institution, Washington, D.C., Gift of Charles Lang Freer, F1899.106.

In his 1892 play *Lady Windemere's Fan*, Wilde spins his entire tale of sexual trans-gression, social compromise, and self-sacrifice around the "fatal fan" given by Lord Windemere to his wife.[134] In another play, produced the following year, two characters spar in ever more pointed language, ending with the following sharp exchange:

LORD ILLINGWORTH: I adore simple pleasures. They are the last refuge of the complex. But, if you wish, let us stay here....The Book of Life begins with a man and a woman in a garden.

MRS. ALLONBY: It ends with Revelations.

LORD ILLINGWORTH: You fence divinely. But the button has come off your foil.

MRS. ALLONBY: I still have the mask.

Wilde uses this punning exchange between a determinedly wicked pair to introduce the existence of Mrs. Arbuthnot, the woman Illingworth has wronged and shamed as "a woman of no importance."[135]

Whistler's masked figure is far more subtle than Oscar Wilde's repartee or Aubrey Beardsley's sinister cover design for the first volume of *The Yellow Book*, which appeared in 1894 [fig. 7.40]. Unlike the rather frank interchanges between men and women mounted on the stage or displayed in a bookshop window, Whistler's little female figure in *Masked Woman* stands alone. One might mistake the pastel as an image of no importance in

7.39

Whistler's vast oeuvre, without a good deal more information than the artist chose to reveal, were it not that sheer beauty invites our contemplation.[136] Scarry considers the cognitive fluidity of beauty:

> The material world constrains us...to see each person and thing in its time and place, its historical context. But mental life doesn't....It is porous, open to the air and light, swings forward while swaying back, scatters its stripes in all directions, and delights to find itself beached beside something invented only that morning or instead standing beside an altar from three millennia ago.[137]

Just as a veil of fog softens a harsh industrial landscape, elegant color transfigures this standard studio nude. Whistler combines a sense of ancient classical art in the figure with exotic otherworlds, suggested by the rich robe, transparent undergarment, mask, and fan. Through his selection of these elements, Whistler encourages the mind to move forward and back in time and through cultures as we look at his frankly seductive, ageless hymn to beauty.

By now Whistler had learned to control his anxieties regarding color, a youthful foible he voiced in early correspondence with Fantin-Latour:

> My God! Color—it's truly a vice! Certainly it's probably got the right to be one of the most beautiful of virtues—if directed by a strong hand—well guided by its master drawing— colour is then a splendid bride with a spouse worthy of her—her lover but also her master,— the most magnificent mistress possible!—and the result can be seen in all the beautiful things produced by their union!

Even so, Whistler went on, if drawing was uncertain or timid, color would "treat her unfortunate companion like a duffer who bores her!...and the result manifests itself in a chaos of intoxication, of trickery, of regrets."[138] Whistler's sexually charged personification of color, with its anxious references to intoxication, trickery, and regrets, resonates not only with the history of London's pleasure gardens, where amatory chaos was common, but also with mid-Victorian design theory that associated color with sensual bodily response.[139]

Yet Whistler gives us no evidence of the duffer in his confidently drawn *Masked Woman*. Much of the color here is carried in the kaleidoscopic folds of the heavy, slippery

FIG. 7.40 Aubrey Beardsley, *The Yellow Book* I, April 1894. VMFA Library.

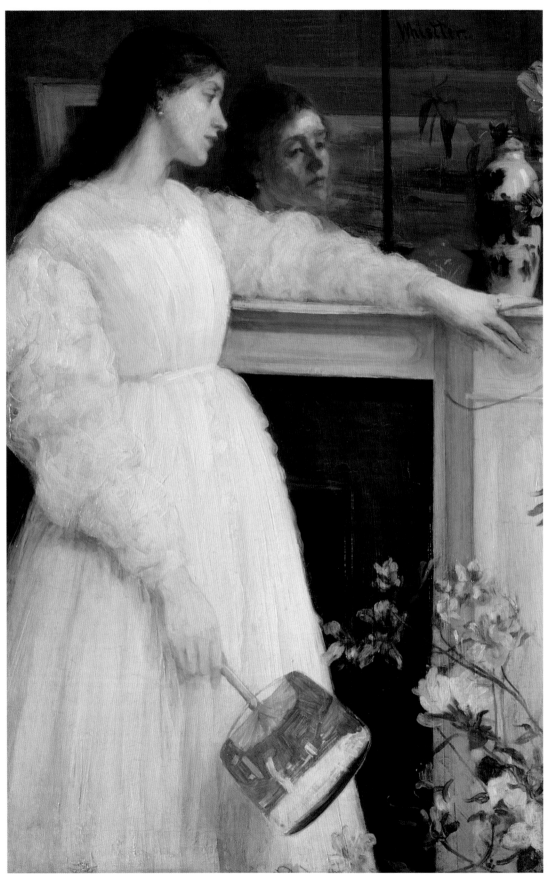

silk robe that seems to stay on the figure's slim shoulders through sheer willpower. Whistler reserved the brightest passage to draw the eye to the model's face. Her mask, mounted on a slender white wand, is decorated with trailing ribbon streamers. Slashed on with a violence that presages the work of Willem de Kooning, Whistler set down the ribbons in a zigzag of hot pink pigment obscuring the model's lips. Here, Whistler retains full control of both color and form. The masked woman is beautiful, but silent—for it is the artist, Whistler himself, who speaks for beauty.

Drawing the "Ten o'Clock" lecture to a close, Whistler intoned,

> With the man, then, and not with the multitude, are her intimacies; and in the book of her life the names inscribed are few—scant, indeed, the list of those who have helped to write her story of love and beauty.[140]

Hindsight shows us that Whistler had engaged in a dangerous liaison as he attempted to establish his relationship with the beautiful. At the end of the eighteenth century, particularly in the writings of Kant, the gendered division of the aesthetic realm between the masculine sublime and the feminine beautiful set forces in motion that would expose Whistler's great aesthetic passion—his uncompromising commitment to beauty in art—to ever increasing misunderstanding.[141] Scarry reminds us that "the sublime *moves*…beauty *charms*."[142] She goes on to examine the unintended yet heavy blow to beauty dealt by this rupturing of the contiguous aesthetic realm:

> The sublime occasioned the demotion of the beautiful because it ensured that the meadow flowers, rather than being perceived in their *continuity* with the august silence of ancient groves (as they had when the two coinhabited the inclusive realm of beauty), were now seen instead as a *counterpoint* to that grove.

She argues that once the beautiful was set in opposition to the sublime, it was easily dismissed as the diminutive member of each aesthetic pair.[143]

Nathaniel Hawthorne's tale, "The Artist of the Beautiful," confirms that this disjunction was out in the open on the eve of Whistler's career.[144] Hawthorne contrasted Robert Danforth, a muscular blacksmith, with Owen Warland, a delicate watchmaker. As Owen battles utilitarian pragmatism, a mechanical butterfly (Nature improved by Art—central to Whistler's agenda) provides the central metaphor. After much arduous, unrewarded labor, Owen finally produces "what seemed to be a jewel box…inlaid with a

G. 7.41 Whistler, *Symphony in White, No. 2: The Little White Girl*, 1864, oil on canvas, 30 x 20 inches. Tate Gallery, London.

fanciful tracery of pearl, representing a boy in pursuit of a butterfly, which, elsewhere, had become a winged spirit, and was flying heavenward." The butterfly itself, "waving the ample magnificence of its purple and gold-speckled wings," is nothing short of miraculous:

> It is impossible to express by words the glory, the splendor, the delicate gorgeousness which were softened into the beauty of this object. Nature's ideal butterfly was here real-ized in all its perfection; not in the pattern of such faded insects as flit among earthly flowers, but of those which hover across the meads of paradise for child-angels and the spirits of departed infants to disport themselves with.[145]

But a living child (scion of Danforth and the girl Owen himself failed to win) quickly destroys the butterfly in his clumsy grasp. Hawthorne concludes, "when the artist rose high enough to achieve the beautiful, the symbol by which he made it perceptible to mortal senses became of little value in his eyes while his spirit possessed itself in the enjoyment of the reality.[146] Like a butterfly pinned to a board, Hawthorne fixes the "artist of the beautiful" as an "irregular genius," an outsider.[147]

Clearly, Whistler exploited his artistic otherness, but the gradual diminution of his reputation after his death coincides with the resurgence of an overtly masculine emphasis upon the power of painting, expressed in low-toned palettes, gritty urban themes, and a general avoidance of gentility. For Whistler, as for Kant, the beautiful was small as well as feminine.[148] "Dainty" was one of Whistler's favorite adjectives, and another, "little," frequently appears in the artist's titles.[149] *Symphony in White, No. 2: The Little White Girl* [fig. 7.41] embodies his devotion to beauty. As the general appreciation of Whistler's contribution built toward its zenith around the time of his death, the picture was widely exhibited, not only in London several times but also in Munich, Glasgow, Antwerp, Venice, Paris, Edinburgh, and Boston.[150] Efforts to acquire this ageless canvas stimulated ever greater offers. Finally A. H. Studd, who had owned *The Little White Girl* since 1892, bequeathed it to the National Gallery in London; the painting finally passed from commodity to icon in 1919.

Yet in an art world increasingly concerned with tough, plebian subject matter, interest in Whistler gradually diminished over the course of the twentieth century, only to rise again on the wings of fresh scholarship in the 1970s and thereafter. Given the ups and downs of the artist's reputation during the past hundred years, Swinburne's poem "Before the Mirror," once pasted to the frame of *The Little White Girl*, gains a

narrative spin that remains poignant long after the artist's death in the summer of 1903:

> I cannot see what pleasures / Or what pains were; / What pale new loves and treasures /
> New years will bear; / What beam will fall, what shower, / What grief or joy for dower; /
> But one thing knows the flower; the flower is fair.

Save for necessary conservation,[151] the beautiful objects Whistler created have remained constant: "one thing knows the flower; the flower is fair."

In constructing her argument for beauty, Scarry examined the etymology of the word "fairness," which refers both to "loveliness of countenance" and to the ethical requirement for "being fair," "playing fair," and "fair distribution." Eventually, she traces "fair" through the word "pact"—the making of a covenant, treaty, or agreement—and to "pax," a word for peace.[152]

A century after Whistler's death, detailed studies on the artist continue to come forth, gradually supplanting the anecdotes and hagiographic paeans of his earliest biographers. These new studies fix Whistler ever more firmly in the pantheon of substantial nineteenth-century artists. But the suspicion still lingers that by carefully manipulating his aesthetic agenda and his public image, the irascible painter somehow didn't play fair with his audience. Reading Whistler's work on multiple levels helps us to make peace with seeming inconsistencies in his long, carefully staged career.

Reviewing a play in 1885, the year of the "Ten o'Clock" lecture, Wilde wrote:

> There is something very pleasurable in seeing and studying the same subject under different
> conditions of art. For life remains eternally unchanged; it is art which, by presenting it
> to us under various forms, enables us to realise its many-sided mysteries, and to catch the
> quality of its most firey-coloured moments.... [W]e ask from the artist...originality of
> treatment, not of subject.[153]

Masked undercurrents of personal, topical, and social engagement can be detected in Whistler's work. They lie just under the surface, thinly veiled from us by layers of shimmering beauty. Far from signaling fragmentation, these undercurrents offer the contrasts that enrich our understanding of Whistler's primary aesthetic agenda and its lasting significance. Our perception of white, an achromatic color of maximum lightness, appears always to depend upon contrast. The same can be said for comprehending the full significance of a white paper.

8. Coda

Mr. Whistler and His Critics:
Revisiting the *Arrangement in White and Yellow*

"In modern life, margin is everything."

—Mrs. Erlynne, in *Lady Windemere's Fan* (1892)

M rs. Erlynne, one of Oscar Wilde's more sympathetic rogues, met the British public when *Lady Windemere's Fan* premiered at the St. James's Theatre, London, in 1892. An adventuress, she is not quite what she seems at first glance. Mrs. Erlynne conducts a life of calculated social and economic speculation— living on margin, as it were. So did Whistler. By 1892, he was riding high, having sold *The Painter's Mother* to the Louvre in a flurry of publicity followed by assorted international accolades.[1] Yet Whistler had arrived only after running considerable social and economic risks, most of them taken in front of—rather than behind—the footlights. If Whistler's greatest speculations were artistic ones, we can better appreciate them for their links to performance, fashion, and display.

Perhaps the most controversial of all Whistler's exhibitions was his 1883 *Arrangement in White and Yellow* [fig. 8.1]. Whistler wrote to the expatriate American sculptor Waldo Story, encouraging him to leave Rome and come to London to see the show. Whistler's gleeful letter sheds much light on his calculated theatricality:

> Well great Shebang on Saturday 17 Feb—Opening of Show and Private View—"Arrangement
> in White and Yellow." I do the Gallery in Bond Street—where I have won my battle and
> am on good terms with the Fine Art Society—having it all my own way of course—hurrah!
> All the World there—Ladie Archie—the Prince—and Various!—especially Various!—
> great glorification—and the Butterfly rampant and all over the place! I can't tell you how
> perfect—though you would instinctively know that there isn't a detail forgotten—Sparkling
> and dainty—dainty to a degree my dear Waldino—and all so sharp—White walls—of

FIG. 8.1 Jared I. Edwards (b. 1938), Smith Edwards Architects, *concept drawing* for reconstruction of Whistler's 1883 *Arrangement in White and Yellow* exhibition, 1994, watercolor on paper, 30 x 24 inches. VMFA.

different whites—with yellow *painted* mouldings—not *gilded!*—yellow velvet curtains—
pale yellow matting—yellow sofas and little chairs—lovely little table yellow—own design—
with yellow pot and *Tiger* lilly! Forty odd *superb* etchings round the white walls in their
exquisite white frames—with the little butterflies—large white butterfly on yellow curtain—
and yellow butterfly on white wall—and finally servant in yellow livery (!) handing catalogue
in brown paper cover same size as Ruskin pamphlet!!![2]

Whistler's white and yellow show burst like a ray of sunshine on fogbound,
soot-ridden London in the winter of 1883 as a clear harbinger of twentieth-century
performance and installation art. Whistler staged the exhibition at the Fine Art Society
in New Bond Street, long a central location for British art and fashion.

The presentation of fifty-one etchings, mostly of Venice, caused an enormous
splash. As for margins, there weren't any. Whistler had cut them off each sheet, leaving
only a tiny, carefully positioned tab that bore his penciled butterfly signature and the
initials "imp" to denote the handmade status of each impression in an age of mechanically
reproduced imagery.[3] Whistler's decision to trim the Venetian proofs coincides with
a journalist's complaint that extra-wide margins on his authorized reproductive print
of *The Painter's Mother* were "really too much of a good thing."[4]

Conservatives in the London art world felt the same about Whistler's theatrical
installations. But the public was ripe for change. During the nineteenth century, as the
audience for fine arts became increasingly middle-class, art displays still imitated the
crowded royal collections of previous centuries [fig. 8.2]. Densely packed galleries with
pictures hung almost floor to ceiling remained customary [fig. 8.3] as Whistler began
to design simpler spaces sympathetic to his own delicate paintings, drawings, and prints.[5]
Alert to the market potential of publicity, Whistler established himself early on as a
social figure of fashion whose spare, elegant interior designs caused much comment, both
positive and negative. As we have seen, by the mid-1870s Whistler was transferring the
pale walls and decorative details of his private studios and residences to arresting public
art displays in commercial galleries.

It is not surprising that Whistler's installations seemed eccentric at the time,
provoking a certain amount of confusion. Didactic museum labels as we know them
were not used in Whistler's day. Instead, small printed catalogues, like the ones held by

FIG. 8.2 George Scharf (1788–1860), *The Royal Academy Exhibition*, 1828, watercolor, 7 7/16 x 10 1/4 inches. Museum of London.

FIG. 8.3 Frederick George Kitton (1856–1904), *Dulwich Gallery*, 1883, pencil, 6 1/2 x 9 3/4 inches. Guildhall Library, Corporation of London.

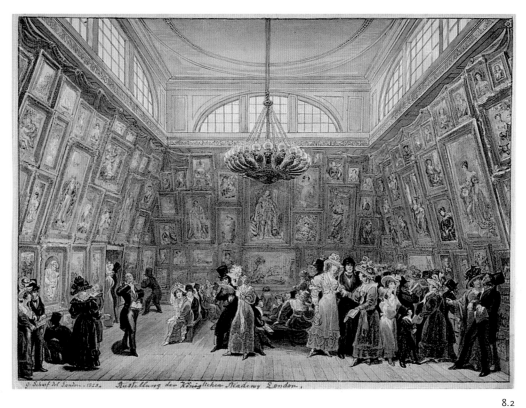

8.2

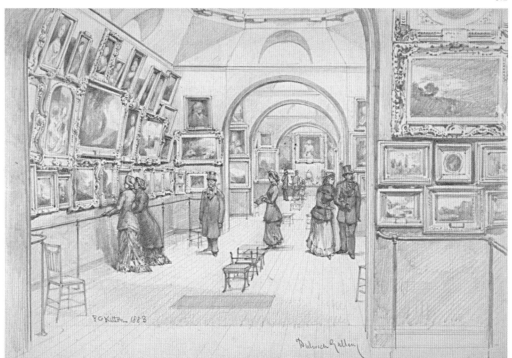

8.3

visitors to the United States Centennial, were the norm [fig. 8.4].
Whistler used this standard information delivery system [fig. 8.5] to
great effect as a vehicle for one of the most hotly debated of all his
texts. Titled "Mr. Whistler and His Critics," it served as gallery guide
for the *Arrangement in White and Yellow*. The artist crowed:

8.

> *such* a catalogue!—The last inspiration!—Sublime simply—
> Never such a thing thought of—I take my dear Waldo, all this
> I have collected of the silly drivel of the wise fools who write,
> and I pepper and salt it about the Catalogue under the different
> etchings I exhibit!—in short I put their nose to the grindstone
> and turn the wheel with a whirr!—I just let it spin!—stopping at
> nothing—marginal notes like in the Paddon Papers—I give 'em
> Hell!—quoting old Solomon about the fool to my heart's content—[6]

Whistler may have been trimming the margins off individual etchings, but in
his modest letterpress gallery catalogue—a list by title of artworks on view in the
exhibition—he made full use of available blank space. The catalogue margins carry
caustic witticisms of his own, set in minuscule type punctuated by expressive little
butterflies and juxtaposed with decontextualized and sometimes heavily edited snippets
of critical commentary ranged under the etching titles [fig. 8.6]. The format was borrowed
from theater journals of the time.[7] In the one tantalizing example Whistler sent to
tempt Waldo Story, he referred to "'Arry"—Whistler plucked this taunting sobriquet from
the title of a popular music-hall song and applied it to Harry Quilter, the art critic
who took advantage of Whistler's bankruptcy to acquire the "White House" at auction.

The entire text of "Mr. Whistler and His Critics" appears below, each entry accom-
panied by an image of the etching described. (The original publication had no images
save for a few of Whistler's saucy butterflies scattered over the pages.) Clearly Whistler
felt that his artistic license covered carte blanche use of anything written about his
work. The quotations were by no means taken exclusively from reviews about etching,
nor were all of them recent. Whistler's very first quotation—"His pictures form a
dangerous precedent"—is lifted from a review written in 1867 addressing paintings
including the *Symphony in White, No. 3*.[8] Many of the quotes came from reviews of

FIG. 8.4 *Visitors Taking Notes at Centennial*, 1876, wood engraving. Library of Congress, Washington, D.C.

the Venice pastel exhibition at the Fine Art Society in 1881, and from commentary on paintings Whistler had exhibited at the Grosvenor Gallery in the spring of 1882.

When possible, Whistler's journalistic snippets have been traced, showing him to be an efficient manipulator. The artist sometimes pulled as many as ten excerpts from a single review.[9] Nor were the reviewers as hostile as Whistler would have us believe.[10] Moreover, if leaving out part of the text didn't suffice, he would make nips and tucks that altered the writer's intent. For example, Whistler correctly quoted the comment that *Little Venice* (no. 20 in the catalogue) was "one of the slightest of the series," but he left out the rest of the commentary: "In its expression of that sense of solitude and isolation which is caused by a first view of the Queen of the Adriatic, 'sitting on her islands beyond three miles of sea,' it is as powerful as any of the twelve."[11] Whistler's text under *The Doorway* (no. 13) read, "The architectural ornaments and the interlacing bars of the gratings are suggested rather than drawn." The journalist had actually written "skillfully and subtly suggested rather than absolutely drawn."[12]

Almost a quarter of the quotes were not ascribed by the artist to any source whatsoever, while others were attributed to a newspaper other than the one that had printed it. Several more have only vague indications such as "the Russian Press" or

8.5

8.6

FIG. 8.5 Whistler, designer, *brown paper cover* for *Etchings & Dry Points, Venice, Second Series*, exhibition catalogue, London, Fine Art Society, February 1883. Freer Gallery of Art Library, Smithsonian Institution, Washington, D.C., Gift of Paul G. Marks.

FIG. 8.6 Whistler, designer, page 14 from "Mr. Whistler and His Critics" in *Etchings & Dry Points, Venice, Second Series*. Freer Gallery of Art Library, Smithsonian Institution, Washington, D.C., Gift of Paul G. Marks.

8.7

FIG. 8.7 George Bernard O'Neill (1828–1917), *Public Opinion*, 1863, oil on canvas, 21 x 11⅜ inches. City Art Gallery, Leeds, England.

FIG. 8.8 Whistler, *butterfly stencil*, 1870s, pierced metal, 6¼ x 6½ inches. Hunterian Art Gallery, Glasgow University, Birnie Philip Bequest.

FIG. 8.9 Whistler, designer, *molding for etching frame*, after 1883, incised and painted wood, 1³⁄₃₂ inches wide x ¹³⁄₁₆ inches deep. Private collection.

a "New York Paper." Of the critics targeted by Whistler, Frederick Wedmore received
the most potshots scissored from his own writings.[13] Whistler even misquoted him,
naughtily substituting "understand" for "understate" with devastating effect (no. 18).
Philip Gilbert Hamerton, an art critic for the *Saturday Review* and author of *Etching and
Etchers* (London 1868, Boston 1876), did not fare much better. His etching revival
colleagueship with Whistler's hated brother-in-law Seymour Haden marked him as an
obvious victim. Sidney Colvin, a critic for the *Pall Mall Gazette*, succeeded Ruskin as
Slade Professor of Fine Art at Cambridge but still got off relatively lightly. Two years
later, Colvin invited Whistler to deliver his "Ten o'Clock" lecture to the Undergraduates'
Fine Arts Society there.[14] Oscar Wilde, himself a noted self-publicist whose final rift
with Whistler had not yet occurred, garnered only a single quote, albeit a memorable
one as yet untraced (no. 27).

8.8

Although the etchings are presented in the order of Whistler's catalogue, the
Victorian "gallery trotter" might or might not have found them hung that way at the
Fine Art Society in 1883.[15] Not yet saturated by a blitz of multimedia imagery, audiences
of the 1880s were more patient than their modern counterparts in matching numbers
on printed lists with images hanging helter-skelter on gallery walls [fig. 8.7]. Indeed, they
were grateful for any help they could get. Once visits to art exhibitions became a popular
form of entertainment, crowds thronged public exhibition halls and commercial galleries.
Those artists who knew how to appeal to the new audiences quickly became famous
public personalities.

Whistler's avant-garde exhibition attracted a wealth of
press coverage. Numerous journalists on both sides of the Atlantic
confirm the decorative details Whistler described in his letter to
Waldo Story. For the *Arrangement in White and Yellow*, the walls at
the Fine Art Society were covered in white felt fabric to a height
of about ten feet and edged top and bottom with a brilliant citron-
yellow ledge and skirting board. Citron is a low-toned acidic yellow
that was fashionable during the 1880s. The walls were "picked
out," or detailed, with stenciled lines and butterflies, also in yellow.
A metal stencil from an earlier Whistler-designed exhibition
survives [fig. 8.8]. However, as Whistler's trademark butterfly

8.9

8.10

signatures continued to evolve over time, it is likely that the butterflies decorating the walls of his 1883 white and yellow exhibition were similar to the one that appears on the cover of the accompanying exhibition catalogue [see fig. 8.5]. The glazed etchings were hung spaciously—their frames, "white, plain, square in section with two light brown lines as their only relief," providing minimum distraction from the etchings themselves [fig. 8.9].[16] We know Whistler favored a standard picture molding, but surviving photographs of his memorial exhibitions indicate that uniform matte sizes typical of modern museum print rooms had yet to become customary. Decorations included a portiere (door curtain) and lambrequin (mantelpiece drape) of thin, soft velvet; a serge-covered sofa in the center of the room; a group of "perilous little cane bottomed chairs"; some yellow Asian pottery; and flowers such as marguerites and narcissi—all in various shades of yellow. "Genuine Indian matting of straw colour" covered the floor. Although the critics complained that the "superabundant yellowness almost gives one the jaundice," there was a general consensus that Whistler had created a background admirably suited to display the etchings.[17]

Once again Whistler revealed his flair for showmanship. An attendant "habited in the tints of a poached egg" circulated through the exhibition selling the brown-covered catalogue that included critical quotations taken out of context by the artist to hoist journalists with their own petards.[18] Catalogue sales went well, and, as he had done a decade earlier, Whistler charged an admission fee. One critic grumbled, "another comic element in the show is that [Mr. Whistler] expects you to pay to see it."[19]

The small spaces of the Fine Art Society were mobbed. Whistler may have worn yellow socks to the private view of his *Arrangement in White and Yellow*, but the aggressive artist was by no means a fashion victim. His "charming foppery" was entirely and purposefully connected to

8.11

FIG. 8.10 Whistler, *design for a butterfly*, 1874, charcoal and watercolor on brown paper, 4 x 3 ⅛ inches. British Museum, London.

FIG. 8.11 *Jacobean cockade*, 1745–46, white silk; with locket and wine glass, each bearing a portrait of Prince Charles Edward Stewart in Highland dress. Museum of Scotland, Edinburgh.

high society. He went so far as to suggest that some of his guests dress in harmony with the exhibition color scheme, and at the private view Whistler presented silken butterflies to a favored few. Like a prestidigitator pulling a rabbit out of a hat, he told Waldo Story triumphantly:

> …as the final tip I am having a lot of lovely little butterflies made in yellow satin and velvet with their little sting in silver wire which will be worn as badges by the women Amazers!!![20]

Elsewhere, Whistler lovingly described this little favor in detail.[21] The "stately dames of fashion [who] might have been seen with the Whistler-badge" included no less than the princess of Wales.[22] Whistler told his brother, "You should have seen the faces when the Princess appeared with my little yellow butterfly on her shoulder!!! — No! mon cher there are no expressions left in the language that were at all worth using on the occasion."[23] Whistler had deployed this gimmick before. Two related watercolor designs for these engaging insects survive from his 1874 one-man exhibition at the Pall Mall Gallery, London [fig. 8.10].[24] A silken butterfly might seem utterly frivolous now, but Whistler used them to enlist powerful members of the elite in what amounted to an artistic insurrection. The "Whistler-badge" as emblem of an American expatriate with Scottish blood had its historical counterpart in the white silk cockades worn to indicate Jacobite adherence in the Scottish cause against the English throne in the mid-eighteenth century [fig. 8.11].

The art was, of course, for sale, and each visitor to the gallery in New Bond Street was a potential customer. Individual impressions were to be had, while two groups selected by Whistler (now popularly called the First and Second Venice Sets) were eventually available en suite. Several portfolio covers designed by the artist for these sets survive in varying condition. Among them, the elegant packaging for an unbroken First Venice Set, acquired by Boston's celebrated collector Isabella Stewart Gardner, still retains fragments of its delicate yellow silk ties [fig. 8.12]. While much larger in scale, the leather-bound, pasteboard portfolio reprises the soft brown paper format characteristic of Whistler's exhibition catalogue covers, a testament to the consistency of his

8.12 Whistler, designer, portfolio covers for *Twelve Etchings of Venice*, ca. 1883, printed cardboard, bound with yellow silk ties. Isabella Stewart Gardner Museum, Boston.

FIG. 8.13 *"The Newest Thing in Wall-Papers,"* wood engraving from *Judy,* 11 December 1878. University of Virginia Libraries.

design. He introduced the brown paper–covered pamphlet in 1878 with *Whistler v. Ruskin: Art and Art Critics.*

A cartoon from *Judy* (11 December 1878) emphasizes the domestic ethos of Whistler's exhibition interiors [fig. 8.13]. An unctuous retailer of "The Newest Thing in Wall-Papers" informs potential customers, "This is artistic, sir. A nocturne in blue and silver. Starlight at Stepney, treated decoratively. P'raps you read what Mr. Frith said about our goods at the Whistler trial, sir? Awfully down on Whistler. Brought us a lot of custom." Eventually, such high-profile controversy brought custom to Whistler as well. He was one of the earliest of his generation to exploit the reality of modern public relations. *Avant la lettre,* Whistler embodied a twentieth-century maxim voiced by well-known Hollywood gossip columnist Hedda Hopper, "It doesn't matter what they say, darling, as long as they say something!"

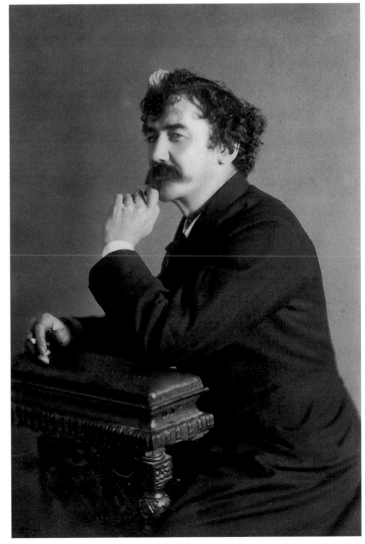

Unlike similarly decorated Impressionist exhibitions in France,[25] Whistler's work had almost immediate impact—doubtless because of the international publicity generated as well as the new ideas showcased. Accompanied by a portrait studio photograph that captured almost as much attention as the prints themselves [fig. 8.14], Whistler's innovative 1883 exhibition traveled straight from London to six American cities where the old-fashioned hanging methods still held sway. His first one-man show to tour the United States reached audiences in New York, Baltimore, Boston, Detroit, and Chicago. Most important, the show had a sixth venue in Philadelphia at the Pennsylvania Academy of the Fine Arts, one of the leading American teaching institutions of the day. Whistler's techniques spread as far away as Minneapolis, Minnesota,

8.14

where John S. Bradstreet, a local decorator who saw the London exhibition, went home and applied its lessons to his own career.[26] Charles Lang Freer, then a budding print collector, could have seen the exhibition in Detroit. In 1887, the man who would number among Whistler's greatest patrons inaugurated his holdings with the Second Venice Set of twenty-six etchings. Eventually Freer built an encyclopedic Whistler collection; he also followed some of Whistler's ideas in decorating his Detroit mansion, and shaping the spaces of the Freer Gallery of Art. Even so independent a patron as Isabella Stewart Gardner, whose mansion cum museum at Fenway Court embodies her own considerable views as a collector, later created a Whistler-inspired yellow room still extant today. Unlike the rest of her rich and crowded displays of art and antiques, this room was sparsely hung with a few choice works by Whistler and others.

Sparely hung, light-colored public exhibition galleries are now commonplace in Europe and America. The example set by Whistler during his lifetime [fig. 8.15] was followed after his death [fig. 8.16] and eventually evolved into standard museum practice for the public presentation of fine art [fig. 8.17].

8.15

FIG. 8.15 *Wall of the first International Exhibition at Knightsbridge, 1898,* with the center group of works arranged by Whistler, photograph. Pennell Collection, Library of Congress, Washington, D.C.

FIG. 8.16 *Whistler memorial exhibition at Copley Hall, Boston, 1903,* photograph. Pennell Collection, Library of Congress, Washington, D.C.

FIG. 8.17 *Cézanne, Gaugin, Seurat, Van Gogh,* installation view of the Museum of Modern Art's first exhibition, New York, 1929, photograph. Museum of Modern Art, New York.

8.16

8.17

Note to the Reader

Most of the etchings reproduced here are held by the Freer Gallery of Art, Smithsonian Institution, Washington, D.C., and the Isabella Stewart Gardner Museum, Boston. In 1887, Charles Lang Freer acquired the entire portfolio entailing the Second Venice Set, *Twenty-six Etchings,* from Knoedler, a New York dealer[27] to whom he paid only $300. Three years later, Mrs. Gardner purchased both the first and second sets of Venetian etchings through Hermann Wunderlich, the dealer who hosted *Arrangement in White and Yellow* in New York.[28] Issued by the Fine Art Society, unbroken suites of the First Venice Set, *Twelve Etchings of Venice,* are particularly rare.[29] Printing the agreed-upon edition overlapped that of the *Twenty-six Etchings,* issued by the Dowdeswell Gallery in 1887 under more carefully controlled circumstances.[30] Over the years Whistler's prices rose as Freer laboriously assembled a First Venice Set through individual acquisitions.[31] In the summer of 1905, just two years after the artist's death, Freer paid £70 for a single impression of *Traghetto* (no. 37). This image, number eleven in the suite of *Twelve Etchings of Venice,* cost him more than his entire Second Venice Set.[32] Some of the most compelling etchings Freer acquired are early proofs that once belonged to Seymour Haden and Thomas Way, men closely associated with Whistler as his print-making career blossomed.[33] Although Freer eventually owned multiple impressions of most of the Venetian etchings,[34] two of them—not selected by Whistler for either portfolio—are so rare that they eluded even this highly focused collector (see nos. 18, 35).

I have used the titles as Whistler gave them in "Mr. Whistler and His Critics," including only the Kennedy catalogue numbers, now standard references in the field. I also note alterations, however slight, to Whistler's titles. Although a number of the prints in the exhibition are drypoints (which involves scratching delicate lines into a bare, ungrounded metal plate), Whistler actually indicated the use of this delicate intaglio technique in only one title (no. 16).[35] Well-meaning efforts to improve Whistler's punctuation,

syntax, or spelling offer evidence of ongoing struggles with the almost willful disorder that characterizes Whistler's oeuvre as he left it to us, having clearly stated in the "Ten o'Clock" lecture his opinion of curators who "pigeonhole the antique."

Early connoisseurs of Whistler's prints showed an alarming affinity for making numbered lists.[36] Since Kennedy's catalogue appeared in 1910, scholars have gradually clarified the confusing history of these prints and the ways in which they were printed and issued, both singly and in sets.[37] Early efforts to parse out Whistler's changes to his etching plates resulted in recorded "states" of the plate, from an "only" state to as many as eleven for images that were troublesome, or at least that continued to engage the artist's attention. Information on the state of each etching reproduced below was not provided in Whistler's original catalogue for the *Arrangement in White and Yellow* exhibition more than a century ago. Having examined several unbroken suites of plates in various institutions, I can confidently assert that Whistler did not trouble himself unduly over what state of an etching was included in any given portfolio. Compare below, for example, *Bead Stringers,* fourth state of eight versus seventh state of eight; or *Furnace Nocturne,* fourth state of seven versus sixth state of seven, from the Freer and Gardner suites of *Venice: Second Series* (nos. 5, 44). It is important to emphasize that, for Whistler, each impression remained an individual work of art.[38]

Indeed, anyone seeking rote consistency from this artist is doomed to disappointment.[39] While it is customary to date these prints from the time of Whistler's initial concepts during the years 1879–81, some plates were still being worked on as late as 1889.[40] I have included a number of early proofs where Whistler did not trim the margins completely to the edge of the plate mark (the noticeable line impressed into a sheet of paper by the edges of a copperplate). These tend to be early pulls, if we can rely upon the elaborate style of the penciled-in butterfly signature. Whistler's butterflies got smaller, less elaborate, and more quickly executed as he toiled over the years to pull the full number of impressions required to complete an edition.[41] Mrs. Gardner's impression of *The Traghetto* (K191) is trimmed to the plate mark and has a very quickly penciled butterfly on a small tab, but Whistler also marked the print on the back, "very early proof pulled in Venice," suggesting that prints pulled early on might be trimmed and signed in pencil later. Readers will also notice that butterfly signatures etched into the copperplate vary in style when they are there at all. Some plates were never signed. Sometimes Whistler

added a butterfly in one of the later states. On occasion, an early butterfly was eradicated for later states, or taken off the plate in a middle state only to reappear in later ones.

The location of Whistler's original copperplate for each etching is given if known. The plates were "cancelled"—that is, defaced—once the artist decided they were too worn down from the pressure of printing, or a sufficient number of proofs had been printed. Of course, "limiting" an edition increases its rarity and, thus, its market value, as Whistler well understood. Nonetheless, in Whistler's case, even impressions from cancelled copperplates remain coveted collector's items, and Freer acquired a few examples. He collected several cancelled plates, and even garnered the eighteenth-century anvil and hammer that Whistler used to work the copper.[42] When Whistler altered or deleted lines etched into the surface by scraping down the metal until the lines disappeared, it left a slight depression in the surface of the plate. Whistler leveled the surface by placing a plate facedown on his anvil and hammering until the hollow was gone. Then he polished the plate, grounded it, and redrew and etched the new lines.[43]

In the printing process, each image comes out reversed. However, in capturing them, Whistler never reversed his subject on the plate to compensate. Rather, with his needle he etched what he saw directly into the copper as if it were a sheet of paper. Having little interest in topographical reportage for its own sake, Whistler would take pleasure in knowing that—even though recent research has identified many of Whistler's most obscure sites[44]—we always see his Venice backwards.

For Théodore Duret, Whistler's prints of Venice were essentially those of a painter. "How these etchings reproduce the impression that one recalls having had oneself!" he wrote. Whistler's prints "applied the acid test" to the city's evanescent appearance as a waterborne flower. "From a distance," said Duret, "it seems an apparition ready to disappear under the sea."[45] Whistler's languid panoramic views of the Serenissima relate to his earliest topographical plates of the American coastline and, at the same time, predict the rising tide of abstraction that would flood leading twentieth-century art circles. From seductive waterside scenes where the Adriatic laps old Venetian pavements, to quiet canals where open doorways invite entry into shadowy spaces receding down dim passageways, Whistler left infinite room for each viewer's imagination.

Mr. Whistler and His Critics:
a Catalogue

ETCHINGS AND DRYPOINTS

———

"Out of their own mouths shall ye judge them."

"Who breaks a butterfly upon a wheel?"

"His pictures form a dangerous precedent."[46]

———

VENICE

"Another crop of Mr. Whistler's little jokes." —*Truth*[47]

1. Murano—Glass Furnace [K217]

334

"Criticism is powerless here." —*Knowledge*[48]

drypoint, 3rd state of 4
brown ink on cream laid paper trimmed to plate mark
not signed in plate
6 ¼ x 9 ³/₁₆ inches

Inscribed recto: on tab: pencil butterfly, imp
 (Whistler's hand)
Inscribed verso: Obach & Co Oct/06 "W 187 Murano
 —Glass Furnace Trial before heavy strokes in
 upper right corner" (Freer's hand)
Provenance: Obach & Co., London, to
 Charles Lang Freer, 1906. 06.239
Cancelled copperplate, Hunterian Art Gallery, Glasgow
K217 as *Glass-Furnace, Murano*

The first image listed in Whistler's little catalogue depicts workingmen on the island of Murano making glass, one of the commercial products for which Venice had been known in England for centuries. One of only two of Whistler's Venice etchings depicting an indoor scene, this particular impression is printed on a page from an old blank book. *Murano—Glass Furnace* reminds us that Whistler's Venetian project was a labor-intensive sojourn intended to rekindle his own career.

2. Doorway and Vine [K196]

"He must not attempt to palm off his deficiencies upon us as manifestations of power." —*Daily Telegraph*[49]

etching, 5th state of 10
brown ink on cream laid paper trimmed to plate mark
signed in plate with butterfly, lower right
9 1/8 x 6 11/16 inches

Inscribed recto, on tab: pencil butterfly, imp
 (Whistler's hand)
Provenance: Knoedler, New York, to
 Charles Lang Freer, 1887. 87.2
Portfolio, *Venice, Second Series*, no. 1

Using a layered grid composition, Whistler here takes the viewer to a humble spot, as yet unlocated, where the distant glimpse of a canal through a *sotto portico*, or passageway, is punctuated by one of his stock small bent figures. Venetian residents, who must have been quite used to being stared at by tourists in search of the picturesque, return the viewer's gaze from an upper window.

3. Wheelwright [K233]

"Their charm depends not at all upon the technical qualities so striking in his earlier work." —*St. James's Gazette*[50]

etching and drypoint, 5th state of 5
brown ink on cream laid paper trimmed to plate mark
signed in plate with butterfly, bottom left
5 x 6 15⁄$_{16}$ inches

Inscribed recto, on tab: pencil butterfly, imp
 (Whistler's hand)
Provenance: Knoedler, New York, to
 Charles Lang Freer, 1887. 87.3
Cancelled copperplate, Art Institute of Chicago
Portfolio, *Venice, Second Series*, no. 2

Venice is so closely associated with travel by water that the appearance of a wheelwright as the third image in the exhibition (and the second in the portfolio of *Twenty-six Etchings*) would have been an unexpected surprise. This impression—again depicting work, not leisure—may have been printed on another section of the same sheet of paper as *Doorway and Vine*, no. 2 above. Whistler pushed the open passageway too far back for the eye to pierce. He expanded the framing grid laterally via the workshop's heavy beams. The newspaper snippet refers to the 1880 exhibition of 12 etchings. This print was not included.

4. San Biagio [K197]

"So far removed from any accepted canons of art as to be beyond the understanding of an ordinary mortal." —*Observer*[51]

etching, 4th state of 9
brown ink on cream laid paper trimmed to plate mark
signed in plate, middle left edge
8 1/4 x 11 15/16 inches

Inscribed recto, on tab: pencil butterfly, imp
 (Whistler's hand)
Provenance: Knoedler, New York, to
 Charles Lang Freer, 1887. 87.4
Cancelled copperplate, Art Institute of Chicago
Portfolio, *Venice, Second Series*, no. 3

Reminiscent of Whistler's etched response to the Thames, this impression also captures some of the picturesque sensibility of earlier Venetian images by Canaletto. Turning his back on the grand view of the Doge's Palace, the churches of Santa Maria della Salute, and San Giorgio Maggiore across the Bacino San Marco (lagoon), Whistler depicted a mid-seventeenth-century warehouse made into residences for the poor on what is now the Riva dei Sette Martiri. The broad bank was suited for drying sails, an activity that probably occupies the man on the left by the open archway. A graceful *sandolo*, similar to the lighters shown in Whistler's Thames prints and paintings, is pulled partway out of the water. Some of the fenestration depicted by Whistler still survives, but the balcony is gone, replaced by a modern iron one. Today, tourists are far more likely to encounter docked cruise ships than Venetian workboats along the built-up quay.

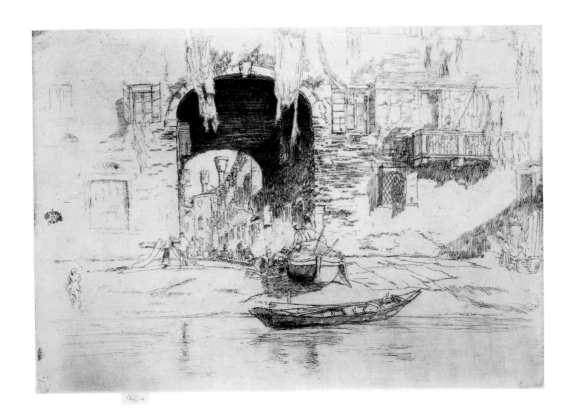

5. Bead Stringers [K198]

"'*Impressionistes,' and of these the various schools are represented by* Mr. Whistler, Mr. Spencer Stanhope, Mr. Walter Crane, and Mr. Strudwick."[52]

Reflection: "Et voila comme on ecrit l'histoire."

etching, 4th state of 8
brown ink on cream laid paper trimmed to plate mark
not signed in plate
8 15/16 x 6 inches

Inscribed recto, on tab: pencil butterfly, imp
 (Whistler's hand)
Provenance: Knoedler, New York, to
 Charles Lang Freer, 1887. 87.5
Cancelled copperplate, Art Institute of Chicago
Portfolio, *Venice, Second Series*, no. 5
K198 as *Bead-Stringers*

Women stringing glass beads for tourists offered a popular subject for artists in Venice, Whistler among them. Here, a tantalizing "37" above the door implies but does not reveal an exact location. Grieve suggests that this image was made in the Corte de la Colone off the Riva dei Sette Martiri. One reaches this "courtyard of the farmers" through the magnificent archway shown by Whistler in *San Biagio* (no. 4). This is one of many etchings where the states in unbroken sets of *Twenty-six Etchings* do not coincide. Compare the impression in the fourth state from Freer's unbroken set to Mrs. Gardner's impression in the seventh state [fig. 5a]. In the seventh state the artist added a butterfly just to the left of the open doorway.

5

5a

6. Fish Shop [K218]

"Those who feel painfully the absence in these works of any feeling for the past glories of Venice." —"'Arry" in the *Spectator*[53]

"Whistler is eminently vulgar."
—*Glasgow Herald*

etching, 6th state of 7
brown ink on cream laid paper trimmed to plate mark
signed in plate with butterfly, middle left
5 1/8 x 8 3/4 inches

Inscribed recto, on tab: pencil butterfly imp
(Whistler's hand)
Inscribed verso: "Fish Shop Venice, Early State from
Thomas Way June/05"
Provenance: Thomas R. Way, London, to
Charles Lang Freer, 1905. 05.195
Cancelled copperplate, Hunterian Art Gallery
K218 as *Fish-Shop, Venice*

The covered passageway Whistler depicts in this scene of gentle commerce heads north-west from the Ponte delle Acque (visible to the right in Whistler's reversed image) toward the Rialto. The old water steps are still in use for unloading merchandise. Today small commercial craft deliver suits rather than seafood, but the Murano-made souvenirs that now crowd the shop windows include glass fish. The window from which Venetians peer out has since disappeared.

7. Turkeys [K199]

"They say very little to the mind."
—F. Wedmore[54]

"It is the artist's pleasure to have them there, and we can't help it."
—*Edinburgh Courant*

etching with drypoint, 1st state of 2
black ink on cream laid paper trimmed to plate mark
not signed in plate
8 3/16 x 5 3/16 inches

Inscribed recto, on tab: pencil butterfly imp
 (Whistler's hand)
Provenance: Knoedler, New York, to
 Charles Lang Freer, 1887; 87.6
Cancelled copperplate, Art Institute of Chicago
Portfolio, *Venice, Second Series*, no. 4

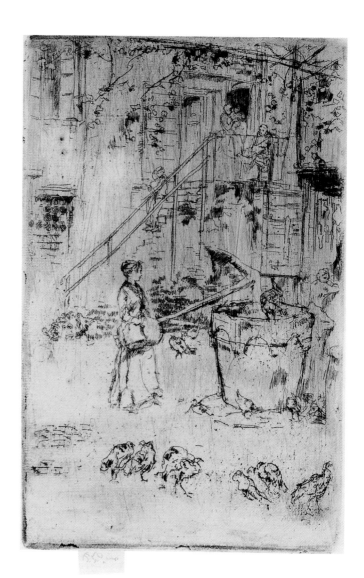

Grieve has identified this site as the Corte Delfina, a small enclosure near the Casa Jankowitz in the Castello section of Venice near the Public Gardens. Whistler resided there for part of his stay in Venice and found many motifs close by. The courtyard site survives, but the huge anchor in the corner is long gone. The large stone well-head has been removed, the crumbling stairway reinforced, and the rickety handrail replaced. Carlo Naya, a photographer contemporary with Whistler, included the Corte Delfina in his views of shabby but picturesque courtyards, a testament to the general interest in preserving at least memories of old architecture that also motivated Whistler. The artist added a butterfly to the second state of the etching.

8. Nocturne Riva [K184]

"The Nocturne is intended to convey an impression of night." —P. G. Hamerton[55]

"The subject did not admit of any drawing." —P. G. Hamerton[56]

"We have seen a great many representations of Venetian skies, but never saw one before consisting of brown smoke with clots of ink in diagonal lines."[57]

etching, 3rd state of 5
black ink on cream wove paper, trimmed, no tab
not signed in plate
7 15/16 x 11 5/8 inches

Inscribed recto, lower left margin: pencil butterfly, imp, "o" (Whistler's hand)
Provenance: Seymour Haden, London, through Wunderlich, New York, to Charles Lang Freer, 1898. 98.379
Portfolio, *Twelve Etchings of Venice*, no. 4
K184 as *Nocturne*

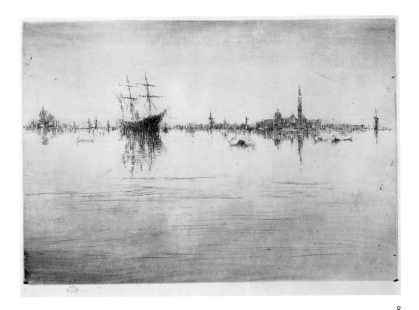

8

The familiar tower of San Giorgio Maggiore breaks the horizon in this serene image, made less anecdotal by Whistler's removal of a typical gondolier who plied the waters in the foreground in an earlier state.[58] Whistler didn't have to walk far from his lodgings in the Casa Jankowitz to look westward across the water toward the far-distant Guidecca. When compared to another print in the Isabella Stewart Gardner Museum (fig. 8a, fifth state), this impression shows what a dramatic difference in effect Whistler could achieve with the same copperplate just by varying the amount of ink he used. Freer's impression has a runic "o" next to the penciled butterfly, possibly an indicator of quality. Mrs. Gardner's print is more forthrightly marked in Whistler's hand as "specially chosen."[59]

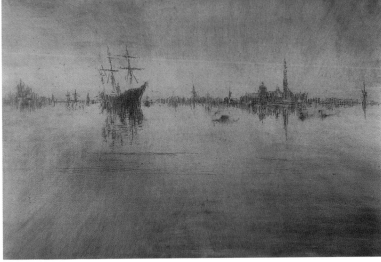

8a

9. Fruit Stall [K200]

"The historical or poetical associations of cities have little charm for Mr. Whistler and no place in his art."[60]

etching, 6th state of 7
brown ink on cream laid paper trimmed to plate mark
signed in plate with butterfly, middle left edge
8 13/16 x 5 15/16 inches

Inscribed recto, on tab: pencil butterfly, imp
 (Whistler's hand)
Provenance: Knoedler, New York, to
 Charles Lang Freer, 1887. 87.7
Cancelled copperplate, Art Institute of Chicago
Portfolio, *Venice, Second Series*, no. 6
K200 as *Fruit-Stall*

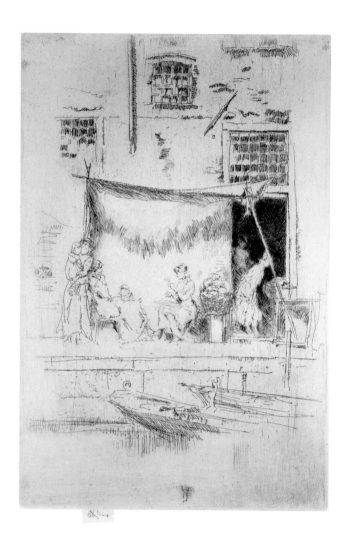

Whistler blended sharp detail with fleeting impression to stage a view of daily life as it might actually be glimpsed from a passing gondola. Choosing a spot close to both the Public Gardens and his own lodgings, Whistler turned his back on a large church, San Giuseppe di Castello, to look across the small Rio de San Isepo. Two gridded windows bracket an awning that serves as a stagelike backdrop for the figures. In actuality, each of the two lights a doorway, but Whistler suppressed one to leave blank space accommodating his butterfly. Though perfectly worked into his balanced composition, the sharp diagonal above and to the left of the dark doorway is a still-extant tie rod that even then helped prevent the plastered brick walls from collapsing. The vertical form is an exposed pipe. Even the circular iron ring used to secure boats to the *fondamenta* (pavement) is still there. The pronounced upright form on the gondola's gunwale is an oar bracket.

10. San Giorgio [K201]

"An artist of incomplete performance."
— F. Wedmore[61]

etching, 4th state of 4
brown ink on cream laid paper trimmed to plate mark
signed in plate with butterfly, lower left
8 3/16 x 11 15/16 inches

Inscribed recto, on tab: pencil butterfly, imp
 (Whistler's hand)
Provenance: Knoedler, New York, to
 Charles Lang Freer, 1887. 87.8
Cancelled copperplate, Art Institute of Chicago
Portfolio, *Venice, Second Series*, no. 7

The title works with the tower (on the near left in Whistler's reversed image) to help visitors place this panoramic view from the Zattere near the Dogana di Mare (customs house). While many of the buildings on the horizon are partially obscured by the insistent verticals of multiple masts, Whistler used a single, large, unarticulated white hull (a Pacific and Orient liner, according to his friend Otto Bacher) to pull the viewer's eye to the distinctive San Giorgio Maggiore. Whistler was looking away to the northeast, toward the distant Church of the Pieta with its colossal portico (near right in the reversed image). The butterfly was not added until the fourth state.

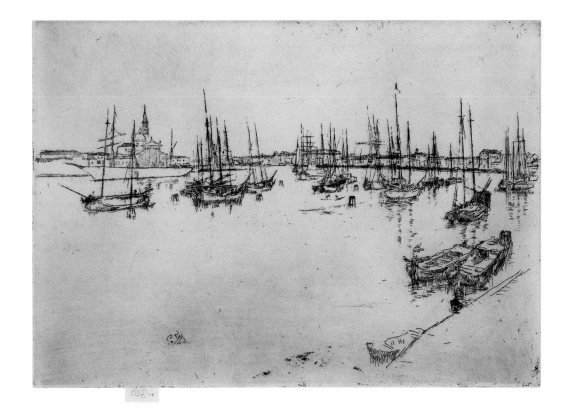

11. The Dyer [K219]

"By having as little to do as possible with tone and light and shade, Mr. Whistler evades great difficulties." —P. G. Hamerton[62]

"All those theoretical principles of the art, of which we have heard so much from Messrs. Haden, Hamerton (?)* and Lalauze, are abandoned." —*St. James's Gazette*[63]

* "Calling me 'a Mr. Hamerton' does me no harm—but it is a breach of ordinary good manners in speaking of a well-known writer."

—Yours obediently, P. G. Hamerton, Sept. 29, 1880. To the Editor of the *New York Tribune*[64]

etching, 1st state of 4
brown ink on cream laid paper trimmed to plate mark
signed in plate, middle left
11 $^{15}/_{16}$ x 9 $^{1}/_{4}$ inches

Inscribed recto on tab: pencil butterfly, imp
 (Whistler's hand)
Provenance: Wunderlich, New York, to
 Charles Lang Freer, 1888. 88.32
Cancelled copperplate, Hunterian Art Gallery

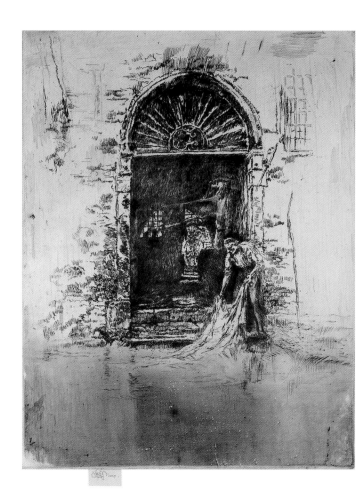

Poor Mr. Hamerton! Whistler's image is, of course, all about light and shade. The light-struck ribs of a huge fan-shaped tympanum over the open door focus the composition. A great deal of ink left on the plate helps give the impression of the murky canal, and sunlight dapples the unidentified workshop interior. The old man pulling heavy, wet fabric from the canal serves to remind us that luxurious fabric was another important Venetian export. Whistler's butterfly hides in the stonework to the left of the doorway.

12. Nocturne Palaces [K202]

"Pictures in darkness are contradictions
in terms." —*Literary World*[65]

etching and drypoint, 7th state of 9
brown ink on cream laid paper trimmed to plate mark
watermark: fragment of fleur-de-lis in shield
not signed in plate
11 9/16 x 7 13/16 inches

Inscribed recto, on tab: pencil butterfly imp
 (Whistler's hand)
Provenance: Knoedler, New York, to
 Charles Lang Freer, 1887, 87.9
Cancelled copperplate, Art Institute of Chicago
Portfolio, *Venice, Second Series*, no. 8
K202 as *Nocturne: Palaces*

Even in modern Venice, the power of a single
winking lantern piercing the darkness can still be
experienced late in the evening, but this partic-
ular site has proved elusive. Grieve's suggestion
of a view from one of the narrow passageways
behind St. Marks Cathedral near the Ponte de
l'Anzolo (Venetian dialect for Angel Bridge) is
highly plausible, given Whistler's penchant for
selectively suppressed detail. This impression
is pulled on an unusually thick sheet, a reminder
that Whistler's choice of various papers was
as important as nonuniform inking and wiping
of a plate in maintaining the unique status
of each proof. In 1893, Freer acquired a single
impression of this print in the eighth state.
He paid $120, more than a third of the cost of
his entire unbroken set of *Twenty-six Etchings*.[66]

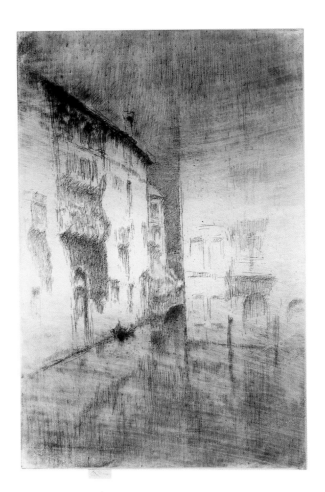

13. The Doorway [K188]

"There is seldom in his Etchings any large arrangement of light and shade."
—P.G. Hamerton[67]

"Short, scratchy lines." —*St. James's Gazette*[68]

"The architectural ornaments and the interlacing bars of the gratings are suggested rather than drawn." —*St. James's Gazette*[69]

"Amateur prodige." —*Saturday Review*[70]

etching, 6th state of 7
brown ink on cream laid paper trimmed to plate mark
signed in plate with butterfly, upper left
11 ½ x 8 inches

Inscribed recto, on tab: pencil butterfly, imp
 (Whistler's hand)
Provenance: Wunderlich, New York, to
 Isabella Stewart Gardner, 1890
Cancelled copperplate, Hunterian Art Gallery
Portfolio, *Twelve Etchings of Venice*, no. 5

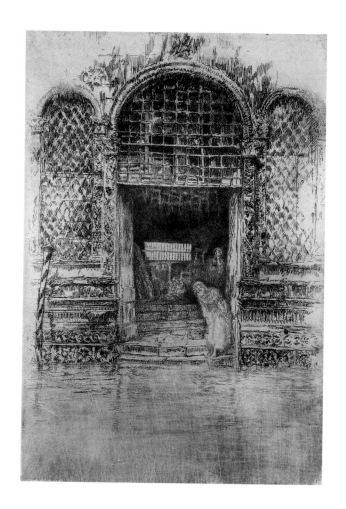

Whistler probably sat in a boat in a narrow *rio* (canal) to make this frontal image of the elegant water portal of the Palazzo Gussoni, a building erected ca. 1500. When Whistler encountered the structure, it was serving as a workshop for repairing chairs—an old craft, we recall, that also figures in the *Cries of London.* Some of the chairs Whistler saw dangle from the ceiling and their legs are just visible just above the open doorway.[71] High up on the richly carved facade, Whistler's butterfly perches like an architectural ornament. At present, the Palazzo Gussoni is being converted into condominiums. (Please note that the tabs indicated on Gardner prints do not show in the photographs.)

14. Long Lagoon [K203]

"We think that London fogs and the muddy old Thames supply Mr. Whistler's needle with subjects more congenial than do the Venetian palaces and lagoons." —*Daily News*[72]

etching, 1st state of 2
brown ink on cream laid paper trimmed to plate mark
watermark: fleur-de-lis in shield with LVG
not signed in plate
6 x 9 inches

Inscribed recto, on tab: pencil butterfly, imp
 (Whistler's hand)
Provenance: Knoedler, New York, to
 Charles Lang Freer, 1887. 87.10
Cancelled copperplate, Art Institute of Chicago
Portfolio, *Venice, Second Series*, no. 9

Whistler took himself once more to the Public Gardens, this time to its easternmost tip to look southwest over the Venetian lagoon toward Palladio's domed church of the Redentore and the distant Guidecca. Posts marking navigable waterways through the shallow lagoon are set next to a passing gondola as reliable signifiers of the site. The watermark on this sheet denotes a paper of particularly fine quality. Whistler added his butterfly in the second state. The composition is remarkably similar to the Thames nocturnes in oil.

15. Temple [K234]

"The work does not feel much." —*Times*[73]

etching, only state
brown ink on cream laid paper trimmed to plate mark
4 x 6 inches
signed in plate with butterfly, lower left

Inscribed recto, on tab: pencil butterfly, imp
 (Whistler's hand)
Inscribed verso: unrecorded Freer collector stamp,
 capital F in circle, red ink
Provenance: Knoedler, New York, to
 Charles Lang Freer, 1887. 87.11
Portfolio, *Venice, Second Series*, no. 10

With this print, Whistler injected a London scene into his group of Venetian scenes. Placid as the image is, the choice, representing a site in or near the Inner Temple, seems trenchant on Whistler's part. The neighborhood is still, as it was then, the haunt of lawyers.[74] Legal difficulties and bankruptcy had driven Whistler from London to Venice in 1879. Typically, Whistler avoided such obvious topics as the nearby Goldsmith's Monument.

16. Little Salute. — (Dry Point.) [K220]

"As for the lucubrations of Mr. Whistler, they come like shadows and will so depart, *and it is unnecessary to disquiet one's self about them.*"[75]

drypoint, 2nd state of 2
brown ink on cream laid paper trimmed to plate mark
signed in plate with butterfly, lower right
3 ¼ x 8 ⁵⁄₁₆ inches

Inscribed recto, on tab: pencil butterfly, imp
Inscribed verso: "ox" (quality indicator?), unrecorded
 Freer collector stamp
Provenance: Wunderlich, New York, to
 Charles Lang Freer, 1889. 89.23
Cancelled copperplate, Hunterian Art Gallery
K220 as *Little Salute*

This delicate panorama marked by the predominant dome of Santa Maria della Salute is the only instance when Whistler drew attention to his use of drypoint in his catalogue. Whistler is showing a view to the southwest, similar to that captured in *Long Venice* (no. 42 below). On the far right of the reversed image is the Church of the Redentore. Whistler added his butterfly to this second state, pulling the proof shown here on a luxurious sheet of paper.

17. The Bridge [K204]

"These works have been done with a swift-
ness and dash that precludes anything like
care and finish."[76]

"These Etchings of Mr. Whistler's are
nothing like so satisfactory as his earlier
Chelsea ones; they neither convey the
idea of space nor have they the delicacy
of handling and treatment which we see
in those."[77]

"He looked at Venice never in detail."
—F. Wedmore[78]

etching, 8th state of 8
brown ink on cream laid paper trimmed to plate mark
signed in plate with butterfly, lower right corner
11 $\frac{9}{16}$ x 7 $\frac{15}{16}$ inches

Inscribed recto, on tab: pencil butterfly, imp
 (Whistler's hand)
Provenance: Knoedler, New York, to
 Charles Lang Freer, 1887. 87.12
Cancelled copperplate, Art Institute of Chicago
Portfolio, *Venice, Second Series*, no. 11

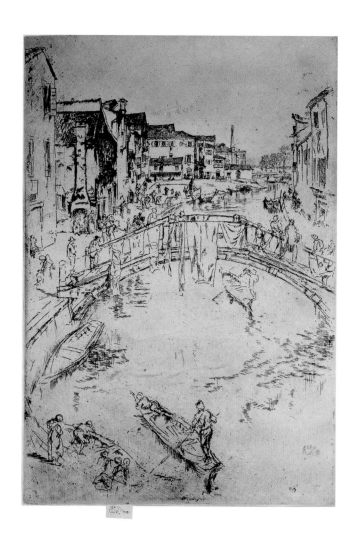

Originally slated for inclusion in the first port-
folio, *The Bridge* was held back until the second.
Whistler removed his butterfly signature from
the plate in the third state, but it reappeared
in the fifth. Grieve has identified this view in the
far western part of the Dorsoduro section of
Venice. Looking north over the Rio de l'Arzere
from a nearby window Whistler obtained his
sharply angled view. Whistler touched subtly on
past history, capturing, in the far distance, a
glimpse of the Campo di Marte, a large parade
ground created during the city's Austrian occu-
pation after the Napoleonic Wars. The neigh-
borhood, already changing by the time Whistler
was in Venice, is far less picturesque now.

18. Wool Carders [K221]

"They have a merit of their own, and I do
not wish to understand it."
*—F. Wedmore[79]

*Mr. Wedmore is the lucky discoverer of the following:
—"Vigour and exquisiteness are denied—are they
not?—even to a Velasquez"![80]

etching and drypoint, 1st state of 3
black ink on white wove paper, untrimmed
touched with brown watercolor
not signed in plate
11 1/4 x 9 inches

Inscribed recto, lower left: pencil butterfly, imp
 (Whistler's hand)
Provenance: Hunterian Art Gallery,
 Birnie Phillip Bequest
Cancelled copperplate, Hunterian Art Gallery
K221 as *Wool-Carders*

Whistler offers another glimpse of Venetian
cottage industry, seen through a dramatic water
portal opening onto a canal. One of the rarest
of the Venetian etchings, this impression bears
watercolor touches, showing it to be a working
tool. Whistler sometimes used watercolor when
experimenting with an image. Heavy inking
similar to the watercolored canal on this proof
can be seen in nos. 11 and 13 above.

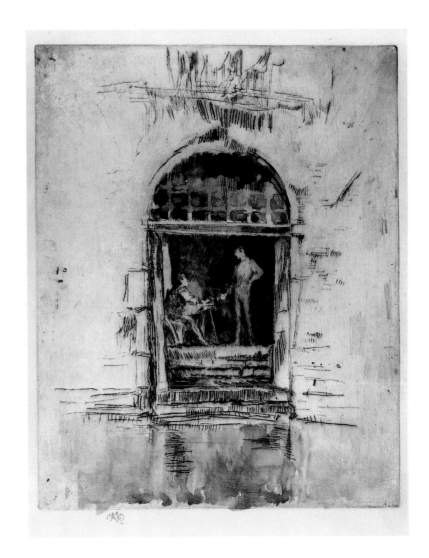

19. Upright Venice [K205]

"Little to recommend them save the
eccentricity of their titles."[81]

etching, 2nd state of 4
brown ink on cream laid paper trimmed to plate mark
signed in plate with butterfly
10 x 7 inches

Inscribed recto, on tab: pencil butterfly, imp
 (Whistler's hand)
Provenance: Knoedler, New York, to
 Charles Lang Freer, 1887. 87.13
Cancelled copperplate, Art Institute of Chicago
Portfolio, *Venice, Second Series*, no. 12

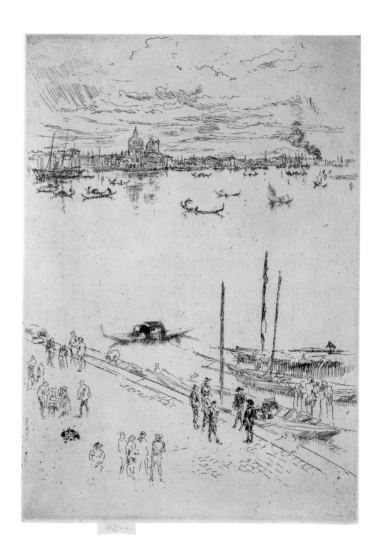

Despite his pronouncements to the contrary,
Whistler here recorded what is essentially a
tourist view of the baroque church of Santa Maria
della Salute seen across the waters of the lagoon.
Artists before him, including Turner, painted
the church from similar viewpoints. The mouth
of the Grand Canal is immediately to the left
of the church in Whistler's reversed image. In the
far distance, the Guidecca is marked by rising
smoke from new factories on the city's outskirts.
A variety of watercraft, from a stately private
gondola with its detachable canopy to a three-
masted seagoing steamship, dots the placid
water. In the foreground, the angled *fondamenta*
populated by scattered figures and the upright
masts reprise elements seen in Whistler's Thames
images. Again, contrary to Whistler's claims
of stylistic independence, his choice of a sharply
angled view taken from a window high above the
subject represents a practice common among
the Impressionists, both European and American.
Numerous images featured in the *Arrangement
in White and Yellow* exhibition were created from
elevated vantage points.

20. Little Venice [K183]

"The Little Venice is one of the slightest of the series." —*St. James's Gazette*[82]

"In the Little Venice and the Little Lagoon Mr. Whistler has attempted to convey impressions by lines far too few for his purpose." —*Daily News*[83]

"Our river is naturally full of effects in *black and white and bistre*. Venetian skies and marbles have colour you cannot suggest with a point and some printer's ink." —*Daily News*[84]

"It is not the Venice of a maiden's fancies." —"'Arry"[85]

etching, only state
black ink on wove paper, trimmed but not to
 plate mark
signed in plate with butterfly, lower left
$7\frac{5}{16}$ x $10\frac{7}{16}$ inches

Inscribed recto, lower left margin: pencil butterfly
 imp (Whistler's hand)
Provenance: Seymour Haden, London, through
 Wunderlich, New York, to Charles Lang Freer,
 1898. 98.378
Portfolio, *Twelve Etchings of Venice*, no. 1

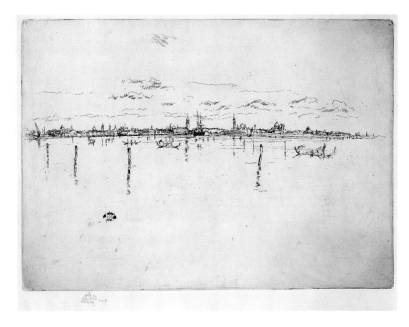

Reinforced by its title, the first of the *Twelve Etchings of Venice* is a typical tourist view, centered by the tall Campanile (bell tower) and the blocky Doge's Palace, with the domes of San Marco barely visible above. Taken from the Lido, Whistler's panorama is so distanced that the city seems to float on a watery horizon, offering the haunting first impression so often glimpsed, remembered, and later recounted by travelers to Venice. Striped poles mark open channels, and gondoliers row their elegant craft across the lagoon. Rarely did Whistler attach a journalist's critical comment to the actual work of art in question, but he did do so here, using the *St. James's Gazette*'s reaction to *Little Venice* when it was first exhibited at the Fine Art Society in 1880.

21. Little Court [K236]

"Merely technical triumphs." —*Standard*[86]

etching, only state
black ink on cream laid paper trimmed to plate mark
watermark: fleur-de-lis
signed in plate with butterfly, upper middle to right
 of window frame
5 x 6⅞ inches

Inscribed recto, on tab: pencil butterfly, imp
 (Whistler's hand)
Provenance: Knoedler, New York, to
 Charles Lang Freer, 1887. 87.14
Portfolio, *Venice, Second Series*, no. 13

Here, Whistler moved from a sweeping Venetian panorama in the previous etching to a street sweeper at work in an enclosed London courtyard. Such urban labors, reminiscent of the *Cries of London*, offered topics that were as familiar to his audience as Venetian views. Courtyards of this type, sharing formal properties with the cloistered Venetian spaces Whistler sometimes depicted in prints and pastels, were quite common in the East End. However, this unidentified scene has very probably been the victim of urban renewal by now.

22. Regent's Quadrant [K239]

"There may be a few who find genius in insanity."[87]

etching, 3rd state of 4
brown ink on cream laid paper trimmed to plate mark
partial unidentified watermark
signed in plate with butterfly, upper right
6 7/16 x 4 11/16 inches

Inscribed recto, on tab: pencil butterfly, imp
 (Whistler's hand)
Inscribed verso: "Obach and Co" (Freer's hand)
Provenance: Obach & Co., London, to
 Charles Lang Freer, 1905. 05.196

Again, Whistler positioned a print in his catalogue to provide a sharp sense of contrast. The humble courtyard in the previous etching is counterbalanced here by a view of Regent Street, one of the most elegant of London's commercial thoroughfares. Freer, one of the ultimate art consumers of his time, owned another impression of this image, in the same state and very likely printed on another piece of the same sheet of paper.[88]

23. Lobster Pots [K235]

"So little in them."* —P.G. Hamerton[89]

*The same Critic holds: "The Thames is beautiful from Maidenhead to Kew, but not from Battersea to Sheerness."[90]

etching, 1st state of 3
brown ink on cream laid paper trimmed to plate mark
signed in plate with butterfly, lower right corner
4¾ x 7¹⁵⁄₁₆ inches

Inscribed recto, on tab: pencil butterfly, imp
 (Whistler's hand)
Inscribed verso: unrecorded Freer collector stamp
Provenance: Knoedler, New York, to
 Charles Lang Freer, 1887. 87.15
Portfolio, *Venice, Second Series*, no. 14
K235 as *Lobster-Pots*

Here, Whistler selected an English scene that resonates with Venetian fishing. At the time, lobster was an inexpensive commodity. The plate is inscribed "Selsea Bill," indicating that Whistler recorded the scene near the home of his sometime agent Charles Augustus Howell. After 1879, the Anglo-Portuguese dealer lived at Old Danner, Selsey Bill, Sussex.[91] Whistler described him as "a creature of top-boots and plumes—splendidly flamboyant" like a guest at a Venetian masque.[92] The first snippet, "so little in them," is particularly apropos—the lobster pots appear to be empty.

24. Riva No. 2 [K206]

"In all his former Etchings he was careful
to give a strong foundation of firm
drawing. In these plates, however, he has
cast aside this painstaking method."

—*St. James's Gazette*[93]

etching, 1st state of 2
brown ink on cream laid paper trimmed to plate mark
signed in plate with butterfly, upper left
8 3/16 x 11 15/16 inches

Inscribed recto, on tab: pencil butterfly, imp
 (Whistler's hand)
Inscribed verso: unrecorded Freer collector stamp
Provenance: Knoedler, New York, to
 Charles Lang Freer, 1887. 87.16
Cancelled copperplate, Art Institute of Chicago
Portfolio, *Venice, Second Series*, no. 15
K206 as *The Riva, No. 2*

Whistler looked down from his room at the
Casa Jankowitz to etch one of the most animated
of all his Venetian prints. Below him, on the
Campo San Biagio, a group of idlers surrounds
a seated man in a broad-brimmed hat. It is
not entirely clear what he is doing, but the group
recalls Whistler's title page for *Twelve Etchings
from Nature* (K25, 1858), which depicted the
artist himself at work amid a throng of fascinated
children. A number of Whistler's friends, the
"Duveneck boys," were eager etchers in Venice.[94]
Across the bridge, the Riva Ca' di Dio stretches
away in an elegant curve toward the most familiar
part of the city, with the heavily pedimented
facade of the Pieta and the domes of San Marco
terminating the image.

25. Islands [K222]

"An artist who has never mastered the subtleties of accurate form."* —F. Wedmore[95]

*Elsewhere Mr. Wedmore is inspired to say—
"The true collector must *gradually* and *painfully* acquire the eye to judge of the impression."[96]

"*This* is possibly the process through which the preacher is passing."

drypoint, 2nd state of 2
brown ink on cream laid paper trimmed to plate mark
not signed in plate
5 x 7 ¹⁵⁄₁₆ inches

Inscribed recto, on tab: pencil butterfly, imp
 (Whistler's hand)
Inscribed verso: "W 193 Islands Obach & Co
 June 1905" (Freer's hand)
Provenance: Obach & Co., London, to
 Charles Lang Freer, 1905. 05.107
Cancelled copperplate, Hunterian Art Gallery

This tenebrous impression addresses the conception of Venice as an evanescent floating dream always on the verge of disappearing under the sea. The image seems to have been taken from out in the lagoon, looking northwest toward two well-known churches that center the panorama. The closest domed building, slightly right of center in Whistler's reversed image, is the Salute. To the left, the dome and tower of San Giorgio pierce the skyline.

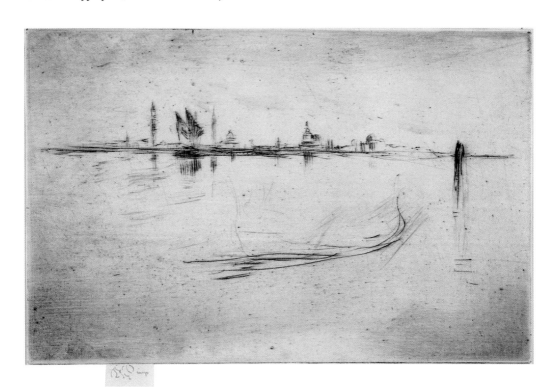

26. The Little Lagoon [K186]

"Well, little new came of it, in etching;
nothing new that was beautiful."
— F. Wedmore[97]

etching, 2nd state of 2
signed in plate with butterfly, lower right
brown ink on cream laid paper, trimmed to plate mark
$8\frac{7}{8}$ x 6 inches

Inscribed recto, on tab: pencil butterfly, imp
 (Whistler's hand)
Inscribed verso: "SH"
Provenance: Seymour Haden, London, through
 Wunderlich, New York, to Charles Lang Freer,
 1898. 98.381
Portfolio, *Twelve Etchings of Venice*, no. 8

The Venetian gondolier bent over his oar became
one of Whistler's ciphers for the Serenissima.
The little figures, scattered throughout the series,
are remarkably similar, as if each oarsman were
caught simultaneously in the same position.
For *The Little Lagoon* Whistler was looking almost
due south from the Casa Jankowitz. In the far
distance on the left of his reversed image is
the Lido, from whence he took the opposite view
in *Little Venice*, no. 20 above.

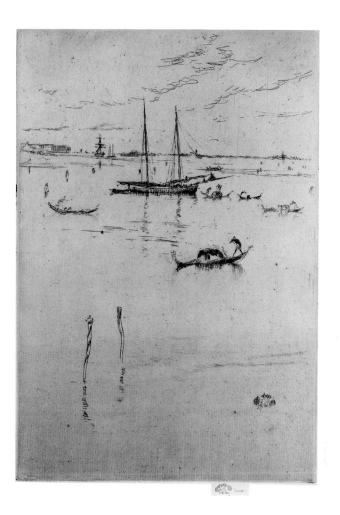

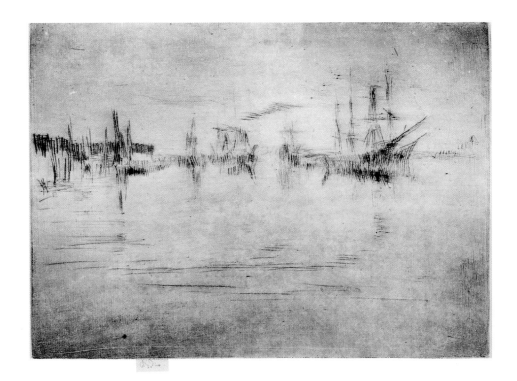

27. Nocturne Shipping [K223]

"This Archimago of the iconographic aoraton, or graphiology of the Hidden."
— *Daily Telegraph*[98]

"Amazing!"

"Popularity is the only insult that has not yet been offered to Mr. Whistler."
—Oscar Wilde

drypoint, 2nd state of 6
black ink on cream laid paper trimmed to plate mark
watermark: BTH in cartouche
not signed in plate
6 $\frac{1}{16}$ x 8 $\frac{11}{16}$ inches

Inscribed recto, on tab: pencil butterfly, imp
 (Whistler's hand)
Inscribed verso: "W 194 Trial—FK & Co Nov 20/07"
 (Freer's hand)
Partial sentence in Flemish, in brown ink
Provenance: Frederick Keppel & Co., New York, to
 Charles Lang Freer, 1907. 07.365
Cancelled copperplate, Hunterian Art Gallery
K223 as *Nocturne: Shipping*

Indulging in the "graphiology of the hidden," Whistler gives the viewer little idea of the location of this image. Were it not included in the exhibition of Venetian views, this harbor scene could be almost anywhere. The impression is printed on a page from a blank book that still bears a partial inscription in Flemish. Archimago is a deceitful enchanter in Spenser's *Faerie Queene*, hardly a flattering allusion, however magical Whistler's prints seem to modern eyes.

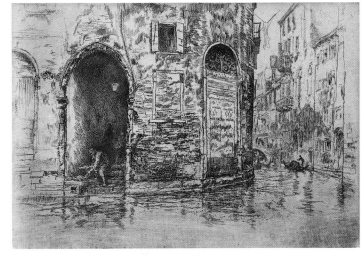

28

28a

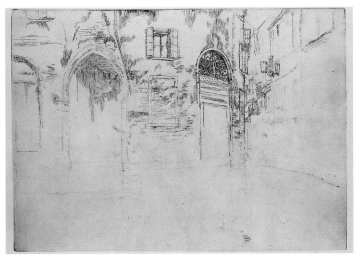

28b

28. Two Doorways [K193]

"It is trying to any sketch without tone to be hung upon a wall as these have been." —P. G. Hamerton[99]

etching, 3rd state of 6
brown ink on cream laid paper trimmed to plate mark
signed in plate with butterfly upper left
8 x 11½ inches

Inscribed recto, on tab: pencil butterfly, imp
 (Whistler's hand)
Provenance: Wunderlich, New York, to
 Isabella Stewart Gardner, 1890
Cancelled copperplate, Hunterian Art Gallery
Portfolio, *Twelve Etchings of Venice*, no. 2
K193 as *The Two Doorways*

Grieve has located this image at a complex spot east of the Rialto Bridge where three *sestieri* (districts) of the city conjoin. Whistler's main focus is on the dimly lit arched doorway where an old man, not unlike *The Dyer* (see no. 11 above), is engaged in unexplained activity. A gondolier rows away around the corner, along the Rio de la Fava, while another approaches, having just passed under the Ponte San Antonio. When we compare this proof, in the third state, to one in the second state, it is clear how much Whistler changed the etching's overall impact [fig. 28a, Freer Gallery 98.389]. Earlier, a much less sinister exchange seemed to be taking place between two men. Another impression, from the first state, shows how carefully Whistler recorded the architectural details, creating a little stage set before deciding what sort of a scene to present here [fig. 28b, Freer Gallery 03.148].

29. Old Women [K224]

"He is never literary." —P.G. Hamerton[100]

drypoint, 1st state of 2
brown ink on cream laid paper trimmed to
 plate mark, but without tab
touched with watercolor
signed in plate with butterfly, upper left
5 x 7 $^{15}/_{16}$ inches

Inscribed verso: "W 195 Old Women Obach & Co.
 Jany 05" (Freer's hand)
Provenance: Obach & Co., London, to
 Charles Lang Freer, 1905. 05.8
Cancelled copperplate, Hunterian Art Gallery

This once-folded sheet is another example of a proof used as a working tool. Whistler touched the sheet with watercolor on the doors and window. Bent over their work, the women at the right are probably making needlepoint lace. One woman, arms akimbo, may be scolding a little boy with his hands in his pockets at the left edge of the composition. Grieve has located this quiet courtyard, again, quite close to Whistler's lodgings at the Casa Jankowitz. While somewhat altered, the two doorways on the west end of the Campiello del Piovan still exist. The composition suggests the geometric shop-front works that would preoccupy Whistler after his return to London.

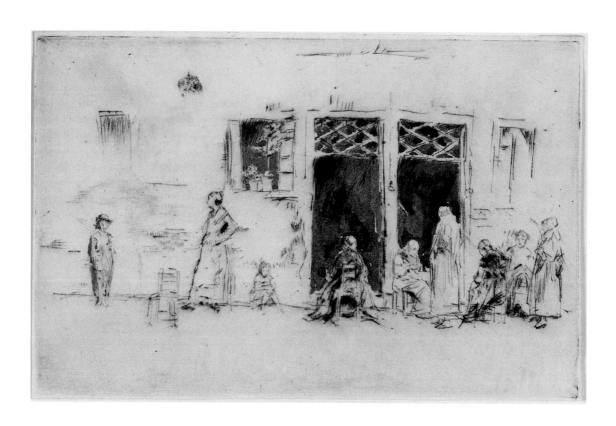

30. Riva [K192]

"He took from London to Venice*
his happy fashion of suggesting lapping
water." —F. Wedmore[101]

*Like Eno's Fruit Salt or the "Anti-mal-de-Mer."

"Even such a well-worn subject as the Riva
degli Schiavoni is made original (?) by being
taken from a high point of view, and looked
at lengthwise, instead of from the canal."[102]

etching, 3rd state of 3
signed in plate with butterfly
brown ink on cream laid paper trimmed to plate mark
$7\,^{15}/_{16}$ x $11\,^{5}/_{8}$ inches

Inscribed recto, on tab: pencil butterfly, imp
(Whistler's hand)
Inscribed verso: "SH" "The Riva No. 1 Trial Proof"
(Freer's hand)
Provenance: Seymour Haden, London, through
Wunderlich, New York, to Charles Lang Freer,
1898. 98.388
Copperplate, Freer Gallery of Art, 92.15
Portfolio, *Twelve Etchings of Venice*, no. 6
K192 as *The Riva No. 1*

Whistler offers the same westward view as no. 24
above, although it is slightly broader, so that
the tall form of the famous Campanile on the
Piazza San Marco is visible at the extreme upper
right corner. But far from the elegant Piazza,
known as the "drawing room of Europe," every-
day Venetians are seen going about their lives
in Whistler's etching. At the right edge of the
image, resting on the pavement, the blocky black
object is a *felze* (detachable gondola roof).

31. Drury Lane [K237]

"In Mr. Whistler's productions one might
safely say that there is no culture."
—*Athenaeum*[103]

etching, only state
brown ink on cream laid paper trimmed to plate mark
signed in plate with butterfly, upper right corner
6 3/8 x 4 inches

Inscribed recto, on tab: pencil butterfly, imp
 (Whistler's hand)
Provenance: Knoedler, New York, to
 Charles Lang Freer, 1887. 87.17
Portfolio, *Venice, Second Series*, no. 16

As this image makes clear, Whistler quite handily
transferred the gridlike architectural composi-
tions that fascinated him in Venice to London
subjects. As the nineteenth century gave way to
the twentieth, American Realist city views popu-
lated by urchins would become standard fare.

32. The Balcony [K207]

"His colour is subversive." —Russian Press

etching, 5th state of 11
black ink on cream laid paper trimmed to plate mark
signed in plate with butterfly, upper left edge
11 $^{11}/_{16}$ x 7 $^{15}/_{16}$ inches

Inscribed recto, on tab: pencil butterfly, imp
 (Whistler's hand)
Provenance: Knoedler, New York, to
 Charles Lang Freer, 1887. 87.18
Cancelled copperplate, Art Institute of Chicago
Portfolio, *Venice, Second Series*, no. 17

What seems to modern eyes a grand palazzo
proves a modest Venetian home on a narrow
canal, as Grieve has discovered. The window
grilles, the Renaissance capitals, even the metal
tie bar (visible as a diagonal form just below
the balcony balustrade to the left of the doorway
in Whistler's reversed image) are still there. Facing
east, No. 66 Santa Croce still catches a bit of
morning sun across the Rio de San Pantalon,
although its setting is now somewhat compro-
mised by a twentieth-century footbridge.

33. Alderney Street [K238]

"The best art may be reproduced
with trouble." — F. Wedmore*[104]

*"I am not a Mede nor a Persian."
— F. Wedmore[105]

etching, 1st state of 2
black ink on cream laid paper trimmed to plate mark
signed in plate with butterfly, upper right edge
6 15/16 x 4 15/16 inches

Inscribed recto, on tab: pencil butterfly, imp
 (Whistler's hand)
Provenance: Wunderlich, New York, to
 Charles Lang Freer, 1900. 00.48
Published, *Gazette des Beaux-Arts*, April 1881,
 in 2nd state[106]

Much remains of the urban landscape Whistler
saw when he looked northeast from a vantage
point in Clarendon Street around the corner from
Alderney Street in Pimlico. To the north, rail-
road tracks leading into Victoria Station cut this
London neighborhood off from the more fash-
ionable town houses of Belgravia. A harnessed
animal standing placidly in Alderney Street wit-
nesses the delivery systems that helped supply
new developments distant from traditional city
markets such as Covent Garden. In the *Arrange-
ment in White and Yellow* exhibition catalogue
Whistler juxtaposed this image of middle-class
housing with his similar Venetian choice,
captured in *The Balcony* (no. 32 above). As was
often the case in Venice, Whistler here chose
a London subject near his current lodgings.
He stayed at 76 Alderney Street while proving
the first Venice set.[107]

34. The Smithy [K240]

"They produce a disappointing impression."[108]

"His Etchings seem weak when framed."*[109]

— P. G. Hamerton

* Mr. Hamerton does also say: "Indifference to beauty is however compatible with splendid success in etching, as the career of Rembrandt proved." —*Etching and Etchers*[110]

etching and drypoint, 5th state of 5
brown ink on cream laid paper trimmed to plate mark
unidentified watermark
signed in plate with butterfly, lower right
6⅞ x 9 inches

Inscribed recto, on tab: pencil butterfly, imp
(Whistler's hand)
Inscribed verso: "The Smithy" (possibly Thomas
R. Way, Jr.) "W197 The Smithy 5th State T. Way—
June/05 W 197" (Freer's hand)
Provenance: Thomas R. Way, London, to
Charles Lang Freer, 1891. 91.3
Cancelled copperplate, Hunterian Art Gallery

The location of this image is not certain but it consistently advances Whistler's thematic use of workingmen in industrial settings marked by sharp contrasts of light and dark. While the image is innocent of "spreading chestnut trees," the meaning of the village blacksmith as a symbol of probity was well established in American art and literature after Longfellow's "Village Blacksmith" poem of 1841. Among the painters who created images of metalsmiths was John F. Weir, son of Whistler's teacher, Robert Weir.

35. Stables [K225]

"An unpleasing thing, and framed in
Mr. Whistler's odd fashion." —City Press

drypoint, 2nd state of 3
black ink on cream laid paper, trimmed to plate mark
partial watermark
not signed in plate
6⁷⁄₁₆ x 9⅛ inches

Inscribed recto, on tab: pencil butterfly, imp
 (Whistler's hand)
Inscribed verso, lower left: "1st proof"; lower right:
 "Whistler"
Provenance: Thos. Agnew & Sons, London, to
 Julie and Anita Zelman, Los Angeles, 1982, to
 Los Angeles County Museum of Art, 1992. 234.10
Cancelled copperplate, Hunterian Art Gallery

Again, one has the impression that Whistler purposefully juxtaposed certain images in his *White and Yellow* catalogue. He seems also to indulge in abstruse puns. Unlike *The Smithy*, no. 34 above, this image has nothing to do with horses. Framed by the Ponte de l'Anzolo (see no. 12 above), Whistler peered into a *cavana*, a place for housing (i.e., "stabling") boats. As Grieve has shown, Whistler found several motifs in this tortuous section of Venice east of the Rialto Bridge. The "stable" was adjacent to a crumbling Gothic building drawn in pastel as the *Marble Palace* [see fig. 7.7].

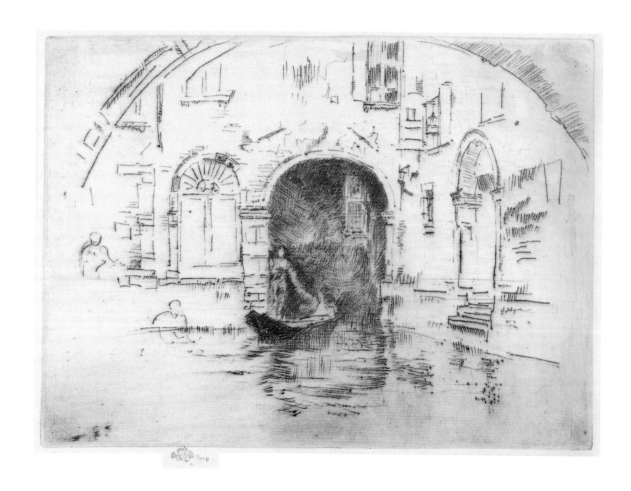

36. The Mast [K195]

"The Mast and the Little Mast are dependent for much of their interest, on the drawing of festoons of cord hanging from unequal heights."* —P.G. Hamerton[111]

*At the service of critics of unequal sizes.

etching, 5th state of 6
brown ink on cream laid paper trimmed to plate mark
unidentified watermark
signed in plate with butterfly, middle left edge
13⅜ x 6⅜ inches

Inscribed recto, on tab: pencil butterfly, imp
 (Whistler's hand)
Inscribed verso, lower right: pencil butterfly,
 "specially chosen proof" (Whistler's hand)[112]
Provenance: Wunderlich, New York, to
 Isabella Stewart Gardner, 1890
Cancelled copperplate, Hunterian Art Gallery
Portfolio, *Twelve Etchings of Venice*, no. 10

Dominating this image, a tall mast topped with the Lion of St. Marks represents a gesture of Venetian maritime dominion that once stood in a now demolished neighborhood near the Campo di Marte, the field on the west end of the city where Austrian troops once paraded. Grieve notes that the column was put up a decade after the occupiers had left the city, but it is no longer there. The column was moved to the nearby Campo San Nicolo dei Mendicoli when the old neighborhood was overrun by the development of a cotton mill. About all that remains of what Whistler beheld is one of the two stone wellheads at the end of the street. Whistler finally signed this plate with his butterfly in the fifth state.

37. Traghetto [K191]

"The artist's present principles seem to deny him any effective chiaroscuro."
—P. G. Hamerton[113]

"Mr. Whistler's figure drawings, generally defective and always incomplete."*[114]

* "Sometimes generally always."

etching, 4th state of 6
signed in plate with butterfly, left edge
brown ink on cream paper trimmed to plate mark
watermark: Arms of Amsterdam; RK (paper mill mark)
9 9/16 x 11 15/16 inches

Inscribed recto, on tab: pencil butterfly, imp
 (Whistler's hand)
Inscribed verso: "Thomas Way"; pencil butterfly
 (Whistler's hand) "From T. Way, June '05"
 (Freer's hand)

Provenance: Thomas R. Way, London, to
 Charles Lang Freer, 1905. 05.183[115]
Cancelled copperplate, Freer Gallery of Art, 02.134
Portfolio, *Twelve Etchings of Venice*, no. 11
K191 as *The Traghetto*, no. 2

Here Whistler depicts boatmen lounging at a table as they wait for foot passengers wishing to be carried west across the Grand Canal at the *traghetto* (ferry) station of Santi Apostoli. Grieve has identified the site as the courtyard of the Ca' da Mosto, close by the Rialto Bridge in the Cannaregio district of Venice. The U-shaped form in the passageway, echoing the form of the large arch above it, is a detached *felze* (gondola roof). Whistler observed the passageway from the opposite point of view when he drew an image of the Ca' da Mosto's canal facade (M758). This particular crossing is no longer in use; the passageway has been barred by a large iron gate. However, anyone negotiating the complex byways of the city using footbridges knows how much time can be saved by such a shortcut.

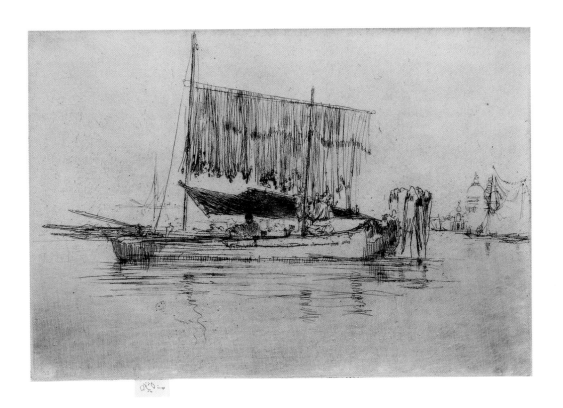

38. Fishing Boat [K208]

"Subjects unimportant in themselves."
—P. G. Hamerton[116]

etching and drypoint, 3rd state of 5
brown ink on cream laid paper trimmed to plate mark
not signed in plate [signed in 1st, removed in 3rd]
6 1/8 x 9 1/8 inches

Inscribed recto, on tab: pencil butterfly, imp
Provenance: Knoedler, New York, to
 Charles Lang Freer, 1887. 87.19
Cancelled copperplate, Art Institute of Chicago
Portfolio, *Venice, Second Series*, no. 18
K208 as *Fishing-Boat*

At anchor in the lagoon, the fishing boat in this image obscures most of the skyline of the tourist's Venice, including St. Marks and the bell tower. However, a glimpse of the large dome of the Salute, as well as the gilded statuette on a globe ornamenting the Dogana di Mare (customs house), helps us to orient Whistler's reversed image. Far from unimportant, the topic of working boats contrasted with leisure provided compelling subjects not only for Whistler but also for several generations of French and American Impressionists.

39. Ponte Piovan [K209]

"Want of variety in the handling."
—*St. James's Gazette*[117]

etching, 5th state of 6
brown ink on cream laid paper trimmed to plate mark
watermark: Post horn, HG
signed in plate with butterfly, middle right
8 $^{15}/_{16}$ x 6 inches

Inscribed recto, on tab: pencil butterfly, imp
 (Whistler's hand)
Provenance: Knoedler, New York, to
 Charles Lang Freer, 1887. 87.20
Cancelled copperplate, Art Institute of Chicago
Portfolio, *Venice, Second Series*, no. 19
K209 as *Ponte del Piovan*

With a full place-name ("Ponte del Piovan Detto
del Voto") etched into the plate, Whistler offers
the kind of signage sometimes seen in earlier
Thames etchings such as *The Adam and Eve,
Old Chelsea* (K175). Grieve notes that this image
provides one of the last known images of an
old shored-up bridge that was demolished in
1880. Whistler's interest in fragile, endangered,
soon-to-vanish structures links many of his
subjects chosen in various locations in Europe
and Britain. Although the bridge is gone, other
details of the scene can still be found, albeit
in altered states. The prominent balcony on the
blocky Ca' Widmann has been rebuilt, and the
arched window next to it is now bricked up. As is
often the case in Venice, the distinctive inverted
funnel-shaped chimney is gone, but one can
still shelter from a sudden downpour under the
Sotto Porto Widmann, the covered passageway
visible directly below the arch of the bridge.

40. Garden [K210]

"An art which is happier in the gloom of a doorway than in the glow of the sunshine, and turns with a pleasant blindness from whatsoever in Nature or Man is of perfect beauty or noble thought." —"'Arry"[118]

etching, 7th state of 8
brown ink on cream laid paper trimmed to plate mark
signed in plate with butterfly, lower middle left
 opposite steps
11 $^{15}/_{16}$ x 9 $^{5}/_{16}$ inches

Inscribed recto, on tab: pencil butterfly, imp
 (Whistler's hand)
Provenance: Knoedler, New York, to
 Charles Lang Freer, 1887. 87.21
Cancelled copperplate, Art Institute of Chicago
Portfolio, *Venice, Second Series*, no. 20

A young boy dabbling one foot in the water as he idles at the canal-side gate to an old garden embodies the dreamy, otherworldly atmosphere that still makes Venice mesmerizing to so many visitors. In the background, some of Whistler's stock characters—the woman holding a baby, the young child near her—are framed by the doorway leading to a dark interior. The composition offers yet another example of Whistler's layered spaces, but his oft-employed formula proves remarkably flexible, providing a sense of continuity to the work as a whole. A large cat on the steps basks on warm stone, indifferent to any passing observer.

41. The Rialto [K211]

"Mr. Whistler has etched too much for his reputation." —F. Wedmore[119]

"Scampering caprice." —S. Colvin*[120]

"Mr. Whistler's drawing, which is sometimes that of a very slovenly master."[121]

*This Critic, it is true, is a Slade Professor.

etching, 2nd state of 2
brown ink on cream laid paper trimmed to plate mark
watermark: fleur-de-lis, LVG
not signed in plate
11 5/8 x 7 7/8 inches

Inscribed recto, on tab: pencil butterfly, imp
 (Whistler's hand)
Inscribed verso: unrecorded Freer collector stamp
Provenance: Knoedler, New York, to
 Charles Lang Freer, 1887. 87.22
Cancelled copperplate, Art Institute of Chicago
Portfolio, *Venice, Second Series*, no. 21

In the exhibition catalogue, Whistler followed the leisurely *Garden* with a bustling image of one of Venice's oldest and best-known market areas. From a window overlooking the Campo San Bartolomeo, Whistler captured the crowded shops lining the approach to the shallow steps of the famous Rialto Bridge, more familiar to Whistler's audience in views of the elegant structure itself arching over the Grand Canal. Farther to the west in Whistler's unconventional depiction of the famous landmark, the tower of San Giovanni Elemosinario rears up on the far side of the bridge. A partial inscription over the striped awning to the right in Whistler's reversed image reads "Vendita Carn...," implying the presence of a butcher's shop. Today the busy marketplace is much as Whistler witnessed it, although among the most dominant features in the area is a garish electronic McDonald's sign.

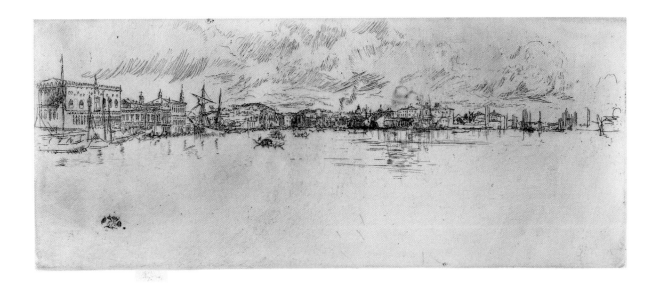

42. Long Venice [K212]

"After all, there are certain accepted canons about what constitutes good drawing, good colour, and good painting; and when an artist deliberately sets himself to ignore or violate all of these, it is desirable that his work should not be classed with that of ordinary artists." —"'Arry"[122]

etching, 5th state of 5
brown ink on cream laid paper trimmed to plate mark
signed in plate with butterfly, lower left corner
5 x 12 1/16 inches

Inscribed recto, on tab: pencil butterfly, imp
 (Whistler's hand)
Provenance: Knoedler, New York, to
 Charles Lang Freer, 1887. 87.23
Cancelled copperplate, Art Institute of Chicago
Portfolio, *Venice, Second Series*, no. 22

Having confounded his audience with an unexpected aspect of the Rialto Bridge, Whistler next presented perhaps the single most touristic panorama of Venice in the entire exhibition. Whistler obtained this view looking west from a spot near the Riva Ca di Dio, close to his lodgings at the Casa Jankowitz. The Doge's Palace is easily recognized at the far left of Whistler's reversed image, as is Sansovino's library, immediately adjacent. Across the opening to the Grand Canal, the by-now familiar domes of the Salute punctuate the vista. By distancing the skyline with open water, which takes up half the sheet, Whistler underscored the shimmering hallucinatory charm of the "Queen of the Adriatic."

43. Nocturne Salute [k226]

"The utter absence, as far as my eye* may be trusted, of gradation." —F. Wedmore[123]

*? [in margin to question critic's eye]

"There are many things in a painter's art which even a photographer cannot understand." —Laudatory notice in Provincial Press

etching, 5th state of 5
brown ink on cream laid paper, trimmed to plate mark
partial watermark: bottom of shield
signed in plate with butterfly, lower left edge
6 x 87⁄8 inches

Inscribed, verso: "Salute—trial proof by Whistler"
 (Freer's hand)
Provenance: Thomas Way to Charles Lang Freer,
 1905. 05.198
Cancelled copperplate, Hunterian Art Gallery
k226 as *Nocturne: Salute*

Whistler used rich inking and selective wiping of his plate to achieve a Turneresque sunset blaze without benefit of color. Again Whistler presents one of the standard tourist views of Venice— the Salute seen across the lagoon from the Molo (quay) near the Piazzetta (see no. 45 below), where gondolas still tie up regularly. Although Whistler greatly abstracted his subject, the image also offers a clear glimpse of the Dogana di Mare's gilded globe and weathercock, silhouetted to the right of the Salute in Whistler's reversed image. Atypically, Whistler trimmed this proof to the plate mark, retaining the small paper tab at lower left, but he never got around to inscribing it with a penciled butterfly. Freer obtained the print after the artist's death.

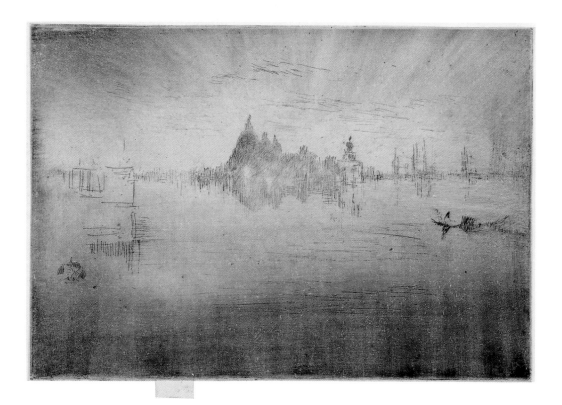

44. Furnace Nocturne [K213]

"There is no moral element in his chiaroscuro." —*Richmond Eagle*

etching, 4th state of 7
brown ink on cream laid paper trimmed to plate mark
signed in plate with butterfly, middle left edge
6 5/8 x 9 1/8 inches

Inscribed recto, on tab: pencil butterfly, imp
 (Whistler's hand)
Provenance: Knoedler, New York, to
 Charles Lang Freer, 1887. 87.24
Cancelled copperplate, Art Institute of Chicago
Portfolio, *Venice, Second Series*, no. 23
K213 as *Nocturne: Furnace*

Visible at the bottom left in the lighter of the two proofs, a gondola prow creeps silently into this dramatically lit scene of a workman at a blazing furnace, oblivious to all but the task at hand, a task that Whistler left to the viewer's imagination. The composition is consistent with other doorway scenes in the *Arrangement in White and Yellow* exhibition, as is the vague countenance at the gridded window, returning our gaze. The proof in Mrs. Gardner's unbroken suite of *Twenty-six Etchings* is in the sixth state [fig. 44a]. Variations in the inking change the atmosphere far more than changes to the plate itself.

44

44a

45. Piazetta [K189]

"Whistler does not take much pains with his work." —New York Paper

"A sort of transatlantic impudence in his cleverness."[124]

"His pictures do not claim to be accurate."[125]

etching, 3rd state of 5
black ink on cream laid paper trimmed but not to plate mark
signed in plate with butterfly, lower middle left
10 x 7 1/8 inches

Inscribed recto, on tab: pencil butterfly, imp (Whistler's hand)
Inscribed verso: SH "W 155 The Piazzetta—Trial Proof" (Freer's hand)

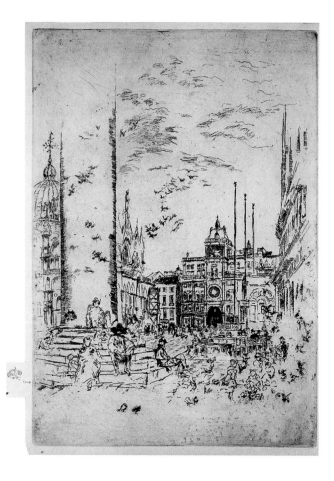

Provenance: Seymour Haden, London, through Wunderlich, New York, to Charles Lang Freer, 1898. 98.386[126]
Cancelled copperplate, Freer Gallery of Art, 02.132
Portfolio, *Twelve Etchings of Venice*, no. 12
K189 as *The Piazzetta*

Whistler may have intentionally twitted his audience by juxtaposing a journalistic commentary on accuracy with a print whose misspelled title designates one of the most familiar spots in the tourist's Venice. The Piazzetta leads from the Molo (quay with gondola stand) bordering the lagoon into the Piazza San Marco. The heavy cornice of Sansovino's library guides the eye back into the enormous square. Flocks of pigeons whose descendants still menace pedestrians are in evidence here. The Campanile di San Marco is out of sight, but its blocky pink and white marble entrance is shown, just beneath three tall masts topped with winged lions, symbol of the Venetian state. Across the wide expanse stands the Clock Tower. Whistler accurately captured the silhouettes of the two mechanical Moors who strike the hour on a colossal bronze bell. Partially hidden by the St. Theodore Column, the intricate Gothic facade and resplendent dome of St. Marks Cathedral emerge to the left of the Clock Tower in Whistler's reversed image. Scaffolding on St. Marks gives evidence of major restoration under way at the time—the project was hotly debated in Victorian England. Whistler left out the crocodile that crowns the St. Theodore Column. His own butterfly, arguably as aggressive as the attribute of the first patron of the ancient Republic, ornaments the column at its base.

46. The Little Mast [K185]

"Form and line are of little account to him."[127]

etching, 1st state of 4
black ink on cream laid paper trimmed to plate mark
signed in plate with butterfly
10½ x 7⅜ inches

Inscribed recto, on tab: pencil butterfly, imp
 (Whistler's hand)
Inscribed verso: "Before the long accidental scratches
 were removed."
Provenance: Frederick Keppel & Co., New York, to
 Charles Lang Freer, 1902. 02.131
Cancelled copperplate, Freer Gallery of Art, 02.130
Portfolio, *Twelve Etchings of Venice*, no. 7

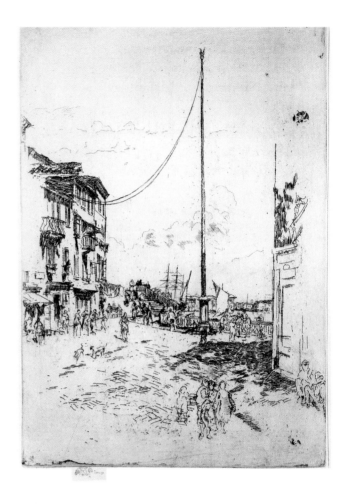

Whistler stood in the broad Via Garibaldi, looking
southwest toward the Ponte de la Veneta Marina
to capture this view. While difficult to make
out, Whistler included next to the mast one of the
bigolante, sturdy young women who sold water
carried in buckets dangling from yokes over their
shoulders. This Venetian type was especially pop-
ular with visiting artists such as Frank Duveneck,
who also worked at this site. Marked by the
butterfly, the building to the right in Whistler's
reversed image was once the home of John
Cabot, the Venetian who discovered Newfound-
land in the service of Henry VIII. A large still-
extant plaque celebrating Cabot's achievement
was erected on the wall in 1881, after Whistler had
left Venice. Apparently at the last minute, *The
Little Mast* was substituted for *The Bridge* (no. 17
above) in the *Twelve Etchings of Venice*. While
Freer was in London during the summer of 1902,
he got a letter and some proofs, including this one
priced at 25 guineas, from the dealer Frederick
Keppel, who wrote, "I am just returned from the
Continent, where I have spent very big money
for a very small showing of rare prints. Prices
are advancing in an unmerciful manner;—and
Whistler's works more than any others."[128]

47. Quiet Canal [K214]

"Herr Whistler stellt ganz wunderbare Productionen aus, die auf Gesetze der Form und der Farbe gegrundet scheinen, die dem Uneingeweihten unverstandlich sind."
—Weiner Presse[129]

"This new manner of Mr. Whistler's is no improvement upon that which helped him to win his fame in this field of art."[130]

etching, 5th state of 5
brown ink on cream laid paper, trimmed to plate mark
not signed in plate
8⅞ x 6 inches

Inscribed recto, on tab: butterfly, imp (Whistler's hand)
Provenance: Knoedler, New York, to
 Charles Lang Freer, 1887. 87.25
Cancelled copperplate, Art Institute of Chicago
Portfolio, *Venice, Second Series*, no. 24

Grieve has located this site in Di Cittra, a section of the city lying east of the Rialto Bridge. Whistler etched *Quiet Canal* at a spot praised by Ruskin, but he virtually ignored the ornate wooden door Ruskin so admired. The Gothic entrance to the Palazzo Soranzo-van Axel-Barozzi is here reduced to an abbreviated set of lines at the end of a blank passage indicating the Fondamenta Sanudo, on the right side of Whistler's reversed image. The artist concentrated instead on the gently curving Rio de la Panada, capturing some of the often-encountered picturesque elements that give Venice its lasting appeal.

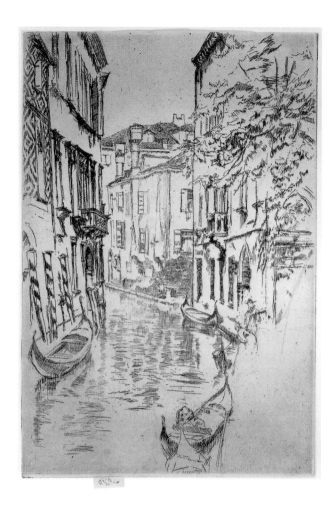

48. Palaces [K187]

"The absence, seemingly, of any power of drawing the forms of water."*
— F. Wedmore[131]

"He has never, so far as we know, attempted to transfer to copper any of the more ambitious works of the architect."
— *Pall Mall Gazette*[132]

"He has been content to show us what his eyes can see, and not what his hand can do." — *St. James's Gazette*[133]

etching, 2nd state of 3
brown ink on laid paper, trimmed to plate mark
signed in plate with butterfly
9 $^{15}/_{16}$ x 14 $^{1}/_{16}$ inches

Inscribed recto, on tab: pencil butterfly, imp (Whistler's hand)
Inscribed verso: "SH"
Provenance: Seymour Haden, London, through Wunderlich, New York, to Charles Lang Freer, 1898. 98.383
Portfolio, *Twelve Etchings of Venice*, no. 9
K187 as *The Palaces*

Venetian Gothic architecture and heavy gondola traffic mark *Palaces* as a typical view, but it is less traditional than it seems at first glance. Whistler included a glimpse of the Ca' d'Oro, the most famous palazzo in Venice, but it serves only to close off the right side of his reversed image. Two less well known structures are rendered in detail—the buff brick Palazzo Pesaro, still in relatively good repair, and the wide, now somewhat shabby pink stucco expanse of the Palazzo Sagredo, with its arched watergates and elegant Venetian Gothic balcony. The old *traghetto* service crossing the Grand Canal next to the Palazzo Sagredo is still in use. The garden space next to the Palazzo Pesaro is now obscured by the Ca' d'Oro vaporetto stop. On this, the largest of the Venetian plates, Whistler's butterfly signature made only a cameo appearance. Absent in the first state, it appears in the second, only to vanish again in the third. This proof was pulled on a sheet from an old blank book.

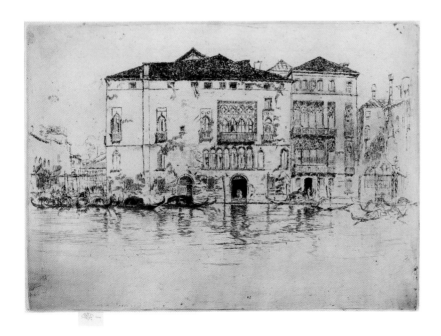

49. Salute Dawn [K215]

"Too sensational." —*Athenaeum*[134]

"Pushing a single artistic principle to the verge of affectation." —Sidney Colvin[135]

etching, 4th state of 4
brown ink on cream laid paper trimmed to plate mark
watermark: LVG
signed in plate with butterfly, upper left in sky
5 x 8 inches

Inscribed recto, on tab: pencil butterfly, imp
 (Whistler's hand)
Provenance: Knoedler, New York, to
 Charles Lang Freer, 1887. 87.26
Cancelled copperplate, Art Institute of Chicago
Portfolio, *Venice, Second Series*, no. 25
K215 as *La Salute: Dawn*

Hovering against the western sky, the towers of San Giorgio and the Campanile di San Marco bracket this familiar Venetian vista taken from the Riva dei Sette Martiri, a broad passageway bordering the lagoon conveniently near Whistler's lodgings (for the opposite view, see no. 4 above). The artist made several images from viewpoints in this area. Atypically, Whistler indicated a time of day in his title. The rising sun most sharply illuminates the distant skyline, which grows hazy as the day progresses.

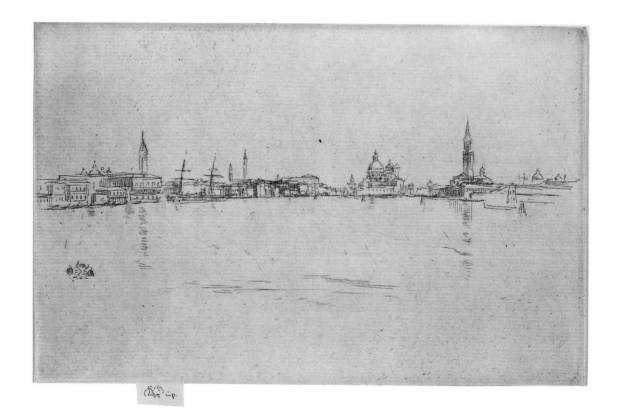

50

50a

50. Beggars [k194]

"In the character of humanity he has not
time to be interested." — *Standard*[136]

"General absence of tone." — P. G. Hamerton[137]

etching, 4th state of 9
brown ink on cream laid paper, untrimmed
 (deckle edge)
partial watermark, 1814
signed in plate with butterfly
11 $^{15}/_{16}$ x 8 $^{1}/_{4}$ inches

Provenance: Seymour Haden through
 Thomas Wilmer Dewing to Charles Lang Freer,
 1898. 98.392
Portfolio, *Twelve Etchings of Venice*, no. 3
k194 as *The Beggars*

Few Venetian plates went through as many significant changes as did *Beggars*. In various states, the mendicants sheltering under the gloomy Sottoportego de la Carozze off the sunny Campo Santa Margarita range from a Rembrandtian bearded old man in the first state [fig. 50a, Freer Gallery 03.149] to melodramatic young woman and child in the second, to the haggard old woman who makes a sharper contrast with the child in third and following states. As a counterpoint to the beggars themselves, as well as several shadowy, sinister figures in the composition, one of the Venetian *bigolante* stands in full sunlight at the far end of the passage. Shouldering her water buckets on a wooden yoke, she offers a silent testament to hard work. One of the first etchings Whistler made in Venice, *Beggars* must have had special significance for an artist working to recoup his finances. Whistler's fortunes were on the rise again by the time of the *Arrangement in White and Yellow* exhibition in 1883, and this work appears at the end of the catalogue.

51. Lagoon: Noon [K216]

"Years ago James Whistler was a person of high promise." —F. Wedmore[138]

"What the art of Mr. Whistler yields is a tertium quid."* —Sidney Colvin[139]

*The quid of sweet and bitter fancy?

etching, 3rd state of 3
 signed in plate with butterfly, lower left
brown ink on cream laid paper, trimmed to plate mark
4 15/16 x 7 15/16 inches

Inscribed recto, on tab: pencil butterfly, imp
 (Whistler's hand)
Inscribed verso: unrecorded Freer collector stamp
Provenance: Knoedler, New York, to
 Charles Lang Freer, 1887. 87.27
Cancelled copperplate, Art Institute of Chicago
Portfolio, *Venice, Second Series*, no. 26

Whistler depicted the Ponte de la Veneta Marina (see no. 46 above) once more in this southeast view across the lagoon toward the distant Lido. A single gondolier rows his stately craft toward the bridge. In contrast, a schooner with several sails raised points its prow in the opposite direction. The last image Whistler selected for his exhibition conjures a sense of the artist's own departure from Venice for London in November 1880.

Despite Whistler's carping response in the *Arrangement in White and Yellow* catalogue, Sidney Colvin correctly detected in Whistler's art a tertium quid—something that escapes classification with either of two mutually exclusive and supposedly exhaustive categories (in this case aestheticism versus realism) but instead shares elements of each.

"All of which gems, I am sincerely thankful to say,
I cannot appreciate."[140]

"As we have hinted, the series does not represent any Venice that we
much care to remember; for who wants to remember the degradation
of what has been noble, the foulness of what has been fair?"
— " 'Arry"* in the "Times."[141]

*The labor of the foolish wearieth every one of them because
he knoweth not how to go to the City.

"Disastrous failures." — F. Wedmore[142]

"Failures that are complete and failures that are partial."
— F. Wedmore[143]

"A publicity rarely bestowed upon failures at all."
— F. Wedmore, Nineteenth Century[144]

"Voila ce qui l'on dit de moi
Dans la Gazette de Hollande."

"Therefore is judgment far from us, neither doth justice
overtake us. We wait for light, but behold obscurity; for brightness,
but we walk in darkness."[145]

"We grope for the wall like the blind, and we grope as if we had
no eyes; we stumble at noonday as in the night."[146]

"We roar all like bears."[147]

Prints not chosen by Whistler for inclusion in the exhibition or in published sets

All copperplates unlocated
All prints in the collection of the Freer Gallery of Art

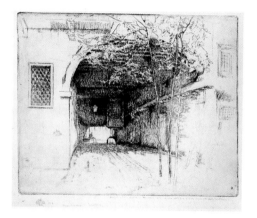

A. The Traghetto, No. I [K190]
drypoint

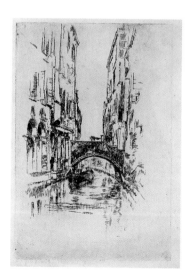

B. Gondola under a Bridge [K227]
etching

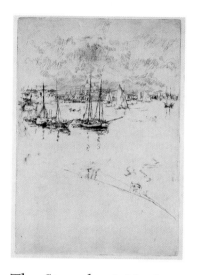

C. The Steamboat, Venice [K228]
etching

D. Shipping, Venice [K229]
etching

E. **Venetian Court** [K230]

drypoint

G. **Venetian Water Carrier** [K232]

drypoint

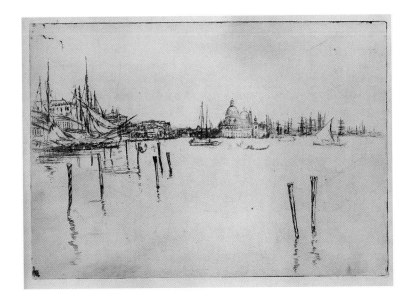

F. **Venice** [K231]

drypoint

CHAPTER 8 | CODA

387

Endnotes

Epigraphs

Prelude
 Whistler 1885, 84.
Fashion's Wheel
 Pope, "Epistle to Dr. Arbuthnot"
 (1735) quoted in Whistler 1883,
 without attribution.
 Old German proverb: Those who
 would be beautiful must suffer.
Women in White
 Collins 1860, 54.
 Wharton 1938, 4.
Houses Beautiful
 Shakespeare, *As You Like It*, II,
 vii, 139.
 See LC PWC II / 937–38.
Style Wars
 Importance of Being Earnest (1895),
 in Wilde 1999, 409.
Punch and Jimmy
 George du Maurier in *Punch,
 or the London Charivari*, vol. 80
 (22 January 1881): 26.
A Little White Paper
 Whistler 1885, 95. This is the last
 sentence in Whistler's "Ten
 o'Clock" lecture.
 Scarry 1999, 86.
Coda
 Lady Windemere's Fan (1892) in
 Wilde 1999, 409.

Acknowledgments

1. YMSM 196. A closely related pastel is called *Souvenir of the Gaiety*, M 664. Whistler had been attending rehearsals of a play called *The Grasshopper* at the Gaiety Theatre. Apparently, a caricature of Whistler painted by Carlo Pellegrini, a cartoonist for *Vanity Fair*, figured as a prop. Whistler, Oscar Wilde, and Frank Miles may also have had a song-and-dance act in this farce. Later Whistler would paint the child star of the show, Nellie Farren. See GUW, "Carlo Pellegrini, 1839–1889."
2. Nicoll 1963, 8.
3. GUL PC I, 41.

Introduction

1. Eliot 1876, 155.
2. Eddy 1903, 214. Over half of Whistler's surviving work in oil is portraiture or hybrid portrait-genre scenes with known models.
3. Curry 1984; Merrill 1998.
4. Casteras and Denney 1996.
5. Ruskin, Letter 79, *Fors Clavigera*, 2 July 1877. The painting was no. 4 in the West Galleries at the Grosvenor. It was priced in the catalogue at £262.10.0. See YMSM 170.
6. There was an auction sale of Whistler's paintings, etchings, drawings, Japanese artifacts, blue-and-white pots, and other household effects at the "White House" on 7 May 1879. On 8 May 1879 he was declared bankrupt and bailiffs took possession of his house. A second Whistler sale took place on 12 February 1880 at Sotheby's; it included more prints and paintings as well as remaining porcelains.
7. Grieve 2000. Most of the obscure Venetian sites named in the following pages are based upon Grieve's impressive work, which enabled me to visit them in person.
8. "Whistler's Wenice; or Pastels by Pastelthwaite," *Punch*, vol. 80 (12 February 1881): 175.
9. Curry 1984.

Chapter 1: PRELUDE

1. Noting this, Richard Dorment reads the picture as a reverie, rich with memories of family concerts. He suggests that the piano in the picture once belonged to Deborah and James's father, Major George Washington Whistler, who died in Russia in 1849. Dorment 1994, 73. Gallery visitors would have recognized proper mourning dress, for "the apparel and apparatus of grief" was big business in Victorian England. Ashelford 2000, 209, 237–40. See also Flanders 2003, 378–83. On white mourning dress for children and younger women, see Harvey 1995, 205–6.
2. Shackelford and Holmes 1986, 13–15.
3. One reviewer wrote, "If the observer will look for a little while at this

singular production, he will perceive that it 'opens out' just as a stereoscopic view will." See "Fine Arts: Royal Academy," *The Athaeneum*, 19 May 1860, cited in full, along with three other reviews in Goebel 1988, 2: 691–92. Invented for scientific use in 1832, the stereoscope peaked as a toy craze in the 1850s, just before Whistler painted this picture. Dorment 1994, cat. no. 11, n. 3. Essentially, the stereoscope domesticated large-scale urban public entertainments—the cosmorama and the panorama. Queen Victoria's endorsement fired the fashion for stereoscopes at home. Altick 1978, 233–34.

4. Crow 1996, 36–37. He notes, "The founding moments for subsequent discourses on both modernist art and mass culture were one and the same. Current debates over both topics invariably begin with the same names— Adorno, Benjamin, Greenberg (less often Schapiro, but that should by now be changing). Very seldom, however, are these debates about both topics together. But at the beginning they always were: the theory of one was the theory of the other. And, in that identity was the realization, occasionally manifest and always latent, that the two were in no fundamental way separable."

5. "Exhibition of the Royal Academy, Second Notice," *The* (London) *Times*, 17 May 1860, 11. The passage in Whistler's picture is ambiguous— colored strokes can be seen beneath the glass, and paintings as well as prints were often glazed in private homes. The practice was lampooned in "A Great Desideratum," *Punch*, vol. 73 (24 February 1877): 84.

6. Compilers of *The Year's Art* chronicled the issue of lucrative reproductive prints starting in 1879. Their statistics indicate fierce competition controlled by the Print Sellers Association. This self-policing body of dealers and

publishers sought to prevent fraud in the marketplace through a complex vetting system based on signing and stamping proofs. See *The Year's Art. A Concise Epitome of All Matters Relating to the Arts of Painting, Sculpture, and Architecture, which have occurred during the year 1879, together with information respecting the events of the year 1880*, compiled by Marcus B. Huish (London, 1880), 108. For new prints, numbers of proofs, and values, see *The Year's Art for 1884* (1885), 175; and for 1887 (1888), 215. The same rules did not apply to original etchings, leaving room for Whistler to create his own "value added" system with margins trimmed to the plate mark save for a tab that was signed in pencil with a butterfly. On occasion Whistler did permit reproductive printmakers to reproduce one of his paintings.

7. Whistler and Haden quarreled irreparably in Paris over Haden's self-righteous insensitivity to the death of James Traer, Haden's erstwhile medical associate, who is pictured in Whistler's etching *The Music Room*. In 1864, after Haden retouched a painting by Alphonse Legros, Whistler wrote to Henri Fantin-Latour relishing "the spirit for battle daily growing between Haden and his devoted brother-in-law." Whistler to Fantin-Latour, 4 January– 3 February 1864. GUW 08036 [LC PWC 1/33/15].

8. It is not entirely clear how Haden reacquired the picture, which does not appear in auction catalogues. YMSM 24.

9. A cynical *Punch* cartoon by George du Maurier shows "young Ernest Raphael Sopely" at work on a portrait of "Lady Midas," who is old and tubby. The artist makes her young and beautiful and "rises thereby to fame and affluence." Du Maurier adds, "Who lives to please must please to live." "Punch's Almanack for 1881," *Punch*, vol. 79 (13 December 1880): n.p.

In another cartoon (signed W. M.) the portrait depicts a prize bull in the manner of Edwin Landseer's *The Monarch of the Glen* (1851). The artist endures "Cattle-show critics" who complain, "Yes—it's like old Ben; but that's not my idea of the picture. We'd have liked the prize cup in the foregrun'. Wouldn't we, my love." The owner's wife replies, "Yes, dear. And we thought of *Our House* in the background, didn't we, Lucy darling?" Lucy darling chimes in, "Yes, Ma dear; and the pretty ribbon with the dear little ticket round his neck." See "Cattle-show critics," *Punch*, vol. 63 (14 December 1872): 252. Many artists faced this dilemma. Economically obliged to paint portraits, Dennis Miller Bunker growled, "I hear my sitter coming, hang him!" Bunker to Joe Evans, 13 October 1887, Dennis Miller Bunker Papers, AAA, Roll 1201. John Singer Sargent decided not to accept further commissions the year before he completed his cycle of Wertheimer family portraits. Kleeblatt 1999, 12–20.

10. Getscher and Marks 1986 compile the literature up to the mid-1980s. At the end of Whistler's life, some recognized that his public facade had hurt the general perception of his art. Kenyon Cox wrote, "There can be little doubt that the just recognition of Whistler as a serious artist was long delayed by the very qualities of the man which kept his name constantly before the public." Cox 1904, 637. Whistler's friend the high-rolling gambler Richard A. Canfield rightly predicted that Whistler's twin postures—eccentric aesthete and dedicated artist—would compromise later understanding of his legacy.

11. Whistler first made the remark in an interview called "Mr. Whistler at Cheyne Walk," *The World: A Journal for Men and Women* (22 May 1878). Later, he incorporated it into his polemical statement of purpose, "The Red Rag,"

in *The Gentle Art of Making Enemies* (1890), a book reprinted frequently thereafter. Thorpe 1994, 52.

12. Schapiro, discussed and analyzed in Crow 1996, 13 ff.

13. Ibid., 13, n. 21. Schapiro argued that the avant-garde identified "the aesthetic itself" with "habits of enjoyment and release produced quite concretely within the existing apparatus of commercial entertainment and tourism—even, and perhaps most of all, when art appeared entirely withdrawn into its own sphere, its own sensibility, its own medium."

14. These reflect entertainments also seen in the London streets and performed at famous gathering spots such as Astley's Amphitheatre (1769–1893) near the Westminster Bridge. For Charles Dickens's description, see "Astley's," in Dickens 1839, 128–34.

15. For details on the picture's development, which involved the use of photographs as well as studio models, see Anne Helmreich's entry in Warner 1997, 103–5. She also enumerates additional types. The picture was first exhibited at the Royal Academy in 1858, where it caused such a sensation that a railing was required to protect it from the enthusiastic crowds.

16. None of the four reviews of the piano picture cited in Goebel offer any personal detail whatsoever. One review, however, inventoried the elements of the composition, making what seems to be the first association of Whistler's work with Velázquez: "There is the same powerful effect obtained by the simplest and sombrest colours— nothing but the dark wood of the piano, the black and white dresses, and under the instrument a green violin and violincello case relieved against a greenish wall, ornamented with two prints in plain frames. Simpler materials could not be well taken in hand." See "Exhibition of the Royal Academy,

Second Notice," *The* (London) *Times*, 17 May 1860, 11.

17. Gautier commented, "If the Venus of Milo recovered her arms and if a society lady were kind enough to lend her her corsage, she could go to a *soirée* with her hair just as it is. What a tribute to the fashion of our time!" Gautier, "De La Mode" (1858), in Simon 1995, 167. The concern with contemporary fashion was not confined to the French avant-garde. Frith's *Derby Day*, with its cross section of class and dress in Britain, was a meticulously observed costume study that set a benchmark in mid-nineteenth-century British art.

18. Whistler to Fantin-Latour, 3 February 1864. GUW 08036 [LC PWC I/33/15]. The woman was actually Miss Boott, a family connection.

19. The Amazons, a warlike nation of women, figure in the labors of Hercules. One particular task is linked to fashion—Hercules sets out to get the girdle of the queen of the Amazons for Admeta. Classical artists usually depict Amazons battling men, so we may presume that the term "amazon" applied to talented horsewomen aroused mixed feelings. A wood engraving by Mary Ellen Edwards published in *The Graphic*, 23 March 1872, shows well-dressed men leering over two women striking fashion-plate poses to show off riding costumes with long trailing skirts. A punning title, *The Special Train for the Meet*, suggests that the racier interpretation of such attire was well known in Britain. Harvey 1995, 204. For recent commentary on such women, who were often kept in St. John's Wood, an affluent section of London, see "The Pretty Horse-breakers of the Grove of the Evangelist" in Crow 1972.

20. The group was formed in 1858 with Whistler, Fantin-Latour, and Legros. Albert Moore replaced Legros in 1865. The informal group of friends aimed

for mutually supportive international marketing. See Dorment 1994, 14.

21. It might be somewhat humbling to consider that elaborate formalist criticism stems from such mundane beginnings as negative Victorian cartoons. In one from *Punch*, vol. 73 (10 February 1877): 51, a "matter-of-fact party" stands before a painting and engages an "ineffable youth" in the following exchange: *Matter-of-Fact Party.* "But it's such a repulsive subject!" *Ineffable Youth.* "'Subject' in art is of no moment! The *Picktchah* is beautiful!" *Matter-of-Fact Party.* "But you'll own the *drawing's* vile, and the *colour's* beastly!" *Ineffable Youth.* "I'm cullah-blind, and don't p'ofess to understand d'awing! The *Picktchah* is beautiful!" *Matter-of-Fact Party* (getting warm). "But it's all out of *Perspective*, hang it! And so abominably *untrue to Nature!*" *Ineffable Youth.* "I don't care about Naytchah, and hate perspective! The Picktchah is *most* beautiful!" *Matter-of-Fact Party* (loosing all self-control). "But dash it all, Man! Where the dickens is the beauty, then?" *Ineffable Youth* (quietly). "In the Picktchah!" (Total defeat of Matter-of-Fact Party.)

22. YMSM 24. Arriving in Paris at the height of the nineteenth-century etching revival, Whistler first demonstrated his skills as a printmaker, and his first jury successes were etchings. He exhibited two at the Salon of 1859.

In London the growth of commercial art galleries was particularly remarkable. Faberman 1996, 147–58. In Whistler's era, single-artist exhibitions were less acceptable and less common in Paris than they were in London, the capital of a "nation of shop keepers."

23. Whistler showed "Two etchings from nature" at the Royal Academy in May 1859, listed without further titles as cat. no. 119. Another pair of etchings, shown at the Salon of 1860 along with *At the Piano* (no. 598), were "Monsieur

Astruc, Redacteur du *Journal l'Artiste*," no. 901, and "Thames—Black Lion Wharf," no. 902. Graves 1906, 4:249.

24. While no catalogue has been traced, a letter written in June 1862 survives: "I promised Morgan, who has the Gallery where is "Ye Whyte Ladye," that you would lend him some *nature mortes* of Fantin's." Whistler, London, to "Charles Price," GUW 09079. [Fitzwilliam Museum, Cambridge, (Whistler 2), MSc.]

25. Whistler's *Au Piano* was no. 1561 at the Salon. The artist's birthplace was given as Baltimore; his nationality as American; his address as 2 Lindsey Row, Chelsea, London; and his French contact, "chez M. Fantin-Latour, rue de Londres, 13." He indicated no master teacher. Whistler also showed one of his etchings as *Sur la Tamise: l'hiver* in the print section of the Salon, no. 1562. See *Explication des Ouvrages de Peinture, Sculpture, Architecture, Gravure et Lithographie des Artistes vivantes exposés au Palais des Champs-Elysées, le 15 Avril 1867* (Paris, 1867), 216. I am grateful to Ted Dalziel at the National Gallery of Art Library, Washington, D.C., for this information.

26. Louis Leroy poked fun at the picture with a cartoon that shows Annie saying, "Maman et moi nous sommes bien peu faites; mais notre coleur est si joli." Louis Leroy, "Au Salon: VII," *Le Charivari*, 9 May 1867, 3. Artists carefully considered which pictures to display in which markets. For a model study of this issue, see "Appendix, Sargent's Exhibition History, 1877–1887" in Simpson 1997, 171–85.

27. The full text of the cartoon, published in *Punch*, vol. 76 (31 May 1879): 249, makes this antithesis clear. Frith, who originally wanted to be an auctioneer rather than an artist, came from a humble background—his parents were both in service before opening a hotel at Harrowgate. Frith would later testify

in support of Ruskin at the Whistler-Ruskin trial, blaming Whistler's French art education for the self-indulgence he perceived in Whistler's work. Jacob Bell (1810–59) had been a fellow art student of Frith; he commissioned the picture, paying 1,500 pounds for it. Ernest Gambart, a dealer, paid the same sum for the lucrative rights to a reproductive engraving. A worldwide tour of the picture arranged by Gambart helped boost sales of the print. MacLeod 1996, 317.

28. Ibid., 391–92.

29. "The Art Sales of 1903," in *The Year's Art for 1903* (1904), 311. An envious footnote added, "On November 25th (1903) the *Nocturne à Venise* [*Nocturne in Blue and Silver: The Lagoon, Venice*, Museum of Fine Arts, Boston] brought 18,500 francs at a Paris sale, given by Mr. W. Marchant."

30. A memorial exhibition of 184 oils, watercolors, and pastels along with 315 prints took place at the Copley Society, Boston, in 1904. A larger show of 750 works was presented by the International Society of Sculptors, Painters and Gravers in London in 1905. That same year in Paris, the École des Beaux-Arts showed 440 works by Whistler.

31. "The shortest memory can recall an afternoon at Christie's, when a work by Whistler was hissed on being submitted for sale." A. C. R. Carter, "The Past Year" in *The Year's Art for 1905* (1906), 5–6. *The Year's Art* listed the entire contents of London's Whistler memorial exhibition except for prints.

32. William Graham sale, Christie's, London, 3 April 1886, no. 120, bought by Robert H.C. Harrison, Liverpool, for 60 guineas, sold for £2,000 by Harrison to the National Art Collections Fund who presented it to the National Gallery, London, 1905. The picture was transferred to the Tate Gallery that same year. YMSM 140. Until 1888, two years after it was hissed at Christie's,

the picture was called *Nocturne in Blue and Silver*, the title still given by *The Year's Art* for 1905.

33. YMSM 24.

Chapter 2:
FASHION'S WHEEL

1. Whistler 1883. This pamphlet served as the catalogue for *Arrangement in White and Yellow*, which opened at the Fine Art Society, 148 New Bond Street, London, on 17 February 1883. In Alexander Pope's "Epistle to Dr. Arbuthnot" (1735), l.307–8 reads, "Satire or sense, alas! can Sporus feel, Who breaks a butterfly upon a wheel?" The line was used in connection with negative press commentary as close to Whistler's 1883 catalogue as Trollope's novel, *The Way We Live Now*, published in 1875. See Trollope 1875, 90. It achieved notoriety again in the 1960s when it was used as the London *Times* leader for 1 July 1967, on Mick Jagger's and Keith Richard's arrest on drug charges—an article that was thought to have contributed to their acquital. I am grateful to Linda Merrill for this toothsome bit.

2. Leyland to Whistler, 24 July 1877, GUW 02593.

3. In the Wickham Flower sale one tiny oil sketch by Whistler, *An Orange Note: Sweet Shop* (YMSM 264), made 360 guineas, and another, *A Note in Blue and Opal: The Sun Cloud* (YMSM 271), made 180 guineas. Both were bought by the dealer Colnaghi, who sold both to Charles Lang Freer. On the same day as the sale, 17 December 1904 (at Sotheby's in New York), a Whistler etching, *Ross Winans* [K88], realized £136. *The Year's Art* detected signs that "the market has begun to treat Whistler as an Old Master." See "The Art Sales of 1904," *The Year's Art for 1904* (1905), 324.

4. For contemporary comment on men's fashion at the time of Whistler's arrival, see Sala 1859, 83. In the 1860s, a loose lounging jacket combined with matching trousers and waistcoat became the lounge suit, aptly dubbed a "suit of dittos." Such garments were not to be worn in town or during a social call, when etiquette demanded a frock coat and top hat. See Ashelford 2000. Eventually "dittos" evolved into today's business suit. See Hollander 1995. The popularity of cigarette smoking, dependent on cheap Turkish tobacco, followed on the heels of the Crimean War, 1853–56.

5. Pennell 1921, 31. Whistler makes the same point obligingly at the end of the "Ten o'Clock," asserting that "the story of the beautiful is already complete." Whistler 1892, 159.

6. Recorded by Bacher 1908. His stories were first recounted in *Century Magazine* in December 1906 and May 1907.

7. "America in Pictures," *New York Times*, 16 April 1879, 6.

8. For a recent study of Americans at the Paris fair, see Fischer 2000.

9. Whistler showed *Symphony in White, No. 2: The Little White Girl* (YMSM 52), *The Andalusian* (YMSM 378), and his last self-portrait, *Brown and Gold* (YMSM 440). In 1900, the United States fielded three times as many American exhibitors in Paris as France had sent French exhibitors to Chicago in 1893. In attempting to establish the parity of American art with European schools in general—and France in particular— the American organizers were driven by the presumption that the new world would supersede the old. This widely held belief was hard to miss when walking toward the portico of the United States Pavilion on the banks of the Seine. An enormous gilded *Chariot of Progress*, driven by a determined woman in Grecian dress, was the building's chief ornament. For color illustration, see Holmes 1903, vol. 2, opp. 224.

10. I first explored these ideas in "Continuous Performance," in Weinberg et al. 1994, 204–19. See ibid., 36–38, on American artists reinventing their personas. Sarah Burns writes, "Because of its gaudy, exaggerated outlines, Whistler's example serves as a highly suggestive vehicle by which to explore the emergence, during the latter decades of the nineteenth century, of the artist as entertainer, incorporated into the nascent culture industry that would grow to vast proportions in the twentieth century." Burns 1996, 222.

11. Frederick Wedmore, in Bendix 1995, 18. Whistler did have prior amateur stage experience, having performed in at least one short charity production, *Twenty Minutes Under an Umbrella*, at the Royal Albert Hall Theatre.

12. Recent studies include Burns 1996, and Denker 1995.

13. Chase 1910, 220, 222. In January 1896, Robert Louis Stevenson published his exploration of the duality of human nature, *The Strange Case of Dr. Jekyll and Mr. Hyde*. With this book he won an international audience.

14. Chase 1910, 222.

15. Burns 1996, 222.

16. As an expatriate American active in Britain and France, Whistler proved hard to classify and thus fell between the floorboards of art histories constructed along nationalistic lines. Major works owned by the Freer in Washington, the Frick in New York, and the Fogg at Harvard cannot be lent; their absence mars every major Whistler retrospective exhibition. Much material is concentrated at the Hunterian Museum, Glasgow University, where it was not particularly accessible until the 1980s. A milestone in the scholarly apparatus necessary for evaluation, the catalogue raisonné of oils (YMSM) was published in 1980, much later than similar catalogues of Whistler's Impressionist contemporaries. Additional critical exhibition catalogues and dissertations, as well as catalogues raisonnés of watercolors, pastels, drawings (M), and lithographs (C), have since been published, greatly widening the scope of our understanding. The searchable electronic archive of Whistler correspondence (GUW) developed by the Whistler Study Centre at the Glasgow University Library, available in 2003, greatly advances the field.

17. For a recent study, see Solkin 1993. His stated aim in writing this perceptive account of the impact of commerce on visual culture is to "make a persuasive case for the modernity of eighteenth-century British art." Components of modernity discussed include Jonathan Tyers's improvements to Vauxhall, the building of the Foundling Hospital, and the advent of London's first independent art exhibitions in these unlikely venues. For the "commercialization of leisure" see McKendrick et al. 1982, 265–85.

18. Poesner 1973; Haskell 1972.

19. The play, by Tom Taylor and Charles Reade, was performed in New York with the actress Laura Keen playing the role of an eighteenth-century British actress, Peg Woffington. *Masks and Faces* (New York, n.d.), p. 57. Dudden 1994.

20. In a way, the one led to the other. One of Whistler's key motivations for suing Ruskin was to recoup monies lost in the quarrel with Leyland over the Peacock Room.

21. YMSM 181, discussed in Merrill 1992, 40–43.

22. Denker 1995, 71.

23. For a full account, see Merrill 1992.

24. This is one of "Four designs for 'the New Coinage.' By permission of the proprietor of the 'Pall Mall Budget.'" The other artists were Millais, Burne-Jones, and Walter Crane. Marillier 1920,

pl. 45. See also Whistler's butterfly on a farthing, M1241. It was drawn in 1890 as a tailpiece for "Art and Art Critics" in *The Gentle Art of Making Enemies*.

25. Curry 1987, 67–82.

26. For the *Mother*'s travels, see MacDonald 1975. In April 1881, the Corporation of Glasgow purchased the *Carlyle* portrait, painted as a counterpart to the *Mother*. The *Carlyle* was the first portrait by Whistler to enter a public collection.

27. Whistler to C. B. Bigelow, 15 February 1894, VMFA.

28. The image was used as a title page for *The Dancing Faun* by Florence Farr, published simultaneously in London and Boston in 1894. For devil, Whistler to Waldo Story, 1 or 7 March 1883, GUW 08155. The full title of Dickens's novel is *Barnaby Rudge: A Tale of the Riot of 'Eighty*, which further extends Whistler's warlike metaphor.

29. Rimbaud 1873. When one of Mapplethorpe's photographs was auctioned (Sotheby's, New York, 6 October 1999, lot 216), the sale catalogue emphasized its limited status and various signatures, recalling the market-driven tiered system of "value added" rarity in the British reproductive print industry established in the nineteenth century and modified by Whistler for his own use.

30. Rimbaud 1873, v.

31. In a perceptive review of the Tate Gallery's 1994 exhibition (Dorment 1994), Paul Richards pegged Whistler as a realist, adding that the exhibition "makes no attempt to summon up the costumed self-promoter. Whistler the snob is ignored by this exhibit; so is Whistler the savage wit, and Whistler the aren't-I-splendid? lecturer, and Whistler, the maestro of magazine publicity." Yet Whistler seems at times "to be half a dozen men" when "we like our painters whole, we insist upon coherence and distrust contradictions." Richards 1995. A recent article on a

spate of Whistler exhibitions begins, "Victorian dandy, publicity-seeking gadfly, and artistic provocateur par excellence, James McNeill Whistler was arguably the most misunderstod artist of his day—and one of the most influential. Although he is the subject of numerous books and detailed studies, he remains an enigma, a gifted and innovative artist whose reputation continues to overshadow his achievements." May 2003.

32. At time of writing, price records for oils at public auction are as follows: Monet, $33,013,500 for *Bassin aux nympheas et sentier au bord de l'eau*, 1900, Sotheby's, London, 30 June 1998, lot 6; Manet, $26,400,000 for *La rue mosnier aux drapeaux*, 1878, Christie's, New York, 14 November 1989, lot 7; Degas, $13,276,500 for *Les blanchisseuses*, 1874, Christie's, London, 30 November 1987, lot 80; Pissarro, $6,605,750 for *La Rue Saint-Lazare*, 1893, Sotheby's, New York, 7 November 2001, lot 11; Whistler, $2,866,000 for *Harmony in Grey: Chelsea in Ice*, 1864, Christie's, New York, 25 May 2000, lot 10. While undoubtedly higher, prices in private sales reflect the same disparity. Of course, the availability of important works is also a factor.

33. In a cartoon Beerbohm left out of *Rossetti and His Circle*, Whistler visits Rossetti's back garden in Cheyne Walk, Chelsea. Hand resting daintily on an impossibly long walking stick, Whistler stands with his back to the wall, as far as possible from Victorian art critic John Ruskin with whom he had so fiercely quarreled over the philosophy of art. Any gravitas in this graphic point-counterpoint is compromised by the presence of the poet Algernon Swinburne, who perches atop the brick wall and leans down to toy with Whistler's white plume of hair.

34. A prunus jar bought "in the days of neglect" for 12 shillings and 6 pence

at a shop in Wardor Street by Louis Huth, one of Whistler's patrons, was later auctioned for a record £5,900 to the London dealer Partridge. A. C. R. Carter described the exhibition of porcelain at the Duveen Galleries in Bond Street; it included the "rich cobalt blue ginger-jar" that "goaded" Partridge into paying such a sum for a similar piece. See "The Past Year," *The Year's Art for 1905* (1906), 7.

35. "Whistler and his Ways. Days when he was hard up and other queer times. Seen in Paris at the Salon—His hair and wrinkles—the story of a mattress —Ruskin's farthing." *New York Times*, 22 March 1885. The white and yellow exhibition was on view at Angell's Pictures & Frames, 158 Westwood Avenue in Detroit at that time. Whistler would not have been pleased that the journalist added an extra decade to his age.

36. During Whistler's lifetime, Chase's portrait of him was shown at the Boston Art Club, 1886; Moore's Art Galleries in New York, 1887; the Inter-State Industrial Exposition, Chicago, 1888; the St. Louis Exposition and Music Hall Association, 1892; and the Pennsylvania Academy of Fine Arts, 1896–97. A continuing history of exhibitions during the twentieth century have helped ensure the longevity of Chase's image for both scholars and the public. Bolger 1980, 84.

37. *Art Review*, vol. 1 (February 1887): 20.

38. For historic associations of black clothing with the devil, see Harvey 1995, 261, n. 4. Harvey discusses Poe's "The Devil in the Belfry" (1839) clad in "a tight-fitting swallow-tailed black coat…black kerseymere knee-breeches, black stockings, and stumpy-looking pumps, with huge bunches of black satin ribbon for bows." Such dress recalls some of Whistler's attire.

39. Whistler, the subject of more than 400 portraits by about a hundred different

painters, printmakers, and illustrators, held the record for most-depicted artist before the twentieth century. For representative examples, see Denker 1995.

40. Simon 1995, 168.

41. Ibid. A central concern for painters of modern life was to escape historical pastiches in their paintings. Subjects wearing modern dress offered one pathway for doing so.

42. Byatt 2001, 1.

43. Menpes recalled Whistler's performance at a hairdresser's salon in Regent Street. Menpes 1904, 34–35.

44. Burns 1996, 223. Sarah Burns is the first scholar to convincingly reconnect Whistler's seemingly polar twin personalities. She writes, "The literature on Whistler spans a huge area between the pulpiest rehashings of his life to the most meticulously documented catalogues of his work. In this span lies the key to his longevity as artist and person. By being both with such intensity and such color, and by so aggressively placing himself in the public eye—flinging himself, not his paint pot, in the public's face—Whistler managed to hold together two realms of taste, the popular and the elite, that in the late nineteenth century were just beginning to show the strains of a widening fissure between them. Writings about Whistler have in the same way spanned that gap to produce an artist whose life alone makes for a good read and whose art alone is more than enough to keep connoisseurs and scholars busy." Ibid., 244–45.

45. Waugh 1964, 112. She distinguishes the dress coat, morning or riding coat, frock coat, great coat, paletot, lounge jacket, and waistcoat, ibid., 112–15.

46. Oscar Wilde's posturing as an aesthete mooning over single blossoms also echoes eighteenth-century mannerisms.

47. Ashelford 2000, 293, 146. During the 1770s these young English noblemen affected Continental manners and fashions, having experienced them on their Grand Tours. Originally the name "Macaroni"—first used in 1764 and derived from the Italian pasta dish they introduced to England—was applied to anything that was chic and stylish, but the term soon became a derogatory one as their single-minded pursuit of "extravagances of dress" led them into flights of sartorial fantasy. Wearing elaborate wigs that towered above their heads, and very tight, short waistcoats and coats, they carried nosegays of flowers and other feminine accessories. Their excesses "marked them out as style victims" and the Macaroni were lampooned without mercy. Ibid., 147.

48. Harvey 1995, 27–28.

49. Waugh 1964, 112.

50. Harvey 1995, 31. Brummell associated with aristocrats, but he did not mimic them; rather, they copied him.

51. Noting that the dandy established the fashion for "simple, and dark, and especially black clothes" in the early 1800s, Harvey cites the Parisian paper *Le Dandy* advising, "English black is the shade most worn," and again, "the black English suit with silk buttons is always required for *grand tenue*" in 1838. Harvey 1995, 31.

52. Ibid., 28. For the maxims of dress see Bulwer-Lytton 1828, chapter 4.

53. Harvey 1995, 29. Carlyle's partly autobiographical work first appeared in *Fraser's Magazine* in 1833–34. The first section describes Teufelsdrockh's imaginary book, *Clothes: Their Origin and Influence*. Clothes are taken as emblems of social and political distinction.

54. Carlyle quoted in Allingham and Radford 1907, 226. Carlyle finally refused to sit again, and Whistler had to locate another model to wear the coat so he could complete the portrait. See Dorment 1994, 143–44.

55. Ibid., 144. Disraeli declined to sit, however.

56. On Disraeli, see Moers 1960, 99. For a recent compendium on the dandy moving well into the twentieth century and beyond European examples, see Fillin-Yeh 2001.

57. Wilde, "A Few Maxims for the Instruction of the Over-Educated" (1894), in Wilde 1999, 1,242.

58. Harvey 1995, 31.

59. For Leyland's early history, see Merrill 1998, 109–15.

60. "In the mid-nineteenth century, black is the uniform both of the fashionable world and of industrial money in the spa, the metropolis and the northern town." Harvey 1995, 36.

61. For an example, see Ashelford 2000, 233, fig. 190.

62. Ibid., 241. The morning coat, with its cutaway tails, was originally intended for riding.

63. Wilde, *Essays and Lectures* (1882), cited by Waugh 1964, 156.

64. Adams 1880, 194–95.

65. Simon 1995, 90 ff. Goncourts quoted ibid., 97. For Hammerstein's Rooftop Garden, see "Continuous Performance," Weinberg et al. 1994, 210–13.

66. Other theaters include the Empire, redecorated in 1903 in the Louis XIV style; the Gaiety, 1908, Louis XV style; Nazimova's 39th Street Theater, 1910, Louis XVI style. Van Hoogstraten 1991. The Folies Bergère, 1911, one of the first dinner theaters in New York, was decorated in a rococo style, including paintings by William de Leftwich Dodge in the manner of Watteau at either side of the proscenium arch. Stern et al. 1983, 217.

67. Nivelon 1737, unpaginated.

68. Ibid.

69. "Iconology, Iconolaters, Iconclasts," Le Corbusier 1925, 6–7. Le Corbusier also illustrated "Khai Dinh, the present emperor of Annam" in resplendent embroidered robes, and "M. Gaston Doumergue, President of the French Republic" wearing a dark suit and

topcoat, holding a silk top hat. Discussing the implications of this, Mark Wigley notes, "It is not by chance that the first thing we know of modern man, the first piece of evidence for his elevation from the degenerate realm of the senses into the realm of the visual, is his clothing. Indeed, Le Corbusier seems to suggest that [men's] clothes were the first objects of everyday life to lose their decoration." Wigley 1995, 16–17.

70. Observing that Baudelaire found black, like death, to be a leveler, Harvey notes, "The association of black dress with democracy is persuasive, if one thinks not only of France, but of nineteenth-century America, where black was very widely worn." Harvey 1995, 27.

71. For a discussion of black dress see Hollander 1978, 365–90. At the end of *Men in Black*, Harvey concludes, "If there is a dominant meaning in the widespread use of black, that meaning is associated at once with intensity and with effacement: with importance, and with the putting on of impersonality. Alone or in ranks, the man in black is the agent of a serious power; and of a power claimed over women and the feminine. Black may be a shadow fallen on the feminine part of man. The ultimate allusion of black is to death, and in the high-black periods, the power the men in black have served has been dead- or death-serious, both at home and in the state." Harvey 1995, 257.

72. Ibid., 127. "Black in the early 1790s was a signal of political conviction on both sides [royal and republican] while difference was marked by the materials chosen." Harvey also observes that republican associations with black suits in France precede political upheaval: "The most notable use of black in these years was not in the Revolution or in its aftermath, but rather in its preliminaries" when the ancient French parliament was reconceived by Louis XVI

in 1788. Black clothing didn't indicate rank, but provided "the common denominator, the sign of a unity in the gathering, while rank [was] marked by accessories to the black." Ibid., 126. In this spirit, George Washington wore a black velvet suit with diamond knee-buckles and carried a dress sword at his second inauguration as president.

73. J. Alden Weir to his father, 1877, cited in Bendix 1995, 283, n. 115. Weir's father, Robert, had been Whistler's drawing instructor. Weir *fils* complained that Whistler's "talk was affected and like that of a spoiled child, hair curled, white pantaloons, patent leather boots and a decided pair of blue socks, one-eyed eye glass and in escorting us to the boat, he carried a cane about the size of a darning needle. Alas! this is the immortal Whistler who I had imagined a substantial man."

74. Shackelford 1984, 27.

75. Similarly, in *Dance Class* (1876) Degas shows Jules Perrot leaning on his staff, which forms a parallel vertical element with the music stand in the foreground of the painting, so that rhythm and music literally bracket many of the dancers. Reproduced ibid., 53, fig. 2.8.

76. Alfred Bryan did the wood engraving for *The World: A Journal for Men and Women*, 27 November 1884. Reproduced Denker 1995, 83.

77. Demonstration painting was not unknown, as witness a photograph of Chase painting a fish still life in front of an audience. Whistler was noted for his long-handled custom-made brushes, some of which survive in the Hunterian Gallery at Glasgow University. But they were not *this* long.

78. Mrs. Julian Hawthorne quoted in Dorment 1994, 201.

79. For details see Susan Grace Galassi with Helen M. Burnham, "Lady Henry Bruce Meux and Lady Archibald Campbell," MacDonald et al. 2003, 160–61.

80. Haweis 1878, 84–85. She continues, "It strikes the artistic eye as cutting the body in pieces, in this way—If you see a fair person dressed in a low dark dress, standing against a light background some way off, the effect will be that of an empty dress hung up, the face, neck and arms being scarcely discernible. On the other hand, against a dark background, the head and bust will be thrown up sharply, and the whole dress and body will disappear."

81. Haweis 1879, 74–75. Temple Bar was taken down in 1878. Weinreb and Hibbert 1983, 881. The last head displayed was that of Francis Towneley, a Jacobite rebel, in 1746. Telescopes could be hired for a shilling a peek. For Whistler's etching of Temple Bar, see K162.

82. Émile Zola published *Nana* in 1880, but his fictive Second Empire courtesan appears in an earlier work, *L'Assommoir*, published in two volumes in 1877. In 1876, Zola's ill-received effort to issue *L'Assommoir* serially coincides with Manet's work on a portrait titled *Nana* (1876–77). Whistler would have been aware of the atmosphere of scandal surrounding these works.

83. "The Truth of Masks: A Note on Illusion" (1885), Wilde 1999, 1,172.

84. After several experiments with exhibitions in various color schemes, Whistler settled on indeterminate yellow-brown and green-gold tonalities that proved rich yet neutral enough to provide an excellent background for both paintings and prints. This color range, seen for example in the second "Notes"—"Harmonies"—"Nocturnes" exhibition at Mssrs. Dowdeswell in May 1886, dominated the rest of Whistler's exhibition schemes, so far as I have been able to determine. Curry 1987, 78 ff.

85. The artist painted at least eleven versions of this composition.

86. Whistler, suppressed edition of *The Gentle Art of Making Enemies*, ed.

Sheridan Ford (1890), discussed by H. Barbara Weinberg, "The American Taste for Spanish Painting," in Tinterow et al. 2002, 260.

87. Louis XIV was so pleased that he kept the portrait and had a copy made for Philip V of Spain, who had commissioned it in the first place.

88. In a lecture delivered at the Tate Gallery, London, I connected the picture to several earlier works, particularly the allegory of *Venus, Cupid, Folly and Time* (1544–45) by Agnolo Bronzino, a picture acquired by the National Gallery in London in 1860. Publication forthcoming.

89. Whistler's remarks to a friend were published on the front page of the *New York Tribune*, 12 October 1886, the year after his *Arrangement in White and Yellow* completed its American tour. Quoted in Bolger 1980, 83. The corresponding portrait of Chase by Whistler is unlocated, so we cannot compare the two.

90. See Simon 1995, 189, for reproduction and discussion of *La Parisienne*. Edited by Ernest Hoschede, a textile merchant who collected modern art, the magazine was "more intellectually oriented than…other fashion magazines." Barter et al. 1998, 53–54.

91. Muffs were one of the accessories the Macaroni carried. "I ride in a chair with my hands in a muff," began one satirical poem of 1766. Anstey, *The New Bath Guide* (1766), cited in Waugh 1964, 105. Such behavior left the Macaroni open to charges of effeminacy. Similar behavior marked the French court of Louis XV during the rococo period. For Whistler's behavior, see Stephenson 2000.

92. Whistler quoted in Pennell 1908, 203.

93. These small dogs derive their name from Pomerania, a former duchy in the region now shared between eastern Germany and western Poland. The picture was no. 42 at the Manchester

exhibit. See Wallace Collection 1968, no. P42.

94. Pomeranians are noted for their loyalty. The highs and lows of demimondaine fashion are not confined to the age of Whistler. The prince of Wales abandoned Mrs. Robinson by 1782. In 1783, "the tragedy of her life took place …when at the age of twenty-four she became paralyzed through taking a cold in a post-chaise during a gallant attempt to save her lover, Colonel Tarleton (later General Sir Banastre Tarleton), from his creditors." She died poor, of course. Ibid., 123. Fragonard and Boucher occasionally gave their pictures of women with lapdogs a more salacious turn.

95. Simon 1995, 189. See also Eliot 1876, 405. The vogue for lapdogs as seen in countless eighteenth-century portraits was to endure well into the twentieth century, supported by such trendsetters as Elsie de Wolfe, the former actress who became America's first successful female interior decorator through her friendship with architect Stanford White. Duez, too, was involved with decoration, playing a major role in the decorative paintings of the Paris Opera.

96. Chase also gave lectures on Whistler. These were later published in the lengthy article that gave us the vivid Jekyll-Hyde metaphor for Whistler's dual personality. Denker 1995, 116–18.

97. Hatton 1884. Eventually Irving made eight tours to the United States, finding them highly lucrative ventures. He departed on his eighth tour in October 1903, shortly after Whistler had died. Irving's profits for the eight tours totaled £579,201.04, a fortune at the time.

98. "In the Art Shops. Whistler's Venice Etchings," *New York Evening Post*, 2 November 1883. When the exhibition was on view in Baltimore during December 1883, the *New York Evening Telegram* described the photograph,

"which hangs among his etchings. [It] shows a quizzical good-humored face, and an attitude that is full of grace and absurdity. His whole air speaks for him of the disregard for conventionality and the desire to shock, astonish and delight. At the same time a peculiarity of his person is a perfectly white tuft of hair sticking straight up from his abundant crop of black wavy locks." GUL PC 3:10.

99. For the picture's somewhat confusing provenance, see YMSM 187. Irving himself owned the picture by 1897. Whistler also made two related etchings, K170, 171.

100. James 1877, reprinted in Sweeney 1989, 143. He began, "I will not speak of Mr. Whistler's 'Nocturne in Black and Gold' and in 'Blue and Silver,' of his 'Arrangements,' 'Harmonies,' and 'Impressions,' because I frankly confess they do not amuse me. The mildest judgment I have heard pronounced upon them is that they are like 'ghosts of Velázquezes,' with the harshest I will not darken my pages."

101. James 1897, reprinted in Sweeney 1989, 259. By then, Whistler had altered the portrait to include Irving's Order of the Garter. James continued, "Look at him…at his best…and hallucination sets in. We are in the presence of one of the prizes marked with two stars in the guidebook; the polished floor is beneath us and the rococo roof above; the great names are ranged about, and the eye is aware of the near window, in its deep recess, that looks out on old gardens or on a celebrated place."

102. Christie's, 16 December 1905, lot no. 148, reported in *The Year's Art for 1905* (1906), pp. 5, 329. The dealers Stevens and Brown, acting on behalf of an American client, were the successful bidders. Prior to auction the *Irving* had been offered to Charles Lang Freer but, he told his London dealer Obach, "the price scared me off." See YMSM 187.

The most expensive eight pictures were all portraits save for a *Virgin and Child* by Botticelli.

103. *The Year's Art* regularly featured art-world luminaries. For the 1895 issue (published 1896) it concentrated on "the more eminent exponents of the Art of Black and White Illustration." Whistler's pleasure at reading that "the versatility" of his own "genius is so generally admitted, that a cogent reason is thereby provided for selecting his portrait as the frontispiece" must have been dampened by Haden's inclusion as president of the Royal Society of Painter-Etchers. Haden had the satisfaction of outliving his younger brother-in-law.

104. Chase 1910, 222–23.

105. Whistler to Rosalind Birnie Philip, 1896, GUW w308.

106. Geffroy quoted YMSM 440.

107. Wilde, *Essays and Lectures* (1882), cited in Waugh 1964, 156.

108. Twain quoted in Paine 1912, vol. 4, 1,341–42.

109. Harvey 1995, 41.

110. Twain quoted in Paine 1912, vol. 4, 1,342.

111. Howells, cited in Gillman 1989, 125.

112. "Wapping Alice" (1897) in Twain 2001, 95–96. The pink ribbon signaled sexual preference. Ibid., 242.

113. The year before Whistler painted his picture, Nathaniel Hawthorne described the neighborhood of Wapping in some detail. Dorment 1994, 103. While no direct connection between Whistler's painting and Twain's story is known, the canvas was in an American collection by 1864. The painting was shown in New York, 1886; the Paris Exposition Universelle, 1867; Baltimore, 1876. See YMSM 35.

114. Paine 1912, vol. 4, p. 1,343.

Chapter 3:
WOMEN IN WHITE

1. "Phrases and Philosophies for the Use of the Young" (1894), in Wilde 1999, 1,245.

2. The other two were designated "symphonies" retroactively and are not inscribed as such. Whistler elides details of the clothing worn by Jo in each of the three paintings so she may or may not be wearing the same dress each time.

3. P.G. Hamerton, *Saturday Review*, 1 June 1867, included as "Critic's Analyisis," in Whistler 1892, 44. Whistler's response, "The Critic's Mind Considered," read, "Bon Dieu! Did this wise person expect white hair and chalked faces? And does he then, in his astounding consequence, believe that a symphony in F contains no other note, but shall be a continued repetition of F, F, F?...Fool!" Ibid., 45.

4. Dorment 1994, 80. Tissot to Whistler, 12 February 1867, GUW [GUL F14]. Degas quoted Whistler's image in *Mll. Fiocre in the Ballet "La Source"* (1867–68).

5. Garfield 2000.

6. George du Maurier, "True Artistic Refinement," *Punch*, vol. 73 (17 February 1877): 66.

7. Unidentified account of an artistic "at home" quoted in Aslin 1969, 148.

8. Haweis 1879, 109. Elsewhere she wrote that white was "most trying in masses near complexions that are not very clear or very rosy." See Haweis 1878, 175–76.

9. The "lingerie dress" was worn by women of all ages from the late 1890s until World War I.

10. Keeping up appearances for a ball at Bath House, Lady Ashburton's residence in Piccadilly, Jane Carlyle recalled, "I got a white silk dress—which first was made high and long sleeved—and then on the very day of the ball was sent back to be cut down to the due pitch of indecency—I could have gone into fits of crying when I put it on—but I looked so astonishing well in it in the candle light, and when I got into the fine rooms amongst the universally bare people I felt so much in keeping that I forgot my neck and arms almost immediately." Quoted in Ashelford 2000, 221, n. 17.

11. "The Truth of Masks: A Note on Illusion" (1885), in Wilde 1999, 1,173.

12. Compare, for example, the dress in Agnolo Bronzino, *Lucretia Panciatichi* (ca. 1540, Florence, Galleria degli Uffizi).

13. Just when young artists were questioning the hegemony of the academic establishment and the salon system, women were seeking more freedom in dress. Costume historian Jane Ashelford discusses how Pre-Raphaelite artists "were inspired by the art of the Early Renaissance and its ideal natural way of life, as they perceived it, in contrast to the crass materialism and ugliness of their own industrial age. They created a style of costume with medieval influences for their female sitters, who echoed it in their daily clothes, rejecting modern fashion in favor of the 'simple and elegant' lines of the past. Women who embraced this style of dress wore loose-waisted gowns cut with wide armholes and a dropped shoulder line, so removing the discomfort caused by setting a sleeve in a fashionably low position. Dispensing with the corset, the crinoline and the fussy and elaborate trimming demanded by fashion gave them freedom of movement, but involved a rejection of high fashion that few women dared to contemplate." Ashelford 2000, 229–31. Essentially a demimondaine, Jo Hiffernan would have had no such fashion scruples.

14. Matthew Morgan's gallery located in Berner's Street.

15. Whistler used Romeike and Curtice

to gather his clippings. Goebel 1988, 1:140–41. A significant factor in the rise of the press in England was repeal of the paper tax in 1861, enabling a spate of inexpensive illustrated newspapers and journals. See Ashelford 2000, 214.

16. Whistler to Lucas, 26 June [1862]. GUW 11977 [Wadsworth Athenaeum, Hartford, Conn.]. Le Corbusier later expressed similar sentiments: "When the cathedrals were white…there were no pontificating coteries…there was no Academy." Le Corbusier 1947, 5.

17. "Fine-Art Gossip," *The Atheneum*, 28 June 1862, 859; 5 July 1862, 23. That Whistler did not completely eschew narrative painting is indicated by *Arrangement in Yellow and Grey: Effie Deans* (1876–78, Rijksmuseum, Amsterdam), which is based on one of Walter Scott's characters in *The Heart of Midlothian* (1818). Whistler inscribed the canvas with a passage from the novel. Again, links to theater and performance are part of the piece. In 1877, as Whistler was engaged with this painting, a play by D. George Hamilton based on the novel was produced at the Albion Theatre, while John Everett Millais exhibited a portrait of "Effie Deans" at the King Street Gallery, London. Dorment 1994, 152.

18. John Sutherland, introduction to Collins 1860, vii. Whistler certainly was well aware of the popular culture around him. The menu for one of his dinners at No. 2 Lindsey Row (21 June 1873) includes "Crème Oncle Tom" and "Purée de Volaille Magenta" — chicken puree dyed magenta or mauve. GUW 10965 [RC HL 76 ADS].

19. Robinson 1951, 137. The quadrille was a particularly flirtatious dance popular at public gardens and other entertainment spots. For the darker implications of this dance, see Nead 2000, 120 ff.

20. The gallery director defended himself in *The Atheneum*, 19 July 1862, 86,

stating that Whistler knew the picture was being advertised as *Woman in White.*

21. The manners and clothing worn by Miss Fairlie's double, Anne Catherick, are similarly described in ambiguous terms: "There was nothing wild, nothing immodest in her manner; it was quiet and self-controlled, a little melancholy and a little touched by suspicion; not exactly the manner of a lady, and, at the same time, not the manner of a woman in the humblest rank of life…her dress—bonnet, shawl, and gown all of white—was, so far as I could guess, certainly not composed of very delicate or very expensive materials." Collins 1860, 20–21.

22. Chemise dresses, or *robes à la créole*, were simply tubes of white muslin cinched with a drawstring at the neck and a sash at the waist. Thought to have originated in the French West Indies, they were seen only in private settings in Britain until Georgiana, the duchess of Devonshire, wore one to a public concert in August 1784. Ashelford 2000, 175. Lady Elizabeth Foster was not only Georgiana's friend but also the lover of Georgiana's husband. Recent studies include Foreman 1998, and Chapman and Dormer 2003.

23. Harvey 1995, 18.

24. Castagnary 1892, 1:179–80.

25. The present location of Whistler's copy is not known. See YMSM 14.

26. Michelet cited in Adhémar 1950, 183. For an extensive treatment of Watteau's impact on nineteenth-century French taste, see Hôtel de la monnaie 1977. For a discussion of Whistler and Watteau see Curry 1984, 35–51.

27. Goncourts: "une création de poème et de rêve." Desnoyers: "C'est le portrait d'une spirite, d'un medium." Quoted in Duret 1904, 22. Various forms of spiritualism were popular at the time.

28. Goncourt brothers, *L'Art au XVIIIe siècle* (1860), quoted Adhémar 1950, 185. "C'est l'amour, mais c'est l'amour

poétique, l'amour qui songe et qui pense, l'amour modern, avec ses aspirations et sa couronne de mélancolie."

29. Whistler copied Gavarni's dancing white clowns. Curry 1984, 37–42. For a discussion of later writers' responses to unclear subject matter in Watteau, see Bryson 1981, 97–126.

30. The painting shows the Lane family. The clown in white-face makeup is George Lupino. The Britannia Theatre was especially famed for bloodcurdling melodrama. Weinreb and Hibbert 1983, 410.

31. "The Bedchambers," in Garrett 1989, 116. Garrett notes that the "best bedchamber" was the second most important room in the house, one where choice furnishings were regularly displayed.

32. Glimcher 1976, 107–8.

33. A visitor to Appledore Island recalled that Celia Thaxter "wore light gray or white dresses, usually made simply and according to her own style, not changing with the prevailing fashions. She nearly always wore a soft white kerchief fastened with an old-fashioned brooch." For discussion and links to the Colonial revival, see Curry 1990, 5 and 194, n. 29.

34. Hobbs 1996, 192.

35. Mantz 1863, 60–61. Mantz went on to chronicle the white objects in the *White Duck* (fig. 3.18), including the white duck, a napkin of damask linen, porcelain, cream, a candle, a silver chandelier, and a sheet of paper, all set against a white background.

36. "Les fonds blancs réussissent trés-bien à M. Oudry. Il y en a eu un cette année d'un genre toute nouveau, et qui sert à nous instruire, que les objects les plus semblables en apparence, ne laissent pas que de differer par les nuances qui les caracterissent.… Sans doute qu'il faut beaucoup d'art pour toute détacher avec la même couleur. Ces tableaux font rarement de grands effets, mais

ils laissent toujours connaître les grand talens des artistes." Mssr. Esteve, "Letter ...sur...le grand Salon" (25 August 1752), quoted in Opperman 1977, 1:208.

37. *Catalogue de tableaux et dessins de l'école française principalement du XVIIIe siècle, tirés des collections d'amateurs...rédigé par M. Ph. Burty* (Paris, ca. 1860).

38. Fantin-Latour to Whistler [15 May 1863], GUW 01081 [GUL Whistler F2]. See Johnson 1981, 174–75, for Whistler's choices of a red-haired model and the use of white lead paint, as related to the English Pre-Raphaelites.

39. "C'est une fort jolie toile pour un boudoir secret." Genevay 1880, 14–15. Comments on Sargent's picture are gathered in Simpson 1997, 92–94.

40. "Il s'agit d'une fantasie melodique, d'un jeu pareil à ceux qu'aimait le maître impeccable, Théophile Gautier. Seul, il aurait pu décrire le tableau singulier et délicat de M. John Sargent." Mantz 1880, 1.

41. "Cette Orientale qui se parfume et ravive ses ardeurs, car telle est, dit-on, la proprieté de l'ambere gris, que l'aventurier Casanova prenait en poudre dans son chocolat." Genevay 1880, 14–15. For the properties of ambergris, see Dalby 2000, 65–68.

42. James 1887, 688, reprinted in Sweeney 1989, 221–22.

43. Stebbins et al. 2002, 125, figs. 34, 35.

44. Wigley 1995, xiv.

45. Ibid., xviii. Wigley cites Gottfried Semper, Le Corbusier, Nikolaus Pevsner, and other architectural writers.

46. Ibid., xxiii.

47. Curry 1984a.

48. Open association with the "wrong" people continued to harm society figures. When the *New York World* included Stanford White in an article on those living fast lives, the prominent architect objected to being linked with "Diamond Jim" Brady and the proprietor of the Haymarket dance hall, men he "did not know and did not wish to be associated with publicly." Stanford White papers, cited Baker 1989, 319.

49. Louis Pasteur first published his germ theory in 1865, claiming that bacteria caused disease. "Health and Disease," Wiener 1973, 2:405–6.

50. The confluence of American Impressionism and Realism is explored in Weinberg et al. 1994.

51. In his picture, Benson makes a wry comment on the fashionable male foppery of past centuries. Above the metal-cornered Asian chest he shows a framed image, perhaps a mezzotint, of a sixteenth-century gentleman wearing a plumed hat curiously like the one the model is trying on. By the time *The Black Hat* was painted, women— not men—were charged with the task of keeping up with the ever-changing fashions. See "The Consumer and the Consumed," in ibid., 267–73.

52. Grant 1880, 198.

53. Genteel as these figures might appear today, the Victorian corset narrowed the waist and emphasized the hips significantly. For centuries large hips have been recognized in many cultures as a sexual signal for the ability to bear children.

54. O'Leary 2002, 17–22.

55. Beeton 1861, 1008–13. See also "Woman's Work," Weinberg et al. 1994, 286–91. For a recent study of laundry in the Victorian era, see Flanders 2003, 118–30.

56. Laundering offered a primary source of income for working women. Laundresses as types appear in modernist paintings (by Degas) and novels (by Zola) and by the turn of the century had become such a cliché that in Kenneth Grahame's *Wind in the Willows* (1908), Toad escapes prison disguised as a washerwoman.

57. Laundry in Venice has retained its poetic nature, at least for male artists and writers. A color photograph by Jean Imbert capturing a scene similar to Stieglitz's work is included in Cocteau and Fraigneau 1957, 32, accompanied by this text: "The sun, still low in the heavens, divides the canal, clothes dry at windows, birds in their cages greet the golden light. And then there is the water. Water which like a trick mirror deforms this sleeping city and gives us an upside down image like that of a camera. But, let there be no mistake about it, this image is the wrong side of the wrong side, the truth of a lie, Venice of dream."

58. As was literature; see James 1899.

59. "American Summer Resorts. VII. Long Branch," *Appleton's Journal*, vol. 12 (3 October 1874): 431.

60. Wharton 1938, 4. Wharton wrote her uncompleted novel at the time when Edward VIII was marrying the American divorcée Wallace Simpson.

61. This French style, stemming from the court of Louis XVI, relied on drawstrings to form puffed swags at the hips. Ashelford 2000, 140–41. The United States did not fully achieve status as a world power until after World War I.

62. Elizabeth Boott, who later married Duveneck, described the group in a letter home: "It certainly would have been impossible in any other nation for ladies to associate with art students as we did....Last winter we organized a club which met once a week at the different houses for drawing in charcoal, modeling, etching, etc., combined with music and tea. We banished all parents quite in the American fashion and the meetings turned out to be very pleasant." Quoted in Duveneck 1970, 87.

63. Cable 1969, 263.

64. Powers ensured that the politically charged meaning of his sculpture was clear to all by providing a printed brochure for use when viewing the statue. Craven 1994, 251–52. The

statue provoked commercial products such as sheet music covers, just as Wilkie Collins's *Woman in White* would later do. See *The Greek Slave Waltz* (1851), illustrated in Wunder 1989, 1:248. See also Hyman 1976, 216–23.

65. Grant 1880, 198.

66. Held on 31 January 1905, at Sherry's Restaurant in a ballroom designed by Stanford White, the banquet featured decorations by Whitney Warren that were "meant to recall the splendor of Versailles," providing an evening's fantasy for some six hundred lavishly costumed guests. Negative publicity prompted the host, the twenty-eight-year-old son of Henry Baldwin Hyde (founder and president of Equitable Life Assurance Society), to leave the country. Cartwright 1905, 305–19. The Bradley-Martin Ball, an earlier benchmark of Gilded Age excess also based on the Royal Court at Versailles, was held at the Waldorf-Astoria Grand Ballroom in February 1897. But de Wolfe carried fantasy further than most. Already a frequent summer visitor to the seat of the ancien régime, she told her public that she would like to buy property there. By 1907, de Wolfe and Marbury were proud owners of the nearby Villa Trianon, a house that had stood vacant since the duc de Nemours, son of King Louis Philippe, had left it in 1848. Smith 1982, 113.

67. For a recent study see Davis 1991.

68. G. H. Hepworth (1893), cited in Weinberg et al. 1994, 258.

69. Barbara Dayer Gallati, "Beauty Unmasked: Ironic Meaning in Dewing's Art," in Hobbs 1996, 63–64. All six of the original Flora Dora actresses, dubbed "goddesses, the first of their class to immortalize the chorus girl," married millionaires. Eventually the play was performed more than five hundred times, giving seventy-three Broadway beauties advantageous exposure. Churchill 1962, 8–10.

70. Cooper 1978, 30. White carnations symbolize pure love. Also at Jo's feet are white lilac, for youthful innocence, and pansies for thoughts. Greenaway 1884, 27, 32. Although meaning in the etiquette of flowers is not precise, other contemporary sources record similar symbolism.

71. "A Foreign Resident," in [T. H. S. Escott], *Society in London* (1885), discussed in Marshall 1998, 97.

72. *Variety*, 22 August 1913, and George Jean Nathan, "The Deadly Cabaret," *Theatre*, December 1912, both cited in Erenberg 1981, 145, nn. 50, 51.

73. Gallati, "Beauty Unmasked," in Hobbs 1996, 66–67.

74. When Dewing moved to Paris in 1895, he wrote to Stanford White about wild evenings with Whistler, MacMonnies, and Freer, who "had a courier who was way up in the art of providing shows" including a salacious male sexual performance "in 7 different manners from an old hairy pale-kneed grandfather down to the young Chicago sport who had stage fright." Quoted in Baker 1998, 275.

75. Fanny Baldwin, "E. W. Godwin and Design for the Theater," in Soros 1999, 341 ff. The tragedy by John Todhunter was based on plays of Sophocles.

76. Lady Archibald Campbell, cited in Lambourne 1996, 170.

77. Ibid.

78. Marshall 1998, 91–127. The first production (December 1883) toured in America. In the second production (September 1884), Anderson tried to be less like a statue, seeking to "combine statuesque beauty with the tender and womanly." Ibid., 105.

79. "Mr. L. Alma-Tadema on 'Galatea'," *Pall Mall Gazette* (10 December 1883), cited in ibid., 105.

80. "The Flame Once Kendal'd," *Punch*, vol. 87 (1884), cited in ibid., 111.

81. The tower had 6,600 incandescent bulbs on its base while 1,400 more outlined the tower. Powerful searchlights played over the structure as well. Baker 1989, 159–61.

82. The Spanish cathedral tower came to widespread public attention when it was restored in 1885–88.

83. The original fifteenth-century sea customs post (*dogana di mare*), built for inspecting ships' cargoes entering Venice, was replaced in the late seventeenth century. The tower was added to protect the entrance to the Grand Canal. The figure of Fortune stands on a large golden ball supported by two bronze Atlases. She resembles a piece mounted on the newel post of Leyland's grand staircase at Prince's Gate. This gilded carving of two female figures, one armed with an oriflamme, was said to have been acquired by the dealer Murrray Marks from a Venetian palace. Whistler later tried unsuccessfully to buy the figure group from Leyland's estate sale (1892). Merrill 1998, 179.

84. James 1909, 47. His next comment captures Whistler's approach to the aestheticized subject: "I call them happy, because even their sordid uses and their vulgar signs melt somehow, with their vague sea-stained pinks and drabs, into that strange gaity of light and colour which is made up of the reflection of superannuated things."

85. Deemed too racy for the Women's Building at the Chicago World's Fair in 1893, the first *Diana* was used on the Agricultural Building, designed by McKim, Meade and White. This version was lost when the building was destroyed by fire.

86. "The Lady Higher Up," Henry 1986, 504.

87. Diana tells Lady Liberty, "Saw a downtown merchant on the roof garden this evening with his stenographer....'H'm!' says he, 'will you take a letter Miss De St. Montmorency?' 'Sure, in a minute,' says she, 'if you make it an X.'" A "French letter" was a euphemism for a condom. Ibid., 503.

88. Wharton 1905, 134–35.

89. Among the department stores having direct impact on Whistler's part of London were Peter Jones in Sloane Square and Harrod's in Knightsbridge. Claire Walsh observes, "Many of the assumptions made about the dramatic rise of the department store and its novelty in the nineteenth century need to be rethought once a clearer picture emerges of retailing in the eighteenth century.…Window-shopping, browsing, the use of seductive display and interior design to enhance the appearance of goods, and shopping as a social activity were all in operation throughout the eighteenth century." See Walsh, "The newness of the department store; a view from the eighteenth century," Crossick and Jaumain 1999, 46–71.

90. Zola 1882. *Au bonheur des dames* was Zola's first novel to be translated into English. The 1883 edition was expurgated; the 1886 edition was not. The subtitle "A Realistic Novel" signaled pornography to the British reader.

91. O'Hagan 1900, 537.

92. Wharton 1905, 12.

93. Carl Kleinschmidt's illustration for *The Delineator* (March 1909) reproduced in Hobbs 1996, 64.

94. Clara Burton Pardee, *Diaries* (1883–1938), 26 May 1909, New York Historical Society, cited Abelson 1989, 40.

95. R. and A. Garrett, *Suggestions for House Decoration in Painting, Woodwork and Furniture* (London, 1876), cited in McNeil 1994, 633.

96. De Wolfe 1913, 48. Parts of her book first appeared as a series of articles commissioned by Theodore Dreiser, then editor of *The Delineator*. A second set of articles was published in *The Ladies' Home Journal*. See Smith 1982, 142–43.

97. "Miss de Wolfe's Exquisite Gowns," *Harper's Bazaar. A Repository of Fashion, Pleasure and Instruction* (3 February 1900), 94.

98. Lavinia Hart, "The Way of the World Justifies Its Title," unidentified newspaper clip (7 November 1901), in de Wolfe scrapbook, cited in Marra 1994, 110. Taking the opposite viewpoint, Oscar Wilde declared realism on the British stage a failure: "The characters in these plays talk on the stage exactly as they would talk off it; they have neither aspirations nor aspirates; they are taken directly from life and reproduce its vulgarity down to the smallest detail; they present the gait, matter, costume and accent of real people, they would pass unnoticed in a third-class railway carriage." See "The Decay of Lying" (1889), in Wilde 1999, 1,079.

99. Adams, cited in Smith 1982, 71.

100. For a summary of this play by Arthur Wing Pinero (1855–1934), see Fort and Kates 1935, 97. The play was first performed on 27 May 1893. It was one of three Pinero plays dealing with sexual double standards.

101. *The Yellow Book*, vol. 1 (April 1894): 157. The original drawing is in the National Gallery, Berlin. A letter from Beardsley to Mrs. Campbell survives. Writing in February or March 1894, the artist thanks the actress for giving him a sitting. See Reade 1967, 345.

102. Pinero, the play's now-obscure author, was once considered the leading British dramatist of the late Victorian period. See J. S. Bratton, introduction to Pinero 1995, vii. Beardsley also drew a "Woman in White," a slight sketch that does not necessarily link directly to Wilkie Collins's novel but, like Whistler's first *White Girl*, nonetheless resonates with the issues raised by earlier works. Reproduced in Reade 1967, 357, no. 437.

103. De Wolfe thus built on the cornerstone of arts-and-crafts theory while rejecting Morris wallpapers and mission furniture as too plebian. Curry 1997, 52–78. Students of the history of aesthetics

may recognize her formula as a version of Thomas Aquinas's threefold division of beauty based on the face and body of Jesus. He advocated "integrity, proportion, claritas." These became key terms for debates on the beautiful up to the early twentieth century. Scarry 1999, 64.

104. For Soane's mirrors at his house, 12–14 Lincoln's Inn Fields, see Richardson and Stevens 1999, 150 ff. Whistler and Godwin made similar use of inset mirrors in the "White House."

105. De Wolfe 1913, 48–49.

106. Whistler's rooms in the Rue du Bac, where he lived from 1892 until 1901, anticipate some of de Wolfe's ideas, such as white walls, light colors, and white-painted furniture. There was, however, no chintz. For a description see Bendix 1995, 185 ff.

107. "My servants' rooms are all attractive. The woodwork of these rooms is white, the walls are cream, the floors are waxed. They are all gay and sweet and cheerful, with white painted beds and chests of drawers and willow chairs, and chintz curtains and bed-coverings that are especially chosen, *not* handed down when they have become too faded to be used elsewhere!" De Wolfe 1913, 50–51.

108. Alexander served from 1909 until his death in 1915. His handsome drawing of Whistler (1886, Metropolitan Museum of Art, New York), made in London for a series of portraits of famous expatriate Americans, is reproduced in Denker 1995, 115.

109. Lutyens to Lady Emily Lytton, cited in Kinchin 1998, 25. Miss Cranston had married John Cochrane, a wealthy engineer eight years her junior in 1892. But she kept her maiden name for business purposes—a very independent choice to make in the 1890s.

110. Lutyens quoted in Stamp 2001, 125.

111. Curry 1984, 42.

112. Baker 1989, 289. Nesbit was sixteen

(but dressed like a schoolgirl of thirteen) when she began her affair with White. The year the photograph was taken, the architect gave his mistress a large pearl on a platinum chain and white fox furs for Christmas. Ibid., 326.

113. Ibid., 328. The Greuze-like photograph is reproduced opposite page 308. In 1903, Elizabeth Marbury and Elsie De Wolfe brought Evelyn back to New York after Thaw beat her during her premarital travels with him. Ibid., 332–33.

114. New York *Daily Graphic*, 17 June 1890, cited in ibid., 155.

115. Baker 1989, 374.

116. Saint-Gaudens quoted in Banta 1987, 450. In the ensuing uproar, the victim, Stanford White, became a villain for a time. Diplomat Henry White wrote McKim from Rome, "I have long feared as you know that he would come to an untimely end, but I must say that I did not expect such a tragedy as the incident which has befallen him." (White's wife, portrayed by Sargent, has been discussed here as one of the women in white.) The furor reached even to Washington, where a resolution condemned the sensational trial proceedings as a "demoralizing influence on the youth of the land" and authorized the president to exclude all publications from the United States mails if they contained "revolting details of this case." Ibid., 378, 388.

117. *The Importance of Being Earnest* (1894), in Wilde 1999, 376.

118. For a description of the set, see Reza 1994, 1.

119. Menpes 1904, 127–28.

Chapter 4:
HOUSES BEAUTIFUL

1. YMSM 62, 63. Whistler called *The Artist's Studio* "un apothéose de tout ce qui peut scandaliser les Académiciens." Whistler to Fantin-Latour, GUW 11477 [LC PWC I/33/1].

2. Whistler described to Fantin-Latour "la fille blanche assise sur un canapé et la Japonaise qui se promene!" in a letter, 16 August 1865, GUW 11477 [LC PWC I/33/1]. Whistler intended to include Fantin-Latour himself along with Albert Moore in the unexecuted painting. Curatorial File, Art Institute of Chicago.

3. They probably met in 1863. YMSM 1:lx.

4. "Performing the Self," Burns 1996, 221–46. She notes (p. 246), "So different in style, Whistler and Warhol shared an acute understanding of the power of the media-generated image and public performance to lend interest and desirability to their aesthetic products, and both were the magicians of the commercialized personality that contributed so much to the life of their fame." Juliet Kinchin provides a similar assessment of Godwin: "His contribution to modernism is generally discussed in relation to his architecture and furniture, but arguably he interacted with the world of avant-garde art in a more sustained and sophisticated way than any other designer or architect at that time. In other words his Modernism was not only revealed in the design of products, but in his whole mindset, the way he lived and his public image, as mediated through the press." Kinchin, "Godwin and Modernism," in Soros 1999, 99 ff.

5. Beatrice Philip (1857–1896), a student in Godwin's office, must have lied about her age on her marriage certificate (GUI) when she married the architect on 4 January 1876. He was her senior by more than two decades. On 11 August 1888, two years after Godwin's death, she married Whistler, another man old enough to be her father.

6. Whistler 1878, 51. Godwin to a client, V&A AAD, 4/23–1988: 16–17.

7. Most Westerners, including Whistler, depended on shops in London and Paris or saw displays of Japanese art at world's fairs. The first of these, an exhibition of *ukiyo-e* prints already in the West, appeared at the South Kensington Exhibition of 1862. Hoping to promote trade and industry, the Japanese finally began mounting their own presentations in 1873. Clearly, Whistler and Godwin were on the same aesthetic wavelength by the time they met shortly after the South Kensington Exhibition. Whistler gave pieces of blue-and-white to Godwin and his mistress, the actress Ellen Terry, according to their daughter Edy. A group of "Blue Willow" transfer ware is still on view at the Ellen Terry Memorial Museum, Smallhythe Place, Kent. For a photograph of Edy as a child wearing a kimono thought to be given her by Whistler, see Soros 1999, 29, fig. 1–11.

8. As early as 1862, Godwin created an unusually spare interior at his house in Bristol, furnished with Persian rugs on wood floors, carefully selected and placed Japanese prints, and plain colored walls. See "Chronology," ibid., 363.

9. For Whistler's links to baroque decoration, see Curry 1984, 53–61. Porcelain stand reproduced on p. 61, fig. 126.

10. Fantin-Latour to Whistler, July 1864, quoted in McMullen 1973, 122.

11. For a general study of the studio as sales point in American art, see Burns 1993, 209–38. She notes (p. 210), "The process of commodification, which involved both accommodation and resistance to new and compelling market conditions, promoted the collapse of culture into commerce and commerce into culture."

12. Kendall Banning, "Staging a Sale," *System* (1909), in ibid., 216–17. Burns adds (p. 218), "The advertising mechanism of the decorated studio was somewhat more subtle, veiled as it was by layers of rhetoric that styled the place as a temple of art, crucible of inspiration [and] haunt of genius."

13. Whistler clearly inspired Charles Caryl Coleman's flowering branches, his signature cipher, and his flattened background surfaces glowing with nuances of color.

14. "A Roman Studio," *The Decorator and Furnisher*, December 1884, 86–87. See also Twain and Warner 1873.

15. Pennell 1921, 271. Whistler saved a press clipping from the *Leicester Post*, 25 April 1885, written only two years after his controversial white and yellow exhibition shocked London before traveling to the United States: "Yellow is the fashionable colour for table decorations at present, and some charming effects have been lately produced by means of yellow satin and daffodils. Imagine a long strip of amber satin, placed upon the table, with a big bowl of daffodils in the center, and small vases of the same pretty flowers arranged on the mats at intervals. Then imagine a hanging lamp and candles with shades of yellow silk, and menus and name cards decorated with sketches of daffodils. Then put posies of daffodils here and there at the edge of the satin, tied up with long green tulip-leaves in lieu of ribbon, and say whether this would not be a harmony in yellow sufficiently pretty to delight the heart of Mr. Whistler himself." GUL BP PC 6:3. For discussion, see Bendix 1995, 89–91.

16. The property had also housed the visionary painter John Martin as well as Isambard Kingdom Brunel, the great Victorian engineer. Pevsner 1952, 6:102. See also Weinreb and Hibbert 1983, 474. The house is named after Robert,

third earl of Lindsey, who acquired the property in the 1660s. In 1750 Count Zinzendorf bought it, adding the mansard roof. During the 1770s, the house was subdivided into five different dwellings. Whistler lived first at No. 7 Lindsey Row; then in 1866 he moved to a grander suite of rooms at No. 2 Lindsey Row, and remained there for the next decade.

17. The eclectic props in the *Princess of the Porcelain Country* (1864–65; see fig. 4.45)—its Japanese screen, Chinese rug, and silk kimono, worn like a Western dressing gown—recall Whistler's drawing room at 7 Lindsey Row. A less cluttered portrait, for which Frances Leyland posed in the drawing room at 2 Lindsey Row during the spring of 1872, shows the room's plain pale walls as well as one of Whistler's rug designs. Similar parallel striations on the original frame carefully amplify the rug's rhythmic checked pattern [see fig. 5.1]. Rosettes on Mrs. Leyland's gossamer train echo an airy spray of blossoming branches breaking into the space. Plainer still, blankness, punctuated only by a rather perfunctory pot of blossoms, forms the background to the portrait of May Alexander (1875, Tate Gallery, London), yet another daughter of the London banker for whom Whistler designed interior color schemes at Aubrey House. The background of this portrait is misted with vaguely defined mauves that shimmer as one moves before the work. Apparently it was painted in W. C. Alexander's newly redecorated dining room, where it was intended to hang. YMSM 127.

18. Anna McNeill Whistler to Anderson Rose, 28 July 1870, GUW 12215 [LC PWC 021].

19. Walkley 1994, 47–49. George Morgan designed the building. His contract tender (offer to build) was £6,610 in 1860, more than double what Whistler's house cost nearly twenty years later.

20. Eventually, Whistler's Chinese export display cabinet, later called "the owl cabinet," ended up in Leighton House, albeit in a compromised state.

21. Burton 1893. For further descriptions of artist-studio houses see Gere and Hoskins 2000, 55–63.

22. Anna McNeill Whistler to Anderson Rose, 28 July 1870, GUW 12215 [LC PWC 021].

23. Ford concluded, "From that day Mr. Whistler has been the acknowledged leader of decoration, and the refinement of his influence can be traced in the details of daily life." Sheridan Ford, cited in Bendix 1995, 80.

24. The exhibition included thirteen oils, thirty-six drawings, fifty etchings, and a painted screen. Whistler's portraits of Thomas Carlyle, Mrs. Louis Huth, Miss Cicely Alexander, and both Mr. and Mrs. Frederick Richards Leyland were first exhibited in this setting.

25. These include the Dulwich Picture Gallery and the National Gallery of Scotland, as well as early galleries at the Boston Museum of Fine Arts and the Metropolitan Museum of Art in New York.

26. See M 909. The dealer, Frederick Keppel, handled numerous Whistlers. Freer bought this watercolor in 1901, two years before the artist's death.

27. Curry 1987, 69.

28. Godwin Diaries, entry for 14 August 1877, in Aslin Papers, V&A AAD. On 12 September 1877 Godwin wrote, "sketched out 4th design for Whistler on my own account." A contract was signed on 6 November 1877. Godwin notes that he charged Whistler £58 for designing the house. See also Godwin Diary, 2 May 1879. Godwin later published the information that the total cost of the house included "architect's charges, not only for this house but for sundry drawings and designs for studios not carried into execution." See Godwin 1879, 119.

29. Whistler to Godwin, 30 January 1878, Aslin Papers, file Whistler G101, V&A AAD. Wickham Flower had advised Whistler to hurry and get the roof completed to forestall the threat from the Board of Works to "put in an injunction."

30. "Watt" probably refers to the furniture manufacturer William Watt, with whom Whistler and Godwin collaborated on decorated furniture. A comment such as "I hope you will make comfortable arrangements with Webb [William Webb, Whistler's current solicitor] so that no more expenses may be incurred than what are absolutely necessary" indicates that the house was not complete when Whistler moved in. Memorandum, GUL Copy #1297.

On 9 September 1878 Godwin wrote to Whistler with "the final statement of account with the delivery of which my professional duties cease." The document states that the original amount of the contract for "Mr. Whistler's House & Studio Tite Street Chelsea" was £1,910. Additions of £920.5.0, less deductions of £103.12.8, brought the total cost of the house to £2,726.12.4.

As of 12 August 1878, there were "certificates" in the amount of £2,660.0.0., leaving a balance of £66.12.4. GUL Copy #1297. Godwin to Whistler, 9 September 1878.

In Godwin's short published article, while the figures do not precisely agree, we do find that the main additional costs were "(1) the addition of fittings; (2) the erection of servants' rooms at the back of the garden, with a glazed corridor leading thereto; (3) experiments in painting; and above all (4) rebuildings, delays, and additions forced by the Board of Works on an unwilling and combative client." See Godwin 1879, 119.

31. Alan Cole, diary extract, 16 October 1878, 281, LC PWC, cited in Bendix 1995, 152.

32. Godwin Diary, 2 May 1879, V&A AAD. Seeing bailiffs at Fallows Green helped Ellen Terry decide to return to the stage in 1874. See Lionel Lambourne, "Edward William Godwin (1833–1886): Aesthetic Polymath," in Soros 1999, 30–31.

33. The house and remaining contents were auctioned on 18 September 1879. See GUL Whistler SC 1879.1: "In Liquidation. Chelsea. Particulars & Conditions of Sale of an excellent brick detached Residence, having a magnificent studio 50 ft. by 30 ft., and known as 'The White House,'" annotated "sold at sale for £2,700 to Quilter." The premises were held from the Metropolitan Board of Works on lease for a term of eighty years from 29 September 1877, with seventy-eight years not yet expired at Michaelmas, 1879. Thus the original lease would have expired in 1957—and the house was destroyed less than a decade after that. Originally, the ground rent was £29 per annum, and the sale document suggests the house could "easily command" an annual rent of £300 in 1879. It continues, "The residence was built by the present occupier for himself, under the superintendence of EW Godwin…and is by design and pattern especially suited to an Artist. The neighborhood is full of interest, lying as it does close to Old Chelsea, and the value of house property here is being daily enhanced by the beautiful specimens of Domestic Architecture, which are springing up on the Chelsea Embankment."

34. Outraged at Quilter's alterations, Whistler wrote to *The World*, "Oh, Atlas! What of the 'Society for the Preservation of Beautiful Buldings'? Where is Ruskin? and what do Morris and Sir William Drake? For behold! Beside the Thames, the work of desecration continues, and the 'White House' swarms with the mason of contract. The architectural *galbe* [contour, shapeliness] that was the joy of the few, and the bedazement of 'the Board,' crumbles beneath the pick, as did the north side of St. Mark's, and history is wiped from the face of Chelsea." Reprinted as "Sacrilege," in Whistler 1892, 124. Whistler was referring to clumsy restoration efforts at St. Mark's in Venice, which caused public outcry in Britain, with Ruskin in the forefront. The scaffolding on St. Mark's is visible in Whistler's etching *Piazzetta*, K189. William Morris had founded "Anti-Scrape" to protest the destruction of historic buildings in England. For demolition date of the "White House," see Denny 1996, 97. Sir William Drake became secretary of the Painter-Etcher Society with whom Whistler quarreled in 1881. See Whistler 1881.

The "White House" survived the blitz that heavily damaged Chelsea during the Second World War, only to be demolished thereafter. Were they able to see it, artist and architect might or might not take some comfort in their loss with the recent appearance in Tite Street of a large new dwelling by Tony Fretton. The house was built for one of the Sainsbury family, which is noted for its patronage of the National Gallery, London. Inserted into the urban fabric near the original site of the "White House," the geometric structure stands, innocent of ornament. However, its reddish materials are considerably more respectful of its nineteenth-century red brick neighbors than Whistlers "White House" would have been.

35. Godwin, "Notes on Current Events," *British Architect and Northern Engineer*, vol. 9 (18 April 1878), quoted in Spencer 1989, 125.

36. See Richard W. Hayes, "An Aesthetic Education: The Architecture Criticism

of E. W. Godwin," in Soros 1999, 119. Hayes cites Godwin, "Ex-Classic Style Called 'Queen Anne,'" *Building News and Engineering Journal*, vol. 28 (16 April 1875): 441. The first building on the site in La Rochelle was begun in 1289. Godwin drew the building as restructured by Francis I (ca. 1544) and Henri IV (1596–1606). Muirhead and Monmarche 1932, 288.

37. Whistler to the Metropolitan Board of Works, 23 May 1878, GUL M331 (draft), in Thorp 1994, 53–54.

38. Aileen Reed notes that "white bricks" meant very pale ones, but not bricks that were glazed with white. Early on, she reports, the house was given a coat of whitewash. See Reed, "The Architectural Career of E. W. Godwin," in Soros 1999, 181, n. 231.

39. "To Mr. Whistler are due the colours and their arrangement on walls and ceilings, as well as on the wood inside and outside, and to him also are due the constructive colours, with bricks and Portland stone for walls and green slate for roof." Godwin 1879, 119.

40. Bushman 1992, 257–58. He adds, "In the eighteenth century, pretentious buildings like churches or great mansions were sometimes white but more often yellow, sand-colored, red, or green. Other structures with no paint at all on their log or board exteriors weathered to a gray-brown."

41. Ibid., 258. Architect Calvert Vaux thought that white-painted buildings "protruded from the surrounding scenery." A white house, "instead of grouping and harmonizing with [the landscape], asserts a right to carry on a separate business on its own account; and this lack of sympathy between the building and its surroundings is very disagreeable to an artistic eye." Vaux, *Villas and Cottages: A Series of Designs Prepared for Execution in the United States* (1864), discussed in Bushman 1992, 258.

42. In *The Buildings of England*, Nikolaus Pevsner notes that the usual English riverside development pattern was broken in Chelsea when Charles II's Royal Hospital was built (1682). During the eighteenth century growth consisted chiefly of brick terrace houses close to the church, similar to those built in other villages around London such as Hampstead or Islington. However, in 1777, Henry Holland began to develop Hans Place, signaling the end of Chelsea as an independent locale. Pevsner 1952, 6: 241–42. During the nineteenth century London and Chelsea fused. For a general study of London neighborhoods populated by artists, see Wedd et al. 2001.

43. Pevsner notes, "About the middle of the century a complete change in the character of Kensington was brought about by the establishment of the museums and academic institutions in its very center. Terraces of tall stuccoed houses, very big and uniform, grew up around them. The whole area between Queen's Gate, the Park, Gloucester Road, and Brompton Road is full of them." Pevsner 1952, 6:241–42.

44. The population rose from 40,000 to 88,000 during those years. According to Pevsner, in the 1870s and '80s "two developments which, though not wholly confined to Chelsea, appear here specially characteristically and extensively. One was the erection of tall, wealthy brick terrace houses in the Cadogan Square neighborhood, in the style which Mr. Lancaster calls Pont Street Dutch, the other the eminently interesting replacement of C18 houses in Cheyne Walk by houses in a very adventurous Late Victorian style by Norman Shaw and such followers of his as C. R. Ashbee and the addition of houses in the same vein and by the same architects along Tite Street and the new Chelsea Embankment." Ibid., 85.

45. Efforts to extend the Chelsea Embankment at Chelsea Reach brought objections to "the County Council's smoothing hand...to be laid on one of the quaintest spots even in Chelsea" where Whistler "produced some of his sweetest nocturnes, inspired by the very scene oleaginous respectability would improve." The journalist went on to say that Whistler's "part of Chelsea is a scene which appeals to everyone's sense of beauty, however rudimentary. The wide silver bay, edged with its low river wall, propped up by decaying brick buttresses, of all colours, where the water strikes them, from sage green to deep crimson, and tufted here and there with timid plant growth. The old barges...moored up at the wharf discharging their cargoes of yellow bricks, with their brown sails hanging listless and their curiously painted masts...everywhere the river glows with little bits of colour." See "Vanishing London: The Doom of Chelsea Reach," *Daily Mail*, 10 July 1896, in Chelsea Miscellany, 1897, 1:41. CPL. A series of late-nineteenth-century articles have been clipped and bound in another scrapbook to record "Chelsea in Olden Time." See Chelsea Miscellany, 1900, 2:187–95, CPL. There are many more examples in what seems almost a local industry of nostalgia.

46. For discussion, see Catherine Arbuthnot, "E. W. Godwin as an Antiquary," in Soros 1999, 55.

47. Godwin 1879a, 261–62. These ideas, visible in the initial rejected concept, gave way to what was essentially a label or signboard on the revised facade design. The pediment then bore "The White House" lettered on a sharp angle, as well as an incised butterfly.

48. The white center pavilions vary slightly. On the east and west sides of the square, each is actually a double house of three bays divided by five pilasters (nos. 18, 19, 46, 47 Bedford

Square). On the south side, no. 32 is a single three-bay house, the windows flanked by four pilasters. The grandest pavilion on the north side, no. 6 is a five-bay single house, once the home of Lord Eldon (1751–1838), who served as Lord Chancellor.

49. Godwin 1879, 119.

50. Widely publicized and photographed, the *Weissenhofseidlung* became a benchmark in associating the ideal of the white wall with the International style of architecture.

51. "The Barn is texture and nothing more," opined one contemporary critic, cited in Lucic 1997, 59. See also her dissertation on Sheeler's use of the past, Lucic 1989.

52. Inigo Jones's Double Cube room at Wilton House displayed a collection of paintings by Van Dyck. Robert Adam's Great Hall (1762–69) at Syon Park was another Double Cube used to display art. Given his involvement with the Northumberland staircase removed to Leyland's new house, Whistler surely knew about Syon Park, built for the duke of Northumberland between 1762 and 1769.

53. Details in the liquidation document give us further valuable information on the interior of the now-lost house. The first floor included "A Dining Room 20 ft. by 15, tastefully decorated in the Queen Anne style with ornamental wood mantel having silvered glass panels and china recesses." This recalls Soane's use of mirrors in his house museum. There were also "a Corner Recess fitted with china shelves and silvered panels; and a Buttery Hatch enclosed in a fixed cabinet with china shelves, and three good bedrooms; also, with separate Staircase, a matchless studio 50 ft by 30, well lighted and very lofty, with Lavatory and WC adjoining." The ground floor boasted a "spacious and lofty drawing room 29 ft. 6 in. by 17 ft. 6 in. and

18 ft. high. With large Queen Anne windows opening on to a grass plot, a deep chimney corner and communicating by folding doors with Entrance Hall, and also with a boudoir; convenient domestic offices, comprising kitchen with American stove and charcoal stove." The house was lit with gas. GUL Whistler SC 1879.

54. Walter Dowdeswell, undated letter [1886, 1887?], GUW 08699. LC PWC ADd; cited in Bendix 1995, 153–54. For additional period descriptions, see ibid.; also Soros, "E. W. Godwin and Interior Design," in Soros 1999, 206–9. The square-paned windows survived radical changes to the house by subsequent owners and were photographed for the "White House," *Vogue*, 1 August 1915, 40. Whistler and/or Godwin probably designed the garden as well.

55. "To secure an abundance of pure, unimpeded air, free from dust, all unnecessary furnishings were eliminated." Garrett 1989, 138.

56. The artist Jacques-Emile Blanche, visiting the "White House" with Paul-Cesar Helleu, wrote, "We went through a series of unfinished rooms distempered with yellow. Japanese matting lay on the floors." Blanche, *Portraits of a Lifetime: The Late Victorian Era: The Edwardian Pageant* (1938), cited in Bendix 1995, 152. Other sources call the matting variously Chinese and Indian.

The liquidation catalogue mentions several types of floor covering. The second floor studio included "a nearly new Turkey carpet" approximately five feet square. In the dining room there was "India matting as laid (about 42 yards)." The drawing room had "India matting as laid, about 60 yards." Apparently Whistler hadn't had time to lay the breakfast room floor; it had "India matting as planned to room (about 20 yards)" along with a "pair blue and white cretonne curtains." The hall and stairs had "brown Brussels

carpet as laid to landing. Blue ditto."

Forbes Robertson describes similar touches in Godwin's own London house at 20 Taviton Street, Gordon Square, where Godwin moved with his mistress in 1874: "The floor was covered with straw-coloured matting, and there was a dado of the same material. Above the dado were white walls and the hangings were of a cretonne with a fine Japanese pattern in delicate grey blue. The chairs were of wicker with cushion like hangings, and in the center of the room was a full size cast of the Venus de Milo." See *A Player Under Three Reigns* (1925), cited in Gere 1989, 280. For Godwin's own descriptions, having parallels with the "White House," see Godwin 1876.

57. Bendix speculates on this possibility in connection with Godwin's later design for Frank Miles's house (1878–79) in Bendix 1995, 159. Soros provides the document source for the Frank Miles house, of which Godwin wrote "studio stairs covered with felt Main stairs Do[ditto] Whistler's stuff." V&A PD, E.248–1963: 72–73 cited in Soros, "E. W. Godwin and Interior Design," in Soros 1999, 222, n. 153.

58. Thomas Jeckyll (1827–1881) was architect of the Peacock Room at 49 Princes Gate, the room Whistler later redecorated, causing the notorious scandal. Collateral damage from the quarrel included Jeckyll's subsequent madness. For details, see Merrill 1998, 260. See also Soros and Arbuthnott 2003.

59. Whistler to Godwin, GUW 01739 [GUL (Whistler G105) ALS]. Godwin received the letter on 22 March 1878. In the letter Whistler also says, "I have given West the plan for garden and corridor &c &c—and he is going on at once!" For tiles, see Herbert and Huggins 1995.

60. Soros, "The Furniture of E. W. Godwin," in Soros 1999, 241–42.

61. Aslin 1986, 24, no. 10.

62. Curry 1998, 126 ff.

63. A drawing for the cabinet is dated "Paris 22 Sep 1877." Soros, "Furniture of Godwin," in Soros 1999, 255. The Pennells thought *The Butterfly Cabinet* was intended for the "White House" although it returned to the Gower Street showroom of Watt and was still for sale four years after the Paris exhibition. Both Bendix (1995, 156) and Merrill (1998, 261 ff.) also suggest it was intended for the "White House."

64. By removing the painted side panels that once flanked the fireplace and making them into doors at the bottom center of the cabinet (where the metal fireplace and its tile surround were originally located), the cabinet has lost its architectural sense of a broad stable-looking base and now appears rather too tall.

65. The reporter continued, "The peacock reappears, the eyes and the breast-feathers of him…the feather is all gold, boldly and softly laid on a gold-tinted wall. The feet to the table legs are tipped with brass, and rest on a yellowish brown velvet rug. Chairs and sofas are covered with yellow, pure rich yellow velvet, darker in shade than the yellow of the wall and edged with yellow fringe. The framework of the sofa has a hint of the Japanese which faintly, but only faintly, suggests itself all through the room." Smalley 1878, 2. One cannot see the upholstered pieces in the extant photograph of the Watt stand. For color illustrations of Kaga ware, see Audsley and Bowes 1875, 184–85. The golden peacock feather motif recalls Whistler's previous work in Leyland's Peacock Room (1876–77, Freer Gallery of Art, Washington, D.C.) where a similar sophisticated sensitivity to color and texture was in operation. Curry 1984, 63–64, 68–69.

66. Smalley 1878, 2.

67. Lucas 1921, 1:80.

68. Discussed in Bendix 1995, 156.

69. Godwin's London house, shared with Ellen Terry, had "India matting" not only on the floors but also as dadoes on some of the wall surfaces. See Nancy B. Wilkinson, "E.W. Godwin and Japonisme in England," in Soros 1999, 76–77. Godwin inscribed the request for "scratches" on an elevation and section of the lower studio fireplace of the "White House" (1878, Victoria and Albert Museum, London), reproduced ibid., 206, figs. 7–32.

69. Turner 1996, 24: 112. According to the *O. E. D.* the archaic meaning of "pargetting" is "to cover with a fair outward appearance," i.e., to whitewash.

70. According to this old chestnut, the newel post was drilled out and the ashes of the burned mortgage poured in before the hole was capped with the ivory button. While for the most part apocryphal, examples do exist. The Noah-Fearing House (1799, Bridgewater, Mass.) has such a button, inserted in 1839.

71. Soros notes, "The prototype was probably the black japanned Sheraton painted chairs with rounded cane seats that were fashionable in England in the 1770s and 1780s and sought after by collectors in the 1870s." See Soros 1999a, 89. For an illustrated discussion of the "burgomaster" chair, which is thought to represent an Eastern shape adapted by European craftsmen working on the east coast of India or in the Dutch East Indies, see Jaffer 2002, 74–75.

72. Godwin 1879a, 261–62.

73. "Art Furniture," part 1, *Building News and Engineering Journal*, vol. 33 (21 December 1877): 614.

74. The staircase was removed from the Percy family's town house before the London Board of Works demolished the building in 1874. Merrill 1998, 178–79.

75. Whistler was not the first Westerner to create dado panels in imitation of lacquer. For commentary on one early example, Schloss Falkenlust (1732–37)—a hunting lodge near Brühl, Germany, where lacquered screens, architectural elements in their own right, were cut up, extended by European artists, and applied as decorative paneling—see Reepen et al. 1996. There wasn't enough Asian material to complete the room at Schloss Falkenlust, so the painted dado panels are entirely Western.

76. The underlying grid, coupled with the stylization of the flowers themselves, would have met with the approval of more than one theorist supposedly at odds with Whistlerian "art for art's sake." For extended discussion and illustrations, see Curry 1984, 160–63. No two panels are alike.

77. Tanizaki 1977, 22.

78. Cecily later recalled, "I was painted at the little house in Chelsea, and at the time he was decorating the staircase; it was to have a dado of gold and it was all done in gold leaf, and he laid it on by himself, I believe; he had numberless little books of gold leaf lying about, and any that weren't exactly the old gold shade he wanted he gave to me." See Pennell 1908, 123. Whistler's mother said of the staircase, "you would be delighted at its brightness in tinted walls and staircases." Anna Whistler to James Gamble, 30 September / 2 October 1874, GUW 06544 [GUL W 547]. For sketch see M 659. Whistler's landlord Sidney Morse also reported that Whistler's dining room walls were distempered in a dull peacock blue, with a lighter, greener wainscot; the doors were white and greenish blue. For a (black-and-white) photograph of this scheme, which anticipates the Peacock Room, see Pennell 1921, opp. 152.

79. Alexander was a banker specializing in the discount market, a lucrative if risky trade. He bought the house in 1873. Gladstone 1922, 52–54. An 1817

watercolor of the *White Room* showing some of the fielded paneling we see in Whistler's later color schemes is reproduced in ibid., opp. 32. See also *Arches in Drawing Room*, a watercolor of 1887, reproduced opp. 50. The Alexander family was interested not only in art but also in issues of social welfare, which resonates with some of Whistler's subject matter in the shop fronts and London street scenes.

80. A series of maps recording the city's gradual encroachment on the grounds is reproduced in ibid. See also Weinreb and Hibbert 1983, 30–31.

81. Lady Mary Coke lived there from 1767 to 1788, following an unsuccessful marriage to the rake Edward, Viscount Coke. Gladstone 1922, 9. Her portrait in white satin, painted by Allan Ramsay in 1762, is reproduced in ibid., opp. 11.

82. Linda Merrill notes that a family friend, the novelist Violet Hunt, recalled that the room's "mouldings round the doors and so on were carried out carefully in many gradations of white." Sadly, however, neither artist nor client was very happy with the result, and "within three or four years the walls were so dirty that Alexander covered them with tapestries and Italian paintings." The paneling was removed by 1913. Merrill 1998, 152–53. For an article on the house, see Nares 1957, 924–25.

83. Fry in *Burlington Magazine* (1916), quoted in Gladstone 1922, 53. The Alexander family bequeathed a nocturne, YMSM 103, and three portraits, including the *Harmony in Grey and Green: Miss Cicely Alexander*, to the Tate, YMSM 127, 129, 130. For works on paper owned by the family, see M.

84. Raoul dos Santos described pale yellow and pale blue rooms decorated by Whistler. "Ses appartements ne sont que des tableaux d'intérieur, à la composition desquels préside du reste un goût exquis." *Moniteur des Arts*, 28 January 1885, GUL Whistler PC 6:17.

85. This and other sketches for Aubrey House reproduced M 487, 488. The color schemes for wall decoration are M 489–92.

86. GUW 06695 [GUL W 689].

87. Ernest Brown, who joined the Fine Art Society in 1878, was instrumental in garnering the commission for Venetian etchings that took Whistler to Venice on the society's behalf. In an 1886 letter Whistler instructed Brown, "Here is a list of colors—Distemper. *First* one coat of light grey (made of simple whitewash and a little Ivory black—*not* the *vegetable black* of the trade—with a very little yellow ochre) *over ceiling and walls—strongly sized*—Walls & ceiling: Now the apple green—*Distemper* light Lemon Chrome. *Antwerp blue* toned slightly with *yellow ochre, & Raw Sienna*, Skirting and All Woodwork: *Oil* Lemon Yellow Ochre / Raw Sienna." M 1104.

88. Adelphi means "brothers." See Weinreb and Hibbert 1983, 6–8. The project marked the beginning of the embankment of the Thames River, which would have profound impact on Whistler's Chelsea a century later. The D'Oyly Cartes resided at the Adelphi from 1881 until 1901.

89. Robert Adam invited Zucchi (1726–1796) to London; he came in 1766, as did Kauffmann (1741–1807). The architect William Chambers supported Cipriani (1727–1785). Designing for the theater, a task previously left to artisans, was elevated to a fine art by the 1770s.

90. Cited and discussed in Gere 1989, 329. Others who used Whistler's ideas for decoration included Sir Thomas Sutherland, William Heinemann, and Mortimer Menpes, as well as those already discussed.

91. Ibid.

92. Menpes 1904, 128.

93. It was reproduced in Edis's book, published in 1881, the year Whistler leased the rooms. The book stemmed from a series of lectures for the Society of Arts on "Decoration Applied to Modern Houses." See Edis 1881.

94. Jervis and Tomlin 1984. By 1908 the house was described as the "most renowned mansion in the capital." See ibid., 3. It is thought that the duke got his ideas for a white and yellow scheme following a visit to Saint Petersburg in 1826. Whistler, too, knew the interiors of that city. At the end of his career, Whistler owned white furniture in the neoclassical style. Soane's south drawing room is recorded in a watercolor of 1825 by J. M. Gandy, reproduced in Dorey et al. 2000, 74.

95. Menpes 1904, 127–28.

96. "The Law of Ripolin: A Coat of Whitewash," in Le Corbusier 1925, 188–92.

97. Menpes 1904, 127–28. Menpes added, "If Whistler were distempering a small house, his first thought would be to create a oneness of colour throughout. For example, he would never dream of introducing into an old-rose room lemon yellows, apple greens, and Antwerp blues: such a room in his opinion must be of one simple, broad color."

98. "Whistler at Dowdeswells'," unidentified press cutting [1886], GUL Whistler PC 3:69.

99. "Mr. Whistler's Pictures," *The Hour*, GUL Whistler PC 1:71. This undated clipping appears with 1874 reviews.

100. In one instance, although the works were small in scale, each was "distinctly seen and on coming away the impression [was] that they are all considerable in dimensions." Whistler to the Dowdeswell Gallery, *The Lessing J. Rosenwald Collection: A Catalogue of the Gifts of Lessing J. Rosenwald to the Library of Congress, 1943–1975* (Washington 1977), cat. no. 1997, case 2, letter 32. Reference is being made to "Notes"—"Harmonies"—"Nocturnes," Whistler's exhibition decorated in flesh color and gray, held

in May 1884 at the Dowdeswell Gallery, 133 New Bond Street, London. At another show, the "bizarre contrast of pallid tints [was] singularly unaggressive. You forget what it is which lends this room its excessive yet temperate light. You only note that the light is there, and that it is applied to the illumination of pictures which demand it. These pictures, from which your attention is distracted by no irrelevant or discordant accessories, show for all they are worth." "Art Babble," *New York Daily News*, 4 October 1883, GUL, Whistler PC 3:57. The exhibition here reviewed was the New York venue of *Arrangement of White and Yellow* at Wunderlich's Gallery, 868 Broadway, October 1883.

101. Godwin 1884. One of many reviews stressed the fashionable nature of the undertaking: "Grey is the favourite colour of the season, and is used for entire costumes without any admixture of colour. The prettiest and rarest shade of it is the tint formed of simple black and white without any blue or pink. The blue grey is trying to most complexions, and is less ladylike than the pure grey. Mr. Whistler's gallery in New Bond-street is decorated with grey and salmon, 'an arrangement in flesh-colour and grey.' His walls are covered with pink serge, the paint of the woodwork and the liveries of his servants in attendance being of the combinations named. Doubtless, now all his admirers will add a touch of salmon to their grey costumes; but they must be careful to select his special shade of grey, which verges on stone colour. This wonderful artist uses frames of greenish gold wherever the picture requires such a setting, noticeably for his marine studies. A strip of angry grey-green sea, framed in green gold, against a dull pink background, is an exquisite arrangement of colour, worthy to be adopted by the

costumière of the period." *Court Circular*, 24 May 1884. Press Clippings. Frame 0552, Whistler papers, GUL AAA #4687.

102. Whistler to Duret, 1885 [April 1887], GUW 09274.

103. Among many useful recent studies are MacLeod 1996; Crossick and Jaumain 1999; and Blanchard 1998. See especially Blanchard's "The Aesthetic Parlor, the Objet d'Art, and the Sedated Self," 85–137.

104. Archibald Stuart Wortley, a director of the Fine Art Society for whom Godwin designed a house and studio, was another possible link. See Aileen Reed, "The Architectural Career of E. W. Godwin," Soros 1999, 182, n. 253.

105. Huish to Godwin, 28 July 1881, RIBA Mss, GoE/2/4. For comment, see O'Callaghan 1976, 5.

106. The changes are recorded in another well-known image by Davison, "The Fine Art Society's Gallery Designed and Executed by George Faulkner Armitage," illustrated in *British Architect and Northern Engineer* (2 January 1891). Again the creation of the sense of private spaces in a public gallery seems to have been the goal. Faberman 1996, 150.

107. Quoted in Baron 1975, 59. For discussion see Faberman 1996, 147–58.

108. The society featured "Mr Ruskin's Drawings by the late J. M. W. Turner, RA, and His own Handiwork Illustrative of Turner, with his Notes" in 1878. Whistler's shows were a group of twelve commissioned etchings in 1880, followed by *Venice Pastels* in 1881 and *Arrangement in White and Yellow* in 1883, accompanied by a catalogue titled *Etchings & Dry Points. Venice. Second Series*. For the first time, Whistler gave his exhibition installation a title separate from its catalogue, indicating that he had come to understand his installations as total works of art.

109. Merrill 1992.

110. See Faberman 1996, 148; Wilkinson 1987, 337.

111. See Godwin's article and illustration, "The loggia of the Manoir d'Ango," *Building News*, vol. 26 (10 April 1874), 390, 392, discussed and reproduced by Hayes, "An Aesthetic Education: The Architecture Criticism of E. W. Godwin," in Soros 1999, 118–19.

112. Lambourne, "Edward William Godwin," in Soros 1999, 30–32. See also Fanny Baldwin, "Godwin and Theater," ibid., 317–18.

113. Gaskell 1853. In her prescriptive text *The Art of Decoration*, Mrs. H. R. Haweis, a taste-making pundit, commented, "Distemper is so cheap…that people really might indulge oftener in the luxury of a clean coat for their room." Haweis 1881, 228.

114. Whistler to Godwin, May 1881, GUL Whistler G118 ALS.

115. *St. James's Gazette*, 1 December 1886, GUL Whistler PC 7:19.

116. Grieve 2000, 43.

117. For a complete listing, see Soros 1999, 400. The series continued from 1874 into 1875.

118. For the use of Shakespearean themes in paintings to decorate the prince of Wales's pavilion at Vauxhall Gardens, see Solkin 1993, 149 ff.

119. "The Shakespeare Dining Room Set," *Building News*, 11 November 1881, 626. The armchair, the most familiar form today, was illustrated. According to *The Cabinet Maker*, vol. 7 (1885/86): 260, "The Shakespeare chair is now in every upholsterer's showroom." See Aslin 1986, 33, and Soros, "Furniture of Godwin," in Soros 1999, 253–54.

120. Baldwin, "Godwin and Theatre," Soros 1999, 331. Dorment notes, "Whistler became friends with Lord and Lady Archibald at the time of the first Grosvenor Gallery exhibition in 1877. "The 'epitome of aestheticism,' [Lady Campbell] stood at the center of a coterie of cultured society figures. …Through his friendships within this circle Whistler could eventually count

among his acquaintance the Prince and Princess of Wales." See Dorment 1994, 212.

121. Edwin Austin Abbey reported seeing it there. Lucas 1921, 1:80.

122. Williams 1972, 382–83.

123. Malcolm 1985.

Chapter 5:
STYLE WARS

1. *The Importance of Being Earnest* (1895), in Wilde 1999, 409.

2. "The Importance of Watteau," in Levy 1995, 10.

3. See front matter to Whistler 1892. First offered in a limited edition of 250 copies, the book was enlarged and reprinted in 1902, becoming the standard text for all subsequent editions. These were numerous. A third edition from 1904 was reprinted in 1907, 1911, 1916, 1936, and 1953. For publication history and reviews, see Getscher and Marks 1986, 14–23. Whistler had initially permitted Sheridan Ford to edit his correspondence but later withdrew his approval. Whistler's first idea for a title was "Scalps." Ibid., 17, no. A 22h.

4. Curry 1984, 251–52; MacDonald et al. 2003, 95–111.

5. "Another Poacher in the Chelsea Preserves," in Whistler 1892, 234. In this particular controversy, first bruited in a letter to *The World*, 26 December 1888, Whistler took issue with an interview on "The Home of Taste" in which his ideas on interior decoration were borrowed without acknowledgment by one of his students.

6. The comfortable *sacque* or "sackback" dress was a loose garment, very different from the restrictive, formal clothing dictated by the court of Louis XIV. In 1718 *La Bagatelle*, a French magazine, averred, "At present comfort seems the only thing that the ladies of Paris care about when dressing." Laver 2002, 130.

7. Levy 1995, 56–57.

8. Whistler 1885, 80.

9. On view for only fifteen days, the unusual picture caused a stir. For provenance, exhibition history, and publication data, see Grasselli and Rosenberg 1984, 446–58. The picture was published frequently in the last four decades of the nineteenth century after an article by the French critic Paul Mantz appeared in 1859. See Mantz 1859, 263–72, 345–53. The painting was exhibited publicly in Berlin in 1883 and also existed in a reproductive print.

10. Levy 1995, 77–82.

11. Robert Pearsall notes, "The more expensive street walkers worked to a system. In the winter when it was cold they would congregate in Burlington Arcade…and when their coy signals were responded to, would glide into prearranged shops to sort out details." Pearsall 1971, 324, cited in Dorment 1994, 212. Dorment goes on to discuss the impact of Hals, Velázquez, and Titian on *Brodequin Jaune*, as well as the implications of boots for Victorian viewers.

12. Whistler to Fantin-Latour, GUW 08045 [September 1867?] [LC PWC 1/33/25]. Discussed in Spencer 1989, 82–83.

13. Bénédite 1905.

14. Robert Jensen argues that, in the discourse of art and money, control over the market for art meant the control over history: "The term 'avant-gardism' arose out of the historical moment in which competing modernisms (most significantly, the replacement of Impressionism by 'Post-Impressionism,' 'Fauvism,' 'Cubism,' 'Expressionism,' and 'Futurism') divided heretofore indivisible modernism into factions. These 'isms' are not just the great creative flow of a generation, but a mentality, haunted by the need for originality, by the need to supersede one's

competitors, by the desire to get a piece of the market share." Jensen 1994, 14–15.

15. Whistler 1885, 80. Journalists trying to peg Whistler often referred to him as an Impressionist, e.g., De Kay 1886. Whistler's catalogue for "Nocturnes, Marines, and Chevalet Pieces" (London, Goupil Gallery, 1892) includes a number of earlier press clippings associating his work with Impressionism, e.g., no. 6, *Nocturne: Trafalgar Square —Snow* (of course a quintessential Impressionist topic) followed by "The word 'Impressionist' has come to have a bad meaning in art. Visions of Whistler come before you when you hear it." Whistler 1892, 301.

16. Cook 1878. A wide range of furnishings typifies the eclectic Aesthetic interior. "My Lady" mixes Georgian silver and wall sconces, Japanese fans, blue-and-white delft tiles, and Chinese porcelain, providing formulaic guidance—the chief purpose of such prescriptive books.

17. Cited and discussed in MacLeod 1996, 272 ff.

18. For the eclectic collecting interests of Boston aesthetes, see Cook 1997, 17–31. For Aestheticism in the White House (Washington, D.C.), during the Arthur administration, see Seale 1986, 1:530–45.

19. See, for example, "Build-up of the Paint Surface," and "Brushwork" in House 1986, 63–108.

20. See, for example, Caffin 1901.

21. "Decay of Lying" (1889), in Wilde 1999, 1,078. It was this barrier between art and life that first blinded Henry James to the significance of Whistler's portrait of Henry Irving.

22. YMSM 56; see also 57 and 58. When Whistler completed the first state of the picture he signed and dated it "Whistler. 1865."

23. "Decay of Lying," in Wilde 1999, 1,078.

24. Solkin 1993, 2.

25. London had at least sixty-four pleasure gardens by the 1780s, catering to varied audiences. Vauxhall was the most elaborate of these gardens, where "for a small admission fee one could take the family, have tea, listen to music, gawp at macaronis, and keep assignations." Porter 1982, 250. See also Edelstein and Allen 1983.

26. Ogborn 1998, 122. Semirural pleasure gardens began appearing on the outskirts of London as early as the seventeenth century.

27. According to Brenda D. Rix this was the most famous of all Rowlandson's works. Rix 1987, 44. There are four known versions, three in watercolor, one in oil.

28. See Baskett and Snelgrove 1972, 53. Hester Thrale, like Boswell, wrote about Johnson, but in contrast to some of the more notorious women in Rowlandson's image of Vauxhall, she was a devoted mother. See Vickery 1998, 115.

29. During the period when *The Balcony* was under way, Whistler occupied two different apartments carved out of a divided-up Lindsey House (1664), which was renamed Lindsey Row. He took his first apartment there in March 1863 and his second in February 1867. He remained there until 1878.

30. According to Southworth 1941, 181, Edward Tyrell Smith bought them for the Banqueting Hall at Cremorne.

31. Surviving correspondence suggests that Whistler acquired the china and kimonos seen in this painting from the shop of Mme. de Soye in the Rue de Rivoli, Paris. Whistler to Fantin-Latour, September 1865, GUW 08037 [LC PWC I/33/17].

32. Whistler described Jo's hair in a letter to Fantin-Latour: "c'est des cheveux les plus beaux que tu n'aie[s] *jamais* vu! d'un rouge non pas doré mais *cuivré*— comme tout ce qu'on a rêvé de Vénitienne!" This letter, describing the painting *Wapping*, goes on to place Jo in a compromising discussion with a sailor. Whistler to Fantin-Latour, January–July 1861, GUW 08042 [LC PWC I/33/02]. For discussion, see Spencer 1982.

33. Celia Madden tempts an idealistic young Methodist minister who falls under the spell of progressive ideas in Frederick 1896. Discussed in Stein 1986, 42–46.

34. J. Lockman, *A Sketch of Spring-Gardens, Vaux-Hall, In a Letter to a Noble Lord* (1752), discussed in Bindman 1997, 22–31.

35. Discussed in Solkin 1993, 111 ff. Vauxhall was one of many sites where a paying audience appropriated music once intended only for the nobility. Influenced by the new market, Handel decided to write his libretto for *The Messiah* in English to reach an audience little acquainted with the Italian texts of his earlier operas.

36. Whistler 1878, 51. Whistler's explanation sidesteps the regular use of quotations from popular and folk music incorporated into "classical" works. For example, Handel used the musical cries of street vendors in formal compositions. Weinreb and Hibbert 1983, 861.

37. "The School of Giorgione," in Pater 1873, 114. The work was originally titled *Studies in the History of the Renaissance*. According to Pater, art is "always striving to be independent of the mere intelligence, to become a matter of pure perception, to get rid of its responsibilities to its subject or material; the ideal examples of poetry and painting being those in which the constituent elements of the composition are so welded together, that the material or subject no longer strikes the intellect only; nor the form, the eye or the ear only; but form and matter, in their union or identity, present one single effect to the 'imaginative reason.'…"

38. Baker 1998.

39. Until the recent reinstallation of the British collections at the Victoria and Albert Museum, the statue stood out markedly from other contemporaneous portrait marbles carved in a formal neoclassical style and shown in the sculpture court. Roubiliac also created a terra-cotta bust of Handel that was then carved in marble for King George III. Today, the bust can be seen at the Foundling Hospital, another early venue for the exhibition of new British art in London, promoted by Hogarth. Handel, like Hogarth, was a governor of the Foundling Hospital, and thus in a position to advocate for the arts.

40. The banyan can also be seen in eighteenth-century portraits contemporary with the statue of Handel. Ribeiro 1995, 103–15.

41. *Daily Post*, 18 April 1738, attributed to John Lockman, Tyers's regular publicist. Cited in Solkin 1993, 113.

42. The piece was first performed in Covent Garden Theatre, London, on 18 February 1743. The words, "Let the bright seraphim in burning row their loud uplifted angel trumpets blow, let the cherubic host in tuneful choirs touch their immortal harps with golden wires," are adapted from John Milton's "At a Solemn Musick" (1633–34). *Sampson* also includes other borrowings from Milton. For complete text, see HWV, no. 57.

43. Critics used musical terminology to describe Whistler's work before the artist took it up himself. Goebel cites numerous examples, as Paul Mantz on "la symphonie du blanc" in Mantz 1863, 60–61. Goebel adds, "Ironically, what would become one of the most frustrating aspects for critics of Whistler's paintings (the titles) was probably suggested by their early reviews of his works." Goebel 1988, 1:165–66. See also Goebel 1999.

44. Solkin 1993, 120. For discussion of the

commercial masquerades of the 1720s
and 1730s, see Castle 1986. Clearly,
masquerades in "typical" paintings of
modern life, such as Manet's *Masked
Ball at the Opera* (1873), have their
eighteenth-century predecessors.

45. Solkin 1993, 147–48. For a list of the
supper-box paintings designed by
Hayman and others, and executed by
Hayman and his assistants in the early
1740s, see Allen 1987, 180–82. He
lists forty-seven paintings. Fourteen
survive in various collections. Many of
the paintings were also engraved. See
also Allen 1986, 113–33.

46. Solkin 1993, 144.

47. Whistler stayed in Wapping in late
July and early October 1859 and again
in August 1860.

48. See Spencer 1982, 131–42. Spencer
notes, "Wapping is still ostensibly a
realist painting. Yet the equality of
tonal relationship between foreground
and background, and the busy formal
complexity of masts and rigging
traversing its surface has an air of
deliberate artifice which was only fully
pronounced in Whistler's 'Japanese'
pictures." Jonathan Ribner avers that
pollution played a role in the Victorian
sense of sin and the river. Studying
responses to a public health crisis in
London epitomized by the "Great
Stink" of 1858, the year before Whistler
moved to London, Ribner examines
examples of caricature, illustration,
and fine art that equate the polluted
river with moral crisis. The association
of the Thames with sin was reduced
after the completion of London's sewer
system. Ribner 2000.

49. So insalubrious, indeed, that Whistler
may have contracted rheumatic fever
there. See du Maurier 1951, 16, 53.

50. Solkin 1993, 143. This seamy topic may
have inspired Arnold Fischar's ballet,
The Wapping Landlady, which premiered
at Covent Garden on 27 April 1767.

51. Whistler, London, to Fantin-Latour,

Paris, ca. January–July 1861,
GUW 08042 [LC PWC, 1/33/02].

52. The Thames Tunnel was begun at
Rotherhithe in 1805. It finally opened
on 25 March 1843. By then, the *Times*
had begun to refer to this difficult piece
of engineering, made possible by Marc
Brunel's patented tunneling shield, as
"the Great Bore." Clayton 2000, 84–91.
See also Weinreb and Hibbert 1983,
884–85. Whistler's father had worked
for Czar Alexander, building Russia's
transcontinental railroad.

53. Whistler's related etching of *Rotherhithe*
(1860, K66) includes the dome of
St. Paul's Cathedral at the left edge.
Whistler himself referred to the back-
ground of the oil, *Wapping*, as being
"like an etching" in an undated letter
to Fantin-Latour, GUW 08042. For
discussion and map of the river, see
Lochnan 1984, 116–20 and fig. 146.
Painting and etching do not depict
the same view. The detail of St. Paul's,
while not in the painting, does help
indicate the etching's location.
However, Whistler did not reverse the
image when working on his copper-
plate, so the printed etching shows the
topography backwards. Whistler's
brand of realism comfortably encom-
passed confused topographical orienta-
tions; the artist also changed titles.
Shown at the Royal Academy as
Rotherhithe in 1862, the print was pub-
lished in the *Thames Set* as *Wapping*.
This little testament to the fluidity of
Whistler's titles can be found through-
out his oeuvre, in all mediums. In
Venice Whistler again etched what he
saw directly onto the plate without
reversing the image, and he did not
reverse his plates. Titles sometimes
refer to the spot from which the etching
was made and sometimes to the place
toward which the eye looks in the
finished image.

54. For more on the London docks, see
Weinreb and Hibbert 1983, 235–37

and 692–93. The Royal Docks lie east
of Bow Creek on the Plaistow Marshes.

55. Personal issues (such as Jo's dislike of
Legros) might also have had a bearing;
see Dorment 1994, 103–4.

56. Tom Taylor, *The* (London) *Times*, 5 May
1864. The picture was sold to Thomas
Winans, Baltimore, 1864. YMSM 35.

57. Nead 2000, 6. She goes on to identify
recent theoretical accounts that
consider the ambiguities of modernity
as well as its engagement with both
past and present.

58. The musical genre was set in 1528
with Clement Janequin's chanson,
La Guerre.

59. For discussion see Curry 1984, 84–85.
When Whistler was in attendance at
Cremorne, the principal pyrotechnist
was J. Wells: "As the night advances,
the Firework Temple receives its
votaries, and Mr. J. Wells, in a succes-
sion of dazzling devices, vindicates his
claim to a foremost place among
pyrotechnic artists." *Daily Telegraph*,
28 July 1875, CPL scrapbook 2:97.

60. For a provocative study of modern
lighting and its impact on painting, see
Blühm and Lippincott 2000. See also
"Gas and Light," Nead 2000, 83–148.

61. At Cremorne, the Grand Pagoda
Orchestra, or Chinese Platform, had
opened in May 1847, "ornamented
in the most profuse and gorgeous
manner... surrounded by a vast
circular platform, intended to be
used as [an] al fresco Salle de Dance
...capable...of affording full space for
the mazy movements of 4,000 dancers
at the same time." See "Entertainments
during Whitsun Week" (May 1847),
newspaper clipping, CPL scrapbook,
SR 130:15. The year before Whistler
took up residence nearby, an admiring
journalist described improvements to
the Chinese Platform's "inclosing iron-
work...enriched, by Defries and Son,
with devices in emerald and garnet
cut-glass drops, and semicircles of

lustres and gas jets, which have a most brilliant effect." The pavilion was about 360 feet in circumference, encrusted with ornamental iron pillars, gas jets, and more than forty plate-glass mirrors in black frames. High above the dancers sat the Grand Pagoda Orchestra, their musical scores illuminated by seventeen gaslit chandeliers. See *Illustrated London News*, 30 May 1857, 516.

62. Taine 1870, 36–37, discussed in Dorment 1994, 134. Whistler was long gone from the halls of the École des Beaux-Arts by the time Taine replaced Viollet-le-Duc in teaching art history and aesthetics in 1864. Taine tempered his explanations of artistic genius with discussions of various contexts (racial, geographical, social, and historic), an approach Whistler would not have found sympathetic.

63. Addison 1712, 3:438–39.

64. Acton, *Prostitution* (1870), cited in Nead 2000, 130.

65. The term "quadrille" descends from opposed ranks of knights forming a square in a tournament. A popular eighteenth-century card game of the same name provided a subject for one of the Vauxhall supper-box paintings, *The Game of Quadrille* (Birmingham, City Art Gallery, ca. 1742–41). See Allen 1987, 180. Whether applied to a tournament, a game of cards, or a flirtatious dance, the term retains the sense of contesting wills.

66. Nead 2000, 127–28.

67. The introduction of the upright piano in about 1827 helped build the middle-class market for quadrilles, polkas, mazurkas, and waltzes published as sheet music with colorful lithographed covers. While the buyers of sheet music did not usually frequent music halls, "the publication of the songs performed there made a rather risqué form of entertainment available to a much more 'respectable' audience." Haill 1981, 5.

68. Wolff 1985, 37 ff.

69. Baudelaire 1964, 7. Baudelaire borrowed the concept from Poe, and he also used it for his poem "To a Passerby." The building in Whistler's painting could be either the old hotel at Cremorne or Ashburnham Hall.

70. Poe 1840. "The Man of the Crowd" was later included in *The Works of the Late Edgar Allan Poe*, 1850. Poe begins his tale with the dark thought that "there are some secrets which do not permit themselves to be told." The protagonist conducts his entire pursuit through the most noxious parts of the city in heavy fog and rain, lit only by "glaring gas lamps."

71. This image of prostitutes and prospective clients, originally titled "Derby Day at Cremorne, Keeping It Up," later slipped into twentieth-century American family rooms as an unidentified introductory graphic for the television program *Cheers*.

72. Dorment 1994, 135 and fig. 66. Whistler could have seen this Gainsborough painting when it was exhibited in 1876 at the Royal Academy.

73. Weinreb and Hibbert 1983, 738–39.

74. "Streets and Obscenity," Nead 2000, 149 ff.

75. British design reformers sought principles on which to base improved commercial design, positioning Queen Victoria's empire to capture international markets. These efforts resulted in the advent of the professional designer. For an interesting study of tastemaking, see Gagnier 1986.

76. Aslin 1969, 13.

77. Ibid. Lionel Lambourne summarizes the history of aesthetics as a modern discipline beginning in the mid-eighteenth century in Lambourne 1996, 10. Citing Aristotle and Plato, he recalls that "Aesthetics is the name given since classical times to the study of the nature of the beautiful, and the theories which have evolved defining

what is meant by the word beauty."

78. See Burke 1987, 19.

79. See Burke, "Painters and Sculptors in an Aesthetic Age," in Burke 1987, 295–339. See also O'Leary 1999. Varied responses to Aestheticism developed over five decades bridging the turn of the nineteenth century. Broad eclecticism embraced sources from ancient Greece, the Italian Renaissance, the Islamic world, medieval Europe, the Far East, and colonial America. Distance—whether in time or place—was essential. The primary concern, seen in both interior decoration and painting, was to create sensitive arrangements of objects in space. This issue proved to have lasting implications for the public display of art.

80. Adams 1984, 12. For a related still life (*Vase of Flowers*, 1864), La Farge painted a Japanese brush pot on a panel that was first gilded.

81. Rossetti 1865. During the 1860s Whistler practiced *japonerie*—Western artists painting Japanese objects as props. But he rapidly became a true *japoniste*, incorporating Asian design principles such as flattening, tertiary color, and bold asymmetric patterning into his own work. Monet was slower to do so, as his image of Madame Monet in a Kimono (*La Japonaise*; also known as *La Japonerie*, 1876) attests.

82. "Any result not absolutely masterly is ignominious failure. Very few persons care for them even artistically, fewer still comprehend them as paintings, while to the callous world at large they become ridiculous." Jarves 1879, 10. For further comments on the arts see Jarves 1864.

83. Whistler considered the Swinburne poem "a rare and graceful tribute from the poet to the painter." Whistler to Editor, *The Morning Post*, 3 August 1902, GUW 09458. For the entire poem, see Swinburne 1866.

84. The Chinese began coming to

California in 1848 and were well received at first, but by the late 1850s race relations were tense, deteriorating almost completely after construction of the transcontinental railroad, in which Chinese immigrant labor played a crucial role. In 1878, President Hayes negotiated a new treaty with China, limiting Chinese immigration. After further pressure, the 1882 Chinese Exclusion Act was passed under President Arthur, who had redecorated parts of the White House in the aesthetic taste. See "The Chinese Issue," in Baydo 1981, 330–32.

85. Lecturing at the Metropolitan Museum in 1893, John La Farge told his students, "you will always give to nature—that is to say; what is outside of you—the character of the lens through which you see it—which is yourself." La Farge 1895, 74–75. Similarly, Walter Pater wrote, "At first sight experience seems to bury us under a flood of external objects, pressing upon us with a sharp and importunate reality" but "when reflexion begins to play upon those objects…the whole scope of observation is dwarfed into the narrow chamber of the individual mind." See "Conclusion" to Pater 1873, 195–96. Fearing that his assertion "Not the fruit of experience, but experience itself, is the end" might "possibly mislead some of those young men into whose hands it might fall," Pater left this section out of the second edition of his book.

86. Zola, "Proudon et Courbet," reprinted in *Mes Haines: causeries littéraires et artistiques* (1879), Geneva 1979, 30. Cartoonists found that aesthetes offered fertile ground. Du Maurier cartoons are particularly telling as he had been a close associate of Whistler in Paris and London. For examples, see Kelly 1996. Du Maurier's take on the attitudes and foibles of the Aesthetic movement reached an American

audience through a novel he illustrated: see Lillie 1882.

87. Siewart 1996, 93–108.

88. Eisenman 1986, 51–59.

89. Monet cited in House 1986, 162. Whistler said of *Nocturne: Blue and Gold—Old Battersea Bridge*, "I did not intend to paint a portrait of the bridge, but only a painting of a moonlight scene. As to what the picture represents, that depends upon who looks at it." Of the *Nocturne in Black and Gold: The Falling Rocket*, the controversial painting that triggered the lawsuit, he told Ruskin's defense attorney, "If it were called 'A View of Cremorne' it would certainly bring about nothing but disappointment on the part of the beholders. It is an artistic arrangement." Whistler cited in Merrill 1992, 145–48, 150–51.

90. Baudelaire 1964, 12.

91. See "The Salon of 1845," Baudelaire 1965, 31–32.

92. Jones 1856. *The Grammar of Ornament* was a tour de force of color printing during the nineteenth century. The original folio book went through many editions in quarto format. Friedman 1978, 53–54. Christopher Dresser was not only Jones's apprentice but also a trained botanist. He was born in 1834, the same year as Whistler and William Morris.

93. Nochlin 1971, 236–37. Applying the theories expressed by La Farge, Pater, and others, Nochlin writes, "Probably the most interesting, and significant, of all…split-offs or transformations of Realist values, as far as the painting of the future was concerned, was the transformation of the Realist concept of truth or honesty, meaning truth or honesty to one's perception of the external physical or social world, to mean truth or honesty either to the nature of the material—i.e., to the nature of the flat surface—and/or to the demands of one's inner 'subjective'

feelings or imagination rather than to some external reality." She adds, "Truth to the nature of the materials was achieved at least theoretically first in England, in the realm of the decorative arts, where the role of subject and imitation of nature could more easily be played down than in the traditionally representational 'high' arts of painting and sculpture."

94. Jones 1867, pl. 92, "From a painted china Vase. A bold composition on the continuous-stem principle."

95. Herbert 1984, 162–69. See also Levine 1977, 136–39.

96. For encaustic floor tiles by John Pollard Seddon, see Cooper 1987, 184. The de Morgan tiles are illustrated in Aslin 1969, 31. Recent general studies include Graves 2002; and Herbert and Huggins 1995.

97. Whistler to George Lucas, 18 January 1873, GUW 09182. Ward 1991 makes it clear that French Impressionists had similar ideas.

98. The very placement of Whistler's stylized monograms on certain frames was done for decorative balance. Whistler recalled of the original frame for *The Falling Rocket*, "The black monogram on the frame was placed in its position with reference to the proper decorative balance of the whole." See Whistler 1892, 9. The last frame Whistler decorated, for *Harmony in Blue and Gold: The Little Blue Girl* (1894–1903, Freer Gallery of Art), was signed, but the painting was not. By making them a carefully integrated pair, Whistler created the potential loss of market value were someone to remove the picture from its surround.

99. See, for example, John Ruskin's "Capitals: Convex Group," in Quill 2000, 68.

100. *The Art Journal* (1867), quoted in Cooper 1987, 98.

101. This type of glass, first seen in Venice in the fifteenth century, incorporates

metallic fragments to imitate aventurine quartz. However, the vase is shaped to resemble a classical kantharos. It is part of a group of modern Venetian glass donated to the Metropolitan Museum in 1881 by James Jackson Jarves, author of *The Art-Idea*. For aventurine, see Battie and Cottle 1991, 196.

102. While Morris wallpapers are characterized by overall patterning, the more conventional commercial papers by Bruce Talbert and Christopher Dresser confine their floral elements in architectural zones: dado, central wall panel, and frieze.

103. Gibson 1893, 226.

104. Duret's advocacy of the Impressionist artists is well known. The French critic promoted what are now commonly accepted "truths" of Impressionism — the juxtaposition of bright primary and secondary colors, as well as the spontaneous rendering of fugitive aspects of nature in the open air. What is less often discussed is how Duret's attitudes toward the development of Impressionism rested on his personal understanding of Japanese art. As he had traveled to Japan in the early 1870s, his voice carried great weight when most Westerners, including Whistler, were dependent on shops in London and Paris or world's fairs for access to Japanese art. Whistler painted Duret's portrait (1883–84, Metropolitan Museum of Art, New York) using the same japanesque color scheme seen in *Variations in Pink and Grey: Chelsea*.

105. Shegami Inaga notes, "The blue which characterizes many *ukiyo-e* prints of the first half of the nineteenth century by Hokusai, Hiroshige, Kuniyoshi, Kunitora and others was a newly imported Western chemical pigment, Prussian blue. The vogue of *bero-ai* (Berliner indigo) was to be followed in the 1870s, at the time of Duret's visit to Japan, by the vogue for the crude

aniline red that was called *beni-guri*, 'analin mania.' What Duret took to be typical Japanese colour was in fact a manifestation of Japanese interest in imported colours and of the insatiable Japanese curiosity about the West that characterized this period of its history." See Inaga 2001, 67–68. See also Smith 2003 and Hickey 1998, 40–46.

106. Weir was an avid collector of Japanese prints, and the painting may well have been partially inspired by one in his possession.

107. A substantial holding of these pieces can be seen in the Hunterian Art Gallery, Glasgow University. The London firm of Robert Dicker engraved the butterflies.

108. For color images of reproduction chairs now at Giverny, see Joyes 1989, 62–63. For a Rossetti armchair, see Parry 1996, 176, no. J. 24.

109. "List I: Oriental Ceramics, Descriptions of Object, purchase date, voucher number, and cost. Marginal notes on disposition," typed ms, FGA, 19, entry 93. For further information see Brunk 1981; Fahlman 1980; and Curry 1984, 11–33.

110. Frelinghuysen et al. 1993. See particularly Julia Meech, "The Other Havemeyer Passion: Collecting Asian Art," 129–50; and Frelinghuysen, "The Havemeyer House," 173–98.

111. See David Waterhouse, "Japan. XXI Collection and Display," in Turner 1996, 17: 427–32.

112. In this case, Cassatt's second cousin Mrs. Riddle had given the china to the artist, who painted the portrait in return. Barter et al. 127, 157, 338.

113. O'Leary 1996, 250–54.

114. Conforti 1997, 23–48.

115. Dresser's design, "Knowledge Is Power" from *The Art of Decorative Design* (1862, pl. XXIV), reproduced Fine Art Society 1972, cover. Dresser plucked the quote from *Religious Meditations of Heresies* written by Francis Bacon

some three hundred years earlier.

116. Synthesis was not exclusive to American painters. Starting in the late 1880s Gauguin formulated a synthesis of realism, personal subjectivity, and aestheticism that he called "synthésisme." Rathbone and Shackelford 2001, 170.

Chapter 6:
PUNCH AND JIMMY

1. Rossetti 1867, 210.

2. Whistler to Leyland, November 1872, GUW 08794 [LC PWC 6B/21/03]. Italics are Whistler's.

3. Charles K. Moss, "John Field: The Irish Romantic," www.classicalmus.hispeed.com. Moss includes a list of Field's nocturnes published in Saint Petersburg, Moscow, Vienna, Leipzig, Berlin, Paris, and London between 1812 and 1832. Field (1782–1837) performed in London and Manchester in 1831–32.

4. Goebel 1988, 1:165–66.

5. The first number appeared on 17 July 1841. Spielmann 1895. The magazine's subtitle — "The London Charivari" — allies it with *Charivari*, a French periodical filled with socially and politically driven cartoons. Henry Mayhew, author of *London Labour and the London Poor* (1851 ff.), edited *Punch* in 1841 and 1842, a reminder of parallel urban concerns in England and France. Whistler's Parisian friendship with George du Maurier, who became a leading illustrator for *Punch*, had much to do with the depth of coverage he later received in the magazine.

6. Whistler chose a self-consciously artistic tondo (circular format) for this garret image. A book labeled "Fuseli" on the floor suggests his early romantic leanings. This and a related drawing, *A Scene from Bohemian Life* (1855–57, Chicago Art Institute), are reproduced and discussed in Curry 1984, pl. 147;

for artistic bohemianism, see Abéles 1986.

7. Murger 1851, 302.

8. Donald 1996.

9. High-profile public schemes of decoration available for Whistler's notice included the "Peacock Frieze" (1866), painted on Minton tiles by Edward John Poynter for the Grill Room at the Victoria and Albert Museum. Reproduced in Lambourne 1999, pl. 45.

10. These satires against women go as far back as the caustic Roman poet Juvenal, who was as fierce on the institution of marriage (Sixth *Satire*) as he was on new money rising in society (First *Satire*). Kimball 2003, 4–8.

11. Foreman 1998, chapters 5–9. See also "Dangerous Excrescences: Wigs, Hair and Masculinity," in Pointon 1993, 107–40.

12. Clumsy parodies of Whistler's work include "Whistler's Wenice; or Pastels by Pastelthwaite," *Punch*, vol. 80 (12 February 1881), 69, which invoked Dickens to tell readers, "Mr. Whistler is the artful Dodger of Venice." In "The G. G. G., or Grosvenor Gallery Guide," *Punch*, vol. 80 (25 June 1881): 300, his portrait of Cicely Alexander was likened to an "Advertisement Picture" while an oft-quoted line from *Endymion* (1818) by John Keats morphed into "A Thing of Beauty is a Jay for ever!" A portrait of Maud appears in "Grosvenor Gems," *Punch*, vol. 82 (20 May 1882): 240, as "No. 127. 'Keep it Dark; or, The Ghost in the Haunted Coalhole.' A Darkie Harmony by Whistler," emphasizing racial as well as artistic otherness. *The Yellow Buskin* appears in "The Grosvenor Gallery Guy'd," *Punch*, vol. 86 (24 May 1884): 244, as "No. 192. Scene in Underground Railway Station. Last train gone. 'Which way? This?' she inquired, indicating the direction with a movement of her head. 'Ah, then I must walk through the tunnel.' If an engine should come along, it's safe to give her a warning by becoming a (J. M'Neile) Whistle."

13. These were later thought to be an architectural series, an assumption Linda Merrill sets aside in favor of poetic links to Edward Burne-Jones's unrealized scheme of illustrations for *The Earthly Paradise* (1868–70) by William Morris. See Merrill 1998, 94–97.

14. *Punch*, vol. 67 (28 November 1874): 226. For exhibition history see YMSM 86. Once Whistler's fellow art student in Paris, du Maurier proved a perceptive cartoonist when it came to Whistler's work. Du Maurier's are the most telling of the lampoons of the Aesthetic movement. They were so telling that Walter Hamilton denounced them in the first written history of the movement. See "Punch's Attacks on the Aesthetes," Hamilton 1882, 82–94.

15. "Such titles strange for Fashion's range/ Of tints we're forced to find,/ Since but of late, as sages state,/ The world was colour blind. / So when at last, with pigments fast / And palette on her thumb, High Art arrives to charm our lives, / she finds us— colour-dumb!" "A Theory Illustrated," *Punch*, vol. 80 (7 May 1881): 209.

16. Whistler was not in Russia until after John Field's death, but he certainly would have heard Field's music, including his nocturnes, which were extremely popular in the upper-class parlors of Saint Petersburg.

17. "Musical Egotism," *Punch*, vol. 73 (28 April 1877): 183.

18. See these *Punch* cartoons: "Present Company Always Excepted," vol. 68 (13 March 1875): 112; "Music At Home," vol. 74 (26 January 1878): 30; "Annals of a Musical Neighbourhood," vol. 74 (22 June 1878): 282; and "Two Thrones," vol. 76 (7 June 1879).

19. Revisionist publications challenging accepted systems of knowledge are discussed in MacLeod 1996, 267–68.

20. "A Whistle for Whistler," *Punch*, vol. 60 (17 June 1871): 245. Numerous cartoons on the fluidity of class lines indicate alarm. Du Maurier's "What we may look forward to, now that the aristocracy is taking to trade" shows Lord Plantagenet, now a grocery store clerk, filling a "fair customer's" order of sugar, soap, and pickles. Asking if he can do anything else, Plantagenet hears, "Er— well-a—I hear your sister-in-law, the duchess of Pentonville, is going to give a garden party at Fulham. Er—would it be asking too much if I were to beg of her grace, through you, the favour of an invitation for myself and my two daughters?" The lord-cum-clerk replies, "It shall be seen to, Madam!" *Punch*, vol. 80 (15 January 1881): 156.

21. The journalist writes, "Before Seymour Haden was Whistler, his brother-in-law, and etching master," adding that Whistler's portfolio "beat everything of the kind that has been turned out since Rembrandt." He advised, "Let all lovers of good art and marvelous etching who want to know what Father Thames was like before he took to having his bed made, invest in Whistler's portfolio. We will answer for it, that—dear as it may be, those who buy it won't say they've paid too dear for their Whistler." See "Whistle for Whistler," *Punch*, vol. 60 (17 June 1871): 245. On the same page Linley Samborne rendered a cartoon of a woman's costume made of huge butterflies, clearly a joking reference to Whistler's evolving butterfly signature. Samborne repeated the joke that fall, using a butterfly for the "Neat thing in collars, Designed for the Gent of the Period." The gent wears a monocle such as Whistler himself affected. See *Punch*, vol. 61 (30 September 1871): 133. These references help establish the ways in which Whistler was associated with fashionable excess.

22. J. M. Whistler to George Whistler, 7 October 1863, GUW 06677 [GUL W671].

23. The *Mother* was exhibited at the Royal Academy, 1872, no. 941, and at Durand-Ruel, Paris, 1873. It was featured in Whistler's first one-man show, London, Pall-Mall, 1874, no. 4.

24. Whistler was elected president of the society in June 1886. His decorative changes were accompanied by auto-cratic reforms, including his demand that any member of the SBA resign all affiliations with other artists' asso-ciations. Instead, Whistler himself resigned from the society in June 1888, followed by a number of painters sympathetic to his aims. Whistler noted tartly, "The 'Artists' have come out, and the 'British' remain."

25. Geneviève Lacambre links the *Mother* and the statue; see Dorment 1994, 141. Whistler owned several photo-graphs of Tanagra figures.

26. Birket Foster chose these chairs for "The Hill" at Witley in 1866; the Hall of Newham College and the Fitzwilliam Museum used them at Cambridge. See Gere and Whiteway 1994, 101, pl. III. Such chairs often can be spotted in artistic interiors, for example, Vita Sackville-West's tower writing room at Sissinghurst.

27. Parry 1996, 160. She quotes Prof. John William Mackail, whose *Life of William Morris* was published in London and New York in 1899. Parry suggests that the name, rather than the design, stems from the discovery of a proto-type in Sussex. Ibid., 168. The chairs were copied by Liberty and Heals, among others. The Regency prototype was probably painted, with the frame imitating bamboo. Jervis 1974, 99.

28. The "Sussex" chair, with its humble vernacular roots, still functioned as an icon of modernity into the twentieth century. For a sitting room illustrated in the *Studio* in 1905, W. J. Neatby combined aggressively bold striped fabrics, a four-square sofa, and a table with a "Sussex" armchair. Reproduced in Cooper 1987, 224, no. 601.

29. "Moore Modernised. For the Use of Contemporary Society. Song for a High-Art Hostess," *Punch*, vol. 80 (16 April 1881): 177.

30. In dissecting this cartoon, Linda Merrill names *The Princess of the Porcelain Country* as a probable visual source and also explores du Maurier's somewhat bitter feelings about being excluded from Whistler's artistic circle. Merrill 1998, 53–56. The composition of *Lange Leizen* is subsumed into another cartoon, "Acute Chinamania" from *Punch Almanack*, 1875, reproduced in Lambourne 1996, 116, as well as "What it has come to," discussed in this essay.

31. Du Maurier preceded "The Six-mark Tea-pot," perhaps the quintessential Aesthetic movement cartoon, with another, less subtle image showing a seated woman holding a teapot as if it were a baby. Her husband hovers over her crossly, saying, "I think you might let me nurse that teapot a little *now*, Margery! You've had it to yourself all the *morning*, you know!" See "The Passion for Old China," *Punch*, vol. 66 (2 May 1874): 189. In du Maurier's "Aptly Quoted from the Advertisement Column," a man comes home with two enormous blue-and-white vases under his arms, only to confront his two chil-dren (smaller than the vases) and his wife on the stairs. The "thrifty wife" exclaims, "Oh, Algernon! *More* useless china! *More* money thrown away when we have so little to spare!" Her "amiable chinamaniac" husband responds, "Pooh! Pooh! My love! 'Money not so much an object as a *comfortable home*,' you know!" The title of the cartoon and the use of italics suggest that Algernon is parroting copy from a commercial blandishment. *Punch*, vol. 73 (15 Dec-ember 1877): 270.

32. "High Art Below Stairs," *Punch*, vol. 80 (16 April 1881): 177. Writers such as Matthew Arnold and Oscar Wilde applied the term "philistine" to those indifferent to aesthetics. The word's archaic use—someone like a bailiff or a critic who was regarded as a natural or traditional enemy because he belonged to a despised class—survives in the snobbish application of the term chiefly to members of the middle class in Victorian England, although many who used it were themselves middle class.

33. Some of these are quite blunt. For example, "A New Rung in the Social Ladder," *Punch*, vol. 86 (12 January 1884): 18, recounts how "Todeson takes to 'Slumming,' and comes across Lady Clara Robinson (née Vere de Vere) …in a Frightful den near Bethnal Green. Oh Joy! She actually invites him to dine with Sir Peter and herself in Grosvenor Square! But, Alas! Instead of rank and fashion, it is only to meet an East End curate and his wife, devoted to the poor;—and Miss Fullalove (the matron of Lady Clara's Home for Juvenile Thieves in Bermondsey), whom he has to lead in to dinner, and who persists in mis-taking him for one of those reclaimed specimens of the 'lower middle class criminal' her ladyship is so fond of being kind to! Todson thinks that 'slumming' doesn't pay, after all!" See also "Mrs. Ponsonby de Tomkyns is moved to speak her mind," *Punch*, vol. 86 (12 April 1884): 174. Lady Clara is "*so* tired of my own dull, stupid set, who can think and talk of nothing but politics and sport," while Mrs. Ponsonby de Tomkyns ("whose Duchesses have been falling off lately, in spite of an entirely new set of Lions") notes, "My *dear* Lady Clara, if you only knew how tired I get of genius, and fame, and originality, and how much I pine for the—er—the repose that stamps the

caste of Vere de Vere! Couldn't we manage an *Exchange?*" Lady Clara "conceives the happy thought of combining the two." Neither cartoon is signed.

34. Lynes et al. 2002.

35. See "The Home," in Weinberg et al. 1994, 247–67, 286–309.

36. Robertson 1990. See also Fischer 2000 and Burns 1995. For an early study, see Douglas 1977.

37. Du Maurier spins the same joke with "Postlethwaite on 'Refraction.'" Invited to come take a swim, the aesthete replies, "Thanks, no. I never bathe. I always see myself so dreadfully fore-shortened in the water, you know!" *Punch*, vol. 80 (15 January 1881): 14.

38. "Athlete and Aesthete," *Punch*, vol. 80 (19 March 1881): 122.

39. See du Maurier, "An Aesthetic Midday Meal," *Punch*, vol. 79 (17 July 1880): 23. "At the luncheon hour, Jellaby Postlethwaite enters a Pastrycook's and calls for a glass of Water, into which he puts a freshly-cut Lily, and loses himself in contemplation thereof."

40. Du Maurier, "Nincompoopiana — the Mutual Admiration Society," *Punch*, vol. 78 (14 February 1880): 66.

41. The same heavy-jawed type serves as femme fatale in Rossetti's paintings. Numerous cartoons reveal fears about class change and the growing inde-pendence of women. In one, titled "Woman's Rights," these fears are distanced by the issue of whether the household cook or the lady's maid takes precedence among the servants at evening prayers. *Punch*, vol. 62 (31 June 1872): 223.

42. Du Maurier's cartoon is roughly coincident with Whistler's decision to employ the term "Nocturne" for his "Moonlights."

43. The rural counterpart to this urban cartoon is "At First Hand" by Charles Keene. A "Country Connoisseur" inquires whether the "Chromos" for

sale are "real" and is assured by a "Country Dealer (Draper and Grocer, etc.)" that they are: "Oh yes, Sir — we always has 'em direct from his studio, sir!" Neither buyer nor seller seems to know that "chromo" meant chromo-lithograph, a commercial reproductive print. *Punch*, vol. 76 (15 February 1879): 63.

44. Anti-Semitic attitudes were a factor in the London art market, in collecting circles, and in the fast-living court surrounding the Prince of Wales. For a study of the impact of anti-Semitism on the reception of work by a leading painter, see Kleeblatt 1999, especially Kathleen Adler's essay, "John Singer Sargent's Portraits of the Wertheimer Family," 21–33.

45. Du Maurier's "Among the Old Masters" shows an artist in a museum gallery copying a picture while a family looks on. Little Tommy says, "I suppose that when this nice, bright, clean, new picture is finished, that nasty dingy old one will be taken down, and this one put in its place!" *Punch*, vol. 67 (1 August 1874): 48.

46. Whistler 1885, 87–88.

47. British slang reinforces the distrust — "prigging" was slang for petty thieving. See Dennis Walder, introductory notes to Dickens 1839, 612, n. 9. Dickens used the term when describing his visit to Newgate Prison.

48. Similar ignorance of old master paint-ing is ridiculed when a "fashionable lady," told the date of a picture, avows, "I should have thought they could paint better than that, so late as the fifteenth century!" See du Maurier, "A Damper," *Punch*, vol. 71 (2 September 1876): 92.

49. "Our Academy Guide," *Punch*, vol. 84 (12 May 1883): 220. Inspired by legiti-mate criticism, select pictures from the Royal Academy annual exhibitions were parodied in facetious "gallery guides" starting in 1877. "The Pick of the Pictures; or, our own handy guide

to the Royal Academy" inaugurates the series. It begins, "The great and thoroughly-deserved success that attended Mr. Henry Blackburn's most useful *Academy Notes*, illustrated with sketches of the principal pictures in the exhibition, decided me, being of an original turn of mind, on publishing, weekly, during the present season, a Handy Guide to the Academy, of which stupendous mental effort this is the first outcome." *Punch*, vol. 73 (12 May 1877): 208. Similar columns parody the Grosvenor Gallery exhibitions after the enterprise opened in 1877. See, for example, "The Grosvenor Gallery Guy'd," *Punch*, vol. 86 (7 June 1884): 268. Whistler's work was sometimes included in these general lampoons.

50. Du Maurier, "The Philosophy of Criticism," *Punch*, vol. 78 (3 July 1880), 301. Similarly, in du Maurier, "The Power of Public Opinion," a young critic visits two studios. He tells an unknown artist that he will "black-guard" his work "so fearfully that lots of people will come forward, out of fair play, and swear it's the greatest work of genius this age has ever seen!" He takes the opposite tack with "Pictor Notus," an established artist who ques-tions his credentials: "If you dare talk in that way to me, sir, I'll be hanged if I don't publish it, as my earnest conviction, that your picture is the one supreme and crowning masterpiece of contemporary art!" The artist, "appalled by the threat," subsides. See *Punch*, vol. 76 (21 June 1879): 282.

51. In 1883, Manchester formally opened its City Art Gallery, featuring "a fine suite" of exhibition rooms. *The Year's Art* reported, "The experiment of a 3d. admission has had the effect of filling the galleries to overflowing. The Annual Exhibition of Oil and Water-colour Paintings is held from August until the end of December: 1,166 works were hung in the sixty-fifth Exhibition

in 1885, which has been the most successful one ever held in this City.... During the first 13 weeks the entrances amounted to £1,745, compared with £1,434, the highest in any previous year; and the sales to £8,096, against £6,100 at any previous Exhibition. The galleries are now lighted by electricity." See *Year's Art for 1885* (1886), 77.

52. Charles Keene, "Art in the Midlands," *Punch*, vol. 85 (22 September 1883): 135.

53. In Charles Keene, "'A Thing of Beauty,' &c." a young man "with aesthetic tastes who has decorated his rooms 'secundum artem'" requests his uncle's opinion of the new carpet. His "commercial" uncle, who "regards Art from another point of view," says "Um! —Ah! Three-plie Axminster, ain't it?" *Punch*, vol. 61 (7 October 1871): 151.

54. W. R. "At the Academy," *Punch*, vol. 60 (10 June 1871): 241. The same topic was treated as fine art by Tissot in *Too Early* (1873), reproduced in Wood 1986, 67.

55. In a similar vein, a "fascinating but frivolous Fair One" tells her hostess, "What a pity your husband doesn't have plate-glass put on his picture, as some people do!" The hostess replies, "You think it makes the pictures richer in tone?" The frivolous response, "I don't know about that, but one can see one's self in them, at least!" Du Maurier, "A Great Disideratum," *Punch*, vol. 73 (24 February 1877): 84.

56. "The Action," Whistler 1892, 5: "The labour of two days, then, is that for which you ask two hundred guineas!" "No; — I ask it for the knowledge of a lifetime."

57. In the days of crammed floor-to-ceiling exhibitions, favored works were hung at eye level, "on the line," where it was easy for visitors to see them.

58. See also Charles Keene, "Triumph!" *Punch*, vol. 78 (22 May 1880): 237. An ecstatic frame maker exults, "By Jove! Jemima—every one of 'em on the Line

again." The message is that the framer was more important than painter.

59. For examples, see Simon 1996.

60. "Fine Arts: Royal Academy," *The Athenaeum* (23 May 1863): 688. The picture in question was *The Last of Old Westminster Bridge* (1862, Museum of Fine Arts, Boston).

61. For a related French cartoon, see "At the Salon: A Painter whose work has been badly placed installs a telescope," *Le Charivari*, 23 May 1880.

62. Stock responses to picturesque views and gothic horrors provide much amusement in Austen 1818.

63. Du Maurier, "The 'Round of the Studios,'" *Punch*, vol. 60 (8 April 1871): 144. Similarly, du Maurier's "Refined Aesthetic Exquisite" in evening dress looks down through his monocle at a young woman who asks, "Been to the Old Masters, Mr. Millefleurs?" He replies, "A—no—a—I—a—go in for High art, you know!" The cartoonist comforts the reader with this aside: "What does he mean? We don't know, no more does she, no more does he. Nobody knows!" *Punch*, vol. 74 (16 March 1878): 118.

64. "Picture Sunday," *Punch*, vol. 64 (29 March 1873): 135.

65. The same charge of ignorance is applied to nobility when Lord Isador's picture — "just a little incident in modern life, Duchess! A young lady, you know, walking into a painter's studio, and dumb-struck at the sight of the lay figure" (artist's wooden model)—mystifies the Duchess. She enthuses, "Charming! So Natural!" before confessing that she can't tell which is the live model and which the articulated dummy clad in a dress. See "Distinguished Amateurs.— The Painter Again," *Punch*, vol. 84 (24 March 1883): 138.

66. Whistler to *New York Tribune*, 12 September 1880, reprinted as "The Fate of an Anecdote," in Whistler 1892, 81–84. Whistler enjoyed further mileage over

this little imbroglio when Hamerton foolishly rose to the bait and complained to the newspaper of "Mr. Whistler's studied discourtesy in calling me 'a Mr. Hamerton.'" This was reprinted as "Conviction," in Whistler 1892, 88–89.

67. Charles Keene, "Oil and Water," *Punch*, vol. 58 (7 May 1870): 179.

68. Du Maurier, "Happy Thought— Division of Labour," *Punch*, vol. 62 (22 June 1872): 253.

69. Listing for Prinsep at the Royal Academy, 1873, in Graves 1906, 3:206.

70. Matthew 8:28–34; Mark 5:1–20, Luke 8:26–39.

71. Prinsep studied at Gleyre's atelier in Paris at the time Whistler and du Maurier were there. He later married Florence Leyland, the daughter of Whistler's first major patron, Frederick Richards Leyland.

72. "Study for the Academy," *Punch*, vol. 68 (27 January 1875): 33.

73. For examples, see Mitchell and Roberts 1996. Nahl's *Sunday Morning in the Mines* is in the Crocker Art Museum, Sacramento, California.

74. Curry 1984, 66–67.

75. When he was painting it, Whistler called it *La Japonaise*. It was exhibited at the Paris Salon (1865, no. 2220) as *La Princesse du Pays de la Porcelaine*. Like other works in Whistler's oeuvre, it acquired further aesthetic descriptors, subject to change and to errors in French grammar. Shown at the International Exhibition in London (1872, no. 261), it was *The Princess, Variations in Flesh Colour and Blue*. Leyland lent it to Brighton (1875, no. 156) where it was called *Arrangement in Flesh Colour and Grey—La Princesse des pays de la Porcelain*. At the Society of Portrait Painters, London (1892, no. 113), it was *Harmony in Flesh-Colour and Grey, La Princesse des Pays de la Porcelain (Portrait de Miss S…)*. It appeared again in London at the International Society of Sculptors, Painters and Gravers

(1898, no. 180) as *Rose and Silver: La Princesse du Pays de la Porcelaine*, under which title it was finally sold to Freer in 1903. YMSM 50.

76. Foord & Dickinson, a firm Whistler had used since the 1860s, made and gilded the frame before Whistler painted it. Thomas Eakins later housed *The Concert Singer* (1892) in a chestnut frame incised with the opening bars of Mendelssohn's *Rest in the Lord*. Reproduced in Smeaton 2000, 66.

77. Merrill 1998, 142–43. Merrill illustrates the surviving fragment, now known as *Girl with Cherry Blossom* (YMSM 90), on p. 144.

78. For Whistler's calculated insult of transferring this frame to *The Gold Scab*, see Merrill 1998, 287–91.

79. Because it was still in the "White House," the bankrupt painter's work was an asset subject to sale by auction. Apparently Leyland sued to keep it out of the house sale, but *The Gold Scab* did appear shortly thereafter in a Sotheby's sale of Whistler's paintings (February 1880), catalogued as "Satirical Painting of a Gentleman styled *The Creditor*." Ibid., 288.

80. Arthur Symons, a contemporary of Whistler, quoted in Pennell 1908, 184.

81. Such portraits chose a guise appropriate to the sitter's rank and occupation, then bent them to the subversive traditions of the satirical portrait print. Daumier, a caricaturist whose work the young Whistler copied, traded on this kind of social subversion with great success.

82. Shackelford and Holmes 1986, 76, no. 22. See also Levitine 1969, 69–77.

83. Rubinstein (1829–1894) had an international concert career rivaling Liszt's. Rubinstein's opera based on a Russian text, *Il Demonio*, or "The Demon," was brought out in Italian at Covent Garden on 21 June 1881. Blom 1968, VII:295–97. Rubinstein inspired the character Klesmer in George Eliot's

Daniel Deronda (1876). This character, who represents artistic freedom, is named after klezmer music, often played by eastern European instrumentalists at Jewish gatherings.

84. Eliot 1876, 103.

85. "Mr. James Whistler at Cheyne Walk," *The World: A Journal for Men and Women*, 22 May 1878, 4–5.

86. Whistler 1892, 334.

Chapter 7:
A LITTLE WHITE PAPER

1. *The World: A Journal for Men and Women*, 14 February 1885, in Thorpe 1994, 95.

2. Whistler's other significant theoretical texts include "The Red Rag" (May 1878) on his titles; "Propositions—No. 2" (May 1884) on what constitutes a finished picture; "Propositions" (April 1886) on etching; and "A Further Proposition" (July 1886) on flesh tone.

3. Presented on 20 February 1885, the lecture lasted just over an hour. For "white lock," see *Sportsman*; for London audience, see *Daily Telegraph*; for "coolness" see *Birmingham Weekly Post*; all cited in Thorpe 1994, 99, 96, 100.

4. Whistler 1885, 86. The original manuscript is in Glasgow: GUL W780.

5. Levy 1995, 13: "It was *natural* to ask for air and lightness and grace. This naturalness belonged to the rococo painters; they, like the rest of their century, were following Nature. But they were not imitating natural appearances. They invoked imagination…"

6. Whistler 1885, 93.

7. *Sportsman*, cited in Thorpe 1994, 99.

8. Whistler spoke at the University Art Society at Cambridge on 24 March 1885 and on 30 April 1885 at Oxford. The lecture was published in Whistler's characteristic brown-paper covers in 1885, then reprinted in 1888 with changes to text, punctuation, and

layout. That year Stéphane Mallarmé translated it for the *Revue Indépendante* (May 1888). Whistler even considered making an American lecture tour, as Oscar Wilde had done in 1882. See Spencer 1989, 212; Getscher and Marks 1986, 6–13; Thorpe 1994, 177–78.

9. "Mr. Whistler's Ten o'Clock," *Pall Mall Gazette*, 21 February 1885, in Wilde 1999, 948–49; and Swinburne 1888, 745–51. A proponent of dress reform, Wilde wailed, "O mea culpa" when wounded by Whistler's cross remark that "Costume is not dress. And the wearers of wardrobes may not be doctors of taste!" Whistler 1885, 91. Swinburne presumed himself among "those unfortunate 'outsiders' for whose judgment or whose 'meddling' Mr. Whistler has so imperial and Olympian a contempt." Whistler's caustic reply to Swinburne in *The World: A Journal for Men and Women*, 3 July 1888, was reprinted as "Et tu, Brute!," helping to polarize the issue of facture versus subject matter in Whistler's art. See Whistler 1892, 259.

10. Whistler 1885, 89.

11. This very expression comes from the ranking of London's trade guilds. The phrase "at sixes and sevens" started with a dispute over precedence between two of London's city livery companies, the Merchant Taylors and the Skinners. They quarreled over who came sixth and who came seventh. Schott 2002, 26.

12. T. R. Way, who sold the drawing to Freer in 1905, thought the subject was Niobe, the daughter of Tantalus. She was turned to stone while bewailing the loss of her children. See Curry 1984, 243.

13. Both Swinburne and Wilde reveal professional jealousy in their disparagement of this aspect of the "Ten o'Clock," but others were more detached. An anonymous critic for the *Saturday Review* lauded Whistler's

publication of his ideas, going so far as to suggest his maxims be printed in railway stations to reach a wider audience. But the journalist regretted that Whistler's commentary seemed to isolate him from his fellow man. "Mr. Whistler's Ten o'Clock," *The Saturday Review*, vol. 65 (26 May 1888): 621.

14. Whistler 1885, 86.

15. "A wise man has uttered a vain thing and filled his belly with the east wind," Whistler 1885, 82: paraphrase of the Book of Job 14:14. See also Loftie 1876. W. J. Loftie was serving as assistant chaplain at the Chapel Royal, Savoy, at the time of his *Plea*, part of a twelve-volume series called *Art at Home*. As much an antiquarian as a clergyman, Loftie had numerous publications to his credit.

16. Whistler 1885, 79, 92. Whistler denied that the artist was any more "the product of civilization than is the scientific truth asserted, dependent upon the wisdom of a period.—The assertion itself requires the *man* to make it—the truth was from the beginning" (Ibid., 92). Given this sensibility, perhaps he would be annoyed to discover that, after his death in 1903, his contribution offered a solid step in the progressive climb toward complete formal abstraction.

17. Similar language creeps into the manifesto-like preface Wilde wrote for the expanded version of *The Picture of Dorian Gray* (1891). Among the aphorisms indebted to Whistler's theories, Wilde wrote: "They are the elect to whom beautiful things mean only Beauty. There is no such thing as a moral or an immoral book." Wilde 1999, 17.

18. Whistler 1885, 80.

19. Loftie 1876, 48, 65.

20. Whistler 1885, 81.

21. Whistler was so anxious for the imprimatur of an official French government purchase of his *Mother* that he was willing to take less than the painting was worth. I am grateful to Pamela Robertson, Hunterian Art Gallery, for this insight.

22. Whistler 1885, 86. Original manuscript: GUL W780. Whistler here takes into account then-current design theory that called for wall elevations where tertiary colors were at floor level, on the dado; secondary colors were in the central panel; while the primary colors (in small amounts) were high up in the frieze and cornice.

23. An ekphrasis, or extended rhetorical description, showcases the author's skill with words but does not seek to leave a detailed factual account of the object described. Rather, ekphrasis tries to convey a visual impression and the emotional responses evoked by an artwork. For a recent study, see Heffernan 1993.

24. Shakespeare, *Henry V*, II, iii, 11, quoted in Whistler 1885, 8.

25. Men who inspired the character of Des Esseintes include Baudelaire, Barbey d'Aurevilly, Edmond de Goncourt, and Comte Robert de Montesquiou-Fézensac — the latter an aesthete whom Whistler met in the late 1880s and painted in 1891. For a recent study see Munhall 1995.

26. Huysmans 1884, 47. Like characters in *La Vie de Bohème* who discover the fiscal joys of conformity, Joris-Karl Huysmans moved through his sensualist exploration of aesthetically harmonized furnishings, food, clothes, books, art, and music—as detailed in *Against Nature*—only to convert to Catholicism and pursue the study of Chartres Cathedral. His return to the Catholic fold brought social recognition, and by 1900 he was president of the Académie Goncourt.

27. Moreau's watercolor *Apparition* was exhibited at the Salon of 1876 as well as at the Paris World's Fair in 1878. Mathieu 1977, 124–28.

28. White, in Huysmans 1884, xxiv–xxv. Elsewhere (p. ix) White notes that Huysmans was "associated (more closely in the public's mind than in actuality) with the project of Naturalist fiction," again echoing Whistler's early interests. Like Zola, Huysmans contributed to "Naturalism's vast mapping of the modern social universe" in works such as *Marthe* (1876), which was subtitled "Story of a Prostitute."

29. According to White (Huysmans 1884, ix), Huysmans described Des Esseintes to Mallarmé (27 October 1882); Whistler's letter rejecting Courbet was sent in September [1867?], GUW 08045 [LC PWC 1/33/25].

30. David Scott, "Goncourt, de," in Turner 1996, 12: 896–97. For further information see Ullmann 1964, 121–45. The Goncourts' focus on the arts of Japan and those of eighteenth-century France, which they linked to contemporary French aesthetic concerns, coincided with Whistler's interests. The Goncourt brothers were particularly fascinated by the conversation of Constantin Guys, singled out by Baudelaire as "the painter of modern life." According to the Goncourts, Guys was "always holding you under the thrall of his highly-coloured, almost visible utterance." Similarly, Whistler's text has a vivid, imagistic quality that could be labeled "decorative." Curry 1984, 71–73.

31. Huysmans 1884, 13–14. White notes an entry by Edmond de Goncourt in his *Journal* (16 May 1884), asserting that he had already discovered these properties of the color orange in *La Maison d'un Artiste* (1881).

32. Other popular names include King's yellow, Montpellier yellow, and Veronese's yellow. Sir John Soane's south drawing room at Lincoln's Inn Fields was painted patent yellow. Dorey et al. 2000, 73 ff.

33. Huysmans 1884, 45.

34. Ibid., 46.

35. Dorian prized this book, for "it seemed to him that in exquisite raiment, and to the delicate sound of flutes, the sins of the world were passing in dumb show before him." Wilde 1999, 96. Discussed by White in Huysmans 1884, xxiii. Wilde first published *The Picture of Dorian Gray* in *Lippincott's Magazine* in 1890.

36. Making this observation, White adds, "This is a question to which the avant-garde movements of the twentieth century have continually turned, not surprisingly without an ultimate resolution." Huysmans 1884, xvii.

37. Whistler 1885, 136. Whistler introduced his doorway format in *La Marchande de Moutard*. For the rest of his life he used doorways to frame deep space and draw the eye into his images. Fine 1984, 33.

38. Whistler to Marcus B. Huish (21–26 January 1880). GUW 02992 [GUL LB 3/8].

39. Howells 1866, 1: 40–41.

40. Ruskin, *The Stones of Venice* (1851–53), cited in ibid., 1:14. Ruskin blamed Byron for the popular romantic view of Venice.

41. James 1882, 3.

42. Ibid., 13.

43. This is particularly evident in a book about Venice by Mortimer Menpes and his daughter, Dorothy. See Menpes and Menpes 1904. Chapters include "A Glimpse into Bohemia" and "Streets, Shops, and Courtyards, Gondolas, and Gondoliers." As the art is derived from Whistler's work, the text includes direct (unacknowledged) borrowings from Howells. Compare Menpes and Menpes 1904, 37–38, with Howells 1866, 1:140–41, for example. For images of Venice influenced by Whistler see Denker 2003.

44. Wilson 2003, 87–88.

45. Dorment 1994, 238, no. 157; M 953.

46. "The Decay of Lying" (1889), in Wilde 1999, 1073.

47. "Of the Donkeys of the Costermongers," Mayhew 1861–62, 1: 27–28. The work was first published serially in 1851–52. An enlarged edition came out in four volumes in 1861–62 and was reprinted in 1865 with illustrations. Mayhew's compassion for those he interviewed and his distrust of moralizing was unusual in social studies at the time. For more sensational Victorian prose see "A Cockney Holiday," Greenwood 1876, 178–79.

48. Whistler uses the donkey similarly in the etching *Alderney Street* (1881, K238).

49. See "Of the Character of the Street-stalls," and "Of Fruit-stall Keepers," Mayhew 1861–62, 52–56. For general discussion of "Street Music" see Weinreb and Hibbert 1983, 861–62. The shouts of medieval street hawkers evolved into stereotyped melodies that later were incorporated into music by a number of "classical" composers ranging from Handel to Edward Elgar.

50. Tuer 1885, 60. Simultaneously published in New York and London, the book aimed to reach a large audience. Like other commercial print ventures, it was also available in limited editions with signed proofs at 2 guineas and signed proofs on satin paper for 4 guineas. Noting rising prices for antique images of street criers, the publishers —Leadenhall Press in London and Scribner & Welford in New York— further urged, "The twelve quaintly old fashioned and beautiful whole-page illustrations are eminently adapted for separate framing." Ibid., 138.

51. By the 1830s, London had a population of more than 1.5 million, twice the size it had been in 1800. London's inhabitants increased by another million by midcentury, largely because of easier access via rail. For a helpful account see Olson 1976. Lochnan points out that Whistler etched images of disappearing London prior to the Venice sojourn. She convincingly links his interest to the historic preservation movements in both England and France. See Lochnan 2003, 40–43.

52. Whistler created shop-front imagery in all mediums, finding inspiration not only in London and small provincial towns but also as far distant as Brussels, Paris, Amsterdam, and coastal towns like Dieppe, Ostend, and Calais.

53. Paulson 1965, 1:145–47, no. 123.

54. Drury Lane, an Elizabethan street, had become notoriously rowdy by the eighteenth century. By the end of the nineteenth century it was a terrible slum, much of which was swept away when Kingsway and Aldwych Street were constructed. Weinreb and Hibbert 1983, 246.

55. "Brokers' and Marine-store Shops" in Dickens 1839, 212. Walder notes, "The importance of the everyday as a spectacle to be imaginatively rehearsed is nowhere more evident than in [Dickens's] depiction of the private and public theatre, the circus, the fairs, the wild-beast shows, the gardens, the 'harmonic meetings,' the exhibitions and dioramas, the dancing, music and games with which the book [*Boz*] is stuffed. The people of London are so conditioned by the appeal of these popular cultural activities that they appear to perform themselves, in their characteristic attitudes, dress and gesture." Walder, in ibid., xxx. The Royal Coburg is now the Old Vic.

56. Compare, for example, Charles Hunt's painting *A Coffee Stall, Westminster* (1881) with Cruikshank's earlier wood engraving (ca. 1839) of the same subject. Reproduced in Lambourne 1999, 135; see also Dickens 1839, opp. 69.

57. In 1877 William Morris founded the first of these, the Society for the Protection of Ancient Buildings, also known as "Anti-Scrape." For recent discussion, see Lochnan 2003.

58. Theatre Royal, Drury Lane, was

established by King Charles II's royal patent in the 1660s; by 1812 it occupied a building at the corner of Catherine and Russell Streets, Covent Garden. During the mid-1700s it was famous for Shakespeare revivals. Grimaldi and Ducrow (a "Harlequin on Horseback") performed at Astley's Amphitheatre, a circus presenting equestrians, conjurers, acrobats, sword fights, and melodramas. See "Ducrow's Horseman-ship and the Carnival of Venice," *The Theatrical Journal* (1849), reprinted Toole-Stott 1958–71, appendix C. See also "Astley's Amphitheatre" (1849), ibid., appendix A. For a description of performers and audiences, tinged with the presence of the "sad clown," see "Astley's" in Dickens 1839, 128–35. Dating back to 1769, the fire-prone Astley's finally fell victim to urban renewal in 1893. Weinreb and Hibbert 1983, 29–30.

59. Whistler to Anna McNeill Whistler, 17–20 March 1849, GUW 06390 [GUL W386].

60. "Buy a Broom" was linked to a street cry. The comic song is further fueled by cross-dressing. John Liston imper-sonated Eliza Vestris in this perform-ance at the Haymarket Theatre, 6 November 1826.

61. Whistler painted the Dickensian character Sam Weller as *The Cobbler*, approximating a passage from *The Pickwick Papers*. Discussed in Curry 1984, 166.

62. Walder in Dickens 1839, xxiv.

63. Dickens 1839, 74. See also "Daylight by Night," Nead 2000, 87–100; and "Turning Night into Day" in Blühm and Lippincott 2000, 26–28.

64. Whistler 1884, no. 58.

65. Whistler 1885, 84.

66. Dickens 1839, 98. Monmouth Street, a continuation of St. Martin's Lane, was absorbed into Shaftesbury Avenue in 1885.

67. Weinreb and Hibbert 1983, 339. Henry

Mayhew is the source.

68. The Quadrant is a curve at the lower end of Regent Street between Piccadilly Circus and Vigo Street. Formerly it had arcades on either side. Regent Street was patronized by high society from about 1820 until the turn of the twentieth century. Ibid., 660–62.

69. *Rag-Shop Milman's Row*, K272; *Rag Shop, St. Martin's Lane*, K282; three views of the Clothes-Exchange, K2887, 288, 289; *Cutler Street, Houndsditch*, K292.

70. Zola, *Correspondance: letters de jeunesse* (1907), cited by Kristin Ross, "Intro-duction" to Zola 1882, xi.

71. Ibid., 347. For the novel, Zola com-pressed fifty years of social and econ-omic change into a five-year period. See Ross, in ibid., vi.

72. Ibid., 14.

73. Ibid., 16.

74. "Monmouth-street is venerable from its antiquity, and respectable from its usefulness. Holywell Street we despise; the red-headed and red-whiskered Jews who forcibly hand you into their squalid houses, and thrust you into a suit of clothes whether you will or not, we detest." Dickens 1839, 96. Holywell Street ran parallel to the Strand on the north side until the widening of the Strand and the making of Aldwych Street in 1899–1905 eradicated it. For recent comment, see "Holywell Street: The London Ghetto," Nead 2000, 161–88.

75. Smith and Thomson 1877–78. The serial publication of *Street Life in London* commenced in February 1877. After appearing in twelve monthly parts, the thirty-six Woodburytypes (a photomechanical process patented by Walter Woodbury in 1864) were published as a complete work. In 1881, at the time Whistler was engaged with his East End etchings in the neighbor-hood of Houndsditch, the same authors published a second group of Woodburytypes as *Street Incidents:*

A Series of Twenty-one Permanent Photographs with Descriptive Letter-press. Thomson was also a major Victorian source for photographs of Asia, partic-ularly China. Ovenden 1997, 37.

76. Preface, Smith and Thomson 1877–78; discussed in Ovenden 1997, 81–82.

77. For example, children appear in all of the etchings of rag shops, including *Old Clothes Shop No. 1*; *Old Clothes Shop No. 2*; *Rag Shop, Millman's Row*; *Rag Shop, St. Martin's Lane*; *Petticoat Lane*; *Clothes Exchange No. 1*; *Clothes Exchange No. 2*. See K257, 258, 272, 282, 285, 287, 288. Whistler's lithograph *Chelsea Rags* (1888) with its sidewalk full of children was obscurely titled a "Song on Stone" when published in the new monthly journal *The Albemarle*, vol. 1 (January 1892). See C26.

78. Smith and Thomson averred that fish sellers found "their principal customers among the poor in such quarters as Whitechapel, Drury Lane, the New Cut, Lambeth; and in the immediate neighboorhood of theatres and places of amusement." The man they inter-viewed said, "You see that youngster coming with his newspapers. He's one of my best eel customers. He and another works the corner where the 'busses stop with 'Echos.' Whenever a gentleman gives him a penny, and takes no change, he comes here for a halfpenny-worth of eels." See "The Seller of Shell-Fish," Smith and Thomson 1877–78, 122–23.

79. Samuel Butler (1835–1902), author of *Erewhon* (1872) and *The Way of All Flesh* (1903), made photographs marked by anti-Victorian sentimentality that are roughly coeval with Whistler's shop-front images. His work incorpo-rates literary references to Shakespeare and Dickens, sharing the penchant for narrative hints seen in Whistler's titles. Children populate images such as *Boys Outside Mr. Bluit's The Chemists Shop*, 1889. For a recent study, see

Shaffer 1988.

80. Sent to the United States in 1886, the painting was exhibited in Chicago, 1893 (no. 744); Philadelphia, 1893–94 (no. 26); and Boston, 1904 (no. 48). YMSM 314.

81. For recent commentary, see H. Barbara Weinberg, "American Artists' Taste for Spanish Painting," in Tinterow et al. 2002, 259–306.

82. Swinburne 1888. Swinburne applied the same argument to the *Carlyle* portrait, asserting, "It would be quite useless for Mr. Whistler to protest …that he never meant to put study of character and revelation of intellect into his portrait of Mr. Carlyle.…The scandalous fact remains, that he has done so."

83. Swinburne here was trying to link Whistler's work to earlier types of poetry, but his reaction to this portrait was almost as personal as Whistler's. The poet had been very close to Mrs. Whistler during the years she resided with her son in Chelsea.

84. Whistler 1885, 86. For the *Projects* (Freer Gallery of Art, ca. 1868) see Merrill 1998, 77 ff.

85. According to Whistler, for a writer "a picture is more or less a hieroglyph or symbol of story—Apart from a few technical terms, for the display of which he finds an occasion, the work is considered absolutely from a literary point of view—indeed from what other can he consider it—and in his essays he deals with it, as with a novel, a history or an anecdote.—He fails entirely, and most naturally to see its excellencies, or demerits, artistic, and so degrades Art—as supposing it a method of bringing about a literary climax—It thus, in his hands, becomes mainly a method of perpetrating something further, and its mission is made a secondary one." Ibid., 86–87.

86. Postmodernist Robert Venturi plucked a concept from literary criticism and applied it to architecture. See Venturi 1966, 30–31. The concept is equally applicable to Whistler's art. For discussion, see Curry 1984, 73.

87. Whistler 1878, 51. Trotty Veck is the impoverished messenger in Dickens's *The Chimes* (1843).

88. Press cutting (June 1884), GUL BP II PC VII, 12. See also YMSM 314. For *Effie Deans* see YMSM 183. There is some question whether or not Whistler added the inscription but he did not, at any rate, choose to remove it.

89. Dorment 1994, 209–10, citing Chesney 1972, 38.

90. "Countless, indeed, the horde of pre-tenders!—but [Art] knew them not!—a teeming, seething, busy mass!—whose virtue was Industry—and whose Industry was vice—Their names go to fill the catalogue of the Collection at home—of the Gallery Abroad—for the delectation of the bagman, and the Critic!—" Whistler 1885, 94.

91. Ibid., 91. Petticoat Lane was the Sunday used-clothing market.

92. Greenwood 1876, 72–73. Greenwood writes about the disreputable Sunday old-clothes market close to Fleet Street where journalists gathered.

93. See, for example, "O' Clo!" and "Old Cloaths" in Tuer 1885, 61, 77. The woodcuts are much older than the publication date of this compendium. Mayhew's woodcut, however, was based on a daguerreotype, which suggests that the stereotypes are not especially exaggerated.

94. "The Old Clothes of St. Giles," Smith and Thomson 1877–78, 56.

95. The first Reform Act (1832) enfran-chised male property owners in heavily populated industrialized towns, signal-ing the transfer of power from the land-holding nobility and gentry. The second Reform Act (1867) enfran-chised the workingman, and the third Reform Act (1884–85) extended the vote to male agricultural workers.

Together these acts democratized the vote, tripling the electorate.

96. Nead 2000, 156. See also 184–89.

97. Solkin 1993, 152. Ordinary folk could visit the pavilion for a small fee. The Shakespearean formula still worked at the end of the nineteenth century when social programming for Hull-House, Jane Addams's settlement house in the near West Side of Chicago, included a (presumably civilizing) Shakespeare Club. See Addams 1910, 414, 435, 458. At the time of my writing (fall 2003) the National Endowment for the Arts has launched a multimil-lion-dollar program to bring live Shakespeare performances to remote American towns.

98. Whistler 1885, 90, quoting Shakespeare, *Troilus and Cressida*, Act III, scene iii. For a recent collection of essays on Shakespeare and art see Martineau et al. 2003.

99. Whistler 1885, 90.

100. Shakespeare 1961, 862–64.

101. Whistler 1885, 91.

102. A London picture dealer writing in 1837 commented that *La Cruche Cassée*, by then in the Louvre, was "much-admired" while *La Laitière* offered "alluring smiles" and a "nonchalant position." Each picture was available in England as a reproductive print. Smith 1837, part 8, 412–13. Anita Brookner discusses Greuze's problematic relations with England, noting that "a consider-able strain of Greuzian feeling runs through English sensibility." She evalu-ates examples by Reynolds, John Hoppner (whose version of *La Cruche Cassée*, called *The Broken Pitcher*, she finds "robustly and manifestly inno-cent in intention"), and others into the mid-nineteenth century. Brookner 1972, 138 ff. See also the nineteenth-century London art annual *The Year's Art*; it frequently lists Greuze when reporting annual statistics on copying at the National Gallery in London.

103. Brookner 1972, 151.

104. Redgrave probably knew Greuze's *La Malédiction Paternelle* through a print source. For a host of recent studies on the issue of the fallen woman in Victorian art, see catalogue entry for *The Outcast* (1851) in Casteras and Parkinson 1988, 136.

105. Ibid., 118, no. 48.

106. "Some Aspects of the London Shops," *Builder*, 25 December 1858, 874.

107. Wilson 2003, 555. Beardsley later created a more overt shock with his prospectus for *The Savoy*. This time he depicted John Bull, bluff emblem of Englishness, but gave him a noticeable erection. The drawing (Fogg Art Museum, Cambridge) is reproduced in Reade 1967, pl. 414. George Moore and other *Savoy* contributors including Shaw demanded that the prospectus be withdrawn, and as a result another was substituted.

108. Whistler 1885, 85.

109. For recent studies see Crossick and Jaumain 1999. See also Lancaster 1995.

110. By 1854 the Crystal Palace was dismantled and removed to Sydenham where it was reerected in a modified form as a place of public entertainment, easily reached by a branch of London's expanding urban railway service.

111. Paxton published his building design in the *Illustrated London News* on 6 July 1850. The name "Crystal Palace" was published in *Punch* on 2 November 1850. For a recent study see Davis 1999.

112. Whistler 1885, 85.

113. Gibbs-Smith 1981, 45. The source of the period quote is not indicated.

114. The phrase was that of William Pitt, earl of Chatham, quoted in a parliamentary debate of 1808 over keeping Hyde Park free of architecture. Walder in Dickens 1839, 559, n 1.

115. Lynda Nead assesses this visionary structure as "an exercise in the ultimate control and segregation of urban space. It separates goods and people on the street, it segregates the elite social classes from their inferiors and it even filters the impurities from the air." She adds, "Perhaps the most extraordinary element of the arcade is its point of transparency; the moment where it ends and the rest of the surrounding city begins. If the strollers on the walkway and passengers on the railway look out of the arcade, what do they see? Perhaps the inhabitants of the outside world looking back at them." Nead 2000, 28.

116. Queen Victoria, journal entry (15 October 1851), cited in Gibbs-Smith 1981, 20.

117. "Mister Whistler's Ten o'Clock" (21 February 1885), in Wilde 1999, 949.

118. Whistler 1885, 85.

119. For a discussion, see House 1980, 78–90.

120. Charles Knight, *London* (1851), and Haydon, *Autobiography* (1853), both cited in ibid., 78.

121. For a discussion, see Smith 1980, 14 ff.

122. John Hollingshead, *Underground London* (1862), quoted in Nead 2000, 93. In her study of London's street lighting and the industry that supported it, Nead quotes Hollingshead and other writers of the era to establish how the "semiotics of gas" embraced not only metropolitan improvement and civic order but also hellish industrial production, urban blight, and occasional highly destructive explosions.

123. See Smith 1980, 14, for a period description of a visit to a mine pit near Bolton, Lancashire, in the early 1840s. There, a Victorian journalist gained "a forcible idea of a descent into Pandemonium." She cites J. L. Kennedy, *Children's Employment Commission, Appendix to First Report of Commissioners, Mines*, part 2, a document from 1842.

124. Gautier, "Une Journée à Londres," *Revue des Deux Mondes*, 15 April 1842; based on his visit to London in March 1842. The essay was reprinted in *Zigzags* (Paris, 1845) and in *Caprices et Zigzags* (Paris, 1852). Quote from Gautier 1852, 106.

125. Ibid., 118–19. For discussion of the importance of this passage, see House 1980, 84.

126. Whistler 1885, 92.

127. Detailed maps indicate the types of industry Whistler saw across the river. Crutchley's *Ordnance Map of London* (ca. 1874, Library of Congress map collection) records a color manufactory, a turpentine manufactory, and a boatyard bracketing Battersea Bridge on the south side of the river. Much of the view was taken up by Battersea Park, facing the Chelsea Embankment. However, moving farther eastward, past the new Chelsea bridge and Victoria railway bridge, Whistler would have seen the Southwark and Vauxhall waterworks, flour mills, the Nine Elms Mill Dock, a whiting works, a pottery works, the Nine Elms Brewery, coal works, cement works, a railroad goods depot, and finally the Phoenix gasworks by the Vauxhall Bridge.

128. Scarry 1999, 3–8.

129. Ibid., 3.

130. Ibid., 9. The drawing also involves replication: this is one of many semi-draped studio nudes lovingly drawn by Whistler during the latter part of his long career.

131. Scarry dissects assumptions about staring that are frequently deployed against beauty: "The political critique of beauty is composed of two distinct arguments. The first urges that beauty, by preoccupying our attention, distracts attention from wrong social arrangements." She continues, "The second argument holds that when we stare at something beautiful, make it an object of sustained regard, our act is destructive to the object. This argument is most often prompted when the gaze is directed toward a human face or form...." She goes on to show that

these two arguments fundamentally contradict each other. Ibid., 58 ff.

132. Whistler to Fantin-Latour, 30 September 1868, LC PWC Box 1: LC 1/0850–855, translated in Thorpe 1994, 32 ff.

133. "The Truth of Masks" (1885), in Wilde 1999, 1,156.

134. *Lady Windemere's Fan*, in ibid., 454. The play was first produced at St. James's Theatre, opening on 20 February 1892. It was published in 1893.

135. *A Woman of No Importance*, in ibid., 477. Written in Norfolk during the summer of 1892, the play was first produced at Haymarket Theatre, opening on 19 April 1893. It was published in October 1894.

136. Whistler used color to conceal and transform his alterations. M 1225.

137. Scarry 1999, 48.

138. Whistler to Fantin-Latour [September 1867?], GUW 08045 [LC PWC 1135125]. Robin Spencer suggests that Whistler "probably derived the metaphor for the relationship between colour and drawing from the French art historian and theorist Charles Blanc." Spencer 1989, 83. Blanc's *Grammaire des arts du dessin* (1867) was serialized in the *Gazette des Beaux-Arts* (he was founder and chief editor). His scientific interpretation of aesthetics, accompanied by general laws governing the expression of beauty, were particularly important to Seurat.

139. In Whistler's day, the notion of color was certainly sexually charged. Associated with sensuality and bodily responses in mid-Victorian British art and design instruction, color was thought to arouse primitive physical responses, particularly in women. Nead 2000, 188. She cites Denis 1995, 1:108–71.

140. Whistler 1885, 94. Elsewhere in the lecture a sexualized Nature "sings her exquisite song to the Artist alone, her son and her master—her son in that he loves her, her master in that he

knows her...." Ibid., 85. In *Cremorne Gardens, No. 2*, a strong touch of coral attracts us to an open fan signaling the availability of the woman in gray who holds it. Facing outward, she proffers her fan as a thinly veiled invitation to dalliance.

141. Kant 1764.

142. Scarry summarizes, "The sublime is male and the beautiful is female....The sublime resides in mountains, Milton's Hell, and tall oaks in a sacred grove; the beautiful resides in flowers and Elysian meadows. The sublime is night, the beautiful day....The sublime is dusk, 'disdain for the world...eternity;' the beautiful is lively gaiety and cheer. ...The sublime is simple; the beautiful is multiple. The sublime is principled, noble, righteous; the beautiful is compassionate and good-hearted." Scarry 1999, 83–84.

143. Ibid., 84. She adds, "One can see how oddly, yet effectively, the demotion from the sublime and the political demotion [of beauty] work together, even while deeply inconsistent with one another. The sublime (an aesthetic of power) rejects beauty on the grounds that it is diminutive, dismissible, not powerful enough. The political rejects beauty on the grounds that it is too powerful, a power expressed both in its ability to visit harm on objects looked at and also in its capacity to so overwhelm our attention that we cannot free our eyes from it long enough to look at injustice. Berated for its power, beauty is simultaneously belittled for its powerlessness."

144. Hawthorne 1844. After printing his story in a periodical, Hawthorne included it in *Mosses from an Old Manse*, published in 1846 and again in 1854.

145. Ibid., 91.

146. Ibid., 95.

147. Warland's loneliness and isolation is a continuing sub-theme in the story.

148. Similarly, Hawthorne states that "characteristic minuteness in [Warland's] objects and accomplishments made the world even more incapable than it might otherwise have been of appreciating [his] genius." Hawthorne 1844, 78.

149. Whistler sometimes but not always added "little" to a title in reference to the physical scale of his object, paralleling common usage in London place-names. The word "little" is often found in place-names for neighborhoods, as "Little Chelsea," or thoroughfares, as "Little Russell Street."

150. *The Little White Girl* was exhibited at the Royal Academy, London (1865); the International Exhibition, London (1872); at Goupil's, a London dealer (1892); in Munich (1892); Glasgow (1893); Antwerp (1894); Venice (1895); Paris Exposition Universelle (1900); Edinburgh (1902); Boston (1904); and Paris (1905). YMSM 52; Dorment 1994, 78.

151. The *Little White Girl* was cleaned and varnished in 1892 (by the picture restorer Richards), when the original frame was replaced at Whistler's suggestion with one of his later reeded moldings. Whistler retouched the picture in 1900 after it was damaged. At about that time he also painted out the original date, "1864."

152. Scarry comments, "One might suppose that 'fairness' as an ethical principle had come not from the adjective for comely beauty but instead from the wholly distinct noun for the yearly agricultural fair, the 'periodical gathering of buyers and sellers.' But it instead...travels from a cluster of roots in European languages...as well as cognates in both Eastern European and Sanskrit, that all originally express the aesthetic use of 'fair' to mean 'beautiful' or 'fit'—fit both in the sense of 'pleasing to the eye' and in the sense of 'firmly placed,' as when something matches or exists in accord

with another thing's shape or size."
Scarry 1999, 91–92.

153. "Olivia at the Lyceum," *Dramatic Review*,
30 May 1885, in Wilde 1999, 955.

Chapter 8:
CODA

1. See Chronology, M 1995, xxxvii–xxxix.
2. Whistler to Waldo Story, 5 February
 1883, Pierpont Morgan Library,
 Heinemann Collection, MS 244,
 reprinted Thorpe 1994, 74–76.
 Emphasis Whistler's. The "Ruskin
 pamphlet" refers to *Whistler vs. Ruskin
 Art and Art Critics* (1878), the first time
 Whistler used brown-paper covers.
3. Huge margins were an affectation of
 the Victorian commercial print market.
 For further information see Chambers
 1999, 63–87.
4. *British Architect and Northern Engineer*,
 vol. 12 (15 August 1879): 60. Whistler's
 few reproductive prints, allowed prima-
 rily for fiscal reasons after his bank-
 ruptcy, include not only the *Mother* but
 also the *Carlyle*. The *British Architect
 and Northern Engineer* announced that
 this mezzotint, 12 x 14 inches, would
 be engraved by Richard Josey "under
 the immediate supervision of the
 painter." Josey also did the *Mother*
 (reproduced Tedeschi 2003, 124).
 Readers were advised to "make early
 application for the *signed artist's proofs*
 which are only three guineas" and of
 "a very limited number." Whistler
 allowed *Arrangement in Brown and
 Black: Miss Rosa Corder* (1875–78,
 The Frick Collection) to be reproduced
 in 1880.
5. The color scheme for Whistler's 1881
 pastel show at the Fine Art Society
 echoed the Venetian red and green
 walls of England's oldest public picture
 gallery, the Dulwich Picture Gallery,
 built 1811–14 to the designs of Sir
 John Soane.

6. Whistler to Story (1883), in Thorpe
 1994, 75. "The Paddon Papers" (1882)
 refers to Whistler's privately printed
 correspondence regarding a quarrel
 with Charles Augustus Howell.
 Getscher and Marks 1986, no. A-5.
7. See particularly copies of the *Entr'acte
 and Limelight*, a contemporary London
 theater publication.
8. "The Royal Academy Exhibition"
 (second notice), *The Chronicle*, 25 May
 1867, GUL PC 1:33. The model for
 Whistler's punctuation is a vintage
 copy of Whistler 1883, owned by the
 Freer Gallery of Art (NE 2012.w4594
 1883b, gift of Paul Marks).
9. A single review of the 1881 exhibition
 of twelve Venetian etchings at the
 Fine Art Society provided quotes for
 cat. nos. 3, *Wheelwright*; 11, *Dyer*; 13,
 Doorway; 20, *Little Venice*; 24, *Riva
 No. 2*; 39, *Ponte Piovan*; 48, *Palaces*.
10. *Chronicle*, 25 May 1867, GUL PC 1:33.
 The reviewer acknowledged "with
 alacrity and delight, the supreme
 artistic charm" of Whistler's paintings.
11. "Mr. Whistler's Venice," *St. James's
 Gazette*, 9 December 1880, GUL PC 4:17.
12. Ibid.
13. Wedmore received no credit from
 Whistler for his numerous positive
 criticisms.
14. GUW 00677.
15. A review for Whistler's 1881 exhibition
 "Twelve Etchings of Venice" com-
 plained about the "twelve impressions
 arranged on a maroon-coloured cloth,
 with rough chalk numbers underneath,
 and not in sequence, possibly a quaint
 conceit on the part of the etcher, but
 not conducive to the convenience of the
 visitor." *British Architect and Northern
 Engineer*, 10 December 1880, GUL PC
 4:19. As commentators do not mention
 this issue in reviews of later shows, we
 can encourage ourselves to hope that
 Whistler heeded the warning.
16. For height of fabric-covered wall,
 see *Building News*, 23 February 1883;

for yellow paint see *Bird O'Freedom*,
20 February 1883; both clippings GUL
PC 6:41. The correspondent for *Bird
O'Freedom* also reported that the etch-
ings were glazed. For "white frames,"
see *Building News*, 23 February 1883,
GUL PC 6:41. Another critic reported
that the lines were gray. "Causerie"
[*Court Circular*], GUL PC 6:43. News-
paper accounts give only an approxi-
mate notion of color, and they do not
always agree, perhaps, in part, because
of differing lighting conditions—one
reporter complained that gaslight for
evening views destroyed Whistler's
carefully orchestrated color harmonies
at the exhibition of Venice pastels in
1881. See *Daily Telegraph*, 5 February
1881, GUL PC 4:48. Moreover, Whistler
favored colors that were difficult to
define, such as fabric in an "indescrib-
able tone of brownish, yellowish,
greenish gold" for an exhibit at the
Society of British Artists. See *Truth*,
6 May 1886, GUL PC 7:22.

17. For "perilous" chairs, see *Ashton
 Standard*, 24 February 1884.
 For "genuine matting," see undated
 "Causerie" [*Court Circular*]. For
 "jaundice," see *Coventry Standard*,
 23 February 1884. All, GUL PC 6:42,
 43, and 41, respectively.
18. Many newspapers describe the
 "poached egg," who was also likened to
 a mustard pot and a stand of crocuses.
 The outfit consisted of a white coat,
 white "bifurcateds" (probably trousers)
 with yellow stripes, along with a
 yellow vest, tie, and socks. See *People*,
 23 February 1883, GUL W PC 6:44.
 Following the exhibition, Whistler sent
 an amusing letter to Marcus Huish
 refusing to pay for rental of the
 costume. "Useless my dear Huish,
 quite useless—Your generous nature
 too heavily handicaps your official
 flights into crime. True I am no busi-
 ness man—but even *I* perceive how
 futile are these furtive attempts to filch

the occasional fiver for the Board's banking balance! You *know* that the yellow man's wages do not come out of my pocket—You agreed to his engagement—livery and all—or he never would have been there at all—he was one of the elements of the Exhibition—like the hangings and various arrangements in Canary—and I shall neither pay for the man—nor his socks—nor his hose—nor anything that is his." Whistler ended the letter by noting that the "poached egg" had sold 1,958 exhibition catalogues for which the artist expected a check in the amount of £6.4.00. Whistler to Huish, GUL Whistler F90 [March or April 1883].

19. *Country Gentleman*, 24 February 1883, GUL PC 6:43.

20. Whistler to Story (1885), in Thorpe 1994, 75–76.

21. Whistler to his brother, Dr. William Whistler, New York Public Library. He included a delicate drawing for this butterfly in the letter, M 879. Whistler told his brother he made "some 80 or 100 little butterflies" out of "white and yellow satin—most exquisite—wonderful little bodies of plush—with the crisp silk wings and the silver barbed sting!"

22. *Pictorial World*, 31 March 1883, GUL PC 8:8. Invitation cards indicated the color scheme to help guests dress accordingly. The novelty of dressing to match one of Whistler's exhibition installations brought forth such comments as, "such a thing as a purple gown should not have been allowed to enter." See "Causerie," *Court Circular*, 24 May 1884, GUL PC 6:54. This was in reference to the flesh-color and gray show of 1884. Whistler's willingness to exploit the "Royals" for publicity was seen much earlier. He indicated to his mother that he welcomed certain visitors to the Peacock Room, including Princess Louise and the fifth marquis of Westminster, for this reason. They

"shew *real* delight in this *beautiful* room, keep up the buzz of publicity most pleasantly in London Society, and this is well, and I hope good may result!!" Whistler to Anna McNeill Whistler, September 1876, GUL Whistler LB 4/22–25.

23. Whistler to his brother in M 879.

24. M 564, 565.

25. Ward 1991.

26. Conforti 1986, 4. Conforti writes, "In 1883, Bradstreet joined twenty-four of his fellow citizens in founding The Minneapolis Society of Fine Arts. [It] eventually spawned…the Minneapolis Institute of Arts…. Having just returned from Europe, where he had seen a show of etchings by James McNeill Whistler, he insisted that one of the rooms be painted the same yellow that had decorated the London gallery." Bradstreet's Whistler etching, acquired from the Fine Art Society show in 1883, was among the first objects to enter the permanent collection of what is now the Minneapolis Institute of Art.

27. FGA document, Freer purchase, 1 November 1887. M. Knoedler & Company were successors to Goupil & Co.

28. Check stub no. 85, 11 April 1890, Isabella Stewart Gardner Museum archives.

29. Eight suites of *Twelve Etchings of Venice* were sold from the 1880 exhibition at the Fine Art Society. Lochnan 1984, 216. Whistler, who had agreed to produce an edition of 100 sets of the twelve prints, was still printing some of the plates late in 1889, and in the end Frederick Goulding had to help get the editions fully printed after Whistler's death. Fine 1984, 23.

30. According to the prospectus, the Second Venice Set was to be issued in editions of thirty in Whistler's specially designed portfolio, which is virtually identical to the packaging of the First Venice Set. Fine 1984, 24. However,

fifteen subjects would be sold separately with a run of twelve impressions each. She adds; "No impressions of the First Venice Set were turned over to the Society between 29 July 1885 and 13 January 1887. With that experience to learn from, the Dowdeswell editions were completed by mid-July 1887." She also notes that, "apart from the official Dowdeswell publications, Whistler was printing these plates as early as August 1882. And they were exhibited in 1883 [in *Arrangement in White and Yellow*] no doubt leading to sales. In fact, throughout the difficulties over the incomplete editions of the first Venice set, Whistler sold many impressions of his other Venice plates through the Fine Art Society." Ibid.

31. A proof of *Little Venice* (K183), no. 1 in the *Twelve Etchings of Venice*, cost Freer $42 in 1893, when he acquired it from Wunderlich in New York. Bill, 19 June 1893, FGA. In 1905, Obach's, London, sold him another proof, marked "Trial proof by Whistler from finished plate, a most perfect impression" for £60, the cost of Freer's entire *Twenty-six Etchings*. See object records, 05.179, FGA.

32. The impression, which Freer considered "a very fine proof," had belonged to Thomas Way, Whistler's close associate in the field of etchings and lithographs. See "48 Etchings from Thomas Way," list in Freer's hand, FGA. With shipping the print cost a total of $343.

33. Freer purchased a group of Haden's prints for the princely sum of $12,000. The artist Thomas Dewing acted as agent. Bill from Hermann Wunderlich and Company, 9 November 1998, FGA. E. G. Kennedy, who later catalogued Whistler's etchings, is listed on the dealer masthead.

34. Listed in Stubbs 1967, 56–64.

35. For further information on the technique see "Drypoint," in Turner 1996, 9:307–10. Whistler's use of drypoint had a deep influence on later print-

makers, and helped stimulate an American etching revival during the 1880s.

36. Wedmore 1899; Mansfield 1909.

37. Getscher 1970; Fine 1984; Lochnan 1984.

38. Other impressions in differing states from the two unbroken Second Venice suites are *San Biagio*, K 197, Freer 4/9, Gardner 9/9; *The Balcony*, K 207, Freer 5/11, Gardner 8/11; *Turkeys*, K 199, Freer 1/2, Gardner 2/2; *Fruit-Stall*, K 200, Freer 6/7, Gardner 7/7; *Long Lagoon*, K 203, Freer 1/2, Gardner 2/2; *Lobster Pots*, K 235, Freer 1/3, Gardner 3/3; *Fishing Boat*, K 208, Freer 3/5, Gardner 4/5; *Ponte Piovan*, K 209, Freer 5/6, Gardner 6/6; *Garden*, K 210, Freer 7/8, Gardner 8/8; *The Rialto*, K 211, Freer 2/2, Gardner 1/2.

39. Even measurements vary from one impression to another. Kennedy notes, "The prints have been carefully measured, and, whenever possible, from more than one impression of the same subject. Sometimes difference in sizes have been quite marked between impressions on Japan paper and those on Dutch paper, the former material, with its more flexible fibre, usually causing a slight increase in the dimensions of the etching. But differences in size are also discovered amongst impressions printed on the same paper. They are caused by pressure of the press, or too much or too little dampening of the paper before printing." See K 1910, xxvii–xxviii.

40. Lochnan 1984, 280–81. Late in 1889 Whistler wrote to dealer Ernest Brown, "About the F.A.S. [Fine Art Society] Venetian etchings, I believe they will come out far more beautifully than ever! I am making of them wonderful new states!" GUL Whistler, F74.

41. For a visual chronology of the evolving butterfly signatures, see M, xiv. Whistler's original agreement with the Fine Art Society for *Twelve Etchings of Venice* was to make an edition of 100 of each plate, with only twenty of these to be pulled by the artist himself. But Whistler wanted to pull all the proofs himself, greatly delaying the process. Fine 1984, 23.

42. Whistler's anvil and hammer. England, eighteenth century. Steel and wood. Freer Gallery of Art, Smithsonian Institution, 08.237; 08.238.

43. Ivins 1943.

44. See especially Grieve 2000.

45. Duret 1904, 259. "Mais comme cette eau-forte reproduit l'impression qu'on se rapelle avoir soi-même éprouvée à l'aspect de Venise! Comme c'est bien la une ville à fleur d'eau qui, de loin semble une apparition prête à rentrer sous la mer."

46. "The Royal Academy Exhibition (Second Notice)," *The Chronicle*, 25 May 1867, GUL PC 1:33.

47. *Truth*, 20 May 1882. GUL PC 4:103. The rubric concerns the Grosvenor Gallery painting show in May 1882, and ends, "The Grosvenor has opened its courtly salon under every possible favour of fashion and aestheticism," an approach Whistler adopted for *White and Yellow*.

48. From a negative review, "The Grosvenor Gallery," *Knowledge, An Illustrated Magazine of Science*, vol. 2: no. 32 (9 June 1882): 17–18.

49. Review of paintings at the Royal Academy, *Daily Telegraph*, Winter 1875, GUL PC 1:81. This rubric, criticizing Whistler's nocturnes, also contains the comment that his works "only come one step nearer pictures than delicately graduated tints on wall paper would do." The journalist received no mercy from Whistler for ending the review with "His etchings have high and rare merits of their own."

50. "Mr. Whistler's Venice," *St. James's Gazette*, 9 December 1880, GUL PC 4:17.

51. A review of Whistler paintings at the Grosvenor, *Observer*, 1 May 1892, GUL PC 4:115.

52. Grosvenor exhibition review, unattributed by Whistler, from *The Leeds Mercury*, 2 May 1882, GUL PC 4:117. Whistler's sarcastic comment, "See, that's how they write the history of art," shows his contempt for a journalist uninformed enough to lump him with the illustrator Walter Crane, the Pre-Raphaelite painter Spencer Stanhope, and John Strudwick, who studied at South Kensington before devoting himself to mythological, religious, allegorical, and genre scenes.

53. Quilter 1880, GUL PC 4:13. Whistler left out, "What has been done, and done with cleverness so great as to be almost genius, is to sketch the passing, everyday aspect of canal, lagoon, and quay…"

54. Wedmore 1879, 338–39.

55. Hamerton 1881, 20. He is reviewing the 1881 exhibition at the Fine Art Society.

56. Ibid.

57. *British Architect and Northern Engineer*, vol. 14 (10 December 1880), GUL PC 4:19, unattributed by Whistler.

58. Impression in second state, Freer Gallery of Art, 03.51. Freer paid $200 for this example at the American Art Association's sale of the A. M. Burritt collection on 26 March 1903. FGA, bill, dated 28 March 1903. Freer's note, added to the bill, makes it clear that he valued this particular impression for its rarity: "This trial proof undescribed by Wedmore." Freer also owned an undescribed intermediate state between 3 and 4 (03.90).

59. See note 111, below.

60. "Mr. Whistler's Pastels at the Fine Art Society," *The Standard*, February 1881, GUL PC 4:67–91, unattributed by Whistler.

61. Wedmore 1879, 334. This is a discussion of the Whistler-Ruskin trial and its implications.

62. Hamerton 1881, 20.

63. "Mr. Whistler's Venice," *St. James's Gazette*, 9 December 1880, GUL PC 4:17. Adolphe Lalauze was a French printmaker and illustrator who was noted

for scenes with children.

64. P. G. Hamerton to editor, *New York Tribune*, 29 September 1880, printed 11 October 1880, 5; reprinted Whistler 1892, 88–99.

65. *Literary World*, 2 June 1882, GUL PC 4:105. This very unfavorable review of the 1882 Grosvenor Gallery exhibition dismissed Whistler's pictures as "a laughing-stock."

66. Freer Gallery of Art, 93.23.

67. Hamerton 1876, 289–90.

68. "Mr. Whistler's Venice," *St. James's Gazette*, 9 December 1880, GUL PC 4:17.

69. Ibid.

70. *Saturday Review*, 3 June 1865, GUL PC 1:1.

71. Bacher 1908, 193–94.

72. "Mr. Whistler's Venice Etchings," *Daily News*, 2 December 1880, GUL PC 4:18.

73. "Mr. Whistler's Etchings of Venice," London *Times*, 25 December 1880, GUL PC 4:11. Whistler featured the one negative remark in a long positive review of the 1880 Venetian print show at the Fine Art Society.

74. For history, see Weinreb and Hibbert 1983, 418–19. The site could be Wren's redbrick buildings in King's Bench Walk, but in general the area was greatly damaged during the Second World War.

75. "Artists of the Future. The Grosvenor Gallery. Letter from Julian Hawthorne," *The New York Tribune*, 7 June 1878, GUL PC 3:51. Unattributed by Whistler. A lucubration is a study, composition, or meditation at night; the term also means a weighty or pretentious statement of ideas.

76. "Mr. Whistler's Venice Pastels," *Pictorial World*, 5 May 1881, GUL PC 4:43. Unattributed by Whistler, who left out that "the very swiftness of the work records how quickly the artist grasps the salient points of the scene upon which he gazes."

77. *British Architect and Northern Engineer*, vol. 14 (10 December 1880), GUL PC 4:19, unattributed by Whistler.

78. Wedmore 1883, 35–36. According to Wedmore, the other three "masters" of etching were Seymour Haden, Alphonse Legros, and Jules Jacquemart.

79. Wedmore 1879, 338–39. Wedmore actually said, "They have a merit of their own, and I do not wish to understate it."

80. Wedmore 1883, 1–2. Wedmore was talking about Seymour Haden here.

81. *Life*, 18 May 1882, GUL PC 3:85. Another Grosvenor Gallery review, unattributed by Whistler.

82. "Mr. Whistler's Venice," *St. James's Gazette*, 9 December 1880, GUL PC 4:17.

83. "Mr. Whistler's Venice Etchings," *Daily News*, 2 December 1880, GUL PC 4:18.

84. Ibid.

85. Quilter 1880, GUL PC 4:13.

86. "Mr. Whistler's Pastels at the Fine Art Society," *The Standard*, February 1881, GUL PC 4:67, 91. This is a review of the 1881 pastel exhibition.

87. "The Grosvenor Gallery Second Notice," *Knowledge*, 16 June 1882, GUL PC 4:119. Unattributed by Whistler.

88. Freer Gallery of Art, 03.303. Freer acquired this print from Thomas Way.

89. Hamerton 1881, 20.

90. Hamerton 1876, 291. He discusses Thames etchings here. His comments are positive.

91. Centre for Whistler Studies, biographical records.

92. Pennell 1921, 58.

93. *St. James's Gazette*, 9 December 1880, GUL PC 4:17.

94. Bacher 1908.

95. Wedmore 1879, 338–39.

96. Wedmore 1883, 36–37.

97. Ibid., 35–36.

98. Undated press clipping, *Daily Telegraph* (1875?), GUL PC 1:85.

99. Hamerton 1881, 20.

100. Hamerton 1876, 288–89.

101. Wedmore 1883, 35–36.

102. Quilter 1880, GUL PC 4:13; unattributed by Whistler.

103. "The Winter Exhibition of Cabinet Pictures in Oil, Dudley Gallery," *The Athenaeum*, 2 November 1872, GUL PC 1:57.

104. Wedmore 1883, 506; discussing Seymour Haden.

105. Ibid., iii–iv. In his "Preface" to *Four Masters of Etching*, Wedmore here refers to having dropped discussion of the Whistler-Ruskin trial that appeared in his earlier article (Wedmore 1879), occasioned by Whistler's "implication" that any critic who couldn't make art himself was unworthy. A Mede was an inhabitant of ancient Medea in Persia.

106. Engraved in lower edge at left, "Gazette des Beaux-Arts"; at right "Imp. Cadart."

107. Lochnan 1984, 211.

108. Hamerton 1881, 20. Unattributed by Whistler.

109. Ibid.

110. Hamerton 1876, 288–89.

111. Hamerton 1881, 20.

112. As with *Nocturne Riva* (cat. no. 8 above), this is another example of "value added" to a fine art print. Ernest Brown wrote Whistler in 1889 to send an impression of *Stables*, requesting that he "Please write on the back 'special proof' or something of that sort." Cited Fine 1984, 115.

113. Hamerton 1881, 20.

114. Wedmore 1883, 34–45, unattributed by Whistler.

115. See "Catalogue prices for purchases made in London, during the summer of 1905," FGA. This was one of forty-eight etchings purchased from Thomas Way for a sum of £1620. Priced at £70 plus freight, this print totaled out at $343; it was much more expensive than most of the prints in the group. Other pricey impressions in the group included *The Forge*, K68; *Courtyard Venice*, K230; and *Gondola Under a Bridge*, K227, all at £70, as well as "a superb" impression of *Little Venice*, K183, at £80 and *Longhouse Dyers Amsterdam*, K406, at £100.

116. Hamerton 1881, 20.

117. "Mr. Whistler's Venice," *St. James's Gazette*, 9 December 1880, GUL PC 4:17.

118. Quilter 1880, GUL PC 4:13.

119. Wedmore 1883, 32–33.

120. Colvin 1874. Of course, Whistler left out the rest of the sentence, "…and singularly direct and concentrated power…" This review of Whistler's first one-man exhibition caught the artist's intent immediately. Colvin wrote, "If there is any case in which an artist is justified in opening a gallery of his own, it is when he is conscious of a distinct vocation for certain kinds of artistic combinations which it takes delicate organs to appreciate, and when experience has taught him that this kind of combination receives scanty welcome at the hands of art's official censors." Colvin found the exhibition "pleasantly matted, tinted, and arranged; with a paneled skirting carrying two tiers of the artist's works, a lower tier of colour sketches, and an upper tier of etchings, and above the skirting some eight or ten oil paintings in quiet keys of colour."

121. Quilter 1880, GUL PC 4:13; unattributed by Whistler.

122. Quilter 1882. GUL PC 4:11.

123. Wedmore 1879, 338–39.

124. "Mr. Whistler's Venice Pastels," *Pan*, 5 February 1881, GUL PC 4:59. Unattributed by Whistler.

125. Ibid., unattributed by Whistler.

126. Freer owned several impressions of this print. One of them (97.52) seems to be pulled on another section of the same sheet as 98.386. The sheet was once a blank book page. It is inscribed by Freer, "Formerly in white frame."

127. "Mr. Whistler's Venice Pastels," *Pan*, 5 February 1881, GUL PC 4:59. Unattributed by Whistler.

128. Keppel to Freer, 2 June 1902, FGA.

129. Translation: "Mr. Whistler exhibits wondrous productions that seem based on the laws of color and form, but the uninitiated cannot understand them."

130. "Mr. Whistler's Venice," *St. James's Gazette*, 9 December 1880, GUL PC 4:171. Perhaps feeling he had cited the newspaper enough, Whistler did not attribute this phrase to the *St. James's Gazette*, whence it came.

131. Wedmore 1883, 34–35.

132. *St. James's Gazette*, 9 December 1880, GUL PC 4:171. Whistler credited a different newspaper, the *Pall Mall Gazette* (on which Sidney Colvin served as a reporter).

133. Ibid.

134. "Mr. Whistler's Pastels," *Athenaeum*, February 1881, GUL PC 4:47.

135. Colvin 1874. The comment was reprinted in "Notes from London," *New York Tribune*, 13 June 1874, GUL PC 1:61.

136. "Mr. Whistler's Pastels at the Fine Art Society," *The Standard*, February 1881, GUL PC 4:67, 91.

137. Hamerton 1881, 20.

138. Wedmore 1883, 28–29.

139. Colvin 1874.

140. Unidentified clipping regarding the Grosvenor Gallery exhibition, London *Times*, 2 May 1882, GUL PC 4:115.

141. Quilter 1880, GUL PC 4:13. This time Whistler credited the London *Times* with publishing the article. Quilter had served as art critic for the *Times* from 1880 to 1881, but reviewed for the *Spectator* from 1876 until 1886. Centre for Whistler Studies biographical files.

142. Wedmore 1879, 342–43.

143. Ibid., 340.

144. Ibid., 342–43.

145. Isaiah, 59:9.

146. Ibid., 59:10.

147. Ibid., 59:11.

Bibliography

List of Works Cited

Abbreviations

AAA — Archives of American Art, Washington, D.C.

C — *The Lithographs of James McNeill Whistler.* Harriet K. Stratis and Martha Tedeschi, eds. 2 vols. Chicago, 1998.

CPL — Chelsea Public Library, Special Collections.

FGA — Archives, Freer Gallery of Art, Washington, D.C.

GUL — Whistler Collection, Special Collections, Glasgow University Library, University of Glasgow.

GUW — *The Correspondence of James McNeill Whistler, 1855–1903.* Margaret MacDonald, Patricia de Montfort, and Nigel Thorp, eds. Online Centenary Edition, Centre for Whistler Studies, University of Glasgow, 2003; www.whistler.arts.gla.ac.uk/correspondence

HWV — Baselt, Bernd, and William Charles Smith. *Verzeichnis der Werke Georg Friedrich Händels.* Leipzig, 1979.

K — Kennedy, Edward G. *The Etched Work of Whistler* (1910). San Francisco, 1987.

LC PWC — E. R. & J. Pennell Collection, Library of Congress, Washington, D.C.

M — MacDonald, Margaret F. *James McNeill Whistler: Drawings, Pastels, and Watercolours. A Catalogue Raisonné.* New Haven, Conn., and London, 1995.

V&A AAD — Olympia Archive of Art and Design, Victoria and Albert Museum, London.

VMFA — Archives, Virginia Museum of Fine Arts, Richmond.

YMSM — Young, Andrew McLaren, Margaret MacDonald, Robin Spencer, and Hamish Miles. *The Paintings of James McNeill Whistler.* 2 vols. New Haven, Conn., and London, 1980.

Detail from fig. 3.30.

Books and Articles

Abéles 1986: Abéles, Luce. *La vie de Bohème.* Les Dossiers du Musée d'Orsay, vol. 6. Paris, 1986.

Abelson 1989: Abelson, Elaine. *When Ladies Go A-Thieving: Middle-Class Shoplifters in the Victorian Department Store.* New York, 1989.

Adams 1880: Adams, Henry. *Democracy* (1880). New York, 1981.

Adams 1984: Adams, Henry. "John La Farge's Roses on a Tray." *Carnegie Magazine,* vol. 57 (January–February 1984): 10–14.

Addams 1910: Addams, Jane. *Twenty Years at Hull-House: with Autobiographical Notes.* New York, 1910.

Addison 1712: Addison, Joseph. *The Spectator* (1712). Ed. Donald F. Bond. 5 vols. Oxford, 1965.

Adhémar 1950: Adhémar, Helene. *Watteau: sa vie—son oeuvre.* Paris, 1950.

Allen 1986: Allen, Brian. "Francis Hayman and the Supper-Box Paintings for Vauxhall Gardens." In *The Rococo in England: A Symposium.* Ed. Charles Hind. London, 1986, 113–33.

Allen 1987: ———. *Francis Hayman.* New Haven, Conn., and London, 1987.

Allingham and Radford 1907: Allingham, H., and D. Radford. *William Allingham, A Diary.* London, 1907.

Altick 1978: Altick, Richard D. *The Shows of London.* Cambridge, Mass., and London, 1978.

Ashelford 2000: Ashelford, Jane. *The Art of Dress: Clothes and Society, 1500–1914.* Rev. ed. London, 2000.

Aslin 1969: Aslin, Elizabeth. *The Aesthetic Movement: Prelude to Art Nouveau* (1969). New York, 1981.

Aslin 1986: ———. *E. W. Godwin: Furniture and Decoration.* London, 1986.

Audsley and Bowes 1875: Audsley, George Ashdown, and James Lord Bowes. *The Keramic Art of Japan.* Liverpool and London, 1875.

Austen 1818: Austen, Jane. *Northanger Abbey.* London, 1818.

Bacher 1908: Bacher, Otto. *With Whistler in Venice.* New York, 1908.

Baker 1998: Baker, Malcolm. "Tyers, Roubiliac and a sculpture's fame: a poem about the commissioning of the Handel statue at Vauxhall." *The Sculpture Journal,* vol. 2 (1998): 41–45.

Baker 1989: Baker, Paul R. *Stanny: The Gilded Life of Stanford White.* New York, 1989.

Banta 1987: Banta, Martha. *Imaging American Women: Idea & Ideals in Cultural History.* New York, 1987.

Baron 1975: Baron, Wendy. *Sickert.* London, 1975.

Barter et al. 1998: Barter, Judith A., Erica E. Hirshler, et al. *Mary Cassatt: Modern Woman.* New York, 1998.

Baskett and Snelgrove 1972: Baskett, John, and Dudley Snelgrove. *English Drawings and Watercolours, 1550–1850, in the Mellon Collection,* exh. cat., Pierpont Morgan Library. New York, 1972.

Battie and Cottle 1991: Battie, David, and Simon Cottle, eds. *Sotheby's Concise Encyclopedia of Glass.* Boston, 1991.

Baudelaire 1964: Baudelaire, Charles. *The Painter of Modern Life and Other Essays.* Trans. and ed. Jonathan Mayne. London, 1964.

Baudelaire 1965: ———. *Art in Paris 1845–1862. Salons and Other Exhibitions Reviewed by Charles Baudelaire.* Trans. and ed. Jonathan Mayne. London, 1965.

Baydo 1981: Baydo, Gerald. *USA: A Synoptic History of America's Past.* New York, 1981.

Beeton 1861: Beeton, Mrs. Isabella. *The Book of Household Management.* London, 1861.

Bendix 1995: Bendix, Deanna Marohn. *Diabolical Designs. Paintings, Interiors, and Exhibitions of James McNeill Whistler.* Washington, D.C., 1995.

Bénédite 1905: Bénédite, Léonce. "Artistes Contemporains: Whistler." *Gazette des Beaux-Arts,* vols. 33–34, nos. 575, 576, 578, 579 (May, June, August, September 1905): 403–10, 496–511, 142–58, 231–46.

Bindman 1997: Bindman, David. "Roubiliac's Statue of Handel and the Keeping of Order in Vauxhall Gardens in the Early Eighteenth Century." *The Sculpture Journal,* vol. 1 (1997): 22–31.

Blanchard 1998: Blanchard, Mary Warner. *Oscar Wilde's America: Counterculture in the Gilded Age.* New Haven, Conn., 1998.

Blom 1968: Blom, Eric, ed. *Grove's Dictionary of Music and Musicians.* 5th ed., 10 vols. New York, 1968.

Blühm and Lippincott 2000: Blühm, Andreas, and Louise Lippincott. *Light! The Industrial Age, 1750–1900: Art & Science, Technology & Society.* New York, 2000.

Bolger 1980: Bolger, Doreen. *American Paintings in the Metropolitan Museum of Art,* vol. 3. *A Catalogue of Works by Artists Born between 1846 and 1864.* Ed. Kathleen Luhrs. New York, 1980.

Brookner 1972: Brookner, Anita. *Greuze: The Rise and Fall of an Eighteenth-Century Phenomenon.* Greenwich, Conn., 1972.

Brunk 1981: Brunk, Thomas W. "The House that Freer Built." *Dichotomy,* vol. 3, no. 4 (Spring 1981): 5–53.

Bryson 1981: Bryson, Norman. "Watteau and Reverie: A Test Case in Combined Analysis." *The Eighteenth Century: Theory and Interpretation,* vol. 22, no. 2 (Spring 1981): 97–126.

Bulfinch 1979: Bulfinch, Thomas. *Myths of Greece and Rome* (1979). Ed. Bryan Holme. Harmondsworth, Middlesex, Eng., 1984.

Bulwer-Lytton 1828: Bulwer-Lytton, Edward. *Pelham, or the Adventures of a Gentleman.* London, 1828.

Burke 1987: Burke, Doreen Bolger, et. al. *In Pursuit of Beauty: Americans and the Aesthetic Movement,* exh. cat., The Metropolitan Museum of Art. New York, 1987.

Burns 1993: Burns, Sarah. "The Price of Beauty: Art, Commerce, and the Late Nineteenth-Century American Studio Interior." *American Iconology: New Approaches to Nineteenth-Century Art and Literature.* Ed. David C. Miller. New Haven, Conn., 1993, 209–38.

Burns 1995: ———. "Revitalizing the 'Painted-out' North: Winslow Homer, Manly Health, and New England Region-

alism in Turn-of-the-century America." *American Art,* vol. 9 (Summer 1995): 20–37.

Burns 1996: ———. *Inventing the Modern Artist: Art and Culture in Gilded Age America.* New Haven, Conn., and London, 1996.

Burton 1893: Burton, Isabel. *The Life of Captain Sir Richard F. Burton* (1893). Boston, 1977.

Bushman 1992: Bushman, Richard L. *The Refinement of America: Persons, Houses, Cities.* New York, 1992.

Byatt 2001: Byatt, A.S. *Portraits in Fiction.* London, 2001.

Cable 1969: Cable, Mary. *American Manners & Morals: A Picture History of How We Behaved and Misbehaved.* New York, 1969.

Caffin 1901: Caffin, Charles H. "Brief Appreciations of Some American Painters, III. James A. McNeill Whistler." *New York Sun,* 3 November 1901.

Cartwright 1905: Cartwright, J.C. "James Hazen Hyde's Costume Ball." *Metropolitan Magazine* (June 1905): 305–19.

Castagnary 1892: Castagnary, Jules-Antoine. *Salons (1857–1879).* 2 vols. Paris, 1892.

Casteras and Denney 1996: Casteras, Susan P., and Colleen Denney, eds. *The Grosvenor Gallery: A Palace of Art in Victorian England.* New Haven and London, 1996.

Casteras and Parkinson 1988: Casteras, Susan P., and Ronald Parkinson, eds. *Richard Redgrave: 1804–1888,* exh. cat., Victoria and Albert Museum and Yale Center for British Art. New Haven, Conn., and London, 1988.

Castle 1986: Castle, Terry. *Masquerade and Civilization: The Carnivalesque in Eighteenth-Century English Culture and Fiction.* London, 1986.

Chambers 1999: Chambers, Emma. *An Indolent and Blundering Art? The Etching Revival and the Redefinition of Etching in England, 1838–1892.* Aldershot, Hampshire, Eng., 1999.

Chapman and Dormer 2003: Chapman, Caroline, and Jane Dormer. *Elizabeth & Georgiana: The Duke of Devonshire and His Two Duchesses.* New York, 2003.

Chase 1910: Chase, William Merritt. "The Two Whistlers, Recollections of a Summer with the Great Etcher." *Century Magazine,* vol. 58 (June 1910): 218–26.

Chesney 1972: Chesney, Kellow. *The Victorian Underworld.* London, 1972.

Churchill 1962: Churchill, Allen. *The Great White Way.* New York, 1962.

Clayton 2000: Clayton, Antony. *Subterranean City: Beneath the Streets of London.* London, 2000.

Cocteau and Fraigneau 1957: Cocteau, Jean, and André Fraigneau. *The Venice I Love.* Trans. Ruth Whipple Fermaud. New York, 1957.

Collins 1860: Collins, William Wilkie. *The Woman in White* (1860). Ed. John Sutherland. Oxford, Eng., 1998.

Colvin 1874: Colvin, Sidney. "Exhibition of Mr. Whistler's Pictures." *The Academy* (13 June 1874): 672–73.

Conforti 1986: Conforti, Michael. "Orientalism on the Upper Mississippi: The Work of John S. Bradstreet." *The Minneapolis Institute of Arts Bulletin,* vol. 65 (1986): 2–35.

Conforti 1997: ———. "The Idealist Enterprise and the Applied Arts." *A Grand Design: The Art of the Victoria and Albert Museum.* Eds. Malcolm Baker and Brenda Richardson. New York, 1997, 23–48.

Cook 1878: Cook, Clarence. *The House Beautiful: essays on beds and tables, stools and candlesticks.* New York, 1878.

Cook 1997: Cook, Edward S. Jr. "Talking or Working: The Conundrum of Moral Aesthetics in Boston's Arts and Crafts Movement." In *Inspiring Reform: Boston's Arts and Crafts Movement.* Eds. Marilee Boyd Meyer et al. Wellesley, Mass., 1997.

Cooper 1978: Cooper, J.C. *An Illustrated Encyclopaedia of Traditional Symbols.* London, 1978.

Cooper 1987: Cooper, Jeremy. *Victorian and Edwardian Furniture and Interiors: From the Gothic Revival to Art Nouveau.* London, 1987.

Cornaro 1882: Cornaro, C. "The Revival of Burano Lace." *The Century,* vol. 23 (January 1882): 330–43.

Cox 1904: Cox, Kenyon. "Whistler and Absolute Painting." *Scribner's Magazine,* vol. 35 (April 1904): 637–39.

Craven 1994: Craven, Wayne. *American Art: History and Culture.* New York, 1994.

Crossick and Jaumain 1999: Crossick, Geoffrey, and Serge Jaumain, eds. *Cathedrals of Consumption: The European Department Store, 1850–1939.* Aldershot, Hampshire, Eng., 1999.

Crow 1972: Crow, Duncan. *The Victorian Woman.* New York, 1972.

Crow 1996: Crow, Thomas. *Modern Art in the Common Culture.* New Haven, Conn., and London, 1996.

Curry 1984: Curry, David Park. *James McNeill Whistler at the Freer Gallery of Art.* New York, 1984.

Curry 1984a: ———. *Winslow Homer: The Croquet Game,* exh. cat., Yale University Art Gallery. New Haven, Conn., 1984.

Curry 1987: ———. "Total Control: Whistler at an Exhibition." *James McNeill Whistler: A Reexamination.* Ed. Ruth E. Fine. Studies in the History of Art, vol. 19. Washington, D.C., 1987, 67–82.

Curry 1990: ———. *Childe Hassam: An Island Garden Revisited.* New York, 1990.

Curry 1997: ———. "Never Complain, Never Explain: Elsie de Wolfe and the Art of Social Change." In *Cultural Leadership in America: Art Matronage and Patronage,* Isabella Stewart Gardner Museum, Boston, 1997, 52–78.

Curry 1998: ———. "Portals to Gardens of the Mind." In *A Covenant of Seasons: Monotypes by Joellyn Duesberry, Poems by Pattiann Rogers.* New York, 1998, 128–51.

Curry et al. 1997: Curry, David Park, Elizabeth O'Leary, and Susan Jensen Rawles. *American Dreams, Paintings and Decorative Arts from the Warner Collection,* exh. cat., Virginia Museum of Fine Arts. Richmond, 1997.

Dalby 2000: Dalby, Andrew. *Dangerous Tastes: The Story of Spices*. Berkeley, 2000.

Davis 1999: Davis, John R. *The Great Exhibition*. Thrupp, Stroud, Gloucestershire, 1999.

Davis 1991: Davis, Tracy C. *Actresses as Working Women: Their Social Identity in Victorian Culture*. London and New York, 1991.

De Goncourt 1881: De Goncourt, Edmond. *La maison d'un artiste*. 2 vols. Paris, 1881.

De Kay 1886: De Kay, Charles. "Whistler: The Head of the Impressionists." *The Art Review* (1886): 1–3.

Denis 1995: Denis, Rafael Cardoso. "The Educated Eye and the Industrial Hand: Art and Design Instruction for the Working Classes in Mid-Victorian Britain." Ph.D. diss., University of London, 1995.

Denker 1995: Denker, Eric. *In Pursuit of the Butterfly: Portraits of James McNeill Whistler*, exh. cat., National Portrait Gallery. Washington, D.C., 1995.

Denker 2003: ———. *Whistler and His Circle in Venice*. London, 2003.

Denny 1996: Denny, Barbara. *Chelsea Past*. London, 1996.

De Wolfe 1913: De Wolfe, Elsie. *The House in Good Taste*. New York, 1913.

Dickens 1839: Dickens, Charles. *Sketches by Boz Illustrative of Every-day Life and Every-day People* (1839). Ed. and Intro. Dennis Walder. London, 1995.

Donald 1996: Donald, Diana. *The Age of Caricature: Satirical Prints in the Reign of George III*. New Haven, Conn., and London, 1996.

Dorey et al. 2000: Dorey, Helen, et al. *A New Description of Sir John Soane's Museum*. 10th ed. rev. London, 2000.

Dorment 1994: Dorment, Richard, and Margaret MacDonald, with Nicolai Cikovsky, Jr., Ruth Fine, and Genevieve Lacambre. *James McNeill Whistler*, exh. cat., Tate Gallery. London, 1994.

Douglas 1977: Douglas, Ann. *The Feminization of American Culture*. New York, 1977.

Dudden 1994: Dudden, Faye E. *Women in the American Theatre: Actresses and Audiences, 1790–1870*. New Haven, Conn., 1994.

Du Maurier 1951: Du Maurier, Daphne, ed. *The Young George du Maurier, Letters, 1860–1867*. London, 1951.

Duveneck 1970: Duveneck, Josephine Whitney. *Frank Duveneck, Painter-Teacher*. San Francisco, 1970.

Duret 1904: Duret, Théodore. *Histoire de James McNeill Whistler*. Paris, 1904.

Eddy 1903: Eddy, Arthur J. *Recollections and Impressions of James A. McNeill Whistler*. Philadelphia and London, 1903.

Edelstein and Allen 1983: Edelstein, T. J., and Brian Allen. *Vauxhall Gardens*, exh. cat., Yale Center for British Art. New Haven, Conn., 1983.

Edis 1881: Edis, Robert W. *Furniture and Decoration of Town Houses*. London, 1881.

Eisenman 1986: Eisenman, Stephen. "The Intransigent Artist or How Impressionists Got Their Name." In *The New Painting: Impressionism, 1874–1886*. Eds. Charles S. Moffett et al. Ex. cat., The Fine Arts Museums of San Francisco, San Francisco, 1986, 51–59.

Eliot 1876: Eliot, George. *Daniel Deronda* (1876). Ed. with intro. and notes by Terence Cave. London, 1995.

Erenberg 1981: Erenberg, Lewis A. *Steppin' Out: New York Nightlife and the Transformation of American Culture, 1890–1930*. Westport, Conn., 1981.

Faberman 1996: Faberman, Hillarie. "'Best Shop in London': The Fine Art Society and the Victorian Art Scene." *The Grosvenor Gallery: A Palace of Art in Victorian England*. Eds. Susan P. Casteras and Colleen Denney. New Haven, Conn., and London, 1996, 147–58.

Fahlman 1980: Fahlman, Betsy. "Wilson Eyre in Detroit: The Charles Lang Freer House." *Winterthur Portfolio*, vol. 15, no. 3 (Autumn 1980): 257–70.

Fillin-Yeh 2001: Fillin-Yeh, Susan, ed. *Dandies: Fashion and Finesse in Art and Culture*. New York, 2001.

Fine 1984: Fine, Ruth. *Drawing Near: Whistler Etchings from the Zelman Collection*. Los Angeles, 1984.

Fine Art Society 1972: Fine Art Society. *Christopher Dresser, 1834–1904: Pottery, Glass, Metalwork*, exh. cat., Fine Art Society Ltd. London, 1972.

Fine Art Society 1976: ———. *One Hundred Years of Exhibitions at the Fine Art Society Ltd.*, exh. cat., Fine Art Society Ltd. London, 1976.

Fischer 2000: Fischer, Diane P., ed. *Paris 1900: The "American School" at the Universal Exposition*. New Brunswick, New Jersey, 2000.

Flanders 2003: Flanders, Judith. *The Victorian House: Domestic Life from Childbirth to Deathbed*. London, 2003.

Foreman 1998: Foreman, Amanda. *Georgiana, Duchess of Devonshire*. London, 1998.

Fort and Kates 1935: Fort, Alice B., and Herbert S. Kates. *Minute History of the Drama*. New York, 1935.

Frederick 1896: Frederick, Harold. *The Damnation of Theron Ware*. Chicago, 1896.

Frelinghuysen, et al. 1993: Frelinghuysen, Alice Cooney, Gary Tinterow et al. *Splendid Legacy: The Havemeyer Collection*, exh. cat., The Metropolitan Museum of Art. New York, 1993.

Friedman 1978: Friedman, Joan M. *Color Printing in England, 1486–1870*, exh. cat., Yale Center for British Art. New Haven, Conn., 1978.

Gagnier 1986: Gagnier, Regenia. *Idylls of the Marketplace: Oscar Wilde and the Victorian Public*. Stanford, 1986.

Garfield 2000: Garfield, Simon. *Mauve: How One Man Invented a Colour that Changed the World*. London, 2000.

Garrett 1989: Garrett, Elisabeth Donaghy. *At Home: The American Family, 1750–1870*. New York, 1989.

Gaskell 1853: Gaskell, Elizabeth Cleghorn. *Cranford* (1853). New York, 1980.

Gautier 1852: Gautier, Théophile. *Caprices et zigzags*. Paris, 1852.

Genevay 1880: Genevay, A. "Salon de 1880 (Huitième Article)." *Le Musée artistique et littéraire*, vol. 4 (1880): 14–15.

Gere 1989: Gere, Charlotte. *Nineteenth-century Decoration: The Art of the Interior*. New York, 1989.

Gere and Hoskins 2000: Gere, Charlotte, and Leslie Hoskins. *The House Beautiful: Oscar Wilde and the Aesthetic Interior*. Aldershot, Hampshire, Eng., 2000.

Gere and Whiteway 1994: Gere, Charlotte, and Michael Whiteway. *Nineteenth-century Design from Pugin to Mackintosh*. London, 1994.

Getscher 1970: Getscher, Robert H. *Whistler and Venice*. Ph.D. diss., Ann Arbor, 1970.

Getscher and Marks 1986: Getscher, Robert H., and Paul G. Marks, eds. *James McNeill Whistler and John Singer Sargent: Two Annotated Bibliographies*. New York and London, 1986.

Gibbs-Smith 1981: Gibbs-Smith, C. H. *The Great Exhibition of 1851*. 2nd ed. London, 1981.

Gibson 1893: Gibson, J. S. "Artistic Homes." *Studio* (September 1893): 226.

Gillman 1989: Gillman, Susan. *Dark Twins: Imposture and Identity in Mark Twain's America*. Chicago, 1989.

Gladstone 1922: Gladstone, Florence M. *Aubrey House, Kensington, 1698–1920*. London, 1922.

Glimcher 1976: Glimcher, Arnold B. *Louise Nevelson*. 2nd ed. New York, 1976.

Godwin 1874: Godwin, E. W. "The Loggia of the Manoir d'Ango." *Building News and Engineering Journal*, vol. 26 (10 April 1874): 392.

Godwin 1876: ———. "My House 'In' London," Parts 1–6. *Architect* (London), vol. 16 (15 July 1876): 33–34; "The Hall" (22 July 1876): 45–46; "The Dining-Room" (29 July 1876): 58–59; "The Drawing-Room" (5 August 1876): 72–73; "The Bedrooms" (12 August 1876): 86;

"Tops and Bottoms" (19 August 1876): 100–101.

Godwin 1879: ———. "Some Facts About 'The White House,' Chelsea." *British Architect and Northern Engineer*, vol. 12 (26 September 1879): 119.

Godwin 1879a: ———. "Studios and Mouldings." *Building News and Engineering Journal*, vol. 36 (7 March 1879): 261–62.

Godwin 1884: ———. "Letter No. 9 to Art Students," *British Architect and Northern Engineer*, vol. 21 (11 July 1884), 13.

Goebel 1988: Goebel, Catherine Carter. "Arrangement in Black and White: The Making of a Whistler Legend." 2 vols. Ph.D. diss., Northwestern University, 1988.

Goebel 1999: ———. "The Brush and the Baton: Influences on Whistler's Choice of Musical Terms for his Titles." *The Whistler Review. Studies of James McNeill Whistler and Nineteenth-century Art*, vol. 1 (1999): 27–36.

Grant 1880: Grant, Robert. *Confessions of a Frivolous Girl, A Story of a Fashionable Life*. Boston, 1880.

Grasselli and Rosenberg 1984: Grasselli, Margaret Morgan, and Pierre Rosenberg. *Watteau, 1684–1721*, exh. cat., The National Gallery of Art. Washington, D.C., 1984.

Graves 2002: Graves, Alan. *Tiles and Tilework of Europe*. London, 2002.

Graves 1906: Graves, Algernon. *The Royal Academy of Arts. A Complete Dictionary of Contributors and Their Work from Its Foundation in 1769 to 1904*. London, 1906.

Greenaway 1884: Greenaway, Kate. *The Language of Flowers* (1884). New York, 1978.

Greenwood 1876: Greenwood, John. *Low Life Deeps: An Account of the Strange Fish to be found there*. London, 1876.

Grieve 2000: Grieve, Alastair. *Whistler's Venice*. New Haven, Conn., and London, 2000.

Haill 1981: Haill, Catherine. *Victorian Illustrated Music Sheets*. London, 1981.

Hamerton 1876: Hamerton, P. G. *Etching and Etchers*. Boston, 1876.

Hamerton 1881: ———. "Art Chronicle." *Portfolio*, vol. 12 (January 1881): 20.

Hamilton 1882: Hamilton, Walter. *The Aesthetic Movement in England*. London, 1882.

Harvey 1995: Harvey, John. *Men in Black*. Chicago, 1995.

Haskell 1972: Haskell, Francis. "The Sad Clown: Some Notes on a Nineteenth-century Myth." *French Nineteenth-century Painting and Literature*. Ed. Ulrich Finke. Manchester, 1972, 2–16.

Hatton 1884: Hatton, Joseph. *Henry Irving's Impressions of America, Narrated in a series of sketches, chronicles, and conversations* (1884). New York, 1971.

Haweis 1878: Haweis, Mary Eliza Joy. *The Art of Beauty*. London, 1878.

Haweis 1879: ———. *The Art of Dress*. London, 1879.

Haweis 1881: ———. *The Art of Decoration*. London, 1881.

Heffernan 1993: Heffernan, J. A. W. *Museum of Words: The Poetics of Ekphrasis from Homer to Ashbery*. Chicago and London, 1993.

Henry 1986: Henry, O. [William Sidney Porter]. *Collected Stories of O. Henry*. Rev. ed. New York, 1986.

Herbert 1984: Herbert, Robert. "The Decorative and the Natural in Monet's Cathedrals." *Aspects of Monet*. Eds. John Rewald and Frances Weitzenhoffer. New York, 1984, 160–79.

Herbert and Huggins 1995: Herbert, Tony, and Kathryn Huggins. *The Decorative Tile in Architecture and Interiors*. London, 1995.

Hickey 1998: Hickey, Gary. "Hokusai Landscape Prints and Prussian Blue." *Proceedings of the Third International Hokusai Conference*. Obuse, Japan, 1998.

Hobbs 1996: Hobbs, Susan A. *The Art of Thomas Wilmer Dewing: Beauty Reconfigured*. Brooklyn, New York, 1996.

Hollander 1978: Hollander, Anne. *Seeing Through Clothes* (1978). London, 1988.

Hollander 1995: ———. *Sex and Suits: The Evolution of Modern Dress*. New York, 1995.

Holmes 1903: Holmes, E. Burton. *Round about Paris*. Paris Exposition, vol. 2, *The Burton Holmes Lectures, with Illustrations from Photographs by the Author*. 10 vols. Battle Creek, Michigan, 1903.

Hôtel de la monnaie 1977: Hôtel de la monnaie. *Pèlerinage à Watteau*, exh. cat., 4 vols., Hôtel de la monnaie. Paris, 1977.

House 1986: House, John. *Monet: Nature into Art*. New Haven, Conn., 1986.

House 1980: ———. "The Impressionist Vision of London." *Victorian Artists and the City: A Collection of Critical Essays*. Eds. Ira Bruce Nadel and F. S. Schwarzbach. New York, 1980, 78–90.

Howells 1866: Howells, William Dean. *Venetian Life* (1866). 2 vols. Boston and New York, 1892.

Huysmans 1884: Huysmans, Karl. *Against Nature* (1884). Trans. Margaret Mauldon. Ed. and intro. Nicholas White. Oxford, Eng., 1998.

Hyman 1976: Hyman, Linda. "*The Greek Slave* by Hiram Powers: High Art as Popular Culture." *Art Journal*, vol. 35, no. 3 (Spring 1976): 216–23.

Inaga 2001: Inaga, Shegami. "Claude Monet. Between 'Impressionism' and 'Japonisme.'" *Monet and Japan*. Eds. Virginia Spate, David Bromfield et al., exh. cat., National Gallery of Australia. Canberra, 2001.

Ivins 1943: Ivins, William Mills. *How Prints Look: Photographs with a Commentary*. New York, 1943.

Jaffer 2002: Jaffer, Amin. *Luxury Goods from India: The Art of the Indian Cabinet-Maker*. London, 2002.

James 1877: James, Henry. "The Picture Season in London." *The Galaxy*, vol. 24, no. 2 (August 1877).

James 1882: ———. "Venice." *The Century Magazine*, vol. 25, no. 1 (November 1882): 3–23.

James 1887: ———. "John S. Sargent." *Harper's New Monthly Magazine*, vol. 75, no. 449 (October 1887).

James 1897: ———. "The Grafton Galleries." *Harper's Weekly*, vol. 41 (June 26, 1897).

James 1899: ———. *The Awkward Age*. New York and London, 1899.

James 1909: ———. *Italian Hours*. Boston and New York, 1909.

Jarves 1864: Jarves, James Jackson. *The Art-Idea* (1864). Ed. Benjamin Rowland, Jr. Cambridge, Mass., 1960.

Jarves 1879: ———. "Art of the Whistler Sort." *New York Times*, 12 January 1879, 10.

Jensen 1994: Jensen, Robert. *Marketing Modernism in Fin-de-Siècle Europe*. Princeton, New Jersey, 1994.

Jervis 1974: Jervis, Simon. "'Sussex' Chairs in 1820." *Furniture History*, vol. 10 (1974): 99.

Jervis and Tomlin 1984: Jervis, Simon, and Maurice Tomlin. *Apsley House, Wellington Museum*. Rev. Jonathan Voak. London, 1995.

Johnson 1981: Johnson, Ronald W. "Whistler's Musical Modes: Symbolist Symphonies, Numinous Nocturnes." *Arts*, vol. 55 (April 1981): 174–75.

Jones 1856: Jones, Owen. *The Grammar of Ornament*. London, 1856.

Jones 1867: ———. *The Grammar of Chinese Ornament Selected from Objects in the South Kensington Museum and Other Collections* (1867). New York, 1987.

Joyes 1989: Joyes, Claire. *Monet's Table: The Cooking Journals of Claude Monet*. Trans. Josephine Bacon. New York, 1989.

Kant 1764: Kant, Immanuel. *Observations on the Feeling of the Beautiful and Sublime* (1764). Trans. John T. Goldthwait. Berkeley, 1991.

Kelly 1996: Kelly, Richard. *The Art of George du Maurier*. Aldershot, Hampshire, Eng., 1996.

Kimball 2003: Kimball, Roger. "Lessons from Juvenal." *The New Criterion*, vol. 12, no. 8 (April 2003): 4–8.

Kinchin 1998: Kinchin, Perella. *Taking Tea with Mackintosh: The Story of Miss Cranston's Tea Rooms*. Rohnert Park, California, 1998.

Kleeblatt 1999: Kleeblatt, Norman L., ed. *John Singer Sargent: Portraits of the Wertheimer Family*, exh. cat., The Jewish Museum. New York, 1999.

La Farge 1895: La Farge, John. *Considerations on Painting; lectures given in the year 1893 at the Metropolitan Museum of New York*. New York, 1895.

Lambourne 1996: Lambourne, Lionel. *The Aesthetic Movement*. London, 1996.

Lambourne 1999: ———. *Victorian Painting*. London, 1999.

Lancaster 1995: Lancaster, Bill. *The Department Store: A Social History*. London, 1995.

Laver 2002: Laver, James. *Costume and Fashion: A Concise History*. 4th ed. London, 2002.

Le Corbusier 1947: Le Corbusier, Charles-Édouard. *When Cathedrals Were White*. Tran. Francis E. Hyslop, Jr. New York, 1947.

Le Corbusier 1925: ———. *L'art décoratif d'aujourd'hui* (1925). Trans. and intro. James I. Dunnett. Cambridge, Mass., 1987.

Levine 1977: Levine, Steven. "Décor/Decorative/Decoration in Claude Monet's Art." *Arts Magazine* (February 1977): 136–39.

Levitine 1969: Levitine, George. "Girodet's New Danae: The Iconography of a Scandal." *Minneapolis Institute of Arts Bulletin*, vol. 58 (1969): 69–77.

Levy 1995: Levy, Michael. "The Importance of Watteau." *Rococo to Revolution: Major Trends in Eighteenth-Century Painting* (1966). London, 1995.

Lillie 1882: Lillie, Lucy C. *Prudence: A Story of Aesthetic London*. New York, 1882.

Lochnan 1984: Lochnan, Katharine. *The Etchings of James McNeill Whistler*. New Haven, Conn., and London, 1984.

Lochnan 2003: ———. "'Picturesque Grandeur and Noble Dignity': Whistler and the Historic Preservation Movement." *The Whistler Review. Studies of James McNeill Whistler and Nineteenth-century Art*, vol. 2 (2003): 37–46.

Loftie 1876: Loftie, William John. *A Plea for Art in the House, with special reference to the economy of collecting works of art, and*

the importance of taste in education and morals. Philadelphia, 1876.

Lucas 1921: Lucas, Edward Verrall. *Edwin Austin Abbey, Royal Academician: The Record of His Life and Work.* 2 vols. New York, 1921.

Lucas 1979: Lucas, George A. *The Diary of George A. Lucas: An American Art Agent in Paris, 1857–1902.* 2 vols. Trans. and intro. Lillian M. C. Randall. Princeton, New Jersey, 1979.

Lucic 1989: Lucic, Karen. "The Present and the Past in the Work of Charles Sheeler." Ph.D. diss., Yale University, 1989.

Lucic 1997: ———. *Charles Sheeler in Doylestown: American Modernism and the Pennsylvania Tradition.* Allentown, Penn., 1997.

Lynes et al. 2002: Lynes, Barbara Buhler, Charles C. Eldredge, and James Moore. *Georgia O'Keeffe and the Calla Lily in American Art, 1860–1940.* New Haven, Conn., 2002.

MacDonald 1975: MacDonald, Margaret F. "Whistler: The Painting of the 'Mother.'" *Gazette des Beaux-Arts,* February, 1975, 73–88.

MacDonald et al. 2003: MacDonald, Margaret F., Susan Grace Galassi, and Aileen Ribeiro, with Patricia de Montfort. *Whistler, Women, & Fashion.* New York, 2003.

MacDonald et al. 2003a: MacDonald, Margaret F., Kevin Sharp, Martha Tedeschi, Georgia Toutziari, and William Vaughan. *Whistler's Mother: An American Icon.* Aldershot, Hampshire, Eng., and Burlington, Vermont, 2003.

MacLeod 1996: MacLeod, Dianne Sachko. *Art and the Victorian Middle Class: Money and the Making of Cultural Identity.* Cambridge, Eng., 1996.

Malcolm 1985: Malcolm, John. *The Godwin Sideboard.* New York, 1985.

Mansfield 1909: Mansfield, Howard. *A Descriptive Catalogue of the Etchings and Drypoints of James Abbott McNeill Whistler.* Chicago, 1909.

Mantz 1859: Mantz, Paul. "L'école française sous la Régence, Antoine Watteau." *Révue Française,* vol. 16 (February–April 1859): 263–72, 345–53.

Mantz 1863: ———. "Salon de 1863. Peinture et Sculpture" *Gazette de Beaux-Arts,* vol. 15 (1863): 60–61.

Mantz 1880: ———. "Le Salon: VII." *Le Temps* (20 June 1880): 1.

Marillier 1920: Marillier, Henry Currie. *The Early Work of Aubrey Beardsley* (1920). New York, 1967.

Marra 1994: Marra, Kim. "Elsie de Wolfe Circa 1901: The Dynamics of Prescriptive Feminine Performance in American Theatre and Society." *Theatre Survey,* vol. 35 (May 1994): 100–119.

Marshall 1998: Marshall, Gail. *Actresses on the Victorian Stage: Feminine Performance and the Galatea Myth.* Cambridge Studies in 19th Century Literature and Culture, vol. 16. Cambridge, Eng., and New York, 1998.

Martineau et al. 2003: Martineau, Jane et. al. *Shakespeare in Art.* London, 2003.

Mathieu 1977: Mathieu, Pierre-Louis. *Gustave Moreau: Complete edition of the finished paintings, watercolors, and drawings.* Trans. James Emmons. Oxford, Eng., 1977.

May 2003: May, Stephen. "Whistler: the Stinging Butterfly." *Artnews,* vol. 102, no. 2 (Feb. 2003): 116.

Mayhew 1861–62: Mayhew, Henry. *London Labour and the London Poor* (1861–62). Intro. Victor Neuburg. London, 1985.

McKendrick et al. 1982: McKendrick, Neil, John Breser, and J. H. Plumb. *The Birth of a Consumer Society: The Commercialization of Eighteenth-Century England.* London, 1982.

McMullen 1973: McMullen, Roy. *Victorian Outside: A Biography of J. A. M. Whistler.* New York, 1973.

McNeil 1994: McNeil, Peter. "Designing Women: Gender, Sexuality, and the Interior Decorator, c. 1890–1940." *Art History,* vol. 17, no. 4 (December 1994): 631–657.

Menpes 1904: Menpes, Mortimer. *Whistler As I Knew Him.* London, 1904.

Menpes and Menpes 1904: Menpes, Mortimer, and Dorothy Menpes. *Venice* (1904). London, 1906.

Merrill 1992: Merrill, Linda. *A Pot of Paint: Aesthetics on Trial in 'Whistler v. Ruskin.'* Washington, D.C., 1992.

Merrill 1998: ———. *The Peacock Room: A Cultural Biography.* New Haven, Conn., 1998.

Mitchell and Roberts 1996: Mitchell, Paul, and Lynn Roberts. *Frameworks: Form, Function and Ornament in European Portrait Frames.* London, 1996.

Moers 1960: Moers, Ellen. *The Dandy.* Lincoln, Nebraska, 1960.

Muirhead and Monmarche 1932: Muirhead, Findlay, and Marcel Monmarche, eds. *The Blue Guides, North-Western France.* 2nd ed. London, 1932.

Munhall 1995: Munhall, Edgar. *Whistler and Montesquieu: The Butterfly and the Bat.* Paris, 1995.

Murger 1851: Murger, Henry. *Scènes de la Bohème* (1851). Trans. Norman Cameron. Intro. Michael Sadlier. London, 1949.

Nares 1957: Nares, Gordon. "Aubrey House, Kensington: The Home of the Misses Alexander." *Country Life,* vol. 121 (9 May 1957): 924–25.

Nead 2000: Nead, Lynda. *Victorian Babylon: People, Streets, and Images in Nineteenth-century London.* New Haven, Conn., and London, 2000.

Nicoll 1963: Nicoll, Allardyce. *The World of Harlequin, a Critical Study of the Commedia Dell'Arte.* Cambridge, Eng., 1963.

Nivelon 1737: Nivelon, F. *The Rudiments of Genteel Behavior.* London, 1737.

Nochlin 1971: Nochlin, Linda. *Realism.* London, 1971.

O'Callaghan 1976: O'Callaghan, John. "The Fine Art Society and E. W. Godwin." *Centenary 1876–1976.* London, 1976.

Ogborn 1998: Ogborn, Miles. *Spaces of Modernity: London's Geographies, 1680–1780.* New York and London, 1998.

O'Hagan 1900: O'Hagan, Anne. "Behind the Scenes in the Big Stores." *Munsey's Magazine,* vol. 22 (January 1900): 537.

O'Leary 1996: O'Leary, Elizabeth. *At Beck and Call: The Representation of Domestic Servants in Nineteenth-Century American Painting.* Washington, D.C., 1996.

O'Leary 1999: ———. "An Age of Surfaces: Aestheticism and American Painting in the Gilded Age." *Nineteenth Century,* vol. 19.1 (Spring 1999): 19–29.

O'Leary 2002: ———. "'You Start with Three Tubs': Laundry and Laundresses in the Maymont Era." *Maymont Notes,* vol. 2 (Fall 2002): 17–22.

Olson 1976: Olson, Donald J. *The Growth of Victorian London.* London, 1976.

Opperman 1977: Opperman, Hal N. "Jean Baptiste Oudry." Ph.D. diss., University of Chicago (1972). New York, 1977.

Ovenden 1997: Ovenden, Richard. *John Thomson (1837–1921) Photography.* Edinburgh, 1997.

Paine 1912: Paine, Albert Bigelow. *Mark Twain: A Biography, the personal and literary life of Samuel Langhorne Clemens.* 4 vols. New York, 1912.

Parry 1996: Parry, Linda, ed. *William Morris.* New York, 1996.

Pater 1873: Pater, Walter. *The Renaissance* (1873). Intro. Arthur Symons. New York, 1919.

Paulson 1965: Paulson, Ronald. *Hogarth's Graphic Works.* 2 vols. New Haven, Conn., and London, 1965.

Pearsall 1971: Pearsall, Robert. *The Worm in the Bud: The World of Victorian Sexuality.* London, 1971.

Pennell 1908: Pennell, E. R., and J. Pennell. *The Life of James McNeill Whistler* (1908), 6th ed. rev. Philadelphia and London, 1919.

Pennell 1921: ———. *The Whistler Journal.* Philadelphia, 1921.

Pevsner 1952: Pevsner, Nikolaus. *The Buildings of England.* Vol. 6, *London Except the Cities of London and Westminster.* Middlesex, Eng., 1952.

Pinero 1995: Pinero, Arthur Wing. *Trelawny of the "Wells" and Other Plays.* Intro. J. S. Bratton. Oxford and New York, 1995.

Poe 1840: Poe, Edgar Allan. "The Man of the Crowd." *Burton's & The Casket* (December 1840).

Poesner 1973: Poesner, Donald. "Watteau mélancolique; la formation d'un mythe." *Bulletin de la Société de l'Histoire de l'Art Français 1973* (1974): 345–61.

Pointon 1993: Pointon, Marcia. *Hanging the Head: Portraiture and Social Formation in Eighteenth-century England.* New Haven, Conn., and London, 1993.

Porter 1982: Porter, Roy. *English Society in the Eighteenth Century.* London, 1982.

Quill 2000: Quill, Sarah, comp. *Ruskin's Venice. The Stones Revisited.* Aldershot, Hampshire, Eng., 2000.

Quilter 1880: Quilter, Harry. "Whistler's 'Venice,' at the Fine-Art Society, New Bond Street." *The Spectator,* 11 December 1880.

Quilter 1882: ———. "The Grosvenor Gallery (First Notice)." *London Times,* 8 May 1882.

Rathbone and Shackelford 2001: Rathbone, Eliza E., and George T. M. Shackelford. *Impressionist Still Life.* New York, 2001.

Reade 1967: Reade, Brian. *Aubrey Beardsley.* New York, 1967.

Reepen et al. 1996: Reepen, Iris, with Irmela Breidenstein and Brigitte Hagedorn. *Chinoiserie: Möbel und Wandverkleidungen.* Bad Homburg vor der Höhe, 1996.

Reza 1994: Reza, Yasmina. *Art* (1994). Trans. Christopher Hampton. New York and London, 1996.

Ribeiro 1995: Ribeiro, Aileen. "'The Whole Art of Dress': Costume in the Work of John Singleton Copley." *John Singleton Copley in America,* exh. cat., The Metropolitan Museum of Art. New York, 1995, 103–15.

Ribner 2000: Ribner, Jonathan P. "The Thames and Sin in the Age of the Great Stink: Some Artistic and Literary Responses to a Victorian Environmental Crisis." *British Art Journal,* vol. 1, no. 2 (Spring 2000): 38–46.

Richards 1995: Richards, Paul. "Hi, Mom! She's Here for a Visit—and a Whistler Reappraisal." *The Washington Post,* 28 May 1995, G1.

Richardson and Stevens 1999: Richardson, Margaret, and MaryAnne Stevens, eds. *John Soane, Architect: Master of Space and Light,* exh. cat., Royal Academy of Arts. London, 1999.

Rimbaud 1873: Rimbaud, Arthur. *A Season in Hell* (1873). Trans. Paul Schmidt. Robert Mapplethorpe, photography. Boston, 1986.

Rix 1987: Rix, Brenda D. *Our Old Friend Rolly: Watercolours, Prints, and Book Illustrations by Thomas Rowlandson in the Collection of the Art Gallery of Ontario,* exh. cat., Art Gallery of Ontario. Toronto, 1987.

Robertson 1990: Robertson, Bruce. *Reckoning with Winslow Homer: His Late Paintings and Their Influence,* exh. cat., Cleveland Museum of Art. Cleveland, 1990.

Robinson 1951: Robinson, Kenneth. *Wilkie Collins: A Biography* (1951). London, 1974.

Rossetti 1865: Rossetti, William Michael. "The Royal Academy Exhibition." *Fraser's Magazine,* June 1865.

Rossetti 1867: ———. "Royal Academy Exhibition." *The Chronicle,* 25 May 1867, 210.

Sala 1859: Sala, George Augustus. *Twice Around the Clock.* London, 1859.

Scarry 1999: Scarry, Elaine. *On Beauty and Being Just.* Princeton, New Jersey, 1999.

Schott 2002: Schott, Ben. *Schott's Original Miscellany.* London, 2002.

Seale 1986: Seale, William. *The President's House.* 2 vols. Washington, D.C., 1986.

Shackelford 1984: Shackelford, George T. M. *Degas: The Dancers,* exh. cat., National Gallery of Art. Washington, D.C., 1984.

Shackelford and Holmes 1986: Shackelford, George T. M., and Mary Tavener Holmes. *A Magic Mirror: The Portrait in France,*

1700–1900, exh. cat., The Museum of Fine Arts Houston. Houston, 1986.

Shaffer 1988: Shaffer, Elinor. *Erewhoms of the Eye: Samuel Butler as Painter, Photographer, and Art Critic.* London, 1988.

Shakespeare 1961: Shakespeare, William. *The Complete Works of Shakespeare.* Ed. Craig Hardin. Glenview, Illinois, 1961.

Siewart 1996: Siewart, John. "Whistler's Decorative Darkness." *The Grosvenor Gallery: A Palace of Art in Victorian England.* Eds. Susan P. Casteras and Colleen Denny. New Haven, Conn., 1996.

Simon 1995: Simon, Marie. *Fashion in Art: The Second Empire and Impressionism.* London, 1995.

Simon 1996: Simon, Jacob. *The Art of the Picture Frame: Artists, Patrons, and the Framing of Portraits in Britain.* London, 1996.

Simpson 1997: Simpson, Marc. *Uncanny Spectacle: The Public Career of the Young John Singer Sargent.* New Haven, Conn., and London, 1997.

Smalley 1878: Smalley, George W. "A Harmony in Yellow and Gold." *New York Tribune,* 6 July 1878, 2. Reprinted in *American Architect and Building News,* vol. 4 (27 July 1878): 36.

Smeaton 2000: Smeaton, Suzanne. "On the Edge of Change: Artist-Designed Frames from Whistler to Marin." *The Gilded Edge: The Art of the Frame.* Ed. Eli Wilner. San Francisco, 2000.

Smith 2003: Smith, Henry. "Rethinking the 'Blue Revolution' in Ukiyo-e." *Hokusai and His Age.* Eds. Gian Carlo Calza and John T. Carpenter. Leiden, 2003.

Smith 1982: Smith, Jane S. *Elsie de Wolfe: A Life in the High Style.* New York, 1982.

Smith 1837: Smith, John. *A Catalogue Raisonné of the works of the most eminent Dutch, Flemish, and French painters…with a copious description of their principal pictures …and the names of the artists by whom they have been engraved.* London, 1837.

Smith 1980: Smith, Sheila M. "'Savages and Martyrs': Images of the Urban Poor in Victorian Literature and Art." *Victorian*

Artists and the City: A Collection of Critical Essays. Eds. Ira Bruce Nadel and F. S. Schwarzbach. New York, 1980, 14–29.

Smith and Thomson 1877–78: Smith, Adolphe, and John Thomson. *Street Life in London: With Permanent Photographic Illustrations.* London, 1877–78.

Solkin 1993: Solkin, David. *Painting for Money: The Visual Arts and the Public Sphere in Eighteenth-Century England.* New Haven, Conn., and London, 1993.

Soros 1999: Soros, Susan Weber, ed. *E. W. Godwin: Aesthetic Movement Architect and Designer.* New Haven, Conn., and London, 1999.

Soros 1999a: ———. *The Secular Furniture of E. W. Godwin with Catalogue Raisonné.* New Haven, Conn., 1999.

Soros and Arbuthnott 2003: Soros, Susan Weber, and Catherine Arbuthnott. *Thomas Jeckyll: Architect and Designer, 1827–1881.* New Haven, Conn., 2003.

Southworth 1941: Southworth, James. G. *Vauxhall Gardens: A Chapter in the Social History of England.* New York, 1941.

Spencer 1982: Spencer, Robin. "Whistler's Subject Matter: 'Wapping' 1860–1864." *Gazette des Beaux-Arts,* vol. v:1365 (October 1982): 131–42.

Spencer 1989: ———, ed. *Whistler: A Retrospective.* New York, 1989.

Spielmann 1895: Spielmann, M. H. *The History of 'Punch.'* New York, 1895.

Stamp 2001: Stamp, Gavin. "The Country Life View of Lutyens." *Country Life,* vol. 195 (10 May 2001): 125.

Stebbins et al. 2002: Stebbins, Theodore E., Gilles Mora, and Karen E. Haas. *The Photography of Charles Sheeler, American Modernist.* Boston, 2002.

Stein 1986: Stein, Roger. "Artifact as Ideology." *In Pursuit of Beauty: Americans and the Aesthetic Movement.* Eds. Doreen Bolger Burke et al., exh. cat., The Metropolitan Museum of Art. New York, 1986, 23–51.

Stephenson 2000: Stephenson, Andrew. "Refashioning Masculinity: Whistler, Aestheticism and National Identity." In *English Art, 1860–1914.* Eds. David Peters

Corbett and Lara Perry. Manchester, 2000, 133–49, 243–48.

Stern et al. 1983: Stern, Robert A. M., Gregory Gilmartin, and John Massengale. *New York, 1900: Metropolitan Architecture and Urbanism, 1890–1915.* New York, 1983.

Stubbs 1967: Stubbs, Burns A. *Paintings, Pastels, Drawings, Prints, and Copper Plates by and attributed to American and European Artists, together with a list of Original Whistleriana, in the Freer Gallery of Art* (1948). 2nd ed. Washington, D.C., 1967.

Sweeney 1989: Sweeney, John L. *Henry James: The Painter's Edge. Notes and Essays on the Pictorial Arts.* Madison, Wisconsin, 1989.

Swinburne 1866: Swinburne, Charles Algernon. *Poems and Ballads.* London, 1866.

Swinburne 1888: ———. "Mr. Whistler's Lecture on Art." *Fortnightly Review* (June 1888): 745–51.

───────────

Taine 1870: Taine, Hyppolyte. *Notes on England* (1870). Trans. and intro. Edward Hyams. London, 1957.

Tanizaki 1977: Tanizaki, Jun'ichiro. *In Praise of Shadows.* Trans. Thomas J. Harper and Edward G. Seidensticker. New Haven, Conn., 1977.

Tedeschi 2003: Tedeschi, Martha. "The face that launched a thousand images: Whistler's *Mother* and popular culture." *Whistler's Mother: An American Icon.* Ed. Margaret F. MacDonald. Aldershot, Hampshire, Eng., 2003, 121–41.

Thorpe 1994: Thorpe, Nigel, ed. *Whistler on Art: Selected Letters and Writings of James McNeill Whistler.* Washington, D.C., 1994.

Tinterow et al. 2002: Tinterow, Gary et al. *Manet/Velázquez: The French Taste for Spanish Painting,* exh. cat., Metropolitan Museum of Art. New York, 2002.

Toole-Stott 1958–71: Toole-Stott, Raymond. *Circus and Allied Arts; a World Bibliography, 1500–1970.* 4 vols. Derby, Eng., 1958–1971.

Trollope 1875: Trollope, Anthony. *The Way We Live Now* (1875). Ed. with intro. and notes by Sir Frank Kermode. New York and London, 2002.

Tuer 1885: Tuer, Andrew W. *Old London Street Cries and the Cries of To-day with Heaps of Quaint Cuts.* London, 1885.

Turner 1996: Turner, Jane, ed. *The Dictionary of Art.* 34 vols. London, 1996.

Twain and Warner 1873: Twain, Mark, and Charles Dudley Warner. *The Gilded Age: A Tale of Today.* Hartford, Conn., 1873.

Twain 2001: Twain, Mark. *How Nancy Jackson Married Kate Wilson and Other Tales of Rebellious Girls & Daring Young Women.* Ed. John Cooley. Lincoln and London, 2001.

Ullmann 1964: Ullmann, S. "New Patterns of Sentence Structure in the Goncourts." *Style in the French Novel.* Oxford, 1964, 121–45.

Van Hoogstraten 1991: Van Hoogstraten, Nicholas. *Lost Broadway Theaters.* New York, 1991.

Venturi 1966: Venturi, Robert. *Complexity and Contradiction in Architecture.* Intro. Vincent Scully. *The Museum of Modern Art Papers on Architecture,* vol. I. New York, 1966.

Vickery 1998: Vickery, Amanda. *The Gentleman's Daughter: Women's Lives in Georgian England.* New Haven, Conn., and London, 1998.

Walkley 1994: Walkley, Giles. *Artists' Houses in London, 1764–1914.* Aldershot, Hampshire, Eng., 1994.

Wallace Collection 1968: Wallace Collection. *Wallace Collection Catalogues: Pictures and Drawings.* 16th ed. London, 1968.

Ward 1991: Ward, Martha. "Impressionist Installations and Private Exhibitions." *The Art Bulletin,* vol. 73 (December 1991): 599–622.

Warner 1997: Warner, Malcolm, ed. *The Victorians: British Painting, 1837–1901,* exh. cat., The National Gallery of Art. Washington, D.C., 1997.

Waugh 1964: Waugh, Norah. *The Cut of Men's Clothes, 1600–1900.* London, 1964.

Wedd, Peltz, and Ross 2001: Wedd, Kit, Lucy Peltz, and Cathy Ross. *Creative Quarters: The Art World in London, 1700–2000.* London, 2001.

Wedmore 1879: Wedmore, Frederick. "Mr. Whistler's Theories and Mr. Whistler's Art." *Nineteenth Century,* vol. 6 (August, 1879): 334–43.

Wedmore 1883: ———. *Four Masters of Etching.* London, 1883.

Wedmore 1899: ———. *Whistler's Etchings, A Study and a Catalogue* (1886). 2nd ed. rev. London, 1899.

Weinberg et al. 1994: Weinberg, Barbara, Doreen Bolger, and David Park Curry. *American Impressionism and Realism: The Painting of Modern Life, 1885–1915,* exh. cat., The Metropolitan Museum of Art. New York, 1994.

Weinreb and Hibbert 1983: Weinreb, Ben, and Christopher Hibbert, eds. *The London Encyclopaedia.* London, 1983.

Wharton 1905: Wharton, Edith. *The House of Mirth* (1905). New York, 1969.

Wharton 1938: ———. *The Buccaneers* (1938), completed by Marion Mainwaring. London, 1993.

Whistler 1878: Whistler, James McNeill. "The Red Rag." *The World,* 22 May 1878. Reprinted in Nigel Thorpe, ed., *Whistler on Art: Selected Letters and Writings of James McNeill Whistler.* Washington, D.C., 1994, 51–53.

Whistler 1881: ———. *The Piker Papers. The Painter-Etchers' Society and Mr. Whistler.* London, 1881.

Whistler 1883: ———. "Mr. Whistler and His Critics." In *Etchings & Dry-points. Venice. Second Series,* exh. cat., Fine Art Society. London, 1883.

Whistler 1884: ———. *"Notes"—"Harmonies"—"Nocturnes,"* exh. cat. London, 1884.

Whistler 1885: ———. "Mr. Whistler's Ten o'Clock" (1885). Reprinted in Thorpe, ed., *Whistler on Art: Selected Letters and Writings of James McNeill Whistler.* Washington, D.C., 1994, 79–95.

Whistler 1890: ———. *The Gentle Art of Making Enemies as pleasingly exemplified in many instances, wherein the serious ones of this earth, carefully exasperated, have been prettily spurred on to unseemliness and indiscretion, while overcome by an undue sense of right.* London, 1890.

Whistler 1892: ———. *The Gentle Art of Making Enemies.* 2d ed. rev. and enl. London, 1892.

Wiener 1973: Wiener, Philip, ed. *Dictionary of the History of Ideas.* 5 vols. New York, 1973.

Wigley 1995: Wigley, Mark. *White Walls, Designer Dresses: The Fashioning of Modern Architecture.* Cambridge, Mass., 1995.

Wilde 1999: Wilde, Oscar. *Collins Complete Works of Oscar Wilde. Centenary Edition.* Ed. Merlin Holland et al. Glasgow, 1999.

Wilkinson 1987: Wilkinson, Nancy B. "Edward William Godwin and Japonisme in England." Ph.D. diss., University of California at Los Angeles, 1987.

Williams 1972: Williams, Lawrence. *I, James McNeill Whistler: An "Autobiography."* New York, 1972.

Wilner 2000: Wilner, Eli, ed. *The Gilded Edge: The Art of the Frame.* San Francisco, 2000.

Wilson 2003: Wilson, A. N. *The Victorians.* New York and London, 2003.

Wolff 1985: Wolff, Janet. "'The Invisible Flâneuse': Women and the Literature of Modernity." *Theory, Culture, and Society,* vol. 2, no. 3 (1985), reprinted in *Feminine Sentences,* Berkeley, 1990, 34–50.

Wood 1986: Wood, Christopher. *Tissot: The Life and Work of Jacques Joseph Tissot, 1836–1902.* London, 1986.

Wunder 1989: Wunder, Richard P. *Hiram Powers: Vermont Sculptor, 1805–1873.* 2 vols. Newark, Delaware, 1989–91.

Zola 1882: Zola, Émile. *Au bonheur des dames* (1882). Trans. Kristin Ross. Berkeley, 1992.

BIBLIOGRAPHY

441

Index

INDEX